# Curating Biocultural Collections

## Collections     A HANDBOOK

# Curating Biocultural Collections
## A HANDBOOK

**Edited by Jan Salick, Katie Konchar and Mark Nesbitt**

**Kew Publishing**
**Royal Botanic Gardens, Kew**

in association with
**Missouri Botanical Garden, St Louis**

First published in 2014 by
Royal Botanic Gardens, Kew
Richmond, Surrey, TW9 3AB, UK
www.kew.org

ISBN 978-1-84246-498-4
eISBN 978-1-84246-509-7

Distributed on behalf of the Royal Botanic Gardens, Kew in North America by the University of Chicago Press, 1427 East 60th Street, Chicago, IL 60637, USA

British Library Cataloguing in Publication Data
A catalogue record for this book is available from the British Library

Funding for the 2011 workshop, 'Biocultural Collections: Establishing Curation Standards', this volume and dissemination of this information was provided by National Science Foundation, Biological Research Collections Award # 1118808 to Dr Jan Salick.

Front jacket photograph by Ben Staver, showing ethnobotanical artefacts in the institutional and staff collections of Missouri Botanical Garden.

Project editor: Sharon Whitehead
Design, typesetting and page layout: Christine Beard
Production manager: Georgina Smith

Printed in Spain by GraphyCems

MIX
Paper from responsible sources
FSC® C007507

For information or to purchase all Kew titles please visit www.kewbooks.com or email publishing@kew.org

Kew's mission is to inspire and deliver science-based plant conservation worldwide, enhancing the quality of life.

Kew receives half of its running costs from Government through the Department for Environment, Food and Rural Affairs (Defra). All other funding needed to support Kew's vital work comes from members, foundations, donors and commercial activities including book sales.

## CONTACT DETAILS FOR EDITORS

JAN SALICK, PhD
Senior Curator
Missouri Botanical Garden
PO Box 299
St. Louis, MO 63166, USA
jan.salick@mobot.org

KATIE KONCHAR, MS
Formerly Research Specialist
Missouri Botanical Garden
katie.konchar@gmail.com

MARK NESBITT, PhD
Curator, Economic Botany Collection
Royal Botanic Gardens, Kew
Richmond, Surrey
TW9 3AB, UK
m.nesbitt@kew.org

## CONTRIBUTING AUTHORS

CATRINA T. ADAMS, Botanical Society of America, cadams@botany.org

MICHELE AUSTIN-DENNEHY, Smithsonian Institution National Museum of Natural History

SERGE BAHUCHET, Muséum National d'Histoire Naturelle, Paris, bahuchet@mnhn.fr

MICHAEL J. BALICK, The New York Botanical Garden, mbalick@nybg.org

HENRIK BALSLEV, University of Aarhus, Denmark, henrik.balslev@biology.au.dk

KAMAL BAWA, University of Massachusetts - Boston, kamal.bawa@umb.edu

LINDA S. BISHOP, Sitting Bull College, lakota_ethnobotanist@hotmail.com

HARVEY BLACKBURN, National Center for Genetic Resources Preservation, harvey.blackburn@ars.usda.gov

KIM BRIDGES, University of Hawai'i at Manoa, kim.bridges@gmail.com

ROBERT BYE, National Autonomous University of Mexico, Institute of Biology Botanical Garden, bye.robert@gmail.com

CAROLINE CORNISH, Royal Botanic Gardens, Kew, United Kingdom, c.cornish@kew.org

NEIL R. CROUCH, South African National Biodiversity Institute (SANBI) & University of KwaZulu-Natal, n.crouch@sanbi.org.za

SANGAY DEMA, National Biodiversity Centre, Ministry of Agriculture and Forests, Bhutan, sdema06@gmail.com

DAVID DIERIG, National Center for Genetic Resources Preservation, david.dierig@ars.usda.gov

DAVID ELLIS, International Potato Center, d.ellis@cgiar.org

GAYLE J. FRITZ, Washington University in Saint Louis, gjfritz@wustl.edu

ASHLEY GLENN, Missouri Botanical Garden, ashley-glenn@mobot.org

K. DAVID HARRISON, Swarthmore College & National Geographic Society, dharris2@swarthmore.edu

Robbie Hart, University of Missouri – Saint Louis, robbiehart@gmail.com

Katherine Herrera, The New York Botanical Garden, kherrera@nybg.org

Matthew Jebb, National Botanic Gardens of Ireland, matthew.jebb@opw.ie

Adrienne Kaeppler, Smithsonian Institution National Museum of Natural History, kaeppler@si.edu

Tom Klobe, University of Hawai'i Art Gallery, klobetm@hawaii.edu

Alyse Kuhlman, Missouri Botanical Garden, alyse.kuhlman@mobot.org

Wayne Law, The New York Botanical Garden, wlaw@nybg.org

Edelmira Linares, National Autonomous University of Mexico, Institute of Biology Botanical Garden, mazari@ibunam2.ibiolgia.unam.mx

Terrance Martin, Illinois State Museum, tmartin@museum.state.il.us

Will McClatchey, Botanical Research Institute of Texas, will.mcclatchey@gmail.com

Charles R. McManis, Washington University in Saint Louis, mcmanis@wulaw.wustl.edu

Jane Mt. Pleasant, Cornell University, jm21@cornell.edu

Deborah M. Pearsall, University of Missouri – Columbia, pearsalld@missouri.edu

John S. Pelletier, Washington University in Saint Louis, jpelletier@wustl.edu

Armand Randrianasolo, Missouri Botanical Garden, armand.randrianasolo@mobot.org

John Rashford, College of Charleston, rashfordj@cofc.edu

Cristina Rico Liria, independent conservator, cricoliria@gmail.com

Matthew H. Robb, de Young Museum / Fine Arts Museums of San Francisco, mrobb@famsf.org

Holly Ruess, USDA, Agricultural Research Service & University of Wisconsin-Madison, Holly.Ruess@ars.usda.gov

Karim Sariahmed, Swarthmore College, abdlkarim23@gmail.com

Pei Shengji, Kunming Institute of Botany, CAS, peishengji@mail.kib.ac.cn

Jim Solomon, Missouri Botanical Garden, jim.solomon@mobot.org

David Spooner, USDA, Agricultural Research Service & University of Wisconsin-Madison, david.spooner@ars.usda.gov

Viviane Stern da Fonseca-Kruel, Botanical Garden Research Institute of Rio de Janeiro, vfonseca@jbrj.gov.br

Michael B. Thomas, Joseph F. Rock Herbarium, University of Hawai'i at Manoa, mbthomas@ hawaii.edu

Jan Timbrook, Santa Barbara Museum of Natural History, jtimbrook@sbnature2.org

Tiziana Ulian, Royal Botanic Gardens, Kew, t.ulian@kew.org

Judith Warnement, Harvard University Botany Libraries, warnemen@oeb.harvard.edu

Alex C. Wiedenhoeft, USDA Forest Products Laboratory, awiedenhoeft@fs.fed.us

Andrew Wyatt, Missouri Botanical Garden, andrew.wyatt@mobot.org

Peter Wyse Jackson, Missouri Botanical Garden, peter.wysejackson@mobot.org

# Contents

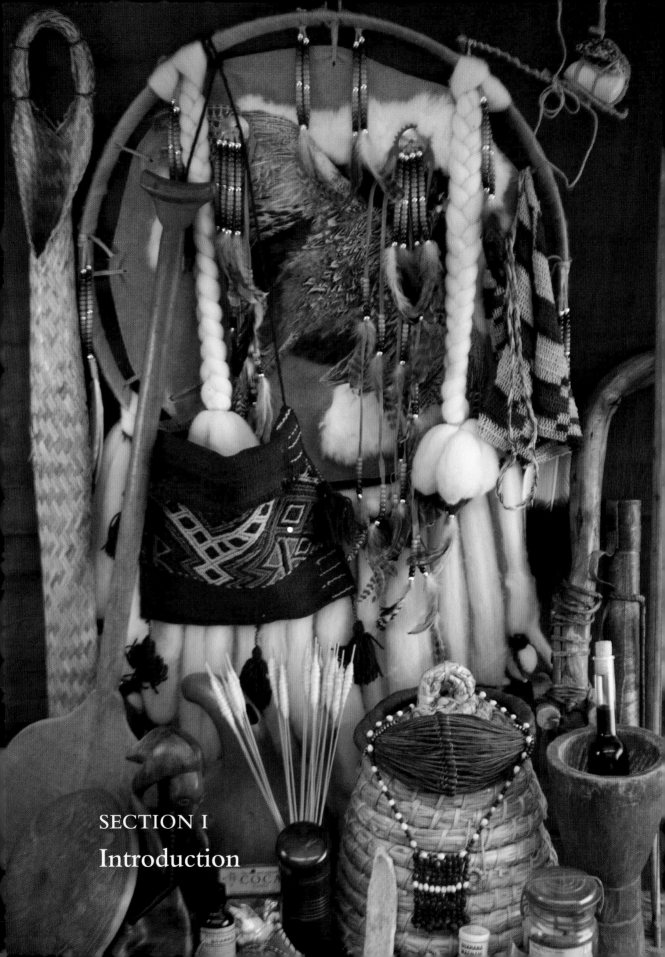

SECTION I

Introduction

# CHAPTER 1

# *Biocultural collections: needs, ethics and goals*

JAN SALICK

Missouri Botanical Garden

KATIE KONCHAR

Missouri Botanical Garden

MARK NESBITT

Royal Botanic Gardens, Kew

Biocultural collections are ethnobiological specimens, artefacts and documents — plant, animal and cultural — that represent dynamic relationships among peoples, biota, and environments (Ethnobiology Working Group, 2003). When thinking about Biocultural Collections, we must think broadly, considering ethnobiology, economic botany, ethnography, archaeology, geography, agriculture, medicine, linguistics, history, art and so on; we must think of large institutional collections and small local collections. It is important to stress that ethnobiology is a dynamic field in which processes, transformations and associations are central. For example, rice is more than a grain: it is planted, grown, domesticated, harvested, selected, cooked, eaten, made into paper, used as symbols and in ritual, and central cosmologically to many cultures. Capturing these dynamic relationships requires more than the collection of objects: documentation of their provenance, language, images, use, processing and ethnographic context — or metadata — are also crucial components.

Biocultural collections are numerous, diverse, and consummately useful, varying widely in size and scope from a few hundred specimens comprising the personal collection of a field ethnobotanist, to institutional collections containing hundreds of thousands of accessions. They include valuable botanical, zoological and ethnographic objects such as biological specimens, natural products and cultural artefacts from around the world, yet they are often neglected, deteriorating, orphaned and inaccessible. Many institutions have inadequate information and equipment to deal with the special curatorial needs of biocultural collections. Their collections languish in old cardboard boxes, abandoned in the back of herbaria or in storage rooms. (For example, The New York Botanical Garden's (NY) Henry Hurd Rusby collection suffered in this way before it was recently curated; Chapter 4.)

The amount of attention and resources devoted to biocultural collections is thus in stark contrast to their immense value. Historical collections form a kind of 'time capsule', preserving evidence of technologies, cultivars, uses and traditional knowledge that are changing or no longer extant, and often otherwise undocumented. Magnificent personal collections are routinely left undocumented and orphaned upon the retirement or death of the collector, and historically valuable biocultural collections rapidly deteriorate if left uncurated (cf. Kautz, 2000). For example, the Hugh Cutler (1912–1998) collection of some 12,000 corn cobs at Missouri Botanical Garden (MO) had been reduced to less than half its original size after sequential transfers among foster institutions.

## WHAT ARE BIOCULTURAL COLLECTIONS?

Briefly summarised, biocultural collections are repositories for plants and animals used by people, products made from them, and/or information and archives about them. They include any object made from plant and/or animal material, and especially those with a specific cultural connotation

or use. Also included is any object not made from plant or animal material but used in processing these materials (e.g. agricultural tools). Such objects often show informative signs of use and wear and can provide information about the plant or animal species for which they were used; they should be connected with records of observations regarding their use (Chapter 12). Any object used in spiritual or religious rituals that are associated with biological processes (e.g. rain dances for crop fertility, healing rituals, burial practices and so on) might be preserved as a biocultural collection. Representations in arts and crafts are also included. Additionally, any information or archives relating to the culture, language, creation, processing, or use of an object within a biocultural collection are essential data, which should be recorded in a way that connects it to that object.

Biocultural collections include:

- **Herbarium, xylarium and zoological specimens** with label information on use, preparation, common name or other cultural and linguistic information. Biocultural vouchers (specimens such as herbarium sheets that enable identifications to be verified) ensure identity and reproducibility, foundations of the scientific method (see Bye 1986, Chapter 22) that enable knowledge of plant and animal uses and processing to be preserved, maintained, and/or renovated.

- **Unprocessed economically useful plant and animal parts:** plant seeds, fruits, roots, leaves, flowers, bark, tubers and so on; animal horn, bone, skin, hair, gut and so on.

- **Plant and animal products and processes** from art, clothing, and commercial food and medicine products to tools, religious artefacts, toys or even refuse. Such objects include: plant and animal fibres (wood, paper, cloth, skin and so on); plant and animal extracts (varnish, starch, latex, resins, waxes, oils, essential oils and so on); processes and tools that transform raw plants and animals into finished products; and medicinal plant and animal products from unprocessed materials to herbal supplements and patented medicines.

- **Ethnographic materials and cultural artefacts** from buttons to boats, items made from or used in processing plant and animal materials, and information regarding an object's cultural or religious context.

- **DNA collections:** frozen tissue or extracted DNA samples from useful plants and animals and their wild relatives.

- **Live collections:** *in situ* and *ex situ* collections of useful plants and animals, including germplasm, tissue in culture, seeds and semen.

- **Palaeoethnobotanical and zoological materials:** archaeological plant and animal remains and modern reference collections.

- **Biocultural documentation:** libraries and archives including cultural texts, research field notes, maps (geographic information system (GIS), electronic or paper), audio and linguistic collections, photo and video archives, ethnobiological prints, and any illustrative materials that depict the products or processing of raw plant or animal materials (books, photographs, prints, drawings, paintings, models, digital images, audio and video).

The breadth and diversity of the biocultural collections described above can provide us with a great wealth of knowledge and documentation about animals and plants and the human cultural practices surrounding their use. However, variety in form and function also creates difficulties in curating, databasing and accessing these materials. A single institution may include some or all types of biocultural collections, each of which is curated differently.

## IMPACTS OF BIOCULTURAL COLLECTIONS

Plants, fungi and animals that have diverse subsistence, cultural, religious and historical uses are the foundation of biocultural collections, and thus biocultural collections have value for a community of users that extends far beyond those involved in basic scientific research. These collections can also be employed in many forms of applied research, including the conservation of plants, animals, and traditional knowledge, natural resource management, and economic and social development, education and community service.

- **Scientific research.** Biocultural collections are used in the biological sciences for taxonomic, morphological, molecular, population, ecological, and global-change research. Additionally, they are used in anthropology, archaeology, chemistry, history, philosophy and other research fields (Chapter 21).

- **Applied research.** Biocultural collections are of vital importance in the applied fields of agriculture, medicine, chemistry, nutrition and horticulture, among others. They provide a valuable record of human innovations in these fields across space and time, and enable cross-cultural perspectives on the value of plants in human societies. Biocultural collection vouchers ensure identity and reproducibility, foundations of the scientific method that enable knowledge of plant and animal uses to be preserved and maintained (Chapter 22).

- **Conservation.** Ethnobiology is a powerful tool, both in conservation (Chapter 23) and for cultural survival (e.g. Redford & Padoch, 1992; Salick & Moseley, 2012). Biocultural collections document local traditions, practices and knowledge, while simultaneously demonstrating the value of particular species. The conservation of useful plants is a major issue of two-fold importance: first, many useful plants are threatened by over-harvesting (e.g. Charron & Gagnon, 1991), and second, people easily understand that the conservation of useful plants is important, thus increasing overall concern for plant and animal conservation. Many collections are historical, they can be used to trace changes in plant and animal populations, patterns of use or landraces (Chapters 21–23). *In situ* and *ex situ* conservation of genetic resources and associated vouchers also play major roles in biocultural collections (Chapters 7, 8 and 10).

- **Natural resource management and development.** New crop development, crop improvement, public health, horticulture and natural resource management often deal with biocultural collections, either by depositing vouchers or by documenting information on indigenous practices and traditional knowledge. Plant genetic resources are components of biocultural collections and the backbone of the development of improved crops, horticultural plants and pharmaceutical products.

- **Education and training.** Today, ethnobiology is a very popular area of study, both with the general public and in academia (Chapter 24). Institutions that house biocultural collections continually receive students at all levels (from children in kindergarten to post-doctoral fellows) and teachers, who visit collections to look for information and investigate research topics. Biocultural materials are extremely valuable in teaching. Students understand the importance of natural resources more easily when they can appreciate their benefits to people as sources of food, fibre, and medicine.

- **Community service.** Local communities relate strongly to ethnobiology, expressing interest both in the study of indigenous peoples and their uses of plants and in local applications for gardening, horticulture and grocery-store botany. Ethnobiological collections, displays, and gardens have high rates of visitation by the community, and biocultural collections materials are in constant use for public programming (Chapter 10).

• **Preservation and restitution of traditional knowledge.** Biocultural collections are host to plants and animals, and materials and objects made from them, that have disappeared from their source communities. Their recovery forms a key part of many initiatives aimed at protecting and reviving the culture, landscape and economy of indigenous societies. Museums, genebanks and other repositories have responded through many changes to curatorial and access policies in the last two decades; more remains to be done (Chapters 17–20).

## TRANSFORMING BIOCULTURAL COLLECTIONS

### Biocultural Collections Group

More than a decade ago, we set up the Biocultural Collections Group to conserve, protect and strengthen biocultural collections. Starting in 2001, individual curators and institutional representatives began to organise meetings within and among many societies and institutions (Table 1). These meetings have explored many topics of concern to those working with biocultural collections in order to identify and discuss our common needs and goals. Our aims include identifying and characterising collections, setting standards for and educating others about collection curation and databasing, communicating ethical standards for collection and curation, funding collections, identifying collection curators and scientists, initiating collaboration among existing collections, and facilitating the identification of threatened and orphaned collections and their transfer into active collections.

### Locating biocultural collections and their curators

Until recently, there has been no inventory of biocultural collections. Aside from prominent collections with active researchers, we often do not know where biocultural collections are, what they contain, or who are the associated researchers and curators. There is nothing equivalent to *Index*

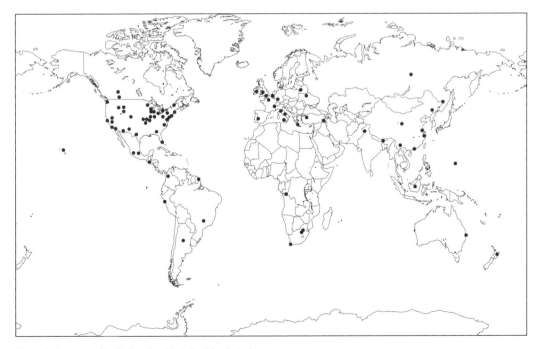

**Figure 1.** Locations of institutions listed in *Index Ethnobotanices*.

*Herbariorum* (Thiers, n.d.) for biocultural collections, and this limits researchers' abilities to find, study and reference collections. It also limits the capability of curators to address common problems of biocultural collections jointly. Recently, we have been trying to meet this need by constructing *Index Ethnobotanices*, a resource analogous to *Index Herbariorum*. Data are generated from the institutions and people who participate in meetings (see Table 1) and by emails to workers at collections listed in *Index Herbariorum* asking about their existing biocultural collections, what kinds of collections they have, where they are located, and who is in charge of curation. A preliminary database, *Index Ethnobotanices*, is now available; it includes an index of institutions housing biocultural collections and a directory of experts.

## TABLE 1

### Meetings of the Biocultural Collections Group 2001–2014

Initials in brackets indicate the *Index Herbariorum* code of the host institution (where applicable).

- First Annual Biocultural Collections Meeting, Bishop Museum (BISH), Hawai'i, USA, 2001.

- Ethnobiologia, Open Forum on Collections for Ethno- and Economic Botany, Naples, Italy, 2001.

- NSF Workshop 'Intellectual Imperatives in Ethnobiology', Missouri Botanical Garden (MO), USA, 2002.

- Second Annual Biocultural Collections Meeting, American Museum of Natural History, New York, USA, 2002.

- Natural Science Collections Alliance Annual Meeting, Washington DC, USA, 2002 (special session on biocultural collections).

- Third Annual Biocultural Collections Meeting, Arizona Sonora Desert Museum (ASDM), Tucson, USA, 2003.

- Fourth Annual Biocultural Collections Meeting, Royal Botanic Gardens, Kew (K), United Kingdom, 2004 (with the International Society of Ethnobiology, Kent).

- Fifth Annual Biocultural Collections Meeting, Chiang Mai, Thailand, 2005 (with the Society of Economic Botany).

- Sixth Annual Biocultural Collections Meeting, Field Museum (F) in Chicago, USA, 2007.

- Seventh Annual Biocultural Collections Meeting, Fayetteville, Arkansas, USA, 2008 (with the Society of Ethnobiology).

- IUBS Committee on Biology & Traditional Knowledge, Missouri Botanical Garden (MO), USA, 2009.

- Eighth Annual Biocultural Collections Meeting, British Columbia Provincial Museum (V), Canada, 2010 (with the International Society of Ethnobiology, Victoria, British Columbia).

- Ninth Annual Biocultural Collections Meeting, St. Louis (MO), USA, 2011 (Botanical Society of America and Society for Economic Botany).

- Tenth Annual Biocultural Collections Meeting, Herbiers de l'Institut Botanique de Montpellier (MPU), France, 2012 (with the International Congress of Ethnobiology).

- Biocultural Collections Workshop on Citizen Science at Society of Ethnobiology meeting, University of North Texas (NTSC), USA, 2013.

- Eleventh Annual Biocultural Collections Meeting, Royal Botanic Gardens, Kew (K), United Kingdom, 2013 (with the Society for Economic Botany meeting at the Eden Project and in Plymouth).

- Twelfth Annual Biocultural Collections Meeting, National Biodiversity Centre, Thimphu (THIM), Bhutan, 2014 (with the International Congress of Ethnobiology, Bhutan).

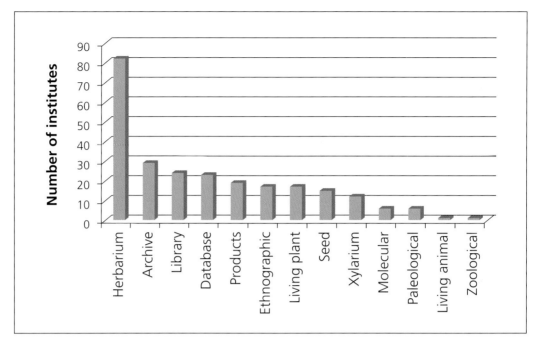

**Figure 2.** Types of biocultural collections in 112 participating institutes surveyed from 2007 to 2009 for *Index Ethnobotanices*. The predominance of herbarium collections is the result of using *Index Herbariorum* to identify potential holdings.

We can see that the distribution of biocultural collections listed in *Index Ethnobotanices* to date is worldwide (Figure 1) but far from complete. Additionally, we can glimpse the wide variety of collection types housed at these institutions (Figure 2). Collections are biased towards herbarium specimens because we contacted institutions through *Index Herbariorum*. In the future, we hope that the websites of biocultural collections and the institutions that house them, curator and researcher web pages and email contacts (with prior informed consent), and online databases and images will be linked to an operational *Index Ethnobotanices*. Please encourage your colleagues and institutions to join our Index online.

## KEY ISSUES FOR BIOCULTURAL COLLECTIONS

During meetings of the Biocultural Collections Group and in editing this book, we have identified several cross-cutting issues that limit biocultural collections: curation standards, databasing and digitisation of images, access and use, ethics, collaboration with indigenous or source communities, funding and staff. Each of these is central to the chapters in this book; here, we draw together these themes, and set out some aspirations for biocultural collections in the near future.

### Curation standards

Because of the varied physical and digital formats they must encompass, and because of the rich data and variety of specimens that can be associated with ethnobiological collections, standard herbarium or zoological curation methods are insufficient for biocultural collections. They require their own curatorial standards, collated from the curation protocols of many other collection types (e.g. McGuire et al., 1993). This book draws from a variety of resources to cover, for example, ethnographic and archaeological artefacts characteristic of biocultural collections (Chapters 2, 5, 6). There are many

curation manuals for the cultural museum sector, many available online, and an important function of this book is to summarise and draw attention to these resources.

Responsibility for improved curation does not lie with curators alone. Collectors must also pay closer attention to the fate of their specimens, to access protocols and permissions and to the sustainability of curation. Sometimes, ethnobiological materials can be collected in multiples, so it is possible to choose multiple depositories to meet varying needs. The well-known ethnobiologists Brent and Elois Berlin are a positive example: recently, they donated their archives and 25,000 voucher specimens to the Smithsonian Institution (US).

## Databases and images

Biocultural collections need to be inventoried and stored electronically; common database terminology needs to be used for cross referencing among collections. Now, inter-operable software and Application Programming Interfaces (APIs) make it possible to search disparate biocultural collections simultaneously across multiple databases. However, biocultural-collection databases first need to be reviewed to implement common standards where possible, and tables of equivalencies should be defined when required (Chapter 11). Databasing and digitisation are a vital element of increased access and use. Searches across multiple collection databases have the potential to virtually reunite dispersed collections, and to reveal unexpected intersections of specimen data and themes among museums and across disciplines.

Few websites have images of their biocultural collections online, but when such resources exist, they are visited frequently. At Missouri Botanical Garden, for example, a website that includes historical images of useful plants has received over 9 million hits per year (www.botanicus.org) and sales of historical images of useful plants are brisk. People are using images of useful plants and animals in all walks of life for education, publication, advertisement, demonstration and decoration, as well as in scientific and humanities research. Biocultural collections and individual ethnobotanists have huge collections of useful plant and animal images, yet these are overwhelmingly unavailable and undocumented.

## Access and use

Underused collections are the most vulnerable, both because it is difficult to make a good case for sustained funding and because when damage occurs to specimens, for example through attack by pests, it will not be noticed until too late. The disadvantage that biocultural collections often suffer in not fitting within narrowly defined institutional missions is also their strength: as an archive of specimens that represent human–nature relationships, they appeal to highly diverse audiences, both in terms of academic disciplines and in terms of background. The key to unlocking these uses and engaging new audiences is collaboration with academic researchers from multiple disciplines, teachers, artists, volunteers and source communities. Our experience is that ethnobiological specimens, particularly artefacts, and the stories that underlie their creation, are charismatic and well able to attract new users. Improving user access to collections, however, requires consideration of artefact preservation (Chapter 2), user safety (Chapter 4), and ethics (Chapters 17–19).

## Ethics

Biocultural collections face special problems of intellectual property that must be addressed before these collections are put into broad usage (Ethnobiology Working Group, 2003; Simmonds, 2009; Chapter 16). Two valuable reviews of ethics in ethnobiology are those by Hardison & Bannister (2011)

and Gilmore & Eshbaugh (2011). The latter propose five critical questions that every ethnobiologist — and, we would argue, every curator — should ask themselves:

1. Have you received proper permission to conduct and publish your research?
2. Have you thought about and incorporated local needs, challenges and priorities into the research project?
3. Who is benefitting from the research and how are collaborating communities and individuals being compensated?
4. How will the results of the research project be shared and used?
5. Are the interests of collaborating communities and individuals being acknowledged and protected when disseminating research results?

## ETHICAL STANDARDS IN ETHNOBIOLOGY

Ethical Standards in Ethnobiology is a collaborative statement of the Ethnobiology Working Group (2003) and was generated during the National Science Foundation Biocomplexity Workshop 'Intellectual Imperatives in Ethnobiology'.

When scientists who are located at different institutions choose to conduct collaborative research, they commonly develop a written agreement outlining the elements of the collaboration including responsibilities, potential benefits, intellectual property agreements, and distribution of results. These agreements are usually intended to protect institutional, individual and collective intellectual property that is developed or identified within the context of the collaboration. This is a crucial and complex requirement of research in general, and of ethnobiology research in particular.

Even the most theoretical, intellectual and non-commercial ethnobiology researcher cannot escape the fact that their research impinges on the local people with whom they work. Researchers working with local or traditional peoples are in a position of trust at the interface between cultures. Ethnobiologists therefore find themselves in a position where the research process of gathering and publishing data raises many ethical questions. In some cases, ethnobiological knowledge is only obtained from traditional specialists after the ethnobiologist has established credibility within that community and with the specialists concerned. Detailed information can often only be obtained after an extended period of interaction. Researchers inescapably must earn trust to do their work, as ethnobiology is not only the study of people and their relationship to the natural world, but also a field of study that involves local people as colleagues, teachers and research participants. We consequently enter into 'collaborations' in which academic institutions and individual researchers form agreements with modern or customary governments, organisations, local communities or corporations that secure the value of intellectual property generated by or identified through the collaborative research process. Recognition of the unique intellectual contributions made by international research colleagues and their extended communities is a central theme in the ethical standards and unique perspectives of ethnobiologists. Ethical standards have also been widely recognised by groups of indigenous and local peoples as a necessary component of collaboration.

In the past, research has sometimes been undertaken without the sanction or prior consent of indigenous and traditional peoples, resulting in wrongful expropriation of cultural and intellectual heritage, and causing harm to and violation of rights of the affected peoples. The research process has often failed to build the capacity of traditional communities and collaborating countries. Aims, products, and local benefits of the research must be defined with local or indigenous communities so that the overall research will include issues of relevance to the community. In addition, research findings are often inaccessible to the indigenous or traditional peoples who provided the original data and knowledge, and benefit-sharing mechanisms for the commercial use of such knowledge or research findings are often lacking.

Researchers in ethnobiology need to encourage actively:

• **recognition of the intellectual contribution** made by local or indigenous communities and specialists — such as herbalists, beekeepers and skilled fishermen — in the development, identification and conservation of crop land races, new natural products and environmental services;

• **equitable distribution of benefits** obtained from the use of their resources (including genetic or chemical structure), to assist local communities and the conservation of biodiversity in their environment; and

• **technology transfer, infrastructure development, capacity building, community-based education programs, policy dialogue and local organisations** to better enable the development of crop varieties and natural products for the benefit of local and indigenous communities.

Codes of ethics, professional standards and research guidelines have been developed by professional societies in response to the problems that can arise in the research process. These include guidelines for best practice developed by the American Anthropological Association (AAA), the International Society of Ethnobiology (ISE), the Society for Economic Botany (SEB) and the Society for Ethnobiology (SE). Specific guidelines have also been developed by regional networks, such as the Manila Declaration developed by natural products chemists from the Asia-Pacific region and indigenous communities. Guidelines for codes of practice and for international agreements have also been developed; adherence to these codes is pivotal in peer-reviewed evaluation of research efforts.

The need for adherence to these professional standards has been recognised by national and international programs. This is a critical requirement if collaboration between international and traditional peoples is to take place. In addition, unless research is linked to the nationally defined priorities of partner countries and institutions, it is bound to be viewed with suspicion by both scientists and politicians in developing countries. For this reason, even when ethnobiology research has a theoretical focus, it is important to involve international partner research organisations and communities in the process of developing research objectives, to ensure that these goals address local needs and issues. In addition, research results need to be returned to research partners in an appropriate manner.

Prior to the conclusion of most collaborative research efforts, there are three important procedural steps. The first step is the verification of research results among the collaborators. The second step is determination of the final disposition of results (publication) and assignment of collective or individual intellectual property (authorship). Ethnobiologists approach the first step in two ways: first, international and local colleagues confirm the results and review final drafts of documents, and then the resulting documents are distributed within the communities in which information has been collected. Typically, special documents are generated that are suitable for local education efforts, are written in local languages, and contain information of interest to local communities, which might be of marginal interest to scientific communities. Approval to publish results is acquired from all knowledge stakeholders and any information that is considered to be sensitive, personal or socially controversial or derisive is deleted. The intellectual property rights of publications are assigned through co-authorship, major acknowledgement of contributions, or receipt of patents, trademarks, copyrights or other warrants of value recognised by the international community. In some cases, ethnobiologists may also need to honour local cultural traditions of intellectual property rights management and ownership in ways that may seem to be inconsistent with Western traditions. When in conflict, ethnobiologists are ethically obligated to honour the viewpoints of their host cultures and colleagues above those of their own cultures or institutions.

## CODES OF ETHICS

The following codes of ethics are essential resources:

*American Alliance of Museums. Code of Ethics for Museums.* www.aam-us.org/resources/ethics-standards-
        and-best-practices/code-of-ethics-for-museums
*American Anthropological Association. Code of Ethics.* www.aaanet.org/issues/policy-advocacy/upload/AAA-
        Ethics-Code-2009.pdf
*International Society of Ethnobiology. Code of Ethics.* http://ethnobiology.net/code-of-ethics/
*Museums Association. Code of Ethics for Museums.* www.museumsassociation.org/ethics
*Society for Economic Botany. Guidelines of Professional Ethics.* www.econbot.org/_about_/index.php?sm=03

For biocultural collections that are generated by fieldwork, questions about the collection, deposition and dissemination of specimens and data should have answers before collecting begins. Such agreements must be safely filed and should form part of a specimen's metadata. Access to some data may be limited (Chapter 11); for example, in order to avoid 'biopiracy', some communities and governments choose to limit access to use data. The chapters on indigenous perspectives in this volume (Chapters 17, 18 and 19) are a reminder to all curators and field workers of the necessity of listening to indigenous communities and working in true partnerships. Ethical collecting requires both meeting the legal requirements set out by international treaties (such as the Convention on Biological Diversity) and national legislation (Chapter 16), and the requirements set out by ethical codes (see Box 'Ethical standards in ethnobiology').

In the case of old specimens, an ethical perspective requires that we research and share their history, both for what it tells us about the circumstances of collection and because it allows specimens to be viewed in their cultural and biological context (Chapter 20). Here, as with new fieldwork, collaboration with source or indigenous communities is essential.

### Collaboration with indigenous peoples

Biocultural collections are obtained, housed and studied internationally; they are often collected from indigenous groups and may be utilised by indigenous groups as well as by scientific researchers and the public to document and preserve traditional knowledge. Equitable partnerships between indigenous groups and international institutions are crucial to the conscientious maintenance, improvement and repatriation (whether in virtual or physical form) of biocultural collections. Many cultural museums, particularly those with ethnographic collections, have actively engaged with indigenous peoples in recent times, leading to a rich body of experience that will assist biocultural collections in ethical behaviour and effective collaborations (see Chapters 17–19) (Kreps, 2009; Peers & Brown, 2003; Sullivan & Edwards, 2003; Sully, 2007).

## Funds and staff

A final issue that faces almost all biocultural collections is funding to pay for curation and curatorial staff. Biocultural collections are seldom mainstream institutional priorities, and so they seldom have a dependable funding stream. Our own initiatives are supported by individual grants that are intermittently funded and by individual commitments superseded by mainstream duties. We cannot curate collections only when funding is available. We find ourselves locked into a chicken and egg conundrum: it is difficult to collect and curate without funding or staff, but funding is not available until we have well-curated collections that demonstrate their utility. Our hope is that funding can be facilitated by collaboration; at any one institution we are a minority, but among multiple institutions and across many disciplines, many people are working with biocultural collections. If proposals are presented by a multitude of biocultural collections, the potential for funding might be increased.

The lessons of this experience are that those involved with biocultural collections must engage in a series of challenging partnerships: curators have obligations to the wider public, to trustees and to professional ethics; community representatives have obligations to represent their broader community, kinship and culture. We must require just and equitable material transfer agreements and intellectual knowledge partnerships between biocultural collections and indigenous groups worldwide in order to facilitate strong, collaborative and continuing relationships.

The rewards in terms of shared learning and power are of great value to all parties, and usually lead to improved curation and displays and often to fresh collecting activities. Starting such collaboration

may be a daunting prospect for a small museum, or one that is far away from the source communities, but collaboration with larger museums that already have such programmes can ease the way.

## SCOPE OF THIS BOOK

This book has grown out of a decade of meetings of the Biocultural Collections Group, during which we prioritised and ordered stages of a process into manageable projects. After identifying collections and curators, we turned to curation itself. As we can do little to improve biocultural collections until we know how to curate them, establishing standards for curation became our goal. This was the aim of the workshop, 'Biocultural Collections: Establishing Curation Standards' held 11 July 2011 at the joint Botanical Society of America and Society for Economic Botany meeting in St. Louis and funded by the National Science Foundation (NSF-BRC grant #1118808 awarded to Jan Salick, Missouri Botanical Garden).

It will be evident that none of the chapters stand alone but must be read in conjunction with others. Curation is a complex enterprise that requires familiarity with a wide range of topics. There is also substantial overlap between the role of, for example, botanic gardens and germplasm collections, or herbaria and artefact collections. In compiling this book, we strived to make the fundamentals of biocultural curation accessible in all their diversity to a wide audience. We are also aware of several biases in this book. Authors are naturally best informed about work within their own institution and their own country. We have worked with authors to broaden coverage, admittedly mainly drawing upon material in English language publications but also looking at work worldwide. We have sought to highlight the increasing recognition of biocultural collections from outside scientific institutions, for example in the form of community genebanks or amateur xylaria. Animals (Hunn, 2011) and fungi (Yamin-Pasternak, 2011) are under-represented in this volume, although much of the content is equally relevant to these important areas of study.

Our success in setting curation standards here will determine future funding. It is paramount that we dedicate ourselves to meeting the needs of biocultural collections. Setting and meeting rigorous standards at our participating institutions will immeasurably further our overarching goal of preserving, maintaining, and/or renovating our biocultural collections. It will enable us to take the next step in the process — collaborating among our biocultural collections to bring catalogues online, and to make them searchable from a joint website for world-wide use.

## Practical curation of biocultural collections

### Materials

The first chapters in this book (Chapters 2–10) are on the practical curation of physical collection materials. The great diversity of specimens and artefacts that make up biocultural collections present challenges for curation, including the provision of storage space and environmental conditions necessary for proper specimen preservation and accessibility. We asked authors to provide basic information and references relevant to the curation of each material type.

### Reference materials and metadata

The second group of chapters (Chapters 11–16) concerns ethnobiological data and archives in the form of paper and electronic records. With the shift to digital formats for field notes, photographs, recordings and data cataloguing and analysis, there are both wider possibilities for data generation (digital photography costs a fraction of film) but also of data loss (as files become corrupt or obsolete).

## Contexts and perspectives on biocultural collections

The third group of chapters (Chapters 17–20) presents and explores indigenous and western perspectives on biocultural collections. These are an important reminder that ethnobiological research is not neutral, but embodies conscious and unconscious biases in the observer. Much past research was carried out to appropriate knowledge and materials or to further an expansionist agenda that was actively harmful to the peoples studied. Modern ethnobiology takes place in partnership with indigenous peoples, but to achieve this, we must first acknowledge its history. Biocultural collections must also draw on the experience of ethnographic museums, which in recent times have entered into extensive partnerships with source communities, resulting both in better-curated and interpreted collections and in enhanced access by source communities to their cultural heritage.

## Broader impacts of biocultural collections

The fourth set of chapters (Chapters 21–26) describes the broader impacts and value of biocultural collections for use in scientific research, conservation, education and exhibition.

## Photo essays

An important role of this book is to showcase the diversity and potential of biocultural collections. We are grateful to many institutions and individuals who have freely provided photographs of their collections, featured both in chapters and as free-standing photo essays following this chapter.

## CONCLUSIONS

It is no coincidence that it was an ethnobiological exhibition of plant-derived foods and materials from the Mancos Cañon, seen at the 1893 Chicago World's Fair, that led J. W. Harshberger (1896) to write his seminal paper coining the term 'ethnobotany' and setting a research and educational agenda that is still relevant today. Over one hundred years later, with renewed interest from researchers and indigenous peoples in modern ethnobiology and great public interest in traditional life ways and sustainable livelihoods, biocultural collections are again recognised as rich resources of ethnobiological data and cultural heritage. We hope this book will play its part in unlocking the inspirational potential of biocultural collections within the framework of modern ethical curatorial standards.

## ACKNOWLEDGEMENTS

We are grateful to the National Science Foundation (Biological Research Collections Award #1118808 to Dr Jan Salick) for funding the workshop 'Biocultural Collections: Establishing Curation Standards' held in St. Louis in 2011, and to the Royal Botanic Gardens, Kew for publishing this volume. All manuscripts were circulated among workshop participants for review; we are also grateful to Peter Gasson, Kate Gold, William Milliken and Luba Dovgan Nurse for reviewing parts of the text and to Rhian Smith, who read the whole text. We also thank all those who supplied additional images.

## *Websites*

*Index Ethnobotanices*. http://ceeb.econbot.org/index.php?module=Pages&func=display&pageid=7

Thiers, B. *Index Herbariorum: a Global Directory of Public Herbaria and Associated Staff*. http://sweetgum.nybg.org/ih/

## *Literature cited*

Bye, R. A. (1986). Voucher specimens in ethnobiological studies and publications. *Journal of Ethnobiology* 6: 1–8.

Charron, D. & Gagnon, D. (1991). The demography of northern populations of *Panax quinquefolium* (American ginseng). *Journal of Ecology* 79: 431-445.

Ethnobiology Working Group (2003). *Intellectual Imperatives in Ethnobiology: NSF Biocomplexity Workshop Report*. Missouri Botanical Garden, St. Louis. www.econbot.org/pdf/NSF_brochure.pdf

Gilmore, M. P. & Eshbaugh, W. H. (2011). From researcher to partner: ethical challenges and issues facing the ethnobiological researcher. In: *Ethnobiology*, eds E. N. Anderson, D. Pearsall, E. Hunn & N. Turner, pp. 51–63. Wiley-Blackwell, Hoboken.

Hardison, P. & Bannister, P. (2011). Ethics in ethnobiology: history, international law and policy, and contemporary issues. In: *Ethnobiology*, eds E. N. Anderson, D. Pearsall, E. Hunn & N. Turner, pp. 27–49. Wiley-Blackwell, Hoboken.

Harshberger, J. W. (1896). The purposes of ethno-botany. *Botanical Gazette* 21: 146–154.

Hunn, E. S. (2011). Ethnozoology. In: *Ethnobiology*, eds E. N. Anderson, D. Pearsall, E. Hunn & N. Turner, pp. 213–230. Wiley-Blackwell, Hoboken.

Kautz, R. R. (2000). Archaeological artifact attrition: time's arrow and collection depletion. *Collection Forum* 14: 33–41.

Kreps, C. (2009). Indigenous curation, museums, and intangible cultural heritage. In: *Intangible Heritage*, ed. J. Smith & N. Akagawa, pp. 193–208. Routledge, Abingdon.

McGuire, P. E., Kimsey, L. S. & Gardner, S. L. (eds) (1993). *Management of University Biological Collections: A Framework for Policy and Practice*. Report No. 11. University of California Genetic Resources Conservation Program, Davis, CA.

Peers, L. & Brown, A. K. (eds) (2003). *Museums and Source Communities: a Routledge Reader*. Routledge, London.

Redford, K. H. & Padoch, C. (eds) (1992). *Conservation of Neotropical Forests: Working from Traditional Resource Use*. Columbia University Press, New York.

Salick, J. & Moseley, R. K. (2012). *Khawa Karpo: Tibetan Traditional Knowledge and Biodiversity Conservation*. Missouri Botanical Garden, St. Louis.

Simmonds, M. S. J. (2009). Opportunities and challenges for ethnobotany at the start of the twenty-first century. In: *Plant-Derived Natural Products: Synthesis, Function, and Application*, pp. 127–140. Springer, Dordrecht.

Sullivan, L. E. & Edwards, A. (2003). *Stewards of the Sacred*. American Association of Museums in cooperation with the Center for the Study of World Religions, Harvard University, Washington, DC.

Sully, D. (ed.) (2007). *Decolonising Conservation: Caring for Maori Meeting Houses Outside New Zealand*. Left Coast Press, Walnut Creek.

Yamin-Pasternak, S. (2011). Ethnomycology: fungi and mushrooms in cultural entanglements. In: *Ethnobiology*, ed. E. N. Anderson, D. Pearsall, E. Hunn & N. Turner, pp. 213–230. Wiley-Blackwell, Hoboken.

# FEATURED BIOCULTURAL COLLECTIONS

MISSOURI BOTANICAL GARDEN  *Biocultural Collection*

NATIONAL BOTANIC GARDENS OF IRELAND  *Economic Botany Collection*

NATIONAL MUSEUM OF NATURAL HISTORY, PARIS  *Ethnobiology Collections*

ROYAL BOTANIC GARDENS, KEW  *Economic Botany Collection*

SMITHSONIAN COLLECTIONS

KATIE KONCHAR & JAN SALICK

The Missouri Biocultural Collection includes artefacts collected locally and those associated with Missouri Botanical Garden research.

RIGHT Traditional Tibetan medicines. Wooden mortar for grinding, Shangri-la, Yunnan, China, 2012 (Salick 9948). In front, collected in the same location and year, from left to right: 'snow tea' lichen (*Thamnolia vermicularis*) (Salick 9927); saffron (*Crocus sativus*), a traditional medicine for colds, fevers, strength and digestion (Salick 9928); snow lotus (*Saussurea laniceps*), traditional medicine used for heart and 'women's diseases' (Salick 9926).

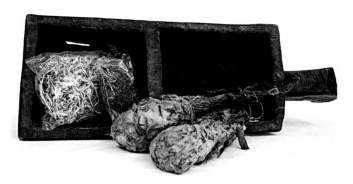

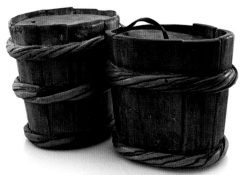

ABOVE Yak butter cheese moulds made of wood and bamboo ties, Shangri-la, Yunnan, China, 2012 (Salick 9922).

RIGHT Tibetan Buddhist religious objects: bell and 'thunderbolt' used by monks during the reading of scriptures, saying of prayers, and in ceremonies to punctuate and indicate power or sacred connections, Deqin, Yunnan, China, 2012 (Salick 9915). Buddhist prayer beads made from the sacred fig or Bhodi tree (*Ficus religiosa*), under which Buddha received enlightenment. Each set of prayer beads includes 108 sacred beads, Shangri-la, Yunnan, China, 2012 (Salick 9916).

LEFT Tibetan yak butter tea ritual: ornate painted yak butter tea churner, Shangri-la, Yunnan; hand-turned *Rhododendron* tea cups, Qiaotou, Yunnan; hand-turned maple (*Acer*) tsampa bowl, Qiaotou; hand-turned *Rhododendron* yak butter bowl, Qiaotou; brass tea pot, traditionally used to serve yak butter tea, Shangri-la; all China, 2012 (Salick 9903, 9909, 9908, 9910 and 9938).

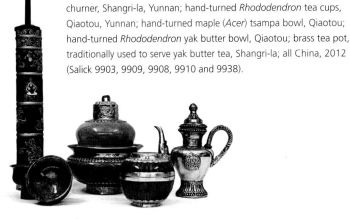

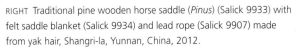

RIGHT Traditional pine wooden horse saddle (*Pinus*) (Salick 9933) with felt saddle blanket (Salick 9934) and lead rope (Salick 9907) made from yak hair, Shangri-la, Yunnan, China, 2012.

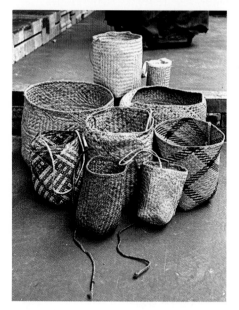

LEFT Malagasi baskets made from materials including raffia (*Raphia ruffia*, now *Raphia farinifera*), lakatra (*Ravenea lakatra*), harefo (*Eleocharis*) and herana (*Cyperus latifolius*).

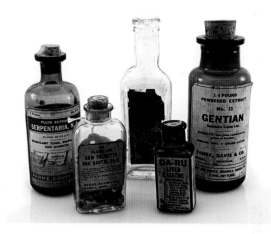

ABOVE 20th century botanical medicines: *Serpentaria*, saw palmetto (*Serenoa repens*) and santal oils; 'pain killing oil' (empty); DA-RU liver laxative and gentian powder bottle.

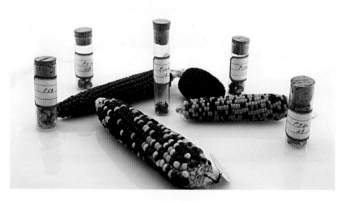

BELOW *Constantine's Rare Collection of the World's Fine Woods.*

ABOVE Cutler maize collection. *Zea mays* cobs and kernels from the Missouri maize collection (early to mid-20th century) were acquired largely through the efforts of Hugh Cutler and Edgar Anderson. These collections document the tremendous genetic diversity of indigenous and traditional maize before the introduction of hybrid varieties in the latter half of the 20th century and more recent genetically modified lines. Their 1942 classification of maize landraces was seminal to subsequent research on the origins of maize.

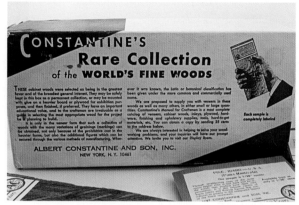

PHOTOS BY ANDREW DOLINKY, © MISSOURI BOTANICAL GARDEN.

Originally part of the collections of the National Museum of Ireland, the bulk of this collection was assembled during the 1890s by Professor Thomas Johnson. Currently, it includes about 5,500 items and continues to expand.

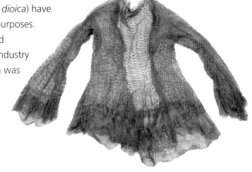

RIGHT Fibres from plants such as marsh mallow (*Althaea officinalis*) and nettle (*Urtica dioica*) have been used to make textiles for craft purposes. Dingle, County Kerry had a short-lived New Zealand flax (*Phormium tenax*) industry at the end of the 19th century, which was supported by Lord Ventry.

LEFT Lichens such as these were traditionally used for dyeing homespun wools.

RIGHT The Letterfrack basket industry. Miss Sophia Sturge established a thriving basket-making industry in Connemara in 1888, which exported baskets throughout Europe and to the Americas.

FAR RIGHT Sphagnum moss was used as a wound dressing during the First World War. It has remarkable properties for absorbing fluids, with deodorising and antiseptic properties. Irish women throughout the country gave up their evenings to collect moss and assemble these dressings.

PHOTOS © NATIONAL BOTANIC GARDENS OF IRELAND.

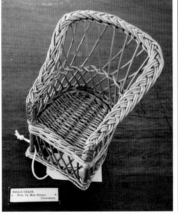

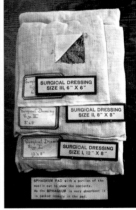

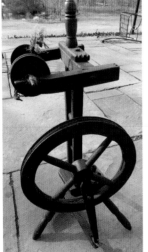

LEFT Flax spinning wheel. The huge textile industry of flax-growing and -spinning, especially in the north of Ireland, tends to dominate our view of a former Irish rural industry. A smaller cottage industry, based on basketry, spinning and weaving, was also a mainstay of many rural economies.
PHOTO © PETER WYSE JACKSON.

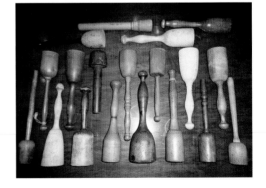

ABOVE RIGHT Wooden potato mashers from Europe and the United States, from the 19th and 20th centuries. Although potato mashers are certainly traditional Irish tools, a variety of similar designs and shapes can be found on both sides of the Atlantic Ocean. In general, fine-grained timbers are used for making such kitchen implements.
PHOTO © PETER WYSE JACKSON.

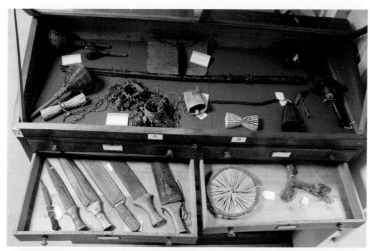

LEFT  Original display case showing African musical instruments, tools and traps.

LEFT  Bread loaves and stamps from central Asia.

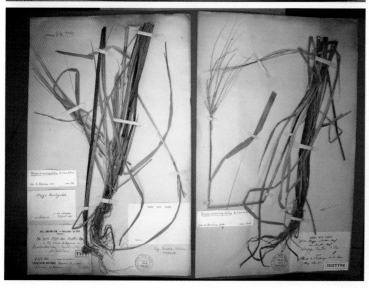

LEFT  Herbarium specimens of wild rice (*Oryza barthii*) from Africa.

BELOW  Date (*Phoenix dactylifera*) collections from North Africa.

PHOTOS © LE MUSÉUM NATIONAL D'HISTOIRE NATURELLE.

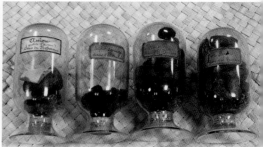

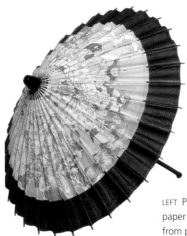

LEFT Parasol made from handmade paper (washi), made of the inner bark from paper mulberry, *Broussonetia papyrifera*. Collected by Sir Harry Parkes, Japan, 1870 (EBC 42852).

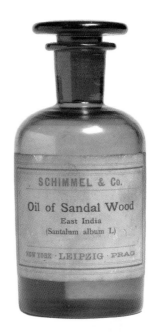

ABOVE Bonnet made from the inner bark of Jamaican lace-bark, *Lagetta lagetto*. Dated to about 1860, and conserved by Emily Brennan, 2009 (EBC44939).

RIGHT Two gourds of curare (*Strychnos toxifera*), collected by Richard Spruce in Guyana, about 1860 (EBC 49120).

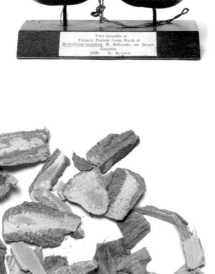

BELOW Fever bark ('kumbandzo'), *Holarrhena pubescens*. Collected by the botanist John Kirk on Dr Livingstone's Zambesi Expedition, central Africa, 1862 (EBC 49736).

ABOVE Sandalwood oil (*Santalum album*), one of the 10,000 *materia medica* given to Kew in 1983 by the Royal Pharmaceutical Society (EBC 77096).

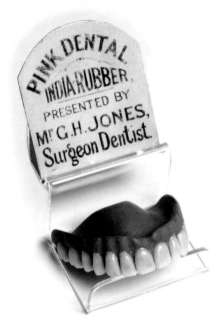

ABOVE Rubber denture (*Hevea brasiliensis*), given by G. H. Jones, 1850–1900 (EBC 44134).

ABOVE Bilum bag collected by H.M.S. Challenger at Humboldt Bay, New Guinea, 1875. Unidentified bast fibre, probably *Thespesia populnea* or *Hibiscus tiliaceus* (EBC 65858).

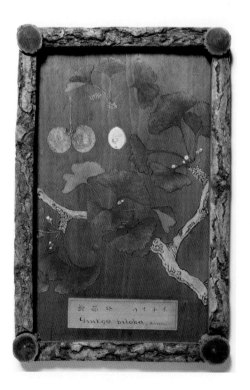

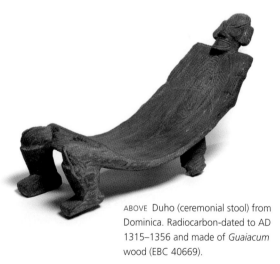

ABOVE Duho (ceremonial stool) from Dominica. Radiocarbon-dated to AD 1315–1356 and made of *Guaiacum* wood (EBC 40669).

LEFT Panel made of ginkgo wood and bark (*Ginkgo biloba*) and bearing a painting of ginkgo branches, leaves and fruits. Made for teaching in Japanese schools, University of Tokyo Botanical Gardens, 1878 (EBC 39979).

The Smithsonian Institution, the world's largest museum and research complex, includes 19 museums and galleries and the National Zoological Park. The total number of artefacts, works of art and specimens in the Smithsonian's collections is estimated at 137 million. The bulk of this material, 127 million specimens and artefacts, is part of the National Museum of Natural History. This includes the United States National Herbarium, founded in 1848, when the first collections were accessioned from the United States Exploring Expedition (50,000 specimens of 10,000 species). Current holdings total 5 million botanical specimens, many of which include ethnobotanical data. In addition, the Smithsonian maintains 2 million library volumes, including rare books and over 136,194 cubic feet of archival material. More than 8 million digital records are available through the Smithsonian Collections Search Center, an online catalogue containing most of the Smithsonian's major collections from museums, archives, libraries and research units, which includes images, videos, audio files, podcasts, blog posts and electronic journals (http://collections.si.edu/search).

## Smithsonian National Museum of Natural History

The collections of the National Museum of Natural History (NMNH) comprise the majority of the Smithsonian's collections, both in scope and in size, representing over 90% of the Institution's collections. Taken together, the collections cover the fields of anthropology, botany, vertebrate and invertebrate zoology, entomology, mineral sciences and palaeontology.

• Anthropology — artefacts and specimens representing cultures from around the world; contains one of the largest collections of North American Indian artefacts, including baskets, pottery, textiles and utilitarian objects.
• Botany — algae, bryophytes, lichens, dinoflagellates, ferns, flowering plants; US Herbarium collection includes pressed and bulky specimens, microslides and live plants in the glasshouse.
• Vertebrate zoology — mammals, birds, reptiles, fish, amphibians; collection includes birds' eggs and nests, fur pelts and elephant skulls.
• Invertebrate zoology — marine animals, including sponges, crayfish, molluscs, worms and shrimp.
• Entomology — butterflies and moths, mosquitoes and beetles; collection includes all 30 of the known orders of insects.
• Mineral sciences — gems, minerals, rocks and meteorites.
• Paleobiology — fossil flora and fauna, sharks' teeth, and microscopic organisms on slides.

These collections form the largest, most comprehensive natural history collection in the world. They serve as primary reference materials for exploring and understanding the solid Earth and planet, biological and cultural diversity, evolutionary relationships, biological conservation and global change. The museum's location in the heart of the nation's capital promotes the sharing of collections-based research findings with key decision makers from around the world.

A few examples from the NMNH Anthropology collection include:

(A) Stone food pounder for making poi (*pohaku ku'i poi*), Hawai'i. The staple food of the Hawaiians was made by mashing cooked *kalo* (*Colocasia esculenta*) corms. It was eaten fresh or fermented from beautiful wooden or gourd bowls. This unique pounder with an animal head was collected during the voyage of the United States Exploring Expedition (1838–1842), the founding collection of the Smithsonian Institution. (16 cm × 9 cm; Catalogue No. E3513-0, Department of Anthropology, Smithsonian Institution). (B) Feathered cape (*'ahu'ula*), Hawai'i. *'Ahu'ula*, red shoulder coverings, were worn by

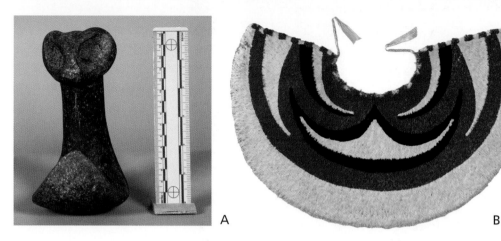

A          B

chiefs in the stratified society of Hawai'i, originally during sacred and dangerous situations, such as warfare and ceremonies. Feathers from honeycreepers or honeyeaters, such as *'i'iwi* (*Vestiaria coccinea*) and *'o'o* (*Moho nobilis*) were tied to a netted backing made of *olona fiber* (*Touchardia latifolia*). This 19th century example, known as the Po'omaikalani cape, is associated with the Maui Royal family. It was given to the Smithsonian institution in 1947 by Princess Abigail W. Kawananakoa. (Length 47 cm (18.75 in), width 93 cm (36.75 in); Catalogue No. E384228-0, Department of Anthropology, Smithsonian Institution.) Photo by Donald E. Hurlbert (Negative No. NHB2010-03984). Captions courtesy of Dr Adrienne L. Kaeppler, Curator of Oceanic Ethnology at the National Museum of Natural History, Smithsonian Institution. Photos © Smithsonian Institution: www.si.edu

## Anthropology Conservation Laboratory (ACL)

The Smithsonian Institution's Anthropology Conservation Laboratory (ACL), located in a modern facility in Maryland, functions as an integral component in the NMNH's Department of Anthropology and has stewardship of its ethnographic, archaeological and physical collections. These collections, gathered from cultures worldwide, are vast and varied. The artefacts in these collections include almost every natural material that humankind has manipulated and fashioned to support life on this planet. Recent projects at the ACL have included the conservation of diverse objects, ranging from Arctic grass baskets to Japanese lacquer Samurai armour and Great Lakes native copper. Understanding the nature of the basic raw materials, the plants, animals and minerals, and how they have been changed and modified for use is a key element in the long-term preservation of these collections. With the support of grants, an ACL team of conservators, interns and volunteers is currently focusing on Polynesian tapa (bark cloth) made primarily from the inner bark of the paper mulberry tree, as well as other plant sources documented in early ethnographic accounts (Figure 1).

Conservators have many resources available as they try to understand the story of each tapa, ranging from the original source materials of plants cultivated or harvested wild, to the manufacturing process utilising wooden beaters and embellishment with both plant- and mineral-based colorants, to the cultural function of each tapa, and finally to the long museum history of well-intentioned but often damaging long-term exhibition and/or overcrowded storage. Many written sources from early botanists and others visiting Polynesia, as well as from today's tapa makers, provide information about the traditional manufacture and collection of tapa. Museum documentation and staff research into the long history of exhibition and collections care at the museum helps conservators understand current object condition.

**Figure 1.** Barkcloth (kapa), Hawai'i. Made from the inner bark of certain plants, usually paper mulberry, which is known in Hawai'i as wauke (*Broussonetia papyrifera*). Cloth was made by stripping the outer bark, soaking the bast, and beating it with a four-sided carved wooden beater. The final beating often has an impressed watermark motif, that was carved into one side of the beater. This kapa was collected during the voyage of the US Exploring Expedition (1838–1842), the founding collection of the Smithsonian Institution. (180 cm × 395 cm; Catalogue No. E3603-0, Department of Anthropology, Smithsonian Institution).

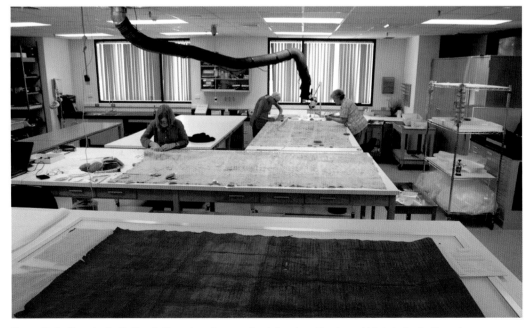

**Figure 2.** Smithsonian Institution Anthropology Conservation Laboratory. Courtesy of Michele Austin-Dennehy, Smithsonian Institution.

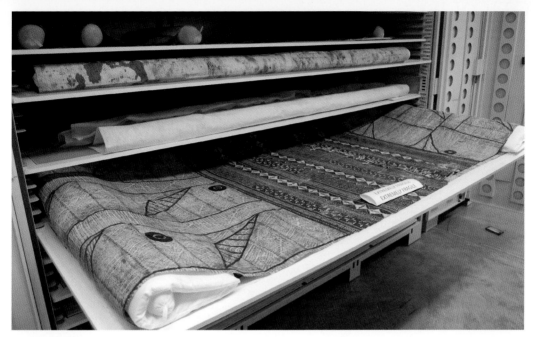

**Figure 3.** Re-housed tapa cloth, Smithsonian Institution.

Today, in the ACL, small folded bundles of tapa are gently opened to reveal the skills and creativity of Polynesians working over 170 years ago to transform plant bast fibre into cloth. The team, guided by Greta Hansen (Head Conservator) and Adrienne Kaeppler (NMNH curator of Oceania), are working with Smithsonian Institution scientists and community scholars from Hawai'i, Fiji, Samoa and the Cook Islands to conserve a remarkable collection of tapa gathered by American sailors and scientists on the US Exploring Expedition 1838–1842. The large modern laboratory provides enough space to open and stabilise the often expansive and fragile tapa (Figure 2).

Using conservation protocols developed over many years, each tapa is humidified to relax fold lines where breaks occur. Tears and losses are stabilised using Japanese tissue and wheat starch paste. Evidence of cultural use is retained and documented. Critical to the project are high-resolution images that will give researchers and cultural practitioners in the Pacific remote access to the very large and often highly decorated tapas. Also, much thought has been given to appropriate long-term storage of these research collections. Flat storage on large light-weight screens is preferred over rolled storage because it allows ease of access while minimising handling (Figure 3).

Smithsonian botanists, as well as colleagues from other institutions, are working to identify the source plants used in tapa manufacture. Scanning electron microscopy (SEM), DNA sequencing and stable isotope analyses are used to explore the difficult species identifications of bast fibres and beaten plant fibres. Community Scholars from Hawai'i have prepared tapa samples using traditional dyes to aid us with the plants, dyes and colorants applied to tapa in the Smithsonian Institution collections and to determine better estimates of the rates of dye fading. Gas chromatography-mass spectrometry (GC-MS) is being pursued to identify the vegetal dyes used to decorate the tapas.

# SECTION II
# Practical curation of biocultural collections — materials

## CHAPTER 2

# *Curating ethnographic specimens*

JAN TIMBROOK
Santa Barbara Museum of Natural History

## WHAT ARE ETHNOGRAPHIC SPECIMENS?

This chapter covers the care of ethnographic biocultural artefacts, that is, cultural objects collected from living peoples and made from, or used to process, plant or animal materials. Other chapters discuss archaeological artefacts and ethnobiological products such as samples of food, medicines and materials.

Examples of ethnographic biocultural objects include: baskets and fibrework; textiles and clothing; wooden objects such as tools and utensils, containers and carvings; artefacts made from animal parts such as hides, leather, feathers, wool, silk, bones, teeth, antler, horn and shells; and more. Many objects contain both plant and animal materials: arrows assembled from cane, wood, stone, pitch, feathers and sinew; feathered baskets trimmed with shell beads; wooden boxes inlaid with ivory or shell; cocoon or rawhide rattles tied with string onto wooden handles; dolls of cotton cloth and leather decorated with quill, hair and inorganic glass beads or tin jingles sewn on with sinew or cotton thread.

Ideally, many of these different materials and composites would be provided with custom environments, tailored to their own specific requirements for optimal conditions. Few institutions are able to provide separate specialised facilities for each kind of object. Most need to find compromises that will at least do no harm. Realising that meeting all the ideal standards is rarely possible, this chapter offers practical suggestions for housing, handling and managing diverse ethnographic objects. Note that even conservators can differ on recommended procedures for collection care, and standards do change with new research. For further information, see the references listed at the end of this chapter. Particularly useful online references include the National Park Service Museum Handbook and Conserve O Grams from the Museum Management Program, US National Park Service; Conservation-Wiki from the American Institute for Conservation of Historic and Artistic Works (AIC); and CCI Notes from the Canadian Conservation Institute.

My perspective is that of a curator who has participated in several collections-care workshops sponsored by the Smithsonian Institution/Office of Museum Services, the Getty Conservation Institute, and the California Association of Museums, and has more than 35 years' experience handling ethnographic collections in a mid-size, non-profit museum with a limited budget. More detailed and specific recommendations can be provided by conservation professionals. It is important to recognise situations that are beyond the capability of staff, that are emergencies, or that require treatment for particularly fragile or significant objects; in these cases, a specialist should be contacted or called in to advise.

Of all the institutions that hold collections, relatively few have conservation staff on site, but it is still possible to obtain advice relatively economically. Conservators are often available for short-term consultation. Grant funding may be available to support conservation surveys and staff training. If there is a conservation training facility in the region, it may be possible to work with their students and staff. Other institutions may also be willing to give free advice. When choosing a conservator, be sure they are qualified or accredited through national conservation organisations.

## ENVIRONMENTAL CONDITIONS

Extremes of temperature and moisture, exposure to light, dust and other pollutants, pests and improper storage and handling can all damage objects. To preserve ethnographic artefacts, the goal is to minimise all of these threats (Canadian Conservation Institute, n.d.; Thomson, 1994).

### Temperature and humidity

High temperature and very low relative humidity make objects brittle, whereas high humidity can foster mould growth. Rapid changes in temperature and humidity cause shrinkage and expansion that over time will damage objects. Different optimal conditions are recommended for various materials, but most important is stability. Most artefacts can tolerate conditions out of their optimal range as long as any fluctuations are minimal and gradual. Factoring in human comfort, target ranges of temperature 65°F (18°C) ± 3°F and relative humidity (rH) 50% ± 5% are usually recommended. Higher humidity and warmer temperatures can promote mould growth and insect infestation. It is generally considered most important to maintain rH at stable levels below 60%, whereas temperature can be allowed more variability. Moister conditions may be appropriate for organic artefacts made and used in humid tropical environments, but rH should not be allowed to exceed 70% (Florian et al., 1990: 200–201).

Collections should not be housed directly against outside walls or in basements, which are often damp, or in attics, which can get very hot. Space near furnaces, next to heating or air-conditioning vents or below water pipes is unsuitable for collections, especially those housed on open shelves (NPS Museum Handbook I: Appendix K15 (online)). Portable humidifiers or dehumidifiers can be used if room air-handling systems cannot provide adequate conditions. In sealed conditions such as closed cabinets, boxes or display cases, silica gel can help to reduce fluctuations in rH. Silica gel must be checked and reconditioned periodically.

### Light

Most objects, even many inorganic ones, are irreversibly damaged by prolonged exposure to light. This includes both visible light and ultraviolet light. Colours will fade and structural damage can occur. Objects should never be exposed to direct sunlight, and there should be no windows in collection storage rooms. Best practice is to keep objects in darkness as much as possible and to use task lighting as needed for study. Ultraviolet filters should be installed on all windows, skylights and fluorescent lights, and these will need to be replaced periodically. Meters are available to check levels of ultraviolet and visible light.

Visible light is measured in lux or foot-candles (1 foot-candle (fc) = approximately 10 lux). For exhibition, both the sensitivity of the various materials and the visibility provided for viewers must be taken into consideration. If possible, light levels should be kept low, usually 10–12 fc (100–120 lux) or even 5 fc (50 lux) for very light-sensitive materials. Dark backgrounds typically make objects appear brighter, so less illumination can be used. Because the duration of exposure — not just the light intensity — is important, exposure time should be as brief as possible. Light-sensitive materials should not be on display for more than three months at a time. Longer periods are acceptable if lamps can be connected to timers or motion sensors, so they turn on when visitors arrive and go off when no one is present (NPS Museum Handbook I, 4: 42–43 (online)). Incandescent bulbs produce much less ultraviolet light than fluorescent lamps, but they give off excessive heat when used in enclosed spaces and should not be used inside an exhibit case or vitrine (Michalski, n.d.). LED lamps are now providing good museum-lighting capability.

# Dust and pollutants

Collection storage and study areas should be kept clean. Where possible, filters should be installed on air-handling systems to keep fine particulates out. Install screens on all operable windows; if windows must be opened for ventilation, take care to keep dust out of collection areas. Establish a cleaning protocol that sets out how often museum spaces should be cleaned.

Ethnographic artefacts are often composites, made from more than one material, which provide challenges for their cleaning. Collection items should be cleaned with great care and knowledge of their materials and condition. For fragile or damaged objects, seek the advice of a trained conservator. For dusty artefacts, surface dust or dirt can be loosened by gently brushing with a soft brush and removed with a vacuum cleaner. Avoid direct contact between the nozzle of a vacuum cleaner and the artefact. Turn the suction down to the lowest level possible and cover the nozzle with a piece of net or nylon stocking, or use specialist conservation equipment (Florian et al., 1990: 217–218). Sometimes dirt or other residue may be part of the ethnographic history of the object, in which case it should not be removed (Canadian Conservation Institute, CCI Notes 6/2 (online)).

No smoking or fireplace fires should be permitted in areas where there are artefacts. Construction materials such as wood and particle board, many paints, glues, plastics, flooring and cleaning supplies such as ammonia may contain solvents or other compounds that can 'off-gas' (release harmful gases). Inert, solvent-free materials should be used, or neutral sealants applied to potentially off-gassing materials.

## PESTS

## Detection

Rodents and insects attack all manner of biocultural specimens. Powdery or granular droppings (frass), moth casings or webbing, shed larval skins or any holes in objects are probably signs of infestation. Learn which insect pests are found in your region and how to identify them. Klein (2008) has good photographs and information that are helpful for identification. Larvae of the carpet beetle (dermestid beetle) and clothes moth eat protein-based materials like wool, fur and feathers. Wood-boring ('powderpost') beetles drill holes in baskets, cane and wood. Silverfish eat paper labels. Meal moths and beetles (such as drugstore and cigarette beetles) infest food samples and stored products. Ants, termites and wood borers may chew on both artefacts and structures. The website of the Integrated Pest Management Working Group is a valuable resource for all aspects of pest management.

## Prevention

Pest prevention is much easier than treatment after an infestation has occurred. Set snap traps at the first sign of rodent activity. Check traps frequently, as carcasses will attract protein-eating insects. Live plants or floral arrangements, in which insect pests can hide, should be kept out of collection areas. Do not allow food or drink in collections storage or work areas. Spills or crumbs left behind will attract insects that may then turn their attention to the collections.

Use door sweeps, weather-stripping, gaskets and caulking to seal up all potential points of entry. Glue traps, which come as flat cardboard sheets that are sticky on one side, can be cut, folded and taped to form little tents. Place these next to the wall on each side of doorways, as well as within collection shelving, to detect insects that are getting in and to stop them before they reach the collections (Child, 1998; Pinniger & Winsor, 2011). Check artefacts and specimens regularly for any sign of insect larvae or adults, powdery droppings, moth casings, new holes, damage to labels and so on, and document any damage for future reference.

Microencapsulated pyrethroid insecticides such as Constrain, in water solution, can be sprayed occasionally on the baseboards around room perimeters. Once dry, and if left undisturbed, these compounds are not toxic to humans, but an insect that walks on the sprayed surface will break the tiny capsules and become exposed to the insecticide. These products are toxic to fish and aquatic invertebrates, so care must be taken to avoid contamination of water. Check the Material Safety Data Sheets for other precautions. Depending on local regulations, they may require application by a licensed pest-control professional.

All new accessions or objects returning from loan should be frozen before they enter the collection, except for specimens such as liquids and other items listed below. If an item is in quarantine prior to entering a collection, or if infestation is suspected, bagging a specimen allows monitoring of pest activity while preventing its spread (Pinniger & Winsor, 2011).

## Treatment

Despite our best efforts, pests sometimes breach our defences. Some ethnographic specimens arrive already infested, such as fur garments with moth or dermestid larvae, and basket foundations harbouring powder-post or cigarette beetles. These must be treated immediately to prevent further damage and to avoid introducing pests into other collections.

## Freezing

The most practical method of pest treatment is freezing, provided that certain conditions can be met (Integrated Pest Management Working Group, Treatment Subgroup, 2008). The freezer should ideally maintain a constant temperature of at least -4°F (-20°C), although in practice -20°F (-29°C) or colder is now preferred by many museums. A chest freezer — one that requires manual defrosting and is opened by lifting the lid — can accommodate most objects. For very large objects, it may be possible to use a walk-in freezer at a natural history museum, a commercial meat-packing plant or a truck on site.

Objects must start at room temperature and as close to 50% rH as possible. They are wrapped with acid-free tissue to absorb any trapped moisture and placed in a sturdy polyethylene bag, the air is then evacuated from the bag which is then sealed tightly with tape that will not fail in low temperatures. Thus bagged, objects are placed in the freezer, but not packed too tightly, so that cold air can circulate. They are left in the closed freezer at -20°F (-29°C) for at least 48–72 hours; in practice, many museums prefer 7 days. Because of the insulating properties of the infested material, the colder the temperature and/or the longer the exposure time, the more effective the treatment will be (Strang, 1992). This treatment will kill adult insects, larvae and eggs.

A shorter method is sometimes used when time and space are limited: the bagged objects spend 48 hours in the freezer, are brought out into room temperature for 24 hours (still bagged), and then returned to the freezer for another 48 hours (Raphael, 1994). Remote sensors such as those used for indoor–outdoor thermometers can monitor the temperature inside the freezer.

Because rapid and extreme changes in temperature do create stresses, freezer treatment is not suitable for objects containing materials made up of layers (such as ivory, lacquer, painting and glass), for objects made up of multiple parts glued together, for objects under tension (such as drums), for canvas or wood-panel paintings, or for wet or waterlogged objects. It is most advisable for stable, dry objects made entirely of wood, textile, leather or paper, or for dry natural history specimens. For other objects, seek advice from a conservator.

After any of these treatments, objects should remain in their bags until they are at room temperature, then inspected and cleaned of all insect evidence. Handling of frozen objects should be minimised because many materials become brittle at low temperature. Document all freezing and cleaning procedures — the dates, temperatures and equipment used — on the object's catalogue record. There are no residual treatments that will prevent re-infestation. Frequent inspection and preventive measures will always be required.

## Pesticides and fumigants

The application of any insecticide or repellent directly to objects is not recommended. Many such compounds leave stains or residue that will attract dirt and cause further problems. Cedar wood and mothballs or crystals (naphthalene) are not effective repellents. Paradichlorobenzene (PDB) crystals have been used in many natural history museums, but their safety for humans has been questioned and their long-term effects on artefacts are uncertain. No-Pest strips (Vapona or Dichlorvos (DDVP)) also pose health hazards, can off-gas or drip, and are not recommended for use near artefacts. 'Bug bombs,' such as those used to rid a home of fleas, are not effective and should never be used around museum specimens.

Many fumigants, such as Vikane (sulfuryl fluoride) which is used to fumigate houses that are infected with termites, will chemically react with artefact materials. The safest treatment is to place objects into a tightly sealed anoxic chamber, vacuum out the oxygen and flood the chamber with carbon dioxide gas for an extended period of time. The equipment needed for this treatment can be expensive and requires special facilities and training.

## MOULD

Conditions favourable to mould growth include high humidity, darkness, poor air circulation, and sometimes warm temperatures (Florian, 2002). Paper, leather, books and some textiles are particularly susceptible. Active mould is detectable under magnification as bushy-looking structures that smear when wiped; inactive mould is powdery.

Mould can be inactivated by moving affected objects to a quarantined area with dry conditions, light exposure and good air circulation. It may be re-activated, however, if these objects are moved back into the same conditions that initially fostered its growth. Before using any chemical treatment, ultraviolet light, elevated temperature or freeze-drying to kill mould, consult a conservator who specialises in the material to be treated.

Dry mould should not be simply brushed off as this will spread its spores. As it is dislodged with a soft brush, mould should be vacuumed up with a HEPA (high-efficiency particulate air filter) or ULPA (ultra-low-penetration air filter) vacuum with adjustable air flow, or using a wet–dry vacuum cleaner modified so that the air intake passes through the vacuum reservoir filled with a Lysol and water solution. Work in a fume hood if possible, and always wear disposable gloves, an appropriate respirator and protective clothing when handling mould-affected items. Seal any contaminated materials, including used gloves and vacuum cleaner bags, in a plastic bag and dispose of them in accordance with local regulations.

The moist environmental conditions that fostered mould growth should be corrected and the area thoroughly cleaned before returning objects to storage. Residual stains from mould are difficult to remove and should be treated by a conservator.

## OTHER HAZARDS

### Security

Unlike most other kinds of biocultural collections, artefacts can be attractive to certain individuals who are more interested in monetary than scientific value. A glance at recent auction catalogues shows that some archaeological and older ethnographic objects can command high prices on the art market. Accordingly, collection repositories are advised to protect objects from theft. Locked doors, alarm systems and video surveillance are justifiable. Keep records of staff, researchers and visitors who enter collection areas, prevent access by unauthorised persons, and do not leave objects out unattended.

### Emergency preparedness, evacuation and recovery

Assess the potential threats to collections — fire, flooding, earthquake, power failure and others — and develop strategies to prevent or minimise their effects. Smoke and water can cause damage far beyond that of the fire itself. Develop plans, identify emergency contacts, delegate staff responsibilities and locate supplies and services before an emergency occurs. Assistance in developing emergency and recovery plans is available from the US National Park Service (NPS Museum Handbook I, 10 (online)), the Northeast Document Conservation Center (online), the Getty Conservation Institute (Dorge & Jones, 1999) and the Heritage Collections Council (2000). Collection disaster plans should be succinct and easy to use. Over-lengthy documents, particularly those that mix wordy policy statements with practical information, are difficult to use and to keep up-to-date.

## HOUSING ETHNOGRAPHIC ARTEFACTS

### Cabinetry

#### Open shelves or closed cabinets?

Open shelving is less expensive and allows air circulation and ease of access to specimens, but leaves objects more vulnerable. Hazards include light, pests, dust, pollutants, water damage if fire sprinklers are activated, and earth movements ranging from earthquakes to ordinary vibration from nearby roads or equipment. Earthquake bars or bungee cords can be attached across the front of open shelves to keep objects from tumbling off. Polyethylene sheeting or retractable window shades can be hung in front of open shelves to minimise objects' exposure to dust and water. Closed cabinets, especially those with gasketed doors that lock, offer better security and protection. They may also help to reduce fluctuations in temperature and rH that occur in the room.

#### Wood

Although wood is easy to work with, it is acidic and might damage artefacts that are kept in contact with it. Plywood, particle board and laminates might contain formaldehyde and glues that 'off-gas' (emit gases harmful to collections). This is of particular concern in closed cabinets where gases reach higher concentrations. Balsa, mahogany, walnut, spruce, poplar and American beech are listed as safe woods; plywood or fibreboard made from these woods may also be acceptable if the adhesive used is formaldehyde-free. Birch, Douglas fir, oak and pine should not be used (AIC Textile Specialty Group, 1998).

Objects should not come into direct contact with wood. Sealants such as shellac or acrylic latex (not alkyd or oil-based) paints should be applied to all wooden surfaces in two coats and allowed to dry for at least one month in a well-ventilated area before being used to house collections. Even then, it is better for objects not to rest directly on the painted surface but on acid-free paper or Ethafoam

placed on the shelf. Aluminised polyethylene or polyester film (Mylar, Marvelseal) bonded onto wood surfaces can also provide an effective barrier.

## Metal

Metal shelving or cabinets must be coated with inert material, not solvent-based paints. Chrome-plated wire baker's racks are acceptable as open shelving. All metal shelves or trays should be covered with Ethafoam or similar material to cushion objects and keep them from sliding around. The best (and most expensive) metal cabinets are made from steel coated with a powdered resin that is electrostatically bonded and then baked, so that the coating contains no solvents that emit harmful vapours. Closed metal cabinets do not provide a very effective buffer against fluctuations in temperature and humidity. They should be fitted with prefabricated silicone door gasket seals to keep out dust, pests and pollutants.

## Materials to support and house objects

Any material that will be in close proximity or come into contact with artefacts should be free of acids and solvents, and not attractive to pests.

## What not to use

Unsuitable materials for housing artefacts include newspaper, craft paper, ordinary tissue paper, cardboard, corrugated cardboard (except archival acid-free corrugated board), permanent-press fabric or fabric with sizing, wool or wool felt, styrofoam and polyurethane (dry-cleaner's) bags. Bubble wrap and foam packing peanuts are acceptable for moving or shipping, but preferably should not be in direct contact with objects and are not for long-term use.

## Generally considered safe

Only neutral, acid-free tissue, papers or cardboards, preferably unbuffered, are acceptable. Buffered papers are preferable when storing plant fibre-based materials and many synthetic materials, but should not be used for artefacts that can be damaged by alkalinity, that is, those that are acidic in composition. These include animal (protein)-based materials, such as wool, silk and leather, and certain prints and photographs (National Park Service, 1995). Cotton and linen fabrics should be washed to remove sizing before use; dyed fabric must be colourfast. Archival-quality, virgin (not recycled) polyethylene and polyester, Mylar (polyester film), Tyvek (polyolefin), Coroplast or Correx (corrugated polypropylene or polyethylene), Plexiglas and Lucite are among plastics considered to be safe. For cushioning and supports, polyethylene foams such as Plastazote, Ethafoam and Volara come in various thicknesses and can be cut and shaped as needed. A complete list of materials that are safe for the storage of textiles (and most other artefact types) can be found on the American Institute for Conservation's website www.conservation-wiki.com.

## Some notes on techniques

Ideally, individual supports should be created so that objects can be picked up without actually touching the object itself. Acid-free boxes or trays can be purchased from University Products, Hollinger MetalEdge, Gaylord or similar companies (see 'Archival materials and supplies' listed at the end of this chapter). Custom trays can be fabricated from archival acid-free corrugated board. Additional supports to prevent objects from tipping within their individual boxes can be carved from thick sheets of Ethafoam or Volara. Versatile beanbags, pillows or 'snakes' to support many kinds of objects can be constructed from washed cotton cloth sewn into various shapes and filled with polyester fibrefill, or clean, dry 'playground' sand, polystyrene or polypropylene pellets, or zinc-plated steel shot.

*Textiles*

Textiles should not be folded but stored flat and in a single layer if possible. If a textile must be folded, the folds should be well padded and the item should be taken out at least every two years, checked, and re-folded in a different configuration (AIC Textile Specialty Group, 1998). One method is to fan-fold the textile into a muslin-covered archival board or tray, staggering the folds and padding them with crumpled unbuffered acid-free tissue (NPS Museum Handbook I: Appendix K14 (online)). If flat textiles must be stacked, they should be interleaved with unbuffered acid-free tissue or other neutral material. This material can also function as a support cradle if made from a length of washed cotton muslin cloth folded over to make a sleeve at each end. Rods inserted into these sleeves enable the textile to be picked up with minimal stress when removing it from the tray. Stacking should only be done with lightweight textiles.

## CURATING ETHNOGRAPHIC TEXTILES

At the Santa Barbara Museum of Natural History, textiles that cannot be housed flat are rolled onto acid-free cardboard tubes. A length of non-woven polyester interfacing is placed over the end of the textile and rolled onto it. This covers the textile and provides support and protection, but still allows visibility. The roll is gently tied with wide cotton twill tape in several places. The catalogue number is written with pigment-based permanent ink on a strip of cotton cloth that is carefully hand-sewn to the textile. A catalogue tag with a photo of the textile is tied to the cardboard tube. For large, heavy textiles, the cardboard rolls are supported on lengths of powder-coated steel pipe, the ends of which rest on notched racks. All ethnographic collections are housed inside closed cabinets made from powder-coated steel and sealed with silicone gaskets to minimise environmental fluctuations and to keep out pests.

Larger textiles can be rolled onto tubes of 3 inches in diameter or larger, made from cardboard that is acid-free or sealed with a barrier material such as MarvelSeal or aluminium foil. Start by rolling a length of acid-free tissue, Tyvek or washed cotton cloth onto the tube, leaving the outer end unrolled to capture the end of the textile as you continue rolling. Particularly for fragile textiles, additional support can be provided with another length of the same material to complete the roll. Some sources recommend that the textile be covered with acid-free tissue as it is rolled, so that it does not come in direct contact with itself. The enclosed textile is tied loosely in place with wide cotton twill tape or strips of sheeting (NPS Museum Handbook I: Appendices K16–17 (online); Canadian Conservation Institute, CCI Notes 13/3 (online)). Detailed guidance on textile conservation and storage is given by Boersma (2007).

The rolling tube is then suspended on a rod projecting at each end to rest on a rack, so as not to place pressure on any one area. Textiles are usually rolled in the warp direction. Lined textiles or those with pile, embroidery or other surface decoration — if they cannot be stored flat — are rolled with the pile or decorated side outward. A tag with the catalogue number and a photograph of the textile should be attached to one end of the tube for ease of identification without having to open the roll.

## Clothing

Hanging may place too much stress on clothing and will distort its shape over the long term. This method should only be considered for garments in good condition with shoulder seams strong and intact and the garment able to support itself without causing strain at the shoulders and waist. Hanging is not suitable for garments that are heavy, stretchy or bias-cut, or for those with heavy beading or other surface decoration. Custom, padded hangers or forms should be constructed for each garment (Merritt, 1994; Canadian Conservation Institute, CCI Notes 13/5 (online)). Washed muslin dust covers should be used to protect each garment from contact with its neighbours, and adequate space should be provided between garments (NPS Museum Handbook I:Appendices K17–19 (online)).

All other clothing and costumes should be stored flat in individual archival boxes if possible, with any creases or folds padded out with rolls of Ethafoam or acid-free tissue folded accordion-style. Hats and headdresses should be supported with acid-free tissue or padded polyethylene foam to preserve their shape, and any loose or dangling parts secured against movement. Drop-sided boxes can provide additional protection for hats. Note that hats made with animal parts may contain pesticide residues including arsenic, and precautions should be taken when handling them (NPS Museum Handbook I:Appendices K22–24 (online)).

## Basketry

Baskets should be placed in a single layer, not stacked. Ideally each basket is placed in its own individual support tray or drop-sided box, so that it can be removed from storage and examined without being handled directly. If space constraints make stacking absolutely necessary, baskets must be arranged so that each one is completely supported and does not put pressure on its neighbours. If stacked, they must be kept from touching one another with layers of acid-free tissue or Tyvek placed between them. Use this interleaved material to lift one basket at a time in order to place your hands under it for support. Never pick up a basket by the rim and do not remove a lid by pulling on its handle.

Basketry hats are often housed in the wearing position, often on a short, padded pedestal base so as not to rest on the easily-damaged rim. Conical burden baskets are best housed vertically – either in a padded supporting cradle or upside down if the rim is stable — not resting on their sides. Soft, flexible baskets may need to be stuffed with tissue in order to maintain their shape.

## HANDLING

Work surfaces where objects are being handled or prepared for storage should be clean and well padded. Use only pencil; keep ink pens and other tools away from the work area.

### Wear gloves

Skin oils can leave residue that will eventually damage objects. It is generally best to wear gloves in order to protect the object and also the wearer, in case there are any toxic materials or sharp projections. Powder-free nitrile gloves are best for both dexterity and minimal discomfort. White cotton gloves are more comfortable and can be washed when they become soiled, but any loose or rough areas on the object can snag on them and they do not provide a secure grip on very smooth objects.

If gloves are not practical, artefact handlers should wash their hands frequently and not use lotions or creams. This is for the protection of the people as well as the objects. Washing hands with D-Lead Soap is recommended after handling older collections where heavy metal contamination is a possibility. Dust masks should be worn when handling or cleaning objects that might harbour dust or mould.

### What not to wear

Artefact handlers should not wear dangling identification badges, bulky rings, necklaces, large metal belt buckles or any clothing or jewellery that can catch on objects. A work apron or lab coat will protect the handler's clothing as well as the artefacts. For safety, do not wear open-toed shoes.

### Provide support

Use both hands to support objects from underneath. Never pick up an object by its rim or handle. A piece of stiff corrugated board or a sheet of tissue or Tyvek can be slid under a delicate object to aid in moving it safely. Only carry one object at a time, know where you are going to put it, and have its destination ready. If a cart or trolley is used to transport multiple objects, make sure they are well secured and padded to minimise damage from contact and vibration.

## LABELLING AND MARKING OBJECTS

The purpose of a label is to link it with data about the object. Objects should be labelled when they come into the collection. A label written on a tag tied onto the object or marked on its box can serve as a temporary label.

### Principles

For the longer term, the accession number or catalogue number must be securely attached directly to the object in such a way that it cannot be easily removed or become separated from the object. It is unwise to house loose items in plastic bags with unattached paper labels: more handling is required to examine objects in bags, which can sometimes cause abrasion or breakage, and the label can easily become separated from the object.

Objects should be marked in a way that is reversible without damaging the object. Permanent labels are used only for very large objects or those with special security needs. The label should be placed so that it is easily seen in storage so as to minimise the need for handling, but inconspicuous if the object will be exhibited. Old numbers should not be obscured; if an old label is removed, it should be documented and retained.

## Direct labels

Because labels or numbers must be reversible, apply a barrier coat before writing the number on the object. Polyvinyl acetate (PVA) emulsion is initially soluble in water and when dry can be removed with acetone or ethanol. Acryloid (or Paraloid) B-72 lacquer is soluble in acetone and ethanol. Either one must be allowed to dry thoroughly before writing the number in quick-drying pigment-based ink: Pigma Pens for black, Y&C Extreme Gel Pen for white. Then a top coat is applied as a sealant. This method is best for non-porous objects.

## Adhered labels

Adhered labels can be used for wood, basketry, some leather or hide objects, or the backing or stretchers of paintings. The label is written with pigment-based ink on Japanese tissue or mulberry paper and adhered to the object with methyl cellulose or PVA adhesive. If printed labels are desired, they must be printed on acid-free 25% cotton rag paper using a dry-toner xerographic process.

### LABELLING: WHAT NOT TO DO

Artefact labelling should not cause any damage. It should be reversible and employ acid-free materials and permanent inks. This Pomo Indian basket in the ethnographic collection at the Santa Barbara Museum of Natural History was labelled in several inappropriate ways. The tag with the catalogue number (on the right) illustrates five common curatorial mistakes: (1) a hole was made in the basket for (2) a stainless steel wire (now corroded) that (3) holds a metal-rimmed tag with (4) the catalogue number written in ballpoint pen and beginning to fade. The catalogue tag is easily viewed without handling the basket, which is good, but (5) it is too conspicuous for exhibition. The original gummed paper label at left, which has been attacked by silverfish, was adhered directly to the basket. It cannot be easily removed without damaging the basket or leaving an adhesive residue. It is part of the history of the basket, however, and if removed should be retained or at least documented.

## Attached labels

For basketry and textiles that are in good condition, labels can be written with ink on cotton or polyester twill tape and sewn on with white cotton thread passing between, not through, the warp and weft strands. Avoid making holes in the object, do not pull the stitches tight, and do not tie knots. For more fragile objects, the label is written on a strip of twill tape twice as long as the writing, then slipped between the elements of the basket or textile and the ends sewn together to make a loop.

In some circumstances, only tied-on tags will be suitable. Acid-free paper tags can be tied on with cotton string, colourfast embroidery floss or unwaxed dental floss (such as Glide brand Teflon monofilament). Remember that paper tags are subject to insect damage and inks may run if the object is oily or conditions are moist. Tyvek may be better than paper, although it must be sealed with a layer of Acryloid B-72 lacquer to create a writeable surface.

### What not to use

Do not write labels with Sharpie marking pens or ballpoint pens, which are not light-fast and can run. Do not attach adhesive tape or adhesive labels, which leave residue. Do not use metal tags or wires, which may corrode. Nail polish and liquid paper correction fluid should not be used to label objects. Detailed information on marking and labelling can be found in publications by Alten (1998) and Buck and Gilmore (2010) and in the NPS Museum Handbook, Part II, Appendix J.

## INFORMATION ABOUT THE OBJECT

In printed and/or digital records for each object, include the following information:

- catalogue number and any previous numbers pertaining to the object;
- name of the object, tribal or cultural affiliation, and geographic region;
- maker's name, date and location where the object was made;
- date and location where the object was originally collected;
- date the object was received, from whom, and its status as gift, loan, purchase, transfer or agreed curation;
- description of the object, materials and technique of manufacture;
- purpose or function of the object;
- condition of the object and date of assessment;
- storage or exhibit location and date;
- name or initials of person entering catalogue information, and date of any additions or changes; and
- one or more photographs of the object.

## CULTURAL CONCERNS

Curators are increasingly aware of the preferences that indigenous people may have about how museums house and care for their cultural artefacts (Johnson et al., 2005; Kaminitz, 2007; Ogden, 2004; also see Chapters 1, 17, 18 and 19). Efforts are made to keep these concerns in mind when curating objects, without unduly compromising museum conservation standards. For example, in designing the Collections Resource Center, the National Museum of the American Indian took pains to ensure that no culture's objects were placed above those of another. Native consultants felt strongly that some natural light should enter the collection room, so a window was strategically positioned in a way that no sunlight would fall on the objects (Bruce Bernstein, personal communication, 2003).

Cultural sensitivities about the materials used in curating artefacts should also be kept in mind. The use of plastics and other synthetics might not be acceptable. If given an explanation of the importance of marking or labelling objects in order to take care of them, and assurance that the method allows removal if necessary, most indigenous people are willing to allow catalogue numbers to be attached or adhered directly to artefacts.

Many Native American people believe that objects are alive and should not be 'suffocated' inside plastic bags. Artefacts are also thought to benefit from human contact. If toxic contaminants are not present and if hands are washed, some curators allow direct handling of certain objects. It may be permissible to allow cultural offerings such as sage, tobacco or bay leaves to be housed with objects, although preferably not in direct contact, and any such materials should be closely inspected for insects first. After careful consideration of both cultural and conservation concerns, ceremonial access may be negotiated for some objects. Many museums provide designated spaces where ceremony can be conducted.

In many cultures, there are restrictions on who is allowed to view or handle certain kinds of objects. Some ceremonial paraphernalia may be seen only by women, only by men, or only by initiated individuals. In such cases, objects are kept in closed archival boxes clearly marked with instructions on restricted access.

Along with the mission to curate — to care for and preserve objects for future generations — comes the responsibility to show respect for the people who made them. This should be manifested in the ways we house, exhibit, handle, study and disseminate information about the materials with which we are entrusted.

## ACKNOWLEDGEMENTS

The other contributors to this volume made many helpful suggestions on an earlier draft of the manuscript. Particular thanks go to Mark Nesbitt for his detailed, insightful comments and additions to the reference list.

## Archival materials and supplies

Archivart: www.archivart.com
Ashley Distributors: www.ashleydistributors.com
Gaylord: www.gaylord.com
Hollinger Metal Edge: www.hollingermetaledge.com
Masterpak: www.masterpak-usa.com
Preservation Equipment: www.preservationequipment.com
Talas: www.talasonline.com
University Products: www.universityproducts.com

## Websites

American Institute for Conservation of Historic and Artistic Works (AIC). www.conservation-wiki.com (information website for conservation techniques and materials)

Canadian Conservation Institute. *CCI Notes*. www.cci-icc.gc.ca/publications/notes/index-eng.aspx

Integrated Pest Management Working Group. www.museumpests.net

Museum Management Program, National Park Service. *Conserve O Grams*. www.nps.gov/history/museum/publications/conserveogram/cons_toc.html

Museum Management Program, National Park Service. *NPS Museum Handbook*. www.nps.gov/history/museum/publications/handbook.html

Northeast Document Conservation Center. *Disaster Planning. A Free Template for Writing Disaster Plans*. www.nedcc.org/disaster/dplan.php

Society for the Preservation of Natural History Collections. www.spnhc.org

## Cited references

Alten, H. (1998). Numbering museum collections: labeling ethnographic objects. ICOM-CC *Ethnographic Conservation Newsletter* 17: 18–21. www.collectioncare.org/cci/ccin.html

AIC Textile Specialty Group (1998). *The Textile Conservation Catalog, Chapter VIII. Storage of Textiles*. American Institute for Conservation of Historic and Artistic Works. www.conservation-wiki.com/index.php?title=TSG_Chapter_VIII._Storage_of_Textiles

Boersma, F. (2007). *Unravelling Textiles: A Handbook for the Preservation of Textile Collections*. Archetype, London.

Buck, R. & Gilmore, J. A. (eds) (2010). *The New Museum Registration Methods*. Fifth edition. American Association of Museums.

Canadian Conservation Institute (n.d.). *Ten Agents of Deterioration*. www.cci-icc.gc.ca/caringfor-prendresoindes/articles/10agents/index-eng.aspx

Child, R. E. (1998). *Monitoring Insect Pests with Sticky Traps*. Conserve O Gram 3/7, Museum Management Program, National Park Service, U.S. Department of the Interior. www.nps.gov/history/museum/publications/conserveogram/03-07.pdf

Dorge, V. & Jones, S. L. (1999). *Building an Emergency Plan: a Guide for Museums and Other Cultural Institutions*. Getty Conservation Institute, Marian del Rey. www.getty.edu/conservation/publications_resources/pdf_publications/emergency.html

Florian, M.-L. E. (2002). *Fungal Facts: Solving Fungal Problems in Heritage Collections*. Archetype, London.

Florian, M.-L. E., Kronkright, D. P. & Norton, R. E. (1990). *The Conservation of Artifacts made from Plant Materials*. J. Paul Getty Trust, Malibu. www.getty.edu/conservation/publications_resources/pdf_publications/pdf/cons_artifacts.pdf

Heritage Collections Council (2000). *Be Prepared — Guidelines for Small Museums for Writing a Disaster Preparedness Plan*. Heritage Collections Council, Canberra. www.collectionsaustralia.net/sector_info_item/2

Integrated Pest Management Working Group, Treatment Subgroup (2008). *Low Temperature Treatment Fact Sheet*. www.museumpests.net/tools/treatments/FINAL-Low_Temp_fact_sheet.pdf

Johnson, J. S., Heald, S., McHugh, K., Brown, E. & Kaminitz, M. (2005). Practical aspects of consultation with communities. *Journal of the American Institute for Conservation* 44: 203–215.

Kaminitz, M. A. (2007). Conservation and living cultures. In: *Sharing Conservation Decisions*, ed. R. Varoli-Piazza, pp. 84–88. ICCROM, Rome. wwwv.iccrom.org/pdf/ICCROM_15_SharingConservDecisions_en.pdf

Klein, D. (2008). *Identifying Museum Insect Pest Damage. Conserve O Gram 3/11*, Museum Management Program, National Park Service, U.S. Department of the Interior. www.nps.gov/history/museum/publications/conserveogram/03-11.pdf

Merritt, J. (1994). *Storage Techniques for Hanging Garments: Padded Hangers. Conserve O Gram 4/5*. Museum Management Program, National Park Service, U.S. Department of the Interior. www.nps.gov/history/museum/publications/conserveogram/04-05.pdf

Michalski, S. (n.d.) *Agent of Deterioration: Light, Ultraviolet and Infrared*. www.cci-icc.gc.ca/caringfor-prendresoindes/articles/10agents/chap08-eng.aspx

National Park Service (1995). *Buffered and Unbuffered Storage Materials. Conserve O Gram 4/9*. www.nps.gov/museum/publications/conserveogram/04-09.pdf

Ogden, S. (2004). *Caring for American Indian Objects*. Minnesota Historical Society (MHS) Press, St. Paul.

Pinniger, D. & Winsor, P. (2011). Integrated pest management. In: *Preventative Conservation in Museums*, ed. C. Caple, pp. 169–196. Routledge, Abingdon.

Raphael, T. (1994). An Insect Pest Control Procedure: the Freezing Process. *Conserve O Gram 3/6*. Museum Management Program, National Park Service, U.S. Department of the Interior. www.nps.gov/history/museum/publications/conserveogram/03-06.pdf

Strang, T. K. (1992). A review of published temperatures for the control of pest insects in museum collections. *Collection Forum* 8 (2): 41–67.

Thomson, G. (1994). *The Museum Environment*. Butterworth-Heinemann, London.

# Herbarium curation of biocultural plant collections and vouchers

JAN SALICK & JAMES SOLOMON

Missouri Botanical Garden

Herbarium curation is well established and documented, so in this Chapter we review this information only briefly and refer readers to more comprehensive references (e.g. Metsger & Byers, 1999; Bridson & Forman, 1998).

Within biocultural archives, herbarium specimens document which plants are used by people, and voucher which plants are being studied or used to produce artefacts and products (Chapters 4, 12, 22). To document an ethnobotanical study properly, it is essential to collect quality vouchers in the form of herbarium specimens and to deposit them in a permanent collection, where they will be available indefinitely to confirm the identity of the plant(s) under discussion (Bye, 1986). All too frequently, studies that use common names and then rely on reference literature to assign scientific names are deeply flawed and the names suspect. Common names are irregularly applied, often circumscribe more than one species and may be applied to wildly divergent species. It is essential for all ethnobotanists to know how to prepare vouchers properly, what information to gather, how to label the specimens, and how to have them identified by specialists. Other topics in this chapter are pertinent to the curation of herbarium collections including permits, shipping, mounting, organising, housing, security and pest control, as are the brief remarks on the design of collection storage space and other considerations. We also take into account the challenges of curating collections in developing countries or on tribal lands where infrastructure may be rudimentary and purposes may be diverse (Chapters 17–19).

## MEMORANDA OF UNDERSTANDING, PERMITS AND PROPERTY RIGHTS

Long before you ever start collecting, make sure that you have strong local collaborations with academic colleagues, government and non-governmental organisations, and with indigenous organisations. Develop mutually beneficial memoranda of understanding (MOUs) with these groups, recognising both intellectual (information) and physical (collections) property rights (see 'Ethical standards in ethnobiology' Box in Chapter 1). Share benefits munificently and obtain 'prior informed consent' before interviewing anyone. There is a wide range of permits that may be required and these will vary from country to country. These permits may include: research visas, entrance permits (e.g. for conservation and protected areas), collecting permits, export permits and import permits. Do not collect any endangered or threatened plants or animals unless for an explicit reason and with all necessary national permits. Two major international conventions, the Convention on International Trade in Endangered Species of Wild Fauna and Flora (CITES) and the Convention on Biological Diversity (CBD) have significant influence on access to biological materials and regulate transport across international borders. All permits, prior-informed-consent forms, and MOUs need to be connected to each specimen within your herbarium database so that it is clear under what conditions and agreements that specimen was collected, how it can be used, and from whom permission can be granted.

BASICS OF MAKING A GOOD VOUCHER SPECIMEN

All ethnobotanists should be familiar with and practiced in collecting and preparing good voucher specimens (Martin, 1995). Here, we draw heavily on and only summarise 'Field Techniques Used by Missouri Botanical Garden' (Liesner, 1992). This publication considers many things that we will not cover here including field books, tools, travel and collecting checklists, further reading and details of all the following topics. A simple summary of these techniques is also available for reference (Brayshaw, 1996).

## Contextual information

### Field data

Data collected in the field should include complete location data: latitude, longitude, elevation, locality (country, state, province and county), description of exact location (and, if necessary, how it was derived) and date. Collector(s) and collection number (maintain a sequential number series starting with 1 and follow it throughout your collecting career; never duplicate collection numbers) need to appear both on the specimen and in the field notebook to cross-reference all recorded information with the specimen and all derivatives (liquid preserved, slides, DNA and so on). Include plant family, genus, species and species-name author along with the name of the person who determined the specimen. The basic rule is that anything that cannot be observed from the dried specimen needs to be noted in the field notes. This includes growth form (e.g. tree, liana, vine, herb and so on), description (e.g. of height, buttresses, unusual features and so on), habitat, colours (of flowers, fruit, bark, sap/resin and so on) and odours. Take pictures and note that these have been retained for reference as metadata and database entry (Chapter 11). If the specimen is preserved in alcohol, note this as it will affect colours and will make the specimen useless for DNA analysis.

### Cultural information

For biocultural collections, ethnobotanical and cultural information is of crucial importance and the more the better. Refer to Chapter 11 to see the minimal information required for database records and to Chapter 12 on cultural information for a more refined appreciation of the context and meaning of collections. Databases are important tools for linking cultural and biological specimens with literature and archival information.

## Specimen collection

Specimens can be collected into bags or field pressed, but for the best quality, they must be permanently pressed the same day. Collect enough material for a minimum of three fertile specimens (with flowers or fruits): one to deposit in a local herbarium, one to deposit in your home herbarium or one that is widely accessible, and one for a specialist who can definitively identify the specimen. Botanists usually collect more duplicates for other herbaria. Always collect enough material for each specimen to fill each herbarium sheet. Be sure to show branching patterns and the top and bottom side of a leaf. If possible, collect extra leaf material in silica gel for DNA extraction (Chapter 7).

### Collect fertile material

Always make the extra effort to gather fertile material. Often, ethnobotanical and field inventories are conducted when or where fertile specimens may not be available. Depending on the taxonomic group and the availability of a specialist, sterile material may be identifiable if sufficient leaves, branching and contextual information is provided. Few institutions are willing to house sterile specimens unless you are doing the research directly with them and they have agreed to house and

manage the vouchers. Sterile specimens, if numerous, can be an institutional burden, so if at all possible, try to avoid collecting sterile specimens.

### Plant vouchers for artefacts and products

All too frequently, no plant specimen vouchers are taken with ethnobotanical artefacts and products that are collected. If available, it is very useful to collect both the artefact or product and the plant(s) from which it is made. For good curation and to maximise information content, it is crucial to cross-reference the artefacts or products, plant specimens, ethnographic information and publications on both labels and in databases (Chapter 12).

### Other collections

Other collections that are often overlooked include agricultural and horticultural varieties, which document changes in germplasm and cultivars in common use over time.

## Preserving plant collections

### Pressed plants

Pressing plants is best done using newspaper and blotting materials in a standard-sized press (18' × 12'/45 × 30 cm) bound with long straps or rope. (Straps with easy slide through buckles can be ordered from various sources, such as the Herbarium Supply Company.) Mounting paper is generally 16.5' × 11.5'/42 cm × 29 cm in size, so specimens should be pressed to a size somewhat smaller; generally, you can fill a tabloid or a half broadsheet newspaper. If plants are small, use several to fill the sheet. Press plants before the specimen begins to wilt. Press at least one leaf or leaflet with top side up and another with bottom side up, with both the base and tip visible (see Liesner, 1992, for further detail); leaves and flowers or fruit should remain on the stem. Paper packets can be folded to include seeds or other detached structures. Cross-sections of thick specimens (such as fruits or branches) will dry quicker than the whole specimen. Label all specimens with the collection number (using a water-proof marker, ink or pencil) on the newspaper and/or on paper tags tied to the specimen. Plant tags are preferred because plants might slip or be changed out of their original newspaper. Presses can accommodate about a metre of specimens inter-leaved with cardboard or metal corrugates (the latter facilitate quicker drying). When drying your plant press, make sure that the airspaces in the corrugates are open to the heat source (run vertically above) and that the metal belt buckles are not on the side of the press nearest the heat source; flip the press over frequently during drying. Remove dried plant specimens from the press and continue drying specimens that are still moist. Change the pressing papers if they become overly damp.

If specimens cannot be dried soon after collecting (within 24-48 hours), then they can be preserved in 70–95% ethyl alcohol. Place the specimens in newspaper folds and number with an alcohol-proof marker or pencil, tie into bundles and place into a heavy plastic bag. Add enough 70–95% alcohol to moisten all of the paper in the bundles thoroughly. Seal the bag to prevent evaporation. Remember that alcohol destroys DNA so this mode of preservation reduces the usefulness of specimens.

### Specimens preserved in liquid

Specimens to be permanently preserved in liquid (e.g. fruits preserved in formalin-acetic acid-alcohol (FAA) or alcohol alone) are not pressed or dried, but put directly into appropriate containers (e.g. borosilicate glass with tight-fitting lids, preferably ground glass tops, but more commonly with sturdy, alcohol-resistant plastic screw tops). Liquid-preserved specimens should always have a label inside the container that is preservative proof. A second label can be affixed to the outside of the container for ease of reading (see Simmons, 1995, for additional details).

*Plant driers*

For drying pressed plants, a plant drier can be built to fit a standard plant press using framing materials such as metal, wood, plastic piping and so on. The drier frame can be placed above various heat sources (electric or kerosene are best) and covered with insulating siding material (wood, reflective hypothermia blankets and so on). Warning: fire is a constant danger and driers should never be used in collection storage spaces or anywhere a potential fire would threaten structures or other property. A drier should never be left unattended for extended periods. Forced air circulation dries quickest but is seldom available in the field where convection drying is usual.

## Preserving mosses, algae and lichens

Curation methods for special plant groups vary (Bridson & Forman, 1998). Bryophytes (mosses, liverworts and hornworts) are collected directly into paper packets and dried as quickly as possible with as little heat as possible. In the herbarium, these packets can be filed directly in drawers or mounted on sheets. Algae collection and preservation is specialised, depending on group. Fungi and lichens should be dried as quickly as possible at warm temperatures or preserved in spirits. Dried specimens are stored in packets or boxes. Slime moulds are collected into boxes.

## Ancillary collections

Herbaria and anthropological or archaeological collections have a wide range of ancillary collections that support ethnobotanical research. In addition to liquid-preserved samples, there may be pollen and spore preparations mounted on slides, anatomical thin sections on slides, carbonised plant fragments, tissue dried in silica gel for DNA analysis and extracted DNA (Chapters 5 and 7). Each of these kinds of collections has its own optimal storage conditions and organisational, management and access issues.

## TRANSPORTING COLLECTIONS

## Shipping

Collections can be shipped using various companies and national services. First, bundle dried specimens tightly in newspaper packets bound (tightly enough to prevent specimens from slipping out of the newspapers but not be crushed) with string or tape. Place these (with no room to move) in cardboard boxes the length and width of a specimen. Pack the boxes tightly or fill with them packing material, and include a species list and a copy of the import permit in each box. Some countries have reliable mail, which is cheap and easy to use; in other places, it is preferable to use companies that can track shipments (such as UPS, FedEx, DHL, or airline or shipping companies). Label the outside of the box clearly, 'Dried scientific specimens (plants) of no commercial value'. Any permits or customs declarations should go in a pouch on the outside of the box with copies inside. You can also put specimens in your personal luggage and then go through the agricultural inspection line at customs; again, you must show your import permit. This process may slow down your transit time, so leave extra time between flights.

## Freezing

As soon as a box of dried specimens arrives at a museum or herbarium, the specimens need to be put directly in a freezer and held at -18°C (0°F) or lower for one–two weeks to kill potential pests (see Chapter 2 for more detail on freezing as pest control).

## HERBARIUM COLLECTIONS

There are many stages in preparing and curating herbarium collections for long-term preservation.

**COLLECTING** A good herbarium specimen must be collected properly. Here, students are being taught to collect and prepare plants for herbarium specimens.

**MOUNTING** Once specimens are collected, pressed, dried, shipped, received by a herbarium and frozen (to kill pests), they will be mounted on heavy acid-free paper. Here, a mounter at the Missouri Botanical Garden is sewing a specimen to a herbarium sheet.

**FOOD LIBRARY IN BAGS**   Biocultural specimens that are collected in markets or shops may be preserved in bags or boxes rather than mounted. This is a drawer from the 'Food Library' at the Missouri Botanical Garden.

Mosses and other life forms may also not be mounted. Here, a moss expert at the Missouri Botanical Garden inspects a specimen in a specialised envelope.

ABOVE Experts identify specimens before they are shelved.

BELOW The Herbarium building at the Missouri Botanical Garden is temperature and humidity controlled to reduce pests and specimen deterioration, with extensive measures for fire prevention and security.

ABOVE Herbarium specimens are shelved in taxonomic order on shelves in rows of compactors within a herbarium.

## SPECIMEN IDENTIFICATION

### Field identification

Initial identification should be attempted in the field, in national herbaria and/or with local experts who are familiar with the flora. This requires access to field guides, local checklists or floras and close collaborations with national herbaria and botanists. Always remember how valuable this in-country consultation is and strengthen your interactions with national collaborators in whatever way possible.

### Consultation with specialists

Later, when the specimens arrive at your herbarium, you will need to contact taxonomic specialists for as many groups as possible for final identifications. This is why you collected an extra specimen for a specialist. There are many references that list taxonomic specialists including: the Integrated Taxonomic Information System (ITIS), Index Herbariorum, the European Distributed Institute of Taxonomy (EDIT), and societal directories including the American Society of Plant Taxonomists (ASPT), the Botanical Society of America (BSA) and International Association for Plant Taxonomy. Amazingly, taxonomic specialists around the world are willing to determine specimens within their specialty in exchange for a duplicate specimen (if the specimens are fertile and well made). Specimen identification is a tremendous service, so treat these botanists with respect and deference.

## SPECIMEN LABELLING AND DATABASING

### Herbarium labels

Before you can send your specimens to experts for determination, you should prepare complete herbarium labels that are suitable for mounting with the specimen. The label will include: the project title; the determination (family, genus, species and species–name author); the collector(s); the collection number; the collection date; the location (elevation, latitude and longitude); the habitat; the plant description (habit, growth form, size, colours and so on); and other information that you collected in the field (including abbreviated ethnobotanical and cultural information).

### Databasing

Label making is often integrated with databasing (Chapter 11), so that all specimen and label information is entered into the institutional database simultaneously. More data can be entered into the database than will appear on the label and this is particularly important for biocultural collections that may have detailed use, preparation, cultural and/or historical information associated with them.

## MOUNTING HERBARIUM SPECIMENS
(See also Bridson & Forman, 1998.)

Mount dried plant specimens only on sturdy, acid-free paper stock to provide the long-term preservation and physical support the specimen needs to withstand handling. Standard paper size varies across herbaria, but in North America 16.5' × 11.5'/42 cm × 29 cm  is usual.

If the specimen is large with multiple parts, mount the parts on two or more mounting sheets. If the plants are small, several can be mounted on one sheet, but be careful to ensure that they have the same collection number from the same locality. Fill the page with no overhanging pieces. Aesthetics can be considered. The label (sized about 9 × 12 cm) goes in the bottom right corner of the sheet, so leave space, or attach the label first, before the specimen. Specimens can be affixed using glued strips

of archival paper, or sewn or glued directly to the paper (never tape or staple!). Use small weights to hold specimens in place while the glue dries.

Small parts that become detached during transport or drying should be placed in a small archival paper envelope affixed to the sheet. Large pieces (such as fruits, woody stems and so on) may be sewn onto the sheet, but very large fruits or other bulky parts should not be mounted on paper but stored in boxes or bags, with a complete label and cross-referenced with the flat sheets.

Thoroughly dry the mounted specimens before stacking, arranging in folders, and filing in herbarium cases.

Bar codes are often added to facilitate finding a specimen in an institutional database.

## ORGANISING AN HERBARIUM COLLECTION
(See also Metsger & Byers, 1999; Bridson & Forman, 1998.)

### Folders

There are three levels of folders used within a herbarium's organisational system: genus, species and type. The folders should be of good-quality acid-free paper, somewhat larger than the mounted specimens. These folders should not be over-filled or specimens can be damaged. Genus and species folders keep specimens of the same genus or species together for easier organisation and retrieval. Type folders protect type specimens (specimens on which biological names are based). They have distinct markings (often red bands and the word TYPE prominently displayed) to promote careful handling and conservation, as well as easy retrieval.

### Filing

Folders are filed either on open shelves, in cabinets (herbarium cases), or in boxes made slighter larger than the dimensions of the folders and then set onto the case shelves. Recently, to use space more efficiently, many herbaria have chosen to use compactors, in which cases or shelves are mounted on rails with no permanent aisles. These shelves can be moved to create an aisle that allows access to the desired specimen. Cases can be made of wood or metal. Fireproof or fire-resistant and insulated metal cases are much preferable.

### Specimen organisation

Different herbaria may be arranged differently. The most common system of specimen organisation is taxonomic, although biocultural collections might be organised by use, culture, history, geography or topic of study (i.e. all specimens from a particular study can be kept together along with publications). Taxonomic organisation of families can follow the Angiosperm Phylogeny Group III (APGIII) phylogeny, an alphabetic scheme, or some other phylogenetic system (such as Engler, Bentham and Hooker, Cronquist or Takhtajan). Generally, the component genera and species within families are organised alphabetically. Leave extra space both to allow reorganisation of portions of the collection when taxonomic changes occur and for the expansion of your collections in the future.

## COLLECTION SPACE DESIGN

Collection spaces should preferably be custom built and designed specifically for herbarium specimen storage (refer to Rose et al., 1995; Bridson & Forman, 1998; Metsger & Byers, 1999). Space must be as waterproof, dust proof and fire proof as possible. Lighting is important for viewing specimens (although specimens should be stored in the dark when not in use to limit degradation).

Equipment is often needed to study plants; previously, this study was limited to simple laboratory work, microscopy and photography, but today it extends to the electron microscopy and molecular studies commonly carried out in major herbaria. Today, we must design the physical and the virtual; an associated virtual herbarium on-line can provide access to people around the world and to people in all walks of life.

## ENVIRONMENTAL CONTROL PROCEDURES

### Climate control

To prevent specimens from deteriorating, they must be stored in low humidity and away from direct sunlight. The best environmental conditions are stable humidity of around 45% rH with low temperatures, the cooler the better, although cold limits the comfort of those working in the herbarium. Usually, these conditions are achieved with air conditioning, dehumidifiers and artificial lighting. Good environmental controls and housekeeping also helps control insect pests or other infestations. For full coverage of best environmental control procedures, see Bridson & Forman (1998) and Metsger & Byers (1999); much of the advice in Chapter 2 is also applicable.

### Pest control

The control of pests is a continuous process in any museum or herbarium. Pests — generally insects, fungi, mould and rodents — must be excluded (physically and chemically), environmentally discouraged (by maintenance of dry, cool and dark conditions), monitored (inspected and trapped) and fumigated, frozen, poisoned and/or trapped when they inevitably appear. Pest control is best referred to the experts (see also Chapter 2; Bridson & Forman (1998)).

### Fire control

Fire is also a major concern in herbaria. Metal cabinets are less flammable than wood. Smoke alarms and fire extinguishers must be installed and readily at hand. Fire sprinkler systems can be employed but necessitate waterproof specimen cabinetry to keep specimens from water damage. Smoking and open flames must be prohibited. Fire doors prevent the spread of fire. Preparation of a workable collection disaster plan, and regular fire drills to train staff are important.

## SECURITY AND PROTECTION

(See also Bridson & Forman, 1998; Metsger & Byers, 1999)

### Access

Access to collections needs to be regulated. Although it may be beneficial to allow collection access to amateur botanists and students, these people may need help and supervision in the herbarium to prevent collection damage. Security involves physical controls (such as doors and locks) and monitoring (e.g. direct or CCTV). Walls or fences often secure the perimeter of a herbarium. Special protection and care may be provided for particularly valuable (e.g. historic or type) specimens, which might be kept in cases with controlled access.

### Specimen handling

Users must know the basics of how to handle collections without causing deterioration. Specimens must be handled carefully or not at all. Never flip specimens over as if they were pages of a book. Dried specimens are fragile and easily broken, so always treat them with care.

## Database security

Databases must be secured from hacking, vandalism and viruses. This can be achieved by firewall and password protections that can be expected to change constantly with newly developing computer hardware, software, hacking skill sets and virus development.

## OBTAINING AND DONATING EXISTING COLLECTIONS

Herbarium collections can be obtained in many ways. So far, we have discussed collecting, which is obviously fundamental, but collections can also be obtained by gift, deposition of vouchers, and orphaned collections from other sources. Orphaned collections — collections that are abandoned or deteriorate when a scientist leaves an institution or dies, or when an institution fails, can no longer afford to maintain a collection or has no interest in maintaining it — are of particular concern in ethnobotany. Only a few institutions have had sustained, long-term interest in ethnobotany collections, so that orphaned collections are numerous and poorly curated. It is much preferable to donate a collection with all concomitant data and publications to a committed institution, rather than losing or allowing deterioration of the collection.

Good herbarium management, to handle all aspects of curation discussed so far, is crucial. Without active, hardworking and dedicated staff to organise, maintain, document, research and communicate the wealth of information in herbaria, the collections are useless.

## SIMPLE STANDARDS FOR USE IN DEVELOPING COUNTRIES OR FOR SMALL COLLECTIONS
(See also Lot & Chiang, 1986 and Victor et al., 2004)

Although standards for herbaria are well developed and can be quite exacting, it is also advantageous and empowering to develop small herbaria in local communities, on native lands and in developing countries. It is important for people to document their local flora, traditional knowledge, uses, and cultural relations with it. Biocultural collections can be particularly important in fulfilling these goals. Curation standards should not be totally ignored but adaptations can be made. After all, herbaria were founded long before air-conditioning and computers, and those early, well-preserved specimens are some of the most valuable for tracing changes and traditions alike. The basics of pressing, drying, mounting and caring for herbarium specimens are universal and need not be expensive. Good housekeeping is the most important component of preservation: keeping a collection clean, dry, well-aired, pest-free and secure. Simple pest control using continuous monitoring through inspection of specimens and sticky traps, and rotational freezing can be effective. Mouse traps are essential. The biggest challenge is often sustaining the will to preserve specimens and associated information over the long-term. Thus training botanists and para-taxonomists becomes an exercise in cultural and intellectual survival (Duckworth et al., 1993).

## Websites

American Society of Plant Taxonomists (ASPT). www.aspt.net

Botanical Society of America (BSA). www.botany.org

Convention on Biological Diversity (CBD). www.cbd.int

Convention on International Trade in Endangered Species of Wild Fauna and Flora (CITES). www. cites.org

European Distributed Institute of Taxonomy (EDIT). www.e-taxonomy.eu

*Index Herbariorum*. http://sciweb.nybg.org/science2/IndexHerbariorum.asp

Integrated Taxonomic Information System (ITIS). www.itis.gov

International Association for Plant Taxonomy. www.iapt-taxon.org

## Literature cited

Brayshaw, T. C. (1996). *Plant Collecting for the Amateur*. Royal British Columbia Museum, Victoria.

Bridson, D. & Forman, L. (eds) (1998). *The Herbarium Handbook*. Royal Botanic Gardens, Kew.

Bye, R. A. (1986). Voucher specimens in ethnobiological studies and publications. *Journal of Ethnobiology* 6: 1–8.

Duckworth, W. D., Genoways, H. H. & Rose, D. L. (1993). *Preserving Natural Science Collections: Chronicle of Our Environmental Heritage*. National Institute for the Conservation of Cultural Property, Washington, DC.

Liesner, R. (1992). *Field Techniques Used by Missouri Botanical Garden*. Missouri Botanical Garden, St. Louis. www.mobot.org/mobot/molib/fieldtechbook

Lot, A. & Chiang, F. (1986). *Manual de Herbario*. Consejo Nacional de la Flora de México.

Martin, G. J. (1995). *Ethnobotany: a Methods Manual*. Chapman & Hall, London.

Metsger, D. A. & Byers, S. C. (eds) (1999). *Managing the Modern Herbarium*. Society for the Preservation of Natural History Collections, Washington, DC.

Rose, C. L., Hawks, C. A. & Genoways, H. H. (eds) (1995). *Storage of Natural History Collections: a Preventive Conservation Approach*. Society for the Preservation of Natural History Collections, Iowa City.

Simmons, J. E. (1995). Storage in fluid preservatives. In: *Storage of Natural History Collections: a Preventive Conservation Approach*, eds C. L. Rose, C. A. Hawks & H. H. Genoways, pp. 161–186. Society for the Preservation of Natural History Collections, Iowa City.

Victor, J. E., Koekemoer, M., Fish, L., Smithies, S. J. & Mössmer, M. (2004). *Herbarium Essentials: The Southern African Herbarium User Manual*. Southern African Botanical Diversity Network Report No. 25. SABONET, Pretoria.

# Curating ethnobiological products

MICHAEL J. BALICK & KATHERINE HERRERA
The New York Botanical Garden

## INTRODUCTION

Collections of useful plant products have a long history, beginning with 17th century cabinets of curiosity and continuing with the establishment of museums of materia medica in medical schools by the early 19th century (Chapter 20). By the mid-19th century, however, the specialist museum of economic botany had evolved, with the first to open at the Royal Botanic Gardens, Kew in 1847. Similar museums, and economic botany galleries within larger museums, followed in St. Louis and Harvard, at The New York Botanical Garden and elsewhere around the world. These museums contained a distinctive suite of specimens: usually worldwide in scope and derived both from indigenous communities and from modern plantations and industry.

As a consequence of their past popularity, many institutions worldwide continue to house collections of ethnobiological products dating back a hundred years or more. The age and diversity of their contents present special challenges to the curator. The same will be true of recent acquisitions, as these are likely to derive both from ethnobotanical fieldwork among communities who use plants to make traditional products such as baskets and clothing, and items purchased from the market to illustrate new trends in consumption, such as traditional medicines and global foodstuffs. Table 1 lists some of the more common products found in such collections.

## TABLE 1

Common ethnobiological products

| | | |
|---|---|---|
| • Alcoholic drinks | • Fruit pulps and juices | • Plant-based fibres |
| • Animal-skin products | • Lacquers and dyes | • Resins |
| • Construction materials | • Oils and fats | • Seeds and seed products |
| • Fermented products | • Pickled products | • Whole or pulverised leaves |

In this chapter, we draw on our experience of curating the Henry Hurd Rusby Collection of Economic Botany, much of which comprised what was referred to as the Museum of Economic Botany of The New York Botanical Garden, to discuss standards for curating ethnobiological products. This is both a historic collection and one that is growing through the ethnobotanical activities of Garden staff today (see Box 'The Henry Hurd Rusby Collection of Economic Botany'). We seek to complement the coverage of standards for collection care elsewhere in this volume (e.g. in Chapter 2) by focusing on artefacts and products of the kind available in markets and shops.

## THE IMPORTANCE OF CULTURAL CONTEXT

As stressed by Serge Bahuchet (Chapter 12), the unique value of a biocultural collection is the opportunity it provides to collect a wide range of information together with the actual specimen. Data for economic products should also include information on the context of the purchase of the product.

This includes data such as: pricing at the time of purchase (including exchange rate) and whether the cost was retail or wholesale; the kind of market the product was obtained from, for example, the types of products the market sells, or whether it is a retail market for local people or a tourist market; the place of the product in the retail chain; its form (e.g. liquid when purchased, which can change with time); and information obtained on the stability of the product (e.g. a food that has a finite shelf life). For contemporary specimens, there should be links to any related multimedia data obtained from audio recordings of interviews, photography and video footage.

Some ethnobiological products are not only physical documents of a culture but also have inherent or invested powers and properties within their cultural context. These must be considered in the handling, treatment and accessibility of the artefact (Chapters 17–19).

## COLLECTION & ACQUISITION

There are three routes to acquisition. First, specimens may be collected as part of a wider ethnobotanical programme. This is ideal because such a programme will make it easy to collect information about the specimens (such as the plant used) from their makers or users, and because prior informed consent for acquisition will be in place. It will also be possible to build up a truly representative collection. Second, artefacts and raw materials can be collected from markets, shops and other retail sources. These have the advantage of being accessible, but information about the items — in particular, which plant(s) they are made from — is much harder to obtain, and objects will not represent the full range of household use. Some items may be modified from their usual format to appeal to tourists. Third, specimens can be acquired from indirect sources, such as by donation or sale from retired scientists or ethnographers. In this case, the receiving institution must be assured that the original acquisition of the specimens was ethical and legal (Chapters 1 and 16), and must obtain written documentation of the donation. It is useful to have an acquisitions policy that sets out criteria for accepting new acquisitions.

If possible, raw materials and finished artefacts should be collected. Half-made artefacts and the tools used can also be valuable for showing how artefacts are made. For example, the Quin collection of Japanese lacquer at Kew (Figure 1) includes finished objects, half-finished demonstration pieces commissioned to show how decoration was applied, jars of lacquer varnish and pigments, and several sets of tools (Prendergast et al., 2001). Ethnobotanical specimens are also important as documents of modern life: new bio-materials or Fairtrade products have as much place in the collection as examples of traditional use.

## SPECIAL CONSIDERATIONS

### Morphology, anatomy and environmental conditions

The morphology, anatomy and composition of major plant group parts are distinctive and determine physical properties. It is therefore useful to consider the processing and use of plant material according to the major organs present (stems, trunks, roots, leaves, seeds and fruits), and according to major plant groups (dicotyledons, monocotyledons, gymnosperms and lower plants). In some cases the harvest or collection of the raw material is determined by the environment. In tropical areas, collection may be limited in the wet season when access to the plants and drying are difficult. Drying during the wet season can result in mould and fungal degradation and staining.

The composition, working properties and durability of the plant material are affected by the harvest time and maturity of the plant (Alexiades, 1996). Some plant materials used in products are

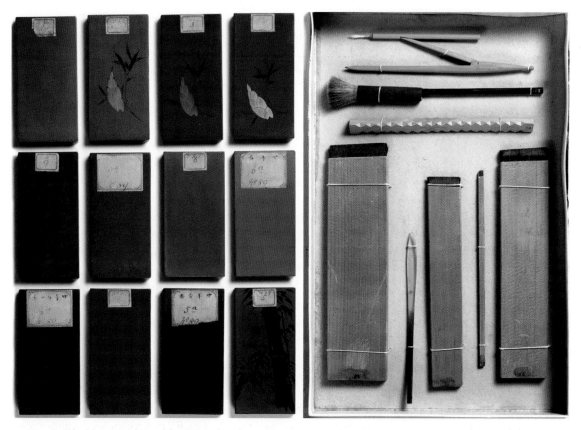

**Figure 1.** Items from the Quin collection of Japanese lacquer, at the Economic Botany Collection, Royal Botanic Gardens, Kew. (Left) sample blocks of lacquer, EBC 67854; (right) tools for applying lacquer and gold, EBC 68562.
PHOTO BY ANDREW MCROBB, © ROYAL BOTANIC GARDENS, KEW.

more easily harvested at particular times of the year. For instance, bark is most easily stripped from a tree when the sap is running and the vascular cambium is moist and active. Harvesting may also be determined by the maturity or immaturity of the plant or plant part. For example, gourds are harvested when fully mature so that the shell will dry hard and durable (Figure 2) and immature bamboo splits and collapses severely upon drying, making it unsuitable for many uses in the production of objects. Leaf strands for baskets and textiles are collected from the immature leaf shoots of the *Livistona* and *Nypa* palms as these strands are easily stripped from the leaves and are soft and flexible. Monocot stems are important sources of material for domestic and commercial uses, as seen in the utilisation of bamboos, rattans and sedges.

Similarly, many monocot leaves, such as those of *Pandanus*, *Musa* and many palms, are used for an array of purposes. Drying plant materials involves reducing the moisture content of their green state to that at equilibrium with the ambient relative humidity. The rate of drying and position during drying will influence cracking, shrinkage and distortion. Because many plant materials are stored between processing stages, thorough drying is necessary to help prevent the growth of mould and mildew. Likewise, one of the greatest problems with the conservation of cellulosic materials is how to retain sufficient moisture to maintain flexibility and prevent extreme shrinkage (Florian et al., 1990).

## Herbal medicines

The collection of herbal medicines requires special procedures. A herbal medicine sample will be far more useful if its processing has been recorded, and if the sample can be directly linked to herbarium voucher specimens. This necessitates working with gatherers or cultivators of medicinal plants to collect the appropriate material for herbarium specimens (i.e. the whole plant; Chapter 3). If possible, have the appropriate parts of other plants from the same population processed into medicines by local people using traditional methods, such as shade drying followed by period of steaming. In this case, there is a direct and unambiguous link between the identity of the plant (as vouched by the herbarium specimen) and the herbal remedy. Documentation of the processing method is also advised. Linguistic, audio, video and/or photographic records will significantly add to the information obtained by your collection (Chapters 14 and 15). If samples are collected from markets, particular care should be taken to record as much information as possible, including the date (see above) and location of the plant's collection, processing methods, and local name(s) of the product.

## Permissions for acquisition and transfer

If specimens have been acquired under an agreement that places conditions on the distribution of the specimens or information associated with them, then specimens must be labelled with a cross-reference to the agreement. Where material is lent or given to an external researcher, a material transfer agreement should state the conditions, such as non-commercial use.

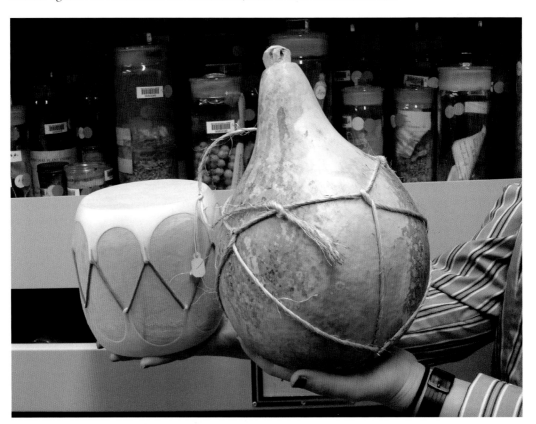

**Figure 2.** (Left) drum, Grila River, cottonwood, Taos; (right) gourd jug, with rough twine carrier and wooden plug, collector Naomi Barotz, 1989, Mexico, Tarahumana indigenous group. PHOTO BY IRINA ADAM, © THE NEW YORK BOTANICAL GARDEN.

## CONSERVATION

It is essential to treat ethnobiological products in the same way that other museum objects are treated — they should be curated and deposited, maintained properly and made available to researchers (Bye, 1986). At the same time, staff members, interns, volunteers and visiting researchers should receive training that is appropriate to their role in how to interact with collections.

### Packaging — new and old

The following storage materials and procedures are suggested for use with ethnobiological products (see also Chapter 2). Acid-free boxes should be used. Folders made from acid-free mount board should be used for protecting and storing small flat artefacts. Fragile objects are wrapped in archival-quality tissue paper. Other products may need support such as pillows (made of cotton cloth filled with polyester fibrefill), coiled cushions (to prevent rocking and abrasion), and cut or cast contour forms (made using acid-free corrugated board and conservation-grade closed-cell polyethylene foam). Some examples of packing techniques (such as tying and sewing onto backings) are also useful for storage, display and support during handling. Larger objects such as canoes, shields, spears, musical instruments and some household items require pallets and framework structures to support and move them safely. All wood and metal supports should be sealed to isolate vaporous components of the wood and to prevent contamination with corrosive products. Some objects are hung by folding over a dowel or tube, or by securing the top edge with Velcro, from a rod, with pressure clamps. Cloth backings applied by conservators to plaited mats can protect them from distortion caused by stretching along the bias weave (Florian et al., 1990).

Raw materials such as herbal remedies, seeds or pieces of gum should be stored in air-tight glass preserving jars, preferably with plastic or rubber-sealed lids. If material is likely to be analysed for bioactivity, it should be stored in dark, cool conditions.

**Figure 3.** (A) Large compactor at the NYBG herbarium; (B) historic jars containing indigo collections; and (C) various curated ethnobotanical products in glass jars.

(A) PHOTO BY IRINA ADAM; (B, C) PHOTOS BY KATHERINE HERRERA. ALL © THE NEW YORK BOTANICAL GARDEN.

Containers for ethnobiological products are sometimes objects worthy of collection in and of themselves, ranging from the flint glass bottles used in the 19th century for curating pharmaceutical and other product collections (Figure 3) to contemporary food and product packaging. It should not be assumed that old packaging must be replaced, particularly if it enhances the display of the specimens or incorporates valuable information about their earlier study and display. If a change of packaging is required, the original label should be preserved. Some ethnobiological products are liquids, such as an alcoholic beverage preserved in its original container (Figure 4). These should be placed upright in the collection, so that there is less opportunity for the liquids to seep out; alternatively, the liquid can be removed (Figure 5). Unless the container is very tightly sealed, however, many liquids in glass or bottles will degrade or disappear over time. We have observed from our own collections that, over a period of a decade or two, tins cans containing liquids can begin to spoil, with the lid, pop-top or entire can expanding and ultimately bursting. Thus, we have chosen to discard the contents of tin cans, both solid and liquids, and to preserve the can with an informative label (Figure 6) (Stober, 2011).

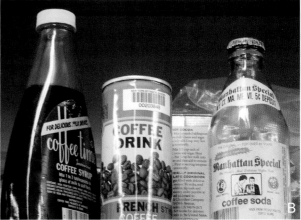

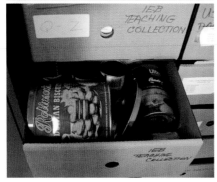

ABOVE LEFT **Figure 4.** Tequila bottle collected by Oakes Ames in 1916 and curated in the Economic Botany Collections of the Harvard University Herbaria. © ECONOMIC BOTANY COLLECTION, HARVARD UNIVERSITY HERBARIA.

ABOVE **Figure 5.** (A) Various commercial ethnobotanical products; and (B) bottles and cans stored in an upright position.
PHOTO BY IRINA ADAM, © THE NEW YORK BOTANICAL GARDEN.

LEFT **Figure 6.** Empty tin cans stored in horizontal position.
PHOTO BY IRINA ADAM, © THE NEW YORK BOTANICAL GARDEN.

The Wing Luke Museum in Seattle also has an important collection of canned and dried foods, pickles and other jarred edibles, and for now, they have left everything in the original packaging completely sealed; no issues with pests or mould have arisen (Stober, 2011). Other institutions preserve their ethnobiological products and foodstuffs without the original wrapper or package, often with the loss of valuable contextual information and the aesthetic properties of old wrappers. The collection at the Lower East Side Tenement Museum contains preserved edible products such as poultry bones, fish scales, garlic cloves, fruit pits, orange peels, raspberries, crusts of old bagels, a piece of Civil War-era hardtack, two metal tins of Nebraskit Survival crackers and many cans of soda and beer. These ethnobiological products are all desiccated, placed in an acid-free box and then placed in Swain double-bags. This method has proven to prevent decay, rust, and/or degradation effectively (Stober, 2011). The Cultural Preservation and Restoration company, based in New Jersey, recommends freeze drying organic products as a way to desiccate and preserve them, even though some products can change their shape and composition during this process. In practice, many foodstuffs can simply be air-dried.

## Environmental conditions

Controlling surroundings and environments is essential to stabilise deteriorating materials and structures and to slow down or prevent deterioration processes that naturally occur with plant-based objects. Climate control is an important factor and is covered in detail in Chapter 2.

## Pest management

Pest management is a great concern for all ethnobiological products in collections. With increasing awareness of health and safety factors, environmental impacts, and their possible effects on artefact materials, reliance on biocides is lessening in favour of alternative methods, such as freezing and habitat modification to discourage pest infestation and growth (Florian et al., 1990). Most critically, dry specimens (unless of made of layered materials) should be frozen before they enter the museum store (Chapters 2 and 3). Additionally, cleaning is important but must be done with care to not modify the artefact. Vacuum suction, compressed air, brush, and solvent cleaning (immersion, vapour, swabs and so on) are generally used by conservators, but sometimes certain artefacts or parts of artefacts are best left undisturbed (Florian et al., 1990; Tumosa & Mecklenburg, 2003). In this, as in most other aspects of collection care, advice should be sought from a professional conservator before undertaking interventive work or before embarking on large-scale repackaging programmes.

## SAFETY AND SECURITY

### Safety for the curator

Curation staff should receive training in how to interact with specific collections. Some ethnobotanical products may contain hazardous elements, such as toxins or allergens. People coming in contact with such materials must be provided with information and training before working with these potentially harmful specimens and artefacts (Kubiatowicz & Benson, 2003).

### Residual toxins

Working with residual toxic or allergenic chemicals that are applied to the artefacts to help preserve them, as well as with the possible toxic chemicals produced by the object itself, necessitates training programmes for safe handling and storage of ethnobotanical collections. For example, at the Science

Museum in Minnesota, the ethnobotanical curators and staff were told by a local ethnopharmacologist that breathing the dust of the barbasco vine (*Tephrosia sinapou*), which contains a potent metabolic poison containing rotenone, could have caused the cognitive dysfunctions, including forgetfulness and minor misjudgement, that some were experiencing when going through drawers containing this material (Kubiatowicz & Benson, 2003). In another example, many years ago, a collection of Chinese lacquerware products was given to the Botanical Museum of Harvard University because the owner discovered that she was highly sensitive to the allergenic compound urushiol. Apparently, it was the severe rash attributed to a lacquer-coated toilet seat that convinced her of this sensitivity (R. E. Schultes, personal communication, 1976). Curators working with this material had to be aware of its potential allergenic properties and their own degree of sensitivity.

## Security

The security of ethnobotanical product collections should also be considered. Psychoactive specimens and traditional artefacts are particularly at risk, as are jewellery and other ethnobotanical products. We suggest working with the department at your institution responsible for security to develop locally appropriate solutions (Chapter 2). Storage of controlled psychoactive substances may require government licensing and special storage, for example in pharmacists' cabinets in a room with limited access.

## INSTITUTIONAL SUPPORT

Financial security must also be considered when curating and building ethnobiological product collections. Too many collections suffer from the results of poor financial planning for their needs — current and future — resulting in 'orphan' collections that are held in storage or even discarded. It is wise to develop an institutional policy and standardised forms for those interested in donating their collections, as well as a statement on the need for financial support. For example, the gift of an ethnobotanical collection to an institution may need to be accompanied with sufficient funds to curate and maintain it.

Ideally, at least one full-time ethnobiological collections curator or manager should be employed by an ethnobiological herbarium and collection. As this is not possible in most cases, a percentage of a single individual's time should be allocated to this responsibility. Ethnobiological collection surveys are not just one-time events; collections must be examined periodically and on a regular basis to monitor the condition of specimens and artefacts and to look for mould, insects and dirt that would indicate the development of environmental problems in storage and display. Additionally, both staff and visiting researchers depend on the guidance and support of the ethnobiological collections curator or manager, as they cannot be expected to identify the chemical and toxicological properties of the materials they are working with or other relevant issues based on visual inspection and accession number.

One example of an historically and scientifically important ethnobotanical collection is that begun by Henry Hurd Rusby, M.D. at The New York Botanical Garden (see Box).

## THE VALUE AND USE OF ETHNOBIOLOGICAL PRODUCT COLLECTIONS

Setting up, or revitalising, an ethnobotanical collection is not complex, but it does require a long-term commitment of resources for curation and storage and, if possible, for display. Before beginning, it is worth giving careful thought as to how a collection is to be used.

## THE HENRY HURD RUSBY COLLECTION OF ECONOMIC BOTANY

The study of economic botany has been one of the major thematic activities of The New York Botanical Garden (NYBG) since its earliest days. The first curator of economic botany, as well as a founder of the Botanical Garden, Henry Hurd Rusby (1855–1940), was a physician and botanist, with a passionate interest in botanical exploration. After graduating as a medical student, he spent two years studying medicinal plants in South America. Rusby made over 60,000 collections from around the world representing 4,000 species, 20 percent of which were new to science (Rusby, 1921; Williams and Fraser, 1992; Rossi-Wilcox, 1993).

Rusby taught at Columbia University and was an active promoter of economic botany as a research focus for the NYBG upon its establishment in 1891. His pharmaceutical collection at The New York College of Pharmacy Drug Museum later served as the core collection of what was to become The New York Botanical Garden's Museum of Economic Botany. The Museum was opened to the public in 1899, displaying ca. 10,000 plants and plant products, organised by their uses. The collection comprises three types of plant products (Stevenson & Beck, 2000). The first are plant collections that are not in a processed form, e.g. ears of corn. The second category is those products that have been processed in a significant way, such as plant fibres used to make paper, including a form of paper made from pressed moss, early wheat straw paper and early newspaper, made from the ground wood of *Picea mariana*. The third category is products from plants that have been manufactured into objects used by people, such as a reed flute from *Phragmites australis*, from the Yuma Indians of Arizona, Croatian umbrella handles from *Castanea sativa*, and snow shoes crafted from *Schoenoplectus tabernaemontani* made by the Klamath Indians of Oregon (Stevenson & Beck, 2000). The collection consists not only of the material gathered during Rusby's personal expeditions, but items that were obtained from many other sources.

The collection was the primary reason for the construction of the Museum building in 1898–1901, at the beginnings of the Garden itself. As the Garden grew in programmatic breadth, the Rusby collection and associated displays began to be reduced to allow room for the expansion of programmes, and the glass jars which contained the bulk of the collection were gradually boxed and placed into storage areas in the basement of the museum. Sadly the conditions for storage in this place were less than ideal, and much of the material was damaged. Hoping to relieve this situation, one of the scientists working at NYBG found room for them at Harvard and what remained of the Rusby collection was shipped to Cambridge.

In the early 1980s, there was a revival of interest in economic botany at NYBG and the Institute of Economic Botany (IEB) was founded in 1981, with Dr. Ghillean T. Prance as its first Director and Michael Balick joining as a staff member . The Rusby Collection was returned to NYBG. At present (2011) 1700 jars remain from the original collection, compared with over 7000 collection numbers in Rusby's published catalogue. Most of the existing material is in airtight jars, those in cracked or broken jars having been placed in similar glassware, as long as the original labels were intact and readable. These are stored on the first floor of the new Herbarium wing in racks according to family, and genus.

The NYBG has two other collections of economic botany artefacts. The Market Products collection comprises materials dating from 1981 onwards. These are kept on the upper shelves of the Rusby collection and include many materials acquired in the ethnic markets of New York City, as well as market products from the areas of the world. Dr. Hans T. Beck contributed significantly to the genesis of this contemporary collection, which also includes many dozens of plant specimens confiscated from travellers entering the country by USDA inspectors at JFK airport. The IEB also has a recent collection of artefacts including items such as baskets and other hand made products from plants. The collections have been bar coded and data based and can be found on the first floor of the Steere Herbarium building.

## Scientific research

The main importance of ethnobotanical specimens is that they act as tangible documents of plant use. In their form, they capture the technology and art involved in the creation of plant products, whether a basket, a medicine or a food-stuff. Much can be captured in writing and photography, but there is no substitute for looking at and handling the actual raw material or artefact. Furthermore, specimens enable new research as research questions or techniques develop; for example, chemical or DNA analysis are now being applied to old specimens collected long before these techniques were invented (Chapters 21 and 22).

Specimens can be used as authentic herbal medicine reference standards. If linked to verified herbarium specimens, they can be used for creating identification and quality-control monographs, for identification of unknown medicines and for authentication. This is illustrated by our recent use of Rusby material for a phytochemical study on black cohosh, *Actaea racemosa* (formerly *Cimicifuga racemosa*, Ranunculaceae), a specimen collected more than 85 years ago (Jiang et al., 2005). The 85-year-old powdered material exhibited biological activity, confirming the stability of the triterpene glycosidic and phenolic compounds found in black cohosh, and showing the very long 'shelf life' that they bestow upon this plant product. Historic specimens in the Kew collection, ranging from sandalwood oil (Howes et al., 2004) to Mayan adhesives (Stacey et al., 2006), have similarly been used as reference materials for a wide range of chemical analyses. This type of applied research shows the importance of collections as a scientific resource for future ethnopharmacological studies.

Another example of the importance of material from economic botany collections was the discovery by Dr Timothy Plowman of type material in the Rusby collection, pertaining to the genus *Erythroxylum*. *Erythroxylom truxillense* was originally described by Rusby in the Druggists' Circular & Chemical Gazette (Rusby, 1901). Accession number 2684 of the Economic Museum of NYBG was a 'specimen of dried leaves in a glass jar (lectotype, ECON, isolectotypes consisting of small samples of this collection deposited at F, NY and USM)' (Plowman, 1979) (Figure 7). Plowman's discovery of *E. novogranatense* (D. Morris) Hieron. var. *truxillense* (Rusby) Plowman comb. nov. was based on his analysis of this material from one of the many glass jars that had been wrapped in newspaper, boxed and stored in the basement. It has since been digitised and made available through NYBG's Virtual Herbarium.

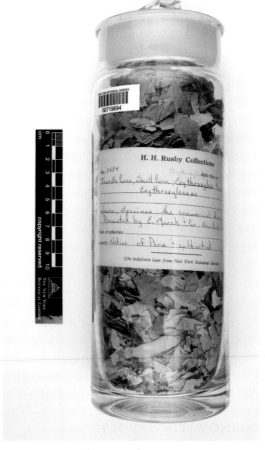

**Figure 7.** Lectotype of *Erythroxylum novogranatense* var. *truxillense* (Rusby) Plowman.

PHOTO BY IRINA ADAM, © THE NEW YORK BOTANICAL GARDEN.

## Public engagement

Ethnobotanical specimens are also compelling tools for public interpretation (Chapters 24–26). They often combine fascinating technology with the beauty of handmade objects. A display that sets specimens in a wider context — highlighting the culture that produced the specimens, the processes of manufacture and the story of how the specimen came to be collected — is likely to be of greatest appeal to the public. However, the surviving 19th century displays — for example at the Museum of Economic Botany in Adelaide and the Plants+People exhibit at the Royal Botanic Gardens, Kew — have now acquired a period charm that is in itself appealing. Historic displays can also be used to discuss the wider context of plant specimens, for example (as in these cases) in the history of empire and botanical exploration. Ethnobotanical collections are also useful in formal education, for example of university students, and in the training of specialists such as CITES inspectors and wildlife crime inspectors (Chapter 24).

## Cultural heritage

A third and increasingly important function is the preservation of cultural heritage. As traditional uses of plants die out, the artefacts in ethnobotanical collections take on a new significance to indigenous groups and anthropologists. Older collections in particular are likely to contain significant artefacts made by indigenous peoples, which can assist in helping people to 'relearn' lost skills. Consultation with indigenous peoples, including diaspora groups, can lead to much better understanding of ethnobotanical specimens. In particular, advice should be sought before items of mortuary or religious significance are displayed, or before ethnographic artefacts are conserved (Chapter 18). If the use and technology of an object is not understood beforehand, conservation may inadvertently erase evidence of how it was used in its indigenous context. In general, ethnobotanical collections place a greater emphasis on the materials and objects of everyday life than do ethnographic museums. An ethnobotanical collection may also play an important role in documenting the history of the institution that houses it, as in the case of the Rusby Collection and NYBG.

## CONCLUSIONS

Ethnobiological product collections have had a long and distinguished history in many major museums and botanical gardens. More than three decades of visitors to The New York Botanical Garden journeyed around the world in their mind's eye, by reading stories of the rare and exotic plant products they experienced in the Museum of Economic Botany. Today, the remaining objects and herbarium specimens are a valuable part of the William and Lynda Steere Herbarium, a priceless record of plants and other ethnobiological products used by people during the past 120 years. We look forward to a time when this and other similar collections from around the world will be appropriately documented, curated and made available more widely for the purposes of teaching and research. Lastly, it is important to acknowledge that these collections are not static; on the contrary, they should grow. It is essential to promote these collections as valuable assets in contemporary teaching and research, and thus to justify and attract the financial support necessary for their curation and dissemination.

## ACKNOWLEDGEMENTS

We are grateful to Dr Richard Rauh for information on the history of the Rusby Collection and to Prof. Robert Bye for suggestions on recording market specimens. Balick is an Associate of The Harvard University Herbaria.

## Websites

*The C. V. Starr Virtual Herbarium of The New York Botanical Garden*. http://sciweb.nybg.org/science2/vii2.asp

## Literature cited

Alexiades, M. N. (ed.) (1996). *Selected Guidelines for Ethnobotanical Research: a Field Manual*. New York Botanical Garden Press, New York.

Bye, R. A., Jr. (1986). Voucher specimens in ethnobiological studies and publications. *Journal of Ethnobiology* 6: 1–8.

Florian, M.-L. E., Kronkright, D. P. & Norton, R. E. (1990). *The Conservation of Artifacts Made From Plant Materials*. Princeton University Press, New Haven.

Howes, M.-J. R., Simmonds, M. S. J. & Kite, G. C. (2004). Evaluation of the quality of sandalwood essential oils by Gas Chromatography–Mass Spectrometry. *Journal of Chromatography* A 1028: 307–312.

Jiang, B., Yang, H., Nuntanakorn, P., Balick, M. J., Kronenberg, F. & Kennelly, E. J. (2005). The value of plant collections in ethnopharmacology: a case study of an 85-year-old black cohosh (*Actaea racemosa* L.) sample. *Journal of Ethnopharmacology* 96: 521–528.

Kubiatowicz, R. & Benson, L. (2003). Oh no! Ethnobotany. The safe handling and storage of hazardous ethnobotanical artifacts. *Collection Forum* 18: 59–73.

Plowman, T. (1979). Botanical perspectives on coca. *Journal of Psychoactive Drugs* 11: 103–117.

Prendergast, H. D. V., Jaeschke, H., Rumball, N. (2001). *A Lacquer Legacy at Kew: the Japanese Collection of John J. Quin*. Royal Botanic Gardens, Kew.

Rossi-Wilcox, S. M. (1993). Henry Hurd Rusby: a biographical sketch and selectively annotated bibliography. *Harvard Papers in Botany* 4: 1–30.

Rusby, H. H. (1901). More concerning truxillo coca leaves. *Druggist's Circular & Chemical Gazette* 45 (March): 47–49.

Rusby, H. H. (1921). Guide to the Economic Museum of the New York Botanical Garden. *Bulletin of the New York Botanical Garden* 11: 1–318.

Stacey, R. J., Cartwright, C. R. & McEwan, C. (2006). Chemical characterisation of ancient Mesoamerican 'copal' resins: preliminary results. *Archaeometry* 48: 323–340.

Stevenson, J.W. & Beck, H. T. (2000). *A proposal for the processing of the historic H. H. Rusby Economic Botany Collection. March 10, 2000.* Institute of Economic Botany, The New York Botanical Garden. 9 pp.

Stober, K. (2011). Food for thought: conserving historical foodstuffs in museums. *Museum* 90: 32–33.

Tumosa, C. S. & Mecklenburg, M. F. (2003). Weight changes on oxidation of drying and semi-drying oils. *Collection Forum* 18: 116–123.

Williams, D. E. & Fraser, S. M. (1992). Henry Hurd Rusby: the father of economic botany at the New York Botanical Garden. *Brittonia* 44: 273–279.

# Curating palaeoethnobotanical specimens and botanical reference collections

DEBORAH M. PEARSALL

University of Missouri

## INTRODUCTION

Palaeoethnobotanical specimens are either plant remains and tissues recovered from archaeological sites, representing human–plant interactions, or plants incorporated into the archaeological record through natural site formation processes, such as wind or water-borne plant remains. There are two important points to make at the outset. First, many kinds of plant remains become incorporated into archaeological sites, representing the diversity of materials covered in other chapters in this book, and more. Second, as part of the archaeological record, palaeoethnobotanical materials are subject to standard archaeological curation practices. I begin, therefore, by reviewing the basic principles and practices for curating archaeological collections, then I discuss the curation of common kinds of palaeoethnobotanical specimens and botanical reference collections. My goal is not to provide detailed guidelines for curating the diverse array of materials found in archaeological sites, but to cover basic and common issues, and to reference sources that provide more details. This review is written from the perspective of a practicing palaeoethnobotanist, and draws from my experiences as well as from literature and web sources. I hope it will be helpful to researchers setting up new laboratories, or to someone who has acquired an 'orphan' collection and is wondering what are reasonable practices that a researcher with limited resources can follow.

## CURATING ARCHAEOLOGICAL COLLECTIONS: BASIC PRINCIPLES AND PRACTICES

Curation is a process that begins in the field and continues in the repository (Sullivan & Childs, 2003). Archaeological collections (in the United Kingdom, archaeological excavation archives (Swain, 2007)) are not just objects and specimens, but the records of where those materials were found: their provenance. In a systematic archaeological collection, documents (such as field notes, photographs, maps and excavation forms) and objects are integrated, making the collection useful for research. Archaeological collections are managed — cared for and made accessible — for the long term; many are in public trust (in the United States, under federal or state ownership; see Swain (2007) for discussion of management in the United Kingdom). By the early 1970s, there were significant problems with curating archaeological collections (for example, large collections from the Works Progress Administration (WPA) era of the 1930s). These problems accelerated during the 1970s and early 1980s with the historic preservation movement (e.g. the Archaeological and Historic Preservation Act of 1974; and the Archeological Resources Protection Act of 1979) and because there was an ethic of conservation that held that the maximum amount of information should be retrieved if a site was excavated. Issue 23 (1980) of *Curator* presents papers from a symposium on curation of archaeological collections that addressed these issues. Unfortunately, regulations for curating federally owned collections were not issued until 1990, when curation was already in crisis from the flood of materials from federally mandated excavations in the United States. This crisis continues, but

progress has been made through better education about, and a stronger commitment to, collections management. Lack of adequate funding and space for collections are continuing problems.

It is beyond the scope of this chapter to discuss the complex issues surrounding reburial of human remains. In 1990 (amended 2003), the Native American Graves Protection and Repatriation Act (NAGPRA) became United States Federal law. Administered through the National Park Service, NAGPRA provides a process through which museums and Federal agencies return certain cultural objects and human remains to lineal descendants and culturally affiliated Indian tribes and Native Hawaiian organisations. Central to NAGPRA is direct engagement through consultation with affected Native groups (Watkins & Ferguson, 2005; Zimmerman, 2006; also Chapters 17 and 18 in this book).

The basics of managing curated archaeological collections include the following policies and procedures (from Sullivan & Childs, 2003; see also Swain, 2007; National Park Service Museum Handbook, 2006).

• **Acquisition:** obtaining legal title and formally adding the collection to the repository; includes determining the costs of processing, conserving and storing collections.

• **Accessioning:** formal inclusion into the institution's collections, which includes a condition report, assignment of a unique number to the object or collection, and the recording of information about the acquisition in the accession register.

• **Cataloguing:** assembling all the primary information about each item in the collection; most importantly, this includes permanently associating a specimen with its archaeological provenance. Catalogues typically include a catalogue number, object name or description, material type, form, quantity, measurements, weight, site number, site location, object provenance, collector and date collected.

• **Collections preparation (labelling):** marking each item or group of items with its permanent identity number using methods and materials that do no damage and are reversible, chemically stable, long-lasting and safe.

• **Collections preparation (conservation):** the assessment of condition and recommendation of action to preserve the object or record in its original state. The best approach is to do as little as possible. All treatments must be reversible over long periods of time. Glues or consolidants that might contaminate an object for scientific analysis should not be used. All interventions must be documented in the permanent record of the collection (see also Williams & Peachey (2010)).

• **Storage:** attention must be paid to spatial layout, environmental controls for different types of collections, security, fire protection and disaster planning. Environmental monitoring and controls typically include temperature, humidity, visible light, ultraviolet radiation, pollutants (e.g. dust, chemicals from unsealed wood shelving, solvents and acidic papers) and pests. The protection of collections is a primary consideration, but storage practices should also be designed to facilitate access to collections by researchers and indigenous communities. Common practices for storage include housing objects and associated records in an artefact container (a bag or box; boxes may have plastic lids for viewing objects without removing them), which is placed in a larger storage container (a cabinet, drawer or box on a shelf). Large objects can be directly marked with provenance information in a way that is reversible without damaging the object (Chapter 2). Provenance labels are placed on all containers. All materials used in artefact containers must be archival quality (acid-free or inert plastic sleeves for photographs; acid-free or buffered folders or polypropylene, polyethylene or polyester sleeves for paper records; 2 mm thick pure polyethylene zip-top bags for a wide range

of materials). Materials of different kinds (e.g. ceramics, lithics and photographs) from the same provenance are placed in different artefact containers. Human remains are treated with respect and housed in a separate area, accessible for consultation with indigenous communities. Unacceptable artefact containers include light-weight or chemically instable plastic bags, paper bags, easily breakable glass bottles and cardboard containers that are not acid-free (e.g. shoe boxes or cigar boxes). Consult a conservator if in doubt about the archival quality of materials. Containers should not be closed with rubber bands, twist ties, tape or string. Concerning paper labels: the Museum Handbook (National Parks Service, 2006) recommends white paper labels with neutral to slightly alkaline pH (pH 6–8) and a lignin content of less than 0.3%. Plastic and metal labels should be avoided (see Chapter 2). Acceptable adhesives for labels include methylcellulose paste (used on herbarium labels) and self-adhesive acrylic labels. Also, see National Parks Service (2006) for details on containers and storage practices for biological collections.

• **Inventory control and data management:** creating a permanent record of the physical location of all objects and records in the collection.

• **De-accessioning:** the process of removing a collection from a repository (and in many cases transferring it to another) because it is outside the scope of collections of the institution, subject to repatriation under NAGPRA, deteriorated beyond research or educational use, hazardous, acquired illegally or cannot be adequately cared for.

• **Public access and use:** procedures designed to allow use of but minimise risks to the collection (such as damage or loss of provenance). Typically, loans are made to institutions, not individuals.

In principle all materials in an archaeological collection are stored together, but in practice palaeoethnobotanical specimens are studied by specialists who may be affiliated with institutions different from that of the repository. Palaeoethnobotanical specimens may therefore be separated from the rest of the collection for extended periods. As discussed below, organic specimens require controlled environmental conditions that might not be available in all repositories.

## PALAEOETHNOBOTANICAL SPECIMENS

Virtually any part of any plant can be found archaeologically, given the right preservation conditions and the right recovery technique. Under desiccated conditions, for example, botanical specimens may include textiles, baked bread, wooden carvings and cubic meters of organic fill. Waterlogged deposits also provide excellent conditions for botanical preservation, as demonstrated by the rich organic record recovered from shipwrecks and bog excavations. Most practicing palaeoethnobotanists will handle few such materials, however, as most excavations take place at sites in which wetting and drying lead to rapid organic decay. The most common botanical specimens recovered from excavations world-wide are charred, the remains of plant tissues that came into contact with fire but did not burn to ash: charred wood, seeds, fruits and roots. These kinds of specimens are commonly referred to as macroremains, because they are visible to the naked eye or can be studied using low-magnification light microscopy (Pearsall, 2000). Macroremains are often recovered in large quantities from habitation sites using a technique called flotation (water separation of lighter botanical materials from site sediments). A flotation sample usually contains both charred macroremains and modern organic soil constituents (rootlets, weed seeds and the like) and is hand-sorted under a microscope. Larger charred macroremains are also commonly recovered both *in situ* during excavation and in the screens used for artefact recovery; it is typical that specimens sent to a palaeoethnobotanist for study will come from all of these sources.

Microremains, plant parts that are not visible to the naked eye, are also recovered from archaeological sites; the most commonly studied are pollen, phytoliths (plant opal silica bodies) and starch (Pearsall, 2000). Microremains are typically extracted from sediment samples collected for this purpose from site contexts of interest, from residues on the surfaces of artefacts such as ground stone and ceramics, and from the calculus of human dentitions. The modes of deposition and preservation are distinctive for pollen, phytoliths and starch, and not all will be recoverable from all archaeological contexts. For example, pollen and starch are not as commonly preserved as phytoliths in archaeological sediments that routinely wet and dry.

## CURATING PALAEOETHNOBOTANICAL SPECIMENS

## Curation starts in the field

The idea behind this principle, as expressed by Sullivan & Childs (2003), is to put in place practices during archaeological excavations that produce palaeoethnobotanical samples that are stable for the long term, to the extent possible, when they arrive at the repository or analysts' laboratories. The practices described here are relevant to palaeoethnobotanical specimens. Light and heavy fractions from flotation should be dried (to 65% rH or less; above this, microorganism activity is likely (Cronyn, 1990)) before placing the material into 2 mm-thick polyethylene zip-top bags. (This acknowledges that damp field conditions may necessitate the opening and final drying of all samples in the lab.) Label the outside of each bag with an indelible marker with full provenance information (or fix a label with this information to the bag), including numbers that link samples to excavation units and other collections. Place inside the bag a tag made of acid-free cardstock with the same information written on it in pencil. *In situ* and screen-recovered macroremains should also be placed in 2 mm-thick zip-top bags and labelled as above. Aluminium foil and paper bags deteriorate and should not be used to contain macroremains; fragile specimens can be protected by placing individual bags into a sturdy, padded box. Charred material intended for radiocarbon dating can also be placed into a polyethylene zip-top bag, which will not contaminate it, but do not place a paper tag inside the bag.

Sediment samples for the recovery of microremains should be placed in 2 mm-thick polyethylene zip-top bags and labelled on the outside. Do not tape bags shut or write on the tape because tape can become brittle and provenance information might be lost. Artefacts that will be used for residue analysis should be bagged individually, unwashed, in 2 mm-thick polyethylene zip-top bags and labelled as above. If artefacts are sampled in the field, residues should be placed in leak-proof polypropylene or polyethylene vials or bottles (if in doubt about water-tightness, place each in a zip-top bag) that are labelled with full provenance information in indelible marker.

## Laboratory and permanent storage: botanical macroremains

### American Archaeology Division example

In the early 1980s, the University of Missouri (MU) American Archaeology Division (AAD) was awarded an NSF Systematic Collections grant to improve the cataloguing and storage of palaeoethnobotanical specimens from early excavations at sites in Missouri (Pearsall et al., 1983). The collection included both dried and charred specimens. Here, I summarise procedures developed for this project as an illustration of laboratory curation practices for dried and charred macroremains.

All botanical specimens from an AAD inventory-numbered storage box were listed on a paper inventory form by scientific name (or as unknown), with count and weight of material, and code for

item type (e.g. for maize: cob, ear, cupule or rachis segment, vegetative portion) and item state (i.e. carbonised, partially carbonised, dried, calcified or modern/fresh). All data were later entered into a mainframe computer program adapted for the project. In addition to identifications and quantities of material, the computer record contained codes for botanical family, and full provenance and site information. The magnetic tape on which data were stored is no longer readable, but the paper inventory forms and computer printouts of the file sorted by site number and botanical family had been archived: a reminder that the curation of digital archives needs as much attention as that of archives in other formats.

Much of the collection consisted of charred botanical remains, which were stable and whose long-term curation required only protection from mechanical breakage. These remains were stored as described below, without any treatment. Part of the collection contained dried, non-carbonised specimens, including corn cobs, nut shells, twinned cord, woven cane basket or mat fragments, squash rind, wood, herbaceous material and seed from a variety of taxa. Examination of several collections of dried materials revealed extensive mould growth on some. To ensure that mould spores were killed and that unaffected specimens were not contaminated, the MU Art History and Archaeology conservator, the late Maura Cornman, recommended that we fumigate all the dried material in the collection after sorting and identification was completed, and before specimens were re-boxed. We constructed a gas-tight fumigation chamber, modelled after the design described by Clapp (1978), in which vapours from thymol crystals killed mould spores. After airing for 24 hours, specimens were re-boxed in new (i.e. mould-free) containers for permanent storage, as described below. A number of dried basketry and other fibrous assemblages were given additional conservation by Cornman following fumigation, including dry-cleaning with a soft bristle brush and air puffer, consolidation with acryloid B-72 lacquer, and mounting on 5 mm Mylar stapled to a sealed wooden frame.

Since the time of this project, thymol has lost favour as a treatment for mould because of its negative effects (degradation) on paper and pigments (Isbell, 1997). Thymol is considered moderately toxic, and should be handled with gloves and in a ventilated space. This chemical effectively kills active mould spores, but it does not have any residual fungicidal effect. Instead, current treatment for mould (which should only be carried out if necessary, with advice from a conservator) includes airing in sunlight and bathing in alcohol to kill active mould on objects, and vacuum aspiration.

In planning storage for the collection, several factors were given high priority: that storage containers protect delicate remains from mechanical breakage; that dried materials be protected from high acidity leading to deterioration; that the collection be protected from dust and insect pests; that the separation of material into provenance units within sites be maintained strictly; and that the organisation of the collection would allow easy coordination with the catalogue. Storage containers and other packing materials were selected by Cornman, with reference to the existing literature on the conservation of perishable materials (e.g. Gardner, 1980). The containers used for storing perishable collections must meet three criteria: durability, stability and neutrality in relation to the items being stored. The following items were chosen for storage of the collection: acid-free tissue paper, polyethylene bubble wrap, acid-free boxes (for dried material storage), 10 dram polyethylene vials, 7 ml sample polyethylene bottles (for seed storage), coated boxes (for carbonised material storage), steel cabinets and wooden drawers (with bottoms perforated with 0.5-inch holes for air circulation; all wood sealed with alkyd resin varnish). Polyethylene microcentrifuge tubes with attached lids were later added for the storage of very small seeds. Three methods of permanent storage were envisioned: drawer storage of boxes or vials of specimens; drawers as primary containers for larger materials; and shelf storage (using existing steel shelves and standard curation boxes).

Drawer storage of individual small boxes and vials was the predominant form of archiving. After materials from each inventory number (assigned when site materials were accessioned) had been sorted, identified, catalogued and fumigated (in the case of dried materials), vials or boxes were selected to house each discrete taxon within each provenance unit. Acid-free boxes or vials were selected for dried specimens; coated boxes or vials for carbonised remains. Acid-free tissue paper was used when necessary to prevent specimens in vials or boxes from moving around. For particularly fragile remains, bubble wrap was cut to fit the box and tissue or cut-out forms in bubble wrap were used to keep the specimen stationary. Samples designated on the original containers as samples for carbon-14 testing, or any wood samples wrapped in aluminium foil, were kept in foil within the box or vial. Labels with complete inventory, site and provenance data were placed on each storage container. Containers were grouped by provenance in the drawers. It was generally possible to limit drawers to one inventory number.

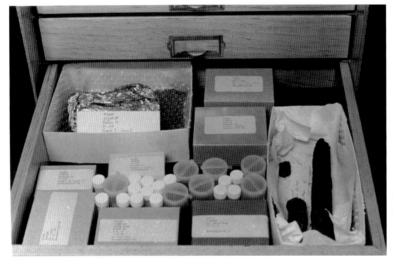

**Figure 1.** Drawer storage of plant macroremains at the American Archaeology Division. Current day practice would be for all boxes to be lidded.
© DEBORAH M. PEARSALL

Rather than purchasing many large acid-free boxes, which are expensive, to house larger dried specimens such as corn cobs or wooden posts, the drawer itself was often used as the primary storage container (Figure 1). If the whole drawer was needed to house the specimen, bubble wrap was cut to line the bottom and sides of the drawer, and the specimen placed on it. Acid-free tissue paper or cut-out bubble wrap forms were used to keep the specimen in place. If the specimen took up only part of a drawer unit, a form was made from acid-free mounting board to completely surround the specimen and bubble wrap padding. Polyethylene foams such as Ethafoam and Volara, rather than bubble wrap, are now used for cushioning and supporting objects in collections (Chapter 2). Provenance information for specimens stored directly in drawer units was typed onto 3' x 5' (7.5 cm x 12.5 cm) index cards, which were placed in the drawers. Bear in mind that open storage areas, such as drawers without backs or with large gaps, can be vulnerable to rodent damage.

When curating macroremains, miscellaneous shipping boxes should be replaced with archival-quality storage boxes. Do not rubber-band individual specimen containers together; place all containers from a sample into a 2 mm-thick polyethylene zip-top bag or archival-quality box. Original laboratory forms and other documents, or good photocopies, should be placed in acid-free folders and curated with the samples. Further advice on curation is available from the websites of the Midwest Archeological Center, the National Park Service and the Smithsonian Museum Conservation Institute.

## Waterlogged specimens

Botanical materials that have been preserved in anaerobic, waterlogged conditions present conservation and curation challenges. It is of fundamental importance that objects remain waterlogged: because water has replaced much of the structure of the specimen, drying will rapidly lead to its distortion or destruction (Swain, 2007). Wood, for example, will splinter, warp, and lose about 90% of its weight, changes that cannot be reversed (Purdy, 1996). Short-term storage in water in a fridge or cold store (Figure 2) is usually possible as this provides cool and dark conditions, but monitoring is essential (Brunning & Watson, 2010; Karsten et al., 2012). Ideally, a long-term storage solution should be arranged before waterlogged material is accessioned.

Guidelines from English Heritage recommend the storage of waterlogged plant and insect remains in 70% ethanol, in plastic or glass tubes (Figure 3) (Robinson, 2008). Ethanol is highly flammable and special arrangements will be necessary for its use and storage; it may also interfere with subsequent radiocarbon dating. Wet storage also requires long-term monitoring, with topping up of tubes as required. If it is likely that waterlogged material will be used for dating, it can be freeze-dried (without the use of additives) but this might affect the morphology of the remains. Although plant remains are sometimes stored in water alone, this brings a high risk of growth of micro-organisms (Robinson, 2008). Freezing has been used as a pre-treatment, with little deleterious effect, and has potential for long-term storage (Vandorpe & Jacomet, 2007); further experimentation on the freezing and freeze-drying of seeds and similar material is required.

The basic principle of stabilising waterlogged wooden objects is to replace water slowly with an alternative material, typically polyethylene glycol (PEG), followed by vacuum freeze-drying (Brunning & Watson, 2010; Swain, 2007) (see Cronyn (1990) and Karsten et al. (2012) for details). Non-vacuum freeze-drying can be conducted in a domestic chest freezer with a fan (for method, see Karsten et al. (2012)). Different molecular weights of PEG will be needed for different materials. Waterlogged wood specimens must be cleaned of soil very gently under the supervision of specialist conservators; Cronyn (1990) recommends gentle water spray and soft brushing. See Hamilton (1999) and Brunning & Watson (2010) for further discussion of the conservation of archaeological materials from underwater sites, including maritime settings.

 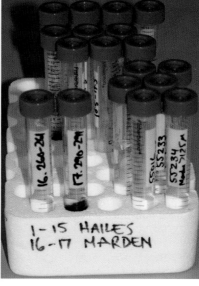

**Figure 2.** Storage of waterlogged samples. (Left) storage prior to processing in a cold store at 4°C; (right) sediment sub-samples in distilled water in temporary cold storage awaiting the extraction of pollen. © ENGLISH HERITAGE.

**Figure 3.** Waterlogged plant remains from Silbury Hill, stored in 70% ethanol. © ENGLISH HERITAGE.

*Desiccated specimens*

Preservation of organic material by complete desiccation is rare, but dry climatic conditions can protect material from gross decay (Cronyn, 1990). 'Dry' wood should be kept dry in the sense that the existing level of water in the specimen should be maintained. This requires fine control of relative humidity: fluctuation of humidity levels is especially destructive as it causes materials to expand and contract. Treatment with a humectant such as glycerol or sorbitol makes dry organic materials less susceptible to humidity changes but should only be undertaken by a conservator with experience in this area. It may be possible to store dry wood specimens at the ambient humidity of the repository by slowly bringing them to that relative humidity level. Freezing is used to kill live insects (Chapter 2). To remove surface soil, dry wood specimens should be lightly brushed.

## Laboratory and permanent storage: microremains

The extraction of microremains from sediments and residues on artefacts and from human dentitions typically create two kinds of samples: slide-mounted extracts examined by the analyst and un-mounted extracts reserved for future study. At the MU lab, phytolith extracts are stored dry in sturdy one-dram glass vials with screw-top lids, to which are fixed Nalgene polylabels with a catalogue number. The MU lab maintains four catalogue sequences: phytolith soil/sediment (PS), phytolith comparative (PC), starch sediment (SS) and starch comparative (SC). The comparative collections are of reference material, usually collected from living plants or preserved plant specimens. Archaeological samples are numbered as they are readied for processing, and all provenance information is entered in the master

soil-processing log book, and later into an electronic spreadsheet. PS vials are archived in numerical order in vial boxes. A standard quantity of extract is mounted in Canada balsam on a glass slide, and covered by a glass cover slip. A Nalgene label with the PS number is fixed to the slide. Various scanning forms are used to record phytolith data; these are all labelled with the PS number, project name, analyst's name, microscope used for scanning and date. Provenance information is not accessed until data are ready to be compiled (i.e. the slides are scanned 'blind'). After a study is completed, slides are transferred to the slide archive (always stored flat), in numerical order by PS number. Paper forms are filed together under the project name. For long-term curation, provenance information should be added to all slides and vials, a process now underway for the MU collection. Slides made 35+ years ago with Canada balsam are somewhat yellowed, but the phytoliths are still visible and fixed in position (scanning is done while the mount is fluid). Slides made with Permount™, another mounting medium that hardens, can be kept from getting air bubbles over time by painting the edges of the cover slip with nail polish (Dolores Piperno, personal communication, November 2011).

The practices and materials used at MU for archaeological starch research are like those just described for phytoliths, with the following differences. Starch extracts are stored wet, in distilled water. No mould has been observed after 12 years, but the long-term stability of these extracts is unknown. Linda Perry (personal communication, November 2011) is experimenting with storing starch extracts in vials in a mixture of water, glycerine and a few drops of ethanol to prevent mould, with success after one year. Dry storage could be achieved by allowing water to evaporate from vials after study completion; success with low temperature drying (40°C) has also been reported (Therin & Lentfer, 2006). At MU, slide-mounts are made by pipetting extract-in-water onto 100% glycerol on a slide. Edges of the cover slip are sealed with nail polish. Typically, the nail polish must be mended for leaking glycerol; slides are not stable for long-term curation. For long-term storage, Linda Perry (personal communication, November 2011) seals slides with Permount™ instead of nail polish, and reports successful storage after 12 years. Other mounting media used in starch research include water (mounts dry and are re-hydrated for viewing), corn syrup, Permount™, Euparol™, Canada balsam and glycerin jelly, among others (Field, 2006). Starch researchers report success with mounting media that harden; the issue here is how long mounts remain fluid to permit rotation of starch grains (Field, 2006).

Like phytolith and starch extracts, pollen extracts are stored in small sturdy vials. There are two approaches to making slide-mounts for examination of pollen: preparation of temporary mounts in liquid glycerol and the use of permanent mounts in silicon oil (Shackley, 1981). Both liquid glycerol and silicon oil produce fluid mounts that permit the rotation of pollen grains, giving advantages over solid mounting agents such as glycerine jelly. The size of pollen grains is often crucial for their identification, and several studies have shown that pollen grains mounted in glycerine are larger than those mounted in silicon oil (Andersen, 1960; Reitsma, 1969; Slutyer, 1997; Meltsov et al., 2008). This is likely to be due to the hygroscopic nature of glycerine, as the pollen exine will absorb any water contained within it, causing the grain to swell (Andersen, 1960; Reitsma, 1969). Silicon oil is chemically inert and non-hygroscopic, making it the preferred mounting agent for pollen preparations (Andersen, 1960; Cushing, 2011). When slides are to be stored for long periods of time it is preferable to seal them by fixing a coverslip to the slide, allowing it to be cleaned and handled more easily (Cushing, 2011). Many sealants have also been shown to cause pollen grains to increase in size, and Cushing (2011) recommends that when grain size is of critical importance, paraffin should be used as a sealant. Several sealants are known to have deleterious effects on the structure of the pollen wall, and frequent checks of pollen reference material are recommended (Cushing, 2011).

## CURATING BOTANICAL REFERENCE COLLECTIONS

Botanical reference collections are modern, identified plant tissues to which unknown archaeological materials are compared (Pearsall, 2000). Reference collections are essential for achieving accurate identifications, and constitute valuable research resources. In this section, I briefly discuss the nature, organisation and curation of 'working' reference collections (see also Chapter 4).

### Types of collections

Botanical reference collections are built to fit the research aims of individual researchers or research teams: 'The content of the reference collection should be framed by the archaeological research questions.' (Field, 2006: 95). Reference collections are therefore highly variable, and evolve over the course of an individual's career and the life of the laboratory. Building comparative collections is part of every practicing palaeoethnobotanist's research activities, and takes time and resources. Typically, botanical reference collections have one or more geographic foci, and will also emphasise one or more kinds of plant tissues (Fritz & Nesbitt, in press). To use the MU lab as an example: our primary geographic focus is the lowland Neotropics, with secondary foci in highland South America and the Eastern woodlands of the United States; collections for the lowland Neotropics include macroremains, phytoliths and starch; the highland South America and Eastern woodlands collections are largely limited to macroremains, but include starch from domesticated plants.

Working botanical reference collections thus consist of cabinets, drawers, vials or boxes of identified, labelled plant tissues and microscope slides, which are pulled out and compared to unknown archaeological specimens. Collections must be easy to access and include quantities of tissues that are sufficient to permit some to be broken up, thin-sectioned, charred, extracted, freshly slide-mounted or otherwise rendered useful for comparisons to unknowns. Reference collections are often affiliated to voucher specimens, which are usually curated at a herbarium (Chapters 3 and 22). Herbaria may also give permission for tissues to be removed from vouchers in their collections for reference purposes (for example, for extraction of phytoliths or pollen). Botanical reference collections may also include materials that are not affiliated to vouchers; for example, plant tissues that were purchased at markets or garden-grown. In these cases, identifications are established from the common name (e.g. corn kernels = *Zea mays*), by consultation with experts, or by comparisons to published identification guides. Care should be taken in obtaining seeds from third-party sources such as botanic gardens as these may be misidentified or mislabelled (Aplin & Heywood, 2008).

Plant collection records (field notebooks, collection data forms, photographs, video recordings and audio records) are other vital components of botanical reference collections. Plant tissue specimens are used for direct comparisons to establish the identities of unknown archaeological materials, but collector's notes on where plants grew and what they were used for can contribute greatly to the interpretation of finds. Chapters 3, 4, 14 and 15 discuss record curation further.

### Collection organisation

For practical reasons, reference collections are generally organised with like-tissues together. In other words, all phytolith slides are stored together, all pollen slides together, all charred wood specimens together, and so on (Figure 4). Alternatively, all classes of macroremains might be housed together. Whichever approach is used, the organisation within collections is often by botanical family, then genus and species. Alphabetical ordering of families facilitates quick access, whereas systematic ordering groups related genera and species together, facilitating comparisons.

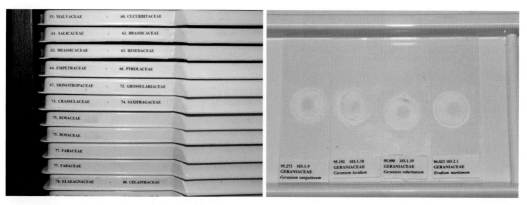

**Figure 4.** Storage of pollen reference collection: glass slides in plastic drawers. © ENGLISH HERITAGE.

Not all botanical reference collections will have associated voucher specimen numbers or field collection numbers, and so it is useful to assign each specimen a unique accession number that can be easily affixed to small storage containers or slides. Unique identifiers facilitate the linking of specimens and slides to field collection numbers, voucher specimen numbers and other information, such as the existence of photographs or information on uses.

The 20,000-slide pollen reference collection at Texas A & M University is entered into an ACCESS database by accession number, and there is also a card catalogue for all slides, arranged in one section by family and in another by genus. Users either go to the computer or to the card catalogue, find the catalogue number for a pollen type of interest, then pull the slide (Vaughn Bryant, personal communication, November 2011). The Natural History Museum Pollen Collection contains around 52,000 slides of pollen and spores (13,000 making up the main collection, plus duplicates). Slides are numbered and are stored in two sequences: the principal sequence of annotated slides arranged alphabetically by family, genus and species; and the second sequence of duplicates in numerical order. There is a central register, based on the slide–number series, that records details of slides, exchanges, micrographs, vials of stored material, how specimens were collected and treatment given to each specimen. Specimen details are also entered into an electronic database. At the MU lab, specimens in the comparative wood collections for the Caribbean and lowland Ecuador are described and sketched on cards, which are arranged by features of wood anatomy used for identification. Charred examples are organised for each region by family, genus and species. A similar 'card catalogue' exists for much of the phytolith comparative collection; in this case, the cards are organised hierarchically by major classes of phytoliths. A subset of the phytolith comparative collection has been photographed and entered into a database that is available online (see Box 'Electronic data storage and access', below).

The formation, housing, databasing and organisation of seed reference collections is covered in detail by Nesbitt et al. (2003). It is desirable that seed collections can be viewed rapidly, as this will allow the easy elimination of many species without further examination. To enable this, seeds are often housed in glass tubes (with plastic stoppers) or in clear plastic boxes, in both cases, laid out in shallow drawers in steel filing cabinets (Figure 5). A drawer can easily be taken to the laboratory bench for viewing. For tubes, small paper labels are printed out from the collection database and placed inside; for boxes, the label can be loose inside the box or (if self-adhesive) glued to the bottom. Labels should not be glued to the lids as this will obscure the view of the seeds within. It is essential that seeds can also be easily accessed for detailed examination and dissection. Sealed systems, such

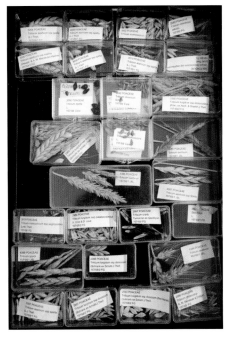

**Figure 5.** Storage of a seed reference collection in plastic boxes, in shallow drawers. The labels bear the accession number, the plant family and species names, the collector's name and number, and the species number following a scheme for United Kingdom plants.
© ENGLISH HERITAGE.

as microscope slide mounts, were used in the past to house seeds, but require that a duplicate set of more easily accessible specimens is also held. Seeds should be frozen before accessioning (Chapter 2); glass and plastic containers have the advantage of halting the spread of any infestation that does remain. Seed collections that are housed in paper bags or envelopes are both vulnerable to pests and hard to use at the bench. As discussed in Chapter 24, the greatest enemy of reference collections is disordering by humans; this is a problem for seed collections as it is often useful to examine different species side-by-side. Great care should be taken in handling, and labels should never be removed from containers.

## Curation of collections

In principle, for the long-term stability of reference collections, the same curation standards and practices used for archaeological collections should also be applied to comparative specimens. The extent to which this level of curation can be achieved depends on available resources and time. Additionally, this might be difficult to achieve due to the nature of materials. For example, neither comparative phytolith nor starch slides in the MU collection are stable for long-term curation. We make comparative phytolith slides with immersion oil sealed with nail polish, as Canada Balsam eventually hardens and rotating phytoliths are important for learning types. Immersion oil slides leak until, eventually, the phytoliths cannot be rotated. Comparative starch slides leak like the archaeological ones discussed earlier. Making new starch slides from comparative specimens is quick and easy; unfortunately, the same cannot be said of extracting phytoliths from plant tissues. Since botanical reference collections are made to be used, a certain amount of wear and tear must be expected. Replenishing and expanding reference collections are on-going processes.

## ELECTRONIC DATA STORAGE AND ACCESS

Electronic data storage and online accessibility of data, images and field records greatly enhance the value of archaeological research results, including those of palaeoethnobotany. As Limp (2005: 1272) puts it, ' … curation of digital data is a central element in archaeological knowledge management.' (italics in original). For palaeoethnobotanists, online access to data permits metadata analyses of regional trends, and digital image databases expand access to botanical reference collections. Limp (2005) provides a comprehensive discussion of the principles of archaeological data curation; see also Chapter 11 for database standards, Chapter 14 for curation of digital images, and Chapter 1 on the importance of having an index (inventory) of collections in electronic form (spreadsheet or database) that can be accessed online. Overall, the database format should draw on standards used in other botanical and archaeological databases; for example, the database fields proposed for seed collections by Nesbitt et al. (2003) are drawn from the database standard used by herbaria.

## PREPARING FOR THE FUTURE OF A COLLECTION

As discussed earlier, palaeoethnobotanical specimens are part of the archaeological record, and ideally, after studies have been completed, they should be curated in the same repository as other site collections. If this is not feasible, for example because controlled environmental conditions cannot be provided, specimens may remain at the analyst's laboratory. Ultimately, the future of such palaeoethnobotanical collections, as well as that of a laboratory's botanical reference collections, will depend on continuity in staffing.

As individual researchers, there is much we can do to prepare collections for a smooth transition to our successors, if institutional support is on-going for a laboratory, or to give collections a good chance of 'adoption' by another institution. To the extent feasible, we should curate palaeoethnobotanical and reference collections for long-term stability, make them accessible (physically and through online electronic databases), maintain good organisation (inventory control and clear association of specimens with provenance information, data forms, photographs and so on) and promote their research value (maintain a strong theme and geographic focus).

## ACKNOWLEDGEMENTS

Thanks to Jan Timbrook for providing information on whether it is safe and advisable to use thymol. Vaughn Bryant, Linda Perry and Dolores Piperno graciously shared their microremains curation practices. Ruth Pelling and Michelle Farrell advised on practice at English Heritage and provided pictures.

## *Websites*

### *Collections Care*

Midwest Archeological Center, National Park Service. *Sources of Archeological Curation Information.*
   www.nps.gov/mwac/reference_materials/curation_info/curation_info.htm
Smithsonian Museum Conservation Institute. www.si.edu/mci

### *Online image databases*

The following lists represent currently functioning websites that host databases and images of phytoliths, starch, pollen and macroremains.

#### Phytoliths

* University of Missouri-Columbia, Paleoethnobotany Laboratory. *Phytolith Database* (on the flora of Ecuador). http://phytolith.missouri.edu
* Dorian Fuller, University College London. *Old World Reference Phytoliths*. www.homepages.ucl. ac.uk/~tcrndfu/phytoliths.html
* M. Blinnikov, St. Cloud State University. *Phytolith Gallery* (on the flora of the Pacific Northwest). http://web.stcloudstate.edu/msblinnikov/phd/phyt.html
* Colonial Williamsburg Research Collections. *Phytolith Database.* http://research.history.org/ archaeological_research/collections/collarchaeobot/phytolithSearch.cfm
* University of the Witwatersrand, Johannesburg. *Wits Online Phytolith Database.* www.wits.ac.za/ academic/science/geosciences/bpi/research/6593/wopd.html
* Grup d'Estudis Paleoecològics i Geoarqueològics (GEPEG), Spain. *Phytolith database.* http:// gepeg.org/enter_PCORE.html

#### Starch

*Starch-id.* http://starch-id.eu/search/starch

#### Pollen

* *University of Arizona Catalog of Internet Pollen and Spore Images* (includes an index of all images on linked sites organised by botanical family and species). www.geo.arizona.edu/palynology/ polonweb.html
* *University of Arizona SEM pollen images.* www.geo.arizona.edu/palynology/sem/semuofa.html
* Australian National University. *Australasian Pollen and Spore Atlas.* http://apsa.anu.edu.au
* USDA Areawide Pest Management Research Unit (APMRU). *Pollen Reference Collection.* http:// pollen.usda.gov
* University of California, Berkeley. *Pollen Key for Selected Plants of the San Francisco Estuary Region.* http://oldweb.geog.berkeley.edu/ProjectsResources/PollenKey/byFamiliesAll-in-1.html
* *The Newcastle Pollen Collection* (for the flora of Australia). www.geo.arizona.edu/palynology/nsw/
* Society for the Promotion of Palynological Research in Austria. PalDat — *Palyological Database.* www.paldat.org

#### Macroremains (archaeobotanical)

* *International Work Group for Palaeoethnobotany* (many helpful links). www.archaeobotany.org/links. php
* Gail Fritz, Washington University, St. Louis. *Laboratory Guide To Archaeological Plant Remains From Eastern North America.* http://artsci.wustl.edu/~gjfritz/

- *Microscopic Wood Anatomy of Central European Species*. www.woodanatomy.ch
- George Willcox, CNRS. *Atlas of Images of Charred Archaeobotanical Finds*. http://g.willcox. pagesperso-orange.fr
- *Paleobot.org* (collaborative resource for seed identification). www.paleobot.org
- Department of Horticulture and Crop Science, Ohio State University. *Seed ID Workshop*. www. oardc.ohio-state.edu/seedid/search.asp
- Groningen Institute of Archaeology. *Digital Seed Atlas of the Netherlands*. http://seeds.eldoc.ub.rug.nl

## Online data sites

There are a number of online regional pollen and macroremains databases to which data from stratigraphic contexts, archaeological sites and modern surface samples are contributed by researchers.

### Pollen databases
- *Canadian Pollen Database*. www.lpc.uottawa.ca/data/cpd/
- *European Pollen Database*. www.europeanpollendatabase.net/
- *Latin American Pollen Database*. www.neotomadb.org/index.php/workgroups/category/lapd
- *North American Pollen Database*. www.neotomadb.org/index.php/workgroups/category/napd
- *Pollen Database for Siberia and the Russian Far East*. www.neotomadb.org/index.php/workgroups/ category/russ
- *South-Eastern Australia Pollen Database*. http://arts.monash.edu.au/ges/research/cpp/polldb.php
- *NOAA Paleoclimatology, Fossil and Surface Pollen Data*. www.ncdc.noaa.gov/paleo/pollen.html
- *CUPOD — Cambridge University Palynological Online Database*. www.quaternary.group.cam.ac.uk/ pollen/
- *Florida Institute of Technology,* Paleoecology. http://research.fit.edu/paleolab/
- *Czech Quaternary Palynological Database*. http://botany.natur.cuni.cz/palycz/
- *Fossil Pollen Database (FPD)* (fossil pollen data from Europe). http://botany.natur.cuni.cz/palycz/ pollen.cerege.fr/fpd-epd
- *IPOL — the Irish Pollen Site Database*. www.ipol.ie
- *Modern Pollen Data for North America*. www.lpc.uottawa.ca/data/modern/
- *Pollen Catalogue of the British Isles* (includes images of pollen and spores and notes on taxonomy). http://chrono.qub.ac.uk/pollen/pc-intro.html

### Macroremains databases
- Simone Riehl, University of Tübingen, *Archaeobotanical Database of Eastern Mediterranean and Near Eastern Sites*. www.cuminum.de/archaeobotany
- Helmut Kroll, Christian-Albrechts-Universität, Kiel. *Literature on Archaeological Remains of Cultivated Plants*. www.archaeobotany.de/database.html
- *Maryland Archeobotany, a 20,000 Year History of People and Plants in Maryland*. www.jefpat.org/ archeobotany
- *Archaeobotanical Computer Database* [*United Kingdom*]. http://intarch.ac.uk/journal/issue1/ tomlinson/toc.html

## Literature cited

Andersen, S. T. (1960). Silicon oil as a mounting medium for pollen grains. *Danmarks Geologiske Undersøgelse Series IV*, 4: 1–24.

Aplin, D. M. & Heywood, V. H. (2008). Do seed lists have a future? *Taxon* 57: 1–3.

Brunning, R. & Watson, J. (2010). *Waterlogged Wood. Guidelines on the Recording, Sampling, Conservation and Curation of Waterlogged Wood.* English Heritage, Swindon. www.english-heritage.org.uk/publications/waterlogged-wood/waterlogged-wood.pdf

Clapp, A. F. (1978). *Curatorial Care of Works of Art on Paper.* Intermuseum Conservation Association, Oberlin.

Cronyn, J. M. (1990). *The Elements of Archaeological Conservation.* Routledge, London.

Cushing, E. J. (2011) Longevity of reference slides of pollen mounted in silicone oil. *Review of Palaeobotany and Palynology* 164: 121–131.

Field, J. (2006). Reference collections. In: *Ancient Starch Research*, ed. R. Torrence & H. Barton, pp. 95–113. Left Coast Press, Walnut Creek.

Fritz, G. J. & Nesbitt, M. (in press). Laboratory analysis and identification of plant macroremains. In: *Method and Theory in Paleoethnobotany*, eds J. M. Marston, J. d. A. Guedes & C. Warinner. University Press of Colorado, Boulder.

Gardner, J. S. (1980). *The Conservation of Fragile Specimens from the Spiro Mounds, Le Flore County, Oklahoma. Contributions from the Scovall Museum, University of Oklahoma*, No. 5. Scovall Museum, University of Oklahoma, Norman.

Hamilton, D. L. (1999). *Methods of Conserving Archaeological Material from Underwater Sites.* Nautical Archaeology Program, Department of Anthropology, Texas A&M University, College Station. http://nautarch.tamu.edu/CRL/conservationmanual/

Isbell, L. H. (1997). The effects of thymol on paper, pigments, and media. *Abbey Newsletter* 21. http://cool.conservation-us.org/byorg/abbey/an/an21/an21-3/an21-308.html

Karsten, A., Graham, K., Jones, J., Mould, Q. & Walton Rogers, P. (2012). *Waterlogged Organic Artefacts: Guidelines on Their Recovery, Analysis and Conservation.* English Heritage, Swindon. www.english-heritage.org.uk/publications/waterlogged-organic-artefacts/woa-guidelines.pdf

Limp, W. F. (2005). Curation of data. In: *Handbook of Archaeological Methods, Volume II*, ed. H. D. G. Maschner & C. Chippindale, pp. 1270–1305. Alta Mira Press, Lanham.

Meltsov, V., Poska, A. & Saar, M. (2008) Pollen size in *Carex*: the effect of different chemical treatments and mounting media. *Grana* 47: 220–233.

National Park Service (2006). *Museum Handbook.* www.nps.gov/mwac/reference_materials/curation_info/curation_info.htm

Nesbitt, M., Colledge, S. & Murray, M. A. (2003). Organisation and management of seed reference collections. *Environmental Archaeology* 8: 77–84.

Pearsall, D. M. (2000). *Paleoethnobotany. A Handbook of Procedures.* Left Coast Press, Walnut Creek.

Pearsall, D. M., Voigt, E. E., Cornman, M. F. & Benfer, A. N. (1983). *Conservation and Cataloging of Botanical Materials in the American Archaeology Division Systematic Collection. A Report to the National Science Foundation.* American Archaeology Division, University of Missouri, Columbia.

Purdy, B. A. (1996). *How to do Archaeology the Right Way.* University Press of Florida, Gainesville.

Reitsma, T. (1969). Size modification of recent pollen grains under different treatments. *Review of Palaeobotany and Palynology* 9: 175–202.

Robinson, D. E. (2008). *Guidelines for the Curation of Waterlogged Macroscopic Plant and Invertebrate Remains*. English Heritage, Swindon. www.english-heritage.org.uk/publications/curation-of-waterlogged-macroscopic-plant-and-invertebrate-remains/

Shackley, M. (1981). *Environmental Archaeology*. Allen and Unwin, London.

Slutyer, A. (1997). Analysis of maize (*Zea mays* subsp. *mays*) pollen: normalizing the effects of microscope-slide mounting media on diameter determinations. *Palynology* 21: 35–39.

Sullivan, L. P. & Childs, S. T. (2003). *Curating Archaeological Collections. From the Field to the Repository*. AltaMira, Walnut Creek.

Swain, H. (2007). *An Introduction to Museum Archaeology*. Cambridge University Press, Cambridge.

Therin, M. & Lentfer, C. (2006). Box 8.4. In: *Ancient Starch Research*, ed. R. Torrence & H. Barton. Left Coast Press, Walnut Creek.

Vandorpe, P. & Jacomet, S. (2007). Comparing different pre-treatment methods for strongly compacted organic sediments prior to wet-sieving: a case study on Roman waterlogged deposits. *Environmental Archaeology* 12: 207–214.

Watkins, J. & Ferguson, T. J. (2005). Working with and working for indigenous communities. In: *Handbook of Archaeological Methods, Volume II*, eds H. D. G. Maschner & C. Chippindale, pp. 1372–1406. AltaMira Press, Lanham.

Williams, E. & Peachey, C. (eds) (2010). *The Conservation of Archaeological Materials. Current Trends and Future Directions*. BAR International Series 2116. Archaeopress, Oxford.

Zimmerman, L. J. (2006). Liberating archaeology, liberation archaeologies, and WAC. *Archaeologies* 2: 85–95.

# Curating ethnozoological and zooarchaeological collections

TERRANCE MARTIN

Illinois State Museum

Ethnozoological collections consist of animal remains (bones, teeth, horn, antlers, shell, feathers and skins) that have been modified into artefacts, expedient tools, recreational objects (e.g. gaming pieces), ornaments (e.g. pendants), clothing and ceremonial objects (e.g. fetishes or objects in medicine bundles). These may come from ethnographic contexts or from archaeological sites. Subsistence remains from refuse deposits at archaeological sites might also be considered as ethnozoological collections. As far as curation is concerned, both material from ethnographic contexts and that from archaeological sites present challenges for storage space and for providing the conditions necessary for the preservation and accessibility of specimens. A third archive category comprises zooarchaeological reference collections, which are comprised of animal skeletons from modern contexts that are used as models for comparison and to enable archaeological animal remains to be identified.

## GENERAL COLLECTIONS MANAGEMENT

There exists a large and growing literature on the curation of collections in museums, whether administered by public and private academic institutions, tribal museums and cultural centres, or by local historical societies. Detailed discussions of collections management are available elsewhere (e.g. Rose & Torres, 1992; Rose et al., 1995; Buck & Gilmore, 1998; Childs & Corcoran, 2000 (online); Sullivan & Childs, 2003; Ogden, 2004a; and websites such as those of the National Park Service (NPS)).

Echoing the NPS Museum Management Program, repositories should strive to maintain specimens in stable condition. The most efficient approach to conservation is to promote conscientiously preventive measures concerning the proper handling of specimens, the storage environment (cabinets, shelves, boxes and climate control of storage areas), pest management and security measures (Chapter 2). Properly designed climate control systems will minimise fluctuations in temperature and relative humidity, which are damaging to fragile ethnozoological specimens by fostering outbreaks of mould and mildew. Preservation of marine and freshwater shells (i.e. bivalves and gastropods) in zooarchaeological and reference collections is threatened by changes in temperature and relative humidity, causing shells to crack and deteriorate. Optimal conditions for ethnozoological collections are 55% rH and 68°F/20°C (Crockford, 1991: 76), or in the ranges of 40–60% relative humidity and 68–72°F/20–22°C (Childs & Corcoran, 2000 (online): Section 8). Collection repositories should also have limited or controlled-access policies. Other security measures include the maintenance of detailed collection inventories (for drawer and box storage). Damage to collections and injury to collections staff or visitors caused by infestations of rodents, insects, spiders and beetles are best prevented by developing strategies of integrated pest management (Jacobs, 1995; Jessup, 1995; Breisch & Greene, 1998; chapter 5 of the NPS Museum Handbook). Condition reports should be routinely compiled for each accessioned collection.

## ETHNOGRAPHIC SPECIMENS MADE FROM ANIMALS

Animal products made into ethnographic objects (i.e. 'cultural objects collected from living peoples', see Chapter 2) include a diverse range of items such as clothing, shields, moccasins, quivers, drumheads and saddles made from skin and skin products (Raphael, 1993; Storch, 2004a); containers, necklaces, headdresses and personal ornaments made from quills, horn, hair, feathers, claws and baleen (Storch, 2004b); tools, necklaces and decorations on clothing and bags made from bone, antler, ivory and teeth (Storch, 2004d); and beads, necklaces, containers and spoons made from various kinds of shells (Storch, 2004c). Each of these categories has special requirements for basic care and storage, special pest concerns and differing routines for handling, display, cleaning and minor repairs (also see Chapter 2). Many ethnographic objects were originally created to function as utilitarian items (e.g. as containers, tools, clothing or apparel), but have become fragile because of the naturally unstable materials from which many of these objects were made (Odgen, 2004b: 25). Thus, many of these objects are especially vulnerable to damage from overcrowded storage, rough handling, fluctuations in relative humidity and temperature, prolonged exposure to ultraviolet and infrared light (which causes them to become faded, brittle or stiff) (NPS Museum Handbook, 4: 33–36), or attack by insects or mould (see Odgen, 2004b). These items present special challenges in that the various raw materials that make up a single object (e.g. buckskin, brass, glass beads, feathers and ribbon) often have 'different and conflicting preservation needs' (Odgen, 2004b: 24).

Ethnographic specimens are best stored without crowding in metal drawers within metal cabinets (e.g. Lane or Delta Designs cabinets). Feathers that are attached to baskets, leather apparel and containers, and other objects composed of animal products, should be housed in conditions similar to those for other ethnographic objects. Customised containers, supports and mounts are also important for the preventive care of objects (see examples described and illustrated by Ogden, 2004c; Rose & Torres, 1992). Special categories of zooarchaeological specimens, such as modified animal remains and rare or extinct species, should also be stored in limited access metal cabinetry. This helps to ensure the preservation of specimens as well as enhancing security and improving accessibility. Collection managers must also give attention to cultural sensitivities when considering the treatment of sacred objects or ways to store and display ceremonial items, making allowances for some religious practices such as smudging or smoking ceremonies (Ogden, 2004a).

The collection and preservation of whole animals is a special topic, for which guidance should be sought from wildlife and museum experts. Useful guides to good museum practice include Stansfield et al. (1994), Carter & Walker (1999), and the NPS Museum Handbook.

## ZOOARCHAEOLOGICAL COLLECTIONS

Approaches to the analysis of zooarchaeological materials have been the subject of much research (Chapman, 1971; Hesse & Wapnish, 1985; Parmalee, 1985; Davis, 1987; Lyman, 1994; Rackham, 1994; Reitz & Wing, 1999). Animal remains, consisting of bones, teeth, cartilage, horns, antlers, scales and shells, are commonly encountered at archaeological sites. Most hard tissues in animals consist of inorganic calcium compounds, primarily calcium phosphate and calcium carbonate. Depending on numerous factors, the specimens that are most likely to survive are those that are composed of a high percentage of inorganics, such as tooth enamel. Structural density also contributes to the survival of tissues (Chapman, 1971: 12–19; Lyman, 1994: 72–87; Reitz & Wing, 1999: 39–40). Waterlogging and desiccation may help to preserve some of the softer animal tissues, such as hide, hair and feathers. Despite the presence of hard tissues, animal remains from human refuse deposits

are usually recovered in fragmentary condition having been broken during the process of butchering, marrow extraction and food preparation.

Environmental conditions at the archaeological site will also affect the preservation of animal remains. Very dry sediments or sediments having moderate acidity and high levels of calcium carbonate offer the best conditions for bone preservation. Burned or calcined specimens typically preserve well because they lack organic material. Specimens that are soft in the ground often harden during the process of drying, and usually will not change shape if little organic material (i.e. collagen) is present. Specimens still retaining collagen may shrink and warp when drying. Controlling ambient relative humidity helps bone stability, and slow drying or wetting may aid in bringing specimens into equilibrium with the relative humidity of the repository (Cronyn, 1990; also see Chapman, 1971: 13–19, Carbone & Keel, 1985: 9–15).

Recovery techniques (dry screening, wet screening and flotation) influence the nature and quantities of animal remains that are obtained from a site. After animal remains are found, they should be very carefully cleaned, and care should be taken not to expose them to extreme physical changes, such as rapid drying or sudden immersion of dry specimens in water (Reitz & Wing, 1999: 369). Containers for specimens should have complete provenience information on internal tags as well as on the exterior to guard against accidental loss of information. To prevent outbreaks of mould and mildew, as well as the disintegration of provenience tags, specimens should be dry before being sealed in bags (except when they were acquired from a waterlogged environment). Small perforations (of 7 mm diameter or smaller, depending on the size of the specimens contained within the bag) made near the top of bags allow air circulation and help to combat wet internal tags and the growth of mould and mildew. Collections should be prepared for transport by packing them in sturdy containers that are lined with adequate padding.

Attention to curation standards for zooarchaeological collections has been addressed by specialists in different venues (Wing, 1983: 10–13; Henry, 1991; Reitz & Wing 1999: 361–377; Reitz et al., 2009). The publication of 'Professional Protocols for Archaeozoology' on the International Council for Archaeozoology (ICAZ) website (Reitz et al., 2009) is particularly noteworthy in that it addresses many topics of special concern, namely the culling of unstudied and 'unidentifiable' archaeological specimens, preserving zooarchaeological collections for future research, careful tracking of specimens loaned to specialists for analysis, balancing destructive analysis requests (e.g. accelerator mass spectrometry (AMS) dating, genetic analysis and isotope analysis) against the loss of finite specimens, archiving zooarchaeological data and access to previously studied collections.

Most often, storage containers for archaeological animal remains are durable, acid-free cardboard or polypropylene boxes, similar to standard-sized record storage boxes. Inside these boxes, specimens are stored in clear polyethylene zip-lock bags of various sizes that are appropriate to the size or volume of the specimens being stored. It is preferable to use fresh zip-lock bags of at least 2 or 4 mil (0.05–0.1 mm) thickness, and not grocery-store-grade sandwich bags. These should have interior acid-free paper labels along with labels on the exterior surface of the bags. Avoid overpacking in order to minimise accidental breakage. Where necessary, interior storage may require additional padding or supports made from acid-free tissue paper, cotton or polyester batting, or rigid mounts made from acid-free cardboard or Ethafoam®. Specimens that are too large for standard-sized curation boxes might require storage in a drawer within a storage cabinet, along with supports or rigid mounts for flat storage.

Larger faunal assemblages from single sites are likely to be accompanied by more complex research designs and varied excavation strategies (surface survey, mechanical stripping of plough zone, shovel

tests, test units and block excavations). Strive for consistent storage procedures so that specimens can be related to their respective excavation units, stratigraphic associations or arbitrary levels. Information should also specify the recovery techniques used for subsets of the collection. If screened, specify the mesh size (which also pertains to heavy fractions of flotation samples). Also important for flotation samples is a record of the original volumes of the samples prior to flotation (permitting calculation of densities for intrasite comparisons of refuse pits or other categories of features). These kinds of detailed information requirements should be included in curation instructions provided to depositors prior to the beginning of the project.

Different thoughts prevail as to whether to curate collections by provenience or by material class. Segregation by material class avoids the risk of damage to fragile objects (such as animal remains) from heavier, more durable items from the same provenience (such as ground stone or large ceramic sherds). Perhaps even more important, storage by material class minimises excessive handling when looking for targeted specimens. At the Illinois State Museum (ISM), with the exception of survey projects resulting in small collections from numerous sites, collections are generally stored by material class and secondarily by provenience. Analysed animal remains are usually stored by provenience instead of by taxon, so that future researchers can access all animal remains from the same feature or level within a test unit in the same storage compartment. Furthermore, identified specimens are stored separately from the samples of animal remains (screened or flotation samples) that have not been analysed.

Finite curation space has forced many repositories to confront the issue of 'what to save?' Avoid having non-specialists make the decision as to which specimens are 'identifiable' and 'unidentifiable', both in the field and at the curation facility. This kind of culling of a faunal collection makes it impossible to carry out taphonomic studies (e.g. consideration of fracturing patterns, rodent or carnivore damage, burning or human processing). It is perhaps more important to evaluate the source of the material so as to save specimens that come from the best contexts (e.g. undisturbed occupation zones). Beware, however, that some specimens of special interest (e.g. extinct passenger pigeon or Carolina parakeet bones) may be found in the ploughzone or in mixed refuse deposits. Hence, decisions on what to discard should be made in consultation with the principle investigators of the site or other specialists in faunal analysis.

In addition to information on site provenience, analysis worksheets such as handwritten notes and tally sheets should be curated. The ISM retains files kept by the late Dr Paul Parmalee for each site he analysed while working at the ISM during the 1950s through to the early 1970s. This is especially useful because many of his findings were presented in short published journal articles or report appendices, where space was limited so as to exclude detailed descriptions of anatomical elements or the criteria he used to estimate the minimum number of individuals for each taxon. Much of this kind of information can be found on the yellow, loose-leaf paper on which he recorded his observations when he analysed specific faunal assemblages.

Concerning the labelling of individual specimens, many of our older collections have provenience information or catalogue numbers printed on the specimens, either in pencil or India ink. When old collections were stored in brown paper bags that deteriorated over time, these inscriptions on the specimens were the only way to salvage the contextual information for those specimens.

For recently obtained faunal collections, whether analysed or not, curatorial personnel should always check to ensure that wet specimens were not placed in bags or other containers prior to thorough air-drying, so as to avoid deterioration of any internal labels and the promulgation of mould and mildew.

Although it is preferable to leave stable specimens from faunal assemblages untreated, sometimes

the exfoliating or delaminating of specimens results from rapid or excessive drying. Based on years of experience working with fragile mammoth and mastodon tusks, ISM palaeontologists use Butvar polyvinyl butyral (PVD) resin as the consolidant of choice. This resin is soluble in acetone or ethyl alcohol, and according to the conservators I have consulted, the treatment is reversible. The resin can be diluted so as to be brushed on as a liquid or used as an adhesive when retained in a thicker solution. Acryloid B-72 is also recommended and is available in small tubes as an adhesive. Consultation with professional conservators is recommended, especially for the special situations confronted in unique collections.

A major consideration in curation is the accessibility of archaeozoological specimens to researchers who seek to verify previous identifications or who request to conduct more advanced analyses. Such researchers might wish to carry out non-destructive analyses, such as obtaining metrical information, or the destructive sampling necessary for radiocarbon dating, DNA extraction and stable isotope analyses. Repositories should maintain a record of researchers who have accessed specific collections, along with the intended purpose, as well as a file on specialised analyses of specific collections that have occurred. Curatorial facilities should also require copies of the technical reports and publications that result from such analyses so that collection personnel can inform any future potential researchers of previous analyses on a collection.

Finally, periodic inspections are necessary in order to check on the status of specimens, the containers they are stored in, and the physical condition of the local storage space and the climate control equipment in all parts of the repository.

## REFERENCE COLLECTIONS OF ANIMAL SKELETONS USED FOR ARCHAEOZOOLOGICAL RESEARCH

An essential component of zooarchaeological analyses is the reference or comparative collection of modern vertebrate skeletons and mollusc shells. The establishment and maintenance of reference collections has been discussed elsewhere (e.g. Chapman, 1971: 41–54; Parmalee, 1985: 66–70; Henry, 1991: 31–38; Reitz & Wing, 1999: 361–373). Despite the usefulness of illustrated osteological references (e.g. Olsen, 1964; Gilbert, 1980), a comprehensive reference collection is essential for accurate identifications (Parmalee, 1985: 66; Reitz & Wing, 1999: 362). The ability to identify zooarchaeological specimens will also depend on factors such as their completeness, the condition of preservation, the biological age of the individual animal, and the distinctive features of the particular animal taxon represented.

Before embarking upon the laborious task of collecting modern specimens for a comparative or reference collection, one must be aware of state and federal laws and procedures that govern the acquisition (such as the requirement for collecting permits), transportation and handling of specimens. Special attention should be given to ensuring that the animals obtained are accurately identified before processing them for their skeletons. This is no problem for most large mammals, but sorting out similar kinds of small rodents or fish by species must be done correctly if such specimens are to be a useful addition to the reference collection. The inclusion of numerous individuals of both sexes and various biological ages for the same species is necessary in order to better represent the range of variation one might encounter when attempting to identify archaeological remains of that species. Also consult the Integrated Taxonomic System (ITIS) website, or similar regional resource outside North America, in order to make sure that the catalogue information for specimens in the reference collection has valid scientific and common names. Also acquire and record basic data associated with the collected modern individuals (i.e. date of acquisition, location, name of collector, weight, standard measurements, sex,

age and reproductive status). Each individual animal in the reference collection should be assigned a unique catalogue number (or field number), and that number should stay with the individual as part of the tracking system (e.g. on durable tags) throughout the stages of preparing the skeleton. Methods of preparing skeletons vary, but most specimens are processed by dermestid beetle larvae or maceration (Reitz & Wing, 1999: 363–365). Suggestions for selecting storage equipment for a reference collection can be found in the comprehensive reference volume by Rose et al. (1995). Once a reference collection is established, routine maintenance and inspections are essential to prevent infiltration by rogue insects, ham beetles and dermestid beetles, pests that can multiply and feed on books and other objects in the repository. Stringent collections-management procedures are also necessary to guard against loss and mixing of parts from various specimens due to careless processing and use.

At the ISM, more than 11,000 whole and partial vertebrate animal skeletons and approximately 30,000 freshwater bivalves are included within the zoology collection, and a laboratory is dedicated to osteological collections and their use. Although this laboratory's primary users are professional zooarchaeologists and undergraduate and graduate college students who are working on zooarchaeology projects for senior or masters theses or dissertations, other zoologists and palaeontologists also visit the lab and consult specimens. Metal cabinets (Delta Designs and Lane) are used to store the skeletons of mammals, birds, fish, reptiles and amphibians. These are arranged in taxonomic order, and multiple individuals of each species are included. Priority is given to animals that would most likely be encountered at archaeological sites in the greater Midwestern United States and the Upper Great Lakes, but other species (bison, pronghorn, moose, wapiti, caribou and mule deer) that might be considered as peripheral in a contemporary setting are also represented. The laboratory is equipped with two library-sized tables for workspaces (Figure 1).

A room-wide countertop along the back wall is where specimens stored in small drawer units are arranged by major anatomical elements for each of the major animal classes. These special 'synoptic collections' enable researchers to perform most their identifications of fragmentary archaeological vertebrate animal remains (Figure 2). The mammal synoptic collection houses significant postcranial bones from the most commonly encountered medium- and small-sized mammal species. The bird synoptic collection includes bones from representatives of 18 orders and additional collections of waterfowl and several passerine songbirds. After narrowing the options, users resort to the cabinets to refine their search for particular bird species. The reptile synoptic collection is devoted to the cranial and postcranial bones of Midwest turtles, along with individual components of the carapace and plastron. The fish synoptic collection is subdivided by families (sunfishes, suckers and catfishes), Great Lakes fish (lake trout, whitefishes, burbot, yellow perch and mooneye), and miscellaneous species (gar, bowfin, freshwater drum, pikes, white bass, walleye and gizzard shad). The greater reference collection contains paddlefish, lake and shovelnose sturgeons, trouts, grayling, American eel and an assortment of marine fish. We also acquired several specimens of introduced species including coho and Chinook salmon, common, grass, bighead and silver carp, alewife, and sea lamprey, in anticipation of future needs and in response to requests from members of the public to identify mysterious, isolated bones found on sandbars in rivers and along beaches (e.g. a carp pharyngeal arch). For internal zooarchaeological analyses, the extensive ISM fish reference collection permits size estimates of identified fish in addition to taxonomic identification, and this is most useful for quantifying minimum numbers of individuals from each fish taxon where large assemblages are involved (Parmalee et al., 1972: 11; Styles, 1981: 118, 150–151).

The ISM's collection of freshwater bivalves was made more accessible to researchers by grant funds from the Institute of Museum and Library Services (IMLS), which supported the purchase of nine Delta

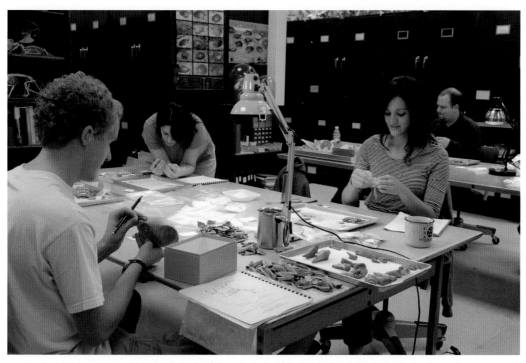

**Figure 1.** The Illinois State Museum laboratory, dedicated to the use and study of osteological collections. Note the metal cabinets (Delta Designs and Lane) used for specimen storage and large flat workspaces. © DOUG CARR, ILLINOIS STATE MUSEUM.

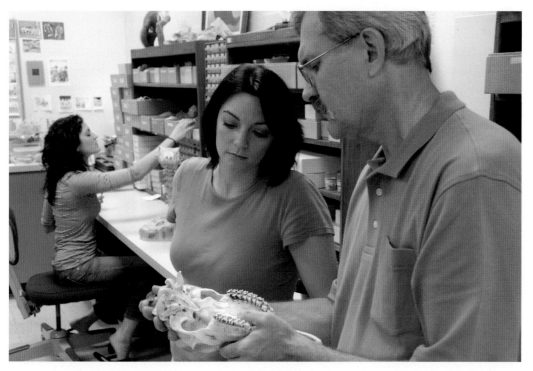

**Figure 2.** The Illinois State Museum laboratory utilizes a room-length countertop for specimen study. Specimens along this wall are stored in small drawer units arranged by major anatomical element for each major animal class. © DOUG CARR, ILLINOIS STATE MUSEUM.

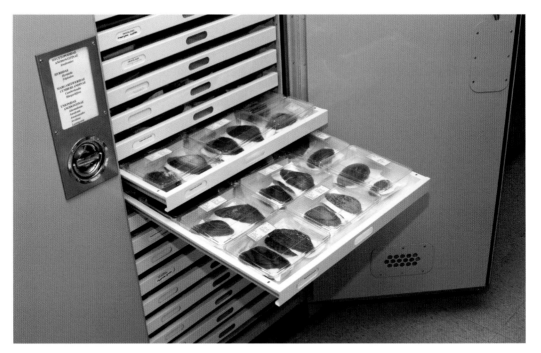

**Figure 3**. The Illinois State Museum houses its collection of freshwater bivalves in Delta Designs metal cabinets with sliding metal drawers. Ethafoam® foam drawer liners minimise vibration; transparent polyethylene terephthalate (PET) specimen boxes and archival-quality interleaving fabric (Reemay®) prevent shell-on-shell abrasion. © DOUG CARR, ILLINOIS STATE MUSEUM.

Designs metal cabinets with sliding metal drawers. Supplies include Ethafoam® foam drawer liners to minimise vibration, transparent specimen boxes made of 100% virgin polyethylene terephthalate (PET) with hinged lids, and archival-quality interleaving fabric (Reemay®) to prevent shell-on-shell abrasion. Shells are organised taxonomically, and each specimen box has a computer-generated label that identifies specimens that are contained within (Illinois State Museum Society, 2003) (Figure 3).

## ARTEFACT CONSERVATION

Despite collection policies that require inspections, decontamination, integrated pest management and closely monitored climate controls, there will sometimes be a need for artefact conservation. Not all repositories and institutions can afford to employ full-time professional conservators on their staff, but there will be a need to consult trained and experienced specialists occasionally. Three organisations are actively engaged in the mission to care for collections. Each maintains helpful websites, and special-needs listservers are also available.

Perhaps most pertinent for managers of ethnozoological and zooarchaeological collections is the Society for the Preservation of Natural History Collections (SPNHC), 'an international society whose mission is to improve the preservation, conservation and management of natural history collections to ensure their continuing value to society.' In addition to information on museum disaster management and museum pests, the SPNHC website provides links to three useful Listservs: the Natural History Collections Listserver, NHCOLL-L; PERMIT-L, a moderated site 'for all scientific collecting issues, biological, paleontological, and geological'; and Pestlist, a 'discussion and information site for all pest related issue[s] in any type of collection'. The SPNHC also publishes its official refereed journal *Collection Forum*, as well as its *SPNHC Newsletter*, their *SPNHC Leaflets* on particular topics, and

several major reference books (e.g. Rose & Torres, 1992; Rose et al., 1995).

Heritage Preservation (formerly the National Institute for Conservation) (2005 (online)) is responsible for Connecting to Collections, an interactive resource that was established in order to 'help smaller museums, libraries, archives, and historical societies locate reliable preservation resources, and to engage with each other and top professionals in the field' (Heritage Preservation, 2005 (online)).

The American Institute for Conservation of Historic and Artistic Works (AIC) has a website featuring 'Save Your Treasures: Connect to the Experts', where one can consult the AIC Resource Center to find links to 'Find a Conservator', 'Stories in Conservation' and 'Frequently Asked Questions', among other options.

Collection managers should consult preservation professionals and professional conservators when confronting conservation issues in their particular collections. Also advisable, if possible, is to develop a regular relationship with these specialists and try to make them familiar with particular collections and individual situations.

## CONCLUSIONS

The recommendations offered here are largely based on experiences at the Illinois State Museum. Additional topics pertaining to curation standards are discussed by Reitz and Wing (1999: 361–377) in their comprehensive text on the subdiscipline of zooarchaeology. Each regional repository that curates large ethnozoological collections will have unique situations concerning available space, cabinetry, personnel, expertise, operating budgets and the nature of the collections in that region. Despite understanding that their biocultural collections make up important parts of our cultural and natural heritage, challenging economic conditions are forcing many curators and collection managers to establish more modest priorities and to ask what is the bare minimum required to maintain the collections for which they are responsible.

Administrators are also coping with drastic budget reductions on an annual basis, and those preventive actions and remedies that are assumed to be 'bare necessities' by repository personnel are now more often perceived as 'luxuries' by those who are not directly involved with such facilities. Each repository must confront these challenges by assessing their own financial situations, personnel capabilities and strategic plans, and must then establish priorities commiserate with limitations. Hopefully, this discussion of ethnozoological collections will help inspire managers of similar collections to appreciate how even small improvements on their own collections policies and procedures could help them to address the curation standards set out in this book.

## ACKNOWLEDGEMENTS

I am grateful to Dr Jan Salick and Katie Konchar, the organisers of the Curation Standards for Biocultural Collections workshop in St. Louis, and to Mark Nesbitt at the Royal Botanic Gardens, Kew, for their attention to numerous details and for their editorial comments. Thanks to fellow participants who provided suggestions on the initial version of this paper that was presented in July, 2011: Dr Deborah M. Pearsall, Dr Jan Timbrook, Dr Mark Nesbitt and Dr Gayle Fritz. I also acknowledge zooarchaeology colleagues, Dr Elizabeth J. Reitz (University of Georgia) and Dr Barnet Pavao-Zuckerman (Arizona State Museum), for their comments and encouragement. Pat Burg, Bronwyn Eves and Dr Jonathan Reyman at the Illinois State Museum provided help with finding reference works and, more importantly, pointed out additional important materials that I was not aware of. Finally, thanks to Illinois State Museum Director Dr Bonnie W. Styles for her support of my efforts on this project. Any remaining omissions, oversights or errors are my responsibility.

## *Websites*

*American Institute for Conservation of Historic and Artistic Works.* http://conservation-us.org

Childs, S. T. & Corcoran, E. (2000). *Managing Archeological Collections: Technical Assistance.* www.nps.gov/archeology/collections

*Connecting to Collections.* www.connectingtocollections.org

*Heritage Preservation.* www.heritagepreservation.org

*Integrated Taxonomic Information System (ITIS).* www.itis.gov

National Park Service. *Museum Management Program.* www.nps.gov/history/museum

National Park Service. *Museum Handbook, Part I: Museum Collections.* www.nps.gov/museum/publications/MHI/mushbkI.html

National Park Service. *Museum Management Program. Conserve O Grams.* www.cr.nps.gov/museum/publications/conserveogram/cons_toc.html

*Society for the Preservation of Natural History Collections.* www.spnhc.org

## *Literature cited*

Breisch, N. L. & Greene, A. (1998). Integrated pest management. In: *The New Museum Registration Methods*, ed. R. A. Buck & J. A. Gilmore, pp. 255–266. American Association of Museums, Washington, DC.

Buck, R. A. & Gilmore, J. A. (ed.) (1998). *The New Museum Registration Methods.* American Association of Museums, Washington, DC.

Carbone, V. A. & Keel, B. C. (1985). Preservation of plant and animal remains. In: *The Analysis of Prehistoric Diets*, ed. R. I. Gilbert, Jr. & J. H. Mielke, pp. 1–19. Academic Press, Orlando.

Carter, D. & Walker, A. K. (1999). *Care and Conservation of Natural History Collections.* Butterworth-Heinemann, Oxford.

Chapman, R. E. (1971). *The Study of Animal Bones from Archaeological Sites.* Seminar Press, London.

Crockford, S. (1991). Environmental controls for primary storage. In: *Guide to the Curation of Archaeozoological Collections: Proceedings of the Curation Workshop Held at the Smithsonian Institution, Washington, D.C. in Conjunction with the Sixth Conference of the International Council of Archaeozoology*, ed. E. Henry, pp. 76–77. Florida Museum of Natural History, Gainesville.

Cronyn, J. M. (1990). *The Elements of Archaeological Conservation.* Routledge, London.

Davis, S. J. M. (1987). *The Archaeology of Animals.* Yale University Press, New Haven.

Gilbert, B. M. (1980). *Mammalian Osteology.* Modern Printing Company, Laramie.

Henry, E. (ed.) (1991). *Guide to the Curation of Archaeozoological Collections: Proceedings of the Curation Workshop Held at the Smithsonian Institution, Washington, D.C. in Conjunction with the Sixth Conference of the International Council of Archaeozoology.* Florida Museum of Natural History, Gainesville.

Hesse, B. & Wapnish, P. (1985). *Animal Bone Archeology: From Objectives to Analysis.* Taraxacum, Inc., Washington, DC.

Illinois State Museum Society (2003). Freshwater bivalve curation project is complete. *Impressions (Newsletter of the Illinois State Museum Society, Springfield)* 9 (3): 4.

Jacobs, J. F. (1995). Pest monitoring case study. In: *Storage of Natural History Collections. Volume 1. A Preventive Conservation Approach*, ed. C. L. Rose, C. A. Hawks & H. H. Genoways, pp. 221–231. Society for the Preservation of Natural History Collections, York.

Jessup, W. C. (1995). Pest management. In: *Storage of Natural History Collections. Volume 1. A Preventive Conservation Approach*, ed. C. L. Rose, C. A. Hawks & H. H. Genoways, pp. 211–220. Society for the Preservation of Natural History Collections, York.

Lyman, R. L. (1994). *Vertebrate Taphonomy*. Cambridge University Press, Cambridge.

Ogden, S. (ed.) (2004a). *Caring for American Indian Objects: A Practical and Cultural Guide*. Minnesota Historical Society Press, St. Paul.

Ogden, S. (2004b). The causes of deterioration and preventive care. In: *Caring for American Indian Objects: A Practical and Cultural Guide*, ed. S. Ogden, pp. 23–39. Minnesota Historical Society Press, St. Paul.

Ogden, S. (2004c). How should cultural items be stored? In: *Caring for American Indian Objects: A Practical and Cultural Guide*, ed. S. Ogden, pp. 40–56. Minnesota Historical Society Press, St. Paul.

Olsen, S. J. (1964). Mammal Remains from Archaeological Sites: 1. Southeastern and Southwestern United States. *Papers of the Peabody Museum of Archaeology and Ethnology* 56 (1), Harvard University, Cambridge.

Parmalee, P. W. (1985). Identification and interpretation of archaeologically derived animal remains. In: *The Analysis of Prehistoric Diets*, eds R. I. Gilbert, Jr. & J. H. Mielke, pp. 61–95. Academic Press, Orlando.

Parmalee, P. W., Paloumpis, A. A. & Wilson, N. (1972). *Animals Utilized by Woodland Peoples Occupying the Apple Creek Site, Illinois*. Reports of Investigations No. 23, Illinois State Museum, Springfield.

Rackham, J. (1994). *Animal Bones*. University of California Press, Berkeley.

Raphael, T. J. (1993). *The care of leather and skin products: a curatorial guide*. Leather Conservation News 9: 1–15.

Reitz, E. J. & Wing, E. S. (1999). *Zooarchaeology*. Cambridge University Press, Cambridge.

Reitz, E. J., Grayson, D., Bar-Oz, G., Borrero, L., Dammers, K., Dobney, K., Payne, S. & Zeder, M. (2009). *International Council for Archaeozoology (ICAZ) Professional Protocols for Archaeozoology*. http://alexandriaarchive.org/icaz/about_protocols.html

Rose, C. L. & de Torres, A. R. (eds) (1992). *Storage of Natural History Collections: Ideas and Practical Solutions*. Society for the Preservation of Natural History Collections, York.

Rose, C. L., Hawks, C. A. & Genoways, H. H. (eds) (1995). *Storage of Natural History Collections: A Preventive Conservation Approach*. Society for the Preservation of Natural History Collections, York.

Stansfield, G., Mathias, J. & Reid, G. (eds) (1994). *Manual of Natural History Curatorship*. HMSO, London.

Storch, P. S. (2004a). Skin and skin products. In: *Caring for American Indian Objects: A Practical and Cultural Guide*, ed. S. Ogden, pp. 113–118. Minnesota Historical Society Press, St. Paul.

Storch, P. S. (2004b). Quills, horn, hair, feathers, claws, and baleen. In: *Caring for American Indian Objects: A Practical and Cultural Guide*, ed. S. Ogden, pp. 119–125. Minnesota Historical Society Press, St. Paul.

Storch, P. S. (2004c). Shell. In: *Caring for American Indian Objects: A Practical and Cultural Guide*, ed. S. Ogden, pp. 126–129. Minnesota Historical Society Press, St. Paul.

Storch, P. S. (2004d). Bone, antler, ivory, and teeth. In: *Caring for American Indian Objects: A Practical and Cultural Guide*, ed. S. Ogden, pp. 130–134. Minnesota Historical Society Press, St. Paul.

Styles, B. W. (1981). *Faunal Exploitation and Resource Selection: Early late Woodland Subsistence in the Lower Illinois Valley*. Scientific Papers No. 1, Northwestern University Archeological Program, Evanston.

Sullivan, L. P. & Child, S. T. (2003). *Curating Archaeological Collections: From the Field to the Repository*. Archaeologist's Toolkit, Vol. 6. AltaMira Press, Walnut Creek.

Wing, E. S. (1983). *A Guide for Archeologists in the Recovery of Zooarcheological Remains*. Special Publication No. 3, Florida Journal of Anthropology, Gainesville.

# Curating DNA specimens

DAVID M. SPOONER
HOLLY RUESS

United States Department of Agriculture, Agricultural Research Service &
Department of Horticulture, University of Wisconsin-Madison

## INTRODUCTION

DNA data are used in a variety of ethnobiological disciplines including archaeology, conservation, ecology, medicinal plants and natural products research, taxonomy and systematics, and studies of crop evolution, crop domestication and genetic diversity. It is frequently convenient to store and share DNA among cooperating research groups, and there are a variety of methods to do this. The purpose of this chapter is to survey a variety of techniques for tissue collection, DNA extraction and DNA storage. It also describes DNA banks, and legal and ethical considerations when sharing DNA internationally.

## THE NEED FOR DNA BANKS

DNA collections serve a variety of needs: helping to formulate conservation strategies, managing the world's biodiversity crisis, managing genetic resource collections, providing DNA for systematic studies ranging from within species analyses to high-level classifications, providing local diversity assessments, providing information on genes and genetic pathways and mechanisms for plant breeders, and serving as backup repositories of genetic information if the organisms become extinct. Chapters 21 to 23 of this book explore further the usefulness of DNA analysis to ethnobiology.

Various reviews have surveyed the need for DNA banks, their organisation and operation, plant collections, DNA isolation and storage procedures, vouchering, the bioinformatics of storage and retrieval systems for DNA collections, and political issues regarding collection and sharing of DNA (De Vicente & Andersson, 2006; Savolainen et al., 2006; Hodkinson et al., 2007; Gemeinholzer et al., 2010). A wide variety of needs for different organisms precludes an exhaustive presentation of protocols in this chapter, especially considering the rapidly emerging field of next-generation sequencing, which is rapidly becoming a dominant technique for DNA sequencing. The purpose of this chapter is to highlight briefly these topics and to direct the reader to references relevant to the establishment and operation of DNA banks.

## DNA BANK NETWORKS

The idea of establishing a network of genomic DNA banks from plants was first proposed by Adams in 1988, who termed it 'DNA Bank-Net'. As of 1994, 40 institutions in 25 nations had expressed interest in the network (Adams, 1994). The idea was to collect plants and then either to extract and store DNA or to place DNA-rich tissues in long-term storage, to include back-up storage at different sites, and to distribute the DNA. The storage sites should have an associated herbarium and good institutional infrastructure for maintaining voucher specimens and databases, as well as facilities for the extraction, storage and distribution of samples. To minimise costs, materials would be collected primarily from

institutions that are regularly engaged in collecting missions, such as the Missouri Botanical Garden, the New York Botanical Garden or the Royal Botanic Gardens, Kew. Tissue samples would be collected in desiccants such as calcium sulphate (Driertite™) or silica gel (see Chase & Hills, 1991) alongside their associated herbarium specimens. The first organisational meeting of DNA Bank-Net was held at the Royal Botanic Gardens, Kew, in 1991 and was attended by 18 invited scientists.

Unfortunately, the DNA Bank Net initiative has remained inactive for several years (R.P. Adams, personal communication, 2011), possibly as a result of the unresolved legal questions related to international agreements on DNA exchange, intellectual property rights and patent protection (Andersson et al., 2006; Davis et al., 2006a,b; Graner et al., 2006). The idea of cooperating DNA banks was further developed by Ryder et al. (2000) for animals and also by Savolainen & Reeves (2004). Graner et al. (2006) provided models of how DNA genebanks could be organised for plant material that is maintained in existing genebanks operated by the International Agricultural Research Centres, focusing on the 35 crops and crop complexes listed in Annex 1 of the International Treaty on Plant Genetic Resources for Food and Agriculture (FAO, 2004). While this would serve workers who are interested in this limited list of crops, such a genebank would have to be extended to all organisms to serve the needs of the wide range of other users outside of the genetic resources community, such as taxonomists working on reconstructing the Tree of Life. At present, a number of institutions store DNA, some of them connected through the DNA Bank Network formed in 2007.

Some DNA banks store extracted DNA, others store tissues in such a way that its constituent DNA is ideally preserved for later extraction. Miller (2006) describes a practical and cost-effective alternative to DNA banking used at the Missouri Botanical Garden. Collectors make an additional leaf sample collection with their herbarium specimen, preserve it in the field with silica gel (Chase & Hills, 1991), and hold these tissue samples in sealable bags with silica gel in an environment within simple storage cabinets that is maintained at −20°C. Use of the samples is restricted to non-commercial molecular systematics research, precluding the necessity to secure time-consuming and costly permissions for commercial use from source countries. The requester is responsible for the isolation of their DNA samples, and a material transfer agreement stating the conditions is sent with every tissue sample. Palacio-Mejía (2006) describes tissue sample storage at the Alexander von Humboldt Biological Resources Research Institute in Bogotá, Colombia. Samples there are stored in liquid nitrogen and available for distribution with stipulations for their use outlined in a material transfer agreement.

Following is a brief summary of some of the major plant DNA banks listed by the DNA Bank Network that have some basic data available from their websites. The list is not comprehensive because of incomplete data.

- **Royal Botanic Gardens, Kew** (http://data.kew.org/dnabank/homepage.html). 40,000 samples, stored at -80°C; will send around 25 μL of variable quality and concentration; there is a charge of around £15 per sample.

- **Plant DNA Bank in Korea** (http://pdbk.korea.ac.kr). Number of samples not stated; distribution costs not stated; website not completely in English.

- **The New York Botanical Garden DNA Bank** (http://sciweb.nybg.org/Science2/DNABank.asp). Samples are for research projects at the Garden; the number of samples and distribution costs are not stated.

- **The Australian Plant DNA Bank** (www.dnabank.com.au). Specialises in Australian native plants.

- **DNA Bank at the Missouri Botanical Garden** (www.wlbcenter.org/dna_banking.htm). 6,226 taxa, from some of the hardest to reach places; will send out dried silica tissue samples.

- **DNA Bank Brazilian Flora Species** (www.jbrj.gov.br/pesquisa/div_molecular/bancodna/sobre_ing.htm). Specialises in the Brazilian flora only, representing 40 families; samples are associated with a voucher specimen, DNA stored at -80°C.

- **DNA Bank at Kirstenbosch, South Africa** (www.sanbi.org/programmes/conservation/dna-bank). Goal is to archive 2,200 South African flowering plants; currently has 4,900 samples; duplicates are stored at the Royal Botanic Gardens, Kew.

- **DNA Bank of the National Institute of Biological Sciences, Japan** (www.dna.affrc.go.jp). Does not store genomic DNA but only cDNA clones, RFLP markers, PAC/BAC clones and YAC filters.

- **Trinity College DNA bank, Ireland** (www.tcd.ie/Botany/research/systematics). 3000 accessions of DNA from a wide range of higher plant families.

While the DNA banks listed above focus on plants, there are also many that are devoted to animals (www.dnabank-network.org/Links.php). An example is The Frozen Zoo® at the San Diego Zoo Institute for Conservation Research, which preserves DNA, frozen and viable cell cultures, semen, embryos, oocytes and ova, blood and tissue specimens from more than 8,400 individuals of over 800 species and subspecies. These samples are used by scientists at the San Diego Zoo and cooperators worldwide in a variety of studies in research areas including conservation biology, evolution, human health and DNA barcoding. Samples from this source have supported the continued study of the human genome (Cohen, 1997).

## LEGAL AND ETHICAL CONSIDERATIONS

As with the collection and shipment of specimens, genebanks are associated with many legal and ethical considerations that have arisen from: 1) The Convention on Biological Diversity, 2) The Convention on International Trade in Endangered Species of Wild Flora and Fauna, and 3) The International Treaty on Plant Genetic Resources for Food and Agriculture. The laws and regulations based on these agreements often differ within each country, and the responsible in-country agencies as well as the interpretation and enforcement of these agreements may change over time. In addition, different countries interpret the rules differently for DNA (as opposed to dried or living plants), making it imperative to plan well in advance before plants or DNA are collected or shipped. These legal and ethical issues are not covered here, but excellent explanations and recommendations for ensuring compliance with these agreements are provided by Davis et al. (2006a) and by Donaldson (2006). Sample material transfer agreements are provided by Savolainen et al. (2006).

## DNA FROM ANCIENT SPECIMENS OR FROM
## NATURAL HISTORY COLLECTIONS

Next-generation sequencing is rapidly accelerating the availability of DNA sequences from ancient samples. Genome sequences from extinct species have tremendous potential to address long-standing questions asked by ethnobiologists. Knapp & Hofreiter (2010) presented strategies for the next-generation DNA sequencing of ancient DNA. As of 2010, more than 20 studies have made use of this technique to obtain sequences from ancient samples from Neanderthals, ancient modern humans, woolly mammoths, polar bears and a wide range of other animals that were associated with humans. There are many challenges in obtaining such sequences because ancient nuclear DNA is usually highly fragmented. The average fragment lengths of polymerase-chain-reaction (PCR)-amplified mitochondrial DNA sequences from Neanderthal specimens dating from 38,000–70,000 years before present (YBP) ranged from 51 to 79 base pairs (bp) (Briggs et al., 2009). Younger specimens, such

as woolly mammoth dating from 28,000 YBP (Poinar et al., 2006), often yield longer fragments and DNA sequences obtained from the nuclear genome as well as from mitochondrial DNA can be amplified successfully.

For plants, plastid DNA with fragment lengths of 440 bp has been obtained from herbarium specimens that are more than 300 years old (Ames & Spooner, 2008); likewise plastid DNA with fragment lengths of 440 bp has been amplified from herbarium specimens of over 200 years old (Andreasen et al., 2009). It seems that the speed and method of drying is one of the most important factors influencing the age to which the DNA can survive and the fragment length that can be obtained (Savolainen et al. 1995; Drábková et al., 2002). To my knowledge, herbarium or old tissue samples from plants have not yet been used for next-generation sequencing of a whole genome.

## CONTAMINATION OF DNA SEQUENCES

Ancient DNA extracts often contain a mixture of bacterial, fungal and human contaminants, complicating the identification of endogenous DNA from the tissue being studied, but these DNA contaminants can be factored out by comparison with extant DNA sequences. For example, the study by Poinar et al. (2006) of the woolly mammoth found that 14.8% of the DNA they sequenced had an environmental source: bacteria (5.8%), eukaryotes (4.2%), possible human (1.4%), dog (1.3%), Achaea (0.2%) and virus (0.1%). While much of this contamination is indigenous to the context from where the specimens were extracted, curators need to place special emphasis on guarding such ancient samples from as much contamination as possible during excavation, transport, storage and DNA extraction.

DNA from museum specimens similarly has many potential sources of error or contamination (Wandeler et al., 2007). One is mislabelling, especially when the DNA is extracted from tissues of previously mislabelled or misidentified specimens. Specimens that lack vouchers are especially problematic, as without a voucher any given tissue cannot be matched back to the original source specimen. Many scientific journals now require vouchers for all specimens analysed (Chapter 22). Cross-contamination can also be problematic for DNA from museum specimens, as it is for ancient DNA; for example, many different specimens are often prepared (i.e. eviscerated) in the field without adequate precautions to avoid cross-contamination. Contamination also can arise from the unintentional introduction of DNA from organisms that are naturally associated with the specimens, such as parasites or organisms (internal or external) on skin or feathers. Sequencing errors also can arise from misincorporated bases that are inserted during enzymatic amplification. Formalin-preserved specimens are especially sensitive to sequencing error. As a consequence, repeated sequencing of independent extractions or cloning may be needed to obtain reliable sequences; this is difficult to achieve as it is desirable to minimise destructive sampling. Wandeler et al. (2007) present a set of guidelines for investigators and museum curators to minimise error and guard the integrity of museum collections. A detailed study plan must be presented to curators before access to collections is granted and a pilot study must insure that realistic procedures are optimised before specimens are sampled.

## OBTAINING AND STORING DNA

Obtaining DNA from plants involves a series of steps: 1) tissue collection (usually from leaves), 2) cell disruption, 3) extraction of DNA and 4) DNA storage. Csiba & Powell (2006) provide a basic explanation and protocol for DNA isolation that works for many plants. This method is based on a modification of the Doyle & Doyle (1987) cetyltrimethyl ammonium bromide (CTAB) extraction method, with additional purification possible by ultracentrifugation of the DNA over caesium

chloride. This method will work for tractable specimens, but many plant tissues are particularly recalcitrant to DNA extraction. As outlined by Systma (1994), compounds that complicate DNA extraction include secondary phenolics, resins, mucilage, polysaccharides, latex, proteins and polyphenols. In addition, structural tissues can make DNA extraction difficult for species with fibrous or leathery leaves. Polysaccharides are probably the main compound causing low yields and purity of DNA, and acidic polysaccharides can make restriction digests difficult. Sytsma (1994) outlines a series of potential solutions for extracting DNA from such recalcitrant plants. He concludes that there is no universal set of DNA isolation procedures that work for all tissues. Regarding storage, the International Society for Biological and Environmental Repositories (ISBER) (2005) provided a first of a series of 'Best Practices for Repositories' that focuses on human biological materials, but these practices are applicable to many collection types.

Following is an outline of basic facts related to tissue collection, DNA extraction and DNA storage.

## 1. Tissue collection

The following six methods for collecting DNA are ranked from the best (and more time-consuming and expensive) to progressively quicker and easier methods.

A. Collect samples in liquid nitrogen, freeze in -80°C, ship on dry ice and grind using liquid nitrogen.

    1. Pros: best quality of DNA can be obtained.

    2. Cons: difficult to find liquid nitrogen and take it into the field; expensive (requires specialised containers) and usually requires import permits (in the United States from the USDA Animal Plant Health Inspection Service and from Plant Protection and Quarantine (USDA-APHIS-PPQ)); samples must be kept frozen until placed in DNA extraction buffer.

B. Collect samples on ice, extract within hours (grind in liquid nitrogen or buffer solution) or freeze to -80°C, extract or freeze dry or lyophilise, grind with mortar and pestle.

    1. Pros: produces high quality DNA; only ice is needed in the field; dried tissue can usually be shipped without any special considerations.

    2. Cons: still requires specialised equipment (a -80°C freezer and a freeze dryer or lyophiliser) near the collection site; samples must be kept dry and out of sunlight until the DNA extraction process.

    3. Notes: some people store the dried tissue at cold temperatures (in order to work with this sample, they must completely thaw it before opening to prevent condensation); in my experience, dried tissue produces good quality DNA after being stored at room temperature, in the dark, for many years; DNA can also be obtained if extraction is done as soon as possible (before freezing) — this would change the procedure to shipping DNA, not tissues.

C. Collect samples in a bag, add silica gel or beads in 10:1 ratio of silica:tissue (Chase & Hills, 1991).

    1. Pros: easy; lightweight option for mailing; doesn't usually require special permission for shipping (but may require export permission).

    2. Cons: sample must be kept dry and in the dark until extraction; drying can be uneven between species; there are reports that over-drying can cause degradation (Lindhal, 1993).

    3. Notes: silica gel can be removed before shipping; storage is in a dry, dark place, in a sealed container with silica; temperature doesn't seem to be a problem, but long-term storage in a -20°C freezer is recommended.

D. Preservation of tissue in 95% ethanol, regular extraction buffer plus pronase E. (Flournoy et al., 1996).

1. Pros: cost-effective.

2. Cons: the shipping cost of liquids (maybe a hazard and may require import permits); there are reports that tissue can be stored in 95% ethanol for 11 months but there is also experimental evidence that alcohol degrades DNA (Särkinen et al., 2012).

E. Preservation of tissue in saturated sodium chloride/CTAB solution (Rogstad, 1992).

1. Pros: works well for at least one month of storage at room temperature.

2. Cons: expensive to ship; toxic chemicals are used; other methods are easier; still requires storage in -20°C freezer after 1 month.

F. Whatman FTA cards (now produced by GE Healthcare Life Sciences) can be used to collect, preserve, store, and extract DNA all on one card. These papers lyse cells, denature proteins and protect nucleic acids from nucleases as well as from oxidative and UV damage.

1. Pros: easy to use and extract DNA (at room temperature, with no toxic chemicals); storage at room temperature (a desiccant is recommended for long-term storage); methods have been developed to prevent cross-contamination; amplification of DNA from blood stored on Whatman papers for up to 17.5 years has been reported.

2. Cons: costly; not much DNA can be stored on one card.

## 2. Cell disruption

Before DNA can be extracted, the cells within the sample tissue must be disrupted. This can be done in various ways, such as grinding using a mortar and pestle or shaking the tissue in a container with metal or glass beads. If the tissue was frozen during collection, it must remain frozen during grinding until it touches the DNA extraction buffer. If the tissue is dried, it must remain dry until it touches the DNA extraction buffer. These procedures protect the DNA from the activity of DNase enzymes within the disrupted cells.

## 3. Extraction of DNA

A. CTAB extraction (Doyle & Doyle, 1987)

1. Pros: cheap; produces high-quality DNA.

2. Cons: time-consuming; high-throughput sampling is limited; uses hazardous chemicals (phenol and/or chloroform).

3. Note: subsequent caesium chloride purification of the DNA will give a higher quality DNA and DNA that lasts longer.

B. Commercial DNA extraction kits based on an initial grinding of DNA and binding on a silica membrane (spin-column) extraction kit.

1. Pros: fast and easy; can scale up to high-throughput extraction with or without a robot.

2. Cons: lower yields; possible shearing with larger genomes; columns can clog up with debris; storage is only recommended for a year at -20°C.

## 4. Storage of DNA

A. Cold storage of DNA in liquid nitrogen or a −80°C freezer.

1. Pros: produces quality DNA that lasts for a long time (hundreds of years); can store highly concentrated or large amounts of DNA in a small space.

2. Cons: requires either constant power (so must be safe from man-made or natural disasters) or constant liquid nitrogen; requires costly, specialised equipment.

B. Dry storage at room temperature (less than 40% relative humidity, or colder, which is better. Bonnet et al. (2010) document that atmospheric water and oxygen are detrimental to DNA preservation at room temperature, but if protected from water and oxygen, dehydrated DNA should maintain its primary structure for many years.

1. IntegenX, GenTegra: 0.05–25 μg per well, storage recorded up to 18 years, $0.50 per sample in a 96-well format or $2.20 for a single tube.

2. Qiagen or QiaSafe: up to 30 μg in 20 μL, storage for up to 6 years recorded, PCR and q-PCR after up to 30 years, up to $0.50 per sample in a 96-well format or $3.58 for a single tube.

3. BioMatrica: DNA stable, 30 μg, storage recorded by accelerated aging conditions equivalent to 30 years at room temperature, up to $0.25 per sample in a 384-well format, $0.50 per sample in a 96-well format or $2 for a single tube.

4. Pros of 1–3: room temperature storage (although a low humidity chamber might be required for very long-term storage); in theory, takes up less space than cold storage.

5. Cons of 1–3: Cost; cheaper with the 96-well format, but easier to retrieve individual samples in single format; not easy to store large amounts of DNA, which will require many sample chambers; stored samples cannot get wet.

## 5. Next-generation sequencing of stored materials

Starting amounts

1. Roche: 3–5 μg (Liu, 2009)
2. Illumina: 0.1–1 μg (Liu, 2009)
3. ABI SOLiD: 0.1–20 μg (Liu, 2009)
4. Pacific Biosciences: 1–20 μg (pacificbiosciences.com)
5. Ion Torrent: 0.125–1 μg (www.lifetechnologies.com/us/en/home/brands/ion-torrent.html)

DNA can be degraded as when sequencing ancient DNA (Knapp & Hofreiter, 2010) but the initial quality of the DNA determines the amount of data obtained.

## ACKNOWLEDGEMENTS

I thank Mark Berres for review of an earlier draft of this manuscript.

## Websites

*Convention on Biological Diversity*. www.cbd.int

*Convention on International Trade in Endangered Species of Wild Flora and Fauna*. www.cites.org

*DNA Bank Network*. www.dnabank-network.org

*International Treaty on Plant Genetic Resources for Food and Agriculture*. www.planttreaty.org

*Frozen Zoo*. www.sandiegozooglobal.org/what_we_do_banking_genetic_resources/frozen_zoo/

## Literature cited

Adams, R. P. (1994). DNA Bank-Net — an overview. In: *Conservation of Plant Genes II: Utilization of Ancient and Modern DNA. Monographs in Systematic Botany from the Missouri Botanical Garden 48*, ed. P. P. Adams, J. S. Miller, E. M. Golderberg & J. E. Adams, pp. 1–13. Missouri Botanical Garden, St. Louis.

Ames, M. & Spooner, D. M. (2008). DNA from herbarium specimens settles a controversy about origins of the European potato. *American Journal of Botany* 95: 252–257.

Andreasen, K., Manktelow, M. & Razafimandimbison, S. G. (2009). Successful DNA amplification of a more than 200-year-old herbarium specimen: recovering genetic material from the Linnaean era. *Taxon* 58: 959–962.

Andersson, M. S., Fuquen, E. M. & de Vicente, M. C. (2006). State of the art in DNA storage: results of a worldwide survey. In: *DNA Banks-Providing Novel Options for Genebanks?* ed. M. C. de Vicente & M. S. Andersson, pp. 6–10. International Plant Genetic Resources Institute, Rome.

Bonnet, J., Colotte, M., Coudy, D., Couallier, V., Portier, J., Morin, B. & Tuffet, S. (2010). Chain and conformation stability of solid-state DNA: implications for room temperature storage. *Nucleic Acids Research* 38: 1531–1546.

Briggs, A. W., Good, J. M., Green, R. E., Krause, J., Maricic, T., Stenzel, U., Lalueza-Fox, C., Rudan, P., Brajković, D., Kućan, Ž., Gušić, I., Schmitz, R., Doronichev, V. B., Golovanova, L. V., de la Rasilla, M., Fortea, J., Rosas, A. & Pääbo, S. (2009). Targeted retrieval and analysis of five Neandertal mtDNA genomes. *Science* 325: 318–321.

Chase, M. W. & Hills, H. H. (1991). Silica gel: an ideal material for field preservation of leaf samples for DNA studies. *Taxon* 40: 215–220.

Cohen, J. (1997). Can cloning help save beleaguered species? *Science* 276: 1329–1330.

Csiba, L. & Powell, M. P. (2006). DNA extraction protocols. In: *DNA and Tissue Banking for Biodiversity and Conservation: Theory, Practice and Uses*, ed. V. Savolainen, M. P. Powell, K. Davis, G. Reeeves & A. Corthals, pp. 48–51, 114–117. Royal Botanic Gardens, Kew.

Davis, K., Williams, C. & Wolfson, M. (2006a). DNA banking and the Convention on Biological Diversity. In: *DNA and Tissue Banking for Biodiversity and Conservation: Theory, Practice and Uses*, ed. V. Savolainen, M. P. Powell, K. Davis, G. Reeves & A. Corthals, pp. 18–30. Royal Botanic Gardens, Kew.

Davis, K., Williams, C., Wolfson, M. & Donaldson, J. (2006b). Practical implementation of the CBD and CITES. In: *DNA and Tissue Banking for Biodiversity and Conservation: Theory, Practice and Uses*, ed. V. Savolainen, M. P. Powell, K. Davis, G. Reeves & A. Corthals, pp. 36–46. Royal Botanic Gardens, Kew.

De Vicente, M. C. & Andersson, M. S. (eds) (2006). *DNA Banks — Providing Novel Options for Genebanks?* International Plant Genetic Resources Institute, Rome.

Donaldson, J. (2006). CITES and DNA banking. Practical implementation of the CBD and CITES. In: *DNA and Tissue Banking for Biodiversity and Conservation: Theory, Practice and Uses*, eds V.

Savolainen, M. P. Powell, K. Davis, G. Reeves & A. Corthals, pp. 30–35. Royal Botanic Gardens, Kew.

Doyle, J. J. & Doyle, J. L. (1987). A rapid DNA isolation procedure for small quantities of fresh leaf tissue. *Phytochemical Bulletin* 19: 11–15.

Drábková, L., Kirschner, J. & Vlček, Č. (2002). Comparison of seven DNA extraction and amplification protocols in historical herbarium specimens of Juncaceae. *Plant Molecular Biology Reporter* 20: 161–175.

FAO (2004). *The International Treaty on Plant Genetic Resources for Food and Agriculture*. Food and Agriculture Organization of the United Nations (FAO), Rome.

Flournoy, L. E., Adams, R. P. & Pandy, R. N. (1996). Interim and archival preservation of plant specimens in alcohols for DNA studies. *BioTechniques* 20: 657–660.

Gemeinholzer, B., Rey, I., Weising, K., Grundmann, M., Muellner, A. N., Zetzsche, H., Droege, G., Seberg, O., Petersen, G., Rawson, D. M. & Weigt, L. A. (2010). Organizing specimen and tissue preservation in the field for subsequent molecular analyses. In: *Manual on Field Recording Techniques and Protocols for All Taxa Biodiversity Inventories*, eds J. Eymann, J. Degreef, C. Häuser, J. C. Monje, Y. Samyn & D. VandenSpiegel. ABC-Taxa 8: 129–157.

Graner, A., Andersson, M. S. & de Vicente, M. C. (2006). A model for DNA banking to enhance the management, distribution and use of *ex situ* stored PGR. In: *DNA Banks —Providing Novel Options for Genebanks?* eds M. C. de Vicente & M. S. Andersson, pp. 69–75. International Plant Genetic Resources Institute, Rome.

Hodkinson, T. R., Waldren, S., Parnell, J. A. N., Kelleher, C. T., Salamin, K. & Salamin, N. (2007). DNA banking for plant breeding, biotechnology and biodiversity evaluation. *Journal of Plant Research* 120: 17–29.

International Society for Biological and Environmental Repositories (ISBER) (2005). Best practices for repositories I: collection, storage and retrieval of human biological materials for research. *Cell Preservation Technology* 3: 5–48.

Knapp, M. & Hofreiter, M. (2010). Next generation sequencing of ancient DNA: requirements, strategies and perspectives. *Genes* 1: 227–243.

Lindahl, T. (1993). Instability and decay of the primary structure of DNA. *Nature* 362: 709–714.

Liu, G. E. (2009). Applications and case studies of the next-generation sequencing technologies in food, nutrition and agriculture. *Recent Patents on Food, Nutrition & Agriculture* 1: 75–79.

Miller, J. S. (2006). Tissue banking for DNA extraction at the Missouri Botanical Garden. In: *DNA and Tissue Banking for Biodiversity and Conservation: Theory, Practice and Uses*, ed. V. Savolainen, M. P. Powell, K. Davis, G. Reeves & A. Corthals, pp. 82–86, 127–128. Royal Botanic Gardens, Kew.

Palacio-Mejía, J. D. (2006). Tissue collections as a means of storing DNA: a contribution to the conservation of Colombian biodiversity. In: *DNA Banks — Providing Novel Options for Genebanks?* ed. M. C. de Vicente & M. S. Andersson, pp. 49–56. International Plant Genetic Resources Institute, Rome.

Poinar, H. N., Schwarz, C., Qi, J., Shapiro, B., MacPhee, R. D. E., Buigues, B., Tikhonov, A., Huson, D. H., Tomsho, L. P. & Auch, A. (2006). Metagenomics to paleogenomics: large-scale sequencing of mammoth DNA. *Science* 311: 392–394.

Rogstad, S. H. (1992). Saturated NaCI-CTAB solution as a means of field preservation of leaves for DNA analyses. *Taxon* 41: 701–708.

Ryder, O. A., McLaren, A., Brenner, S., Zhang, Y.-P. & Benirschke, K. (2000). DNA banks for endangered animal species. *Science* 288: 275–277.

Särkinen, T., Staats, M., Richardson, J. E., Cowan, R. S. & Bakker, F. T. (2012). How to open the treasure chest? Optimising DNA extraction from herbarium specimens. *PloS One* 7(8): e43808. www.plosone.org/article/info:doi/10.1371/journal.pone.0043808

Savolainen, V. & Reeves, G. (2004). A plea for DNA banking. *Science* 304: 1445.

Savolainen, V., Cuénoud, P., Spichiger, R., Martinez, M. D. P., Crèvecoeur, M. & Manen, J-F. (1995). The use of herbarium specimens in DNA phylogenetics: evaluation and improvement. *Plant Systematics and Evolution* 197: 87–98.

Savolainen, V., Powell, M. P., Davis, K., Reeves, G. & Corthals, A. (eds) (2006). *DNA and Tissue Banking for Biodiversity and Conservation: Theory, Practice and Uses*. Royal Botanic Gardens, Kew.

Sytsma, K. J. (1994). DNA extraction from recalcitrant plants: long, pure, and simple? In: *Conservation of Plant Genes II: Utilization of Ancient and Modern DNA. Monographs in Systematic Botany from the Missouri Botanical Garden* 48, eds P. P. Adams, J. S. Miller, E. M. Golderberg & J. E. Adams, pp. 69–81. Missouri Botanical Garden, St. Louis.

Wandeler, P., Hoeck, P. E. A. & Keller, L. F. (2007). Back to the future: museum specimens in population genetics. *Trends in Ecology & Evolution* 22: 634–642.

# Curating seeds and other genetic resources for ethnobiology

DAVID DIERIG
HARVEY BLACKBURN
DAVID ELLIS
National Center for Genetic Resources Preservation,
United States Department of Agriculture

MARK NESBITT
Royal Botanic Gardens, Kew

## INTRODUCTION

The term genetic resources, or germplasm, refers to propagating material of plants and animals, including seeds, pollen, vegetative propagules and animal semen. It can also encompass whole plants and animals, in their role as reservoirs of genetic material. Germplasm forms the basis of plant and animal reproduction, and thus of the conservation and generation of genetic diversity. Although germplasm conservation is usually thought of as a tool for making the diversity of crops and their wild relatives available to plant breeders, it is now recognised as having equally important roles in the reintroduction of traditional crops to farm fields or gardens, or of wild species to wild habitats.

In theory, germplasm and ethnobiology should be closely interlinked. Plant germplasm, for example, has two central attributes that are relevant to ethnobiology: use, and threatened conservation status. A significant proportion of all plants fall directly within the 'useful plants' brief of the ethnobotanist. Karl Hammer et al. (2003: 242) have estimated that about 122,000 of the world's approximately 300,000 known higher plant species are useful as crops or crop wild relatives, and there are probably tens of thousands of species that humans can use for other purposes. The vulnerable status of a significant proportion of plants is not disputed: between a quarter and a third of all plant species are threatened by extinction, and massive losses of agricultural biodiversity have occurred over the past 50 years. For ethnobiology, a discipline much concerned with sustainable development, germplasm conservation is clearly central. Yet, the three most-used ethnobotany manuals barely mention germplasm or genebanks, and the same is true of almost all ethnobotanical papers (Martin, 1995; Alexiades, 1996; Anderson et al., 2011).

In this chapter we have two aims. The first is to orientate ethnobiologists in the variety of techniques used to preserve germplasm. Although it is now widely accepted that an approach that uses and integrates all of these will be most successful in preserving biodiversity, publications still tend to cover just one technique. Here, we touch on all, although giving most attention to seed genebanks. Second, we put forward some suggestions on how the ethnobiologist can integrate genebank collections into their research and practice. We expect these will also be useful to institutional germplasm curators seeking to take a more ethnobotanical approach to collections. In this chapter, we give details of storage practices for plant and animal germplasm at the United States' National Center for Genetic Resources Preservation, but in general we avoid giving too much detail on collecting and curation, as these topics are well covered in guides, many available online.

## CONSERVING GERMPLASM: CHANGING METHODS AND CONCEPTS

### Beginnings

Techniques for maintaining germplasm are widely used in traditional agriculture, and undoubtedly date back to the beginnings of farming (Brush, 2004). The concept of separate, permanent collections of germplasm is much more recent, dating to the development of classical plant breeding at the end of the 19th century. The emphasis shifted from botanic gardens, which typically preserved representative species as one or a few living plants, to genebanks that preserved as wide a range of populations as possible, typically as seeds. The genebank both protected genetic diversity and made it available on request to the plant breeder. Early examples of genebanks include the Bureau of Applied Botany in St. Petersburg, founded in 1894 and collecting on a large-scale since 1908 (now the N. I. Vavilov Research Institute of Plant Industry), and the United States' Office of Foreign Seed and Plant Introduction founded in 1898 (Loskutov, 1999; Pistorious, 1997). By contrast, the development and use of national gene banks for livestock is relatively new. The US Department of Agriculture was only given a remit to preserve animal germplasm in 1990 (Blackburn, 2009).

### Expansion and standardisation

The 1970s saw two major advances in plant germplasm. The International Board for Plant Genetic Resources (later IPGRI, now Bioversity International) was founded in 1974 and acted as a catalyst for the formation of many genebanks worldwide, as well as establishing common standards for collection management. At the same time, experiments showed that storage at -18°C (-0.4°F) or below meant that the seeds of many species could be stored for decades or centuries. This reduced the need for frequent regeneration of seed, with its associated risk of hybridisation and other changes to preserved diversity.

For much of the 20th century, efforts to preserve genetic diversity in plants were based on the provision of a resource for plant breeders. Plant and animal germplasm was collected worldwide and stored in genebanks in locations that made it easily accessible to researchers and breeders. This effort was successful, with the collection of hundreds of thousands of accessions, and their use in work such as the Green Revolution of the 1960s, which massively increased the yield of wheat, rice and maize. International and national genebanks continue to fulfil this role, not only in anticipation of climatic changes, natural disasters, or new pathogens that could lead to germplasm extinction, but also to safeguard resources for future uses in new areas of agriculture, such as bioenergy, new food sources from plants, or the development of medicinal plants. As cultivated crops and animals are threatened with pests and diseases that could damage or even lead to the extinction of cultivars or lines, these collections take on even greater importance. Plant and animal breeders look to these biocultural collections to provide new resistant cultivars, lines or genes, and need access to high degrees of genetic variation to assure food security along with other agricultural products (Jackson et al., 2007).

### Community participation

Towards the end of the 20th century, there was increasing awareness among agronomists that farmers themselves continued to play a major role in the maintenance of traditional landraces of crops and animals, despite all the pressures on their preservation. Studies showed that farmers continued to grow landraces of crops alongside newly introduced cultivars, and that these were continuing to evolve under the influence of changing environment and farmer selection (Brush, 2004). At the same time, it became clear that national and international genebanks were not easily accessible to farmers, either those desiring to innovate with new materials or those wishing to reintroduce crops and animals

formerly cultivated but now lost from their communities. Notably, Gary Nabhan's *Enduring Seeds* (1989) drew attention to the vulnerability of native crops in North America, and the importance of their continued cultivation in the preservation of Native American cultures. This implied that preserved germplasm should be distributed not only to plant breeders but also to farmers and gardeners, and that this distribution would benefit not only food security but also the conservation of traditional cultures. As discussed late in this chapter, new forms of genebank evolved that were based on community collaborations.

## Wild plants

Most genebanks focus on crops and domesticated animals, and their wild relatives, and thus support agriculture. Conservation of the remaining wild species — some 200,000 in the case of flowering plants — usually depends on conservation of their habitats or on their cultivation in botanic gardens. The establishment of the Millennium Seed Bank by the Royal Botanic Gardens, Kew in 2000, which stores the seeds of wild plants rather than crops, has greatly increased the proportion of wild plant species housed in genebanks. Partnerships in over 50 countries have led to over 40,000 species (over 10% of flowering plant species) being collected and stored. Seedbank preservation is now one of the recognised strategies of wild plant conservation.

## Animals

Given the diverse nature of preserving animal genetic diversity and the variable set of needs in different countries, there have been difficulties in creating standardised protocols for preserving animal germplasm. To date, animal genebanks are best developed in the USA (National Center for Genetic Resources Preservation, National Animal Germplasm Program), Canada (Canadian Animal Genetic Resources Program), the Netherlands (Centre for Genetic Resources (CGN)) and France.

## WHERE IS GERMPLASM CONSERVED?

## Introduction: *in situ* and *ex situ* conservation

*In situ* conservation is the maintenance of germplasm in its original habitat; in farmers' fields in the case of domesticated animals and plants, or in wild habitats in the case of wild plants (in practice the distinction between these habitat types is blurred). In *ex situ* conservation, the plant or animal germplasm is maintained elsewhere. Both forms of conservation have their advantages. During *in situ* conservation, the plants or animals will continue to evolve, for example in response to climate change, generating new diversity. The germplasm is easily made available to local users through seed sale or exchange or through community genebanks. The preservation of traditional agricultural techniques, which are often necessary for the survival of traditional crop landraces, may lead to strengthened cultural heritage. *In situ* conservation efforts aimed at specific wild plants are likely to involve landscape conservation with wider benefits for biodiversity. In contrast, *ex situ* conservation will capture snapshots of germplasm at specific points in time, potentially saving diversity that is later lost. Seed longevity in *ex situ* storage can be highly predictable. *Ex situ* conservation of plants uses three techniques: growing plants in field genebanks, freezing seeds, and *in vitro* conservation, in which plant tissues such as buds, meristems and embryos are cultured in the laboratory.

Storage as frozen seeds is by far the least labour-intensive and cheapest method of *ex situ* preservation, and accounts for the great majority of accessions in genebanks. There, are however, two obstacles to the preservation of all plant species as frozen seeds. First, not all seeds can be frozen.

Part of the treatment before freezing is to dry seeds, otherwise ice will form on freezing and the seed will be killed. However, the seeds of many species are desiccation-intolerant and will be killed during the drying process; these are known as recalcitrant seeds. By contrast, seeds that survive drying, and which can therefore be frozen, are known as orthodox seeds. Recalcitrant seeds are most common in wetter habitats (Tweddle et al., 2003). Second, some plants reproduce exclusively by vegetative means, or are clones that can only be preserved by vegetative propagation. In these cases, field genebanks and *in vitro* conservation must be used. Field conservation, through the cultivation of plants, is relatively simple to implement is but labour-intensive and leaves the germplasm vulnerable to disease. *In vitro* techniques require good laboratory facilities (González-Arno et al., 2008).

Animal germplasm is preserved through cryopreservation (Figure 1) of semen as the primary mechanism, followed by embryo collections at a smaller rate and scale. For an example storage protocol for animal germplasm, see Box 'Storage protocols for animals at the National Center for Genetic Resources Preservation (NCGRP)'. Living collections are also important (Tempelman et al., 2007).

## UNITED STATES NATIONAL PLANT GERMPLASM SYSTEM

This is a network of over 20 regional sites including Plant Introduction Stations, field sites, programmes, and centres curating individual crops and maintaining active collections. Examples include the Plant Introduction Station in Ames, Iowa, which has responsibility for over 20,000 collections of corn (*Zea mays*) along with other crops that grow well in that area. The Plant Introduction Station in Griffin, Georgia, has responsibility for the sorghum collection; wheat is maintained in Aberdeen, Indiana.

The National Center for Genetic Resources Preservation (NCGRP) has a mission 'to acquire, evaluate, preserve, and provide a national collection of genetic resources to secure the biological diversity that underpins a sustainable US agricultural economy through diligent stewardship, research, and communication.' It is one of the largest genebanks in the world, currently safeguarding over 875,000 plant collections and 652,295 animal collections, most with agricultural emphasis. This number represents 7,474 different plant species of 1,274 genera, as well as 13 agricultural animal species and over 130 breeds. These accessions are freely distributed to any qualified research scientist in the world. The centre is the long-term storage facility for the base collection of the United States' National Plant Germplasm System (NPGS) as well as the base collection for the United States' Animal Germplasm Program.

Seeds or vegetative plant parts are sent to NCGRP from field sites for duplicate backup. Crop-specific curators manage new collections and the regeneration of existing collections. Each agricultural crop (sometimes a group of similar crops) and wild relative species has a curator responsible for its collection and regeneration. The curator assigned to a crop or group of crops and wild relatives usually sets the criteria by which seeds or propagules are organised in long-term storage.

Requests for crop material can be submitted through the Genetic Resource Information Network (GRIN) website, first by searching the database, then by using the link to 'Request this Germplasm'. More specific information about different crops can be obtained from individual curators via www.ars-grin.gov/npgs/holdings.html by clicking on a geographical location of interest.

Unlike plants, all of the United States' frozen animal germplasm is housed within the NCGRP. The National Animal Germplasm Program maintains germplasm from major, minor and rare animal breeds of agricultural importance. In addition, it facilitates the actions of livestock species committees that are comprised of the United States Department of Agriculture's (USDA) Agricultural Research Service, university and industry representatives.

See also Box 'Storage protocols for seeds at the National Center for Genetic Resources Preservation (NCGRP)'.

## *Ex situ* conservation: seed and tissue collections

The Food and Agriculture Organisation of the United Nations (FAO) estimates that there are some 1,750 genebanks, holding 7.4 million accessions. About 25–30% of these are distinct accessions, the remainder being duplicates (FAO, 2010). About 130 genebanks hold more than 10,000 accessions; some major genebanks are listed in Table 1. By far the largest collection is that held in the various institutes of the Consultative Group on International Agricultural Research (CGIAR), including the International Rice Research Institute (IRRI), the International Maize and Wheat Improvement Center (CIMMYT), and the International Potato Center (CIP). It is common for large genebanks to be composed of such regional centres, which allow a wide range of plants to be grown in appropriate environmental conditions.

Genebanks do more than store germplasm. Two essential aspects of genebank research are into storage and germination. Seeds must be assessed to see if they are orthodox or recalcitrant, or intermediate, as this will determine the technique used to store them (Gold & Hay, 2008). Germination presents major challenges; for example, the discovery of smoke-stimulated germination as late as the mid-1990s has enabled many South African plants and Australian plants to be propagated for the first time (Staden et al., 2008). Genebanks also carry out routine testing of accessions before, at the start of, and at regular intervals during storage, to check propagation rates and viability. Germination of the seeds of wild plants may present major challenges; for example, the discovery of smoke-stimulated germination, as late as the mid-1990s, has enabled many South African plants and Australian plants to be propagated for the first time (Staden et al., 2008). Much information on seed storage behaviour and germination requirements is summarised in the Millennium Seed Bank's online Seed Information Database.

Most seed accessions in genebanks are relatively small: the preferred size for a base collection is usually 1,500–2,000 seeds; additional seed allows for distribution to users. For experimental and breeding work, small numbers of seeds are adequate, but for landscape restoration, 2–7 kg or more

## TABLE 1

Major plant genebanks

| NAME, LOCATION | NUMBER OF ACCESSIONS | COVERAGE |
| --- | --- | --- |
| CGIAR, various countries | 750,000 | Crops and wild relatives |
| National Plant Germplasm System, USA | 536,000 | Crops and wild relatives |
| Chinese Academy of Agricultural Sciences, China | 351,000 | Crops and wild relatives |
| National Bureau of Plant Genetic Resources, India | 349,000 | Crops and wild relatives |
| N.I. Vavilov Research Institute of Plant Industry (VIR), Russia | 322,000 | Crops and wild relatives |
| National Institute of Agrobiological Sciences, Japan | 243,000 | Crops and wild relatives |
| Leibniz Institute of Plant Genetics and Crop Plant Research, Germany | 148,000 | Crops and wild relatives |
| Plant Germplasm System, Canada | 113,000 | Crops and wild relatives |
| National Genetic Resources Platform, Brazil | 107,000 | Crops and wild relatives |
| Millennium Seed Bank, United Kingdom | 60,000 | Wild plants |

of seed will be required per hectare. The need for large quantities of seed from seed banks is a major challenge for genebanks (Hardwick et al., 2011). It can be met by scaling up production, or by the creation of specialist seed banks such as that of the Utah Division of Wildlife Resources, which is able to store 340 tons of seed (Merritt & Dixon, 2011).

## *Ex situ* conservation: field genebanks

Field genebanks are well suited to clonally reproduced plants that do not reproduce true from seed, and for plants whose seeds cannot be stored frozen. They are often used for trees, which require less maintenance than tuber or seed crops; for example, more than 250 accessions of almond trees are grown at Zaragoza in Spain, over 500 olive accessions are maintained in Marrakech, Morocco, and the National Fruit Collection at Brogdale Farm, United Kingdom, has over 3,500 cultivars and landraces. Living collections of vegetatively reproduced crops include the Centre for Pacific Crops and Trees in Fiji, which has more than 1,100 taro land races, and major field collections of potato and sweet potato (the latter grown in greenhouses) at the International Potato Centre (CIP) in Peru. Living collections are vulnerable to disease, and those at CIP and other institutes are usually also held as *in vitro* tissue cultures.

Because plant cultivation does not require expensive facilities, it lends itself well to community genebanks, and to networked genebanks in which plants are kept at a number of locations. For example, the United Kingdom's Plant Heritage organisation (formerly the National Council for the Conservation of Plants and Gardens) is a collective of 650 specialist collections of ornamental plants located in both private and institutional gardens. Another network of living collections, in this case worldwide and focusing on medicinal plants, is Sacred Seeds (see p. 353). In both cases, a central office shares guidance on best practice, enables links between gardens and raises public visibility.

Botanic gardens already cultivate 80,000 plant species and have great potential to act as field genebanks, because of the strength of horticultural skills possessed by their staff (Chapter 10). The founding of Botanic Gardens Conservation International in 1987, and the first Global Strategy for Plant Conservation (2002), led botanic gardens to take a more strategic approach to conservation. This is important because individual gardens have relatively little space, leading to highly incomplete representation of plant species and of infra-species variation. For example, of 1,002 tree species recorded as Critically Endangered, only 192 are in cultivation within botanic gardens (Oldfield, 2009). The genetic basis of introductions can be narrow; for example, the dawn redwood *Metasequoia glyptostroboides* grows in 187 gardens but these plantings are derived from the seeds of just three trees (Oldfield, 2009). The quality of collections management continues to be uneven in botanic gardens (Maunder et al., 2001; Blackmore et al., 2011), and does not always match progress made in this area in other forms of genebanking. Cultivation of wild plants in botanic gardens can also lead to populations that are maladapted for reintroduction into the wild (Enßlin et al., 2011), suggesting that closer integration of living collections with seed and tissue storage in genebanks is required.

## *In situ* conservation

The impact of new varieties of crops on traditional farming became particularly noticeable in the 1960s as the Green Revolution took hold. It was thought that most traditional land races would be displaced by new cultivars, but research on farms (especially, but not only, those in marginal areas) in the 1980s found unexpectedly high survival rates of land races and showed that farmers maintained these alongside high-input, high-yielding modern varieties (Brush & Meng, 1998). It has been eloquently argued by Nazarea (2005) that crop diversity survives in the margins — in gardens,

among enthusiasts — but it is now clear that it also survives globalisation in farmers' fields. Examples include potatoes in Peru (de Haan et al., 2010), manioc in Brazil (Emperaire & Peroni, 2007), trees in Indonesian forest gardens (Marjokorpi & Ruokolainen, 2003) and home gardens worldwide (Webb & Kabir, 2009).

There are many unresolved questions when considering how *in situ* conservation can best be sustained, but there are some successful cases of the premium marketing of traditional products, with a clearly identified area of origin (Bardsley, 2003). For example, emmer wheat (also known as farro, *Triticum dicoccum*) is grown in Tuscany and marketed throughout Europe under European Union certificates of Protected Designation of Origin (PDO) or Protected Geographical Indication (PGI). Payments to farmers can sometimes be direct (Narloch et al., 2011). The mechanisms of farmer selection and of seed exchange among traditional farmers that lead to the survival and generation of crop diversity are still poorly understood, but research in this area is highly active, in part because of the vital role of seed exchange in food security (Pautasso et al., 2012).

While the concept of *in situ* conservation is relatively new for crops, it is much longer established for wild plants, at least in developed countries. Here, nature reserves date back to the early 20th century, and there is a well-established methodology for the maintenance of biodiversity-rich landscapes, albeit in the context of pressure from industrial agriculture, housing and infrastructure (Given, 1995; Hamilton & Hamilton, 2006). *In situ* conservation for the wild relatives of crops, however, has come later, as they fall between two conservation sectors: that focusing on crop biodiversity and that focusing on wild plants. A series of major projects funded by the World Bank in the 1990s has led to the establishment of protected areas and management tools, both documented at the Crop Wild Relatives Portal website. *In situ* conservation has a long history among indigenous peoples, for example in the form of sacred groves that also function to protect plants (Anderson et al., 2005).

## The role of community genebanks

Community genebanks focus on providing crop varieties for immediate use by local growers; in general, they do not hold wild relatives, which are mainly of use in plant breeding programmes. There is usually no long-term or frozen storage; seeds are 'lent' out to farmers, who then return a larger quantity after the harvest. The genebank is therefore continuously replenished. The genebank can draw material from local grower networks and from institutional genebanks. Such genebanks have developed both in developing countries, such as Ethiopia (Bezabih, 2008), India (Arunachalam et al., 2006) and Nepal (Sthapit et al., 2005), and in developed countries, such as France (Enjalbert et al., 2011).

In the USA, two organisations for community seed exchange operate on a large scale. Native Seeds/SEARCH works in the south-west of the USA and north-west Mexico and has about 2,000 arid land crops growing on a central farm. Seed Savers Exchange works mainly in the mid-West of the USA and preserves over 25,000 varieties; these are both preserved on a central farm and exchanged between members, thus blending the attributes of a seed genebank with those of a community genebank. Seed is backed up at the USDA Seed Bank in Fort Collins, and at Svalbard Global Seed Vault in Norway. In the United Kingdom, the Heritage Seed Library preserves about 800 accessions of traditional vegetables for garden production, which are kept and grown in a central garden and in the gardens of volunteer 'seed guardians'. In the case of domesticated animals, organisations such as the Rare Breeds Survival Trust (in the UK) and the American Livestock Breeds Conservancy (USA) act as central coordination points for breeding efforts carried out by individual farmers.

## STORAGE PROTOCOLS FOR SEEDS AT THE NATIONAL CENTRE FOR GENETIC RESOURCES PRESERVATION (NCGRP)

The ethnobiological collection at the NCGRP preserves plant seeds and propagules, and animal germplasm (Appendix 2). Full protocols for storage are found on the USDA Plant and Animal Genetic Resource Preservation Research Unit website. For further guidance on how to collect, store and process seeds, see the manuals listed in Table 2.

At the field sites, seeds are dried to ambient conditions and cleaned to remove empty seeds and chaff. A sample of seed from each accession is retained at the field site for regeneration, multiplication, distribution, characterisation and evaluation, and comprises an active collection. The active collections are stored at 10°C to -20°C. The United States' National Plant Germplasm System (NPGS) base collection contains all the inventories of each accession including the original sample and earlier regenerations.

One of the considerations of seed storage is whether seeds are classified as orthodox, recalcitrant, or intermediate according to their dehydration behaviour. Orthodox seeds can easily withstand freezing because they can survive desiccation to below 10% moisture content thanks to their accumulation of protective sugars and proteins. Recalcitrant seeds cannot tolerate desiccation to 10% moisture content. The viability of stored seeds is periodically monitored using standard germination assays. A fresh sample of seed is obtained if seed supply is too low or if the proportion of seeds that germinate decreases below about 60%. A fresh inventory usually contains between 1,500 and 3,000 seeds.

When seed samples are received at NCGRP, the following steps are taken to assure proper storage conditions. **1)** Seed is placed at 5°C until unpackaged, logged into the database and inventoried (which takes 1–5 days). **2)** Seed moisture content is adjusted at 5°C to 25% relative humidity by placing it in an equilibration room for 3–4 weeks. **3)** Seed may be temporarily stored at -18°C for up to 4 months awaiting an initial viability assessment using standard germination tests. **4)** Seed quality is assessed through germination tests that use 'The Association of Official Seed Analysts' rules as a guideline (AOSA, 2011). Germination procedures are specific to each species. Under most circumstances, four replications of 50 seeds are evaluated for initial germination and viability. For collections considered for storage in liquid nitrogen, two of the four replications are exposed to liquid nitrogen for 24 hours prior to germination. **5)** Germination data are entered into the Genetic Resource Information Network (GRIN). **6)** The seed sample is weighed to determine seed number. **7)** Seed is packaged in a heat-sealable aluminium foil laminate bag. **8)** The package is labelled with bar code and location labels. **9)** Data on seed weight, seed number and storage location are entered into GRIN. **10)** Packaged seed is placed into NCGRP's -20°C storage vault or liquid nitrogen for long-term storage (Figure 1).

Similar procedures are used by other genebanks. Seed at the International Crops Research Institute for the Semi-arid Tropics (ICRISAT) is processed by cleaning seed samples of extraneous materials, drying seeds to 8–10% moisture content for medium-term storage and to 3–7% for long term storage. Subsamples of a crop variety should be tested for the proper moisture levels. Seed viability is tested after drying and poor quality samples are sent for regeneration. Dry seeds that are frequently distributed are packed in plastic bottles or aluminium screw cap cans and placed in storage. The base collections are stored at –20°C for long-term storage and at 4°C and 20–30% relative humidity for medium-term storage. For a discussion on containers for seed storage, see Manger et al. (2003).

**Figure 1.** Cryopreservation is used for long-term storage at the National Center for Genetic Resources Preservation in Fort Collins, Colorado. Plant or animal germplasm is placed in a cryotank and submerged in liquid nitrogen or its vapour. © DR DAVID DIERIG.

## Safeguarding germplasm

Genebanks are at risk from routine mishaps resulting from loss of electrical power, natural disasters and war, all having the potential to cause devastating loss of seeds and other forms of germplasm. Duplication of accessions is an effective precaution against the catastrophic failure of a genebank. For example, both the NCGRP and Kew's Millennium Seed Bank provide seed storage for other genebanks around the world, including government agencies, universities, botanical gardens, non-governmental organisations (NGOs) and Native American tribes. Access and Benefit Sharing Agreements (ABSA) with the depositor determine the conditions of storage and use of material. In some cases these are 'black box' agreements, in which ownership of the seed is retained by the depositor and the seed is not freely distributed or listed in the genebank's database. This service is typically provided free of charge, and all black-box-stored material is returned to the owner upon written request. The ultimate 'black box' is the Svalbard Global Seed Vault, which opened in Norway in 2008. This provides storage for about 700,000 accessions drawn from genebanks around the world.

## INTELLECTUAL PROPERTY RIGHTS, LEGAL AND ETHICAL ISSUES FOR GENETIC RESOURCES

Dodds et al. (2007), Moore & Williams (2011) and Engels et al. (2011) offer useful reviews of these complex issues. This is a fast-moving field and up-to-date advice is essential. Until the 1980s, genetic resources were collected and distributed with few restrictions. The implementation of the Convention on Biological Diversity (CBD) in 1993 required prior informed consent and benefit-sharing agreements to be in place, in particular for transfers of biological material across national borders. Most international work that involves plant collecting takes place in accordance with agreements made under the provisions of the CBD; Moore and Williams (2011: 6) offer useful guidance on the exact procedures required.

The International Treaty on Plant Genetic Resources for Food and Agriculture, which came into force in 2004, is a system for the exchange of germplasm of major crop taxa between member states, within the framework of the CBD but without requiring new bilateral agreements for each case. For the 64 crops (and wild relatives) covered by the Treaty, genetic resources are made available under the terms of a standard Material Transfer Agreement. This allows use for research and breeding, with provision for benefit-sharing if the genetic resources are commercialised. The Treaty recognises the contribution of farmers and indigenous peoples' traditional knowledge of agricultural biodiversity.

Two other treaties are primarily concerned with plant breeders' rights (for commercial varieties) and will be of less relevance to ethnobotanists: the International Union for the Protection of New Varieties (UPOV), which focuses on plant varieties, and the Agreement on Trade-Related Aspects of Intellectual Property Rights (TRIPS).

Much germplasm is held under bilateral agreements. Examples of cooperative agreements for plant germplasm at NCGRP include those for *Fraxinus* (ash) resources in the USA and Canada that are threatened by an invasive alien insect, the Emerald Ash Borer (EAB). The agreement facilitates the collection and storage of seed and helps to ensure that the genetic diversity of this important native tree is available for research to breed resistant trees, and for reintroduction of ash once adequate environmental control measures for EAB are developed. Another example concerns the storage of rare, sensitive, threatened and/or endangered plant species identified by the Center for Plant Conservation (CPC) as being in need of conservation. In addition, an agreement concerning the germination data, long-term storage, curation and viability testing of the United States' Bureau of Land Management

(BLM) Seeds of Success (SOS) National Collection provides for the long-term conservation storage of native plant genetic resources. In a final example, collaborations with the International Center for the Improvement of Maize and Wheat (CIMMYT) in Mexico, aid the conservation and regeneration of maize collections such as those found in the Hustecas region of Mexico, also monitoring populations of *Tripsacum* species in Mexico and regenerating or collecting seed from maize, *Tripsacum* and teosinte.

## ETHNOBIOLOGY AND GERMPLASM

In the light of the issues and procedures surveyed in this chapter, here, we propose several guidelines for ethnobiologists.

### Germplasm preservation is central to modern ethnobiology

Today, ethnobiology has changed from being primarily descriptive, or a tool for bioprospecting by external parties, to being a discipline that is applied to the betterment of the societies within which it works. One of the central threats to many communities is loss of diversity, both of domesticated and wild plants and animals. In the case of crop plants, ethnobotanists have played a major role in documenting and explaining crop diversity; examples include cassava in the Peruvian Amazon rainforest (Salick et al., 1997), sago palm in Indonesia (Ellen, 2006) and cider apples in the UK and USA (Reedy et al., 2009). Ethnobotanical fieldwork will often determine that crop diversity is being lost, but it is rare that this kind of fieldwork is integrated with or leads on to germplasm collection. Similarly, ethnobotanists often document significant decline in wild plant populations resulting from overharvesting or habitat destruction. Of course, both for crops and wild plants, the first response will be to support *in situ* conservation, for example through community management. However, an integrated approach to conservation, as advocated above, would lead to simultaneous *ex situ* conservation in a genebank, providing a safeguard in case *in situ* conservation fails.

### Germplasm restoration is a powerful tool

The use of wild plant material held in genebanks is an integral part of species recovery, which focuses on individual taxa, and of restoration ecology, which focuses on revegetating degraded landscapes. It has obvious application to ethnobiology in the recovery of habitats and species recorded as once being in use, but now lost. The return of crop-plant germplasm from genebanks to source communities also has great potential, demonstrated in the successful work of Native Seeds/SEARCH, in returning local landraces to Native American farmers in the southwest USA, and through the flow of seeds from institutional genebanks to community genebanks.

### Germplasm preservation and restoration are not easy

While we advocate an active role for ethnobiologists in germplasm collection and use, we must point out that special skills are required to overcome the potential obstacles. *Ex situ* conservation must take place within the appropriate ethical and legal framework, and must be based on a detailed assessment of the best way to preserve and propagate the plant. For major crops, these techniques may be well documented, but new research might be required for lesser-known plants. The collection of seed from wild plants requires a strategy to ensure that the seed collecting does not unnecessarily threaten the collected population (Way, 2003). Germplasm restoration also requires careful thought: is the plant culturally appropriate and being reintroduced to the right place? Could it be invasive or carrying disease? How will propagation and habitat management be achieved, particularly for wild plants?

## Well-tested methodologies and advice are available

Fortunately, the questions raised above have already been researched, and the answers applied to real life cases. The widespread location of genebanks, and the availability of several methods manuals (Table 2), means that the ethnobiologist has easy access to advice and practical help. We strongly recommend that contact is made with nearby genebanks (and other germplasm projects) at an early stage if preservation or restoration is proposed, especially if a lesser-known or recalcitrant species is involved. Collection of orthodox seeds can (with careful guidance) be carried out by an ethnobotanist, but it may be preferable (and essential in the case of recalcitrant seeds or living plants) to invite a genebank team to visit the field area.

## TABLE 2

Handbooks on germplasm

| TOPIC | TITLE | REFERENCE |
|---|---|---|
| *In situ* preservation of useful plants and crops | *People, Plants, and Protected Areas: a Guide to In Situ Management* | Tuxill & Nabhan, 2001 |
| *In situ* preservation of crop wild relatives | *Conserving Plant Genetic Diversity in Protected Areas* | Iriondo et al., 2008 |
| | *Crop Wild Relatives: a Manual of In Situ Conservation* | Hunter & Heywood, 2011 |
| All aspects of collecting plant germplasm | *Collecting Plant Genetic Diversity: Technical Guidelines* | Guarino et al., 1995; online as *Crop Genebank Knowledge Bases Wiki* website |
| | *Collecting Plant Genetic Diversity: Technical Guidelines.* 2011 update | Guarino et al., 2011 |
| | *ENSCONET Seed Collecting Manual for Wild Species* | ENSCONET, 2009a |
| Seed collecting, preservation and propagation | *Seed Conservation: Turning Science into Practice* | Smith et al., 2003 |
| Seed handling and storage | *Manual of Seed Handling in Genebanks* | Rao et al., 2006 |
| | ENSCONET Seed Collecting Manual for Wild Species | ENSCONET, 2009b |
| Genebank management | *A Guide to Effective Management of Germplasm Collections* | Engels & Visser, 2003 |
| Wild plant collecting and storage | *Ex situ Plant Conservation: Supporting Species Survival in the Wild* | Guerrant et al., 2004 |
| Plant reintroduction and restoration ecology | *A Handbook for Botanic Gardens on the Reintroduction of Plants to the Wild* | Akeroyd & Wyse Jackson, 1995 |
| | *Restoring Diversity: Strategies for Reintroduction of Endangered Plants* | Falk et al., 1996 |
| | *Restoring Disturbed Landscapes: Putting Principles into Practice* | Tongway & Ludwig, 2010 |
| | *Restoring Tropical Forests: a Practical Guide* | Elliott et al., 2013 |

## PROJECT MGU: THE USEFUL PLANTS PROJECT AT THE MILLENNIUM SEED BANK (MSB)

TIZIANA ULIAN

The origins of the Millennium Seed Bank (MSB) lie in research into seed storage and germination carried out at the Royal Botanic Gardens, Kew from the 1960s onwards. In 2000, a purpose-built genebank was opened at Kew's second garden, at Wakehurst Place (Sussex, England) and collecting activities greatly increased in scale. The MSB now collaborates with 170 institutions in more than 50 countries, with the resulting seed collections being stored both in the country of collection and in the MSB. Access and benefit-sharing agreements are in place with each partner. The MSB strongly emphasises capacity-building in partner countries, including extensive training, and provides advice on the construction of new genebanks.

The focus of the MSB is on the seeds of wild plant species, many of which are used by local communities. The Useful Plants Project works with local communities in Botswana, Kenya, Mali, Mexico and South Africa through the Millennium Seed Bank Partnership. The first stage is for the communities to identify those plants of the greatest use and lowest availability, as well as obstacles to their use such as difficulty in propagation. The project then assists with the collection and *ex situ* storage of seeds in local and national genebanks, with training and enhancing facilities in local communities, with the development of propagation protocols, and with *in situ* conservation (Figures 2 and 3). Target species have included the baobab tree (*Adansonia digitata*), the sausage tree (*Kigelia africana*), the mongongo tree (*Schinziophyton rautanenii*) and the morma bean (*Tylosema esculentum*) in Africa, and the Mexican oregano (*Lippia graveolens*) and xoconochtli (*Stenocereus stellatus*).

LEFT **Figure 2.** Community nursery enhanced through the Useful Plants Project in Tharaka, Kenya. © TIZIANA ULIAN.

RIGHT **Figure 3.** Four-year-old plant of ngálăma (*Anogeissus leiocarpus*) planted in the community plot in Kougue, Mali. It is one of the plants used to make bògòlanfini, a traditional Malian mudcloth. It is also used as a human and livestock anthelmintic for treating worms, and for treatment of protozoan diseases in animals. © MOCTAR SACANDE.

Bear in mind that establishing a new germplasm repository is a major undertaking that will require significant follow-up. If starting a new genebank, or *in situ* conservation project, we strongly recommend also depositing duplicate collections in a well-established genebank that can guarantee long-term storage.

Collecting animal germplasm in remote locations necessitates the need for portable lab equipment (a microscope, battery-operated spectrometers and liquid nitrogen) and either freezing samples in the field or arranging for the shipment of perishable samples to a location where they can be cryopreserved.

## Germplasm preservation should be an outcome of community consultation

The traditional approach to germplasm collection has been long-distance journeys during which plant seed is collected from the wild and from farmers from several locations each day. This technique has been highly successful in rapidly building up genebanks for crops and their wild relatives, but naturally results in little exchange of information between collectors and communities. By contrast, ethnobiologists are much more likely than traditional germplasm collectors to study an area long-term and to develop long-term relationships with the community that hosts them. This means that priorities for germplasm preservation or restoration will arise out of community discussion, facilitated as need be by the ethnobiologist. In addition to meeting the legal requirements outlined above, transfer of germplasm material (and related traditional knowledge) must meet the ethical standards of ethnobiology (Chapter 1). Community involvement is as important for *in situ* conservation; success requires that conservation practices are embedded in local communities (de Boef et al., 2012).

Where the initiative for germplasm conservation comes from an external genebank, then it is necessary to establish a working relationship with indigenous groups before any collection takes place. In some instances this process can take several years.

## Ethnobiology has much to contribute to germplasm research and preservation

Ethnobiologists have much to offer germplasm collection programmes. They bring skills in prioritising species for use and conservation through quantitative field research methods (Gold & McBurney, 2012). For example, Albuquerque et al. (2009) assessed the conservation priorities of 166 useful plant species in the caatinga vegetation of north-eastern Brazil. High priority was allocated to plants that had multiple uses but were rare in home gardens or in the wild. A similar approach is taken by the Useful Plants Project at the Millennium Seed Bank (see Box 'The Useful Plants Project at the Millennium Seed Bank').

Ethnobiologists bring more than a utilitarian perspective; they can also bring their role as 'trained experts in gathering, filtering, and managing local knowledge, and in fostering engagement with local communities. Ethnobotanists can ensure that issues, such as prior informed consent, respectful use of local community members' time and resources, data ownership and the sharing of results and benefits with local communities, are managed properly and in accordance with agreements such as the Convention on Biological Diversity.' (Saslis-Lagoudakis & Clarke, 2012).

## GERMPLASM AND INDIGENOUS KNOWLEDGE

Indigenous knowledge of relevant collections has not been fully appreciated, or captured in the data management systems of modern genebanks. The traditional methods of local farmers are as important as the methods used by modern, mechanised agriculture, although there have been few efforts to preserve this knowledge. Preservation of cultural information supports and complements the genetic, agronomic and physiological characterisation of many important crops (Nazarea, 1998). Even basic information, such as common names, that does exist is hard to locate because genebank catalogues are notoriously complex (Pinheiro de Carvalho, 2012); new data portals such as GENESYS (www. genesys-pgr.org) and Global-GRIN (www.grin-global.org) offer hope of easier access.

The genetic resource collectors of the 20th century, such as Jack Harlan and Nikolai Vavilov, were keenly interested in the traditional uses of plants, and were careful recorders in field notebooks and photographs. Many of the data they collected were published, but cannot easily be connected to relevant plant accessions. The collecting notebooks of these pioneers have great potential as research resources if digitised and cross-linked to the relevant accessions still held in genebanks.

In the 1980s, the importance of indigenous knowledge became more widely appreciated, and formal procedures were instituted for its collection alongside germplasm. Guarino & Friis-Hansen (1995), Nazarea (1998) and Quek & Friis-Hansen (2011) give detailed guidance on making traditional knowledge journals and on 'memory banking', a procedure analogous to 'seed banking'. Many of the procedures will be familiar to the ethnobiologist, but working with crops and domesticated animals does require background knowledge to enable the right questions to be asked.

There are significant obstacles to the preservation and transmission of indigenous knowledge once plants reach *ex situ* preservation, for example in a genebank. Knowledge can be hard to preserve in written form, particularly in a form compatible with the databases used to store genebank data. Access to indigenous knowledge will, of course, be framed by the agreements made with the holder of that knowledge. As in the wider world of ethnobotany, these issues are still not fully resolved (Chapter 1).

## CONCLUSIONS

The worlds of genetic resources and ethnobiology share common aims and overlapping methodologies, yet hardly interact. Greater engagement between the two would lead to enhanced preservation of biodiversity, the opportunity for more nuanced investigation of research problems, and a greater flow of benefits from germplasm repositories to local communities.

## Websites

*Crop Genebank Knowledge Bases Wiki.* http://cropgenebank.wikispaces.com

*Crop Wild Relatives Portal.* www.cropwildrelatives.org

International Crops Research Institute for the semi-Arid Tropics (ICRISAT). *On-line Genebank Manual.* www.icrisat.org/gene-bank-manual.htm

*Seed Conservation: Turning Science into Practice.* www.kew.org/science-research-data/kew-in-depth/msbp/publications-data-resources/technical-resources/seed-conservation-science-practice

Royal Botanic Gardens, Kew. *Seed Information Database (SID).* http://data.kew.org/sid

United States Department of Agriculture. *Genetic Resource Information Network (GRIN).* www.ars-grin.gov

United States Department of Agriculture. *National Animal Germplasm Program.* www.ars.usda.gov/Main/docs.htm?docid=16979

United States Department of Agriculture. *USDA Plant and Animal Genetic Resource Preservation Research Unit.* www.ars.usda.gov/main/site_main.htm?modecode=54-02-05-03

## Literature cited

Akeroyd, J. & Wyse Jackson, P. (1995). *A Handbook for Botanic Gardens on the Reintroduction of Plants to the Wild.* Botanic Gardens Conservation International, Kew. www.plants2020.net/document/0206/

Albuquerque, U. P., Araujo, T. A. S., Ramos, M. A., do Nascimento, V. T., de Lucena, R. F. P., Monteiro, J. M., Alencar, N. L. & Araujo, E. D. (2009). How ethnobotany can aid biodiversity conservation: reflections on investigations in the semi-arid region of NE Brazil. *Biodiversity and Conservation* 18: 127–150.

Alexiades, M. N. (ed.) (1996). *Selected Guidelines for Ethnobotanical Research: a Field Manual.* New York Botanical Garden, New York.

Anderson, D. M., Salick, J., Moseley, R. K. & Xiaokun, O. (2005). Conserving the sacred Medicine Mountains: a vegetation analysis of Tibetan sacred sites in northwest Yunnan. *Biodiversity and Conservation* 14: 3065–3091.

Anderson, E. N., Pearsall, D. M., Hunn, E. S. & Turner, N. J. (eds) (2011). *Ethnobiology.* John Wiley, Hoboken.

AOSA (2011). *Rules for Testing Seeds.* 4 volumes. The Association of Official Seed Analysts, Ithaca.

Arunachalam, V., Chaudhury, S. S., Sarangi, S. K., Ray, T., Mohanty, B. P., Nambi, V. A. & Mishra, S. (2006). *Rising on Rice: The Story of Jeypore.* MS Swaminathan Research Foundation, Chennai. www.mssrf.org/bd/bd-pub/rising%20on%20rice_booklet.pdf

Bardsley, D. (2003). Risk alleviation via *in situ* agrobiodiversity conservation: drawing from experiences in Switzerland, Turkey and Nepal. *Agriculture Ecosystems & Environment* 99: 149–157.

Bezabih, M. (2008). Agrobiodiversity conservation under an imperfect seed system: the role of community seed banking schemes. *Agricultural Economics* 38: 77–87.

Blackburn, H. D. (2009). Genebank development for the conservation of livestock genetic resources in the United States of America. *Livestock Science* 120: 196–203.

Blackmore, S., Gibby, M. & Rae, D. (2011). Strengthening the scientific contribution of botanic gardens to the second phase of the Global Strategy for Plant Conservation. *Botanical Journal of the Linnean Society* 166: 267–281.

Brush, S. B. (2004). *Farmers' Bounty: Locating Crop Diversity in the Contemporary World*. Yale University Press, New Haven.

Brush, S. B. & Meng, E. (1998). Farmers' valuation and conservation of crop genetic resources. *Genetic Resources and Crop Evolution* 45: 139–150.

de Boef, W. S., Thijssen, M. H., Shrestha, P., Subedi, A., Feyissa, R., Gezu, G., Canci, A., Ferreira, M. A. J. D., Dias, T., Swain, S. & Sthapit, B. R. (2012). Moving beyond the dilemma: practices that contribute to the on-farm management of agrobiodiversity. *Journal of Sustainable Agriculture* 36: 788–809.

de Haan, S., Nunez, J., Bonierbale, M. & Ghislain, M. (2010). Multilevel agrobiodiversity and conservation of Andean potatoes in central Peru. *Mountain Research and Development* 30: 222–231.

Dodds, J., Krattiger, A. & Kowalski, S.P. (2007). Plants, germplasm, genebanks, and intellectual property: principles, options, and management. In: *Intellectual Property Management in Health and Agricultural Innovation: a Handbook of Best Practices*, eds A. Krattiger, R. T. Mahoney & L. Nelsen, pp. 389–400. MIHR, Oxford and PIPRA, Davis. www.iphandbook.org

Ellen, R. F. (2006). Local knowledge and management of sago palm (*Metroxylon sagu* Rottboell) diversity in south central Seram, Maluku, Eastern Indonesia. *Journal of Ethnobiology* 26: 258–298.

Elliot, S., Blakesley, D. & Hardwick, K. (2013). *Restoring Tropical Forests: a Practical Guide*. Royal Botanic Gardens, Kew.

Emperaire, L. & Peroni, N. (2007). Traditional management of agrobiodiversity in Brazil: a case study of manioc. *Human Ecology* 35: 761–768.

Engels, J. M. M. & Visser, L. ed. (2003). *A Guide to Effective Management of Germplasm Collections*. International Plant Genetic Resources Institute, Rome. http://cropgenebank.sgrp.cgiar.org/images/file/learning_space/genebankmanual6.pdf

Engels, J. M., Dempewolf, H. & Henson-Apollonio, V. (2011). Ethical considerations in agro-biodiversity research, collecting, and use. *Journal of Agricultural and Environmental Ethics* 24: 107–126.

Enjalbert, J., Dawson, J. C., Paillard, S., Rhoné, B., Rousselle, Y., Thomas, M., & Goldringer, I. (2011). Dynamic management of crop diversity: from an experimental approach to on-farm conservation. *Comptes Rendus Biologies* 334: 458–468.

Enßlin, A., Sandner, T. M., & Matthies, D. (2011). Consequences of *ex situ* cultivation of plants: Genetic diversity, fitness and adaptation of the monocarpic *Cynoglossum officinale* L. in botanic gardens. *Biological Conservation* 144: 272–278.

ENSCONET (2009a). *ENSCONET Seed Collecting Manual for Wild Species*. http://ensconet.maich.gr/PDF/Collecting_protocol_English.pdf

ENSCONET (2009b). *ENSCONET Curation Protocols & Recommendations*. http://ensconet.maich.gr/PDF/Curation_protocol_English.pdf

FAO (2010). *Second Report on the State of the World's Plant Genetic Resources for Food and Agriculture*. www.fao.org/agriculture/crops/core-themes/theme/seeds-pgr/sow/sow2/en/

Falk, D. A., Millar, C. I. & Olwell, M. (eds) (1996). *Restoring Diversity: Strategies for Reintroduction of Endangered Plants*. Island Press, Washington, DC.

Given, D. (1995). *Principles and Practices of Plant Conservation*. Timber Press, Portland.

Gold, K. & Hay, F. (2008). *Identifying desiccation sensitive seeds*. Technical Information Sheet 10. Millennium Seed Bank Project, Wakehurst Place. www.kew.org/ucm/groups/public/documents/document/ppcont_014355.pdf

Gold, K. & McBurney, R. ( 2012). Conservation of plant diversity for sustainable diets. In: *Sustainable diets and biodiversity: directions and solutions for policy, research and action*, eds B. Burlingame & S. Dernini, pp. 108–114. FAO, Rome. www.fao.org/docrep/016/i3004e/i3004e.pdf

González-Arno, M.T., Panta, A., Roca, W.M., Escobar, R.H. & Engelman, F. (2008). Development of large scale application of cryopreservation techniques for shoot and somatic embryo cultures of tropical crops. *Plant Cell, Tissue and Organ Culture* 92: 1–13.

Guarino, L., Ramanatha Rao, V., Reid, R. (eds) (1995). *Collecting Plant Genetic Diversity: Technical Guidelines*. CAB International, Wallingford. http://cropgenebank.wikispaces.com/Collecting+Manual

Guarino, L. & Friis-Hansen, E. (1995). Collecting plant genetic resources and documenting associated indigenous knowledge in the field: a participatory approach. In: *Collecting Plant Genetic Diversity: Technical Guidelines*, eds L. Guarino, V. Ramanatha Rao & R. Reid, pp. 195–228. CAB International, Wallingford.

Guarino, L., Rao, V. R. & Goldberg, E. (eds) (2011). *Collecting Plant Genetic Diversity: Technical Guidelines*. 2011 update. Bioversity International, Rome. http://cropgenebank.sgrp.cgiar.org/index.php?option=com_content&view=article&id=390&Itemid=557

Guerrant, E. O., Havens, K. & Maunder, M. (eds) (2004). *Ex situ Plant Conservation: Supporting Species Survival in the Wild*. Island Press, Washington, DC.

Hamilton, A. C. & Hamilton, P. (2006). *Plant Conservation: an Ecosystem Approach*. Earthscan, London.

Hammer, K., Arrowsmith, N. & Gladis, T. (2003). Agrobiodiversity with emphasis on plant genetic resources. *Naturwissenschaften* 90: 241–250.

Hardwick, K. A., Fiedler, P., Lee, L. C., Pavlik, B., Hobbs, R. J., Aronson, J., Bidartondo, M., Black, E., Coates, D., Daws, M. I., Dixon, K., Elliott, S., Ewing, K., Gann, G., Gibbons, D., Gratzfeld, J., Hamilton, M., Hardman, D., Harris, J., Holmes, P. M., Jones, M., Mabberley, D., Mackenzie, A., Magdalena, C., Marrs, R., Milliken, W., Mills, A., Lughadha, E. N., Ramsay, M., Smith, P., Taylor, N., Trivedi, C., Way, M., Whaley, O. & Hopper, S. D. (2011). The role of botanic gardens in the science and practice of ecological restoration. *Conservation Biology* 25: 265–275.

Hunter, D. & Heywood, V. (2011). *Crop Wild Relatives: a Manual of In Situ Conservation*. Earthscan, London.

Iriondo, J. M., Maxted, N., & Dulloo, M. E. (2008). *Conserving Plant Genetic Diversity in Protected Areas*. CABI, Wallingford.

Jackson, L. E., Pascual, U. & Hodgkin, T. (2007). Utilizing and conserving agrobiodiversity in agricultural landscapes. *Agriculture Ecosystems & Environment* 121: 196–210.

Loskutov, I. G. (1999). *A History of World Collection of Plant Genetic Resources in Russia*. International Plant Genetic Resources Institute, Rome.

Manger, K., Adams, J. & Probert, R. J. (2003). Selecting seed containers for the Millennium Seed Bank Project: a technical review and survey. In: *Seed Conservation: Turning Science into Practice*, eds R. D. Smith, J. B. Dickie, S.H. Linington, H.W. Pritchard & R. J. Probert, pp. 639–652. Royal Botanic Gardens, Kew.

Marjokorpi, A. & Ruokolainen, K. (2003). The role of traditional forest gardens in the conservation of tree species in West Kalimantan, Indonesia. *Biodiversity and Conservation* 12: 799–822.

Martin, G. (1995). *Ethnobotany: a Methods Manual*. Chapman & Hall, London.

Maunder, M., Higgens, S. & Culham, A. (2001). The effectiveness of botanic garden collections in supporting plant conservation: a European case study. *Biodiversity and Conservation* 10: 383–401.

Merritt, D. J. & Dixon, K. W. (2011). Restoration seed banks — a matter of scale. *Science* 332: 424–425.

Nabhan, G. (1989). *Enduring Seeds*. North Point Press, San Francisco.

Moore, G. & Williams, K. A. (2011). Legal issues in plant germplasm collecting. In: *Collecting Plant Genetic Diversity: Technical Guidelines — 2011 update*, eds L. Guarino, V. Ramanatha Rao & E. Goldberg. Bioversity International, Rome. http://cropgenebank.sgrp.cgiar.org/index.php?option=com_content&view=article&id=669

Narloch, U., Drucker, A. G. & Pascual, U. (2011). Payments for agrobiodiversity conservation services for sustained on-farm utilization of plant and animal genetic resources. *Ecological Economics* 70: 1837–1845.

Nazarea, V. D. (1998). *Cultural Memory and Biodiversity*. University of Arizona Press, Tucson.

Nazarea, V. D. (2005). *Heirloom Seeds and their Keepers: Marginality and Memory in the Conservation of Biological Diversity*. University of Arizona Press, Tucson.

Oldfield, S. F. (2009). Botanic gardens and the conservation of tree species. *Trends in Plant Science* 14: 581–583.

Pautasso, M., Aistara, G., Barnaud, A., Caillon, S., Clouvel, P., Coomes, O., Delêtre, M., Demeulenaere, E., Santis, P., Döring, T., Eloy, L., Emperaire, L., Garine, E., Goldringer, I., Jarvis, D., Joly, H., Leclerc, C., Louafi, S., Martin, P., Massol, F., McGuire, S., McKey, D., Padoch, C., Soler, C., Thomas, M. & Tramontini, S. (2012). Seed exchange networks for agrobiodiversity conservation. A review. *Agronomy for Sustainable Development* 33: 151–175.

Pinheiro de Carvalho, M. A. A., Bebeli, P. J., Bettencourt, E., Costa, G., Dias, S., Dos Santos, T. M. M. & Slaski, J. J. (2012). Cereal landraces genetic resources in worldwide genebanks. A review. *Agronomy for Sustainable Development* 33: 177–203.

Pistorious, R. (1997). *Scientists, Plants and Politics: A History of the Plant Genetic Resources Movement*. International Plant Genetic Resources Institute, Rome.

Quek, P. & Friis-Hansen, E. (2011). Collecting plant genetic resources and documenting associated indigenous knowledge in the field: a participatory approach. In: *Collecting Plant Genetic Diversity: Technical guidelines — 2011 update*, eds L. Guarino, V. Ramanatha Rao & E. Goldberg. Bioversity International, Rome. http://cropgenebank.sgrp.cgiar.org/images/file/procedures/collecting2011/Chapter18-2011.pdf

Rao, N. K., Hanson, J., Dulloo, M. E., Ghosh, K., Nowell, A. & Iarinde, M. (2006). *Manual of Seed Handling in Genebanks*. Bioversity International, Rome. http://cropgenebank.sgrp.cgiar.org/images/file/learning_space/genebankmanual8.pdf

Reedy, D., McClatchey, W. C., Smith, C., Lau, Y. H., & Bridges, K. W. (2009). A mouthful of diversity: knowledge of cider apple cultivars in the United Kingdom and northwest United States. *Economic Botany* 63: 2–15.

Salick, J., Cellinese, N. & Knapp, S. (1997). Indigenous diversity of cassava: generation, maintenance, use and loss among the Amuesha, Peruvian Upper Amazon. *Economic Botany* 51: 6–19.

Saslis-Lagoudakis, C. H., & Clarke, A. C. (2012). Ethnobiology: the missing link in ecology and evolution. *Trends in Ecology & Evolution* 28: 67–68.

Smith, R. D., Dickie, J. B., Linington, S. H., Pritchard, H. W. & Probert, R. J. (eds) (2003). *Seed Conservation: Turning Science into Practice*. Royal Botanic Gardens, Kew. www.kew.org/science-research-data/kew-in-depth/msbp/publications-data-resources/technical-resources/seed-conservation-science-practice

Staden, J. V., Brown, N. A., Jäger, A. K., & Johnson, T. A. (2008). Smoke as a germination cue. *Plant Species Biology* 15: 167–178.

Sthapit, B. R., Upadhyay, M. P., Shrestha, P. K. & Jarvis, D. J. (eds) (2005). *On-farm Conservation of Agricultural Biodiversity in Nepal*. Bioversity International, Rome.

Tempelman, K. A. & Cardellino, R. A. (eds) (2007). *People and Animals, Traditional Livestock Keepers: Guardians of Domestic Animal Diversity*. Food and Agriculture Organization of the United Nations (FAO), Rome.

Tongway, D. J. & Ludwig, J. A. (2010). *Restoring Disturbed Landscapes: Putting Principles into Practice*. Island Press, Washington DC.

Tweddle, J. C., Dickie, J. B., Baskin, C. C. & Baskin, J. M. (2003). Ecological aspects of seed desiccation sensitivity. *Journal of Ecology* 91: 294–304.

Tuxill, J. D. & Nabhan, G. P. (2001). *People, Plants, and Protected Areas: a Guide to In Situ Management*. Earthscan, London.

Way, M. J. (2003). Collecting seed from non-domesticated plants for long-term conservation. In: *Seed Conservation: Turning Science into Practice*, eds R. D. Smith, J. B. Dickie, S. H. Linington, H.W. Pritchard & R. J. Probert, pp. 163–201. Royal Botanic Gardens, Kew. www.kew.org/ucm/groups/public/documents/document/ppcont_013771.pdf

Webb, E. L. & Kabir, M. E. (2009). Home gardening for tropical biodiversity conservation. *Conservation Biology* 23: 1641–1644.

CHAPTER 9

# *Curating xylaria*

ALEX C. WIEDENHOEFT

Forest Products Laboratory, Forest Service,
United States Department of Agriculture

## WOOD AS A BIOCULTURAL MATERIAL

Wood is perhaps the quintessential material used in most human cultures. In prehistoric times, it was employed, either directly or indirectly, to provide most human needs: warmth, shelter, and nearly all manner of tools suitable for procuring food, water and security (Beeckman, 2003). In modern times it continues to play important roles in human cultures (Radkau, 2012). Despite its ubiquity as a technological material, it is often a surprise to the general public, and even to other biologists, that xylaria, or collections of wood specimens, exist.

## XYLARIA

Throughout this chapter, the word xylarium is used in place of wood collection. This use indicates a conceptual separation between informal wood collections (e.g. a woodworker's personal set of favourite or reference specimens) and more formally organised xylaria of scientific wood specimens, which are most frequently associated with research or academic institutions and often have affiliated microscope slide collections and herbaria (Lamb & Curtis, 2005).

Unlike more traditional botanical collections (such as herbaria) or more modern collections (such as DNA libraries), wood is comparatively commonly collected by the non-botanical public, with collections ranging from a few choice pieces of favourite woods to hundreds or thousands of rigorously collected specimens. Some collections compiled by wood enthusiasts rival or surpass the scientific quality, and even quantity, of some of the more modest institutional xylaria around the world. There are wood collectors, most associated with the International Wood Collectors Society who have demonstrated botanical and organisational commitment in collecting and depositing herbarium-quality vouchers for their wood specimens. Their work in that regard justifies acknowledgement, and it is hoped that this entry into the research literature will make scientists aware of the resources available outside of institutional xylaria. This is particularly important for wood, because private, hobbyist collectors probably outnumber the professional botanists with the necessary field skills, patience and perseverance to collect wood specimens of high scientific value and quality (for Belgium and the Netherlands, see van der Dussen & Miedema, 2008).

Institutional xylaria are listed in the Index Xylariorum, first published in 1967; the fourth and most current edition is maintained online (Lynch & Gasson, 2010 (online)). It lists 158 xylaria, 81 with current information.

## XYLARIUM CURATION

The simplicity of xylarium curation can be attributed to the ease of physical and botanical curation of wood specimens, and to the comparatively simple modes of loaning specimens and providing access to collections.

## Specimen format

The concept of distinct wood collections first appeared in central Europe in the late 18th century, with the preparation and sale of Holzbibliotheken, comprising boxes made from the wood of the species concerned, and containing other parts of the tree such as dried flowers and leaves (Feuchter-Schawelka et al., 2001). The concept of a more utilitarian wood collection, destined to be sampled for wood anatomical purposes, probably dates to the mid-19th century. The Royal Botanic Gardens, Kew was collecting wood specimens of this kind from 1847 (Cornish et al., in press); many xylaria were established subsequently with a peak in the 1940s and 1950s. The typical specimen format was a piece of timber, usually lacking bark, shaped like a book and of varying size (often about 12 cm high, 8 cm deep and 4 cm wide). Although well adapted to the study of commercial timbers that predominated in the period 1850–1950, such samples are less well-suited to current research as they lack bark and only represent a small part of a tree's diameter.

Modern specimens are often from small woody plants, in which case it may be possible to cut whole pieces of stem and branch. In the case of larger trees, the specimen format will depend on whether a fallen or felled trunk is available. If it is, then an entire stem disc (cross-section) may be cut; if this will be too large, then a wedge-shaped piece (in both cases about 5 cm thick) can be cut that stretches from the centre of the trunk to the bark. Such samples enable ecological studies that rely on tree-ring width, anatomical studies looking at different parts of the xylem, and studies of the tree bark. Such specimens are far more 'future-proof' than the traditional format. If a fallen tree is not available, then a similar disc can usually be cut off from a branch without damaging the tree. Juvenile wood often differs anatomically from mature wood, however, especially with regard to quantitative features such as vessel diameter and frequency.

## Physical curation

The physical curation of a xylarium is perhaps the simplest of any biological collection. Although wood exhibits dimensional change with changes in relative humidity in the environment, if wood specimens are 'dry' (i.e. a moisture content below about 20%) when they are accessioned into a xylarium, they are not particularly susceptible to biological attack, will experience few chemical changes over the course of tens to hundreds of years, and will change dimension only slightly. Provided that they are not stored in direct sunlight, wood specimens should last indefinitely under such conditions. Even when exposed to direct sunlight, only the surface millimetre of tissue is likely to be altered. In this regard, the specimens comprising the heart of a xylarium are extremely stable and forgiving materials for physical curation. Nonetheless, to avoid the risk of attack by mould or insects, or of distortion of specimens under highly variable relative humidity or temperature, wood specimens must be kept in reasonably stable environments of the kind described in Chapter 2.

## Botanical curation

The botanical curation of a xylarium is quite similar to that of a herbarium, except that far fewer researchers are interested in wood specimens, so the traffic through a xylarium is proportionally less. Taxonomic inertia tends to be significant, resulting in longer retention times for entrenched taxonomic schemes and a resultant use of archaic names. A practical factor that works in synergy with the paucity of scientific visitors to xylaria is the general trend across much of the world to reduce institutional support for xylaria. With fewer professional curators, updating the taxonomic system used in a xylarium becomes an impossible task. Researchers interested in exploring the contents of

**Figure 1.** Specimens in drawers of (left) the Madison xylarium (MADw) and (right) the Samuel J. Record Memorial xylarium (SJRw), both in the Center for Wood Anatomy Research at the Forest Products Laboratory (FPL) in Madison. MADw was founded at the FPL by Eloise Gerry, the first female scientist in the US Forest Service. It is the active xylarium to which specimens are accessioned when new collections arrive. SJRw was formerly at Yale University and is curated as a static, memorial collection that is available for research. © ALEX WIEDENHOEFT.

a xylarium to study any particular taxon would be well-advised to approach the xylarium catalogue with a robust understanding of the synonymy in the group of interest.

The proportion of wood specimens vouchered as herbarium specimens varies greatly between xylaria. Vouchering has only become standard practice since the 1980s. Nevertheless, older specimens often derive from sources such as forestry departments or arboreta that were generally able to accurately identify trees, and a surprisingly high proportion may be vouchered by herbarium specimens (Chapter 22).

## Specimen exchanges, loans and public access

Specimen exchanges and loans generally take one of two forms, either a wholesale transfer of a xylarium-sized (i.e. full-size) duplicate specimen cut from the same tree as the specimen in the donor's xylarium, or the sharing of a small sectioning block of about 1 cm$^3$ suitable for making microscope slides. In as much as the primary function of xylaria in the past has been as repositories for specimens for wood anatomical research, the transfer of a well-prepared sectioning block is more than sufficient to provide representative material. The recipient typically provides the donor with a permanent microscope slide prepared from the block. In the USA, a number of xylaria not only failed to provide specimens, but did not respond to formal requests for sectioning blocks as recently as 2006 (personal observation). It is reasonable to assume that the xylaria that are failing to respond

are probably in legitimate danger of being discarded by the host institution, as they tend to be space-intensive. General public access to most xylaria is restricted or prohibited in line with practice for herbaria, although the robust nature of wood specimens means that they are well-suited for use in public engagement.

## Digitisation of xylaria

Some biological collections such as herbaria have moved toward digitising their contents. For most scientific uses, a macroscopic scan of wood is virtually useless; the beauty of wood structure is at varying microscopic scales. The most comprehensive database of wood anatomy, Inside Wood (2004, online), features 7,800 descriptions and 41,437 images, made up of modern woods (6,070 descriptions, 39,112 images) and fossil woods (1,730 descriptions, 2,325 images). Other wood collections, for example at the Forestry and Forest Products Research Institute in Japan (Database of Japanese Woods, 2002, online), have placed both macroscopic and microscopic images online. Macroscopic images in books are often life-size and show the colour or grain of wood (Lincoln, 1986; Hoadley, 2000; Flynn & Holder, 2001). Digital images can be less true to colour and size, but nonetheless show the characteristic figuring of wood surfaces which can be valuable to designers and furniture historians. The labels on wood specimens can be of historic or scientific interest, and form an important resource for historians (Bowett, 2012).

## Non-traditional uses of xylarium specimens

Wood anatomical studies are not the only scientific endeavours to which xylaria can contribute. Xylaria are potential storehouses of both plastid and nuclear plant DNA. The successful visualisation and extraction of DNA from long-stored specimens (Abe et al., 2011) demonstrates that xylarium specimens can serve as a source of plant DNA. Two main limitations of xylarium specimens as a source for DNA are the low DNA content of wood as a tissue, and the difficulties associated with extracting and purifying high-quality DNA from wood. The former limitation is a biological one, and must be considered on a taxon-by-taxon basis. The latter limitation is technological, solvable

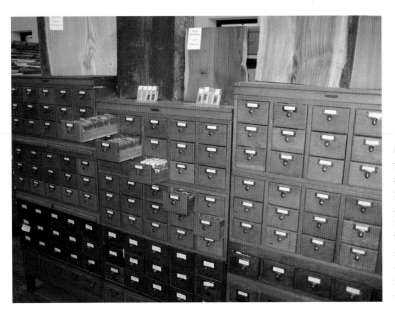

**Figure 2.** Cabinets housing the prepared slide collection associated with MADw and SJRw, in the Center for Wood Anatomy Research at the Forest Products Laboratory in Madison, WI. Both stained and unstained slides are included in the collection. Note specimens from the Jesup wood collection atop the cabinets. © ALEX WIEDENHOEFT.

and a topic of ongoing research at a number of laboratories around the world (Asif & Cannon, 2005; Ogden et al., 2008; Lowe & Cross, 2011; Rachmayanti et al., 2009).

Wood is also a reliable source of stable isotopes for a variety of types of research, including determining the provenience of museum artefacts, understanding palaeoclimate (van Bergen & Poole, 2002; Ward et al., 2005), exploring environmental effects on physiological processes, and even tracing the origin of illegally felled trees (Kagawa & Leavitt, 2009). Xylaria, especially those with vouchered specimens with detailed collection information, are well-suited to provide a rich source of material for isotopic studies if the requisite sample sizes are small.

The value of wood as a material for making beautiful and functional objects, such as furniture, is largely taken for granted. Ebony, rosewood, mahogany, walnut and zebrawood all derive their beauty from their chemistries. In general terms, the basic chemical constituents of wood are cellulose, hemicellulose and lignin. When these constituents are the only chemicals in a wood, the wood is a whitish colour, and such whitish woods are not typically valued as highly as richly coloured woods. The non-white colours in wood are imparted by a host of secondary plant compounds, collectively known as extractives. Extractive chemistry is a rich source of information for applications similar to those in isotopic research, such as provenancing and physiology, and can only be obtained from wood; unlike DNA, no other tissue will suffice to provide specimens. Thus, xylaria are potential sources of numerous chemical compounds that would otherwise require collection from a tree *in situ*. The use of infrared spectroscopy to separate similar woods is based on variation in their extractive chemistries (Brunner et al., 1996; Tsuchikawa et al., 2003a, 2003b; Kite et al., 2010; Braga et al., 2011; Pastore et al., 2011) and such methods must be calibrated by first obtaining reference spectra, some or all of which can be collected from xylarium specimens.

Depending on the nature of the specimens in a xylarium, tree-ring data can also be available. Some xylaria have only one small specimen per accession, but in some cases, a pith-to-bark transect or even an entire stem disk is stored. In these latter cases, tree-ring data are available across the entire age of the tree. With bark present and a known collection date, such tree-ring chronologies can be accurately calibrated. Generally, xylarium specimens do not represent ancient wood, so such chronologies will not date back the thousands of years desirable for some types of tree-ring research, such as studies of the incidence of cyclical disturbances such as fires over long time frames for a region. Instead, they typically provide a range of specimens from a variety of species and sites spanning the past few decades or centuries.

## THE FUTURE OF XYLARIA

### General trends in xylarium longevity

The future of xylaria is an open question. As early as 1973, William L. Stern lamented the ongoing decline of institutional wood collections (Stern, 1973). Historically, most xylaria have been active only so long as they were championed by one or more researchers at an institution. With the loss of a champion, there is generally the loss of xylarium activity and sometimes loss of the xylarium itself. Many older collections have seen closure or consolidation. For example, in the past 55 years, the Forest Products Laboratory (FPL) in Madison, WI, has acquired the Yale University xylarium (the Samuel J. Record collection, last championed by William L. Stern), the Chicago Field Museum xylarium, the Jessup wood collection, and the Houghton, Michigan xylarium (Miller, 1999). It is important to note, however, that in some parts of the world, particularly in Brazil, new xylaria are being formed. It may be that rather than seeing a decline in xylaria, we are instead seeing a shift in the loci of active xylaria.

## Societal benefits of xylaria and conclusions

The value of biocultural collections can be difficult to articulate to the general public, and demonstrating the tangible benefits of the expense and effort spent establishing, curating and growing such collections is an ongoing challenge for most scientists who champion them. Historically, this has been the situation at the FPL wood collection in Madison, but recent societal events have changed the dynamic for the better. With increased interest in combating illegal logging, the FPL xylarium has been approached numerous times by Federal law enforcement and Department of Justice personnel in search of scientific expertise to perform forensic identifications of wood. All such identifications depend on the strength of the reference collection supporting them; collections are central to robust, scientifically sound forensic identification and prosecution (for current perspectives, see Wiedenhoeft & Baas, 2011). By means of such forensic work, it has been possible to increase awareness and acknowledgment of the scientific and social benefits of a xylarium. Demonstrating that a xylarium, with its silent, low-tech blocks of wood, has a tangible value might help to raise societal awareness of all biocultural collections so that they are curated, grown and preserved for the future.

## Websites

*Database of Japanese Woods*. http://f030091.ffpri.affrc.go.jp/index-E1.html

*International Wood Collectors Society*. www.iwcs.org

*InsideWood*. http://insidewood.lib.ncsu.edu/search

Lynch, A. H. & Gasson, P. E. *Index Xylariorum IV*. www.kew.org/collections/wood-index/Index_Xylariorum4.htm

## Literature cited

Abe, H., Watanabe, U., Yoshida, K., Kuroda, K. & Zhang, C. (2011). Changes in organelle and DNA quality, quantity, and distribution in the wood of *Cryptomeria japonica* over long-term storage. *IAWA Journal* 32: 263–272.

Asif, M. J. & Cannon, C. H. (2005). DNA extraction from processed wood: a case study for the identification of an endangered timber species (*Gonystylus bancanus*). *Plant Molecular Biology Reporter* 23: 185–192.

Beeckman, H. (2003). A xylarium for the sustainable management of biodiversity: the Wood Collection of the Royal Museum for Central Africa, Tervuren, Belgium. *Bulletin de l'APAD* 26: 2–11.

Bowett, A. (2012). *Woods in British Furniture-Making 1400–1900: an Illustrated Historical Dictionary*. Oblong Creative, Wetherby & Royal Botanic Gardens, Kew.

Braga, J. W. B., Pastore, T. C. M., Coradin, V. T. R., Camargos, J. A. A. & Silva, A. R. (2011). The use of Near Infrared Spectroscopy to identify solid wood specimens of *Swietenia macrophylla* (CITES Appendix II). *IAWA Journal* 32: 285–296.

Brunner, M., Eugster, R., Trenka, E. & Bergamin-Strotz, L. (1996). FT-NIR spectroscopy and wood identification. *Holzforschung* 50: 130–134.

Cornish, C., Gasson, P. and Nesbitt, M. (In press). The wood collection (xylarium) of the Royal Botanic Gardens, Kew. *IAWA Journal*.

Feuchter-Schawelka, A., Freitag, W. & Grosser, D. (2001). *Alte Holzsammlungen. Die Ebersberger Holzbibliothek: Vorgänger, Vorbilder und Nachfolger*. Der Landkreis Ebersberg. Geschichte und Gegenwart, Band 8. Deutscher Sparkassen Verlag, Stuttgart.

Flynn, J. H. Jr & Holder, C. D. (eds) (2001). *A Guide to Useful Woods of the World*. Second edition. Forest Products Society, Madison.

Hoadley, R. B. (2000). *Understanding Wood: a Craftsman's Guide to Wood Technology*. Taunton Press, Newtown.

Kagawa, A. & Leavitt, S. (2009). Stable carbon isotopes of tree rings as a tool to pinpoint the geographic origin of timber. *Journal of Wood Science* 56: 175–183.

Kite, G. C., Green, P. W. C., Veitch, N. C., Groves, M., Gasson, P. E. & Simmonds, M. S. J. (2010). Dalnigrin, a neoflavonoid marker for the identification of Brazilian rosewood (*Dalbergia nigra*) in CITES enforcement. *Phytochemistry* 71: 1122–1131.

Lamb, H. & Curtis, A. (2005). *A Guide for Developing a Wood Collection*. Forest Products Society, Madison.

Lincoln, W. A. (1986). *World Woods in Colour*. Stobart & Son Ltd, London.

Lowe, A. J. & Cross, H. B. (2011). The application of DNA methods to timber tracking and origin verification. *IAWA Journal* 32: 251–262.

Miller, R. B. (1999). Xylaria at the Forest Products Laboratory: past, present, and future. In: *Wood to Survive*, Annales. Sciences Economiques 25, ed. F. Maes & H. Beeckmann, pp. 243–254. Musee Royal de l'Afrique Centrale, Tervuren.

Ogden, R., McGough, H. N., Cowan, R. S., Chua, L., Groves, M. & McEwing, R. (2008). SNP-based method for the genetic identification of ramin *Gonystylus* spp. timber and products: applied research meeting CITES enforcement needs. *Endangered Species Research* 9: 255–261.

Pastore, T. C. M., Braga, J. W. B., Coradin, V. T. R., Magalhães, W. L. E., Okino, E. Y. A., Camargos, J. A. A., de Muñiz, G. I. B., Bressan, O. A. & Davrieux, F. (2011). Near infrared spectroscopy (NIRS) as a potential tool for monitoring trade of similar woods: discrimination of true mahogany, cedar, andiroba, and curupixá. *Holzforschung* 65: 73–80.

Rachmayanti, Y., Leinemann, L., Gailing, O. & Finkeldey, R. (2009). DNA from processed and unprocessed wood: factors influencing the isolation success. *Forensic Science International: Genetics* 3: 185–192.

Radkau, J. (2012). *Wood: a History*. Polity Press, Cambridge.

Stern, W. L. (1973). The wood collection: what should be its future? *Arnoldia* 33: 67–80.

Tsuchikawa, S., Inoue, K., Noma, J. & Hayashi, K. (2003a). Application of near-infrared spectroscopy to wood discrimination. *Journal of Wood Science* 49: 29–35.

Tsuchikawa, S., Yamato, K. & Inoue, K. (2003b). Discriminant analysis of wood-based materials using near-infrared spectroscopy. *Journal of Wood Science* 49: 275–280.

van Bergen, P. & Poole, I. (2002). Stable carbon isotopes of wood: a clue to paleoclimate? *Palaeogeography, Palaeoclimatology, and Palaeoecology* 182: 31–45.

van der Dussen, L. & Miedema, T. (2008). *Houtcollecties van België en Nederland*. www.nehosoc.nl/documenten/leden/document27.pdf

Ward, J., Harris, J., Cerling, T., Wiedenhoeft, A., Lott, M., Dearing, M-D., Coltrain, J. & Ehleringer, J. (2005). Carbon starvation in glacial trees recovered from the La Brea tar pits, southern California. *Proceedings of the National Academy of Science of the United States of America* 102: 690–694.

Wiedenhoeft, A. C. & Baas, P. (eds) (2011). Wood science for promoting legal timber harvest. *IAWA Journal* 32: 121–297.

# Living plant collections and ethnobotany in botanic gardens

ANDREW WYATT
Missouri Botanical Garden

## PURPOSE AND SCOPE OF LIVING PLANT COLLECTIONS

From their inception, botanic gardens have had ethnobotany as a guiding discipline in the development of living collections. Modern day botanic gardens can trace their lineages back to the medieval physic gardens. Since 1545 when the first botanical garden (Orto Botanico) was founded in Padua, Italy, living collections in botanic gardens have played major roles in the exploration, discovery, introduction and research of many of the plants that we interact with in our everyday lives, including those used for food, building materials, medicines and landscaping.

The difference between a botanic garden and a park lies in its functions. A botanic garden grows plants for education, research, conservation and aesthetic display, whereas a park will focus on display and recreation. There are more than 2,700 botanic gardens in the world, hosting over 150 million visitors annually, and with living collections of 80,000 plant species (Wyse Jackson & Sutherland, 2000). They are therefore a major resource in a world where as many as a third of all plants face extinction (Oldfield, 2010). Many botanic gardens house a wide range of collections and science departments; the focus of this chapter is on living collections. Other collections discussed elsewhere in this book include herbaria (Chapters 3 and 22), DNA banks (Chapter 7), libraries and archives (Chapter 13) and ethnobotanical artefacts (Chapters 4 and 12).

This chapter is aimed both at curators of living collections who are curious about the potential of ethnobotany and at ethnobiologists wishing to develop living collections of plants. It provides guidance on important aspects of living collections management and information on existing botanic garden networks. The role of living plant collections — particularly those with an ethnobotanical focus — is discussed, including the conservation of plants of ethnobotanical relevance and the importance of communication with varied audiences.

## MANAGEMENT OF LIVING PLANT COLLECTIONS

Gardens can be made anywhere but they require year-round care, and careful thought should be given as to how this will be achieved. There are many examples of ethnobotanical gardens abandoned a few years after establishment. Location within an institution that has an existing garden, and garden staff, can help to assure the survival of a garden.

As the role of living collections continually evolves, the development of sound living collection policies, collection databases, procedures for accurate labelling and tracking of collections, and collection mapping are of great importance and are covered in this chapter. For more guidance on botanic garden management, refer to manuals by Hohn (2008) and Leadlay & Greene (1998).

## Policies

Many plants in living collections are of uncertain origin and thus of uncertain relevance to research and conservation (Blackmore et al., 2011; Rae, 2011). There is a strong trend towards developing collection policies to guide collection priorities and the re-evaluation of specimens, sharpening the focus on well-documented material of known origin. For example, the Natural History Museum in Paris has re-evaluated all 6,300 taxa in its living collections, leading to the disposal of specimens from some regions that are well represented at other botanic gardens (Delmas et al., 2011).

Collection policies are critical to maintaining and developing living collections as they help integrate organisational activities (Rae, 1996; Dosmann, 2007). The nature and diversity of collections differs both with geographic location and age of botanic gardens. Botanic gardens are shifting from large representative collections to more regionally focused collections (Parmentier & Pautasso, 2010). The size and diversity of living collections also reflects population size and gross domestic product (GDP) (Golding et al., 2010).

Collection policies establish long- and short-term goals for living collections under a garden's mission, but they should not be seen as fixed documents. They are dynamic, allowing collection directions to be regularly revised so that living plant collections remain relevant to new challenges. To have an impact on plant conservation, living collections policies must not be confined to a single institution's collection, but must take into consideration the collaborative, multi-institutional development of *ex situ* genetic resources. Living collections often develop around research goals; special consideration needs to be given to the fate of collections when that research has finished (Rae, 1993).

## Databases

Botanic garden living collections have always been supported by data. Early in the development of botanic gardens, the primary device for cataloguing living collections was the log book. This process of paper-based record keeping has been replaced by computerised databases. The application of database recording remains a challenge for many botanic gardens because of its resource-intensive nature. Although there are always areas for improvement, for the most part, botanic gardens have developed very strong processes for recording data associated with plants.

It is important to be able to communicate and compare records with other botanical institutions, and advances in digital record keeping have made this easier. Being able to track the genetics of living plants across botanic gardens' collections is of increasing importance in plant conservation efforts. One of the main challenges that exist is working with the large number of database formats which are utilised: 'Information systems have allowed us to analyse data in unprecedented quantity. In order to feed this data requirement and see a global picture, individual institutions, networks and alliances will have to find an easy and acceptable way of sharing our datasets, our plant records will have to cope with this demand' (Wyse Jackson, 2003).

BG-Base is the most widely used stand-alone database for living collections. It is used at 184 sites in 28 countries, including the New York Botanical Garden, Singapore Botanic Gardens, and the Royal Horticultural Society in the United Kingdom. The International Transfer Format for Botanic Garden Plant Records (ITF) has been developed by the Botanic Gardens Conservation International (BGCI) to facilitate the exchange of data among gardens.

BGCI's PlantSearch database was designed to allow botanic gardens to submit lists of rare plants in their collections in order to compare it to the lists of collections at other botanic gardens, enabling the assessment of rare plant holdings across many institutions. This is a great step forward,

currently holding 575,000 records, but it still relies on manually uploading a list that could become out of date as the actual collections holdings of individual institutions change and institutional records are updated.

The Plant Collections project tried to address this issue of updating and comparing data. This web-based system was designed to allow querying of information from multiple institutions with a variety of incompatible database formats; it represented a significant step forward for coordinating germplasm representation within botanic gardens. Nevertheless, the system relies on third-party updating of information, which has proven difficult, and the project is no longer active. The search for an easy way to compare database records to aid in the conservation of genetic resources continues.

## Labelling and tracking of collections

'Labelling plants with scientific accession tags in a botanic garden is one of the most critical steps in keeping track, and maintaining the genetic purity, of a botanic collection. If a labelling system breaks down it can result in a drastically de-valued collection, because the link to the plant's origin is lost' (Chapin & Smith, 1998). Unlike the controlled environment in which other types of biocultural collections are stored, outdoor collections represent several distinct challenges. Extremes of weather conditions destroy labels made of certain materials; cold weather can make plastic brittle and sun can fade certain inks making labels unreadable. In recent years, several gardens have gone through natural disasters; if labels are destroyed by weather conditions or natural disaster, it can be almost impossible to link the data back to the plant. Labels often suffer damage from garden maintenance operations and equipment. Other problems can be attributed to visitors removing labels and taking them home.

The results of a survey sent to 120 gardens in 18 countries (Maurer, 1999) illustrate the complexity of and cost associated with both material choice and the labelling process. Labelling of collections is a very dynamic process and relies on individual horticulturists' making sure that labels are applied to the plant correctly. This may sound simple but plants reproduce, die and are removed to make way for new plants. The horticultural practices around labelling require continual effort to ensure that plants remain labelled correctly.

### Accession labels

The speed of production and placement of durable accession labels – whether an accession is in the permanent collection or under propagation in a nursery — is critical. Embossed labels made of either steel or aluminium are best as permanent accession labels because the letters and accession numbers are impressed into the metal, hence the labels do not fade and are almost indestructible. They are quick to produce, but hard for visitors to read (see recommendations for interpretive labels below).

Many gardens use commercial nursery tags temporarily to label accessions under propagation or to tag new accessions until they can be labelled with permanent accession labels. Even the best nursery tags degrade very quickly outside and ink from permanent markers fades over time. This can result in mislabelling or even the loss of the information connected to a plant. Thermal nursery label printers have significant advantages: labels can be printed extremely fast, and the printing and label materials are extremely durable.

Particularly when dealing with vegetative propagation, it is often necessary to put new collection material into production as soon as possible before assigning an accession number or permanent label. In this case, the collection number assigned to the collection in the field can be temporarily used on durable nursery labels (e.g. thermal nursery labels). This ensures the connection between the unnumbered accession and the original field data until an accession number can be generated.

*Interpretive labels*

Plastic or aluminium engraved labels are most often used as collections interpretative labels. They can be produced in house with a rotary engraver or a laser engraver, or custom ordered from a supplier. In-house engraving has greater flexibility and allows for a fast turnaround, but for many smaller gardens, the cost of such systems is prohibitive. A protocol for the placement of an interpretive label helps visitors find the label and the associated plant; for instance, the standard policy at the Santa Barbara Botanic Garden is to place the label 30 cm (1 ft) away from the plant on the right-hand side when facing the plant from the path.

Some gardens have both accession and interpretative information on the same labels, but gardens that utilise a single label for both accession and interpretive information have reported significantly more problems with loss of connection between plant and record (Maurer, 1999).

## Data gathering and mapping

Mapping of specimen location within gardens is fast becoming an essential tool for the curation of living collections, generating information that can be analysed using Geographic Information Systems (GIS). Mapping has evolved into a comprehensive tool for information management and decision making (Burke & Morgan, 2009), as well as playing a significant role in information gathering and analysis for field collecting (Neufeld et al., 2003). Digital maps also increase interpretative possibilities, providing potential for the use of hand-held devices and interactive displays that enhance visitor experience. Geographic Positioning System (GPS) data for wild-source, field-collected specimens can be used as a tool for setting future collection site priorities by analysing climate, soil type and weather conditions for target areas.

Digital maps can help guide and develop living collections and provide information for collections management. They can be used in crucial analyses and predictions, including analyse of soil type, area calculations for designing of plant displays, cost predictions, predictions of a wide range of resource needs (including quantity analyses for fertiliser or soil-amendment needs), and analyses of disease patterns in collections. Perhaps the most important use is in developing management plans for living collections. Mapping systems can record current condition and can be used to predict changes to collections over time, choosing among predictions of future outcomes of collections development. Mapping systems are particularly useful when linked to a plant records system; this enables visual representation of collections.

## NETWORKS FOR LIVING COLLECTIONS

The foundation of Botanic Gardens Conservation International (BGCI) in 1987 and the activity of regional networks have greatly increased the efficacy of botanic gardens. There is, however, still scope for more collaboration, both between gardens and with other types of institution such as gene banks and other repositories of germplasm (see Chapter 8 and Merritt & Dixon, 2011). Collaborations with other botanic gardens are particularly important given that just 20% of botanic gardens are located in the tropics, the region in which biodiversity is most under threat (Chen et al., 2009; Golding et al., 2010).

The resources currently available to help guide and support the curation of living collections in North America include the American Association of Public Gardens (APGA) and the North American Plants Collections Consortium (NAPCC), which aid in capacity building for and networking among curators. Similar associations exist in many countries; regional networks include the European Botanic Gardens Consortium and Botanic Gardens Australia and New Zealand.

For the most comprehensive information surrounding the curation of living collections, BGCI, PlantNetwork (The Plant Collections Network of Britain and Ireland), and the International Plant Exchange Network (IPEN) represent the best sources of information.

## Botanic Gardens Conservation International

Botanic Gardens Conservation International (BGCI) represents over 600 member institutions, mostly botanic gardens, in 118 countries. It supports and empowers members and the wider conservation community so that their knowledge and expertise can be applied to reversing the threat of extinction facing one third of all plants. BGCI maintains a website and publishes significant amounts of information regarding the curation of living collections; it also acts as a networking hub for curatorial staff.

## PlantNetwork

PlantNetwork includes over 150 botanic gardens in the United Kingdom and Ireland. Its aims are: 'Promoting botanical collections in Britain and Ireland as a national resource for research, conservation and education' and 'Facilitating networking and training among holders of plant collections through a programme of conferences and workshops and a regular newsletter'. PlantNetwork provides a forum for curators to network and learn from each other's experience.

## International Plant Exchange Network (IPEN)

The International Plant Exchange Network (IPEN) was developed as a model for community building, operating under the guidelines of the Access to Benefits Sharing (ABS) requirements of the Convention on Biological Diversity (CBD). All exchange that takes place under the scheme is regulated by Material Transfer Agreements that specify non-commercial use. One of the difficulties with botanic gardens sharing plant material is that each institution assigns plant material a new accession record; it can be difficult and time consuming to identify institutions that are holding a given plant. Under the IPEN, plant material is assigned a tracking number that easily identifies the original source of plant material, making it easier for botanic gardens to compare material in their collections.

## THE ROLE OF LIVING PLANT COLLECTIONS IN A CHANGING ENVIRONMENT

A living collection policy should clearly outline the goal(s) of a living collection within the community – both local and global. Both short- and long-term goals are, however, subject to change, and policies can be revised so that living collections can adapt to new goals and changing roles. Broadly, the ability to propagate and cultivate virtually any plant is a skill of obvious relevance to conservation and restoration projects (Donaldson, 2009; Hardwick et al., 2011) as well as to education and interpretation.

## Conservation

The first Global Strategy for Plant Conservation (GSPC), 2002–2010, is widely recognised as having led to many successes, not because it brought additional funding but because it enabled biodiversity organisations to redeploy existing resources to meet clear targets (Oldfield, 2010; Blackmore et al., 2011; Williams et al., 2012). A second GSPC (2011–2020) is now in force, and like the first, includes several targets that are of direct relevance to living collections and ethnobotany:

Target 9. 70% of the genetic diversity of crops including their wild relatives and other socio-economically valuable plant species conserved, while respecting, preserving and maintaining associated indigenous and local knowledge.

Target 12. All wild-harvested plant-based products sourced sustainably.

Target 13. Indigenous and local knowledge innovations and practices associated with plant resources maintained or increased, as appropriate, to support customary use, sustainable livelihoods, local food security and health care.

Much of the conservation effort of botanic gardens is focused on a small number of highly threatened plant species that are on the verge of extinction and with limited evidence of use by humans. However, living collections can take an active role in the conservation of useful plants. The collection of breadfruit at Kahanu Garden, Hawai'i is the most comprehensive in existence, and forms the basis of a large programme of restoration of this cultivated plant into old habitats and introduction to new. In New Zealand, a collection of 50 varieties of the weaving plant, harakeke (*Phormium tenax*), formed by Rene Orchiston, is grown as a living collection by Manaaki Whenua/Landcare Research. Material is distributed to schools, weavers and community groups for planting, and also forms the basis of an active research programme into the genetics and fibre properties of harakeke (Scheele, 2005; Scheele & Smissen, 2010).

The move to more structured and purposeful research using living collections is an essential response to frequent criticisms that that they are insufficiently used or even, because of their narrow scope and uncertain origin, unsuitable for research and conservation (Maunder at al., 2001a, 2001b, 2004; Hamilton, 2004; Donaldson, 2009: 610).

Writing in 2004, Alan Hamilton took a cautious view of the role of living medicinal plant collections in botanic gardens: 'these living collections consist of only one or a few specimens of each species and, while sometimes of value educationally, they are of limited use from the point of view of genetic conservation.' However, Waylen (2006) gives several other examples of the conservation and restoration of useful plants, and there is great potential for botanic gardens to be more active in this role. As with germplasm collections, ethnobotanists have an important role in enabling communities to determine which species should be conservation and research priorities for botanic gardens.

## Education

Botanic gardens have a reputation as authoritative and independent institutions, and their living collections form an engaging place in which to tackle complex subjects such as biodiversity loss, climate change and the role of indigenous peoples (Havens et al., 2006). As the teaching of plant sciences shrinks in universities, the role of botanic gardens in formal training also becomes more important. As botanic gardens evolve in response to these changes, opportunities are emerging for greater engagement with modern ethnobotany. The skills that ethnobotanists bring are highly relevant to modern botanic gardens, and now is the time to foster those links (Chapter 24).

General advice on botanic garden education is available on the websites of the BGCI, and the (UK-based but of wide relevance) Botanic Gardens Education Network. Jones & Hoversten (2004), in their useful guide to the design of ethnobotanical gardens, emphasise the importance of telling compelling stories, whether through written or spoken interpretation.

**Figure 1.** Biocultural collections from Madagascar formed part of the Missouri Botanical Garden Orchid Show in 2013.
© MISSOURI BOTANICAL GARDEN.

## Interpretation

Plants do not look their best in museum displays and so are often under-represented in the galleries of natural history museums. Botanic gardens therefore play a particularly important role in communicating plants to a wide range of audiences, ranging from visiting families to indigenous peoples. In the same way that ethnobotanists work at different scales, from worldwide surveys (e.g. 'Medicinal plants of the world') to nuanced ethnographic studies undertaken within a single community (e.g. Innerhofer & Bernhardt, 2011), botanic gardens likewise present their living collections at different levels of detail and specificity. The most important element in designing an ethnobotanical display is to first decide its purpose, as this will to a large extent define its content.

Care is needed in researching interpretation for ethnobotanical displays. Two common problems are the use of inaccurate data from unverified internet sources, and bland statements of plant use that do not link uses to their cultural context. Plant uses or meanings should be assigned to the time and community to which they belong, to avoid creating a 'laundry list' of unconnected uses. Botanical names should be checked against standard floras or checklists to ensure they are current and correctly spelt. Interpretation of specialist topics should be developed in collaboration with experts on that subject, who may well be outside the botanic garden. These points might seem obvious, but failure to follow these practices has led to embarrassing errors at major botanic gardens.

## Advocacy and environment

One of the major challenges to improving community action on conservation is the disconnect that exists between our everyday lives and the natural world. The best method for improving awareness of the need for conservation is to create appreciation of plants in the lives of individuals. Ethnobotany can help the public appreciate the importance of plants to their lives. The Eden Project in Cornwall, UK has displays that both connect the visitor to the use of the plants and also illustrate how the production and transport of plant products affect people's lives. This is achieved by integrating into displays the typical living conditions of families who are involved in producing crops.

Displays can help visitors make positive environmental choices in their daily lives — a refined interpretation of biocultural interactions. Types of displays could include micro-habitat conservation displays, displays of plant groups that could be adversely affected by climate change, demonstrations about how to select plants for landscaping and habitat restoration, illustrations of storm run-off mitigation or pollution control, or suggestions on the use of native plants for sustainable gardening. Living collections can also be used to run climate change experiments (Primack & Miller-Rushing, 2009) or experiments on the effects of pollution on plants. Willison (2006) offers specific guidance on education for sustainable development in botanic gardens.

### Thematic gardens

Displays can also set plants in a global context, challenging visitors to think about the place of plants in different cultures. For example, the Garden of World Medicine at London's Chelsea Physic Garden features about 150 medicinal plants arranged by eight world traditions: Ayurvedic, Native American, Maori, Australian Aboriginal, Chinese, South African, Mediterranean and northern European. A separate Pharmaceutical Garden covers 50 plants that are the source of therapeutic compounds of proven value in current western medicine, arranged by the type of illness: oncology, cardiology, dermatology and so on. Such displays can also be arranged by part of the body. Living collections can also be used to explore plant chemistry (much of it medicinal), as in the innovative collaboration

## LIVING BIOCULTURAL COLLECTIONS

Living biocultural collections can demonstrate diverse uses.

**Food** LEFT In cooking, lime (*Citrus aurantiifolia*) is valued for the acidity of its juice, the floral aroma of its zest and its pickling properties in making ceviche. It is a very common ingredient in Mexican, Vietnamese and Thai dishes. High in vitamin C, it prevents scurvy, giving British sailors the nickname 'Limeys'. It is also used in drinks, perfumes, aromatherapy and medicine.

**Fibre** RIGHT The kapok tree (*Ceiba pentandra*) produces pods that contain seeds surrounded by a fluffy, yellowish fibre. The fibre is light, buoyant, resistant to water and fire and is used to stuff mattresses, pillows, upholstery, life jackets and toys such as teddy bears. The Maya native people consider kapok to be a sacred tree.

**Medicine and pesticide** LEFT The neem tree (*Azadirachta indica*) has been used in south Asia for over two millennia for its medicinal properties. Neem products are believed to be anthelmintic, antifungal, antidiabetic, antibacterial, antiviral, contraceptive and sedative. It is a major component in Ayurvedic medicine and can also be used as a natural alternative to synthetic pesticides.

**Spice** ABOVE RIGHT The nutmeg tree (*Myristica fragrans*) is native to the Spice Islands (the Moluccas) of Indonesia. It is important for two spices derived from the fruit: nutmeg and mace. Nutmeg is the seed of the tree whereas mace is the dried, reddish covering or aril of the seed.

**Anaesthesia** RIGHT Curare vine (*Strychnos toxifera*) provides an arrow poison used by indigenous tribes in South America. It has been used in western medicine as a muscle relaxant in anaesthesia.

**Sacred plant** RIGHT The Indian banyan (*Ficus benghalensis*) is a large tree of the Indian subcontinent, which is considered sacred in India. The tree itself is often worshipped and temples may be sheltered under its extensive canopy. This specimen is in the Climatron at the Missouri Botanical Garden.

between the Cambridge University Botanic Garden and the Cambridge Crystallographic Data Centre (Battle et al., 2012).

Plant-use displays can also be historical, as in the Nosegay Garden at the Royal Botanic Gardens, Kew. Opened in 1969, the Garden is situated next to the 17th century Kew Palace, and consists of medicinal plants that are native to Britain or introduced before 1700. In addition to standard botanical data, each plant label bears the 17th century common name and a quotation from a herbal (a text describing medicinal plants and their uses).

### Indigenous gardens

There is a long history of useful plant displays in botanic gardens, but a more recent innovation is the ethnobotanical garden linked to a specific culture or community. In part, this is related to the rising interest within botanic gardens in showcasing and conserving native plants and ecosystems. For example, the taqwsheblu Vi Hilbert Ethnobotanical Garden at Seattle University draws on the linguistic and botanical practices of First Peoples in the Puget Sound Region. The garden is roughly divided into four biomes, or representative ecological areas of the Pacific Northwest: alpine, lowland forest, wetland and prairie. All plants are labelled in an indigenous language, Lushootseed, as well as in English and Latin. The emphasis in interpretation is as much on the sustainable relationships that First Peoples developed with plants as it is on their uses. The Garden was created as a shared project between university grounds staff, who sought a more sustainable use for a turfed area of the campus, an anthropology faculty member, and indigenous Lushootseed scholars and teachers. It is used for teaching university students and both native and non-native members of the local community.

**Figure 2.** Shell midden interpretive area at the taqwsheblu Vi Hilbert Ethnobotanical Garden, Seattle University. Vine maple and sword fern visible behind. © ROBERT EFIRD.

**Figure 3.** Collection of breadfruit trees (*Artocarpus altilis*) at Kahanu Garden, Hawai'i. © JIM WISEMAN.

Many other ethnobotanical gardens have been created in partnership with indigenous peoples, either within existing gardens, or as in the case of medicinal plant gardens in Benin, in villages (Akpona et al., 2009). They all share an emphasis on communicating the broader context of indigenous relationships with the natural world, as well as the uses of individual species. This is referred to by Jones & Hoversten (2004: 161) as the 'lifeway approach', which provokes thought and dialogue, presenting alternative theories and differing points of view. Such gardens act both to interpret indigenous culture to non-native visitors and to foster the transmission of knowledge within indigenous communities. At the Kahanu Garden, part of the National Tropical Botanical Garden in Hawai'i, the living collections focus on plants of the Pacific Islands, particularly those of ethnobotanical value to Hawaiians and other cultures of Polynesia, Micronesia and Melanesia. The Garden maintains a specialist collection of 120 varieties of 'Ulu (*Artocarpus altilis*) or breadfruit, and promotes its cultivation and use both in Hawai'i and throughout the tropics. At a time when changes in diet are leading to diabetes and other health problems among indigenous peoples, ethnobotanical gardens have an important role in promoting traditional, healthy foodstuffs.

All of these gardens share an ambition to communicate the broader context of people–environment relations among indigenous peoples. This typically includes reciprocity in the harvesting of wild plants, and concepts of the relatedness of humans to animals, plants and landscape (Pierotti & Wildcat, 2000; Chapters 17 and 18). Careful thought as to means of interpretation, and collaboration with the relevant indigenous people, will be required to convey these complex concepts (see also Box 'Ethical standards in ethnobiology' in Chapter 1).

## CHALLENGES

In responding to the changing role of living collections addressed in this chapter, curators of living plant collections should be aware of some common challenges.

### Staff training

Ensuring an adequately trained and experienced staff is an ongoing challenge. Horticulturists who work in botanic gardens are required to be display-focused and have knowledge of living collections. Maintaining this skill set can be difficult for gardens.

### *Ex situ* conservation

Living collections are dynamic. They are the product of a continual process (Walker, 2009). They also require sustained resources. The reduction of resources for living collections can result in the significant loss of value for *ex situ* conservation; years of careful work can disappear in a season.

### Threats to natural resources

The availability of natural resources will present a potential challenge for many living collections in the future. It is becoming evident that securing adequate water supply and protection from drought conditions will become more difficult. The spread of pests and diseases caused by globalisation and climate change can have devastating effects on *ex situ* collections. Strategies must be in place for reducing losses to living collections. This also represents significant opportunities for gardens to play an educational role and to support research on these topics.

### Communicating value and gaining support

Gardens can be interpreted in many different ways. Most visitors recognise the beauty of a garden, but it is incumbent upon a garden to help visitors recognise the value of the living collections. Curators must be aware of this and balance aesthetics with the accessibility of scientific collections. Changes in garden design and function must be communicated clearly in order to create understanding regarding the need to modify collections.

## Websites

*American Public Gardens Association.* www.publicgardens.org

*BG-Base.* www.bg-base.com

Botanic Gardens Conservation International. *PlantSearch.* www.bgci.org/plant_search.php

*Botanic Gardens Australia and New Zealand.* www.bganz.org.au

*Botanic Gardens Conservation International (BGCI).* www.bgci.org

*Botanic Gardens Education Network.* www.bgen.org.uk

*European Botanic Gardens Consortium.* www.botanicgardens.eu

*International Plant Exchange Network (IPEN).* www.bgci.org/resources/ipen

*International Transfer Format for Botanic Garden Plant Records (ITF).* www.tdwg.org/standards/102

*North American Plants Collections Consortium (NAPCC).* www.ars-grin.gov/npgs/napcc.html

*PlantNetwork.* www.plantnetwork.org

## Literature cited

Akpona, H. A., Sogbohossou, E., Sinsin, B., Houngnihin, R. A., Akpona, J. D. T. & Akouehou, G. (2009). Botanical gardens as a tool for preserving plant diversity, threatened relic forest and indigenous knowledge on traditional medicine in Benin. In: *Traditional Forest-related Knowledge and Sustainable Forest Management in Africa.* Papers from the conference held in Accra, Ghana, 15–17 October 2008. IUFRO World Series 2009, Vol. 23, eds J. A. Parotta, A. Oteng-Yeboah & J. Cobbinah, pp. 5–13. IUFRO (International Union of Forestry Research Organizations) Secretariat, Vienna. www.iufro.org/download/file/6991/153/ws23_pdf/

Battle, G. M., Kyd, G. O., Groom, C. R., Allen, F. H., Day, J. & Upson, T. (2012). Up the garden path: a chemical trail through the Cambridge University Botanic Garden. *Journal of Chemical Education* 89: 1390–1394.

Blackmore, S., Gibby, M. & Rae, D. (2011). Strengthening the scientific contribution of botanic gardens to the second phase of the Global Strategy for Plant Conservation. *Botanical Journal of the Linnean Society* 166: 267–281.

Burke, M. T. & Morgan, B. (2009). Digital mapping beyond living collections curation. *Public Garden* 3: 9–10.

Chapin, M. H. & Smith, S. (1998). Tagging along in tropical botanic gardens — the experience of the National Tropical Botanic Garden, Hawai'i. *Botanic Garden Conservation News* 3 (1). www.bgci.org/worldwide/article/207/

Chen, J., Cannon, C. H. & Hu, H. (2009). Tropical botanical gardens: at the *in situ* ecosystem management frontier. *Trends in Plant Science* 14: 584–589.

Delmas, M., Larpin, D. & Haevermans, T. (2011). Rethinking the links between systematic studies and *ex situ* living collections as a contribution to the Global Strategy for Plant Conservation. *Biodiversity and Conservation* 20: 287–294.

Donaldson, J. S. (2009). Botanic gardens science for conservation and global change. *Trends in Plant Science* 14: 608–613.

Dosmann, M. S. (2007). Curatorial notes: an updated living collections policy at the Arnold Arboretum. *Arnoldia* 66: 10–21.

Golding, J., Güsewell, S., Kreft, H., Kuzevanov, V., Lehvävirta, S., Parmentier, I. & Pautasso, M. (2010). Species-richness patterns of the living collections of the world's botanic gardens: a matter of socio-economics? *Annals of Botany* 105: 689–696.

Hamilton, A. C. (2004). Medicinal plants, conservation and livelihoods. *Biodiversity and Conservation* 13: 1477–1517.

Hardwick, K. A., Fiedler, P., Lee, L. C., Pavlik, B., Hobbs, R. J., Aronson, J., Bidartondo, M., Black, E., Coates, D., Daws, M. I., Dixon, K., Elliott, S., Ewing, K., Gann, G., Gibbons, D., Gratzfeld, J., Hamilton, M., Hardman, D., Harris, J., Holmes, P. M., Jones, M., Mabberley, D., Mackenzie, A., Magdalena, C., Marrs, R., Milliken, W., Mills, A., Lughadha, E. N., Ramsay, M., Smith, P., Taylor, N., Trivedi, C., Way, M., Whaley, O. & Hopper, S. D. (2011). The role of botanic gardens in the science and practice of ecological restoration. *Conservation Biology* 25: 265–275.

Havens, H., Vitt, P., Maunder, M., Guerrant, E. & Dixson, K. (2006). *Ex situ* plant conservation and beyond. *BioScience* 56: 525–531.

Hohn, T. C. (2008). *Curatorial Practices for Botanical Gardens.* Altamira Press, Lanham.

Innerhofer, S. & Bernhardt, K. G. (2011). Ethnobotanic garden design in the Ecuadorian Amazon. *Biodiversity and Conservation* 20: 429–439.

Jones, S. B. & Hoversten, M. E. (2004). Attributes of a successful ethnobotanical garden. *Landscape Journal* 23: 153–169.

Leadlay, E. & Greene, J. (eds) (1998). *The Darwin Technical Manual for Botanic Gardens.* Botanic Gardens Conservation International, Kew.

Maunder, M., Lyte, B., Dransfield, J. & Baker, W. (2001a). The conservation value of botanic garden palm collections. *Biological Conservation* 98: 259–271.

Maunder, M., Higgens, S. & Culham, A. (2001b). The effectiveness of botanic garden collections in supporting plant conservation: a European case study. *Biodiversity and Conservation* 10: 383–401.

Maunder, M., Guerrant, E., Havens, K. & Dixson, K. (2004). Realizing the full potential of *ex situ* contributions to global plant conservation. In: *Ex situ Plant Conservation Supporting Species Survival in the Wild*, ed. E. O. Guerrant, K. Havens & M. Maunder, pp. 389–418. Island Press, Washington DC.

Maurer, R. (1999). Labelling our collections — results of a survey. *Botanic Garden Conservation News* 3 (3). www.bgci.org/worldwide/article/124/

Merritt, D. J. & Dixon, K. W. (2011). Restoration seed banks-a matter of scale. *Science* 332: 424–425.

Neufeld, D., Guuralnick, R., Glaubitz, R. & Allen, R. (2003). Museum collections data and online mapping applications: a new resource for land managers. *Mountain Research and Development* 23: 334–337.

Oldfield, S. (2010) Plant conservation: facing tough choices. *BioScience* 60: 778–779.

Parmentier, I. & Pautasso, M. (2010). Species-richness of the living collections of the world's botanical gardens — patterns within continents. *Kew Bulletin* 65: 519–524.

Pierotti, R. & Wildcat, D. (2000). Traditional ecological knowledge: the third alternative (commentary). *Ecological Applications* 10: 1333–1340.

Primack, B. & Miller-Rushing, A. J. (2009). The role of botanic gardens in climate change research. *New Phytologist* 182: 303–313.

Rae, D. (1993). De-accessions policy for plant collections: responsibility versus practicality. *Botanic Garden Conservation News* 2 (2). www.bgci.org/worldwide/article/0058/

Rae, D. (1996). Plant collections policies — are guidelines needed? *Botanic Garden Conservation News* 2 (6). www.bgci.org/worldwide/article/158/

Rae, D. (2011). Fit for purpose: the importance of quality standards in the cultivation and use of live plant collections for conservation. *Biodiversity and Conservation* 20: 241–258.

Scheele, S. (2005). *Harakeke: the Rene Orchiston Collection*, 3rd ed. Manaaki Whenua Press, Lincoln.

Scheele, S. & Smissen, R. (2010). Insights into the origin and identity of national New Zealand flax collection plants from Simple Sequence Repeat (SSR) genotyping. *New Zealand Journal of Botany* 48: 41–54.

Walker, T. (2009). *Creating an Accessions Policy*. http://plantnetwork.org/proceedings/wales-2009/creating-an-accession-policy/

Waylen, K. (2006). Botanic gardens: using biodiversity to improve human wellbeing. *Medicinal Plant Conservation* 12: 4–8.

Williams, S. J., Jones, J. P. G., Clubbe, C., Sharrock, S. & Gibbons, J. M. (2012). Why are some biodiversity policies implemented and others ignored? Lessons from the uptake of the Global Strategy for Plant Conservation by botanic gardens. *Biodiversity and Conservation* 21: 175–187.

Willison, J. (2006). *Education for Sustainable Development: Guidelines for Action in Botanic Gardens*. Botanic Gardens Conservation International, Kew. www.bgci.org/files/Worldwide/Education/PDFS/education_for_sustainable_development_guidelines_final.pdf

Wyse Jackson, D. (2003). Record keeping in 2003. *Botanic Garden Conservation News* 3. www.bgci.org/worldwide/article/159/

Wyse Jackson, P. & Sutherland, L. (2000). *International Agenda for Botanic Gardens in Conservation*. Botanic Gardens Conservation International, Kew.

# SECTION III

# Practical curation of biocultural collections — reference materials and metadata

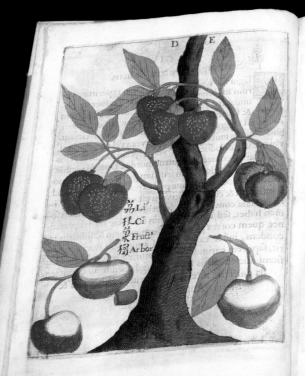

# Database standards for biocultural collections

ALYSE KUHLMAN & JAN SALICK

Missouri Botanical Garden

## INTRODUCTION

Ethnobiological research occurs in various disciplines including botany, anthropology, medicine, geography, history and art. Owing to this broad interdisciplinary base, creative research collaborations can be formed when the appropriate interconnections are made (see Chapter 21). Collaborative interconnections have equal potential for curation and use of biocultural collections. One way to foster these collaborations is through the use of compatible and searchable databases. By building compatible databases that provide a means to search for both items within biocultural collections, and their curators, we aim to connect researchers and to make collection holdings more accessible. Initial steps toward this latter goal are to encourage institutions holding biocultural collections around the world to properly curate their specimens, to add specimens to compatible databases, and to make their databases available online. In this chapter, we address databasing and online access, and we look ahead to the possibilities of interconnecting disparate biocultural collections databases through a single portal with a shared search engine, which we will refer to as the Biocultural Collections Online Search Portal (BOP).

## ROLE OF DATABASES

In the process of conducting ethnobiological research, institutions accrue relevant biological and cultural material, thus building biocultural collections. For any collection, its databasing is crucial to proper curation. There are some institutions that already have online biocultural databases. Institutions such as the American Museum of Natural History, the Smithsonian Institute, the Field Museum, the University of Michigan (Native American Ethnobotany), Missouri Botanical Garden and the Royal Botanic Gardens, Kew recognise the power of the internet to disseminate data and biological information to those who might not otherwise have access, and to make it conveniently available to all.

Our goals for BOP parallel progress being made in other fields of research. More and more disciplines call for open-access online collections. For example, archaeobotanical research will greatly benefit from the launch of Paleobot.org, an open-access collaborative website that links individual researchers to data, images and open discussion centering on unidentified palaeoethnobotanical remains (Warinner et al., 2011). Already there are searchable online databases for compiled biological information that have been created and are used by many with great success. The Global Biodiversity Information Facility (GBIF) is a great example of a powerful multi-institutional online resource providing data for all levels of research, from grade-school projects to undergraduate research projects to professional multi-million-dollar research projects. To make any online search portal effective, the source data (each institution's online database in the case of the BOP) needs to be organised, accurate and searchable (Bartolo, 2006). Data publishers contributing to GBIF use standards that are built upon the existing Biodiversity Information Standards (TDWG; formerly The International Working Group on Taxonomic Databases), and GBIF provides helpful web application tools to transfer data into the

correct format. It is important that we encourage all biocultural collections to build databases that are compatible with (although potentially different from) one another, so that eventually we can create a comprehensive searchable biocultural collections database in order to advance the field of ethnobiology.

## IMPORTANCE OF STANDARDS

The intent of this chapter is not to dictate the software programmes, methods or terms that each institution must use when establishing a collections database. Rather, we look to give direction and guidance on how to establish a database, provide terms and keywords that all biocultural collections databases should consider, and hope to inform successful database design. For example, databases of predominately cultural collections (see Chapters 4 and 12) will differ from databases of predominately biological collections. The term 'standards' in this chapter will refer to the idea of database compatibility, controlled vocabularies, and the use of the same resources, as these are means to making the BOP a reality. We outline the important core data elements, or pieces of information, that biocultural collection databases might include and that could be integrated into the BOP. By standardising (or at least translating) our terms, we hope to facilitate the transition toward interlinking online databases of biocultural collections for institutions of all sizes, for many types of collections and for the greatest diversity of uses.

## DATABASE DESIGN

It is our belief that a successful database begins with thoughtful design and attention to detail, which are inextricable from proper curation guidelines and standards. We favour a more elaborate database design with many fields (some or many of which will not be filled in every record) over a less extensive or static database design with fewer fields (and more complete records). Although it is less aesthetically pleasing to have records with empty fields, the ability to store more data and to atomise complex data is flexible and of greater benefit in the long run. Nevertheless, in a database with many fields, it is wise to designate some fields as core fields that must be filled in for each accession. Even a small collection and/ or a collection still in its infancy will benefit from comprehensive data recording from the beginning.

Although a database does not need to be created from expensive software, creating a relational database is highly recommended. Within a relational database, interrelated pieces of information are linked yet managed separately. A relational database stores related data in separate files (tables), and can easily combine these data elements through queries and reports based on Structured Query Language (SQL) programming. Microsoft Access is an example of a common program that can be used to build a relational database. The ability of a relational database to combine and separate data elements is a logical way to store complex data systems. A relational database is best because of the multifaceted nature of the cultural and biological information contained within a biocultural collection. If this option is not available, a detailed spreadsheet can be a good start to proper curation if it is well designed.

## CONTROLLED VOCABULARY

Biocultural collections contain data that are significant to a wide range of disciplines and will be accessed by a number of different users with varying needs. By developing user-friendly and comprehensive database standards, we aim to accommodate diverse types and levels of research inquiry. We recognise that each institution and collection is different, but we encourage biocultural databases to be designed and implemented with an interdisciplinary approach. Biological collections are usually accessed through binomial nomenclature (Berendsohn *et al.*, 1999). Cultural collections

might be accessed through geography, language, tribe or subcultural group. Biocultural collections will be accessed through all of these terms in addition to vernacular names, use categories and plant or animal parts. Accommodating this entire schema will result in the most user-friendly and productive searchable online biocultural database.

As we will be drawing information from a large number of different resources, it is crucial that we implement controlled vocabularies (e.g. drop-down menus) when applicable. For example, a drop-down list of country names will be beneficial in data entry. Controlled vocabularies ensure consistent terminologies, which help to avoid misspellings and confusing duplicate records. Research indicates that there is an average error rate of 1–3 % in human-entered data, caused by misspellings, typographical errors and misuse of standardised and non-standardised abbreviations (Wei, 2006). Misspellings of searchable terms that are stored in a database can lead to misinformation and a corrupted database with little application for the user. Duplicate records, identical information entered numerous times as the result of upload error or data entry error, can cause confusing search results and inaccurate data collection (Philippi, 2006). We can work to eliminate these problems from the beginning by adopting the terminologies from international data standards lists such as those for herbaria: the Herbarium Information Standards and Protocols for Interchange of Data (HISPID), the International Organization for Standardization (ISO), The Plant List and International Plant Name Index (IPNI). A full list of useful checklists, standards, and indices is given at the end of this chapter.

## CORE DATABASE ELEMENTS

Obviously, the internet is a powerful tool to connect researchers and collections. As research institutions build their compatible databases and bring them online, a single website can be created to link all partner institutions' databases. In the future, this website can be used to host the BOP, or a search function that enables users to access information in each database through one centralised web interface (Stein, 2003). The BOP would not be the storage facility for the data from each institution, but rather a collector and sorter of key metadata from partnering institutions, operating in much the same way as GBIF. The BOP would therefore rely on individual institutions to provide clean data that is properly entered.

The disparate nature of our collections means that some databases will contain information that is not pertinent or relevant to other collections. Standardising our databases does not mean that we all need to create the exact same database. Individual database design can be unique to each institution; but by developing new databases, or reworking old databases, with similar and translatable fields, we will be able to include more data into our compilation efforts and thus better serve future ethnobiological research. All databases that interface with the BOP should include the following elements, which we consider to be core data, meaning these data will be present for every accession (see below for explanations):

- accession number
- type of accession
- title or name of the accession

The type of accession and its title or name are both fundamental ways to address an object. All of the data recorded for these three core elements are determined and assigned by the cataloguer, and therefore all accessions should have these data elements present. Additionally, the partner institution databases might include the following data elements (although these will not be populated for every specimen or every institution):

- scientific name and author
- vernacular name
- collector
- collection number
- date
- donor
- donor number
- local expert
- language
- ethnic group or cultural affiliation
- geographical unit

- locality
- geographic coordinates of origin
- use
- production or processing of artefact
- creator, maker or artisan
- cross-referenced collections
- image
- literature or archives
- collection permits and/or agreements
- notes

Many types of data fields are employed in a single database. Of course, all fields could be open text fields in which any value can be entered and stored. Preferably, to reduce error and irregularity, fields can be controlled by drop-down lists, relational fields (which would link to a separate table within a database causing any new data values to be entered into that table first), or defined data fields (e.g. integer fields with only room for 10 digits). Some fields require controlled vocabulary or defined lists in order to guide proper data management and ease data entry. For instance, a drop-down list of all the countries in the world ensures correct spelling. However, a drop-down list of vernacular names does not make any sense. The following is a brief explanation of data fields for our proposed data elements. We suggest all partner institutions consider these data fields when designing their biocultural collections databases.

## Accession number

Open text field or (better) automatically generated. When curating a collection or creating a database, it is essential to assign a unique accession number to each individual specimen (Bridson & Forman, 1998). The accession number can be any combination of numerals and/or letters and should be recorded on both the item and within the database. This unique number will identify the specimen should the tag or item become disorganised, lost or damaged.

## Type of accession

Drop-down list or open text field. There are various types of accessions that might be included in an institution's biocultural collection, and especially within the BOP. Therefore, it is very important that we note what type of accession is associated with the data. Biocultural collections include the following (Chapter 1):

- herbarium, xylarium or zoological specimen
- unprocessed plant or animal part
- plant or animal product, fibre or extract
- ethnographic material and/or cultural artefact
- DNA collection
- live collection
- archaeological material

- image
- map
- book or archive
- film or video
- photographs or prints
- audio recordings

## Title or name

Open text field. In cultural collections, there might be a name or title given by the culture to an object. In some cases, there is no cultural name and a descriptive name given by the collector or institution is used instead. It might be necessary to construct a title for the piece, and the cataloguer should take cues from other data elements when naming an object (Baca *et al.*, 2006). The title for an artefact might include the associated indigenous tribe name, a defining characteristic, and the use or the source (e.g. the collector or donor name) of the artefact. For example, a dugout canoe from Madagascar might be titled 'lakana', the vernacular name for a boat; it could be titled 'Betsimisaraka canoe', the name of the tribe who carved it; or it could be titled 'Malagasy canoe', 'dugout canoe' or 'Jackfruit-carved canoe'. An open text field is best for names or titles as they can be either a single word or a phrase.

## Taxon name(s) and author

Multiple open text fields or relational data fields. The full name of a species includes the family, genus, species epithet and the author (Bisby, 1994). In order for any term that might be used in a search query to be found, we must atomise our data, or break it into the smallest components. Rather than having the full scientific name (down to subvariant) combined in one field, it is standard to have one field for family, one for genus, one for species and so forth (Morris, 2005; Herbarium Information Standards and Protocols for Interchange of Data (HISPID) 3 (online)). If the full scientific name were stored in one field, then our search capabilities would be compromised. For example, if a user wanted to search for all the records associated with the genus *Echinacea* (including data from all the species), they would search for the scientific genus '*Echinacea*'. If our names were combined on one line, the most basic search function would only show those records containing identifications of *Echinacea* only, not those records that have species determinations (e.g. *Echinacea purpurea*), unless they used the wildcard symbol in their search query. However, if the family, genus, and species names were stored in separate relational fields, a simple search for '*Echinacea*' within genus field would return all records determined at least to the genus *Echinacea*.

The taxon name and author fields are good examples of the need for controlled vocabulary. Latin binomials are often difficult to spell and easily lead to data entry errors. Wherever possible, botanical names should be validated against a relevant flora or checklist to ensure that names are correctly spelled and are accepted. The global checklist for plant names, The Plant List, is still in its infancy; therefore local checklists, online databases (such as Missouri Botanical Garden's Tropicos) and taxonomists should be consulted. Author names are prone to many variations of abbreviation and punctuation; fortunately a standard list exists, incorporated into the International Plant Names Index (IPNI). A list of appropriate sources and websites can be found at the end of this chapter.

## Vernacular name

Multiple open text fields. Vernacular names (or common names) often tell a lot about a collection. Recording vernacular names along with their meanings is a powerful tool that allows us to better understand the use, meaning and significance of an object. Furthermore, the non-expert user of the database may first access the information through a vernacular name, rather than using a scientific name (Hussey *et al.*, 2006). The vernacular name(s) text field should be accompanied by a couple of other text fields: one field to capture meaning and another one to note the language or dialect of the name. A plant species can only have one scientific name, but there are no rules or regulations for the

common names (Moerman, 2009). Because one vernacular name may be linked to several species, or conversely one species may have multiple vernacular names, it is best if the vernacular name(s) are linked to the specimen for which it is actually recorded, rather than to a scientific name in general. Furthermore, each object record should have room available for multiple common names.

## Collector

Open text field. A senior collector should be assigned to every accession. The senior collector is indexed first by last name, then first name or initial and finally by middle initial (see HISPID 3). A senior collector is the main person charged with being responsible for collecting the item. Any additional collectors who assisted the senior collector can be added in the notes field.

## Collection number

Open text field. The collection number is associated with the collector information. In herbarium collections, each voucher specimen has a collector name and unique number. These reference an entry in the collector's field notebook that gives details on the plant's ecology, appearance, location, name and so on (Chapters 3 and 22).

## Date

Drop-down list or open text field. There are three dates that might be entered for a specimen: date of collection, date of acquisition by the institution, and date of origination or creation of an object. These may or may not be known or applicable for each specimen, but if they are known, they should all be noted in separate fields. Dates should be recorded using day, month and year values (atomised to avoid confusion). Standard dating format is the western (non-lunar) calendar.

## Donor

Open text field or relational drop-down list. The person, institution or business from which the accession was obtained should be recorded only where this is different from the collector (i.e. when a specimen comes via an intermediary). This applies whether the specimen is donated or purchased. Ethnobiological collections often receive material from a wide variety of sources (e.g. transfers from other collections). The earlier history of a specimen is important and must be recorded in this field. It can be left blank for specimens received directly from the specimen collector.

## Donor number

Open text field. This field is relevant if a donated specimen bears an accession number or other codes designated in its previous collection.

## Local expert

Multiple open text fields. Local expert (or local consultant) is usually the name of the person interviewed in the field. Information such as name, age, occupation, expertise and gender is helpful to put the use and other artefact data into context. None of these data are necessarily openly shared without special permission. (Permission protocol options will be discussed later in this chapter).

## Language

Drop-down list or open text field. Ethnobiological information should always be linked to the associated language. We propose using the list of world languages compiled in *Ethnologue, Languages*

*of the World*. This comprehensive list of living languages includes the International Organization of Standards (ISO) 639.3 language code abbreviations, which help immensely in cataloguing languages. Language data are also a proxy for ethnicity, which can be more difficult to define.

## Ethnic group or cultural affiliation

Open text field. There is no recognised standard for the description of ethnic groups, and thus language is the best approximation (but see Price (1990) for a useful classification of ethnic groups). Ethnicity is only a free-listed field, into which terms are added based on local expert information. How do local experts describe their own ethnic identity? For example, recently, we chose to identify a Peruvian ethnic group as Yanesha (Hamlin & Salick, 2003) rather than Amuesha (Salick, 1989) as these people had subsequently decided thus to identify themselves. Such inconsistencies will make data recorded under ethnic group somewhat difficult to search. Nonetheless, ethnic identity is fundamental to ethnobiology and to our records.

## Geographical unit

Drop-down list. Use of the TDWG World Geographical Scheme for Recording Plant Distributions allows hierarchical searching by location, at levels ranging from continent to province (Brummitt, 2001). It will be most useful in international collections where the ability to search by multiple-country regions is most valuable.

## Locality

Open text field. The locality is specific information about the location where the collection was made. Information including local place name, distance from large town, and precise directions, is included in the locality field.

## Geographic coordinates

Restricted numerical field. Recording the exact latitude and longitude locations of voucher collections (botany and zoology), excavations (archaeology), interviews and or artefacts (anthropology) is a fundamental component of scientific research and collection management. As the Global Positioning System (GPS) is readily available for field use, it is now easy to get the accurate geographic coordinates of collection locations. For historic collections or collections made without the availability of GPS, geographic coordinates must be assigned from map coordinates. Whenever possible, geographic coordinates should be recorded in degree-minute-second, decimal degrees or UTM format (drop down choice), which are all easily inter-converted into latitude (N-S) and longitude (E-W).

## Use categories

Drop-down list. Biocultural Collections Database standards must also consider the 'Use Category' standards to be implemented. One data collection standard that is widely used, although in need of revision and simplification, is the *Economic Botany Data Collection Standard* (Cook, 1995 (also online)). The Field Museum, the Missouri Botanical Garden and other institutions have chosen to develop their own simplified models (see Table 1). While institutions may use their own system for classifying use, we will need to define equivalencies among databases. Use is perhaps the most controversial of the data fields because of intellectual property rights. Depending on agreements, it might be that these data are shared only with special permission. We address equivalency and intellectual property rights later in this chapter.

## TABLE 1

Tropicos (Missouri Botanical Garden) ethnobotany module level one and two categories for use(s).

A. Food — human
   i. Beverages
   ii. Condiments, herbs and spices
   iii. Fruits and vegetables
   iv. Legumes and pulses
   v. Grains and rice
   vi. Root and tuber carbohydrates
   vii. Nuts
   viii. Additives
   ix. Other

B. Food — animal
   i. Fodder, forage, graze and silage
   ii. Browse
   iii. Invertebrate food
   iv. Fruits
   v. Other

C. Medicines — human and veterinary
   i. Blood and circulatory system
   ii. Dental
   iii. Digestive system
   iv. Endocrine system (hormones)
   v. Female and male reproductive systems
   vi. Urinary system
   vii. Immune system
   viii. Metabolic system, fevers and nutrition
   ix. Muscular-skeletal systems
   x. Nervous system and mental health
   xi. Respiratory system
   xii. Sensory systems
   xiii. Skin and related tissues
   xiv. Infections, parasites and fungi
   xv. Inflammation and pain
   xvi. Poisons and antidotes
   xvii. Zoopharmacognosy
   xviii. 'Humors'
   xix. Belief systems
   xx. General, non-specific symptoms
   xxi. Other

D. Chemicals
   i. Latex and rubber
   ii. Resins and non-edible gums
   iii. Oils (non-edible), waxes and soaps
   iv. Dyes, paints and colours
   v. Tannins and flavonoids
   vi. Aromatics
   vii. Solvents

D. Chemicals (contd)
   viii. Adhesives
   ix. Other

E. Fuels
   i. Firewood and charcoal
   ii. Oils, alcohols, resins and waxes
   iii. Other

F. Fibres
   i. Cloth, clothing, apparel and thread
   ii. Paper
   iii. Baskets and fibre containers, fibre household goods and fibre handicrafts
   iv. Rope, string and netting
   v. Other

G. Cultural uses
   i. Handicrafts (non-fibre)
   ii. Recreation, games, sports and toys
   iii. Religion
   iv. Accessories, cosmetics and jewellery
   v. Musical instruments and art
   vi. Psychoactive drugs
   vii. Other

H. Construction and structural materials
   i. Timber
   ii. Furniture
   iii. Building material
   iv. Tools and utensils
   v. Transportation
   vi. Other

I. Environmental
   i. Barriers and boundaries
   ii. Erosion control
   iii. Fertilizers and soil improvement
   iv. Ornamentals
   v. Pollution control
   vi. Pest control
   vii. Other

J. Other
   i. Research
   ii. Genetic resources

K. Notes: details on use(s)

## Production or processing methods

Open text field. A description of the procedures used to make the artefact could be noted in this text field. For example, noting that a basket's weft and warp are both made from an unpolished strand of spruce root might help to distinguish the artefact as an Alutiiq basket rather than a Tlingit basket (Lee, 2006). Since most medicinals are mixtures, it is as important to describe the medicinal preparation with its components as it is to identify use (Bussmann, 2010). (See further discussion of production and use fields in Chapter 12.)

## Maker, creator or artisan

Open text field. This field contains information on the person who created the object. Additional fields that could be added in this section of your database include the cultural affiliation of the maker, creator or artisan, and the date or time period of creation.

## Cross-referenced collections

A specimen might have associated specimens, either in the same collection or elsewhere, for example a basket might have a plant voucher specimen in a separate herbarium (Chapters 3 and 22) and cultural information filed elsewhere (Chapter 12). One of the most important categories is of cross-referenced material are images, both those deriving from fieldwork that show a specimen in context and studio photographs or prints that enable users elsewhere to view specimens (Chapter 14). Portable document files (PDFs) of any publications citing the collections or that are associated with the items should also be attached or linked to the record (Chapter 13). The organisation of additional data fields will depend on the complexity and size of a collection. A fully featured cross reference will include at least three fields: one for specimen type (perhaps using the drop-down list of categories already presented above), one for specimen location (e.g. using *Index Herbariorum* codes), and one for accession number. The integration of disparate collections is taking on new vitality recently with the development of automated search processes.

## Image

Specialty field. Digitising collections is becoming increasingly common. Uploaded images in an online collection database might, depending on the resolution, provide all the information a researcher needs, rendering expensive travel to institutions or loan requests unnecessary.

## Literature and archives

Relational field or open text field. Any published literature or archives on the specimen or collection that contains the object should be referenced, cross-referenced and/or attached.

## Collection agreements and permits

Image field. Scanned permits, collection agreements, prior informed consent forms, data use protocol and intellectual property should be attached to each collection as available. Documenting agreements is increasingly mandatory. This will also be important in determining access to collection information (see intellectual property below).

## Notes

Open text field. Notation about the specimen can include additional information about the local expert, history of the item, stories associated with the collection and any other useful information. More data is always better than less, and the information recorded in this field can be extensive.

## A LOOK AT TWO ONLINE DATABASES

Each institution will be dealing with their own unique collections and therefore will need to build databases that work for their own needs. Even though these databases may look different to users, we can design them to be compatible with a future online searchable portal (i.e. BOP). Here, we take a look at two very different databases, The American Museum of Natural History's (AMNH) Anthropology Collections Database for cultural artefacts (Figure 1) and the Missouri Botanical Garden (MOBOT) Tropicos database for plant specimens (Figure 2). We selected these two databases to highlight their various strengths and to illustrate how two such different collections can be integrated into one centralised interface. The AMNH database is a great example of a straight-forward comprehensive search engine that allows the user to find information about cultural collections quickly and easily. The Tropicos botanical database includes a wealth of information that provides valuable links to maps, statistics and even allows the user to build their own complex SQL query.

## American Museum of Natural History Anthropology Collections Database

The American Museum of Natural History houses a major anthropology collection. Its comprehensive online database allows internet users to browse and search their collections. Users are given access to images of 200,000 of the 500,000 items in the collection, as well as additional information pertaining to the culture, region and material of each item. By looking at the design of AMNH's Anthropology Collections Database, we can see how a large collection of unrelated materials can be successfully managed and accessed (see Figure 1).

On the front page of the collections database, users can either select a continent to search or choose to search globally. They are then taken to the second tier of the database. From here the user can further refine their search by choosing from a drop-down list of regions within the continent or by cultures identified within the continent.

Keywords can be searched within a number of categories: object name/catalogue number, material, technique, locale, donor or collector, and acquisition year. Additionally, the user can choose to search by other properties (see website for full options available). Therefore, from the basic search function, a user can refine their search as much or as little as they please. As noted on the AMNH website, the following is the minimal amount of information entered into the database for each object: catalogue number, accession number, nature of accession (e.g. expedition, gift or purchase), collector, provenience, object name, materials, dimensions, condition, and storage location. The AMNH search engine works well because of its simplicity and its stunning images.

## Missouri Botanical Garden's Tropicos

The Missouri Botanical Garden's Tropicos database has been a pioneer in botanical database systems and a source of computerised botanical knowledge for over 25 years (Allen, 1993). It is a fully interactive online searchable database of over 1.25 million plant names and nearly 4 million specimens. We look at Tropicos (Figure 2, top) as an example of how a highly evolved, very specific, and heavily

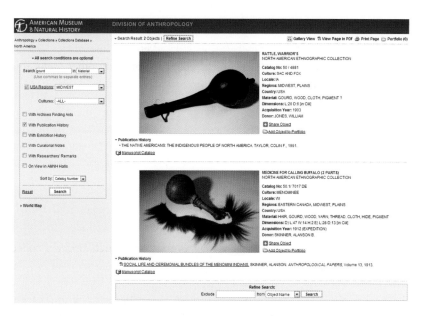

**Figure 1.** Search results from the American Museum of Natural History collections database. Here, a user created a search query for all the gourd artefacts from the North American Midwest with publication history. To do this, they searched for 'gourd' in the 'Material' drop-down list, selecting 'Midwest' from their USA Regions drop-down list, and checking 'With Publication History' from the search menu. Just as easily, they could create a query to access all items in the collection that are made from plant fibre by typing 'plant fibre' in the 'Material' drop-down list. These searches yield two objects and 29,147 objects, respectively. Note the search parameters to the left and the ethnobiological information under 'Material' on the right. See www.amnh.org/our-research/anthropology/collections/database.

**Figure 2.** The Missouri Botanical Garden Tropicos specimen pages. A Tropicos specimen page (top) is completed for all herbarium plant specimens at the Missouri Botanical Garden. The Tropicos ethnobotany fields (bottom) are starting to be completed for specimens with ethnobotanical information. This new Ethnobotany page recognises that plants can have multiple uses, so the module allows multiple selections from the Level One category 'Usage'. A single specimen can have as many uses attached to it as needed. This relatively small amount of ethnobiological data adds depth to the already dynamic Tropicos database, which includes the complete voucher information for a botanical specimen including date, location, scientific name, collector and so on. (See www.tropicos.org.)

populated database can integrate new data components — in this case, ethnobotanical information — into its system.

Tropicos has recently begun to include both ethnobotany information to accessioned herbarium vouchers and ethnobotanical artefacts of or pertaining to plants within the Tropicos Ethnobotany module (Figure 2, bottom). The data from a plant voucher or artefact can be searched by many fields through both the standard Tropicos specimen data and now through the Ethnobotany module by scientific name or common name (in advanced search options), collector name and number, geographic data (country, upper and lower political subcategories), use categories, and local expert information.

## Tropicos specimen entry

There are a multitude of fields that can be populated when entering specimen data into Tropicos. Standard (and straightforward) fields for every Tropicos specimen include current taxonomic identification ('Current determination'), collector information, collection number, collection date, and collection location (which includes country and up to two more sub-political entities). Most entries also have geographic coordinates, elevation, description of plant (from field notes) ('Description'), and specimen condition (in flower, sterile and so on). Locality is also often noted, thereby providing more detailed directions to the area of collection.

Ethnobotany data collected in the field by any Missouri Botanical Garden botanist can be added to their associated plant voucher in the Tropicos ethnobotany module. The module can also be used to record local expert data, consisting of a local expert's name, age, expertise or occupation and ethnic group. These are all open text fields. Beyond these fields, the database concentrates on uses. Each use is classified into one of the Level One use categories, which are simplified from the TDWG Economic Botany standards. After working in the field conducting ethnobotany interviews and surveys, we found the need to reclassify the top-level categories of the TDWG. Our categories have been field tested by curators, scientists and students alike, as well as by native and non-native English speakers. We took the 13 top-level states of Cook's (1995) TDWG standards and re-worked them into ten simplified categories. Our Level One drop-listed categories are as follows:

1. Food – human
2. Food – animal
3. Medicines – human and veterinary
4. Chemicals
5. Fuels
6. Fibres
7. Cultural uses
8. Construction and structural materials
9. Environmental
10. Other

In the ethnobotany module, a drop-down list of Level Two categories, called 'usage', is populated after the Level One category has been selected. Our Level Two subcategories for usage are shown in Table 1. Each use is then associated with a plant part. The user can choose from the drop-down list, which includes leaf, stem, flower, seed, fruit, bark, wood, root, tuber, whole plant or above-ground plant. Additionally, notes on the preparation of the plant part can be added to each use. Thus, each recorded use is attached to a specific plant part, preparation notes, category of use, and the scope of use (Figure 2).

## EQUIVALENCY OF USE CATEGORIES

Over and above the other data elements, the use category can use different systems and may differ significantly. Most other fields are self-evident in value and easily translatable. For example, whether collection date is recorded as 15-6-2011 or June 15, 2011 we come to the same conclusion, the item was collected on the 15th day of June in the year 2011.

These two database examples show that no two collection databases will be exactly alike, but that they are not completely exclusive. If we can build equivalencies between database fields, we will be able to bridge the disparate collections together by using a single data-interface system (such as the proposed Biocultural Collections Online Search Portal (BOP)). In order to do this, we need to agree upon equivalencies among use categories.

## TABLE 2

Use category equivalencies among four prominent ethnobotany databases.

| MOBOT | IUCN | Field Museum | TDWG |
|---|---|---|---|
| 1. Food — human | 1. Food — human | Edible | 0100 Food, 0200 Food Additives |
| 2. Food — animal | 2. Food — animal | Edible | 0300 Animal Food, 0400 Bee Plants, 0500 Invertebrate Food |
| 3. Medicines — human and veterinary | 3. Medicines — human and veterinary, 4. Poisons | Drug, Medicinal, Poisons | 1100 Medicines, 0900 Vertebrate Poisons, 1000 Non-vertebrate poisons |
| 4. Chemicals | 5. Manufacturing chemicals, 6. Other chemicals | Material | 0600 Materials |
| 5. Fuels | 7. Fuel | Fuel | 0700 Fuels |
| 6. Fibres | 8. Fibre, 10. Wearing apparel, accessories, 11. Other household goods | Material | 0600 Materials |
| 7. Cultural uses | 10. Wearing apparel, accessories, 12. Handicrafts, jewelry, decorations | Art object, Communication artefact, Material, Personal artefact, Recreation artefact, Societal artefact, Transportation artefact | 0600 Materials, 0800 Social uses |
| 8. Construction and structural materials | 9. Construction and structural materials, 11. Other household goods | Tools or equipment, Building, furnishing, Product | 0600 Materials |
| 9. Environmental | 13. Pets or display animals, horticulture | No equivalent | 1200 environmental uses |
| 10. Other | 14. Research | Unclassified artefact | 1300 gene sources |

Biocultural collections are based on how a plant or animal, plant or animal product, or artefact is used. How we organise and classify these categories is essential to database development and interfacing. Although each institution can use their own classification system, it is vital that all of our systems have equivalencies. Otherwise, we will create ineffective and confusing search results for our online users.

The TDWG database standard (Cook, 1995) and the standards of the International Union for Conservation of Nature (IUCN) and Field Museum provide examples that can be integrated into the current MOBOT system (Table 2). There are, however, many more classification systems currently in use. Equivalencies among classification systems must be a top priority in forming an online interface system for biocultural collections.

## CONCERNS

### Intellectual property rights

The nature and purpose of an online biocultural collections database is to disseminate information about our useful collections to researchers and to a broader audience. We must keep in mind, however, that an online database can be accessed by users other than well-meaning researchers and the general public. Moreover, commercial interests mine ethnobiological research for product discovery without ever making contact with the indigenous population from which the information was received (intellectual property (IP) holders) and without giving proper acknowledgement or compensation (Bannister & Barret, 2004). Therefore, we must be able to share our collections while still protecting the rights of the groups who provided the information (Graves, 2000).

One route is to limit the information that is available to most users; for example, the Missouri Botanical Gardens' Tropicos database only shows high-level ethnobotanical information, not details. Another possibility is to require users to login to BOP and database websites in order to see full specimen descriptions. Basic information, such as taxon name and country, can be given to users without a login, but more sensitive data such as use would be 'greyed out', much in the same way as herbaria grey out the location coordinates of endangered species which they must keep from rapacious commercial collectors. This means that IP information would not be shown to the casual online user nor to any commercial interest that has not developed a fully beneficial contract with IP holders. By applying for permission to access the complete details of a specimen, one would need to agree to Terms and Conditions and be approved by the individual institution where the data and property agreements are housed. Another solution might be to require an agreement such as that imposed by the GBIF Data Use Agreement before results are shown. In this agreement, the requestor must identify ownership of data in any subsequent use and must agree to any further conditions imposed by individual data suppliers.

Another model to control the type of data that are accessible to users is The Utah Bat Conservation Cooperative's (UBCC, www.utahbats.org) BATBASE, an online geodatabase that stores all data collected on Utah's bat population and has two distinct levels of data. Data providers determine whether their contribution is marked Category I or Category II. Category I data can include biological and locality data but users do not have the ability to publish the data. Category II data also contain biological and locality data and can be available for publication with the consent of the data provider or through approval of the UBCC. Very basic data (number of species and population numbers of bats in each county) can be accessed from the front page, but login rights for the BATBASE require a seven-page paper application to be submitted for approval. (For further discussions on intellectual property see Chapters 1 and 16.)

## COLLECTION AGREEMENTS AND PERMITS

Any permits, agreements, promises and special instructions must be honoured at all times. All stipulations or terms associated with the sale or gift of an object from an outside party must be attached to the database and honoured at all times. Collecting, importing and exporting permits must be obtained as appropriate and attached to the database. When given permission to collect, interview, buy or import/export (or any other situation in which permission is needed) always note the source of permission (e.g. authority name or figure) for future reference (Bridson & Forman, 1989). It is not enough just to record a permit number or to include a check box to indicate that prior informed consent was given. It is increasingly mandatory to attach scanned agreements and permits to all data. This is done to protect the rights of both the local expert and the collector. Free and clear title ownership must be verifiable for any specimen.

## CONCLUSION

Biocultural collections play an important role in the future of ethnobiological research. Making biocultural collections available online is the first and most important step as it will allow current and future collaborations to benefit from shared data. In order to move towards a centralised online interface (BOP), we must plan our database design carefully. Although we need not construct the exact same database, we should be capturing similar types of data. One challenge will be to find a set of cultural use categories or equivalencies that are comprehensive enough to cover the multitude of ways biological objects are used. Finally, when sharing our data, we must put the cultures that our collections and associated information represent first and foremost, respect their intellectual property rights, honour the agreements we made when obtaining the data and share benefits.

## Online database resources

### Herbaria

*Herbarium Information Standards and Protocols for Interchange of Data (HISPID)*. http://plantnet.rbgsyd.nsw.gov.au/HISCOM/HISPID/HISPID3/hispidright.html

### Plant taxonomy

*Catalogue of Life*. www.catalogueoflife.org

*Germplasm Resource Information Network (GRIN)*. www.ars-grin.gov

*International Plant Name Index (IPNI)*. www.ipni.org (Note: IPNI does not indicate which names are currently in use).

*The Plant List*. www.theplantlist.org

Missouri Botanical Garden. *Tropicos*. www.tropicos.org

Royal Botanic Gardens, Kew. *World Checklist of Selected Plant Families*. http://apps.kew.org/wcsp

Other name databases are listed by Paton *et al.* (2008.)

### Cultural artefacts

*Cataloging Cultural Objects (CCO)*. http://cco.vrafoundation.org

### Uses

*Economic Botany Data Collection Standard*. www.tdwg.org/standards/103

*IUCN Utilization Authority File (Version 1.0)*. http://intranet.iucn.org/webfiles/doc/SSC/RedList/AuthorityF/utilization.rtf

### Geographic place names

*Country Codes — ISO 3166*. www.iso.org/iso/iso_3166_code_lists

*TDWG World Geographical Scheme*. www.tdwg.org/standards/109

### Languages

*Ethnologue, Languages of the World*. www.ethnologue.com

Library of Congress. *ISO Codes for the Representation of Names of Languages*. www.loc.gov/standards/iso 639-5

### Online biocultural databases

American Museum of Natural History. *Anthropology Collections Database*. http://research.amnh.org/anthropology/database/collections

Field Museum. *Economic Botany Collections Database*. http://emuweb.fieldmuseum.org/botany/search_eb.php

*Global Biodiversity Information Facility*. www.gbif.org

Missouri Botanical Garden. *Tropicos*. www.tropicos.org

*Paleobot.org*. www.paleobot.org

Royal Botanic Gardens, Kew. *Economic Botany Collection database*. http://apps.kew.org/ecbot/search

# Literature cited

Allen, W. H. (1993). The rise of the botanical database. *BioScience* 43: 274–279.

Bannister, K. & Barrett, K. (2004). Weighing the proverbial 'ounce of prevention' against the 'pound of cure' in a biocultural context: a role for the precautionary principle in ethnobiological research. In: *Ethnobotany and Conservation of Biocultural Diversity, Advances in Economic Botany 15*, eds T. J. S. Carlson & L. Maffi, pp. 307–339. New York Botanical Garden Press, New York.

Baca, M., Harping, P., Lanzi, E., McRae, L. & Whiteside, A. (eds) (2006). *Cataloging Cultural Objects: a Guide to Describing Cultural Works and their Images*. American Library Association, Chicago.

Bartolo, L. M. (2006). International scientific data, standards, and digital libraries: an NSF NSDL (U.S.) and CODATA workshop. *Data Science Journal* 2006: 165–167.

Berendsohn, W. G., Anagnostopoulos, A., Hagedorn, G., Jakupovic, J., Nimis, P. L., Valdés, B., Güntsch, A., Pankhurst, R. J. & White, R. J. (1999). A comprehensive reference model for biological collections and surveys. *Taxon* 48: 511–562.

Bisby, F. A. (1994). *Plant Names in Botanical Databases. Plant Taxonomic Database Standards No. 3*. International Working Group on Taxonomic Databases for Plant Sciences (TDWG). www.tdwg.org/standards/113/download/113-528-1-RV.pdf

Bridson, D. & L. Forman (eds) (1998). *The Herbarium Handbook*, 3rd edn. Royal Botanic Gardens, Kew.

Brummitt, R. K. (2001). *World Geographical Scheme for Recording Plant Distributions*, 2nd edn. Hunt Institute for Botanical Documentation, Carnegie Mellon University, Pittsburgh. http://www.nhm.ac.uk/hosted_sites/tdwg/TDWG_geo2.pdf

Bussmann R. W., Glenn, A., Meyer, K., Kuhlman, A. & Townesmith, A. (2010). Herbal mixtures in traditional medicine in northern Peru. *Journal of Ethnobiology and Ethnomedicine* 6: 10. www.ethnobiomed.com/content/6/1/10

Cook. F. E. M. (1995). *Economic Botany Data Collection Standard*. Royal Botanic Gardens, Kew.

Graves, G. R. (2000). Costs and benefits of web access to museum data. *Trends in Ecology & Evolution* 15: 374.

Hamlin, C. C. & Salick, J. (2003). Yanesha agriculture in the upper Peruvian Amazon: persistence and change fifteen years down the 'road'. *Economic Botany* 57: 163–180.

Hussey, C., Wilkinson, S. & Tweddle, J. (2006). Delivering a name-server for biodiversity information. *Data Science Journal* 5: 18–28.

Lee, M. (2006). 'If it's not a Tlingit basket, then what is it?': toward the definition of an Alutiiq twined spruce root basket type. *Arctic Anthropology* 43: 164–171.

Moerman, D. E. (2009). *Native American Medicinal Plants: an Ethnobotanical Dictionary*. Timber Press, Portland.

Morris, P. J. (2005). Relational database design and implementation for biodiversity informatics *PhyloInformatics* 7: 1–66.

Paton, A.J., Brummitt, N., Govaerts, R., Harman, K. Hinchcliffe, S., Allkin, R. & NicLughadha, E. (2008). Towards Target 1 of The Global Strategy For Plant Conservation: a working list of all known plant species — progress and prospects. *Taxon* 57: 602–611.

Price, D. (1990). *Atlas of World Cultures: a Geographical Guide to Ethnographic Literature*. Sage, London.

Salick, J. (1989). Ecological basis of Amuesha agriculture. In: *Resource Management in Amazonia: Indigenous and Folk Strategies, Advances in Economic Botany 7*, eds D. A. Posey & W. Balée, pp. 189–212. New York Botanical Garden Press, New York.

Stein, L. D. (2003). Integrating biological databases. *Nature Reviews Genetics* 4: 337–345.

Philippi, S. & Köhler, J. (2006). Addressing the problems with life-science databases for traditional uses and systems biology. *Nature Reviews Genetics* 7: 482–488.

Warinner, C., d'Alpoim Guedes, J. & Goode, D. (2011). Paleobot.org: establishing open-access online reference collections for archaeobôtanical research. *Vegetation History and Archaeobotany* 20: 241–244.

Wei, M. (2006). Improving database standards through eliminating duplicate records. *Data Science Journal* 5: 127–142.

# Curating ethnographic information for biocultural collections

SERGE BAHUCHET

Muséum National d'Histoire Naturelle, Paris.

The importance of cultural information for biocultural collections is clearly described in an old booklet *Summary Instructions for the Collectors of Ethnographical Objects*, published as a guide to collecting for the Musée de l'Homme, Paris, which opened in 1938:

> 'The object is nothing but a witness that should be considered based on the information it provides about a given civilisation, and not by its aesthetic value ... We learn more about a civilisation from the most common objects. A tin can, for example, better characterises our society than the most sumptuous jewel or the rarest stamp ... By surrounding the object with a mass of information, technical or otherwise, and with all documentation (photos, drawings and observations), the object is neither dead, removed from its context, nor incapable of supporting cultural reconstruction.' (Anon., 1931: 8, 10; my translation).

## FUNCTIONS AND USES OF BIOCULTURAL COLLECTIONS: VOUCHER SPECIMENS AND CULTURAL ARTEFACTS

### Voucher specimens

Ethnobiological vouchers (i.e. botanical and zoological specimens that confirm the scientific names of organisms, see Chapter 22) correspond principally to a step of the research process; they do not constitute an end in themselves. Vouchers carry cultural information and reflect local knowledge. They should be linked to documents containing that information (such as field notes, publications, drawings, photographs and films showing the techniques used). From the perspective of an ethnobiologist, what matters is the information. The most important function of ethnobiological specimens is to enable the determination of the scientific name of the source organism, which might initially be known only by the local name obtained from members of the community being studied. Once collected, the specimens mainly verify animal or plant identity, but also can be used for ethnobiological comparisons or phylogenetics (Chapter 22). Thus while most ethnobotanical and ethnozoological voucher specimens have value for identification and reference, they have their seminal meaning in associated cultural data that provide each object with ethnographic context.

### Cultural artefacts

As summarised long ago by Marcel Mauss, the founder of French anthropology: 'Each object must be studied 1) in itself, 2) in relation to the peoples who use it, 3) in relation to the total observed system.' (Mauss, 1947: 34; my translation). To obtain ethnographic information about each object, we must ask two types of questions. First, what is the use and function of the object? Second, with what material is it made and how is it made? Any object has to be placed in relation with materials, both the materials of which the object is made and the materials it is used to transform. In a biocultural collection, links must be made between information on a series of objects and information on a particular ethnobiological specimen within that series.

## BIOCULTURAL COLLECTIONS OF FRENCH MUSÉUM NATIONAL D'HISTOIRE NATURELLE, PARIS

The French National Museum of Natural History (MNHN) possesses four series of collections dealing with the human species: the oldest is human anatomy and physical (or biological) anthropology, beginning with the origin of the MNHN (18th century), then prehistory (19th century), ethnography, and last ethnobotany (early 20th century). The herbarium (MNHN Laboratoire de Phanérogamie, founded 1635) also has collections of useful plants. Only the ethnography and ethnobotany collections are considered here, as biocultural collections of direct relevance to this chapter on ethnographic information. In 2002, the majority of the ethnographic collection was given to a new museum of Primitive Art outside of the jurisdiction of the MNHN, the Musée du Quai Branly, which opened in 2006 and can no longer be considered an ethnographic museum (Rivet & Rivière, 1930; Bahuchet, 2002; Mohen, 2004).

 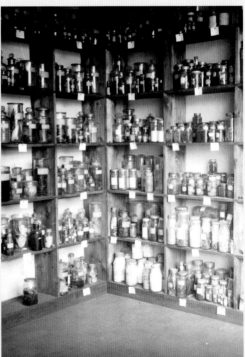

Wood collection (left) and seed collection (right), both at the Laboratoire d'Agronomie Coloniale, Muséum National d'Histoire Naturelle, Paris in the 1950s. © DIRECTION DES BIBLIOTHÈQUES ET DE LA DOCUMENTATION DU MNHN, PARIS.

The ethnobiology collection has its origin in the Laboratory of Colonial Agronomy, founded by Auguste Chevalier. It is mainly devoted to plants of economic value from the tropics, including over 50,000 herbarium specimens of wild and cultivated plants (such as rice, sorghum or coffee), herbals, an ethnozoological section, and also collections of over 3,500 artefacts including objects related to ethnomedicine and various tools or implements for hunting, fishing or cultivating (Portères, 1961; Bahuchet & Lizet, 2003). The ethnobiology collection has special strengths in Central Africa, Timor and Peru, as well as in France.

Objects may represent process. Artefacts illustrate the modes of intervention of human societies on their environment, techniques and processes, as well as ways of transforming raw material. Any object is both the result of a manufacturing process and, through its use, the means of a process of transformation. It is made of (raw) material and often used to transform another material: Material 1 → Object → Material 2.

Additionally, any object is at the intersection of four systems. First, the object is made; it is a product of a technical process (the system of production). Second, it is a tool used to do something (system of use). Third, the object is possibly borrowed, purchased or exchanged (system of consumption) and thus becomes a commodity. Finally, it is considered in comparison with other objects, it is inserted into a system of objects (Figure 1).

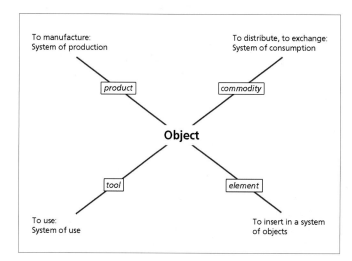

To manufacture:
System of production

To distribute, to exchange:
System of consumption

product

commodity

**Object**

tool

element

To use:
System of use

To insert in a system
of objects

**Figure 1.** Culturally, any object is at the intersection of four human-generated systems. It is a *product* within a *system of production*; a *tool* within a system *of use*; a *commodity* within *system of consumption*; and an *element* within a system *of objects*. Documenting the place of any object within these systems provides cultural information basic to biocultural collections.

In a museum, a tool without cultural documentation is often incomprehensible, and may appear almost useless as far as cultural significance is concerned (for example, see Figure 2). To reconstruct *a posteriori* (i.e. from general principles or from the tool's effects) the way of manipulation of an object could be a painstaking activity; therefore it is much easier to observe the manipulation of the object and how it is used in its original context. While collecting the object in the field, it is of primary importance to document the gestures associated with use. For instance, how a tool is placed in relation to the body provides a great deal of insight into its usefulness and efficiency. If any other parts of the body besides the hands (the feet for instance) are used, such information further explains the tool design and use technique. Photographs and drawings as well as videos obtained at the time of collection are most helpful when placing the tool in its position of use, and depicting any succession of gestures.

**Figure 2.** Billhook from Cambodia used for rice harvest. Without documentation, we could not know how this object would be used or what gestures would be associated with its use.
PHOTO BY J.C. DOMENECH, © MNHN

Photographs and videos can also be used to document various stages of the manufacturing process (for example, see Figure 3). In such cases, it is useful to place the object's ethnographic information in a technical sequence ('chaîne technique' (Balfet, 1975)), that separates the process into elementary steps and then to associate this information with the collected object. For basketry and textiles in general, observation of the process of making in the field avoids many subsequent difficulties: 'In the numerous cases where the working procedures are unknown, it is often very hard to determine which method has been used without tedious and difficult investigations' (Seiler-Baldinger, 1994: chapter xv).

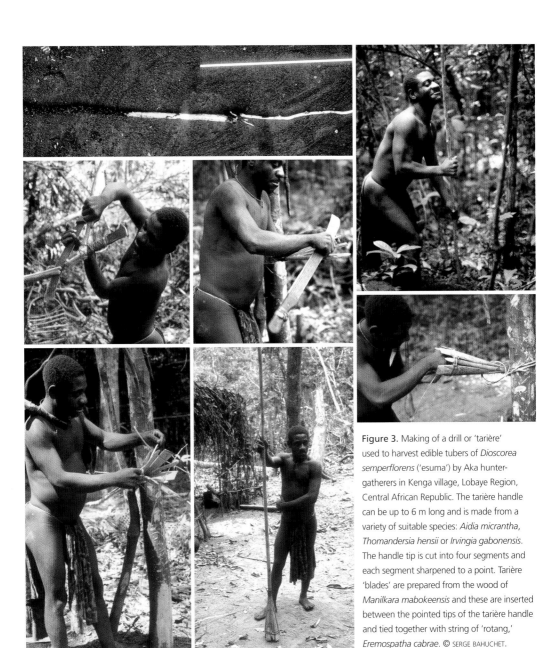

**Figure 3.** Making of a drill or 'tarière' used to harvest edible tubers of *Dioscorea semperflorens* ('esuma') by Aka hunter-gatherers in Kenga village, Lobaye Region, Central African Republic. The tarière handle can be up to 6 m long and is made from a variety of suitable species: *Aidia micrantha*, *Thomandersia hensii* or *Irvingia gabonensis*. The handle tip is cut into four segments and each segment sharpened to a point. Tarière 'blades' are prepared from the wood of *Manilkara mabokeensis* and these are inserted between the pointed tips of the tarière handle and tied together with string of 'rotang,' *Eremospatha cabrae*. © SERGE BAHUCHET.

# RECOVERING CULTURAL CONTEXT: A BASKETRY SHIELD FROM THE AMAZON

CRISTINA RICO LIRIA

This 'shield of timbo-titica' was collected by Richard Spruce near the Rio Uaupés in the Brazilian Amazon, and entered Kew's Economic Botany Collection in 1852. Spruce spent 15 years making botanical collections in the Amazon, and was a meticulous collector. In this case, however, he noted only the rough location — the Rio Vaupés — and the materials, pitch of 'anani' (*Symphonia globulifera*) and 'timbo-titica' for the basketry. The shield was studied in 2012, as a conservation project at Camberwell College of Arts, offering the opportunity to research the piece in detail for the first time since its arrival at Kew.

Technical analysis of the shield was carried out prior to conservation and rehousing. Consultation with William Milliken, an ethnobotanist familiar with the Amazon, enabled the identification of the basketry material as the aerial roots of the 'titica' vine (*Heteropsis flexuosa*), which remain widely used throughout the Amazon. Passive elements are split from the inner part of the root, while the active elements are split from the outer part, with the epidermis visible. Examination under ultra-violet light revealed otherwise invisible traces of paint, showing that the resin of *Symphonia globulifera* was not the only paint used, and leading to a reassessment of the painted patterns.

Ethnographic context came from contact with the Museu de Arqueologia et Etnologia (MAE), University of São Paulo, who identified the shield as a ceremonial object

ABOVE Shield from the Rio Uaupés, Brazil (EBC 67762). Diameter 600 mm. PHOTO © ROYAL BOTANIC GARDENS, KEW

LEFT Tukano dancers with shield, c. 1900 (Koch-Grünberg, 1923: plate VII).

usually associated with the Desana people, of the Tukano linguistic family. Similar shields were found in other museum collections, usually dating to about 1900. The ethnologist Koch-Grünberg (1923) illustrates a shield being carried and describes them as former war objects, used to capture women for exogamous marriages, but later used in ritual dances. The form of the shield is linked to a complex mythology.

The shield has been conserved and returned to the Economic Botany Collection, with much more known about how it was made and used. The next step for this and the 300+ other artefacts collected by Spruce is for Kew's curators to consult with the Desana people. It is thought that these shields are no longer made, in which case the exchange of information will be doubly valuable.

Where such information has not been collected with an artefact, as is often the case with older collections, all is not lost (see Box 'Recovering cultural context: a basketry shield from the Amazon'). Careful technical analysis of the construction of an artefact can reveal how it was made, and experimentation and the use of ethnographic analogies can show how it was used. Consultation with the source community is essential, even when an artefact is no longer used, because community members might have other knowledge, for example of weaving techniques, relevant to understanding the object. Engagement with source communities also enables the sharing of information embodied in museum objects.

## ETHNOGRAPHIC INFORMATION

### Cultural information concerning ethnobotanical and ethnozoological specimens

As far as ethnobiological specimens (i.e. plant and animal samples) are concerned, beside the usual information that describes the object (Chapters 2, 3, 4), there is much cultural information to gather. Cultural questions can largely be divided between those specific to cultivated and those relevant to non-cultivated specimens.

#### Non-cultivated species

*Non-cultivated plant material* Who gathers it, how and where? Are there any specific rituals associated with gathering the plant? What is the local name of the plant? Are there different names for individual parts of the plant (fruit, stem, leaves and so on) or for successive growth stages (seedling, sapling or adult plants for instance)? Is the gathered plant or plant part in a special local classification category (e.g. different life forms of life, such as 'trees', 'vines' or 'herbs')? Are there other species that are considered similar or in the same category?

*Utilisation of plants* How is each plant transformed and the material prepared? How is it transported? What is the use of it? What kind of tool is used for the preparation? What kind of object is made from the plant? In each instance, it is necessary to note the local names of objects used in gathering or processing the species under study. Whenever possible, take pictures of the process and of the tools (with a scale) and collect the tools as well as voucher specimens. Does the same person who gathered the plant make the object under study? Is there any type of trade with it? What are the economic or political ramifications of its gathering? Is there any regulation of its gathering?

*Wild animals* What is the name of the animal? Are there different names according to age and gender? If the animal lives in herds, is there a specific name for the group? How and where is the wild animal hunted or fished? What tools or weapons are used to capture the animal and what are their local names? Which activities are carried out by whom? What particular animal behaviour is of interest in catching the prey? How is the animal used? What part? For what? By whom? Are there preservation techniques? Is there trade? Are there specific rituals before or after the catch?

#### Cultivated species

*Cultivated plant* Is it part of a named variety? Where is it cultivated; is it grown in the village (close to the house, in a garden or in a field)? Is it part of the agrarian cycle? Who planted it (age, gender and so on)? Are there any specific protections or treatments applied to the plant? How is the soil prepared? Are specific fertilisers used? Are there specific methods and rituals for planting and harvesting? Are there specific tools for planting or harvesting? How is the crop transported, processed, used, traded and so on?

# ARTISAN TOBACCO CULTIVATION AND CIGAR PREPARATION IN THE VALLE DE VINALES, NORTH OF PINAR DEL RIO, WESTERN CUBA, 2012.

PETER WYSE JACKSON

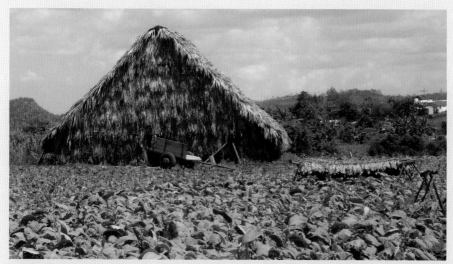

1. Tobacco (*Nicotiana tabacum*) fields (with drying house and rack in the background).

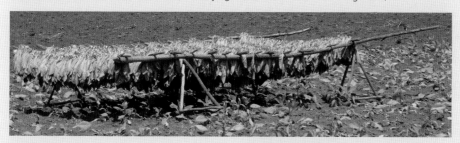

2. Field drying rack.

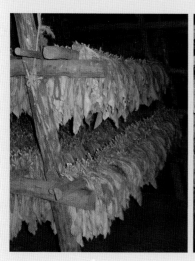

3. Tobacco is tied in small bundles and brought into the drying house to dry on tiered racks, gradually turning from green (left) to brown (right).

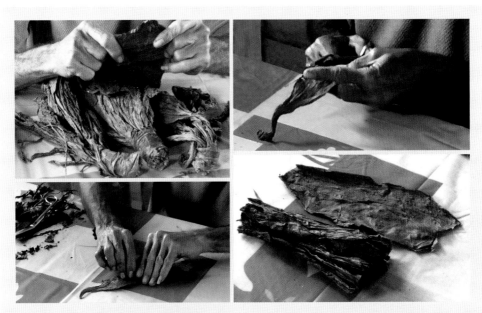

4. (Clockwise) A local craftsman carefully extracts and smoothes out each leaf from the dried tobacco bundles, selecting those that will be used for a cigar's outer and inner layers. The leaves for the inner layers are then cut into long strips and arranged in bundles for wrapping.

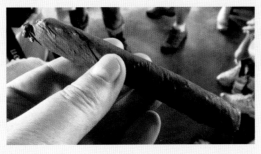

5. Final product.

ALL PHOTOS © PETER WYSE JACKSON

*Animals* Is this animal considered to be tamed or domesticated? Is it given a personal name? Are there different named categories for males, females, young or castrated animals? Is it considered as a particular breed or line? Is it kept alone or in a herd? Is it kept close to the house, in or outside the settlement, with or without a specific shelter? Who is in charge of the husbandry? Who feeds the animal? Is the animal killed for use? Who can kill it? Are they special cries to attract or to herd it? Are there special tools for the raising the animal: to hobble, to harness, to kill? What animal product is used (milk, eggs, blood, wool, meat and so on)? What tools are used to obtain the animal product? Every time a tool or object is mentioned in relation with the ethnobiological specimen, it is recommended to note its name in the local language, to take a picture of it alone and being manipulated, and if possible, to collect it for the biocultural collection.

These questions are just some examples of questions that provide relevant biocultural information about the object.

# HARVESTING OF MASTIC (*PISTACIA LENTISCUS*) IN CHIOS, GREECE.

## PETER WYSE JACKSON

Mastic has been traditionally harvested in the Aegean island of Chios for centuries. Mastic production in Chios has been granted 'Protected Designation of Origin' status within the European Union.

2. Calcium carbonate is spread in the cleared area around the base of the tree to aid in catching the falling sap harvested from the tree.

1. Leaf and other loose material is cleared away from the base of the mastic tree.

4. Sap is sifted from the calcium carbonate using a sieve.

3. Cuts are made using a knife to release sap at various places along the tree branches.

5. Large pieces of mastic sap can then be removed from the calcium carbonate and soil for use as medicine, food or other purposes.

Examples of questionnaires or field protocols may be found in ethnobotanical manuals such as Alexiades (1996) and Martin (1995) (in English) or Bouquiaux & Thomas (1987: 573–950) (in French). For specific guidance on recording the uses of wild (and domesticated) food plants, see also Mason & Nesbitt (2009) and Nesbitt et al. (1996), for basketry Wendrich (1991), for food systems Kuhnlein et al. (2006), for textiles Seiler-Baldinger (1994) and for musical instruments Dournon (2000). Reference to the types of technologies used to manufacture biocultural artefacts (e.g. for fibre extraction) can be found in the book by Florian, Kronkright and Norton (1990). Sturtevant (1967) provides official categories for ethnographic specimens curated by the Smithsonian Institution and serves to guide the curation of ethnographic materials once collected.

## Information to be collected along with a cultural artefact in the field

### Collection information
- Where was it collected? Location (village, region, country); place it was found in reference to the use and/or the maker (e.g. was it in a market or a shop?).
- Was it collected in place where it was made?
- How was the object exchanged (e.g. was it a gift, traded or purchased (at what price?))?

### Naming
- What is the name of the object in the local language? If it has several parts, what are the names of each part?
- What is the meaning of the object's name in the local language? Does it have to do with the object's function, material or shape?

### Manufacture of the object
- How was it made? Was it made by the user themselves, by a craftsman, or in a factory? Is it locally made or imported?
- What are the raw materials? Include the names of each material in the local language and any scientific names. If possible, take pictures and collect samples of the species used and link these to the object(s).
- What are the origins of the raw materials (e.g., gathered directly by the user or the craftsman, or obtained from somebody else (in which case, were they given or purchased?)? Where were the materials gathered or at what price were they purchased?
- What processes of transformation are applied to the raw material between harvest and use in manufacturing?
- How is the artefact made, and with which tools?

### Use of the object
- What is the function of the object? Is it of general use (multipurpose) or for a specialised activity?
- Is it used alone or in association with other tools?
- When is it used (e.g., seasons, periods of the year, specific rituals or festivals, and so on)?
- Who uses it (e.g. men, women, children, everybody)?
- How is it transported for use?
- Where is it used?
- How is it handled and manipulated when used?
- Can it be used by its owner only or also by other persons? Can it be borrowed?
- How is it stored in its home environment?

## Examples of record cards for collecting cultural information in the field

Tables 1 and 2 give two examples of record cards used in the French Museum of Natural History. Other examples of questions about tools can be found in Gregory & Altman (1989). This information will be included in the catalogue or database when an object enters into the collections.

### TABLE 1
Descriptive card for collections of the Musée de l'Homme for the objects. (Anon., 1931)

1) Place of origin: country, region, locality.
2) Name (in English, in the local language with literal translation; local names of every different part of the item).
3) Description: material; scientific and local names; technique of fabrication; form and shape; decoration and design.
4) Further notes: information as precise and numerous as possible on the making, the area of making, the use, the area of use, the ideas and customs connected with the object, etc.
5) Ethnic information (tribe, sub-tribe, descent group; personal name of the individual which made use of it).
6) By whom and when the object was collected (name of the collector, date of collection; name and dates of the mission).
7) Condition of sending to the Museum (to fill by the museum: donation, purchase, exchanges, deposit).
8) Iconographic references (numbers corresponding to photos or drawings showing the making, the use, the object itself in the various stages of its making).
9) Bibliography (reference to the notes of collectors; publications, monographs and so on).
10) Author of the card and date.

### TABLE 2
Sample of the Paris MNHN field card for cataloguing objects.

| Card for ethnobiological objects |
| --- |
| Place |
| Country |
| Ethnic group, population |
| English name of the object |
| Local name |
| Use |
| Description<br>Production (craft industry, factory…)<br>State (new, worn…)<br>Number of parts |
| Material |
| Place of acquisition (home, market, store) |
| Mode of acquisition (purchase, gift, etc.) |
| Price (specify money) |
| Collector<br>Context of the collection |
| Date of collection<br>Date of entry into the Museum |

## LINKING THE INFORMATION TO AND AMONG THE COLLECTIONS

The creation of links between voucher specimens and ethnographic artefacts is essential. In addition, every specimen or artefact should ideally be linked to all available cultural data and all existing iconography. These cultural data are collected in the field as described above, and may be further available in written records or publications, through consultation with source communities, or through close examination of the objects themselves.

## DRAFT STRUCTURE FOR THE ETHNOBIOLOGICAL DATABASE IN THE MUSÉUM NATIONAL D'HISTOIRE NATURELLE, PARIS

FLORA PENNEC, SIMON JURAVER, MARINA QUIÑE AND SERGE BAHUCHET

A relational database was conceived for ethnographic objects or artefacts that allows linked data tables including those used to capture information on the object, collector, composition, material, use, process, documents and media. These tables are linked by common data elements and can be searched to allow information to be extracted on specified data elements. A record, that is all data for one accession, need not be complete except for required data elements. Some data elements are linked to multiple records (e.g. collector, material, document and so on). As indicated in Chapter 11 of this book, some fields will follow standards (e.g. category of use, language, scientific name, country and so on).

In museums, sometimes there are specimens already entered in the collections that lack detailed information. In these cases, it is of prime importance to recreate ethnographic information about a collection. This information is often held in a different place than the specimen (for example, in monographs concerning a given society, or still in the field notes of the researcher), so every effort must be made to draw together as much information as possible from the collector at the time of object accession. It is also necessary to extract the relevant cultural data from everywhere we can find them (e.g. dissertations, books, papers, field notes, illustrations, photographs, drawings, films and videos).

Interlinking collections, databases, and archives is becoming increasingly essential in our multi-informational age. These linkages form an information-rich trove of people and of plant or animals artefacts and data relating to them that can be used in research, conservation, education and cultural survival. Sharing biocultural information is part of the responsibility of the national institutions, including natural history museums and herbaria, specifically in the context of the Convention on Biological Diversity, which acknowledges the necessity to repatriate information (Article 17.2). Repatriation of the traditional knowledge of indigenous and local communities was again asserted during the 10th Conference of the Parties (Nagoya Meeting, 2010):

- Decision X-42: '*The Tkarihwaié:ri Code of Ethical Conduct to Ensure Respect for the Cultural and Intellectual Heritage of Indigenous and Local Communities*', § 23: 'Repatriation efforts ought to be made to facilitate the repatriation of information in order to facilitate the recovery of traditional knowledge of biological diversity.'
- Decision X/43: '*Multi-year programme of work on the implementation of Article 8(j) and related provisions of the Convention on Biological Diversity*': 'The purpose of task 15 is to develop guidelines that would facilitate repatriation of information, including cultural property, in accordance with Article 17, paragraph 2, of the Convention on Biological Diversity, in order to facilitate the recovery of traditional knowledge of biological diversity.' 'Task 15 is intended to build on, and enhance, existing repatriation activities undertaken by Parties, Governments and other entities including museums, herbaria and botanical gardens, databases, registers, gene-banks, etc.'

Further linkages among other sources of information on peoples, plant or animal materials, culture and environment might be contemplated. Such partnerships might involve art museums, history museums, archaeological museums, personal collections, indigenous peoples in their native environments and so on. We are only beginning to pull together the resources that will help us to understand biocultural interrelationships.

## Literature cited

Alexiades, M. N. (ed.) (1996). *Selected Guidelines for Ethnobotanical Research: a Field Manual*. New York Botanical Garden, Bronx.

Anon. (1931). *Instructions Sommaires pour les Collecteurs d'Objets Ethnographiques*. Musée d'ethnographie (Muséum National d'Histoire Naturelle) et mission scientifique Daka-Djibouti, Paris.

Bahuchet, S. (2002). L'Homme indigeste? Mort et transfiguration d'un Musée de l'Homme. In: *Le Musée Cannibale*, eds M.-O. Gonseth, J. Hainard & R. Kaehr, pp. 59–84. Musée d'Ethnographie, Neuchâtel.

Bahuchet, S. & Lizet, B. (2003). L'Ethnobotanique au Muséum National d'Histoire Naturelle. les hommes, les idées, les structures. In: *Plantes, Sociétés, Savoirs, Symboles. Matériaux pour une Ethnobotanique Européenne, Les Cahiers de Salagon 8*, eds P. Lieutaghi & D. Musset, pp. 15–32. Musée-conservatoire de Salagon et Les Alpes de Lumière, Mane.

Balfet, H. (1975). Technologie. In: *Éléments d'Ethnologie*, vol. 2, ed. R. Cresswell, pp. 44–79. Armand Colin, Paris.

Bouquiaux, L. & Thomas, J. M. C. (eds) (1987). *Enquête et Description des Langues à Tradition Orale. Vol III: Approche Thématique*. SELAF, Paris.

Dournon, G. (2000). *Handbook for the Collection of Traditional Music and Musical Instruments*. UNESCO, Paris.

Florian, M.-L. E., Kronkright, D. P. & Norton, R. E. (1990). *The Conservation of Artifacts Made from Plant Materials*. Getty Publications, Los Angeles.

Gregory, C. A. & Altman, J. C. (1989). *Observing the Economy*. Routledge, London.

Koch-Grünberg, T. (1923). *Zwei Jahre bei den Indianern Nordwest-Brasiliens*. Strecker, Stuttgart.

Kuhnlein, H. V., Smitasiri, S., Yesudas, S., Bhattacharjee, L., Dan, L. & Ahmed, S. (2006) *Documenting Traditional Food Systems of Indigenous Peoples: International Case Studies — Guidelines for Procedures*. Centre for Indigenous Peoples' Nutrition and Environment, McGill University, Sainte-Anne-de-Bellevue. www.mcgill.ca/files/cine/manual.pdf

Martin, G. J. (1995). *Ethnobotany. A Methods Manual*. Chapman & Hall, London.

Mason, S. & Nesbitt, M. (2009). Acorns as food in southeast Turkey: implications for past subsistence in southwest Asia. In: *From Foragers to Farmers: Papers in Honour of Gordon C. Hillman*, eds A. S. Fairbairn & E. Weiss, pp. 71–85. Oxbow Books, Oxford.

Mauss, M. (1947). *Manuel d'Ethnographie*. Payot, Paris.

Mohen J.-P. (ed.) (2004). *Le Nouveau Musée de l'Homme*. Odile Jacob/Muséum National d'Histoire Naturelle, Paris.

Nesbitt, M., Hillman, G., Peña Chocarro, L. Samuel, D. & Szabó, A. T. (1996). Checklist for recording the cultivation and uses of hulled wheats. In: *Hulled Wheats. Proceedings of the First International Workshop on Hulled Wheats. Promoting the Conservation and Use of Underutilized and Neglected Crops 4*, eds S. Padulosi, K. Hammer & J. Heller, pp. 234–245. International Plant Genetic Resources Institute, Rome.

Portères, R. (1961). L'Ethnobotanique: place — objet — méthode — philosophie. *Journal d'Agriculture Tropicale et de Botanique Appliquée* 8: 102–109.

Rivet, P. & Rivière, G.-H. (1930). La réorganisation du Musée d'ethnographie du Trocadéro. *Bulletin du Muséum (Paris) 2e série 2/5*: 1–10.

Seiler-Baldinger, A. (1994). *Textiles: a Classification of Techniques*. Bathurst: Crawford House. 256 pp.

Sturtevant, W. C. (1967). *Guide to Field Collecting of Ethnographic Specimens*. Smithsonian Institution, Museum of Natural History (Vol. 503).

Wendrich, W. (1991). *Who is Afraid of Basketry: a Guide to Recording Basketry and Cordage for Archaeologists and Ethnographers*. Leiden University Centre for Non-Western Studies, Leiden.

CHAPTER 13

# Cataloguing and curation of ethnobiological books and archives

JUDITH WARNEMENT

Harvard University Botany Libraries

Collection curation is an ongoing process that requires clear policies, administrative support, adequate funding, qualified staff, and a secure physical and technical infrastructure. Curators work best when they engage in collaborative relationships with other professionals in their fields of expertise, agree on common standards and share expertise and training. The work of curating biocultural books and archives is very rewarding because the materials are inherently interesting and often quite rare and beautiful. Interactions with the scholars who consult the collections often increase a curator's knowledge and can improve curatorial practices.

Librarians and archivists follow somewhat divergent paths to learn the skills of their professions. This chapter attempts to provide an overview of the standards and practices followed by each profession and to provide useful links to resources on cataloguing subscription services, professional organisations, educational opportunities, suppliers of conservation enclosures and materials, and related topics. It is written from the perspective of a library administrator who relies on an excellent professional staff. Together, we curate a group of important historic libraries that are embedded with equally significant herbaria and museums. We are a research unit in a major university that employs a host of talented faculty, librarians, museum curators, conservators and facilities professionals, who generously share their expertise. Curators should build a community of experts to rely on by contacting local or state libraries, museums, historical societies, regional networks or consortia, and professional organisations.

## POLICIES

Curators should be guided by the organisation's collection policy, which defines the scope, range and priorities for the collection. The policy should be consulted when additions to the collection are considered. For example, the Harvard Botany Libraries maintain the published and unpublished materials that document the history and support the research of the Harvard University Herbaria (HUH). Books that are outside the scope of the collections are offered to other libraries. Archival materials that relate to the herbaria are retained, but the faculty members' professorial papers are transferred to the Harvard University Archives. The Botany Libraries occasionally accept non-Harvard collections recommended by the faculty and curatorial staff because of their value to the research goals of HUH.

Access policies are equally important to guide the library staff and users in the most appropriate use of materials. Libraries often require appointments and special registration procedures and may take other security precautions prior to presenting special collections materials to users. Policies are usually posted on a library's website, and contacting the library prior to a visit is encouraged.

## BOTANICAL AND ECONOMIC BOTANY LIBRARY COLLECTIONS OF HARVARD

Harvard has been collecting plants and botanical books since the Harvard Botanic Garden was founded in 1805. Asa Gray (1810–1888) arrived in 1842 and immediately began to build his herbarium and library. William Hooker (1785–1865) inspired Gray to build a museum of vegetable products in 1858 with a gift of duplicate economic botany specimens. George Lincoln Goodale (1839–1923) offered Plants and Human Affairs, the first course on economic botany offered in the United States and established the Harvard Botanical Museum to exhibit the growing collection of natural product specimens and the beautiful glass models of plants created by Leopold and Rudolf Blaschka. His protégé, Oakes Ames (1874–1950) taught Plants and Human Affairs starting in 1909 and soon amassed an impressive collection of books and specimens to support it. He also hired botanist Frederic T. Hubbard (1875–1962) who was joined by Alfred F. Hill (1869-1960) who in turn authored *Economic Botany: a Textbook of Useful Plants and Plant Products* (Schultes, 1963; 1977). The collections were greatly enriched by subsequent directors of the Botanical Museum, notably Paul C. Mangelsdorf (1899-1989), known for his work on maize, and his successor Richard Evans Schultes. The Economic Botany Library and Herbarium of Oakes Ames have grown to nearly 30,000 volumes and more than 40,000 specimens while the Harvard Botany Libraries collectively hold more than 250,000 volumes, some of which date to the 15th century.

**Image**: D-E. Li-ci, Lum-yen. **Source**: Boym, Michel. *Flora sinensis*, Viennæ: Rictij, 1656. Library of the Arnold Arboretum.

**Image**: Frontis. Sagopalme. **Source**: Eichelberg, Johann Friedrich A. *Naturgetreue Abbildungen und ausführliche Beschreibungen aller in- und ausländischen Gewächse. Waarenkunde.* Zürich: Meyer und Zeller, 1845.

**Image**: fol. 305. Traite du Chocolate. **Source**: Dufour, Philippe Sylvestre. *Traitez nouveaux & curieux du café.* 2. éd. Lyon: Deville, 1688.

## CURATION OF BOOKS

Curation is top priority and a daily challenge, and is often triggered by use rather than by design. Library staff members are well-trained and supervise the handling of all fragile, rare and oversized material. A variety of foam or other flexible cradles and book weights are available to ensure that bindings are supported and pages are held or turned without causing damage. Damaged items are reviewed by a curator who recommends a level of treatment based on available resources. The library staff members routinely perform simple paper repairs, tie loose or broken bindings with linen tape, create simple folders or boxes, or use acid-free envelopes and binders to rehouse items. Links to suppliers are provided at the end of this chapter. The library also orders custom enclosures from a commercial bindery and requests professional conservation treatment from the University's state-of-the-art conservation facility.

## LIBRARY RECORDS AND ORGANISATIONS DEDICATED TO THEM

The physical object is the first thing that comes to mind when one thinks of curation, but maintaining the records associated with the objects or collections is equally important because they are the primary facilitators for discovery and access. Records are updated to accommodate changes in cataloguing rules and subject headings, and to reflect the changes in status or the addition of surrogate copies (e.g. microfilm or digital copies) and preservation notes. Library users are very familiar with bibliographic records, but they might not know how these records are created. Cooperative cataloguing practices in North American libraries are highly evolved thanks to many initiatives supported and promoted by the Library of Congress (LC), in cooperation with library organisations, and Online Computer Library Center, Inc. (OCLC), the premier cataloguing utility, which has nearly 26,000 member libraries.

When a new book arrives on a cataloguer's desk, he or she will log into OCLC through a subscription service to search for the title in the database of more than 233,000,000 records. A matching MAchine-Readable Cataloguing (MARC) record can be imported to the local catalogue for modification. Established in the 1960s, the MARC format provides the protocol for computers to exchange and interpret bibliographic information, and it continues to underpin most automated catalogues. MARC is complemented by an accompanying a set of rules, the Anglo American Cataloguing Rules, 2nd ed. (AACR2), which guide bibliographic description and access to both printed and unprinted materials. AACR was first published in 1967 and then revised in 1988. A new set of standards called Resource Description and Access (RDA) has been developed and was implemented in 2013.

In addition to standards for description and field structure, LC maintains the name and subject authority files, posting updates on its website fifty-one weeks out of the year. Library of Congress Subject Headings (LCSH) began in 1898 with the publication of LC's first integrated dictionary catalogue. Other libraries adopted the model, and LCSH now serves thousands of libraries world-wide and is the de facto standard for subject cataloguing and indexing. The LC name authority file standardises all categories of names including personal, corporate, conference, and geographic names, and series and uniform titles. These combined authority files are freely available on the web.

The International Federation of Library Associations and Institutions (IFLA) is the leading international body representing the interests of libraries and has adopted the same or compatible standards. It sponsored the development and maintenance of the Universal MARC format (UNIMARC) to facilitate international exchange by promoting the use of common authorities, bibliographic records, classification systems and holdings information. The Virtual International

## CONSERVATION AT THE PETER H. RAVEN LIBRARY, MISSOURI BOTANICAL GARDEN

LEFT Missouri Botanical Garden's book conservation room, where restoration and repairs to books and archives are made. Custom book boxes, bindings and various book enclosures are used.

ABOVE During book restoration, heavy crank presses or simple lead weights, such as those pictured here, can be used to aid the adherence of new binding pastes.

ABOVE Leather covers, such as this one on *A Curious Herbal* by Elizabeth Blackwell, were characteristically tooled with gold leaf.

ABOVE Tooling is done using engraved metal implements that impress a design on the cover of a book. They include fillets (pictured here), pallets and finishing tools.

ABOVE Maps and other archives can be encased in polyester film which, unlike lamination, does not permanently adhere to the material surface, thus providing protection while allowing air circulation within the enclosed space.

Authority File (VIAF) hosted by OCLC is a particularly useful resource. Other web services that are supported by libraries and museums can link to MARC records, or the MARC format can be converted to other formats like Dublin Core or XML if necessary. The Library of Congress offers a list of such services on their website and is referenced at the end of this chapter. LC records are considered the gold standard of cataloguing, but the quality of IFLA members' records is highly variable. When two or more records exist for a title, the experienced cataloguer will select the one that most closely adheres to the LC standards, import that record into a local system and then upgrade or modify it to suit local needs. The obvious advantage of shared cataloguing is that it increases productivity.

In our library Harvard University, approximately 20% of our new titles are represented by LC records and another 50% are based on OCLC member libraries' records, often contributed by New York Botanical Garden or Missouri Botanical Garden cataloguers. The remaining 30% require original cataloguing contributed to OCLC by the Botany Libraries cataloguer. LC also provides two subscription-based cataloguing services: Cataloger's Desktop, which integrates cataloguing rules, and Classification Web, which provides access to LC classification schedules, name and subject headings, and genre or form headings.

## Cataloguing systems

The Dewey Decimal system is in wide use internationally but the LC Classification system is widely used in North American academic libraries (see systems comparisons in Table 1). The Botany Libraries at Harvard incorporated the LC system for new monographs in 1990 and selectively reclassified and integrated materials from the four different legacy systems. The older local classification systems are still in use and the schemes used for economic and medical plants devised by Frederic T. Hubbard are summarised below. Working with so many different systems allows us to appreciate the strengths and weaknesses of each. It is essential to understand the basic organisational structure of each system in order to find materials.

Materials on a single topic are relatively easy to classify, and fit neatly into the LC system. Interdisciplinary topics like ethnobiology present a challenge because they are legitimately classified and filed across the entire LC classification scheme. Taxonomists are very familiar with the notion of 'lumping and splitting' and one can see that the Dewey system items are 'lumped' together under 581.6, whereas Hubbard's system and the LC system (Table 1) 'split' ethnobiological titles into very refined subdivisions.

Assigning call numbers is a very subjective process and numbers can sometimes appear to be inconsistently applied when the books are grouped on the shelf. We have noticed this in the LC call numbers assigned to books on medicinal plants and ethnobotany. Therefore, our cataloguer reviews all of the OCLC-imported call numbers and modifies them when necessary. We group the medically-oriented books that feature the plant as the primary subject into QK99 for medical botany. The books that focus on a disease and cure are classified into Rs for medicine and therapeutics.

The cataloguer assigns corresponding LC subject headings and is guided by the notes provided in the authority record. Scientific names are inconsistently represented in the LC subject authority. In fact, the cataloguer is often referred to a common name as the authorised heading. Some libraries add scientific names in a local field, but librarians in larger systems like Harvard are discouraged from doing this.

When one searches the term, 'Medicinal plants' in the public LC Authority file, the system guides the user through a series of screens that list related, broader and narrower terms in addition to the valid authority record. The fields indicate appropriate LC call numbers (053 fields), display

## TABLE 1

Comparisons of Library Cataloguing Systems for botanical, ethnobotanical and biocultural entries

(A) SUMMARY OF THE DEWEY DECIMAL SYSTEM FOR NATURAL SCIENCES AND MATHEMATICS

| | |
|---|---|
| 500  Natural sciences and mathematics | 580  Botanical sciences |
| 508  Natural history | 581  Botany |
| 509  Historical, areas, persons treatment | 581.6  Ethnobotany |
| 561  Paleobotany | 582  Spermatophyta (seed-bearing plants) |
| 570  Life sciences | 583  Dicotyledones |
| 572  Human races | 584  Monocotyledones |
| 573  Physical anthropology | 585  Gymnospermae (Pinophyta) |
| 574  Biology | 586  Cryptogamia (seedless plants) |
| 575  Evolution and genetics | 587  Pteridophyta (vascular cryptograms) |
| 577  General nature of life | 588  Bryophyta |
| 579  Collection and preservation | |

(B) SUMMARY OF LIBRARY OF CONGRESS CLASSIFICATION SYSTEM ASSIGNED TO ETHNOLOGICAL TITLES

| | |
|---|---|
| B | Philosophy, psychology, religion |
| C | Auxiliary sciences of history, history of civilization, archaeology |
| D | History: Europe |
| E–F | History: America. United States — local history, Canada, Latin America |
| G | Geography, anthropology, human ecology, folklore, customs |
| H | Social sciences (economic history and conditions, land use, commerce, social history) |
| Q | Science (geology, paleobotany, natural history, biology, botany, zoology) |
| R | Medicine, therapeutics, pharmacy and materia medica |
| S | Agriculture, plant culture, forests and forestry |
| T | Technology, applied uses of products and materials |

(C) SUMMARY OF HUBBARD'S CLASSIFICATION SYSTEM FOR ECONOMIC BOTANY LIBRARY OF OAKES AMES, HARVARD

| Group | Class numbers | Subjects |
|---|---|---|
| I | 10–12 | Gums, resins, rubber |
| II | 20–25 | Oils, perfumes, etc. |
| III | 30–35 | Dyes and tannins |
| IV | 40–49 | Fibres and textiles |
| V | 50–59.9 | Drugs and allied products |
| VI | 60–69.9 | Food products |
| VII | 70–78.4 | Forest products |
| VIII | 80–89 | Miscellaneous (journals, archaeology, anthropology, etc.) |
| IX | 90–98 | Economic uses (agriculture, horticulture, forestry, etc.) |

# TABLE 2

Library of Congress Subject Authority Records for various biocultural subjects

(A) MEDICINAL PLANTS

| Record: | Explanation of fields: |
|---|---|
| 040 __ la DLC lc DLC ld DLC | DLC Library of Congress symbol |
| 053 _0 la QK99 lc Botany | LC call number for botany |
| 053 _0 la SB293 lb SB295 lc Culture | LC call numbers for agriculture |
| 150 __ la Medicinal plants | 100s fields are authority forms |
| 450 __ la Drug plants | 400s authority is used for these terms |
| 550 __ lw g la Plants, Useful | 500s are related terms |
| 550 __ la Botanical drug industry | |
| 550 __ la Botany, Medical | |
| 550 __ la Materia medica, Vegetable | |
| 550 __ la Psychotropic plants | |
| 680 __ li Here are entered works on the description and/or the cultivation of medicinal plants. Works on the discipline of medical botany are entered under Botany, Medical. | 600s are notes and references |

(B) ETHNOBOTANY

040 __ la DLC lc DLC ld DLC
053 _0 la GN476.73
150 __ la Ethnobotany
360 __ li subdivision la Ethnobotany li under ethnic groups
450 __ la Indigenous peoples lx Ethnobotany
550 __ lw g la Ethnobiology
550 __ la Plants lv Folklore
550 __ la Human-plant relationships
670 __ la Brush, S.B. Valuing local knowledge, 1995.

(C) TRADITIONAL MEDICINE

040 __ la DLC lc DLC ld DLC
053 _0 la GN477 lb GN477.7 lc Ethnology
053 _0 la GR880 lc Folklore
150 __ la Traditional medicine
360 __ li subdivision la Medicine li under ethnic groups
450 __ la Ethnic medicine
450 __ la Ethnomedicine
450 __ lw nne la Folk medicine
450 __ la Home cures
450 __ la Home medicine
450 __ la Home remedies
450 __ la Indigenous medicine
450 __ la Medical folklore
450 __ lw nne la Medicine, Primitive
450 __ la Primitive medicine
450 __ lw nne la Surgery, Primitive
550 __ lw g la Alternative medicine
550 __ lw g la Folklore
550 __ lw g la Medical anthropology
550 __ la Ethnopharmacology

the authorised heading (150 field), broader and related terms (550 fields) and unauthorised terms (450 field). The authority record also suggests how to correctly apply the term (680 field). Table 2A outlines the record for Medicinal plants.

Ethnobotanical titles that are classified within anthropology (GN) are also reviewed. Those in which a specific culture is the main focus are grouped under GN, and books on useful, edible or poisonous plants are moved to the appropriate QK ranges. The LC subject headings for Traditional medicine and Ethnobotany show that LC favours using the anthropology GN classes for these titles (See Table 2B). Locally, the GN geographic subdivisions are used in a non-standard way. Ethnobotany books subdivided by ethnic groups that are usually classified in history ranges (D–F) are grouped together instead under GN and then subdivided geographically. This approach is cautiously recommended because it requires a dedicated cataloguer who documents local practices so that they can be consistently applied in the future.

The holdings field attached to a bibliographic record includes details associated with each piece. The call number or alternative shelf mark that indicates the location of the piece is the most important information for the user, but the library may also add public and internal notes to distinguish copies, trace the provenance, add conservation notes or record other information. Barcodes or other unique identifiers enhance inventory control. The coding in these fields can also generate messages in the public catalogue about local access policies.

## TABLE 3

### Harvard catalogue record with detailed holdings

---

**HOLLIS number:** 005607886

**Author:** Trappen, J. E. van der (Jan Everard)

**Title:** Specimen historico-medicum de Coffea/submittit Johannes Everhardus van der Trappen.

**Publisher:** Trajecti ad Rhenum [Utrecht]: Kemink & Filium, 1843.

**Description:** 152 p.; 22 cm.

**Note:** Thesis (doctoral) — Academia Rheno-Trajectina, 1843.

**Note:** Includes bibliographical references (p. [145]–152) and index.

**Reference:** Pritzel, 9436.

**Subject:** Coffee — Therapeutic use — History.

**Other Titles:** Harvard economic botany preservation microfilm project; 00535.

**Location:** Networked Resource: Online: http://nrs.harvard.edu/urn-3:HUL.FIG:005607886

**Reproduction note:** Electronic reproduction. Google Book Search Library Project, 2008.

**Restrictions:** Access to portions of this material may be restricted. Botany Arnold (Cambr.) MH 270.2 T68.3
This item may be available to use inside the library, but non-circulating. Contact Botany Arnold (Cambr.) for more information.

**Location:** Botany Econ. Botany 61 Collection Status Barcode In-library use Not checked out.

**Location:** Microforms (Lamont) Harvard Depository Film W 21625

**Reproduction note:** Microfilm. Harvard College Library Imaging Services, 2003. 1 microfilm reel; 35 mm.

**Please note:** For availability of this copy, see: Kopp, Andre /Les ananas / Record Number: 5614681. This item may be available to use inside the library, but non-circulating. Contact Microforms (Lamont) for more information.

---

Both the bibliographic record and item records are routinely updated if the status of an item changes. For example, the record shown in Table 3 shows notes and holdings that reflect a microfilm project and the locations of the microfilm, as well as the Google Books project note and link to the digital version. The notes are added when the reformatting process is completed.

Most automated library systems include circulation systems that track usage. Use of special collections materials may require detailed record keeping, including detailed user registration, paging forms and permission forms. Permissions to cite, publish or reformat materials are guided by copyright and an institution's policies. Permissions are generally granted to support teaching, scholarly research, preservation and access. Requests from commercial sources often require assistance from the legal department to negotiate fees and contracts or licenses. For commercial uses of ethnobotany materials, other considerations might apply such as intellectual property rights and benefit sharing (see Chapters 1, 11 and 16).

## DIGITISATION OF PRINTED WORKS

The digitisation of printed works enhances access to materials beyond library walls and reduces the handling of often fragile physical works. Since the mid-1990s, scholars have become increasingly reliant on consulting journals through institutional subscriptions, but are often less aware of the wealth of historical material freely available online. Additionally, many new and valuable resources are only published electronically. Providing access to a broad range of electronic resources and search portals is an essential role for libraries.

Google Books and the Internet Archive offer the largest collections of digitised materials. Google Books is easy to search and is a good starting point, but is inconsistent in its approach to the availability of full text for out-of-copyright volumes. The Internet Archive is more rigorous in its cataloguing and consistent in the application of copyright restrictions, but has a more rigid search interface. Part of its natural history content is derived from two other projects. Botanicus is the book digitisation initiative of the Missouri Botanical Garden, which inspired the global collaboration known as the Biodiversity Heritage Library (BHL). Both platforms contain specialist facilities designed to support taxonomic research, while the Internet Archive allows full text searching. BHL has evolved to deliver primary source materials, including field notes and correspondence. Digitisation not only makes it easier to see specific materials; it is also an enormously powerful tool for searching full text, bypassing the limitations of traditional cataloguing.

In addition to the international projects, regional projects often digitise material of interest to ethnobotanists. For example, the European Union funded the development of Europeana to serve as a portal to national or regional scanning projects throughout Europe. One project of particular interest is the National Library of France Gallica site, which delivers about 370,000 books and a wealth of primary source materials that document natural history and exploration. The Biodiversity Heritage Library is a member of Europeana and the content is also delivered via its portal. Researchers should not assume that the rich content found deep within these websites can be discovered by a simple Google search.

## CURATION OF ARCHIVAL MATERIALS

The organisation and description of archival collections use the same LC authorities and bibliographic standards used for books, but are supplemented by guidelines and tools supported by the Society of American Archivists (SAA). The public catalogue may include a summary record for a collection that gives a brief description, conveys its extent in linear feet, and notes the history and provenance. Name

## STORAGE AND DISPLAY AT THE PETER H. RAVEN LIBRARY, MISSOURI BOTANICAL GARDEN

ABOVE Overview of Missouri Botanical Garden's rare book room, which houses treasures such as the first edition, first printing of Charles Darwin's *On the Origin of Species* in a secure, climate controlled environment.

ABOVE Folio shelving with rollers can assist in transferring large books to and from shelves as well as limit damage from shelf friction.

ABOVE Protective book boxes can be custom made to fit rare books. Pictured: *Latin Herbarius* by Peter Schöffer, 1484.

ABOVE Foam book cradles are appropriate for supporting rare books while in use. *Species Plantarum*, Carl von Linné, 1753 displayed on foam cradle.

LEFT

*Les liliacées* by Pierre Joseph Redouté, 1805–1816. This book underwent conservation at MBG in the 1980s during which time it was cleaned and rebound. The tissue divisions placed in between the face-to-face images prevent accidental offprinting.

and subject tracings are included for significant individuals, materials, institutions, other topics and the various media (or form and genre terms) represented in the material. The holdings statement may display a shelf mark and information together with access information (e.g. access may be restricted). The HOLLIS record (Table 4) briefly describes the contents of the Richard Evans Schultes Collection in the Botany Libraries and includes a link to a more extensive finding aid. Web-based finding aids are encoded in the archival standard, Encoded Archival Description (EAD) or HTML, or may be available in PDF format.

An archival finding aid provides a detailed description of a collection and includes a brief biography of the individual or history of the organisation, a summary of the scope, content and provenance of the collection, and is organised into the series that comprise the collection. The series are often divided by material type and can include correspondence, research, publications, awards, images and so on. Original or unique materials come first and published materials file at the end. Significant correspondents and collaborators are listed chronologically, and other appropriate names, topics and elements are listed. Artefacts or specimens that are considered part of a collection are often itemised. For example, the scope and content note that describes the Schultes collection says: 'The Richard Evans Schultes Papers contain correspondence, research notes, unpublished manuscripts, printed material, collection lists, identification and classification lists, maps, photographs, prints, plates, newspaper clippings, first draft copies of writings, and species research. The bulk of the collection is primarily printed material collected

## TABLE 4

Harvard Catalogue Record for the papers of Richard Evans Schultes

---

**HOLLIS number:** 012798895

**Author:** Schultes, Richard Evans.

Title: Papers of Richard Evans Schultes, 1937–1999

**History notes:** Richard Evans Schultes, 1915–2001, American ethnobotanist, educated at Harvard University; worked for the United States Department of Agriculture's Bureau of Plant Industry, later served as curator of the Orchid Herbarium of Oakes Ames (1953–1958), Curator of Economic Botany (1958–1985), executive director of the Botanical Museum (1967–1970), and director of the Museum (1970–1985).

**Summary:** Consists of correspondence, research notes, unpublished manuscripts, printed material, collection lists, identification and classification lists, maps, photographs, prints, plates, newspaper clippings, first draft copies of writings, and species research. The bulk of the collection is primarily printed material collected by Schultes in addition to a large amount of research notes on rubber plant species and the ethnobotanical use of plants.

**Cite as:** Richard Evans Schultes Papers. Economic Botany Archives of Oakes Ames, Harvard University.

**Subject:** Schultes, Richard Evans. Schultes, Richard Evans — Correspondence.

**Subject:** Ethnobotany. Hevea.

**Form/Genre:** Correspondence. Research notes. Drafts (documents). Clippings (information artefacts). Photographs. Maps. Field notes. Laboratory notebooks. Projectors (image projectors). Audiocassettes. Videotapes.

**INTERNET LINK:** Finding aid HTML: www.huh.harvard.edu/libraries/schultes.htm

**Location:** Botany Econ. Botany Archives Library Info

**Restrictions:** Access restricted; access to qualified researchers by appointment only.

**Finding aids:** Inventory available in library or via the Internet: folder level control.

**Authors:** Schultes, Richard Evans.

---

**Figure 1.** A selection of books on ethnobiological topics.
PHOTO: JULIE LAFARGE MCINTOSH, © HARVARD UNIVERSITY HERBARIA BOTANY LIBRARIES

by RES in addition to a large amount of research notes on rubber plant species and the ethnobotanical use of plants. The collection is organised in the following series. I. Correspondence. II. Identification and classification notes. III. Hevea research. IV. Ethnobotany research. V. Manuscripts. VII. Subject files. VIII. Newspaper clippings (biographical information). IX. Miscellaneous material. X. Oversize material.' Dr. Schultes's professorial papers are deposited at the Harvard University Archives and appear on a separate record in HOLLIS, but there is no finding aid available for the collection.

Locating archival materials can be very challenging. Depositories often have backlogs of uncatalogued collections and those collections that are catalogued usually only offer general rather than item-level descriptions of individual documents. If the obvious route — a Google search — does not lead to a discovery, then there are others to try. The ArchiveGrid, hosted by OCLC,

**Figure 2.** Richard Evans Schultes field notes, 1952. Source: Richards Evens Schultes Papers. © HARVARD UNIVERSITY HERBARIA ECONOMIC BOTANY ARCHIVES.

allows researchers to search for primary source material held in archives, special collections and manuscript collections around the world. Researchers can also find contact information for individual repositories to obtain further assistance. Union catalogues are increasingly available; the USA has, among others, the National Union Catalog of Manuscript Collections (NUCMC). Locating the website of a country's national archive is always a good starting point when looking for union catalogues. Archivists at likely repositories should be consulted to see if they hold relevant material that has not been digitally catalogued, or if they know of material held elsewhere.

In addition to describing and cataloguing collections, archivists must also physically process the materials. This includes removing rusty staples and paper clips, enclosing acidic objects, discarding duplicates and sorting misfiled materials. Preservation photocopies are made and damaged items are stored with the originals. Materials are organised chronologically in acid-free files and stored by series in acid-free document boxes or in file cabinets. Photographs, glass slides, artefacts, and oversized items are stored in appropriate enclosures. Archival storage areas are usually secure, climate-controlled and furnished with sturdy wide flat shelving that can hold many document boxes. Open space for large objects and other storage options such as art racks, file cabinets, flat files and safes are common. Larger institutions may attach a barcode to each box for remote storage inventory control and retrieval.

Archivists who want to develop their skills can take advantage of continuing education classes offered by the Society of American Archivists (SAA) and SAA regional chapters. SAA also publishes useful guidelines. The Archivists' Toolkit™ is an open-source archival data management system that helps to integrate archival processing and production and to promote data standardisation. Archivists should investigate funding opportunities offered by government agencies, cultural institutions and philanthropic organisations that support curation, digitisation and enhanced access to archival collections.

The Botany Libraries' various archival collections include a range of early photographic images (Chapter 14) including daguerreotypes, tin types, salt prints, albumen prints, glass lantern and stereoscopic slides. The Economic Botany Herbarium collection includes amber, silver, ivory, lacquer (Chapters 2, 4) and an assortment of original illustrations. Selecting appropriate enclosures for each type of medium often requires research and consultation, so having a circle of experts to call upon for advice is helpful. Each item is inventoried and noted in the finding aid to enhance discovery and access and is made available by appointment to scholars, used in classes and loaned for exhibits. The piece is inspected before and after every use and rehoused when necessary.

## PALMER COLLECTION AT HARVARD

All of the unpublished material and related correspondence associated with the United States' South Seas Exploring Expedition, also known as the Wilkes Expedition, and the field notes from Edward Palmer's collecting trips to Mexico and the southern USA from 1853 through 1910, are available via a page delivery service (PDS) in HOLLIS. The Palmer notes have been consulted frequently and were our highest priority because of their condition. Palmer's notes were in pencil made on oversized and acidic brown newsprint. The leaves of notes were repaired and many were encapsulated prior to scanning. This meant that they had to be reordered and rehoused when they were returned from the imaging lab.

A 'permission to examine' form is completed for every archives request. The forms are archived to document the use of the collections and as references to subsequent requests. They are often accompanied by requests to publish images. The condition of the item and the methods available to create an image safely must be considered prior to granting permission. Many archives now allow users to undertake their own digital photography — without flash — for research use. Harvard Libraries offers limited low-cost scanning options and can arrange for more specialised fee-for-service solutions from another Harvard department. Requests for scholarly use are routinely approved, whereas requests for commercial use are reviewed with administrators and might involve consultation with the legal department. The Harvard University Herbaria permission forms can be accessed conveniently on the HUH website.

There are many examples of the large-scale digitisation of archives relevant to ethnobotany: perhaps the most significant at present is the photography and abstracting of over 25,000 letters written to directors of the Royal Botanic Gardens, Kew between 1841 and 1920. These are now available to researchers via JSTOR Plant Science (Figure 3). Digitisation makes archives more accessible to distant users, but also has the added advantage of improved cataloguing. For example, in the JSTOR project, each letter has a formal catalogue record (a level of detail not usually available for archives), and additionally a detailed summary of the letter's contents, carefully chosen so as to include the names of people, plants and places featuring in the originals. Handwritten texts are not susceptible to Optical Character Recognition (OCR); the preparation of detailed abstracts is thus a good compromise in place of time-consuming full transcription.

Other archival collections have been reformatted and delivered via the internet to promote scholarly research with funds from the Harvard University Library Open Collections Program. Tools are being developed to link published materials and field notes in library archives to specimens in the herbarium. Biodiversity Heritage (BHL) partner libraries have a grant from the Institute of Museum and Library Services (IMLS) to digitise specimens, field notes, published works and related content. For example, the Harvard University Herbaria project will deliver content on the flora of

**Figure 3.** Screenshot from JSTOR Plant Science, showing a letter from Sir John Kirk to Sir Joseph Dalton Hooker; from H. M. S. Pioneer, River Shire, Malawi; 9 Jan 1861.
© ROYAL BOTANIC GARDENS, KEW.

**Figure 4.** Screenshot from Biodiversity Heritage Library, showing a page from Walter Deane's Lists of New England plants, Cambridge, Massachusetts, 1899.

© HARVARD UNIVERSITY HERBARIA ECONOMIC BOTANY ARCHIVES.

the Middlesex Fells Reservation in Medford, Massachusetts from 1896 to the present (Figure 4). All of the BHL materials will link to the Smithsonian's Field Book Project funded by the Council for Library and Information Resources (CLIR). The participating institutions will describe their collections using TDWG's Natural Collections Descriptions (NCD) standard.

## CONCLUSION

Librarians and archivists follow well-established international standards for the creation of bibliographic records and finding aids to describe books, journals, manuscripts, artefacts and archival collections. The ability to share records improves the overall efficiency of the staff and ensures high-quality cataloguing. A cataloguer's ability to adopt or adapt a classification system is largely dependent upon the size and structure of the parent institution. Local modifications can improve discovery and access as long as the library can maintain the practice. However, highly customised cataloguing that works well in a stand-alone institution might inhibit the ability to merge records in a shared catalogue such as the Biodiversity Heritage Library.

Maintaining the bibliographic description as well as the physical object is an ongoing challenge. It is doubtful that any of our collections will have the resources to be curated perfectly, and at any given moment we might face an emerging discipline, a new technology, a burst pipe or a surprise package in the mail with materials that need to be integrated into the collections. Every day is a challenge, but also an opportunity to learn something new.

## Conservation supplies

Bookmakers, Inc. www.bookmakerscatalog.com (Clarkson foam book supports)
Demco Archival Supplies. www.demco.com
Gaylord Archival Supplies. www.gaylord.com (Closed-cell polyethylene book mounts)
Hollinger Metal Edge. www.hollingermetaledge.com
University Products Archival Supplies. www.universityproducts.com

## Websites

*Anglo American Cataloging Tools, 2nd ed.* (AACR2). www.aacr2.org
*ArchiveGrid*. http://beta.worldcat.org/archivegrid
*Archivists' Toolkit™* (AT). www.archiviststoolkit.org
*Biodiversity Heritage Library (BHL)*. http://biodiversitylibrary.org
*Biodiversity Heritage Library (BHL)*. *Field Notes*. www.biodiversitylibrary.org/subject/Field+notes
*Botanicus*. www.botanicus.org
*Council on Botanical and Horticultural Libraries (CBHL)*. www.cbhl.net
*Council for Library and Information Resources (CLIR)*. www.clir.org
*Europeana*. www.europeana.eu
*Gallica*. http://gallica.bnf.fr
*Google Books*. http://books.google.com
*Guild of Book Workers*. http://guildofbookworkers.org
*Harvard Botany Libraries*. *Economic Botany Archives*. www.huh.harvard.edu/libraries/economic.htm
*Harvard Botany Libraries*. *Tina & R. Gordon Wasson Ethnomycological Collection Archives*. www.huh.harvard.edu/libraries/wasson.htm
*Harvard University Herbaria permission forms* www.huh.harvard.edu/collections/publish_images_permission.html
*Harvard University Library Catalog (HOLLIS)*. http://lib.harvard.edu
*Harvard University Library Open Collections Program*. http://ocp.hul.harvard.edu/expeditions
*Harvard University Weissman Preservation Center*. http://preserve.harvard.edu
*Institute of Museum and Library Services (IMLS)*. www.imls.gov
*International Federation of Library Associations and Institutions (IFLA)*. www.ifla.org
*Internet Archive*. http://archive.org/details/texts (full text search: http://openlibrary.org/search/inside)
*JSTOR Plant Science*. http://plants.jstor.org
*Library of Congress Authorities*. http://authorities.loc.gov
*Library of Congress Cataloger's Desktop*. www.loc.gov/cds/desktop
*Library of Congress Cataloging and Acquisitions*. www.loc.gov/aba
*Library of Congress. Encoded Archival Description (EAD)*. www.loc.gov/ead
*Library of Congress Classification Web*. www.loc.gov/cds/classweb
*Library of Congress Classification Outline*. www.loc.gov/catdir/cpso/lcco
*Library of Congress Subject Headings (LCSH)*. http://authorities.loc.gov
*MARC Format for Bibliographic Data*. www.loc.gov/marc/bibliographic
*MARC to Dublin Core Crosswalk*. www.loc.gov/marc/marc2dc.html
*MARC Tools*. www.loc.gov/marc/marctools.html
*National Union Catalog of Manuscript Collections (NUCMC)*. www.loc.gov/coll/nucmc
*OCLC Cataloging via Connexion®*. www.oclc.org/connexion

Palmer, Edward. *Collecting trips to Mexico and the Southern United States from 1853–1910.* http://ocp.hul.harvard.edu/expeditions/palmer.html

*Rare Book School (RBS).* www.rarebookschool.org

*Resource Description & Access (RDA) Toolkit.* www.rdatoolkit.org

*Resources for New Archivists.* www.library.yale.edu/~kspicher/mssrepos/resources_gateway1.htm

*Smithsonian Institution Field Book Project.* www.mnh.si.edu/rc/fieldbooks

*Society of American Archivists (SAA).* www2.archivists.org

*Society of American Archivists Describing Archives: a Content Standard (DACS).* www.archivists.org/catalog/stds99

*Smithsonian Institution Archives Field Book Project.* http://siarchives.si.edu/blog/field-book-project-uncovering-hidden-gems-smithsonian

*Taxonomic Database Working Group (TDWG) Natural Collections Descriptions (NCD).* www.tdwg.org/activities/ncd

*United States South Seas Exploring Expedition (The Wilkes Expedition) Papers.* http://ocp.hul.harvard.edu/expeditions/wilkes.html

*Virtual International Authority File (VIAF).* http://viaf.org

## Literature cited

Schultes, R. E. (1963). Frederic Tracy Hubbard (1875–1962). *Taxon* 12: 1–2.

Schultes, R. E. (1977). Albert Frederick Hill and economic botany. *Economic Botany* 37: 378–382.

CHAPTER 14

# Curating ethnobiological photographs

WILL MCCLATCHEY

Botanical Research Institute of Texas and University of Hawai'i at Manoa

KIM BRIDGES

University of Hawai'i at Manoa, Honolulu, Hawai'i

## INTRODUCTION

Twenty-five years ago, the fact that photography was expensive was reflected in our efforts to budget carefully how much slide film we took to the field, making sure that it would stretch over months of work, and in the time we took to frame and compose each image. As a result, many of us have piles of slides that we spent fortunes to produce. The conservation of these slides has been a big concern, but standardised methods for conservation of these resources have already been developed. Therefore, after briefly reviewing what to do with our past materials, this chapter focuses on the exponential increase in data that has come about with the digital revolution over the last two decades. Now, it is not at all difficult to generate more images in a single day than were produced in an entire year twenty years ago. How are we to manage this massive increase in data? How should it be sorted? How can it be archived in such a way that researchers now and in the future can reasonably access it and make sense of it? It is likely that we are generating more information than we can use. If that is the case, then what are we to do about it? These are difficult questions for ethnobiologists, most of whom have traditionally been associated with herbaria, museums and other archives, where accumulation of data is a tradition that has not often involved culling processes. As our discipline has accepted new technologies, new methods and new opportunities, perhaps we will also choose new mechanisms for curation.

## APPLICATION OF SCIENTIFIC PRINCIPLES OF DATA COLLECTION AND MANAGEMENT TO THE CURATION OF DIGITAL IMAGES

International working groups have been wrestling with the challenges of standardising and managing scientific data in general (e.g. Dreyer et al., 2009). For the most part, botanists collect standardised parts of plants to serve as specimens representing those plants (Chapters 3 and 22; Alexiades, 1996). Attempts are made to collect these in standard sizes and to store them in standard ways (Bridson & Forman, 1998). While there are exceptions within botanical collections and within herbaria where unusual collections are curated, the field-method standards that are used for training students of botany are centred on the use of a general rule, rather than on the exceptions. The same approach may be applied to ethnobiological photography. It is best to begin with standards and then to work with non-standardised materials, either to fit them into the system logically or to treat them as special collections. Here, we focus primarily on the archiving of simple digital images, but we also consider some of the more unusual types of digital images that are now being generated.

It is important to begin with three points. Images used as supporting evidence for ethnobiological research: 1) do not merely consist of plants or animals in various conditions, including voucher specimens; but 2) often include the context in which plants or animals are used (e.g. humans and human cultures, natural and artificial environments); and 3) may include images from the very large scale (e.g. satellite imagery, aerial photography, panorama) to the very small or microscopic scales (e.g. various forms of optical and electron microscopy imagery).

Two aspects of the concept of sampling in science are important to the archival conservation of images. First, researchers must balance under- and oversampling. With digital photography, oversampling is a distinct possibility, particularly as the speed of the photographic process and the storage capacity of some cameras now matches that of video equipment (leading to streams of individual frames that can be assembled into video). Second, it is important to consider systematic sampling (methodology), sample integrity and result reporting. When applying most scientific methods, for example when laying out a diversity assessment plot or conducting an ethnographic interview, researchers would not think about loosely collecting data and then using their personal biases to select the particular samples to report as 'most interesting'; but this is exactly what often happens with photography in ethnobiological research. Researchers should be explicit in their photographic production methodology, culling process and methods for the selection of specific photographs for conservation as 'representative' of the work. (Details of these methods are beyond the scope of this chapter).

Some basic principles about research data need to be remembered when considering the curation of photographic materials, particularly digital photographs. 1) Original data samples should be preserved and referenced as voucher evidence of research. 2) Contextual data (e.g. placing data in space and time) associated with evidential samples are just as critical as the samples themselves. Images gathered at different times and places should not be combined into a single image. 3) Image integrity is essential for the research process. Therefore, original photographic samples should be minimally processed. When curated images have been processed, the processing software, settings and processing manipulations used should be recorded with the sample. 4) Archived data should not be stored in such a way that it is modified through resizing, resampling or reformatting in the process of storage or retrieval. The most common problematic examples involve photo-sharing systems (e.g. Flickr, Picasa and SmugMug), word processors (e.g. Word, Word Perfect, Open Office Writer and Google Docs), presentation programmes (e.g. Power Point, Corel Presentations, Impress or Prezi), video editing software (e.g. Final Cut Pro or Premiere Pro), and other software that does not store images in their original file formats and at their original size.

## PERSPECTIVES ON THE PHOTOGRAPHIC CONSERVATION PROCESS

### Conservation of photographic materials

The care and conservation of physical photographs has long involved three aspects (Zucker, 1985): 1) selection of images to be conserved through a process of determining the significance of collections; 2) development of secure storage and handling procedures for the photographic materials that balance conservation and user needs; and 3) disaster prevention and management planning for events that could impact collections. Photographs selected for conservation should be managed in different ways based upon their product format stability and method of use (Wilhelm & Brower, 1993). Although standards were originally developed for traditional, chemical-based photography, the same concerns need to be considered for digital images.

Standards for photographic production and conservation have been generated by the American National Standards Institute, the International Electrotechnical Commission and the International Organization for Standardization (ISO). The standards generated by subgroups of each of these organisations are intended to reduce variation in products so that quality is improved and conservation efforts are more predictable and effective. Several organisations provide up-to-date information about photograph conservation, each with specialty groups focused on photographic materials.

These include the American Institute for Conservation of Historic and Artistic Works, the Image Permanence Institute, and the International Council of Museums – Committee for Conservation (see also Lavedrine (2003) and Ritzenthaler & Vogt-O'Connor (2006)).

Two approaches to conservation that need to be emphasised are the generation of high-quality archival copies (Benson, 2009) and the production of digital copies. Depending on the materials used for archival copies, they may in fact last longer, even with regular use, than originals (Hodges, 2003). Digital copies, once made, are very easy to use and distribute. However, the process of generating either archival or digital copies inevitably involves wear and damage to the original, thus reducing its total life. The storage of copies also may be costly (Chapman, 2003). Therefore, it is important to weigh the value of producing copies in relation to the simple conservation and use of originals.

## Life cycle of a data object

There are several steps in the curation process that need to support the entire life cycle of a data object, starting with its generation and ensuring the long-term preservation of the metadata itself (Dreyer et al., 2009):

- planning for preservation (e.g. Kulovits, 2009);
- standardising collections;
- collecting materials and data;
- processing, sorting and filing collections according to the preservation standard;
- improving the process;
- disseminating the above cycle for community review and/or adoption.

## Establishing workflow

Development of a clear and resilient workflow process is the fundamental key to success in curating collections of images. If this process is simple, it will be followed. If it is automated, it will happen. If it is implemented as a fundamental and necessary activity, it will have a chance of being effective. The lack of implementation is the primary reason for failure of most workflow plans. A few recommendations concerning workflow are listed here.

- Place digital-archive images in large collection folders with few internal divisions and don't waste time on renaming individual image files with details such as the name of specific plants or locations.
- Once an archival collection is built and backed up, DO NOT add more content to that collection. Consider it as a permanent, 'read only' record.
- Make frequent (daily or weekly) back-up copies of currently active collections. Plan to close these and convert these into an archival collection as soon as possible. Image files should become an archival collection as soon as photographic data from a project are collected and processed for storage. Keep as few items as possible in categories that need to be backed up on a regular basis.
- Use software to batch-process digital images (changing file names and so on) rather than changing them manually. Mistakes happen through manual entry, which also wastes a lot of time.
- File names should be unique (e.g. using an alphanumeric system), and may include abbreviated details — such as the initials of the photographer, date and photograph number — because these attributes can be rapidly changed over a large number of images using software and will create unique file names.
- Files should be found in only one location within a catalogue. There should not be copies in multiple locations (except for in duplicate or backup archives).

An important feature of photographs (of any sort, including digital images) that often distinguishes them from other kinds of data objects is that they easily exist as both original versions and as multiple copies or transformed versions. Transformed and resized sets may be produced for display or accessing purposes, but the primary archival version should remain the single highest-quality version that was originally generated either in a physical or digital format.

Determination of archival units (e.g. files, collections or hard-drives) and file-naming and organisational structures is important and should be carried out a priori for a particular user group. A system needs to be developed that will not change over time. A robust system meet both current researcher interests and those of future researchers without a need for changing the filing system. Ideally, this balance will function within the framework, recognising that current research is actively using recent image files, while older image files are archived allowing limited access.

## A PROCESS FOR IMAGE ACCESSION

### Selection of images

Researchers and curators need to enter into discussion to determine what information concerning digital images should be conserved. If digital images are considered to be field research data results, the same as any other form of data, then it would be very unusual to sort through the data and remove data points that are unseemly, less useful or redundant, especially if the images were generated from a systematic method. If there was no scientific method behind the generation of the images, then there may be reason to question the scientific basis on which the images represent supporting evidence for a scientific research project. The balance between these two conversations is weighty and will result in decisions about what should be retained and how much culling is reasonable.

Current ethnobiological research projects often generate thousands or even tens of thousands of high-megapixel (5–10+Mb) images over periods of weeks to months. A curator needs to develop a system for archiving these images for current and future research access without excessive resource and staffing demands. The simplest system is to archive all images in one collection under a single title. This is an obvious system that is often employed in archives. The files in such a system are labelled with a name such as 'The Archibald Expedition'. This is not, in fact, terribly useful for future researchers, especially those in multi-disciplinary fields such as Ethnobiology. A label that identifies the origin of data in time and space is generally more useful. A collection label of 'New Guinea 1936' is therefore more intuitive and provides sufficient context for a wide range of researchers to enter the collection and explore further.

Images within a collection should be preserved within their original file format. There is a temptation to standardise all images to the same file format (perhaps JPEG) for curation, but the original should be preserved. The United States' National Archives has developed detailed standards for the digitisation and electronic archiving of photographic materials and for the storage of associated metadata (Puglia et al., 2004). The guidelines include advice on the inclusion or exclusion of digital photographic records. Excluded images include:

• Low-resolution photographs typically created for posting on agency websites (i.e. all files created at less than 2 megapixels, or scanned as less than 2000 line files).

• Digital photographs captured within office automation applications (e.g. those in word processing, spreadsheet and presentation applications).

• Digital aerial photography and photogrammetric and satellite imagery.

• Vector-based images, such as records created using graphic arts software or computer-aided design (CAD) applications.

Archival collections of digital images should be identified, accessioned and then closed. It is rather precarious to hold a collection open because this leads to problems in the process of ongoing data back-up. If a particular collection of digital images is accepted to be curated, it should be given working-file status. Then, after the dataset has been properly prepared for the archive, the entire collection should be archived as a closed collection.

Researchers will often edit images. Edited images may be submitted as part of collections but it is critical that unedited originals are also submitted as these are the actual data. If edited images are submitted after an archival collection has been closed, then they should be archived as a new collection and not placed within the closed archive.

## Metadata

Each image file has metadata embedded or coded within it. This is information about the image that is stored within the same file. These data are different from information within a database that is stored separately from the image files. Metadata are descriptors that relate to the specific image, such as the date and time the image was taken and the kind of camera that was used. Some metadata are automatically inserted by the camera either using preset features or features determined by the user. Other data fields can be filled in by researchers, curators or others. Metadata can be added, changed or deleted, but always moves with the image file. The International Press Telecommunications Council metadata core and extension standard (IPTC) (Saunders, 2010) has been established as a format standard for digital metadata content. The IPTC is constructed upon a guiding 'Embedded Metadata Manifesto'.

• Metadata is essential to describe, identify and track digital media and should be applied to all media items that are exchanged as files or by other means such as data streams.
• Media file formats should provide the means to embed metadata in ways that can be read and handled by different software systems.
• Metadata fields, their semantics (including labels on the user interface) and values, should not be changed across metadata formats.
• Copyright management information metadata must never be removed from the files.
• Other metadata should only be removed from files by agreement with their copyright holders.

More information about the Manifesto is available (IPTC Photo Metadata Working Group, 2007 (see website)). Table 1 shows the core IPTC metadata fields.

The Simple Dublin Core metadata standards also include a number of fields that are generally applicable to data collected with images (Table 2). Dublin Core is a set of common vocabulary terms developed by ISO intended for data discovery through search engines and other electronic exploration and information accumulation systems. There are different versions of the Dublin Core, some with specific sets of expected content and others that are less specific. A less specific data standard is being more widely employed in libraries and archives and is likely to be more familiar to both researchers and curators.

Metadata should be embedded within files in order for the descriptive data to move efficiently with the files, but some software packages are designed to generate 'sidecar files', usually requiring proprietary software to match the sidecar file with the image file and thus keep the associated data with the image. This is a crucial difference from a curation standpoint. Individuals submitting images for archival storage need to be aware of the difference between the editing of metadata within a file and the generation of sidecar files. It is probably wise for curators to elect to only curate files with internal metadata rather than to become involved in managing complex file sets of images, sidecar

## TABLE 1
Core IPTC metadata fields (after Saunders, 2010).

| INFORMATION | IPTC CORE FIELDS | NOTES ON USE |
|---|---|---|
| Contact | Creator's contact details | The creator of the image. This data does not change, even if copyright changes hands. |
| | Creator | Creator's job title. This could be the job title of a staff photographer, freelancer or other role. |
| | (Address, City, State/Province, Postal code, Country, Phone, Email, Website) | How to contact the creator of the image (who is not necessarily the supplier, which is catered for in IPTC Extension) |
| Image | Date created | The date, and optionally the time, the image was created. This can be copied from the Exif information |
| | Intellectual genre | The artistic or intellectual nature of an image expressed in terms from a controlled vocabulary. The IPTC Genre News-codes can can be found at www. newscodes.org. They are not specific to photos. The IPTC Scene Code Controlled list includes IPTC Scene News-codes (e.g. close up, action or night scene). See www.newscodes.org |
| | Location (Sub-location, City, State/Province, Country, ISO country code) | This is a legacy field used to indicate the location of the image. We recommend using 'Location Created' or 'Location Shown' in IPTC Extension to distinguish between the location where the image was shot and the location shown in the image. |
| Content | Headline | A brief summary of the description, this field is where an abbreviated reference to the image contents is required (e.g. a short descriptor for news items, for use under thumbnails in a database, or as a shoot reference.) |
| | Description | This field contains the image caption: the who, what, where, when and why of the image contents. |
| | Keywords | Keywords are search terms for finding the image; they may be single words or phrases. |
| | IPTC subject code | Specifies subjects from the Subject-Newscodes controlled vocabulary. See www.newscodes.org. |
| | Description writer | The name of the person involved in writing, editing or correcting the description of the content. |
| Status | Title | The title is a shorthand reference for the item, which can be text or numeric. It is often used for the file name or picture number. |
| | Job ID | This is a job number used to track and identify the job for which the image was supplied. |

**TABLE 1** (contd)

| INFORMATION | IPTC CORE FIELDS | NOTES ON USE |
|---|---|---|
| Status (contd) | Instructions | Instructions from the provider or creator of the image. This field can contain information about restrictions on image use (not catered for in Rights usage terms), about embargos or about technical details that might assist in good reproduction. |
| | Credit line | The credit that should be displayed when the image is published. |
| | Source | Identifies the original owner of the copyright for the image, which can sometimes be different from the 'Creator'. |
| | Copyright notice | Contains the formal notice of current copyright ownership. |
| | Rights usage terms | Contains licensing instructions on the way the image can be used. (The PLUS fields can also be used to give more precise licensing information.) |

**TABLE 2**

Selected fields from the Simple Dublin Core (ISO 15836:2009) that apply directly to ethnobiological photographs.

| DUBLIN CORE FIELD | COMMENTS |
|---|---|
| 1. Title | No title is needed for ethnobiological images |
| 2. Creator | The photographer should be identified, at least by initials |
| 3. Subject | Major species and cultural classification using standards such as Cook (1995) |
| 4. Description | The specific location as described in a country's gazetteer |
| 6. Contributor | Name and e-mail address of contact individual who submitted the image |
| 7. Date | Date image was made |
| 15. Rights | Intellectual property rights need to be clearly addressed. For ethnobiological images, this often involves multiple concerns: informed consent of individuals represented, confidentiality of information as illustrated within images (of plants, processes or rituals), biodiversity conservation concerns relating to rare taxa, rare environments or activities involving these. Rights should be listed as either 'open access' or 'restricted access' followed by elaboration as needed. |
| Undefined area | GPS information is not part of the standard fields but needs to be incorporated and provided. There are different ways to do this, such as providing supplementary documents, sidecar files or reassigning one of the primary categories such as '4 Description'. |

files and the appropriate software to access the relationship between them. There are many kinds of software that are able to edit metadata, creating seamless embedded files (e.g. Photo Mechanic).

It is best to edit metadata as completely as possible before image files are accessioned. The updating of metadata is, however, an exception to a general rule of not modifying the content of files and folders within collections once they have been accessioned. If new information is learned, it is good to add this information to the metadata files as part of the ongoing development of the value of the collection. These notes can be flagged as additions with dates given for updates, without modification of the primary information of the image itself.

Increasingly, we are employing methods such as 'crowdsourcing' that encourage either the production of a collection of photographs by a large number of people (a crowd) (Howe, 2006, 2009) and/or the editing of metadata associated with the collection of photographs (Lafreniere & Terry, 2011).

## Using databases?

The future role of databases versus metadata is controversial, but the preferential use of metadata for photographs is growing in popularity (Dansinger, 2011). It is our opinion that databases are the networking system of the past and not the future, but biological research organisations, universities, museums and others holding biocultural collections are heavily invested in databases. New data-management standards and software are being developed that may provide alternatives to or intermediates between the use of databases and metadata (see w3c website). The w3c working group has established several discussion groups that are worth knowing about. Topics are updated regularly and include lists of software that have adopted more flexible standards. The w3c group is one of several that are exploring the general concept of 'Post-relational' or 'No-SQL' data sifting. This is the process of sorting through both the file names and the metadata within or associated with a particular file or database. Many current web search engines, such as Google, can actually do this but do not always do it. For example, when you use Google Scholar, it uses a data-sifting mode that searches through the metadata of PDF files and the databases of specific websites, mostly from publishers. Software applications are being developed to address the future need to examine metadata from files that are managed with or without databases. One example is DUN: Data Undiscovered, a system that can be plugged into a site. It can function within an environment such as a website and be used to do generalised searches, or to collect and process specific types of data as does a data-scraper service. Data scraping is the extraction of information from human-readable files, such as web pages. Data-scraper services (e.g. Data SIFT or Ruby Rail) may function as plug-ins and are the logical precursors to what is needed to search personal computers or the internet for files containing desired metadata. It is even possible to instruct them to go out into the internet and periodically collect and update specific kinds of data, sort it and present it in ways that are meaningful for researchers.

## Development of secure storage and handling procedures

There are two kinds of security that we are concerned about: the physical security and the intellectual security of the collections. The physical security includes the building location and the cyber-infrastructure. Once these are established, then the processing, sorting and filing of collections may be managed in a way that ensures their physical and intellectual security.

Collections of images need to be physically stored in secure locations that are climate controlled (Conway, 2001). Ideally, these collections are stored on redundant (e.g. **redundant array of independent disks** (RAID)) computer servers that are not accessible via direct internet access, so that they are secure from problems that could leak in from outside sources. Entire copies of collections

should be made periodically and stored in 'off-site' or 'dark archive' locations that are more secure and have limited access. These dark copies should never be used except in cases of complete loss of the primary archival collections. Content that is accessed by the public needs to be copies stored on different physical machines from those that are used for the archive. A common problem is having the working system that curators use also be the same system that the public is accessing, and the same system that holds the archive. This is a precarious situation that is asking for trouble. At least two if not three distinct copies need to be maintained at all times for security purposes.

Files often arrive from researchers in a structure that makes sense to the researcher and may or may not make sense to the archival facility. It is perfectly reasonable, however, for the archive to develop a standard file structure that is prominently posted within the organisation's website to provide directions for the submission of data to be stored. Researchers should be asked to sort their data into folders that are consistent with the facility's format. Researchers should also be expected to provide standardised metadata within image files and to rename files following a standardised protocol. All of this will lead to much less work for the facility and to greater ease of use of the collections in the future. It will also deter researchers from simply dumping large volumes of inappropriately named and organised images on the archive. It might seem that this would deter researchers from participation, but in fact, researchers who genuinely desire that their work be archived will see this as a mark of quality and seek out depositories that use a standardised protocol rather than insist on working with archives that are willing to receive uncurated images and waste resources managing them.

Handling procedures for collections include the sorting and filing of individual files within collections. Once files have been placed by researchers or curators within a structure of folders they should not be moved, even if errors in location are discovered. File names should also remain the same. Nevertheless, efforts should be made to update and improve the quality of metadata that is embedded within image files. Copies of files should be made for individual use but these should never be saved back into the archive.

Periodically, depending on the hardware being used, complete copies of all data should be prepared as part of ongoing efforts to combat data erosion. This is becoming less and less of a problem, but might still be necessary in the near future. It is important to constantly consider the relative cost of upgrading to new storage media versus the improved security provided by newer higher-quality storage devices.

Each image file should have some indication of its ownership or intellectual property rights (see Table 1). Intellectual security is important when considering the distribution of image data from within an archive. Some images within a collection may be specifically released by the photographer as 'open access' or 'creative commons', but this does not mean that all images in the collection are free for unrestricted distribution. There are different types of open access (Anonymous, 2003) and the distribution constraints need to be clarified with each photographer. Does the photographer intend for images to be used for 'any' purpose or only for 'non-profit' purposes? Or does the photographer have something else in mind? Have the individuals featured within the image given their informed consent for the image to be used in the way that it is being used? This permission requirement varies from country to country. For some countries (e.g. France) permissions must be obtained for images of places, plants and other things, as well as for images of people (Act of Parliament, 1970).

One of the roles of curation is making collections available to people for wider use. This involves exposing the collections to risk, both the risk of losing the images and the risk of losing control of the images. 'Risk management is the sum of all activities directed toward acceptably accommodating the possibility of failure in a program' (Grose Beamsley, 1999: 361). Risk of losing control of the

images is a complicated issue that involves balancing concerns of freedom of access to information with recognition of real and intellectual property rights (see Chapter 16). This involves disputes about whether control over publically owned collections is justified. Less rigid control is possible over the digital content of collections that are placed in open-access portals on the internet. Steps that have been taken to balance access include:

- providing knowledge of resource availability, but not complete access, through the internet;
- posting only lists of collections available;
- posting reduced-quality versions of images; and
- posting samples of available images rather than complete collections.

The trend appears to be moving toward placing as much content online as possible in order to improve access and the usefulness of collections. The security risk (both physical and intellectual) must be considered and evaluated as part of plans for the posting of digital images.

Once the decision has been made to provide access to images over the internet, the issue becomes a matter of balancing cost and quality. A number of robust, free or low-cost options exist for the distribution of large numbers of low-quality images (e.g. Flickr, Picasa, SmugMug or WebShots). It may be more desirable, however, to distribute higher-quality images, recognising that this comes at a price because it requires either the maintenance of a local server, plug computing or the use of bulk-rate cloud computing. Local servers are the most expensive option but provide the most control over the platform management. Plug computing (e.g. Pogoplug) is an inexpensive option but provides limited ability to broadcast its availability and it still requires links to some form of website or other notification system. It is also relatively slow. Cloud computing is a very secure form of storage and that is available from a variety of distribution services, with some companies (e.g. Amazon S3) promoting storage that is backed up in multiple geographic locations for disaster prevention.

## Disaster prevention and management planning

Fires, floods, tornados, earthquakes, tsunami, hurricanes or typhoons, and many other sorts of disasters can suddenly destroy an entire archival collection that has been curated. Fortunately, digital collections are different from almost all other types of collections in that they can be perfectly copied and stored in remote locations for complete recovery. Therefore, it is possible to prepare adequately for digital disasters by asking some basic questions:

- What are the most likely disasters to strike in my area? To affect my facility?
- Is there a different facility in another area that is unlikely to be hit by the same disaster and that could be used as an alternative storage facility? Is this facility sufficiently different?
- Can a convenient and efficient, periodic (daily, weekly or monthly) back-up system be developed?

One good way to approach this situation is to find another organisation with similar needs for long-term storage and offer to exchange storage for each other's dark archive. This can be cost-effective and can lead to the development of good inter-institutional alliances.

Good management planning for disasters involves the identification of possible events and the development of preventative measures. It also includes the establishment of specific plans that will be used in the event of each sort of disaster. These plans need to be practiced periodically, like fire drills, so that all staff members know automatically what they need to do and so that any actions needed to protect collections are taken as quickly as possible. It is best to have collections protected in automatic ways so that human safety is the first priority in an emergency situation.

# Virtual repatriation

Virtual repatriation, or visual access to biocultural materials that are collected and stored outside of the source culture, is one benefit of digitisation (Christen, 2009) that should be considered by ethnobiologists. The processes involved and many important aspects of this process have been reviewed by Hunter (2005). If this process is desired, consider preparing digital images of all kinds of biocultural collections by taking the following steps.

- Select a biocultural collection item (e.g. an artefact, physical photograph or biological specimen) and assign it a unique accession number if it does not already have one.
- Make a single digital photographic image of the item using the best possible camera settings in raw format.
- Edit the metadata within the raw image file to include all known information about the biocultural collection. (Apply any standard format that the organisation desires or use no standard, but if at all possible, include the location where and time when the collection was made.)
- For complex objects, additional images might be needed. These should be given the same accession number but with the addition of a decimal value, letter or other additional identifier that will link the related images together.
- Upload each image file onto a website that has the level of access or restriction desired for the particular file. (Several different sites should be used if different levels of access or restriction are desired.) If possible, the images should be uploaded onto simple sites that have little structure, perhaps only listings of accession numbers.
- As file content is loaded onto websites, it becomes searchable on the internet. The metadata content is also searchable, although not all search engines support metadata access.

# Conservation of digital images

Two different classes of digital images are being widely curated: 1) digital images that have probably been generated within the curation facility of physical content that is being curated (e.g. images of herbarium specimens, artefacts or photographic slides), and 2) digital images generated by researchers and others, for example during fieldwork, that may or may not be represented by materials in the curation facility (or elsewhere). The images of this latter category are increasingly being considered to be primary source materials and are likely to be irreplaceable. Images of the first type are secondary source materials and can be considered as surrogate primary sources that are suitable for sharing widely over the internet.

Digital images are prepared in a number of file formats. When curating images, it is just as important to curate a copy of the software that is needed to access the files. This is analogous to traditional archives maintaining a variety of slide-, microfiche-, glass plate-readers and so on in order to access information in preserved photographic materials. A curator should maintain a record of the categories of file formats being preserved (these may be in different generations) and the software and hardware being preserved in order to access each file format.

Traditional images (e.g. photographs, slides, negatives, glass plates) have different problems with degradation over time (Wilhelm & Brower, 1993). Likewise, digital images can lose integrity (Grose Beamsley, 1999), but this is increasingly being addressed with more resilient systems that are self-correcting, automatically restoring lost information through the management and comparison of multiple copies of data files. This requires newer technologies, both hardware and software, and the periodic movement of files from older storage media. All of this will take time and money in order to increase conservation security. The costs of digital preservation have been reviewed recently (Eakin et al., 2008).

## A SPECIFIC EXAMPLE OF ARCHIVAL STORAGE

An effort was made by the Botany Department of the University of Hawai`i to develop a system for archival storage of digital photo collections from past and ongoing ethnobotanical research, beginning in 1998. Over a period of three years, a system was developed in which images produced within research projects are organised using an archival workflow involving the following steps:

**1.** Digital photographs are taken in a field site following one of three reproducible methodologies: a) repeat photography of pre-determined subjects or materials at each data collection event with similar scale, frame and relationships for comparative purposes (e.g. Reedy et al., 2009); b) contextual documentation of study sites, interviews, transects and so on (e.g. Rakotonandrasana et al.,2005); or c) step-by-step photo-representation (documentation) of complex processes learned in cultural settings (e.g. McClatchey & Cox, 1992). If people are photographed, then permission to use their images is requested (McClatchey et al., 2004). Prior informed consent is also often needed to conduct photographic work in many communities/countries.

**2.** The file names of all of the images that were produced (ideally on the same day) are batch converted using software (e.g. BIMP Lite or Phatch) to strings that consist of the photographers initials, the date and the camera-assigned image number. These components provide a unique string that is unlikely to be duplicated elsewhere. The files are then copied onto pairs of backup drives on which images are sorted into folders labelled by date within folders labelled by country within folders labelled by region (Africa, Asia, Australia, Europe, Oceania, North America and South America). Ideally, each backup drive is kept in a different location while in the field for safety. All of the disk drives are updated daily with new images after they have gone through file-name conversion. Note that multiple individuals can add to these collections without having to coordinate their file naming.

**3.** Duplicate backup copies of images stored on hard drives are returned to the university via two different routes. This may be two different persons on different flights or may be different forms of shipment, but these copies are never transported together. When they arrive at the university, they are kept in different buildings.

**4.** Two distinct backup locations are maintained, one that is easily accessible and one that is inaccessible and secure. As new images are received from field sites in the form of pairs of backup drives, these are copied onto RAID systems or Drobo systems that provide multiple levels of file integrity for long-term archival continuity. New files are added under year categories. Only the current year is considered to be 'active.' All past years are closed archival files and do not have any content added or removed. The year folders each have geographic folders (listed above), which in turn have country folders, illustrating the countries where research was conducted in that particular year. Country folders are then divided into date folders for work that was conducted on specific dates. At no time are folders or files named for plants (species, families, etc.), cultures, or other content-related information. Rather, this information is encoded in the following step.

**5.** Metadata are saved within each image file following the Simple Dublin Core Standard using the same software used for step 2. It is important to embed metadata rather than to save it within sidecar files that require specific software (e.g. Adobe Photo Sorter). Important metadata include the location (GPS if possible) of the images, plants and people in the images, herbarium specimens collected from plants seen in the image, and other observations.

**6.** Researchers have regular working access to one backup copy of all digital photographs. The copy is stored and treated as a read-only server with archival access online from anywhere in the world. The duplicate back-up is not accessible online and is completely isolated from any internet or intranet systems on a blind computer that is only used for data back-up. Each time researchers return from the field with new data, they are added to the current year's folder. The current year's folder is then copied onto a second drive as a duplicate that is stored in a different secure location. Data within folders containing information from previous years, within each of the systems, are never modified.

The workflow is then enhanced to allow easy access, sharing and use.

**1.** Researchers extract the photos from a specific photography event (research project, field location, country, plant group, culture and so on) with the goal of creating a collection or set of high-quality images. As these images are selected, copies are made into a different hard drive that is used as a specific project working drive. The images are stored within a file structure that mirrors the original (year, region, country, date and file name) so that they can later be re-associated with their originals.

**2.** The collection of copies is then enhanced. A broad range of graphics-editing software is used for enhancement, depending on the desired end use, but a common product is Adobe Photoshop. As each image is enhanced, it is critical that either the file type be changed or an additional letter or number be added to the file name string to indicate that a modification has been made. Names should be otherwise left intact and stored within their original folder structure.

**3.** The collection of copies is added to the archives under a NEW category of enhanced images. These collections are sorted by meaningful project titles such as 'Samoan kava', 'Hawaiian medicinal plants', '2003 Research in Marshall Islands' or 'Rongalap Atoll Transects'. Collections are NEVER merged back into the original archival sets from which they were copied.

**4.** Smaller-size collections are made available through online image-hosting services (e.g. SmugMug, Flickr or Picasa). These also serve as tertiary forms of back-up for the archives.

**5.** Moderate-size collections are made available to small or specialised groups of users through a password-protected plug computer service (e.g. Pogoplug, iConnect or CloudPlug). This allows for limited access and distribution of images for which there are concerns about open distribution.

## CURATION OF SPECIAL TYPES OF DIGITAL COLLECTIONS

**Digital video collections** include both original segments and highly edited or finished works. With both video and still imagery, it is common for much more content to be generated than is actually used. However, still images are generated as distinct units, whereas video is a stream of interconnected units. 'Editing' or the selection of the images (units) to be used (or not) in a video is important and is similar to the process of selecting images to be preserved (or not) from a collection of still images. For curatorial purposes, however, it is desirable to retain copies of all original and edited materials.

**Panoramic photographs** have wide aspect ratios and typically are distinguished from images produced by wide-angle lenses. Panoramic photos may be produced from single exposures or from stitching together overlapping images that are produced from the same focal position using the same focal settings.

**Very high resolution images (VHRI)** including Gigapan images (http://gigapan.org) are not fundamentally different from other images except in the volume of information they include. Files are currently 5–70 gigapixels in size (Heckbert et al., 2010) with 100–gigapixel files expected in the very near future. They may focus on any subject matter and at any scale, although some of the earliest uses were for very large panoramic photographs. VHRI are challenging for curation because their large file sizes require more storage, faster processors, and a different sampling protocol for online viewing. Nevertheless, curators developing procedures for handling Gigapan files will be well positioned for dealing with digital submissions, which are likely to continue to increase in size, in the near future. Tiling uses many panoramic images, with up to 15 levels of resolution, so these files are highly redundant. It is possible to store just the original images that were used to construct the Gigapan image. It is also possible to store the original images, the processed image and the software that was used to merge the individual images.

**Three-dimensional (3D) images** are becoming increasingly important for the documentation and analysis of cultural and plant materials (Zhu et al., 2007; Wu & Wang, 2009). 3D images are primarily formed in two ways: as composites and/or interpolations of multiple adjacent two-dimensional images of real objects or as whole-object scans. The composite layers may be formed from traditional or digital photographs, satellite imagery, 2D laser scans, sonograms or any combination of these or from other 2D images that can be related to each other. 3D images may also be produced with scanners that capture point clouds representing the shape or architecture of objects in the real world, such as trees (Zhu et al., 2008). These differ from 3D computer graphics that are vector- or model-based algorithmic extrapolations that may or may not be based upon real objects. 3D image files can be distinguished from 3D graphic vector files by their formats. The distinction is important because the former may represent actual data, whereas the later may represent theoretical models, or fictional or non-scientific content, but not actual data. 3D images will be stored in 2D raster (bitmap) formats such as JPEG, BMP, GIF, PNG, RAW and TIFF. 3D graphic vector files are compiled in formats such as IMML, U3D, VRML and XVL. Digital stereo formats (PNG Stereo and JPEG Stereo) have also been developed; these are produced as slightly off-set side-by-side pairs of images that may be viewed under the correct stereo relationship, yielding a 3D perspective from only two images.

Storage requirements for 3D image files vary dramatically from as little as two images for simple JPEG Stereo files, to very large volumes of data for the composites needed to describe real-world objects such as whole plants, plants parts (e.g. fruits, seeds, leaves, phytoliths), or cultural artefacts.

**Palaeoethnobotany and zoology 3D.** Archaeologists have long wrestled with the curation of vast amounts of multiple kinds of data including large numbers of photographs that are supporting materials (Marquardt et al., 1982; see Chapters 5 and 6).

**Digital animation** is increasingly being used to model real and artificial ecological situations (Zamuda et al., 2007; Ch'ng, 2011). The files generated from these experiments are used as the basis for scientific publications and therefore need to be archived as evidence of research activity, even though they often are not based upon raw data from the real world. File sizes can vary depending on the experimental design, but may in fact be much smaller if only the initial conditions, settings, software, and final states are needed for archival reference.

**Light-field capture cameras** are being released that allow for 'focus after the fact pictures'. This format differs from either 2D or 3D in that it captures the entire light field within the view of the camera, and software can be used subsequently to select one or more 2D or 3D focal fields. Conservation of these images involves the storage of the raw unfocused light-field data, selected images extracted from the field, and a copy of the proprietary software needed to extract images from the light field.

## CONCLUSIONS

Photography has undergone profound changes as the result of a conversion from chemical-based technology to a digital technology. We have been witness to a tremendous burst in productivity and have become the beneficiaries of the increase in creativity that digital technologies allow. Many outcomes of this technology change impact the curation process, not least the production of large volumes of data that may need to be archived and curated.

Among the questions that need to be resolved by the modern curator are: 'Do I really need to curate all of these digital images?' and 'How can I manage the images that are accepted for curation

and make them available for future researchers?' While some suggestions have been provided here, the chapter has hopefully served primarily as a springboard for discussion.

We believe, very strongly, that it is essential for everyone — from photographer to curator — to develop a coordinated set of habits that centre on the workflow associated with the generation, processing, metadata production, and archiving of image information. Once, we could leisurely label a few sheets of slides after a field trip, but now, we need to be able to deal effectively with tens of thousands of digital images and do so in ways that reflect well on our science.

Volume storage capabilities continue to grow at a rapid pace. Image size and camera productivity continue to grow too. There is every reason to believe that in the future it will be possible to generate, store and access vast volumes of data, but how will we codify that imagery? What will we do with it? How will we capture it so that it is scientifically significant?

Probably the most important questions that we need to address are those that we have been ignoring. How can we be more systematic in the ways that we use photography so that the digital images that we generate consistently have real scientific meaning? And, how can we plan for that systematic activity and automatically generate metadata tags associated with images in order to remove as many manual handling steps as possible?

## ACKNOWLEDGMENTS

Valerie McClatchey and David Reedy provided many of the insights and specific pieces of information in this paper and read several drafts.

## Websites

Amazon. *Amazon Simple Storage Service (Amazon S3)*. http://aws.amazon.com/s3

*American Institute for Conservation of Historic and Artistic Works*. www.conservation-us.org

*Data SIFT*. http://datasift.com

*DUN: Data Undiscovered*. http://dataundiscovered.com

*Image Permanence Institute*. www.imagepermanenceinstitute.org

*International Council of Museums – Committee for Conservation*. www.icom-cc.org

*International Electrotechnical Commission*. www.iec.ch

*International Organization for Standardization (ISO)*. www.iso.org

IPTC Photo Metadata Working Group. *Embedded Metadata Manifesto*. www.iptc.org/site/Photo_Metadata/Embedded_Metadata_Manifesto_(2011)

National Archives. *Expanding Acceptable Transfer Requirements: Transfer Instructions for Permanent Electronic Records. Digital Photographic Records*. www.archives.gov/records-mgmt/initiatives/digital-photo-records.html

*National Standards Institute*. www.ansi.org

*Photo Mechanic*. www.camerabits.com/site/PhotoMechanic.php

*Pogoplug*. https://pogoplug.com/

*RAID*. http://en.wikipedia.org/wiki/RAID

*Ruby Rail*. http://rubyonrails.org/

*W3*. www.w3.org/XML/Query/#implementations

## Literature cited

Act of Parliament. (1970). *French Civil Code, Article 9, Right to Privacy*. Act no. 70-643, 17 July, 1970.

Alexiades, M. N. (ed.) (1996). *Selected Guidelines for Ethnobotanical Research*. New York Botanical Garden Press, New York.

Anonymous (2003). *Berlin Declaration on Open Access to Knowledge in the Sciences and Humanities*. http://edoc.mpg.de

Benson, A. C. (2009). The archival photograph and its meaning: formalisms for modeling images. *Journal of Archival Organization* 7: 148–187.

Bridson, D. & Forman, L. (ed.) (1998). *The Herbarium Handbook*. Royal Botanic Gardens, Kew.

Chapman, S. (2003). Counting the costs of digital preservation: is repository storage affordable? *Journal of Digital Information* 4: 208–214.

Ch'ng, E. (2011). Realistic placement of plants for virtual environments. *IEEE Computer Graphics and Applications* 31: 66–77.

Christen, K. (2009). Access and accountability: the ecology of information sharing in the digital age. *Anthropology News* 50: 4–5.

Cook, F. E. M. (1995). *Economic Botany Data Collection Standard*. Royal Botanic Gardens, Kew.

Conway, P. (2001). The preservation environment. In: *Library Off-Site Shelving: Guide for High-Density Facilities*, eds D. A. Nitecki & C. L. Kendrick, pp. 89–118. Libraries Unlimited, Englewood.

Dansinger, A. L. (2011). Embedded metadata: friend or foe to our digital collections. *Library Student Journal*. www.librarystudentjournal.org/index.php/lsj/article/view/210/290

Dreyer, M., Neuroth, H., Carrier, S., Greenberg, J., Abrams, S., Cruse, P., Kunze, J., Day, M., Neilson, C., Ball, A. & Russell, R. (2009). Curation of scientific datasets: trends, current

initiatives and solutions. In: *Digital Curation: Practice, Promise and Prospects*, eds H. R. Tibbo, C. Hank, C. A. Lee & R. Clemmens, pp. 68–69. Calmens, Chapel Hill.

Eakin, L. Friedlander, A., Schonfeld, R. & Choudhury, S. (2008). *A Selective Literature Review on Digital Preservation Sustainability*. http://brtf.sdsc.edu/biblio/Cost_Literature_Review.pdf

Grose Beamsley, T. (1999). Securing digital image assets in museums and libraries: a risk management approach. *Library Trends* 48: 359–378.

Heckbert, P. S., Goldberg, M., O'Donnell, G., Henderson, R., Tew, K. & Sargent, R. (2010). How many pixels? Statistics from the GigaPan Website. *Fine International Conference on Gigapixel Imaging for Science*. Paper 15. http://repository.cmu.edu/gigapixel/15

Hodges, R. S. (ed.) (2003). *The Guild Handbook of Scientific Illustration*. John Wiley, Hoboken.

Howe, J. (2006). The rise of crowdsourcing. *Wired* 14.06. www.wired.com/wired/archive/14.06/crowds.html

Howe, J. (2009). *Crowdsourcing: Why the Power of the Crowd is Driving the Future of Business*. Three Rivers Press, New York.

Hunter, J. (2005). The role of information technologies in indigenous knowledge management. In: *Australian Indigenous Knowledge and Libraries*, eds M. Nakata & M. Langton, pp. 94–108. UTSePress, Sydney. http://epress.lib.uts.edu.au

Kulovits, H., Becker, C., Kraxner, M. & Rauber, A. (2009). Invited demo: creating a preservation plan using the preservation planning tool Plato. In: *Digital Curation: Practice, Promise and Prospects*, eds H. R. Tibbo, C. Hank, C. A. Lee & R. Clemmens, pp. 45–46. Calmens, Chapel Hill.

Lafreniere, B. & Terry, M. (2011). Socially-adaptable interfaces: crowdsourcing customization. *CHI 2011 Workshop on Crowdsourcing and Human Computation. Systems, Studies and Platforms*. http://crowdresearch.org/chi2011-workshop/

Lavedrine, B. (2003). *A Guide to the Preventive Conservation of Photograph Collections*. Getty Conservation Institute, Los Angeles.

Marquardt, W. H., Montet-White, A. & Scholtz, S. C. (1982). Resolving the crisis in archaeological collections curation. *American Antiquity* 47: 409–418.

McClatchey, W. & Cox, P. A. (1992). Use of the sago palm *Metroxylon warburgii* in the Polynesian Island, Rotuma. *Economic Botany* 46: 305–309.

McClatchey, W., Thaman, R. & Juvik, S. (2004). Ethnobiodiversity surveys of human/ecosystem relationships. In: *Biodiversity Assessment of Tropical Island Ecosystems*, eds D. Mueller Dombois, K. Bridges & C. Daehler, pp. 159–196. University of Hawaii Press, Honolulu.

Puglia, S. Reed, J. & Rhodes, E. (2004). *Technical Guidelines for Digitizing Archival Materials for Electronic Access: Creation of Production Master Files-raster Images*. U.S. National Archives and Records Administration, College Park, Maryland. www.archives.gov/preservation/technical/guidelines.html

Rakotonandrasana, S. R., Gollin, L. X. & McClatchey, W. (2005). Ethnobotanical research at Analalava, Madagascar: a photo essay. *Ethnobotanical Research & Applications* 3: 391–403.

Reedy, D., McClatchey, W. C., Smith, C., Han Lau, Y. & Bridges, K. W. (2009). A mouthful of diversity; knowledge of cider apple cultivars in the United Kingdom and NW United States. *Economic Botany* 63: 2–15.

Ritzenthaler, M. L. & Vogt-O'Connor, D. (2006). *Photographs: Archival Care and Management*. Society of American Archivists, Chicago.

Saunders, S. (2010). *Image Metadata Handbook*. IPTC Photometadata Working Group, Centre of the Picture Industry (CEPIC) and IPTC, London.

Wilhelm, H. & Brower, C. (1993). *The Permanence and Care of Color Photographs: Traditional and Digital Color Prints, Color Negatives, Slides, and Motion Pictures*. Preservation Publishing Company, Grinnell.

Wu, Y. & Wang, C. (2009). Extended depth of focus image for phytolith analysis. *Journal of Archaeological Science* 36: 2253–2257.

Zamuda, A., Brest, J., Guid, N., & Zumer, V. (2007, September). Modelling, simulation, and visualization of forest ecosystems. In: *EUROCON, 2007. The International Conference on 'Computer as a Tool'*, pp. 2600–2606. Warsaw: IEEE.

Zhu, C., Zhang, X., Hu, B. & Jaeger, M. (2008). Reconstruction of tree crown shape from scanned data. In: *Technologies for E-Learning and Digital Entertainment. Third International Conference, Edutainment 2008 (Lecture Notes in Computer Science 5093)*, eds Z. Pan, X. Zhang, A. El Rhalibi, W. Woo & Y. Li, pp. 745–756. Springer, Heidelberg.

Zhu, T., Zhu, Y., Seah, H. S., Tian, F. & Yan, X. (2007). Plant modeling and its application in digital agriculture museum. In: *Proceedings of the 2nd International Conference on Virtual Reality*, ed. R. Shumaker, pp. 748–757. Springer, Heidelberg.

Zucker, B. (1985). Photographs: their care and conservation. Conservation of library materials. *Illinois Libraries* 67: 699–704.

# Linguistic and audio-video collections in ethnobiology

K. DAVID HARRISON

Swarthmore College and National Geographic Society

KARIM SARIAHMED

Swarthmore College

## INTRODUCTION

Set against the backdrop of parallel extinctions of species and languages, those working in both linguistics and ethnobiology are facing the urgent task of documenting a vast, vanishing knowledge base. Increasingly, this process of documentation is done not predominantly in print media, as it had been for many decades, but using digital audio and video recordings. Once recorded, this body of indigenous knowledge provides many different frameworks for thought and unique forms of expertise, which can offer new perspectives to modern science and should be taken just as seriously. As Hunn (2008) notes, 'The outstanding differences between modern and folk sciences are first of all a consequence of transformations in the scale of scientific enterprise, rather than attributable to any fundamental advance in the quality of human thought.'

Most ethnobiological knowledge is orally transmitted, not written down, and is stored only in human memory. The act of transmission involves speech (typically between native speakers and in an indigenous language), as well as demonstration (e.g. of hunting, gathering, processing, and other technologies). It follows that the most accurate and richest way to document (and conserve) this knowledge would be to preserve acts of transmission digitally by recording speakers talking about what they know about plants and animals. Therefore, ethnobiological studies will yield audio and video resources. These, in turn, can function as a repository of community intellectual property, which may be shared with a wider audience if the community so chooses. Digital (audio and video) recording potentially enhances both the robustness of local transmission and the possibilities for dissemination and conservation of the knowledge base.

Neither linguistics nor ethnobiology researchers can adequately attempt to document the ethnobiological knowledge base alone, or apart from the indigenous communities that are the owners of this knowledge. Thus, it is appropriate to examine how the two domains are interdependent and complementary, and how they can best serve the varied stakeholders. This chapter explores some links between ethnobiology and linguistics, and then outlines current best practices in the domain of linguistic documentation and curating of audio-video materials. We conclude by suggesting ways in which linguistics and ethnobiology can complement one another. This chapter complements Will McClatchey's recent (2011) guide to field methods in ethnobiology and linguistics.

## HOW CAN ETHNOBIOLOGISTS BENEFIT FROM COLLABORATION WITH LINGUISTS AND ANTHROPOLOGISTS?

Linguistic anthropology offers scientists a window onto local environmental knowledge, which does not replace but rather supplements knowledge that is scientifically discovered. It does so by seriously

considering the labels indigenous people assign to flora and fauna, as well as their understanding of taxonomic and hierarchical relations among species. Such local knowledge has often been neglected or discounted in the history of science, leading to a false discovery paradigm where 'new species' are claimed to have been 'discovered' by outsiders, when in fact they were well known to the local inhabitants all along (e.g. Ragupathy et al., 2009). Many reports of new species by popular news outlets make little mention of the fact that cultures exist even in remote areas, much less that they may have a deep understanding of their environment.

The tools to record accurately the phonetics, semantics and everyday usage of local biological terms come from linguistics. At the most basic level, they are used for careful phonetic transcription of words and sentences of the target language. In current practice, this typically involves audio and video recordings. What emerges from a careful linguistic documentation is not only labels for species and environmental phenomena, but also entire taxonomies of knowledge and a holistic understanding of how the pieces of an ecosystem fit together. The ethnobiological information content is distributed across a range of linguistic structures ranging from, at the small end of the scale, phonemes and morphemes, to, at the large end of the scale, creation myths, stories and entire epic tales. A language must therefore be encountered holistically, and at all levels of structure and all domains of usage, if we are to fully apprehend the biological knowledge found therein.

Linguistics can make us aware of biases in language. The words chosen to represent a given idea encode a culture's values, and the world view reflected by these values may be imposed on languages other than English when we attempt to document them. World views play a significant role in how people interact with their environment, as Carbaugh (1992) demonstrates in his discussion of 'cultural geography'. Examining the language used by different stakeholders to describe a given space can elucidate 'the ways in which a people symbolise their land, the place it holds in their lives, what they see in it, and seek from it'. The Tofa people of Siberia, for example, have a unit of measure which they call kösh, which indicates the distance a reindeer (with rider) can travel in a day (Harrison, 2007). The actual distance represented by this unit is obviously variable depending on climate, terrain and a host of other variables, yet it provides a coherent unit of measure for the Tofa. Speakers of Hanunóo in the Philippines distinguish six different primary directions (Conklin, 1954), speakers of Bantawa Rai in Nepal encode vertical distance in their paradigms of motion verbs (Hart, 2004), and Ambae speakers in Vanuatu (Hyslop, 1999) encode both island topography and wind direction in their directional verbs. The linguistic system encodes selected environmental factors, and, it follows, the local environment cannot be fully understood without reference to the linguistic system that it is used to describe it. This reflection of culture in language is the point of entry for understanding the dynamic between culture and ecology.

Finally, linguistic research into metaphor helps us understand that our own modes of discourse and inquiry are culturally contingent. Everyday talk provides numerous examples of metaphorical thinking: in English, for example, the future lies in front and the past behind, a time metaphor that seems entirely intuitive to us. But in Tuvan, these are reversed, the past being what lies in front and is therefore visible, while the future lurks behind us, unseen and unexpected. Scientific discourse too, whether in climatology or genetics, is permeated by and dependent upon metaphor, and thus upon the specific repertoire of metaphors provided by a given language (Hartl, 2008). As Larsen (2011) notes: 'The way we speak about the natural world is not a transparent window, because it reflects the culture in which we live and its priorities and values.' Larsen goes on to point out that scientific concepts such as 'biodiversity hot spot', 'fitness', 'genetic drift', 'global warming' and so on are all English-specific metaphors that inform not only our abstract concepts but our ability to

reason about environmental issues. Other languages may employ an entirely different repertoire of environmental metaphors, for example the El Niño/La Niña-Southern Oscillation, a climate pattern whose name has been recently borrowed from Spanish into English, but which was already known in pre-Colombian South America (Caviedes, 2001).

## HOW CAN LINGUISTS BENEFIT FROM COLLABORATION WITH BIOLOGISTS?

The linguist's aim is to achieve a full description of a language. To do so, we must record all words for flora and fauna, as well as meteorological and other phenomena. This requires the field linguist to be versed in basic biological or botanical practice. As adaptive systems, languages show lexical diversification for domains that are ecologically relevant. A good example of this is the sea ice taxonomy found in the Yupik language of Alaska. Yupik elders (Oozeva et al., 2004) list 99 terms that describe sea ice, each with a detailed description and drawing. For example, the term nuyileq is described by the Yupik elders as, 'Crushed ice beginning to spread out; dangerous to walk on. The ice is dissolving, but still has not dispersed in water, although it is vulnerable for one to fall through and sink. Sometimes seals can surface on this ice because the water is starting to appear.' Any linguistic description of the Yupik language would be incomplete without this lexical domain. Similarly, any description of the arctic ice ecosystem would be incomplete without the accumulated knowledge and scientific observations of the Yupik elders.

Linguistic data have long been recorded by hand and maintained in print formats such as grammars, dictionaries and parallel texts, but as we move further into the digital age, best practices are evolving. Video and audio recording of linguistic data is now the norm. Our ability to share audio and video files on the internet means that the linguistic and ethnobiological knowledge base is increasingly being shaped by more open, participatory documentation and includes more crowd-sourced content. Next, we outline some of the ways in which linguistic and cultural documentation is enhanced by ethnobiological content and best practices in the emerging digital age.

## BEST PRACTICES: ETHNOGRAPHIC STUDIES, TALKING DICTIONARIES, DATABASES, AND YOUTUBE

### Traditional ethnography

Ethnography provides a valuable set of tools because it makes us attend to linguistic forms not in isolation (looking only at phonology, phonetics or syntax) but in the holistic cultural context where meaning is created. Eugene Hunn's (2008) attention to the nuances of language and taxonomy is exemplary of this approach. His analysis of Gbëë Zapotec plant names helps him draw conclusions about the conceptual structure that shapes this people's understanding of plants. One unique structure consists of prefixed life-form references that can be hierarchically 'layered' into the name for a single plant. In English, the words for 'tree' and 'flower' are distinct, but if someone refers to a tree, it is understood that, depending on the kind of tree and the time of year, it may or may not have flowers. A tree can be described as 'flowering', but the tree's identity is not determined by this. In Gbëë Zapotec, however, the 'hummingbird flower herb' is referred to differently depending on its state. When in full flower it has a 'flower' prefix, guièe-dzǐng, while a vegetative tree of the same species has an 'herb' prefix, guìzh-dzǐng. Multiple prefixes can also form compounds. Yàg-guièe-yǎl, for example, means 'frangipani flower tree'.

Hunn also compares the Linnean taxonomy with Gbëë Zapotec folk taxonomy. In some domains, the correspondence is very strong; for example, for birds there is a nearly 1:1 match of terminal Linnean taxa to terminal folk taxa. An instance of discrepancy was the over-differentiation of domestic chickens by the Gbëë Zapotec, who distinguish nine types of chicken based on features that are culturally salient in Zapotec but not in English.

Hunn's findings, made possible by his attention to indigenous nomenclature, bring a deeper understanding of Gbëë Zapotec culture within our reach. Moving forward, we will be able to live up to this high standard of cultural documentation by taking advantage of the new technological resources at our disposal.

The recording and documentation of endangered languages requires hours of elicitation and generates immense stores of data. These databases are an important source of ethnobiological information, particularly because the lexicons of many endangered languages are devoted significantly to ethnobiological nomenclature and folk taxonomy. Organising all of these data into a useful resource for ethnobiologists presents many challenges, but in this age of digital and crowd-sourced databases, we are well-equipped to face these challenges.

## Cultural significance of nomenclature and taxonomy

Names reflect culture-specific knowledge, and thus the best dictionaries of ethnobotany include plant names in the local language, not just the major contact language or the binomial Linnean name. This makes for not only for a fuller account of the environment but also for a more accurate one. Conklin (1954: 96) documented 1,625 Hanunóo plant names falling into five major categories, which set a very high bar for future ethnobotanical studies. Few languages — or plant nomenclatures —have yet been the object of such careful documentation.

The taxonomies of modern western science are based on organismal morphology and on hypotheses about evolutionary origin. This nomenclature on its own is not the most useful for addressing the concerns of ethnobiology, because the categorisation imposed by these names is rarely relevant to a plant's role in an indigenous community. This role includes not only the practical uses of the plant but also information about the plant's cultivation, its cultural significance and also the people's general perception of nature. The name given to a plant by an indigenous group of people to whom that plant is culturally significant may contain a lot of useful information about this cultural context. Understanding this important context should be one of the main goals of ethnobiological researchers, and it should be considered by anyone involved in pharmacology, conservation or development initiatives.

Publications (print or digital) by indigenous communities express cultural concerns and values, and so they are invaluable resources of ethnobiological knowledge. Lepcha scholar and linguist K. P. Tamsang, the former General Secretary of the Indigenous Lepcha Tribal Association, authored the *Glossary of Lepcha Medicinal Plants* (Tamsang, 2004). In format, it is similar to some of the best ethnobotanical dictionaries. The book contains Lepcha names, their phonetic pronunciations in English, Linnean botanical names, pictures of the plants, and descriptions of how different parts of the plants are prepared and the ailments they treat. It is important to study the ethnobiological knowledge from the indigenous point of view, because the organisation of the information and the placement of emphasis will reflect the indigenous culture. One important feature of the Lepcha glossary of medicinal plants is that it is organised by the Lepcha names, unlike western dictionaries of ethnobotany which tend to be alphabetised by the Linnean name. This organisation is useful for ethnobiological study because it might reveal relationships between uses or features of a plant and its name.

One pattern that has emerged in analyses of plant nomenclature is that plant names sometimes include animal names (e.g. tiger lily or cat tail), but it is rare that an animal name will contain the name for a plant. Stepp's quantitative analysis of plant names with animal loan words (Stepp, 2002: 171–179) showed that plants that were traditionally protected or cultivated by the Tzeltal Maya of Highland Chiapas were significantly less likely to contain animal loanwords. This shows one direct relationship between the name given to a plant and its cultural prominence. More data on these types of relationships will shed light on how ethnobiological nomenclature emerges and develops, and perhaps even suggest universals in human engagement with the environment.

Another important consideration in ethnobiological nomenclature, besides the nature of the names themselves, is who uses the names. Variation in the names given to a single plant is nearly endless. Names vary not only across cultural and linguistic boundaries but also between individuals. It is apparent from the comparison of folk taxonomies that humans' categorisation of the environment depends on its culturally salient features, but what can be learned from ideolectic variation? Collins and Liukkonen (2002) show that intracultural consensus on the name for a plant is related to the usefulness of the plant among the Q'eqchi Mayans. The more useful a plant is, the more likely it is that any two given people will agree on its name.

The study also found that the western notion of 'plant' as a category is entirely etic. Plants were often labelled by the terms for their anatomical parts, but these same terms are also used for animal bodies and even abiotic entities such as mountains. This suggests a more holistic understanding of nature. The Q'eqchi Mayans also often describe wild and cultivated varieties of similar plants by attaching an animal component to the name for the cultivated variety in order to name the wild variety. For example, a type of lily grown in gardens is called klaux, but the weedy variety is called Xklaux k'uch (or hawk klaux). Ethnobiologists seeking to understand how different groups conceive and represent their environment must pay close attention to patterns in linguistic nomenclature and taxonomy because the way people choose to structure information reveals what is important to them.

The findings of these kinds of studies help us understand how groups of indigenous people think about their surroundings, and how their way of thinking enables them to adapt. Stepping beyond our western conception and categorisation of our natural surroundings grants us access to insights about different survival methodologies and how knowledge of them is acquired and shared. Effectively documenting language so that it can be closely examined through different lenses is the first step towards this understanding. The vast majority of the world's languages await basic documentation of their ethnobiological lexica, and still lack even the most rudimentary systematic recording of their words in audio and video digital media.

## Online lexica

The lexica of indigenous languages are typically found to contain a significant percentage of ethnobiological terms. These require proper documentation using linguistic techniques, including context-based elicitation (e.g. discussing the plants with the speaker in the local environment). Once these lexemes are collected as transcriptions and audio files, possibly with accompanying photographs and indexed to collected specimens, they can be databased online. Examples of such work include two talking dictionary projects built by one of the co-authors of this chapter (K. David Harrison) for the endangered languages Siletz Dee-ni (Oregon Athanbaskan, USA) and Matukar Panau (Oceanic, Papua New Guinea) (Anderson & Harrison, 2007; Anderson et al., 2010). These databases are also models of how technology can potentially assist in organising ethnobotanical information and making it readily accessible. The dictionaries — products of linguist-community collaboration, funded by the

Living Tongues Institute and National Geographic Society — are searchable in both English and their respective endangered languages, and have audio recordings of native speakers as well as associated images (Figure 1).

It is possible to learn about Matukar ethnobotany by conducting very simple searches in the Matukar talking dictionary. A search for the word 'leaf' generates a few hits pertaining to betel leaves, among other things. Moving forward with the assumption that betel plants are important in Matukar culture, a search for 'betel' yields 29 different entries that offer insights into the cultural significance of the betel nut tree and its uses. Images that are attached to certain entries show Matukar people indicating all the culturally salient parts of the tree. The different entries tell you that the betel nuts grow in bunches on trees. The Matukar people peel them with their teeth and chew them, and they are used for bartering. This is not a great wealth of information because the current scope of the dictionary is somewhat limited. Nevertheless, as more data are collected, maintaining the information in this searchable format will make the dictionary invaluable to people studying ethnobiology. New search algorithms related to different semantic domains will also make it easier to find topical information and to identify patterns.

Talking dictionaries represent one possible model for curating audio data. They are durable (so long as the server is maintained), open to community collaboration, sensitive to community intellectual property (data can be password protected) and relatively inexpensive to maintain. They provide a rich, searchable context for the data, accompanied by metadata (e.g. name and location of speaker, dialect), and in some cases, photographs of the named objects.

Figure 1. *The Matukar online talking dictionary*, showing four of the twenty-one lexical entries (with accompanying audio files) that appear when searching for 'coconut'.
© LIVING TONGUES INSTITUTE FOR ENDANGERED LANGUAGES.

## Scientific databases and crowd-sourced resources

Some audio and video information that is being made available is curated formally, in an attempt to build useful scientific resources, but there is also a robust informal sector, where data are not curated but are contributed and uploaded by volunteers.

FishBase is a good example of the former. In recent years, this database has expanded to include fish names for many indigenous and endangered languages. If the site has data for a language, a user can pull up a list of words for different fishes in that language. These words link to pages containing biological and ecological information about the species, with the western scientific name at the top of the page. In many cases, many different words in a single language link to the same fish page, indicating that the classification system in that language may have a more detailed taxonomy than western science. Inuktitut, for example, has nearly ten different words linking to the 'Atlantic salmon' page. Scientists studying fish would benefit from studying the knowledge contained in languages such as Inuktitut. Adding audio recordings to such a database, modelled after those in talking dictionaries, would make the database an even richer resource, both for scientific analysis and for cultural transmission.

Crowd-sourced data sets continue to emerge, though in some cases they are not yet organised or tagged in any way that would allow a user to filter ethnobiological data. One such example is the website Forvo, which boasts 1,168,024 words with 1,215,742 recorded pronunciations in 281 languages. Largely crowd-sourced, the site allows users to upload their own recordings. Words are minimally tagged, for example, across the entire data set, 2,191 words are tagged as belonging to the category 'zoology'. The focus of this site is, however, on audio recordings of pronunciations not on word definitions, so many words lack translations or definitions, limiting the scientific usefulness of the data set. Still, this kind of initiative exemplifies the crowd-sourced and organically evolving accretion of data that will surely continue to expand, and searchability across these data sets will improve.

## CURATING DIGITAL VIDEO AND AUDIO

Linguistics has been revolutionised by the ability to record speech in high-quality audio and video, and to analyse, annotate and share these resources both within the scientific community and among a broader audience. At the same time, digital data introduce new challenges relating to data portability, access and archiving (Simons & Bird, 2003). In response to the urgent need to document endangered languages, major funding initiatives, consortia and archives have been established over the past decade, including The Endangered Languages Archive (ELAR) at the School of Oriental and African Studies (SOAS) of the University of London, Dokumentation bedrohter Sprache, Nijmegen (DoBeS), Resource Network for Linguistic Diversity (RNLD) and the Enduring Voices Project (National Geographic Society).

Yet the collection of new material, by both professional linguists and others, rapidly outpaces the ability of archives to ingest, organise and meta-tag it. As a result, most linguists and many community activists have an impossible backlog of data that they will never adequately explore. New participatory, crowd-sourced and distributed models are needed at both the front end (collection) and back end (archiving). These should be guided by the better availability of data for scientific analysis and community use.

YouTube is rapidly emerging as an important tool for both research and cultural preservation. It is also a good way to curate data. If properly tagged, related data sets will find each other, and will be accessible to the widest possible audience. We can suggest a set of tags to make linguistic-ethnobiological data more cohesive or easier to find. A series of Koro ethnobotany videos are an exemplary model for how indigenous people can use YouTube to contribute directly to the body of ethnobiological knowledge (Figure 2).

In these videos (listed in the Appendix), Anthony Degio, a native speaker of the endangered Koro-Aka language in northeast India, shows and describes the practical and medicinal uses of the plants with which he is familiar. He gives both their local name and an approximate translation in English. The ability to have ethnobotanical knowledge shared directly by indigenous peoples with a wider, indeed global, audience is invaluable. When they speak for themselves, not only do indigenous people share unique knowledge but their speech also can attune us to other facets of their culture, like their language attitudes and processes of language endangerment and extinction. This is

Koro Ethnobotany: 11 plants and their uses in Koro culture.

**Figure 2.** Anthony Degio, a speaker of Koro Aka, narrates and demonstrates traditional Koro knowledge about medicinal plants. Video filmed by K. David Harrison in Arunachal Pradesh, India in 2010, and uploaded to YouTube with the permission of the speaker and the Koro community (www.youtube.com/watch?v=yYGKLW-28lY&feature=relmfu).

evident when Anthony shows the jungle yam, and then explains that the Koro people 'used to say x' to refer to it. It is clear from this kind of description that he is aware of the language shift occurring among his people.

Suggestion engines and other features on YouTube make it an invaluable research tool, as we will demonstrate with the example of sangre de drago or dragon's blood, a tree sap that has many different medicinal uses. A video entitled 'harvesting Sangre de drago (dragon's blood)' was on one of the first few pages of the results of a search for 'ethnobotany' on YouTube. This showed a Waorani man (not named in the video) in the Amazon basin of Ecuador extracting the sap from a tree with a machete. This video was very well-labelled and can be found by people interested in the substance itself, in the Waorani people or in ethnobotany in general. Its title contains the name of the substance in two languages, and its tags include 'ethnobotany', 'anthropology', 'Ecuador', 'Amazon' and 'Waorani'. Suggestions that are associated with the video lead to a documentary-style commentary on the medicinal properties of sangre de drago by a pharmacist being lead through the Amazon by a local naturalist. Another related video, featuring a man in Yemen, talks about how this substance can be used to stop bleeding. In another video, this same man shows how the stem of a different plant can also be used for a similar purpose.

These videos amount to just a few minutes of content but they represent the beginning of the first sangre de drago video archive. As more ethnobotanists, scholars and people with firsthand experience begin to plug in to this network of ethnobiological information sources, the knowledge pool will expand. Nevertheless, as our searches showed, this public curation system is far from perfect. The best way to ensure that this information is accessible in a coherent form is to be explicit and consistent in labelling and tagging videos, and also to consider the full range of people who will have valuable information to contribute. It is important for the tags to include different names for the organisms described in the video, the local language and ethnicity, and the region where they are found, including the continent, country and other regional parameters that are likely to be used as search terms. 'Ethnobotany' and 'ethnobiology' are important tags, but not everybody with valuable information to offer is aware of these fields. Many videos concerning ethnobiology have tags such as 'wild foods', 'alternative medicine', 'natural healing' or 'traditional medicine'. Including tags such as these will link a video to a wider range of resources.

## THE FUTURE OF CURATING AND THE ROLE OF INDIGENOUS COMMUNITIES

We wish to emphasise that ethnobiology, like linguistics, cannot be attempted solely by professional scholars or outsiders, but must be thoroughly participatory, community-based, and respectful of the intellectual property rights pertaining to traditional knowledge. Collaborative projects that document languages must respect the intellectual property rights of all stakeholders in addition to informed consent for sharing information. We believe that traditional 'curated' collections, or stores of data controlled by a single researcher or institution, will gradually evolve into something more diffuse, more crowd-sourced and more likely to be uploaded to public access sites such as YouTube. This trend might have both negative and positive effects in terms of data longevity and searchability, but it is the wave of the future in curating audio and video collections. Given the lack of resources to document all of the world's ethnobiological knowledge, and the urgency imposed by the erosion of this knowledge base, we welcome the vast new possibilities offered by the curator-less, crowd-sourced model of data preservation.

## *Appendix — some ethnobotanical videos on YouTube*

Anthony Degio, a native speaker of the endangered Koro-Aka language in northeast India: http://youtu.be/RA-xjzwfpqU, http://youtu.be/yYGKLW-28lY

Sangre de Drago: http://youtu.be/2Chiq9F4lW8, http://youtu.be/2njrYklU5y0, http://youtu.be/jKmaR24qPpk, http://youtu.be/yKhMXdbSp7I

Eating 'piton': http://youtu.be/AwUv4yguE8g

Berry for hunting dogs: http://youtu.be/gf4esj8S0GI

'Uncle Poison' (documentary about a faith healer): http://youtu.be/IC6LDM522mQ

*Amanita muscaria*: http://youtu.be/sCfQuxSnwyw

## *Websites*

*FishBase*. http://fishbase.org

*Forvo*. www.forvo.com

School of Oriental and African Studies. *Endangered Languages Archive*. http://elar.soas.ac.uk

*DoBeS: Documentation of Endangered Languages*. www.mpi.nl/resources/data/dobes

*Matukar–English Online Talking Dictionary*. http://matukar.swarthmore.edu

*RNLD: Resource Network for Linguistic Diversity*. www.rnld.org

National Geographic Society. *Enduring Voices Project*. http://travel.nationalgeographic.co.uk/travel/enduring-voices

## *Literature cited*

Anderson, G. D. S., Barth, D. & Harrison, K. D. (2010). *Matukar Talking Dictionary*. Living Tongues Institute for Endangered Languages. http://matukar.talkingdictionary.org

Anderson, G. D. S. & Harrison, K. D. (2007). *Siletz Talking Dictionary*. Living Tongues Institute for Endangered Languages. http://siletz.talkingdictionary.org

Carbaugh, D. (1992). 'The mountain' and 'The project': duelling depictions of a natural environment. In: *Proceedings of the Conference on the Discourse of Environmental Advocacy*, eds J. Cantrill & C. Oravec, pp. 360–376. University of Utah Humanities Center, Salt Lake City.

Caviedes, C. N. (2001). *El Niño in History: Storming Through the Ages*. University of Florida Press, Gainesville.

Collins, D. A. & Liukkonen, J. R. (2002). What's in a Name? Plant Lexical Variation among the Q'eqchi Maya, Alta Verapaz, Guatemala. In: *Ethnobiology and Biocultural Diversity: Proceedings of the Seventh International Congress of Ethnobiology*, eds J. R. Stepp, F. S. Wyndham & R. K. Zarger, pp. 614–627. University of Georgia Press, Athens.

Conklin, H. C. (1954). *The Relation of Hanunóo Culture to the Plant World*. PhD Dissertation, Yale University, New Haven.

Harrison, K. D. (2007). *When Languages Die: The Extinction of the World's Languages and the Erosion of Human Knowledge*. Oxford University Press, Oxford.

Hart, R. (2004). *Up and Down the Mountain*. Undergraduate thesis, Swarthmore College, Swarthmore. www.swarthmore.edu/SocSci/Linguistics/Papers/2004/hart_robbie.pdf

Hartl, G. (2008). *Linguistic Metaphor in Biological Theory: An Analysis of Linguistic Concepts in Molecular Genetics*. VDM Verlag, Saarbrücken.

Hunn, E. S. (2008). *A Zapotec Natural History*. University of Arizona Press, Tucson.

Hyslop, C. (1999). The linguistics of inhabiting space: spatial reference in the north-east Ambae language. *Oceania* 70: 25–42.

Larson, B. (2011). *Metaphors for Environmental Sustainability: Redefining Our Relationship With Nature*. Yale University Press, New Haven.

McClatchey, W. (2011). Ethnobiology: basic methods for documenting biological knowledge represented in languages. In: *The Oxford Handbook of Linguistic Fieldwork*, ed. N. Thieberger, pp. 281–297. Oxford University Press, Oxford.

Oozeva, C., Noongwook, C., Noongwook, G., Alowa, C. & Krupnik, I. (2004). *Watching Ice and Weather Our Way: Sikumengllu Eslamengllu Esghapalleghput*. Arctic Studies Center, Smithsonian Institution, Washington, DC.

Ragupathy, S., Newmaster, S. G., Murugesan, M. & Balasubramaniam, V. (2009). DNA barcoding discriminates a new cryptic grass species revealed in an ethnobotany study by the hill tribes of the Western Ghats in Southern India. *Molecular Ecology Resources* 9 (Suppl. 1): 164–171.

Simons, G. & Bird, S. (2003). Seven dimensions of portability for language documentation and description. *Language* 79: 557–582.

Stepp, J. R. (2002). Wasps' claws and jaguars' whiskers: animals names in Tzeltal Maya ethnobotanical nomenclature. In: *Ethnobiology and Biocultural Diversity: Proceedings of the Seventh International Congress of Ethnobiology*, eds J. R. Stepp, F. S. Wyndham & R. K. Zarger, pp. 171–179. University of Georgia Press, Athens.

Tamsang, K. P. (2004). *Glossary of Lepcha Medicine*. Mani Printing Press, Indigenous Lepcha Tribal Association, Kalimpong.

# CHAPTER 16

# *Legal aspects of biocultural collections*

CHARLES R. MCMANIS
JOHN S. PELLETIER
Washington University School of Law, Saint Louis

## INTRODUCTION

As museum curators collect, curate and display biocultural collections, it is vitally important that they consider the legal ramifications of the decisions they make. Biocultural collections, and the curation of such collections, raise a number of legal issues that are unique, as a result of the complex cultural and artistic significance and the biological nature of such objects. For example, what intellectual property and tangible property rights exist for biocultural objects? Who owns these rights? Is the object a piece of cultural property, and if so, what domestic law and international treaties affect the ownership, sale, purchase, import, and export of such objects? Are the animal or plant materials used to make a particular object subject to wildlife laws that might limit a museum's ability to acquire the object legally?

As illustrated above, the law that affects the curation of biocultural collections is anything but simple. The management and curating of these collections implicates real property law, intellectual property law, wildlife law, cultural property law, contract law and corporate law, to name just a few. Furthermore, the management of collections involves additional considerations such as insurance and tax considerations. In the interest of brevity, and to avoid reiterating information that is widely available regarding the law affecting museum management, this chapter focuses on the legal issues that are most salient and unique to biocultural collections. As such, this chapter alone does not provide a comprehensive guide to the legal aspects of museum curating. Moreover, each object accessioned, deaccessioned or loaned presents a unique set of legal issues, and thus it is always advised that curators consult museum professionals and qualified attorneys in order to assure that these valuable collections are dealt with in a manner that is compliant with the various relevant legal requirements and standards (Phelan, 1982).

Compliance with the law is, of course, not sufficient. Curators must also act in an ethical fashion (see Chapter 1). For biocultural collections, this means working according to the principles set out in the codes of ethics of the principle professional bodies, including the International Society of Ethnobiology and the Society for Economic Botany, as well as the codes of museum bodies such as the Museums Association (UK) and the American Alliance of Museums (USA).

The law cited here is specific to the USA, but most countries with well-developed museum sectors have similar legal frameworks and will face similar issues. Advice that is specific to other countries should be sought from national museum associations and government agencies.

This chapter first addresses tangible property issues: legal issues concerning the physical object. Second, it addresses intellectual property issues: questions regarding copyright and artists' rights with respect to expression embodied in a biocultural object or the rights of innovators, including traditional healers or agriculturalists, in utilitarian aspects of a cultural object.

TANGIBLE PROPERTY ISSUES

## Ownership of biocultural objects

One of the most important concepts for curators to understand is that ownership rights for objects (personal property) and intellectual property rights (such as copyrights, artists rights, patents, and trademarks) are separate legal rights. Often, these rights are owned by different persons or entities; thus, it is important to consider the ownership of tangible property rights and intellectual property rights separately. Issues concerning intellectual property rights are considered below. Ownership of the physical objects that comprise biocultural collections implicates the law of personal property. Personal property, as opposed to real property, refers to '[a]ny movable or intangible thing that is subject to ownership and not classified as real property' (Garner, 2009). Real property, on the other hand, refers to '[l]and anything growing on, attached to, or erected on it, excluding anything that may be severed without injury to the land' (Garner, 2009). Generally speaking, this area of law is governed by common law doctrine — that is, '[t]he body of law derived from judicial decisions, rather than from statutes or constitutions' (Garner, 2009). Depending on the laws of a particular state, specific federal legislation and the legal classification of particular objects, state common law doctrine is supplemented and often affected significantly by state and federal statutory law and international treaties.

The first question curators should ask when considering the purchase, sale or evaluation of biocultural objects is 'who possesses title to the object at issue?' The term 'title', as it is used in the legal sense, connotes 'the possession of rights of ownership' in a particular piece of personal property (Marlano, 1998: 65). Of course, although in some instances these rights of ownership will be complete — that is, the person or entity who has title retains all ownership rights in the object — often title will not be complete or 'absolute'. Completeness of title impacts the degree to which certain property rights have been reserved by a prior transferor or other party (Marlano 1998: 65). As such, curators must determine whether the title is indeed complete and how the completeness of title might affect their choice to accession objects and their ability to display and deaccession objects in the future (Marlano, 1998: 65). In the museum setting, intellectual property rights in objects and gifts transferred to museums subject to certain restrictions are common sources of limitations on the completeness of title in particular objects (Marlano 1998: 65).

In addition to considering whether title to a particular biocultural object is complete, curators should also consider the quality of title in biocultural objects. Quality of title refers to two aspects of the title in a piece of property: (1) whether the title is 'good title' and (2) whether the title conveyed in a particular object is as it has been represented (Marlano, 1998: 65). The term 'good title' means that title has legally passed and thus is no longer encumbered. Beyond being certain that good title has legally passed, usually via a written document such as a deed, curators should be concerned as to whether the title conveyed in a sale or purchase has been accurately represented during negotiations (Marlano, 1998: 65). This of course requires that curators do their due diligence by independently researching the objects they intend to acquire or dispose of. The following sections discuss various topics that can affect either the quality or the completeness of title, with a particular focus on topics that are particularly relevant to biocultural collections.

## Restricted gifts

'Most gifts transfer full ownership — absolute ownership (if personal property) or ownership in fee simple absolute (if land)' (*Restatement (Third) of Prop.: Wills & Donative Transfers*, § 6.1 cmt. B). In the museum context, however, donors often want to ensure that the objects they donate are used

for a particular purpose or in a particular manner. Therefore, donors will often give 'restricted gifts'. The term 'restricted gifts' broadly refers to objects that are transferred to a museum subject to certain restrictions, such as limitations on use, display or disposal of a particular object (Marlano, 1998: 65).

In order for a gift to be valid (1) the donor must manifest donative intent and (2) the donee must accept the gift (*Restatement (Third) of Prop.: Wills & Donative Transfers* § 6.1.). 'The transfer of personal property, necessary to perfect a gift, may be made (1) by delivering the property to the donee or (2) by inter vivos donative document' (*Restatement (Third) of Prop.: Wills & Donative Transfers* § 6.2). Curators and museum boards or trustees should carefully consider the acceptance of gifts, particularly of those that are subject to certain restrictions. In general, acceptance of gifts of substantial value is presumed unless the donee exercises the 'right to refuse or disclaim under an applicable disclaimer statute or, in the absence of an applicable disclaimer statute, within a reasonable time after learning of the gift' (*Restatement (Third) of Prop.: Wills & Donative Transfers* § 6.1, cmt. i). Failing to adequately refuse or disclaim a gift with onerous restrictions, or accepting a restricted gift without a thorough understanding of the impact of a particular restriction, has the potential to create substantial conflict with the legal duties of the museum to manage collections for the benefit of its patrons (Marlano, 1998: 136). As such, museums should develop and implement policies regarding the acceptance of gifts in order to avoid the pitfalls of accepting gifts with onerous restrictions (Lanman, 2011).

Once a gift has been accepted, issues often arise regarding whether there are any restrictions on the gift and the meaning of any restrictive language. Such issues might arise where a formal deed of gift was not executed or where the parties are no longer alive to consult regarding the meaning of the restrictive language or oral conveyances (Marlano, 1998: 139–140). Generally speaking, in the absence of express terms imposing restrictions on a gift, courts have held that conditions or restrictions on gifts will be unenforceable (Marlano, 1998: 140–141). Where the meaning of particular express restrictions is unclear or ambiguous, courts will interpret the language of restriction based on the extrinsic evidence of the intent of the parties. In *Frick Collection v. Goldstein*, 83 N.Y.S.2d 142, 147 (N.Y. Sup. Ct. 1948), *aff'd*, 86 N.Y.S.2d. 464 (N.Y. App. Div. 1949), the court explained that

> '[t]he authorities are clear that extrinsic evidence as to the testator's intention may be received only when the testator, either by the ambiguity of the language he employed, or by the ambiguity of his related conduct, has raised a doubt as to his intention'.

Nevertheless, as in *Museum of Fine Arts v. Beland*, 735 N.E.2d 1248, 1251 (Mass. 2000), courts may refuse to consider extrinsic evidence regarding whether a museum could sell a gifted object subject to a restriction because the language of the restriction, in the court's opinion, is unambiguous. Additionally, as in *Frick*, courts will be reluctant to read restrictions extending beyond the language of the restriction. In that regard the *Frick* court explained,

> '[w]hile the courts may transpose, disregard, reject or insert words or phrases to effectuate a legal testamentary intent lawfully declared, regardless of the inadequacy or incorrectness of expression … they have, however, no authority to construct under the guise of construing, nor to add a dispositive provision where one does not exist in fact or can be inferred from the language of the testator and *the attending circumstances at the date of the execution of the will*'
> (*Frick*, 83 N.Y.S.2d at 147).

Where gifts are given in the form of charitable trust and restrictions have become difficult or impossible to comply with over time, museums are not without legal relief — courts may provide

equitable remedies under the doctrine of *cy pres* or the doctrine of equitable deviation. The doctrine of *cy pres* provides that

> '[i]f property is given in trust to be applied to a particular charitable purpose, and it is or becomes impossible or impracticable or illegal to carry out the particular purpose, and if the settlor manifested a more general intention to devote the property to charitable purposes, the trust will not fail but the court will direct the application of the property to some charitable purpose which falls within the *general charitable intention of the settlor*'
>
> (*Restatement (Second) of Trusts* § 399).

On the other hand, the doctrine of equitable deviation allows the court to

> 'direct or permit the trustee of a charitable trust to deviate from a term of the trust if it appears to the court that compliance is impossible or illegal, or that owing to circumstances not known to the settlor and not anticipated by him compliance would defeat or substantially impair the accomplishment of the purposes of the trust'
>
> (*Restatement (Second) of Trusts* § 381).

These doctrines provide recipients of charitable gifts with court-mandated relief, allowing them to deviate from restrictions, provided that the deviation is in line with the donor's intent (Marlano, 1998: 143–149). Courts may, however, refuse to apply these doctrines where there have not been 'reasonable efforts' to comply with the restriction. (*Museum of Fine Arts v. Beland*, 735 N.E.2d at 1252 (Mass. 2000) refusing to apply the doctrines of *cy pres* and equitable deviation to allow the Museum of Fine Arts to sell a number of unexhibited paintings where the museum sale of the paintings went against the donors intent and the trustees had not made 'reasonable efforts' to comply with the restriction.)

## Buying and selling biocultural objects: the uniform commercial code and contract law

The buying and selling of biocultural objects will be governed by one of two bodies of state law: the Uniform Commercial Code (UCC) or the common-law of contracts. The UCC is a model code that has been enacted, at least in part, in most states except for Louisiana. The relevant portion of the UCC affecting the buying and selling of biocultural collections is Article 2, which governs the sale of goods. In order to be governed by the UCC, the property being sold or purchased must fall within the UCC's definition of goods. The UCC defines goods as 'all things that are movable at the time of identification to a contract for sale. The term includes future goods, specially manufactured goods, the unborn young of animals, growing crops, and other identified things attached to realty . . .' (U.C.C. § 2-103, 2003). In cases involving art, courts are generally finding that art qualifies as a good under the UCC and as such the UCC applies to such transactions (Darraby, 2010: § 4:1). In light of this precedent, it is likely that the UCC definition of goods is broad enough to include biocultural objects.

The provisions of UCC that are most important and significant when dealing with the buying and selling of biocultural objects are the provisions regarding warranties. A warranty is '[a]n express or implied promise that something in furtherance of a contract is guaranteed by one of the contracting parties' — that is, 'a ... promise that the thing being sold is as represented or promised' (Garner, 2009). Often, in the museum context, warranties are important because buyers want some guarantee as to the authenticity of particular objects. The UCC provides the framework for a number of warranties including warranty of title, express warranties and implied warranties.

*Warranty of title*

The UCC provides that unless 'disclaimed or modified only by specific language or by circumstances that give the buyer reason to know that the seller does not claim title, that the seller is purporting to sell only the right or title as the seller or a third person may have, or that the seller is selling subject to any claims of infringement or the like,' the seller warrants that 'title conveyed shall be good and its transfer rightful' and 'shall be delivered free from any security interest or other lien or encumbrance of which the buyer at the time of contracting has no knowledge' (U.C.C. § 2-312, 2003). This implied warranty provides protection for museums buying art to some extent, providing the basis for a cause of action against the seller where title to a biocultural object is not legally owned by the seller or is encumbered in some way.

*Express warranties*

Express warranties are warranties that are 'created by the overt words or actions of the seller' (Garner, 2009). An example of this type of warranty as applied to biocultural collections might consist of an express provision detailing the origin or maker of a particular biocultural object. Under the UCC, an express warranty can be created in one of three ways: (1) an affirmation or promise by the seller that is the basis of the bargain creates an express warrant that the goods will conform to the affirmation or promise; (2) a description of the goods warrants that the goods will match the description; and (3) a sample or model warrants that the goods will conform to the condition of the sample or model (U.C.C. § 2-313, 2003).

*Implied warranties*

Finally, the UCC provides for two types of implied warranties: warranty of merchantability (U.C.C. § 2-314, 2003) and warranty of fitness for a particular purpose (U.C.C. § 2-314, 2003). These warranties may, however, be disclaimed, excluded or modified (U.C.C. § 2-316, 2003). Courts have examined whether these implied warranties apply to authentications of art, but they have reached mixed results (e.g. *Balog v. Center of Art-Hawaii*, 745 F. Supp. 1556, 1563 (D. Haw. 1990) holding that neither implied warranty applied to works of art; *McKie v. R. H. Love Galleries, Inc.*, 1990 WL 179797, at 2-3 (N.D. Ill. 1990) allowing claims for breach of implied warranty of merchantability and implied warranty of fitness for a particular purchase regarding the authentication of artwork to go forward on a motion to dismiss).

## Stolen and unlawfully obtained biocultural objects

The previous section addressed issues regarding commercial law and the law of contracts, which governs warranties that particular objects are what a seller represents them to be and that good title has been conveyed. Whether or not good title is conveyed in a particular transaction may often depend on various international and domestic statutory and common law doctrines, which govern ownership. Furthermore, these same laws will often govern what should happen to those objects when they are stolen or unlawfully obtained. The following section attempts to identify some of the more prominent and important laws and treaties affecting stolen objects.

In 1970, in response to concerns regarding the ownership of cultural property and stolen and illicit import and export of the same, The United Nations Educational, Scientific, and Cultural Organization (UNESCO) finalised and promulgated the *Convention on the Means of Protecting and Preventing the Illicit Import, Export, and Transfer of Ownership of Cultural Property*, Nov. 14, 1990, 823 U.N.T.S. 231 [hereinafter UNESCO convention]. The UNESCO convention, in general

terms, provides minimum international standards for ownership of cultural property, recovery of unlawfully obtained cultural property, and enforcement procedures for illicit activities related to the unlawful importation and exportation of cultural property (UNESCO convention, arts. 4-14). Cultural property, as defined by the UNESCO convention, is 'property which, on religious or secular grounds, is specifically designated by each State as being of importance for archaeology, prehistory, history, literature, art or science …' (UNESCO convention, art. 1). The convention delineates specific categories of objects that constitute cultural property, with perhaps the category most significant to biocultural collections being '[r]are collections and specimens of fauna, flora, minerals and anatomy, and objects of palaeontological interest' (UNESCO Convention, art. 1). Under the UNESCO convention, ownership rights in objects designated as cultural property under article I are vested in the nations from which they originate giving those nations the right to prohibit or permit the exportation of cultural property.

Initially, the United States' and the art community were in disagreement over the extent to which the UNESCO convention should be implemented in US domestic law (Hoffman, 2006: 160). After a prolonged debate, in 1983 Congress finally passed the *Convention on Cultural Property Implementation Act* (CPIA; 19 U.S.C. §§ 2601-13, 2003). The CPIA only implements certain portions of the UNESCO conventions — specifically articles 7(b) and 9, 'which call for concerted action among nations to prevent trade in specific items of cultural property in emergency situations' (Hoffman, 2006: 160). Thus, the CPIA provides a mechanism by which foreign nations can stop importation of cultural property into the USA and effect the return of objects that are either designated by a requesting nation as 'in jeopardy of pillage' (CPIA; 19 U.S.C. § 2602 (a)(1)(A)) or 'documented as appertaining to the inventory of a museum or religious or secular public monument … which is stolen' (CPIA; 19 U.S.C. § 2607). Whereas the latter is relatively self-explanatory, in order for the US to impose importation restrictions for objects in 'jeopardy of pillage' the requesting party must demonstrate that: (1) it has taken steps to protect its cultural property; (2) that the import restriction request would have 'substantial benefit'; (3) that other 'less drastic' measures would be ineffective; and (4) that the restriction is consistent with the 'general interests of the international community in the exchange of cultural property for scientific, cultural and educational purposes' (CPIA; 19 U.S.C. § 2602(a)(1)). Exceptions are made for property that has been imported or exported for temporary exhibition or if the property has been in the USA for specified periods of time and acquired without knowledge that the property was unlawfully obtained (CPIA; 19 U.S.C. § 2611).

Domestically, the US has enacted positive law, which protects cultural property within US borders. In particular, federal law focuses on the protection of Native American cultural property. The *Native American Graves Protection and Repatriation Act* (NAGPRA; 25 U.S.C. §§ 3001-13, 2006) creates ownership rights in, regulates the excavation and removal of, and creates enforcement mechanisms for unlawful takings of Native American cultural property. More specifically, § 3002 of NAGPRA vests title and ownership of Native American cultural property in the ancestors of the tribe to which the property is attributed (NAGPRA; 25 U.S.C. § 3002). Thus, the tribes have control over whether or not this property is to be kept or relinquished by transferring title to another person or entity (NAGPRA; 25 U.S.C. § 3002(e)). Finally, NAGPRA requires the return of cultural property and proscribes civil penalties for failure to do so (NAGPRA; 25 U.S.C. §§ 3004, 3007).

Where importation restrictions to do not prevent the exchange of stolen or unlawfully obtained property, other actions at common law or pursuant to statues may provide relief for both *bona fide* owners of stolen property and purchasers of stolen property, and may also impose criminal penalties for theft. First, under the *National Stolen Property Act* of 1948 (NSPA; 18 U.S.C. §§ 2314-15, 2006),

the US has pursued claims against persons who traffic stolen cultural property. Under the NSPA, it is a crime to knowingly 'transport, transmit, or transfer in interstate or foreign commerce' stolen goods which are valued at $5,000 or more (NSPA; 18 U.S.C. § 2314). In *United States v. McClain* (545 F.2d 998 5th Cir., 1977), the leading case regarding the NSPA and its application to cultural property, the Fifth Circuit upheld a conviction of defendants who conspired to transport and receive pre-Columbian artefacts under the NSPA. In addition to statutory claims, owners of stolen property — also referred to as stolen chattels — might file claims for the tort of conversion or replevin. The tort of conversion is a claim against another for 'intentional exercise of dominion or control over a chattel which so seriously interferes with the right of another to control it that the actor may justly be required to pay the other the full value of the chattel' *(Restatement (Second) of Torts, 1965: §222A).* On the other hand, and action for replevin, a plaintiff may request in lieu of damages the return of the property *(Restatement (Second) of Torts, 1965:* § 922, cmt. B).

Because good title can only be conveyed by the rightful owner, curators need to be diligent in researching the origins of certain biocultural items in order to ascertain whether a seller is conveying good title and whether museums are the rightful owners of objects already in their collections (U.C.C. § 2-403(2003)). Furthermore, where property is stolen, museums have recourse through a number of statutory, common law and international treaties to obtain relief.

## Specific issues regarding objects made from animals or plants

The nature of the materials used in creating the objects that make up biocultural collections — plant and animal products — broadens the areas of law that might affect the buying, selling and loaning of biocultural collections. Of unique importance are a number of wildlife and conservation laws that regulate trade in particular plants and animals. It is important for curators to consider the materials that are used in biocultural objects and any unique trade regulations that may affect legal trade in such objects. The following discussion provides a summary of the various international and domestic laws that can affect trade in biocultural collections.

Internationally, the *Convention on International Trade in Endangered Species of Wild Fauna and Flora* (1973) [hereinafter CITES] is an international treaty that limits trade in a variety of designated animals and plants. In the USA, this treaty is administered by the United States' Fish and Wildlife Service (USFWS). CITES organises the various species in to three categories: (1) 'species threatened with extinction'; (2) 'species which although not necessarily now threatened with extinction may become so unless trade in specimens of such species is subject to strict regulation in order to avoid utilisation incompatible with their survival and other species which must be subject to regulation in order that trade in specimens of certain species … may be brought under effective control'; and (3) 'species which a Party identifies as being subject to regulation within its jurisdiction for the purpose of restricting exploitation, and as needing the cooperation of other Parties in the control of trade' (CITES, art. II). These various categories of species, which are detailed in CITES appendices I–III, are subject to various trade regulations, with the strictest regulations applying to the first category and least restrictive applying to the third category (CITES, arts. III–V). Most relevant to the curation of biocultural collections is that import or export of any object containing parts of animals or plants that are listed in one of the three appendices must be accompanied by one or two permits, always one from the relevant authority in the exporting nation, and in the case of CITES Appendix I material, one from the importing nation (CITES, arts. III–V). In some cases, an import permit is required by national law for Appendix II and III material too, so requirements must

always be checked in advance of shipping. 'Non-commercial loan, donation or exchange between scientists or scientific institutions registered by a Management Authority of their State, of herbarium specimens, other preserved, dried or embedded museum specimens, and live plant material which carry a label issued or approved by a Management Authority' is exempted from CITES permit requirements (CITES, art. VI, § 6), but special documentation, in the form of a Certificate of Scientific Exchange, is still required.

Domestically, there are a number of federal laws in the USA that not only provide general prohibitions and regulations on the trade of animals, plants, and parts thereof, but also finely tailored laws that protect very specific species. The *Lacey Act* makes it unlawful for any person to 'import, export, transport, sell, receive, acquire, or purchase any fish or wildlife or plant taken, possessed, transported, or sold in violation of any law, treaty, or regulation of the USA or in violation of any Indian tribal law' or violations of state laws in interstate commerce (16 U.S.C. § 3372(a)). Violation of CITES or the other laws discussed would likely amount to a violation of the *Lacey Act*, which provides for both civil and criminal penalties. Civil penalties can be as high as $10,000 per violation (16 U.S.C. § 3373(a)). Criminal penalties can be up to a $20,000 fine per offence or 5 years in prison for offences that constitute a felony and up to $10,000 or one year in prison for misdemeanours (16 U.S.C. § 3373(d)).

In addition to the *Lacey Act*, there are a number of federal laws that more specifically prohibit trade in certain plants and animals and parts thereof. First, the Endangered Species Act (ESA), which like the *Lacey Act* is administered by the USFWS, creates a number of violations that prohibit importation, exportation, taking, possessing, selling or offering for sale, delivering, carrying, transporting, shipping, and destroying an 'endangered' species of fish, wildlife or plant (16 U.S.C. § 1538(a)). Furthermore, the ESA also prohibits the violation of any regulation pertaining to 'threatened' species of fish, wildlife, or plant (16 U.S.C. §§ 1538(a)(1)(G), 1538(a)(2)(E)). Species categorised as endangered or threatened are evaluated and designated on the basis of criteria set forth in 16 U.S.C. § 1533(a)(1) by the Secretary of the Interior 'solely on the basis of the best scientific and commercial data available' (16 U.S.C. § 1533(b)(1)). The Secretary categorises a species as endangered or threatened because of any of the following factors:

(A) the present or threatened destruction, modification, or curtailment of its habitat or range; (B) overutilization for commercial, recreational, scientific, or educational purposes; (C) disease or predation; (D) the inadequacy of existing regulatory mechanisms; or (E) other natural or manmade factors affecting its continued existence. (16 U.S.C. 1533(a)(1))

In addition to creating protection for threatened and endangered species, sections 1527a and 1539 of the ESA implement CITES, giving the Secretary of the Interior management authority and scientific authority under CITES and prohibiting the trade or possession of specimens in violation of CITES. Under the ESA, the Secretary of the Interior has the authority to grant permits for activities that would otherwise violate the ESA or CITES (16 U.S.C. § 1539(a)). Violations can result in both civil and criminal penalties, with civil penalties of up to $25,000 per offense and criminal penalties of a fine of up to $50,000 or one year in prison or both (16 U.S.C. § 1540). In addition to the ESA, there are a number of more specific federal laws protecting more specific species, including: the *Migratory Bird Treaty Act* (16 U.S.C. §§ 703-12), which prohibits trading and hunting of certain migratory birds pursuant to treaties between the USA and Mexico and the UK; the *Eagle Protection Act* (16 U.S.C. § 668), which makes it unlawful to 'take, possess, sell, purchase, barter, offer to sell, purchase or barter, transport, export or import, at any time or in any manner' any bald eagle or

golden eagle, parts thereof, eggs or nests; the *African Elephant Conservation Act* (16 U.S.C. §§ 4201-46), which prohibits the import or export of raw and worked ivory; the *Marine Mammal Protection Act* (16 U.S.C. §§ 1361-1407), which prohibits the taking of marine mammals; the *Plant Protection Act* (7 U.S.C. § 7711), which prohibits the import, export, and movement in interstate commerce of plant pests without a permit; the *Wild Bird Conservation Act* (16 U.S.C. § 4904); and the *Antarctic Conservation Act* (Z6. U.S.C. § 2401).

These laws essentially require that curators be knowledgeable about the materials used in making particular biocultural objects and that proper permits are obtained when collecting objects that contain plant and animal materials that are subject to restrictions. Failure to obtain such permits could potentially result in large civil judgments or fines, and in the destruction of specimens. Furthermore, attorneys advising curators should be acutely aware of wildlife laws and regulations so that they can adequately advise curators as to when they do and do not need to seek permits to acquire or sell biocultural objects.

## Specific issues regarding antiquities and archaeological objects

Often, biocultural objects will qualify as antiquities or archaeological objects and thus it is necessary to explore laws that affect ownership of and trade in such objects. As noted in the previous section, the UNESCO convention sets certain international standards for the protection of cultural property, which are implemented to a degree by the CPIA. The UNESCO convention includes archaeological products and antiquities in its definition of cultural property. In response to the UNESCO convention, many museums in the USA and elsewhere have adopted 1970 as a 'threshold for the application of more rigorous standards to the acquisition of archaeological materials and ancient art', strongly discouraging the acquisition of a work 'unless provenance research substantiates that the work was outside its country of probable modern discovery before 1970 or was legally exported from its probable country of modern discovery after 1970' (Association of Art Museum Directors, 2008). Museums must also undertake due diligence on acquisitions with regard to the spoliation of cultural and biological collections during the Nazi/World War II era (1933–1945).

The *Antiquities Act* of 1906 prohibits removal or destruction of antiquities from US-owned property without a permit (16 U.S.C. §§ 432-33). Permits can be issued to reputable museums, among other entities (16 U.S.C. § 432). Penalties for failure to obtain a necessary permit include $500 fine or 90 days in prison (16 U.S.C. § 433).

The *Archaeological Resources Protection Act* of 1979 (ARPA; 16 U.S.C. §§ 470aa-mm 2006), prohibits unauthorised 'removal, excavation, damage, alteration, or defacement' and trafficking of archaeological resources excavated or removed from federal or Indian lands in violation of federal, state or local laws. For purposes of the ARPA, 'archaeological resources' include 'pottery, basketry, bottles, weapons, weapon projectiles, tools, structures or portions of structures, pit houses, rock paintings, rock carvings, intaglios, graves, human skeletal materials, or any portion or piece of any of the foregoing items' (ARPA; 16 U.S.C. § 470bb). Although removal is generally prohibited, museums may obtain a permit to remove archaeological resources from public lands and Indian lands. Criminal penalties for violations of the ARPA can be up to $20,000 and 2 years in prison for a first offense and $100,000 and 5 years in prison for subsequent offenses (ARPA; 16 U.S.C. § 470ee(d)). Civil penalties are determined by Federal land managers (ARPA; 16 U.S.C. § 470ff). Furthermore, the ARPA also contains a reward provision, providing that half of the reward should be payable to persons who notify the Federal land manager of offences (16 U.S.C. § 470gg(a)).

## INTELLECTUAL PROPERTY ISSUES

## Copyright

### General issues

In the USA, copyright law has constitutional foundations. The United States' Constitution states 'Congress shall have the power … To promote the Progress of Science … by securing for limited Times to Authors … the exclusive Right to their … Writings …' (U.S. Const. art. 1, cl. 8, § 8). Pursuant to this constitutional power, Congress enacted the *Copyright Act* and its various amendments to protect 'original works of authorship' which are 'fixed in a tangible medium of expression' (17 U.S.C. § 102(a)). Originality merely requires that 'the work was independently created by the author … and that it possesses at least some minimal degree of creativity' (*Fiest Publ'ns v. Rural Tel. Serv. Co.,* 499 U.S. 340, 346 (1991)). The *Copyright Act* illustrates the type of subject matter that qualifies for protection. These categories include literary works, musical works, dramatic works, choreography, pictorial, graphical or sculptural works, motion pictures and audio-visual works, sound recordings and architectural works (17 U.S.C. § 102(a)). These categories are not limitative — they are merely illustrative and do not limit the scope of subject matter protectable by copyright to those categories (17 U.S.C. § 101). Ideas, processes, systems, methods of operation, concepts, principles and discoveries, and useful articles are excluded from the subject matter of copyright and are therefore not protectable under the *Copyright Act* (17 U.S.C. §§ 101, 102(b)).

**Rights.** *The Copyright Act* provides copyright holders with a number of exclusive rights, which in part depend on the nature of the subject matter. Copyright holders of all works retain the exclusive right to reproduce, prepare derivative works and distribute copies (17 U.S.C. § 106). The rights to reproduce and distribute are relatively self-explanatory, but the right to prepare derivative works requires further explanation. A derivative work 'is a work based on one or more pre-existing works … in which a work may be recast, transformed, or adapted' (17 U.S.C. § 101). The classic example of a derivative work would be adapting a book into a motion picture. Additionally, the rights to perform works publically, display works publically and perform publically by means of digital audio transmission apply to specific categories of works. The right to perform publically applies to literary, musical, dramatic, choreographic and audio-visual works (17 U.S.C. § 106(4)). The right to display publically, which is of particular significance in the museum context, applies to literary, musical, dramatic, choreographic, and pictorial, graphical or sculptural works (17 U.S.C. § 106(5)). The right to perform publically by means of digital audio transmission is reserved for sound recordings only (17 U.S.C. § 106(6)).

**Ownership and duration.** Under the current version of the *Copyright Act*, ownership of copyrightable subject matter fixed on or after 1 January 1978 vests in the author of the work upon fixation and persists for the life of the author plus 70 years (17 U.S.C §§ 201(a), 302(a)). A joint work, that is 'a work prepared by two or more with the intention that their contributions be merged together as inseparable or interdependent parts of a unitary whole', vests in both authors upon fixation and persists for the life of the last surviving author plus 70 years (17 U.S.C §§ 101, 201(a), 302(b)). Under the current version of the *Copyright Act*, works for hire are treated differently than those fixed by a single author or joint authors. A work for hire, for purpose of the *Copyright Act*, is: (1) 'a work prepared by an employee in the scope of his or her employment'; or (2) a work which is 'specially ordered or commissioned' and for use in a finite number of categories of copyrightable works (17 U.S.C. § 101). Ownership of works for hire vest in the employer or person for whom the work was created, absent an express written agreement to the contrary, for 95 years from publication or 120 years from

fixation, whichever comes first (17 U.S.C. §§ 201(b), 302(c)). Although registration of copyright with the United States' Copyright Office is not a prerequisite to ownership, registration within five years of publication constitutes *prima facie* evidence of ownership in court and is a prerequisite to filing a lawsuit for infringement (17 U.S.C. 410(c), 411(a)). The ownership and duration of copyright of works created before 1 January 1978 are subject to complicated formalities and durations which vary from the ownership rights and durations applying to works created on or after that date, and are too dense to explain concisely here. As such, assessing ownership interest in works created before 1 January 1978 should be done by an experienced copyright attorney.

**Transfers of ownership and licensing.** Under the *Copyright Act*, transfers of copyright ownership must be made in writing (17 U.S.C. § 204). For purposes of the copyright act, 'transfers of copyright ownership' constitutes virtually any transfer of right, including exclusive licenses. However, it does not include non-exclusive licenses (17 U.S.C. § 101). Transferors or licensors may transfer any one of the exclusive rights separately or all of the exclusive rights.

**Infringement.** Infringement of copyright occurs when any one of the exclusive rights described above are violated (17 U.S.C. § 501). Infringement claims may be brought by a 'legal or beneficial owner of an exclusive right' (17 U.S.C. § 501). In order to prove copyright infringement, a plaintiff must show: (1) ownership of a valid copyright; and (2) unauthorised copying. As previously mentioned, registration constitutes *prima facie* evidence of ownership. Proving unauthorised copying requires a showing of copying and improper appropriation. Copying may be shown by producing: (1) direct evidence of copying; (2) circumstantial evidence of access to the copyrighted work and substantial similarity between the infringing work and the copyrighted work; or (3) evidence of striking similarity (Nimmer & Nimmer, 2011: § 13.01). Remedies for infringement include injunctions, damages and criminal fines (17 U.S.C. §§ 502, 503–06). Civil damages for infringement can be calculated in the amount of plaintiff's losses, defendant's profits, or statutory damages up to $150,000 per infringed work (17 U.S.C. §§ 503-05).

**Defences.** The first defence to a claim of copyright infringement would be to attack the plaintiff's *prima facie* case of copyright infringement — that is, to attack the originality of the copyrighted work or to argue that the appropriation of a particular copyrighted work is permissible under one of the safe-harbour provisions in sections 107–122 of the *Copyright Act* or is *de minimis*. The de minimis-use doctrine provides a defence where the copying 'is so trivial that it falls below the quantitative threshold of substantial similarity' (*Sandoval v. New Line Cinema Corp.*, 147 F.3d 215, 217 (2d. Cir., 1998)). Another common defence, is the fair-use defence, which is codified in 17 U.S.C. § 107. The fair-use doctrine provides a four-factor analysis to determine whether a use is non-infringing and thus a fair one. The four factors include: (1) 'the purpose and character of the use'; (2) 'the nature of the copyrighted work'; (3) 'the amount and substantiality of the portion used in relation to the copyrighted work as a whole'; and (4) 'the effect of the use upon the potential market for or the value of the copyrighted work' (17 U.S.C. § 107).

### Biocultural collections and copyright

**Biocultural objects as copyrightable subject matter.** The first question museums should ask regarding their biocultural collections is whether a particular biocultural object is copyrightable subject matter. Generally speaking, the threshold for copyrightable subject matter (originality and fixation) is a relatively low one. Biocultural objects such as paintings or sculptures are clearly within the subject matter of copyright. However, where objects are to some extent utilitarian, such as a carved gourd, woven satchel with natural dyes, or seed necklace, under the useful article doctrine

such objects will not be protectable, as they are objects 'having an intrinsic utilitarian function that is not merely to portray the appearance of the article or to convey information' (17 U.S.C. § 101). Such works may still be protectable but only if 'the design incorporates pictorial, graphic or sculptural features that can be identified *separately from, and are capable of existing independently of, the utilitarian aspects of the article'* (17 U.S.C. § 101). Other useful articles are outside the scope of copyright.

The second question curators should ask is whether those objects that are copyrightable are still subject to copyright protection. For works created on or after 1 January 1978, these works receive protection upon fixation and still persist. Works created prior to that date may be subject to a variety of formalities in order to acquire protection or copyright may have expired and the work may have moved into the public domain. For those objects that retain copyright protection, museums may need to obtain licenses or transfers of copyright in order to reproduce or display such works.

**Digitisation and documentation of biocultural collections.** Currently, a large part of what museums do is to provide access to collections beyond the confines of the museum walls. This means that collections are being digitised and made available in various forms for educational and commercial purposes. Museums generally take on two different roles in this regard: that of copyright users and that of copyright owners (Pessach, 2007). Depending on the use of digitised images, museums may need to license copyrighted works from relevant copyright holders in order to legally use digitised images of such objects. However, such a use might be a fair one if the museum simply uses the digital image in educational material that accompanies exhibitions (Appel, 1999).

Digitised images and documentation of biocultural collections by museums may result in copyrights of those images and documentation. The major question here is whether such images and documentation rise to the level of originality necessary to be protectable under the US copyright regime. Addressing this issue, one court has held that a museum's digitised images that simply amount to a 'slavish copy' will not meet the requisite level of originality needed to be eligible for copyright protection (*Bridgeman Art Library Ltd. v. Corel Corp.*, 39 F. Supp. 2d 191, 192 (S.D.N.Y. 1999)). However, *Bridgeman* dealt with exact digital replicas of public domain paintings — images of biocultural objects may not be slavish copies, and to that extent should be protected by copyright. Furthermore, provided that images are copyrightable, museums may take advantage of access protections available under the *Digital Millennium Copyright Act*, which among other things, creates a cause of action for the circumvention of access protection measures (17 U.S.C § 1201).

## VARA and artists rights

Artists' rights are not well protected in the USA, but the *Visual Artists Rights Act of 1990* (VARA) does provide some protection. VARA gives visual artists the right to 'claim authorship in their works', prevent the use of their name in connection with works they did not create or which has been destroyed, mutilated or modified, prevent the 'intentional distortion, mutilation, or other modification of the work' and 'prevent any destruction of works of recognized stature' (17 U.S.C. § 106A(a)). These rights are separate from any copyright and persist for the life of the artist (17 U.S.C. § 106A(b), (d)). Furthermore, these rights cannot be transferred, although the artist can waive these rights (17 U.S.C. § 106A(e)).

## Traditional knowledge

In recent years, a great deal of national and international attention has been given to the topic of providing legal protection for traditional knowledge. A variety of international agreements, including the *Convention on Biological Diversity* (1992) and the *Nagoya Protocol on Access to Genetic*

*Resources* (2010), the World Trade Organization *Agreement on Trade-related Aspects of Intellectual Property Rights* (1994) (popularly known as the TRIPS Agreement), and the Food and Agricultural Organization (FAO) *International Treaty on Plant Genetic Resources for Food and Agriculture* (2001), are potentially relevant to the establishment of such protection. National legislation addressing the legal protection of traditional knowledge is rapidly evolving (McManis, 2007). Curators of biocultural collections should thus consult attorneys who have expertise in this rapidly evolving field of law to ensure that the rights of traditional knowledge holders are properly recognised.

## CONCLUSION

As illustrated above, the law affecting curating biocultural collections is diverse and complex. Legal issues regarding tangible property, intellectual property and management of collections are just the tip of the iceberg. Navigating these laws is not simple, but being knowledgeable about potential legal issues that might impact the collection and preservation of these important collections will only aid curators in their difficult task. This chapter highlights some of the major legal issues affecting these collections. Curators should keep these issues in mind when accessioning, de-accessioning and managing collections. Finally, curators should consult knowledgeable attorneys in an effort to be sure that all of the legal issues affecting biocultural collections, not just the ones discussed here, are accounted for and addressed in an effective manner.

## Legislation and case law cited

*Agreement on Trade-related Aspects of Intellectual Property Rights* (1994). www.worldtradelaw.net/uragreements/tripsagreement.pdf

*Antiquities Act of 1906*, 16 U.S.C. §§ 432-33 (2006).

*Archaeological Resources Protection Act of 1979*, 16 U.S.C. §§ 470aa-mm (2006).

*Balog v. Center of Art-Hawaii*, 745 F. Supp. 1556, 1563 (D. Haw. 1990).

*Bridgeman Art Library Ltd. v. Corel Corp.*, 39 F. Supp. 2d 191, 192 (S.D.N.Y. 1999).

*Convention on Biological Diversity* (1992). www.fao.org/legal/treaties/033t-e.htm

*Convention on Cultural Property Implementation Act*, 19 U.S.C. §§ 2601-13 (2006).

*Convention on International Trade in Endangered Species of Wild Fauna and Flora*, Jan. 13, 1973, 27.2 U.S.T. 1087, 993 U.N.T.S. 244.

*Convention on the Means of Protecting and Preventing the Illicit Import, Export, and Transfer of Ownership of Cultural Property*, Nov. 14, 1990, 823 U.N.T.S. 231.

*Copyright Act*, 17 U.S.C. §§ 101-1332 (2006).

*Endangered Species Act*, 16 U.S.C. §§ 1531-48 (2006).

*Fiest Publ'ns v. Rural Tel. Serv. Co.*, 499 U.S. 340, 346 (1991).

*Frick Collection v. Goldstein*, 83 N.Y.S.2d 142, 147 (N.Y. Sup. Ct. 1948), aff'd, 86 N.Y.S.2d. 464 (N.Y. App. Div. 1949).

*International Treaty on Plant Genetic Resources for Food and Agriculture* (2001). www.fao.org/legal/treaties/033t-e.htm

*Lacey Act*, 16 U.S.C. §§ 3371-78 (2006).

*McKie v. R. H. Love Galleries, Inc.*, 1990 WL 179797 (N.D. Ill. 1990).

*Digital Millennium Copyright Act* 1998

*Museum of Fine Arts v. Beland*, 735 N.E.2d 1248 (Mass. 2000).

*National Stolen Property Act of 1948*, 18 U.S.C. §§ 2314-15 (2006).

*Native American Graves Protection and Repatriation Act (NAGPRA)*, 25 U.S.C. §§ 3001-13 (2006).

*Restatement (Second) of Torts* (1965).

*Restatement (Second) of Trusts* (1959).

*Restatement (Third) of Prop.: Wills & Donative Transfers* (2003).

*Sandoval v. New Line Cinema Corp.*, 147 F.3d 215 (2d. Cir.) (1998).

*Uniform Commercial Code (U.C.C.)* (2003).

*United States v. McClain*, 545 F.2d 998 (5th Cir.) (1977).

*Visual Artists Rights Act of 1990*, 17 U.S.C. § 107A (2006).

World Trade Organization *Agreement on Trade-related Aspects of Intellectual Property Rights* (TRIPS) 1994.

## Literature cited

Appel, S. (1999) Copyright, digitization of images, and art museums: cyber space and other new frontiers. *UCLA Entertainment Law Review* 6: 149–233.

Association of Art Museum Directors (2008). *New Report on Acquisition of Archaeological Materials and Ancient Art.* www.aamd.org/newsroom/documents/2008ReportAndRelease.pdf

Darraby, J. (2010). *Art, Artifact, Architecture and Museum Law.* Second edition. West Publishing Co., St. Paul.

Garner, B. A. (ed.) (2009). *Black's Law Dictionary.* Ninth edition. West Publishing Co., St. Paul.

Hoffman, B. T. (2006). International art transactions and the resolution of art and cultural property disputes: a United States perspective. In: *Art and Cultural Heritage: Law, Policy, and Practice*, ed. B. T. Hoffman, pp. 159–177. Cambridge University Press, New York.

Lanman, H. A. (2011). The museum of modern art gift acceptance policy and guidelines. In: *Course of Study Materials: Legal Issues in Museum Administration*. ALI–ABA. www.moma.org/docs/about/MoMAGiftAcceptancePolicy.pdf

Marlano, M. (1998). *A Legal Primer On Managing Museum Collections*. Second edition. Smithsonian Institution Press, Washington, D.C.

McManis, C. R. (2007). *Biodiversity & the Law: Intellectual Property, Biotechnology & Traditional Knowledge*. Earthscan, London.

Nimmer, M. B. & Nimmer, D. (2011). *Nimmer on Copyright*. Revised edition. Matthew Bender, Albany.

Pessach, G. (2007). Museums, digitization, and copyright law: taking stock and looking ahead. *Journal of International Media and Entertainment Law* 1: 253–282.

Phelan, M. E. (1982). *Museums and the Law*. American Association for State and Local History, Nashville.

# SECTION IV
# Contents and perspectives
# on cultural collections

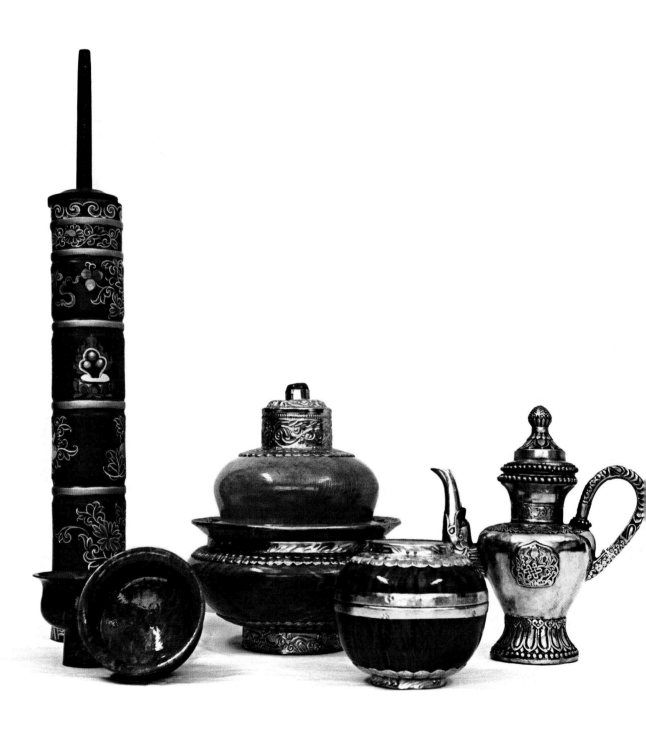

# CHAPTER 17

# *Indigenous perceptions of biocultural collections*

JANE MT. PLEASANT
Cornell University

## INTRODUCTION

Researchers and administrative staff working in botanic gardens and museums often meet with resistance or even hostility when they attempt to engage indigenous communities in what the institutions see as common goals and shared interests around biocultural collections. A long history of exploitation, both recent and long past, constrains current relationships between Western institutions, representing predominantly settler and developed nations' interests, and indigenous communities, tribes and nations. These relationships are further complicated because of the association or involvement of modern biocultural collections with other critical issues, such as indigenous knowledge, intellectual property rights, bioprospecting, biological commodification and repatriation. The ongoing discourse reflects profound differences between the views of indigenous peoples and those of non-Native governments, universities, researchers and collecting institutions, which affect current perspectives on the objectives, methodologies and ownership of biocultural collections. Successful collaborations between institutions and indigenous communities will require that garden and museum staffs have a thorough knowledge of these historical relationships, as well as an understanding of contemporary political, social, cultural and economic factors that impact specific communities. The challenges are substantial.

Because indigenous communities occupy a vast array of geographic, environmental, social, political and economic spaces, it is impossible to provide a single or unifying analysis for addressing indigenous perspectives on biocultural collections that is either accurate or useful. Instead, in this chapter, I focus on Native communities located within the geographic boundaries of the USA, and to a lesser extent, First Nations situated within Canada. These communities have much in common. First, Native peoples in present-day USA and Canada share a history of being subjected to genocide and colonisation, initially by European colonial powers and later by the settler states that succeeded them. Second, most have been deeply affected by Native social movements around sovereignty and self-determination that emerged in the 1960s. Finally, indigenous communities in the USA and Canada today face profound challenges in maintaining and enhancing traditional lifeways because they are surrounded by dominant majority cultures that are indifferent or hostile to their existence.

In this chapter, I begin with an examination of the historical relationships between indigenous communities and botanic gardens or museums. Europeans and Americans used plants in multiple ways to disempower and displace Native communities; these past actions continue to influence contemporary relationships. Botanic gardens and museums facilitated the development of plant-based enterprises that enabled Europeans and Americans to colonise Native peoples across North America. But more importantly, the drive to collect plants and the emergence of Linnaean plant taxonomy displaced traditional plant knowledge, erasing indigenous plant names and usurping Native claims to ownership and control of their natural resources. I then describe the ways in which Native American sovereignty profoundly influences contemporary relationships between Western

governments (with their associated institutions) and indigenous nations, tracing Native sovereignty from colonial times through to today. Two examples demonstrate the complex interactions between Native communities and the US and Canadian governments and their institutions. Both focus on the concerns of Native communities relating to natural resources and highlight issues of sovereignty and indigenous knowledge as they affect collaborations between Native nations and Western institutions. The intersection of these factors has important implications for collecting institutions. Contemporary scholarship sharply challenges the current roles of museums and botanic gardens and their relationships with multinational industries that use botanical products and information. Finally, I identify practices and strategies that may help institutions that are concerned with biocultural collections to develop productive, equitable relationships with Native partners.

## HISTORY OF RELATIONSHIPS BETWEEN NATIVE COMMUNITIES AND PLANT COLLECTORS

Indigenous peoples in the western hemisphere have a long and conflicted history with botanic gardens and museums. As early as the 16th century, botanic gardens served as repositories for plants collected from indigenous lands, largely without permission or compensation. Many of these plants and their products were used to strengthen the power of western nation states at the expense of Native tribes and communities (Brockway, 1979; Livingstone, 2003). In summarising the role of botanists working for Kew Gardens in the 19th century, Mackay (1996: 39) writes '… the work of the collectors was part of a broader effort in the era of early industrialization to systematize and rationalize assessments of the non-Western world so as to streamline the process of exploitation'.

Beginning in the 16th century, Europeans reported on and collected the biological resources of North America with particular focus on economically important plants. They described in considerable detail the plants they encountered as they established colonies along the Atlantic coast, noting potential food crops, forage plants, timber products, fibre plants and medicinals (Reveal, 1992). Many plants (maize, beans, squash, sunflower, Jerusalem artichoke and groundnut) provided crucial food for early settlements, but colonists also quickly identified and grew plants that could be used for trade. In the southeast, tobacco, indigo, and sugar cane grown on plantations, enabled their owners to amass enormous wealth using slave and indentured labour. In the northeast, plants with medicinal properties, as well as fruits, vegetables and flowering plants, soon became profitable trade items in the European market, enabling the colonies to grow and expand (Sumner, 2004).

European governments and influential individuals demanded access to and assumed ownership of the wealth of botanical materials from the Americas. Thousands of plants from the western hemisphere were soon found in gardens and museums across Europe, as states, business enterprises and individuals competed to cultivate and market them (Pavord, 2005). Botanic gardens were used to: 1) identify plants that could serve the growing needs of European states; 2) ascertain appropriate growing conditions for optimal production; 3) acclimatise plants to new environments; and 4) regulate and control the movement of plant materials over space and time (Brockway, 1979; Parry, 2004). Knowledge about plants played a crucial role in the expansion of European empires across the globe. Within the Americas, trees for shipbuilding, maize to feed settlers and their animals, and tobacco and indigo for European markets were just a few of the plants that supported the expansion and profitability of European colonies.

## NAMING AND CLAIMING

Plants served more than direct economic needs. The influx of thousands of new plants from the western hemisphere forced European botanists to restructure their classification systems to account for an ever-increasing number of plants. Plant scientists competed fiercely to develop systems that could be used to classify all the world's plants, including those from the Americas and other colonies (Pavord, 2005). Collectors from Europe travelled to North America, racing to find and ship plant specimens back to Europe and to be the first to name them. Descriptions and illustrations of these plants, with their new names, appeared in the growing botanical literature centred in Europe (Brockway, 1979; Bleichmar, 2005; Lewis, 2005). Classification and naming of American plants developed the expanding field of plant taxonomy, building the reputations and personal wealth of individual botanists, and enabling Europeans to lay claim to the botanical resources of the western hemisphere.

The USA, after independence from England, moved quickly to establish its own claims to the natural resources of North America. In 1804, President Thomas Jefferson commissioned Meriwether Lewis and William Clark to explore and document territories west of the Mississippi River as they sought out a river route to the Pacific coast. A major objective of the expedition was to describe and collect plants that could benefit the new republic (Brockway, 1979; Earle & Reveal, 2003). At the end of the expedition, Lewis's notes on the plants filled several volumes and he delivered almost 200 plant specimens to the American Philosophical Society in Philadelphia (Munger & Thomas, 2003). American botanists quarrelled for the right to identify the plants according to Linnaean principles and then to name plants that were previously unknown to them (Earle & Reveal, 2003). This process continued over the next 200 years as American plant collectors systematically exploited indigenous territories in the USA and Canada (McKelvey, 1955; Reveal, 1992), asserting their rights to collect, name and classify plants that had been named and used by Native peoples for millennia. Not coincidentally, by the 20th century the colonists had also removed Native peoples in the USA from more than 95% of the lands they once controlled.

Although many Western scientists today recognise the immense injustices and profound losses that indigenous peoples in the Americas have endured as the result of colonisation, most fail to acknowledge the effects of US (and Canadian) claims to the continent's botanical resources and the destruction of the indigenous knowledge that occurred as a result of the imposition of Western science. For example, Reveal (1992: 6; italics mine) states, 'To Columbus goes the honour of being the first to effectively 'discover' the New World; to him also goes the infamy of being the first to exploit its people and its natural resources... His was not a gentle conquest. *Yet, over the last five hundred years there has been a far more gentle conquest by naturalists searching to understand the New World's unique flora.* Like the land itself, many of the plants were well known to the people who used them to feed, clothe, and heal themselves.' Reveal makes clear his discomfort with Western exploitation of indigenous peoples and Columbus' claim to have discovered new lands. He even notes that indigenous peoples in the Americas knew and used many of the hemisphere's plant resources. Nevertheless, he assumes that Western naturalists were engaged in a superior form of knowledge making, implicitly judging indigenous knowledge as inferior to Western science. Reveal fails to acknowledge the link between naming and classifying the continent's flora and the dispossession and colonisation of its indigenous peoples; he further ignores the devastating effects of the loss of indigenous plant knowledge. According to Reveal, the imposition of Western science and the US's control of the hemisphere's natural resources was accomplished 'gently' by 'naturalists searching to understand'. Native peoples view the situation very differently.

## NATIVE KNOWLEDGE AND RESISTANCE

For centuries before the arrival of Europeans, indigenous peoples developed, managed and stewarded their biological resources, developing a rich foundation of knowledge about plant and animal life and the ecosystems that supported them (Kidwell, 1992; Deloria, 1995; Cajete, 2000; Pierotti & Wildcat, 2000). Native knowledge systems were embedded within cultural traditions and transmitted across time and space using complex ceremonies and rituals. Dynamic knowledge systems enabled Native farmers and other plant users to adapt their practices to changing conditions. Early accounts by Europeans indicated that Native peoples had extensive and deep knowledge regarding the plants and natural resources in their territories (Sauer, 1971, 1980; Hurt, 1987); they often aided Europeans in collecting and identifying plants and frequently shared their knowledge about how to use them (Reveal, 1992).

Despite the persistent and frequently brutal actions of Europeans and Americans to wrest control of biological resources and to extinguish Native knowledge systems, Native peoples maintained extensive knowledge about plants, animals and their interactions. Much of this information was preserved by knowledge-holders who knew and transmitted information about plants and animals, even when their social, cultural and political institutions were largely dismantled. They worked to educate apprentices, enabling them to identify, manage and use the most important plants. In some communities, individual families held and passed important information over generations, sustaining knowledge in the face of disempowerment, social disruption and extreme poverty. In some cases, knowledge holders who feared the loss of critical information intentionally worked with American anthropologists and ethnobotanists to transfer knowledge (Parker, 1910; Fenton, 1940; Wilson, 1987; Geniusz, 2009). These varied strategies to maintain knowledge have left a complex residual of colonial relationships and indigenous self-determination in many Native communities.

## NATIVE AMERICAN SOVEREIGNTY

Before the USA existed, Native nations interacted with European powers as sovereign entities; Native leaders negotiated political compacts, treaties and alliances on a government-to-government basis, acting on behalf of groups of people who resided in specific territories. Because Native nations existed before the establishment of the USA, on lands that other nations (European) recognised as sovereign entities, these nations hold sovereign status today, although it may be limited or contested by federal and state governments. As a result, the political status of Native peoples today differs fundamentally from all other racial minority groups (Deloria & Lytle, 1998; Wilkins & Stark, 2011).

In 1831, the United States' Supreme Court declared tribes 'domestic, dependent nations' with the contradictory right to political autonomy, yet subject to US protection and control (*Cherokee Nation v. Georgia, 1831*). Policies and laws that emanated from this first Supreme Court decision have likewise been contradictory, sometimes supporting Native sovereignty and at other times allowing the US government to act unilaterally (Wilkins & Stark, 2011). The political history of US interactions with Native nations largely reflects the intensity of the US's need for Native lands and resources, and the abilities of Native peoples to resist colonisation and assert their sovereign status.

By the middle of the 19th century, most Native peoples had been forcibly removed from their traditional homelands to reservations administered by the Bureau of Indian Affairs, where they could be 'civilised' and assimilated. The *General Allotment Act* of 1887 divided reservation lands held in common by tribes and allowed them to be sold to non-Indians. As a result, by the end of the 19th century Indian-controlled lands were diminished by more than 95%. The *Indian Reorganization Act*

of 1934 attempted to redress some of these injustices by ending the allotment policy and granting some tribes limited self-rule. But after WWII, the Federal government moved to terminate federal benefits and support services for many of these same communities. Under this policy, between 1945 and 1960, over 100 tribes and bands lost their status as sovereign nations. As of 2010, the federal government recognised 565 indigenous entities, including 335 Indian nations, tribes, bands and pueblos in the lower 48 states as well as 230 Alaskan Native villages. (The indigenous peoples of Hawai'i are not recognised but have a unique status under federal law.) States, but not the federal government, recognise another 56 tribes. Today, more than 300 tribes have current applications for federal recognition in a process that is lengthy and often highly politicised. Federal recognition has important economic and political consequences for Native communities as it establishes specific legal rights and determines eligibility for many programmes and services (Wilkins & Stark, 2011).

From their first encounters with European colonial powers and continuing with their increasingly brutal subjugation by the US, Native nations, with varying effectiveness, resisted this dispossession. But beginning in 1960, with the rise of the Red Power movement, a broad-based effort by Native peoples successfully organised and demanded control over their own communities, asserting their right to control their governments, schools, and health, justice, and economic systems (Josephy et al., 1999; Fixico, 2007). In response, President Nixon in 1970 called for an end to the termination policy and supported tribal self-determination. Additional legislation in the 1970s provided means for terminated nations to regain their status, and assisted Native nations in expanding their access to education and health services and providing protection of religious expression. Legislation and executive orders enacted since 1990 provide some support to preserve indigenous languages, provide limited protection for Native American religions, and mandate the return of burial remains and culturally significant materials to Native communities. Many of these efforts have been undermined over the past 25 years by Supreme Court decisions that have constrained tribal sovereignty and by Congressional attempts to abrogate Indian treaties (Wilkins & Stark, 2011). Native peoples, however, continue to assert their sovereignty and to develop self-governing nations.

## DECOLONISATION, NATION BUILDING AND RESTRUCTURING RELATIONSHIPS WITH COLLECTING INSTITUTIONS

Over the past 50 years, Native scholars and leaders, educated in majority and tribally controlled educational institutions, have critically analysed the effects of colonisation on their communities and have embarked on the arduous task of nation building, looking to traditional institutions and knowledge systems to revitalise their communities. A large body of literature reflects this scholarship (Warrior, 1995; Forbes, 1998; Alfred, 1999; Smith, 1999; Coffey & Tsosie, 2001; McGregor, 2004; Wilson, 2004; Alfred & Corntassel, 2005; Atalay, 2006; Barker, 2006; Hoxie, 2008). Native communities are also re-examining and restructuring their relationships with majority governments (federal, state and local) and the many institutions and agencies associated with them. Native nations have established government- to-government relationships with federal and state agencies to manage resources that cross shared political boundaries, writing and enforcing their own policies for resource use within their territories (Ransom & Ettenger, 2001; Ranco, 2008). Native peoples today also actively challenge academic disciplines, including anthropology, archaeology, ethnobiology, history and sociology, among others, for their past and contemporary analyses of indigenous cultures and peoples. Many have established protocols for academic research conducted within their territories and insist on the right to control the publication and use of information collected from their communities (Smith, 1999).

As Native peoples work to rebuild their nations, issues of resource management, indigenous knowledge and sovereignty merge in complex ways that affect how indigenous communities respond to and interact with external institutions and agencies. Increasingly, Native nations are asserting their rights to establish the conditions and parameters of these interactions; they insist on using their traditional knowledge systems and protocols to guide the relationships. Below, I describe two examples that demonstrate this. These examples focus on the management of natural resources, as most Native peoples regard relationships with the land as primary, setting the stage for all other actions. Both examples suggest ways in which collecting institutions working with biocultural collections might begin to forge more productive and equitable relationships with Native communities.

## ANISHINABEG (OJIBWAY) NATIONS

The Anishinabeg reside in five states and four provinces in the USA and Canada. They are governed by local bands and tribes with a decentralised political and economic system; most of the tribes and bands within the USA are federally recognised. Before the arrival of Europeans, Anishinabeg communities occupied enormous tracts of lands around the Great Lakes and west into the prairies of present-day USA and Canada. They used their robust and extensive knowledge systems to manage sustainably resources that spanned multiple ecosystems, allowing the Anishinabeg to prosper for centuries (LaDuke, 1992).

After the arrival of Europeans, the Anishinabeg retained control of their territories, interacting with settlers primarily through the fur trade. But by the end of the 18th century, their lands were rapidly encroached by Americans moving west. The Anishinabeg resisted American incursions militarily during the Revolutionary War and the War of 1812, siding with Britain. During the 19th century, the US government coerced many Anishinabeg nations to cede large tracts of land in a series of treaties, and eventually most Anishinabeg were confined to small reservations in the USA and Canada (Vennum, 1988; Loew, 1997).

The Anishinabeg, however, continued to protest the loss of their lands and to demand enforcement of their treaty rights. By the 1960s, they were active in the Red Power movement, with three of their members founding the American Indian Movement (AIM). Since the 1970s, the Anishinabeg have been involved in multiple conflicts over their rights to manage and use their resource base without interference from state or federal authorities (Loew, 1997). Their attempts to preserve tribal fishing, hunting and forestry rights, granted under treaties, have placed them at the forefront of indigenous struggles for self-determination. Increasingly, they have used sovereignty as a framework to structure their political response, and have vigorously asserted that their traditional knowledge underlies the most appropriate way to manage these resources. Many Anishinabeg today are actively engaged in rebuilding their traditional ways of life, revitalising their languages and strengthening traditional knowledge systems (LaDuke, 1999; Geniusz, 2009).

The Anishinabeg struggle to maintain control over wild rice has been a focal point of their resistance (LaDuke & Carlson, 2003). They have opposed efforts by the University of Minnesota to conduct research on the wild rice genome and have contested actions by non-Native researchers and growers to domesticate wild rice, improve its productivity and grow it in commercial paddies. The Anishinabeg identify four interrelated reasons for their opposition to these activities: 1) economic harm to tribal members; 2) violation of federal law and treaties; 3) contamination or replacement of traditional and naturally occurring strains with genetically altered rice; and 4) denigration or loss of plant materials that are fundamental to Anishinabeg well-being and cultural integrity (LaDuke, 2004, 2005; Clancy & Adamek, 2005).

The wild rice conflict between the Anishinabeg and the University of Minnesota demonstrates fundamental differences in worldview between Native and non-Native communities that highlight the enormous challenges that Native peoples face in practicing self-determination and maintaining traditional lifeways. While wild rice is seen as critical for Anishinabeg economic self-sufficiency, their ability to control how it is managed also represents a more fundamental right to frame their lives and act in ways that support a worldview that is profoundly different from Western perspectives. Although the Anishinabeg have been unsuccessful in resolving their differences concerning wild rice with the University of Minnesota, community leaders continue to strengthen tribal self-determination by reclaiming and implementing their traditional knowledge. Anishinabeg community leaders and scholars are also working to preserve and revitalise their traditional plant knowledge (Geniusz, 2009). Drawing on the knowledge of contemporary elders, with careful use of texts produced by Western scientists in the 19th and 20th centuries, they are reconstructing plant knowledge in order to educate their young people. In some cases, they are working collaboratively with Western ethnobotanists on projects of mutual concern and interest.

## HAUDENOSAUNEE (IROQUOIS CONFEDERACY)

The Haudenosaunee today live in 17 communities, most of which are located around the Great Lakes in Canada and the USA. They include the Mohawk, Oneida, Onondaga, Cayuga and Seneca nations, who united to form the Confederacy sometime between 1300 and 1500, and the Tuscarora, who joined in the early 18th century. Governance within the Confederacy is based on the Great Law of Peace, with its emphasis on three key tenets that shape Iroquois political life: peace, power and righteousness (Vecsey, 1986; Alfred, 1999; Ransom & Ettenger, 2001; King, 2006). Another oral text, *Words that Come before All Else*, identifies the responsibilities of the Haudenosaunee as they interact with all parts of the Cosmos. It emphasises thankfulness, reciprocity and connection as fundamental values that inform how people are to live within the natural world (Cornelius, 1992).

Prior to and during the colonial period, the Haudenosaunee occupied or controlled large portions of northeast North America, including most of present-day New York, much of north-western Pennsylvania and eastern Ohio, together with extensive areas in southern Ontario. With their productive agricultural base, robust political organisation and strategic diplomacy, they effectively constrained European colonial powers, retaining control of their extensive territories for more than 200 hundred years of European encroachment (Richter, 1992; Parmenter, 2010). But on the eve of the Revolutionary War, the Confederacy faltered, unable to develop consensus over which side, if any, to support in the growing conflict. By the end of the war, the Haudenosaunee had lost control of most of their traditional territories, and by 1850, they were living on small reservations in New York, Wisconsin, Kansas, Ontario and Quebec (Hauptman, 1999). Despite the enormous loss of land and the profound disruption of their communities, the Haudenosaunee continued to preserve and use essential elements of their political, social and cultural frameworks (Hauptman, 2008). Critical oral texts with their associated ceremonies were recited in Iroquois longhouses, and traditional methods of governance were practiced without interruption over this long period of US domination. At the time of the Red Power movement, the Haudenosaunee provided essential leadership, drawing on their traditional teachings to inspire and model an effective indigenous response to US domination (Hauptman, 1986).

Today, Iroquois nations have dynamic, robust communities that provide essential services including health, education and law enforcement, as well as judicial and regulatory functions. Haudenosaunee scholars are at the forefront of current discourse on decolonisation, sovereignty and nation building (Alfred, 1999; Alfred & Corntassel, 2005; Mohawk, 2010; Rickard, 2011).

Haudenosaunee community leaders and scholars have focused specifically on environmental issues and the ways in which traditional knowledge can be used to respond to contemporary problems in their territories (Haudenosaunee Environmental Task Force, 1992; Cornelius, 1999; Tarbell & Arquette, 2000; Ransom & Ettenger, 2001; Doxtater, 2004; King, 2006; Mt. Pleasant, 2006).

The Akwesasne Mohawk community experienced severe environmental contamination caused by US or Canadian corporations and industries and were declared a Superfund Cleanup Site in 1990 by the Environmental Protection Agency (EPA). But the EPA refused to allow the Mohawk community to participate actively in decision-making regarding the clean-up (The Akwesasne Task Force on the Environment, 1997). The Haudenosaunee Environmental Task Force (HETF) was established in 1994 to address environmental problems within Iroquois communities on a Confederacy-wide basis (Ransom & Ettenger, 2001). They developed a two-pronged approach. First, they insisted that traditional Haudenosaunee teachings be used as the foundation for any proposed remedy. Haudenosaunee worldview and their relationship with the natural world differ profoundly from Euro-American approaches. Grounded in a belief system that places people within nature, rather than separate from it, the Haudenosaunee identify sustained responsibility and reciprocity as foundational principles for human interactions with the environment. Discussion of ownership, rights and profit are remarkably absent from this belief system, whereas human effects on other parts of the environment, both present and future, are primary.

Second, they used the Two-Row Wampum Belt (Kaswentha) to establish a protocol for their relationships with external governments and agencies as they worked to resolve problems. This treaty belt was created in the 17th century to recognise an agreement between the Confederacy and Dutch settlers living in Iroquois territory in eastern New York. Alternating parallel bands of white and purple wampum beads run the length of the band; one purple row represents the canoe of the Haudenosaunee while the other is a European ship. Both vessels travel within a wide band of white beads, the river shared by both vessels. According to the Haudenosaunee, the belt signifies these key points: 1) the vessels are equal in size, indicating parity in the relationship; 2) neither interferes with the other as they make their way on the river, with each vessel pursuing its own course and maintaining its own traditions; and 3) they share a common resource, the water, which both must protect and value. The Kaswentha has been used to frame the ways in which the Haudenosaunee interact with external governments, first with the Dutch, French and English, and more recently with the USA and Canada. It asserts Haudenosaunee sovereignty within their territories while simultaneously permitting others to use Haudenosaunee resources, supporting collaboration for common goals.

Using these two strategies (traditional knowledge and the Kaswentha), the HETF has established successful partnerships with external governments, agencies, researchers and funding institutions to address environmental problems within their territories. Iroquois leaders note that respect for and protection of traditional knowledge by external institutions strengthens Haudenosaunee sovereignty, which further enhances collaboration between their nations and Western institutions (Ransom & Ettenger, 2001).

## CONNECTIONS AND IMPLICATIONS

These two examples highlight the complex and interrelated roles that sovereignty and traditional knowledge play in contemporary relationships between Native communities and Western governments (and their associated institutions), with critical implications for botanic gardens and museums. First, federally recognised Native nations within the USA have a significant body of established federal law that supports (sometimes unevenly) their right to self-determination and their ability to control and

manage their resource base. Furthermore, in 1998, federal agencies were ordered to 'establish and engage in meaningful consultation and collaboration with tribal governments in matters that affect their communities' (Wilkins & Stark, 2011). This executive order was renewed and strengthened by President Obama in 2009. Native nations are actively using these laws and policies to support and enhance their longstanding efforts for self-determination. Within Native communities, they are engaged in vigorous discussions on what sovereignty means; significant differences in its meaning and implementation occur both within and between communities. Collecting institutions that intend to work with Native nations must be knowledgeable and respectful of the legal frameworks within which these nations operate.

Native leaders and scholars increasingly use a decolonial perspective to analyse their current conditions and to frame strategies for addressing problems (Alfred, 1999; Smith, 1999). Indigenous and other scholars have explicitly used these methodologies to examine historical relationships between Western institutions (including governments, museums and universities) and indigenous communities. They argue that while Native communities today have considerable ability to assert their autonomy, persistent and insidious colonial practices and ideologies continue to constrain and limit indigenous self-determination (Smith, 1999; Geniusz, 2009).

Native peoples are specifically engaged in critical reappraisals of their relationships with museums, questioning the ways in which these institutions represent Native communities through collections of material culture and human remains (Canadian Museum of Civilization, 1996; Simpson, 1996; Clavir, 2002; Sleeper-Smith, 2009). The emergence of tribally controlled museums and the establishment of the National Museum of the American Indian in Washington DC have profoundly altered the discussion as Native curators and researchers demand equal and respectful relationships with their non-Native counterparts (Cobb, 2005; Brady, 2008; Child, 2009; Lonetree, 2009; Shannon, 2009). These discussions will likely impact Native communities as they negotiate partnerships with botanic gardens and other collecting institutions.

Furthermore, scholars in many disciplines are vigorously examining the roles of museums and botanic gardens in supporting the imperial goals of colonial powers in the 17th, 18th and 19th centuries (Mackay, 1996; Miller & Reill, 1996; Schiebinger, 2004; Schiebinger & Swan, 2005). They connect the advancement of Western science, carried out by scholars working with botanic gardens and museums, with the growth of imperialism. More recently, scholars have compared these historic actions with contemporary bioprospecting by transnational firms in indigenous territories (Parry, 2004, 2006). Parry argues that, beginning in 1985, the expansion of the global pharmaceutical industry, along with significant technological breakthroughs, catalysed new efforts to move biological resources from tropical regions to industrial centres. She notes specifically contracts between the National Cancer Institute (NCI) and botanic gardens and universities to collect a wide range of plant materials from tropical areas to be used in pharmacological research. Parry writes, 'Through this system of subcontracting, the NCI was able to create a network of collectors and a geography of collection, the scale and extent of which was astonishingly wide and certainly unprecedented in the area of pharmacological research' (Parry, 2004: 110).

Many indigenous leaders and communities view these actions by Western scientists and collecting institutions with considerable alarm. Contemporary efforts to collect biological resources suggest a new round of colonisation, subjugation and impoverishment (Takeshita, 2001). Native peoples fear that their traditional knowledge will be exploited, their territories compromised and their well-being threatened. Increasingly, communities within the USA and Canada are joining with indigenous communities across the globe to develop common strategies and actions to resist these efforts.

## SUGGESTED PRACTICES FOR COLLECTING INSTITUTIONS

Relationships today between Native nations and collecting institutions are likely to be complex, reflecting both historical exploitation and contemporary assertions of Native sovereignty and self-determination. Researchers and staff who work for collecting institutions will need extensive knowledge about the interactions between Native communities and Western institutions across extensive time periods. Although the interests and goals of Native communities may not always align with those of botanic gardens and museums, several strategies can help gardens and museums to identify areas of common concern and to build ethical, collaborative partnerships.

1. Learn the political and cultural history of the community. Where are their original homelands? How and when were they removed from these lands? Are they engaged in current legal efforts to reclaim lands and/or to enforce treaties?

2. Know the community's traditional forms of governance and how they govern themselves today. Identify and work first with official leaders who hold the authority to establish relationships with external people and institutions. Respect and support tribal sovereignty.

3. Learn about the community's traditional knowledge. Identify fundamental differences in worldview and consider how these differences may affect the relationship. Identify your assumptions about knowledge and consider how they affect your views about other knowledge systems. How is knowledge accessed and transferred within the community? What protocols are in place, both formal and informal, that control knowledge? Respect these protocols.

4. Identify the community's scholars and knowledge holders, both historical and contemporary. Read what these people have written (or said) and are writing (or saying) about their communities, histories and critical issues.

5. Inquire about the community's concerns; listen carefully to determine ways that you might work together to address these problems.

6. Identify others who have developed successful relationships with the community and examine the factors that contributed to their success.

# Literature cited

Alfred, T. (1999). *Peace, Power, Righteousness: an Indigenous Manifesto*. Oxford University Press, Don Mills.

Alfred, T. & Corntassel, J. (2005). Being indigenous: resurgences against contemporary colonialism. *Government & Opposition* 40: 597–614.

Atalay, S. (2006). Indigenous archaeology as decolonizing practice. *American Indian Quarterly* 30: 280–310.

Barker, J. (2006). Gender, sovereignty, and the discourse of rights in native women's activism. *Meridians* 7: 127–161.

Bleichmar, D. (2005). Books, bodies, fields: Sixteenth Century transatlantic encounters with the New World. In: *Colonial Botany: Science, Commerce, and Politics in the Early Modern World*, eds L. Schiebinger & C. Swan, pp. 83–99. University of Pennsylvania Press, Philadelphia.

Brady, M. J. (2008). Governmentality and the National Museum of the American Indian: understanding the indigenous museum in a settler society. *Social Identities: Journal for the Study of Race, Nation and Culture* 14: 763–773.

Brockway, L. (1979). *Science and Colonial Expansion: the Role of the British Royal Botanic Gardens*. Academic Press, New York.

Cajete, G. (2000). *Native Science: Natural Laws of Interdependence*. Clear Light Publishers, Santa Fe.

Canadian Museum of Civilization (1996). *Curatorship: Indigenous Perspectives in Post-Colonial Societies: Proceedings*. Canadian Museum of Civilization with the Commonwealth Association of Museums and the University of Victoria, Ottawa.

Child, B. J. (2009). Creation of the tribal museum. In: *Contesting Knowledge*, ed. S. Sleep-Smith, pp. 251–256. University of Nebraska Press, Lincoln.

Clancy, F. & Adamek, M. (2005). Teaching as public scholarship: tribal perspectives and democracy in the classroom. In: *Engaging Campus and Community: The Practice of Public Scholarship in the State and Land-Grant University System*, eds S. J. Peters, N. R. Jordan, M. Adamek & T. R. Alter, pp. 227–266. Charles F. Kettering Foundation, Dayton, Ohio.

Clavir, M. (2002). *Preserving What Is Valued: Museums, Conservation, and First Nations*. University of British Columbia Press, Vancouver.

Cobb, A. J. (2005). The National Museum of the American Indian as cultural sovereignty. *American Quarterly* 57: 485–506.

Coffey, W. & Tsosie, R. A. (2001). Rethinking the tribal sovereignty doctrine: cultural sovereignty and the collective future of Indian nations. *Stanford Policy and Law Review* 12: 191–222.

Cornelius, C. (1992). The Thanksgiving Address: an expression of Haudenosaunee worldview. *Akwe:kon Journal* 9 (3): 14–25.

Cornelius, C. (1999). *Iroquois Corn in a Culture-Based Curriculum: A Framework for Respectfully Teaching About Cultures*. State University of New York Press, Albany.

Deloria, V. (1995). *Red Earth, White Lies: Native Americans and the Myth of Scientific Fact*. Scribner, New York.

Deloria, V. & Lytle, C. M. (1998). *The Nations Within: The Past and Future of American Indian Sovereignty*. University of Texas Press, Austin.

Doxtater, M. G. (2004). Indigenous knowledge in the decolonial era. *American Indian Quarterly* 28: 618–633.

Earle, A. S. & Reveal, J. L. (2003). *Lewis and Clark's Green World: The Expedition and its Plants*. Farcountry Press, Helena.

Fenton, W. (1940). *An Herbarium from the Allegany Senecas*. Lewis Historical Publishing Co., Lewis.

Fixico, D. D. (2007). Witness to change: fifty years of Indian activism and tribal politics. In: *Beyond Red Power: American Indian Politics and Activism Since 1970*, eds D. M. Cobb & L. Fowler, pp. 2–15. School for Advanced Research Press, Santa Fe.

Forbes, J. D. (1998). Intellectual self-determination and sovereignty: implications for native studies and for native intellectuals. *Wicazo Sa Review* 13: 11–23.

Geniusz, W. D. (2009). *Our Knowledge Is Not Primitive: Decolonizing Botanical Anishinaabe Teachings*. Syracuse University Press, Syracuse.

Haudenosaunee Environmental Task Force (1992). *Words That Come Before All Else: Environmental Philosophies of the Haudenosaunee*. Native North American Travelling College, New York.

Hauptman, L. M. (1986). *The Iroquois Struggle for Survival: World War II to Red Power*. Syracuse University Press, Syracuse.

Hauptman, L. M. (1999). *Conspiracy of Interests: Iroquois Dispossession and the Rise of New York State*. Syracuse University Press, Syracuse.

Hauptman, L. M. (2008). *Seven Generations of Iroquois Leadership: The Six Nations Since 1800*. Syracuse University Press, Syracuse.

Hoxie, F. E. (2008). Retrieving the red continent: settler colonialism and the history of American Indians in the US. *Ethnic and Racial Studies* 31: 1153–1167.

Hurt, D. (1987). *Indian Agriculture in America: Prehistory to the Present*. University Press of Kansas, Lawrence.

Josephy, A. M., Nagel, J. & Johnson, T. (1999). *Red Power: The American Indians' Fight for Freedom*. University of Nebraska Press, Lincoln.

Kidwell, C. S. (1992). Systems of knowledge. In: *America in 1492: The World of Indian Peoples Before the Arrival of Columbus*, ed. A. M. Josephy, Jr., pp. 369–403. Knopf, New York.

King, J. T. (2006). The value of water and the meaning of water law for the Native Americans known as the Haudenosaunee. *Cornell Journal of Law and Public Policy* 16: 449–472.

LaDuke, W. (1992). Indigenous environmental perspectives: a North American primer. *Akwe:kon Journal* 9 (2): 52–71.

LaDuke, W. (1999). *All Our Relations: Native Struggles for Land and Life*. South End Press, Cambridge.

LaDuke, W. (2004). The political economy of wild rice: indigenous heritage and university research. *Multinational Monitor* 25: 27–29.

LaDuke, W. (2005). *Recovering the Sacred: The Power of Naming and Claiming*. South End Press, Cambridge.

LaDuke, W. & Carlson, B. (2003). *Our Manoomin, Our Life: The Anishinaabeg Struggle to Protect Wild Rice*. White Earth Land Recovery Project, Ponsford.

Lewis, A. J. (2005). Gathering for the republic: botany in early republican America. In: *Colonial Botany: Science, Commerce, and Politics in the Early Modern World*, eds L. Schiebinger & C. Swan, pp. 66–80. University of Pennsylvania Press, Philadelphia.

Livingstone, D. N. (2003). *Putting Science in its Place: Geographies of Scientific Knowledge*. University of Chicago Press, Chicago.

Loew, P. (1997). Hidden transcripts in the Chippewa treaty rights struggle: a twice-told story. Race, resistance, and the politics of power. *American Indian Quarterly* 21: 713–729.

Lonetree, A. (2009). Museums as sites of decolonization. In: *Contesting Knowledge*, ed. S. Sleeper-Smith, pp. 322–337. University of Nebraska Press, Lincoln.

Mackay, D. (1996). Agents of empire. In: *Visions of Empire: Voyages, Botany, and Representations of Nature*, eds D. P. Miller & P. H. Reill, pp. 38–57. Cambridge University Press, Cambridge.

McGregor, D. (2004). Coming full circle: indigenous knowledge, environment, and our future. *American Indian Quarterly* 28: 385–411.

McKelvey, S. D. (1955). *Botanical Exploration of the Trans-Mississippi West, 1790–1850*. Arnold Arboretum of Harvard University, Jamaica Plain.

Miller, D. P. & Reill, P. H. (eds) (1996). *Visions of Empire: Voyages, Botany, and Representations of Nature*. Cambridge University Press, Cambridge.

Mohawk, J. (2010). *Thinking in Indian: a John Mohawk reader*. Fulcrum, Golden.

Mt. Pleasant, J. (2006). The science behind the Three Sisters Mound System: an agronomic assessment of an indigenous agricultural system in the northeast. In: *Histories of Maize*, eds J. E. Staller, R. H. Tykot & B. F. Benz, pp. 529–537. Elsevier Academic Press, Amsterdam.

Munger, S. H. & Thomas, C. S. (2003). *Common to this Country: Botanical Discoveries of Lewis and Clark*. Artisan, New York.

Parker, A. (1910). Iroquois uses of maize and other food plants. *New York State Museum Bulletin* 144: 5–113.

Parmenter, J. (2010). *The Edge of the Woods: Iroquoia, 1534–1701*. Michigan State University Press, East Lansing.

Parry, B. (2004). *Trading the Genome: Investigating the Commodification of Bio-Information*. Columbia University Press, New York.

Parry, B. (2006). New spaces of biological commodification: the dynamics of trade in genetic resources and 'bioinformation'. *Interdisciplinary Science Reviews* 31: 19–31.

Pavord, A. (2005). *The Naming of Names: The Search for Order in the World of Plants*. Bloomsbury, New York.

Pierotti, R. & Wildcat, D. (2000). Traditional ecological knowledge: the third alternative (Commentary). *Ecological Applications* 10: 1333–1340.

Ranco, D. J. (2008). The trust responsibility and limited sovereignty: what can environmental justice groups learn from Indian nations? *Society & Natural Resources* 21: 354–362.

Ransom, J. W. & Ettenger, K. T. (2001). 'Polishing the Kaswentha': a Haudenosaunee view of environmental cooperation. *Environmental Science and Policy* 4: 219–228.

Reveal, J. L. (1992). *Gentle Conquest: The Botanical Discovery of North America with Illustrations from the Library of Congress*. Starwood, Washington DC.

Richter, D. K. (1992). *The Ordeal of the Long-house: the Peoples of the Iroquois League in the Era of European Colonization*. University of North Carolina Press, Chapel Hill.

Rickard, J. (2011). Visualizing sovereignty in the time of biometric sensors. *South Atlantic Quarterly* 110: 465–486.

Sauer, C. O. (1971). *Sixteenth Century North America; the Land and the People as Seen by the Europeans*. University of California Press, Berkeley.

Sauer, C. O. (1980). *Seventeenth Century North America*. Turtle Island, Berkeley.

Schiebinger, L. (2004). Feminist history of colonial science. *Hypatia* 19: 233–254.

Schiebinger, L. L. & Swan, C. (2005). *Colonial Botany: Science, Commerce, and Politics in the Early Modern World*. University of Pennsylvania Press, Philadelphia.

Shannon, J. (2009). The construction of native voice at the National Museum of the American Indian. In: *Contesting Knowledge*, ed. S. Sleeper-Smith, pp. 218–247. University of Nebraska Press, Lincoln.

Simpson, M. G. (1996). *Making Representations: Museums in the Post-Colonial Era*. Routledge, London.

Sleeper-Smith, S. (ed.) (2009). *Contesting Knowledge: Museums and Indigenous Perspectives*. University of Nebraska Press, Lincoln.

Smith, L. T. (1999). *Decolonizing Methodologies: Research and Indigenous Peoples*. Zed Books, New York.

Sumner, J. (2004). *American Household Botany: a History of Useful Plants*, 1620–1900. Timber Press, Portland.

Takeshita, C. (2001). Bioprospecting and its discontents: indigenous resistances as legitimate politics. *Alternatives: Global, Local, Political* 26: 259–283.

Tarbell, A. & Arquette, M. (2000). Akwesasne: a Native American community's resistance to cultural and environmental damage. In: *Reclaiming the Environmental Debate: The Politics of Health in a Toxic Culture*, ed. R. Hofrichter, pp. 93–111. MIT Press, Cambridge.

The Akwesasne Task Force on the Environment (1997). Superfund clean-up at Akwesasne: a case study in environmental injustice. *International Journal of Contemporary Sociology* 34: 267–290.

Vecsey, C. (1986). The story and structure of the Iroquois Confederacy. *Journal of the American Academy of Religion* 54: 79–106.

Vennum, T. (1988). *Wild Rice and the Ojibway People*. Minnesota Historical Society Press, St. Paul.

Warrior, R. A. (1995). *Tribal Secrets: Recovering American Indian Intellectual Traditions*. University of Minnesota Press, Minneapolis.

Wilkins, D. E. & Stark, H. K. (2011). *American Indian Politics and the American Political System*. Rowman & Littlefield, Lanham.

Wilson, G. L. (1987). *Buffalo Bird Woman's Garden: Agriculture of the Hidatsa Indians*. Minnesota Historical Society Press, St. Paul.

Wilson, W. A. (2004). Indigenous knowledge recovery is indigenous empowerment. *American Indian Quarterly* 28: 359–374.

# Native American perspectives on biocultural collections and cultural restoration

LINDA S. BISHOP

Sitting Bull College

Throughout our colonised history, Native peoples have nurtured a relationship with museums and similar institutions that ranged from tenuous to utterly ferocious. Whether it was the bones of our ancestors or discarded pottery, the public seemed fascinated and intent on owning any shred of Indigenous pre-colonial life. In some cases, it took federal legislation, in the form of the Native American Graves Protection and Repatriation Act, to force institutions to return ancestral remains and funerary objects, and tribes began protesting the use of biocultural exhibitions that showcased medicine bundles and sacred masks. Recently, however, many tribes are building their own museums and storehouses to protect such items, and some Native Americans have even chosen to donate items to public institutions for this same reason.

Why the change of heart? In recent decades, Indigenous youth have been expressing a great desire to learn traditional skills such as net tying, healing, quillwork, tool-making and archery. In some areas, few people have retained these skills, and even fewer families have actual examples of these technologies. Hence, many Natives Americans are beginning to see value in museum collections as opportunities for cultural restoration.

The use of biocultural collections as storehouses for cultural restoration is not necessarily a new idea among some museums, botanical gardens and similar institutions (Chapter 1), but many of these establishments do not understand the complex needs and concerns of tribal entities. Therefore, there is a great need for Indigenous perspectives to inform standards for the storage, use and understanding of biocultural collections. I have chosen to provide this perspective through the use of my own people's customary methodology.

The Lakota people are a storytelling people. It is tradition among Indigenous peoples to pass our entire way of life from generation to generation through the use of oral storytelling and physical demonstration. When making recommendations to any person, group or institution, it is appropriate to do so by offering examples — stories — to demonstrate relevancy and need. Most of the ideas in this paper are the result of two decades of discussions with Native elders and other knowledge holders from numerous reservations. From these discussions have emerged three primary concepts that I hope will be useful in forming standards for biocultural collections: context, access and respect. These ideas overlap in many ways, but their differences are perhaps as important as their similarities.

## CONTEXT

Most institutions that house items of cultural relevance to Indigenous peoples understand the importance of context. Webster's dictionary defines context as '*the interrelated conditions in which something exists or occurs*' and I think this definition is appropriate for biocultural collections. Institutions should take responsibility for the context of each item housed within their walls. This includes the name of the person who made the item and their story, who the item belonged to, the cultural significance of the item, materials used, and any pertinent background story and/or information. Cultural and historical

context will 'bring items to life' for the Native people with whom we are working and for the people that visit and support our public institutions.

Years ago, I went with a Lakota tribal member to a museum in North Dakota that was well-known for its collection of Lakota quillwork. As we walked the halls and looked in huge, climate-controlled drawers, a beautiful pair of quilled moccasins caught my friend's eye. As I got closer to the object, I saw a tag that read 'Jenny Gall – daughter of Chief Gall'.

Jenny Gall was my friend's great-grandmother. He had heard stories about these moccasins as a child. They were made by Jenny Gall after a vision she had of stars rising over rugged mountain peaks. No one in the family had known the fate of these special shoes — until that day.

My friend contemplated the item for a moment and then went to get a museum employee. He explained that the daughter of Chief Gall had, indeed, made and decorated these moccasins with quills that she had dyed herself. She had come up with the design after a fitful night of sleep, during which she dreamt of huge, shining stars that slowly rose up behind dark blue mountain peaks. She knew that the vision was important, and after months of prayer and consultation with elders, she came to understand that the stars were her descendants, overcoming difficult obstacles and rising above the darkness. She told her grandchildren that whenever she was in despair about the loss of Lakota lands or culture, she would look down at her moccasins and feel better about the fate of her beloved family — they helped her to believe that everything would turn out alright.

And now these same shoes — the comforting vision of his grandmother who was the daughter of the great Chief Gall — sat in a dark, unlabeled drawer among a hundred other drawers in one of a thousand museums on the Northern Great Plains. How, my friend asked the museum employee, would anyone ever know the story of those moccasins?

My friend did not have an issue with the fact that the moccasins were housed in this museum. He was actually quite grateful that they were safe and protected. It was the missing context of the item that concerned him. It was the fact that no one would know the story of his grandmother's vision and her dream for the future of her family. To the museum and its patrons, they were simply items of beauty that belonged to a long-dead daughter of a Lakota chief. There are literally millions of nameless, story-less, context-less items sitting on dusty museum shelves throughout the world. Some pieces will never come out of the contextual darkness because there is no one to tell their story — or their history. The moccasins, on the other hand, were still alive in the memory of Jenny Gall's descendants. The museum could have learned this story many years ago if they had only made a simple phone call.

## ACCESS

Historically, Indigenous peoples have had only limited access to biocultural collections; relationships between tribes and institutions that house such collections have been tenuous. If we are to begin to alleviate these issues, it is important to define what is meant by 'access'. In a perfect world, Indigenous peoples would maintain ownership and control of items that have been created by their people. Obviously, this is not completely possible, nor is it universally desirable as many tribes do not have appropriate facilities to protect such items. Nevertheless, access can still be attained through understanding and compromise. Thus, access refers to the ability to see, handle, use and model biocultural artefacts. This is complete and open access — any compromise that limits this should be made through careful consultation with affected parties.

I recently had a wonderful visit to a museum in the Pacific Northwest. In a well-lit, well-guarded, upstairs room I met an amazing man who I will refer to as 'The Curator.' He is the guardian of some

of the museums biocultural collections. 'The Curator' is passionate about informing the public of the museum's collections and he is even more passionate about allowing open access to local tribal peoples so that they can teach their youth about making fishing nets from nettles or cooking hearty meals from various seaweed species. That collection is an amazing resource, showcasing hundreds of traditional foods, building materials and medicines.

It was the aforementioned nettle fishing net that first caught my attention. I touched the intricately woven net and noted thousands of knots that must have taken a great deal of time to tie. I thought of the hands that lovingly made the net and I wondered if someone's grandchild sat on the floor watching his or her grandfather making nets such as this. Although this net was made by a Squamish man from Vancouver Island, I felt a connection with the material. Many tribes, including the Lakota, used *Urtica* species to make fibres for nets and rope, and I wondered if my own relatives had ever made a net such as this. Without thinking, I held the net to my nose to see if I could smell the forest or the sea or even the home of the man who made this work of art. 'Ummmm, I wouldn't do that if I were you,' said 'The Curator', 'The items in this collection have to be treated with a chemical protectant. It can be harmful if inhaled'.

My heart literally sank in my chest. Here was this incredible museum with an even more incredible staff of sensitive, kind, sincere people who very much want Native people to have complete and open access to these items — yet most mothers wouldn't want their child touching the artefacts for fear of harmful toxins. Obviously, I understood the necessity behind the use of the protectant, but that did little to reassure me. In the hearts and minds of Indigenous people, these items are more than just museum exhibits, and having open access can mean the difference between a tenuous relationship with institutions and a truly reciprocal relationship. Access is more than just being able to view and study an item. It is the ability to connect with a piece of your people's spirit — to connect with those who came before you.

## RESPECT

Lakota children are taught of the unquestionable, unending, inherent sacredness of the pipe, or 'channuŋpa' in the Lakota language. The pipe was brought to the Lakota people by the White Buffalo Calf Woman, who taught them about the miracles that happen when one prays with the pipe. It is one object that still guides people's lives and dealings with the outside world.

When I took my family to a museum in the mid-western USA, I never expected to see a pipe sitting in a large glass case. I never imagined that many people see the channuŋpa as an art object — and object of beauty — rather than the vitally sacred item it is to me and my family.

No one carries a pipe unless they have earned the right to do so. This is accomplished through years of participation in ceremonies such as the sweatlodge and vision quest. A 'pipe carrier' is someone who sets a good example for the entire community. It is a huge responsibility, and not one that is taken lightly. Also, when a pipe is stored, it is never put together, with the stem and the bowl touching. This is only done if the pipe is going to be smoked or 'fed'.

And yet there it was, sitting in a museum, with the stem and bowl glued together. I ushered my kids out of the room so that they would not have to see this spirit, this relative — a living entity — displayed that way, essentially dead in spirit. I immediately went to the museum curator and explained to them the significance of the pipe and, if it was going to be part of a museum's collection, the way that it should properly be stored.

The look on his face was at first blank, and then hostile. 'This is just a piece of rock and a piece of wood. I don't care about your heathen religion or anything that you have to say'. Obviously, this

is an extreme example of racism and disrespect, but these situations are not exactly rare. At best, institutions ignore Indigenous people's requests. At worst, they are hostile.

Another of my favourite anecdotes is the story of an Indigenous group of New Mexican Pueblo people and their dealings with a government organisation. The government wanted to build a tall fence around the sacred volcanoes that stand to the west of Albuquerque. The Pueblo immediately protested this act, as a fence might disrupt the paths of 'kachinas' who walk down from the volcanoes when they are called to ceremonies and feast days. The government workers suggested that the pueblos should draw a map of the kachina's paths, so they can put up gates on the fence for the kachinas to open and walk through.

Indigenous people, for the most part, do not get angry in situations such as this, because we understand that ignorance arises simply from a lack of information. This is why it is so vital for Native peoples to share certain information with museums, botanical gardens and other institutions. The fact is, for my tribe and my family, everything that we do is sacred. Every plant that we harvest, whether it is ground up, boiled and used to tan bison hides or simply dug up and chewed, is sacred and should be afforded great respect by people and institutions who house biocultural collections.

The fact is, I can never look upon biocultural collections – even those in wonderful and reputable institutions – without a tinge of sadness. Although I am grateful and even happy that these items will be safely housed and protected for the use and education of future generations, I cannot help but feel sorrow. I mourn every seed that was never planted, every net that is not cast, and every one of our animal relatives that were sacrificed, but never fed or perpetuated the people. Instead these sacred items are turned into artefacts — pieces of artwork — sitting in a room with no breath, no heart and no life.

But I also find joy in the fact that these items are here for future generations of Native people — not as oddities, exhibits and curios but as tools for us to regain, renew and revitalise traditions that are not extinct or forgotten, but are perhaps battered, beaten and bruised. The fact remains that our climate is changing, urban sprawl is expanding and agriculture continues to value monoculture. Therefore, plant communities are changing and shifting. Many Native people believe that we may one day live in the deserts of North Dakota, rather than the grasslands of North Dakota. Wouldn't it be remarkable if biocultural collections served as both storehouses of cultural knowledge, as well as knowledge banks, to which Indigenous groups may turn during a time of cultural desertification?

# Multicultural perspectives on biocultural collections

NEIL R. CROUCH
South African National Biodiversity Institute

HENRIK BALSLEV
University of Aarhus

KAMAL BAWA
University of Massachusetts, Boston

ROBERT BYE
National Autonomous University of Mexico

SANGAY DEMA
National Biodiversity Centre, Ministry of Agriculture and Forests, Bhutan

EDELMIRA LINARES
National Autonomous University of Mexico

PEI SHENGJI
Kunming Institute of Botany

ARMAND RANDRIANASOLO
Missouri Botanical Garden

JOHN RASHFORD
College of Charleston

## INTRODUCTION

The broad definition applied to the concept of biocultural collections — objects representing the interactions among plants, people and environments (Chapter 1) — when coupled to the diversity of multicultural and institutional perspectives on such collections, potentially gives rise to numerous issues, not all of which are discussed in this chapter. Furthermore, although the authors of this contribution are based for the most part in the developing world, the source of many biocultural artefacts, our experiences are largely those of academics who curate and collect these artefacts, rather than those of creators or originators of the works themselves. A limited capacity to appreciate fully the perspectives of the originator and user groups is accordingly acknowledged, although an attempt has been made to raise general cultural concerns of which we are aware.

A full appreciation of what biocultural objects are should lead to discussions about their multiple current values and their inherent potential for agricultural, social, economic and cultural advancement and so on. Those who consider themselves custodians or curators of such collections should reorient their role(s) from institutional isolation, toward participation in a networked community of institutions who learn from each other and who in collaboration can potentially deliver more than the sum of their parts. Curation standards should look well beyond the scientific or technical curation standards that are required for long-term conservation and preservation of biocultural artefacts and articles, implicitly to enable and facilitate benefits not only for the inhabitants of their own countries but more

importantly for those in the artefacts' countries of origin. We must essentially create an interactive global community for biocultural collections, curators and originators.

Accordingly, this chapter discusses a number of issues that must be addressed in order to facilitate this goal by establishing curation standards and guidelines for biocultural collections. These issues were brought forward by a panel of the authors at the 2011 workshop 'Biocultural Collections: Establishing Curating Standards'.

## LOCATION OF BIOCULTURAL COLLECTIONS

Various reasons, including inadequate budget, bad planning and poor advocacy, have led to the existence of underfunded institutions and orphaned-yet-valuable biocultural collections, including those of individuals important in the history of ethnobotany, in many countries. Consequently, it would be useful to develop standards for dealing with such endangered or orphaned collections: procedures for identifying and evaluating them, and for determining appropriate action, should they be deemed worthy of preservation.

Some argue that it is better to expatriate collections to sites where they are curated effectively rather than to leave them to disintegrate in their existing location. Indeed, it can be argued that it is better to access a web-based image of an intact artefact secured in a well-resourced facility than it is to hold its decomposed remains in a poorly resourced one. The deaccessioning of museum holdings to allow them to be donated or repatriated is, though, a typically arduous and bureaucratic process. Accordingly, better-resourced institutions should, whenever feasible, consider facilitating temporary loans to source communities.

The transfer of biocultural artefacts does raise the question of the local impacts of their loss, even if temporary. If collections are located so as to allow access by those whose cultures are represented, these people can potentially support cultural and biodiversity conservation through education and, by preserving materials (such as seeds of land races) and related knowledge, can help with local environmental management and climate change impacts. Opportunities exist too for cross-cultural information sharing within regions, to break down barriers of prejudice and xenophobia that are maintained by ignorance. Accordingly, the retention of small local biocultural collections is favoured, associated as they may be with local cultural products such as medicinal plants or traditional textile projects. Significant challenges remain, however, for funding well-curated biocultural collections of any size in developing countries. It would be useful if guidelines for local decision makers whose responsibilities include the management of biocultural collections could be prepared, drawing on existing practice in the wider museum community (see Chapter 1). Similarly, standards for the creation, preservation or development of community-based biocultural collections would be useful, especially if they provided information concerning their relevance for local biocultural conservation or education and for economic development, including their potential role in product development and in ecological, cultural or historical tourism. Similar guidelines are being developed for plant germplasm and genebanks, recognising that a combination of interlinked local, national and international genebanks is the best way to serve varied user groups (Chapter 8).

## SOUND DATA COLLECTION

Sound curation starts with comprehensive field data collection, and does not commence when an object arrives at a museum or other repository. Researchers should pay careful attention to all cultural aspects surrounding the collection of objects that they intend to acquire (Chapter 12). This requires that they obtain as complete a set of data as possible on site before removing the objects from their original

locality. Doing so will minimise the likelihood of later misinterpretation and/or misrepresentation. For example, when cultural information is incomplete, objects may be misinterpreted in displays or in academic reports, or may be handled and displayed in culturally insensitive ways (Chapter 18). The development of curation guidelines that emphasise and facilitate this aspect is crucial if full value is to be obtained from collections, and particularly if cultural sensitivities are to be addressed. Cognisance within these guidelines of interpersonal interactions among researchers, creators and user groups is important: successful information flow at this level requires the ability of researchers to behave well and fairly (Chapter 1) and to understand and respect other world views. Such behaviour strengthens relationships, research and networking opportunities, and ultimately the value of material accessions.

## RESPECT

A biocultural artefact should receive respect in handling and display procedures commensurate with that provided in its place of origin (Chapter 18). When biocultural objects are removed from the proximity of the originators and transferred to museums, it is increasingly recognised that, regardless of their physical displacement, the objects retain cultural and/or spiritual significance for the originators. This continued and sensitive tie with far-removed people gives rise to their concerns that due respect is accorded to objects in the care of others, regardless of how or when the objects were acquired. The appropriate respect expected may be in conflict not only with the storage and handling policies of the museum, but also with the activities of insensitive curators who might view or treat the articles as inanimate objects of academic, artistic or educational value only. Curation policies should stipulate sensitive curation, and the need to accommodate the broader cultural perspectives of the originators of works. Considerate accommodation should extend as far as possible, without compromising the safekeeping of the objects, even if this consideration complicates the curation of collections (Chapter 1). The heterogeneous character of biocultural collections brings with it responsibility as well as opportunity.

Extra costs incurred in the course of 'culturally respectful curation' may require a budget, although for the most part, proper respect is unlikely to have financial implications. Instead, conducting an established curation approach within a new frame and mind set is much of what is required, and would in itself represent substantial progress. Education and understanding will be required on the part of curators, with originators and cultural representatives necessarily imparting insights. If these insights were not already documented at the time of collection, contemporary research may be necessary. In a digital age when many repositories have on-line accession registers and many traditional peoples now have access to the internet, it is possible to inform and collaborate at reasonable cost. Nevertheless, whenever possible, face-to-face communication and interactions are best as they facilitate access by customary groups to artefacts that are of special interest and importance to them.

The input of the peoples of origin is, in itself, a paradigm shift that should be included in new curation standards for biocultural collections. Museums have historically distanced the originators from the objects of their making by placing the items on view behind glass or in secure storage facilities, both out of sight and beyond access to all but approved researchers. It is on record that some materials already in the care of repositories, acquired legally in the context of the laws of the day and currently well managed, are nonetheless contentiously requested for repatriation. It should be noted, however, that requests for repatriation are very few and include not only objects of great financial or artistic value but also a number of items of cultural or spiritual value which arguably should be returned to communities who value them. Fair and open consideration of cultural value systems should be encouraged, on a case-by-case basis, with engagement viewed as an opportunity

to explore collaboration, networking and educational opportunities as much as cultural or spiritual restitution (Chapter 1).

## PRIOR INFORMED CONSENT

Wherever possible, the acquisition of biocultural artefacts should be accompanied by material transfer agreements and proof of prior informed consent from the originators of the artefacts concerning the future use of the materials and associated traditional knowledge (Chapter 1). Where objects are traded, this is not always possible but curation policies should nonetheless acknowledge and respect traditional knowledge and related biodiversity; for example, they must be compliant with the Convention on Biological Diversity (CBD).

## LEGAL ISSUES

Biocultural collections should not be acquired illegally, with reference to both the laws of the countries of origin and receipt and to international conventions such as CBD and the Convention on International Trade in Endangered Species of Wild Fauna and Flora (CITES) (Chapter 16). Accordingly, biocultural collections comprising plants and animals whose export, import or trade is restricted should only be collected with appropriate permits. In view of the likely ratification of the Nagoya Protocol, the movement of biological materials between countries will become more strictly regulated. Further, artefacts that are considered antiquities in the country of origin and which are restricted for trade should not be acquired. The possibility of linking the legal certification and international movement of biocultural collections to the regulatory mechanisms and clearing houses of Parties to the Nagoya Protocol should be investigated. Appropriate curation standards for dealing with culturally or legally sensitive biocultural material (e.g. human remains), in terms of their collection, storage and presentation, are required.

## CURATION STANDARDS FOR COLLECTIONS OF DIFFERING SIZES AND FUNDING LEVELS

It is necessary to develop procedures for curating collections of different sizes and for bringing together holders of collections of different kinds and purposes. For example, institutes of traditional medicine that hold collections of medicinal plants and products would perceive the function of their collection to be wholly different from those of collections in a textile museum, even though both are dedicated to the preservation of tangible and intangible heritage. Similarly, a textile museum based in a developing country would probably be smaller than one based in the developed world. Should a manual, such as this, set optimal curation standards or should it suggest minimum or flexible standards across a spectrum of categories? It seems likely that both should be welcomed so as to avoid marginalisation of poorly resourced collections; such coverage has been attempted in this book. Standards should also be set for institutional networking among institutions to promote sharing of information and non-financial resources. (For an example case, see Box 'Repatriation of the Zimbabwe Birds'.) An emphasis on the development of internet-based tools that are designed to elevate biocultural curation standards would be welcomed; such tool developments could be modelled on projects such as the Global Plants Initiative, funded by the Andrew W. Mellon Foundation. This initiative is an excellent example of how, using the web, images and data can be repatriated to source countries (virtual repatriation) without the need for the physical return of objects dispersed globally, in this instance type-specimen herbarium sheets.

# REPATRIATION OF THE ZIMBABWE BIRDS

NEIL R. CROUCH

The repatriation of biocultural artefacts is usually done in gestures of goodwill or in recompense for historical confiscation or other unethical acquisition of goods. This is often not a smooth or easy process, as demonstrated by the return to the Republic of Zimbabwe in 1981 of five of the eight known Zimbabwe birds, from South Africa. These specimens were removed from the site of the ruins of Great Zimbabwe, described as the most sacred place at Zimbabwe, starting in 1889 with subsequent movement and transfer of ownership (including purchase by Cecil John Rhodes, then Prime Minister of the Cape Colony).

The soapstone (mica-schist) bird-like objects are each about 30 cm long, perched atop pillars of more than 1 m height. A stylised Zimbabwe bird filial is shown in Figure 1. The birds play a primary role in Shona ideology: birds of prey bring messages from God and ancestor spirits can take on the form of eagles. Additionally, the birds are depicted in Zimbabwe's National Flag, on its currency (Figure 2) and medals, and in many other ways, so that they are thought of as being part of the country's heritage.

The first documented attempt to repatriate these relics was made in 1927, with much ensuing discussion and disagreement over the form (replicas or originals) and conditions of repatriation (housing, curation and ownership). Finally, on 29 January 1981, two Air Force of Zimbabwe Dakota planes flew out of Ysterplaat air force base in Cape Town with five Zimbabwe birds on board. The planes had earlier delivered the Hymenopteran collection of the National Museum of Zimbabwe in Bulawayo in exchange. Unfortunately, rancorous discussions and disagreements still surround this repatriation.

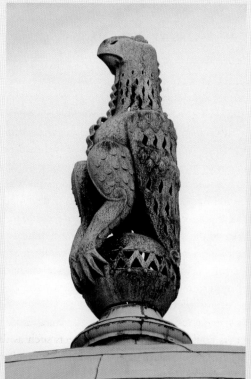

LEFT **Figure 1.** Highly stylised Zimbabwe Bird filial on Rhodes House, Oxford, UK. © MICHELE WALTERS

BELOW **Figure 2.** Stylised Zimbabwe Bird design on the 20 cent coin of the former Republic of Rhodesia. © TANZA CROUCH.

## DATABASES

Online databases and metadatabases (Chapter 11) can give people around the world access to biocultural collections that are relevant to their interest. This is inevitable and to be welcomed. Virtual access is not a substitute for the real thing but is certainly complementary and supplementary and may service the needs of a large part of the user community. Given the diversity of both biocultural collections and the institutions that manage them, it may not be feasible to apply universal curation standards, but there are some areas of common ground that will allow for standardisation. The development of a customisable (non-imposing) database that takes care of all of these fields could help pave the way forward for the standardisation of biocultural collections of different types and purposes. The presentation of a flexible and adaptable system should prove an excellent networking opportunity in itself, as many different biocultural collection holders need be brought on board, from the arts, humanities, biological sciences, medicine and so on. The issue of data sensitivity and the need to grey out certain fields to protect intellectual property is inevitably raised, as is the question of who should identify what information is sensitive. Consultation with the original holders of information that is not yet placed in the public domain is crucial to build trust and buy-in to what could be an exceedingly useful tool. This process should be welcomed as inherently networking-in-action and a model for biocultural collections management.

Through online databases, information can be repatriated to source countries, scholarship facilitated, interpretation provided for debate, and cultural or intellectual property sensitivities explicitly or implicitly highlighted. Decision makers can be informed about the importance of biocultural collections and how they have been and will remain a productive contribution to society, in a time of global change (land use, climate etc.).

## NETWORKING — ACCOMMODATING THE DIVERSITY OF COLLECTIONS AND BRIDGING THE NORTH-SOUTH DIVIDE

Significant improvement is required in communication between institutions or museums of developed countries that currently possess objects from developing countries, and the developing countries themselves. Researchers working at institutions or museums located in developed countries often have better means to travel internationally to conduct research and to acquire biocultural collections. Once back in their home institutions, the knowledge they have obtained is shared with peers through normal channels (papers, books and conference presentations), many of which are inaccessible to researchers in the source countries, even less to the indigenous peoples from whom artefacts are often collected. Greater consideration should be given to sharing advances in knowledge with counterparts in the developing world. Establishing meaningful and extensive collaborations that lead to the preservation of traditional knowledge and related biodiversity in the countries of origin must be prioritised. With current digital technology available world-wide, the challenges are less technical than financial, and the initiative for sharing needs to be taken by the better-resourced partners. Information technology offers enormous opportunities to connect with each other, to move forward and to explore opportunities, and the means are there to share. Attempts to establish standards for biocultural collections should at an early stage in the process bring on board stakeholders in biocultural collections based in the South, first through informing them of the initiative to do so, and then by engaging them in a manner that accommodates their fiscal, scientific and physical curation realities. The most important stage in which to include all relevant holders of biocultural collections is during the development of curation databases and standards, which have the potential to link biocultural collections both nationally and globally.

In this book, various authors have attempted to address the issues and concerns brought forward by a panel of the authors during the 2011 meeting Biocultural Collections: Establishing Curation Standards. These issues continue to be discussed among international collaborating institutions and we continually strive to bring new insight to this discussion. New institutes, collections or curators can contribute by joining Index Ethnobotanices, a global network of those interested in curating biocultural collections (Chapter 1).

## CHAPTER 20

# Historical perspectives on Western ethnobotanical collections

CAROLINE CORNISH
MARK NESBITT
Royal Botanic Gardens, Kew

## INTRODUCTION

Modern ethnobotany has a clear agenda centred on hypothesis-driven, quantitative analysis of plant use, usually applied for the benefit of the source community but often providing wider societal benefits (cf. Martin, 1995; Alexiades, 1996; Ethnobiology Working Group, 2003). The origins of modern ethnobotany lie, however, in more varied approaches, as set out by Wade Davis:

> 'Ethnobotany as an academic discipline has its roots in the numerous observations of explorers, traders, missionaries, naturalists, anthropologists, and botanists concerning the use of plants by the seemingly exotic cultures of the world ... For much of Western intellectual history, botany and what we now know as ethnobotany were synonymous fields of knowledge. Indeed, at its inception, ethnobotany was less an academic discipline than a point of view, one perspective by which European scholars and plant explorers went about classifying the natural world... From the start, then, ethnobotany has been intimately linked to botanical exploration, and its history has run parallel to the evolution of both systematic and economic botany.'
>
> (Davis, 1995: 40–41)

In this chapter, we seek to show how collections of ethnobotanical specimens have varied and changed through time in tandem with these wider changes in the discipline. In our view, ethnobotanical collections, whether old or new, are not only a rich source of data for contemporary ethnobotanists but are fundamental to understanding the evolution of ethnobotany (broadly defined) as a discipline.

Ethnobotanical knowledge resides in many forms: in memory, in books, manuscripts and photographs, in botanic gardens and in herbarium specimens. Our focus is on ethnobotanical specimens narrowly defined; that is, plant materials chosen to illustrate their use by humans, either in the form of raw materials (a cotton boll, for example), or in the form of partly or completely processed products and artefacts (a cotton textile, in this case). Such specimens have a long history and are highly effective in conveying knowledge, not only of the plant part used but also of the way in which it is processed.

As the quote above from Davis suggests, the history of ethnobotany is often framed in a Western context. It is clear, however, that the systematic study of useful plants is not restricted to Western cultures; for example, Li Shizhen published his *Compendium of Materia Medica* in China in 1593 (Li, 2003). Nonetheless, the origins of today's museums and natural history collections around the world are widely recognised as being in the cabinets of curiosity of the European Renaissance, mediated by the classifying urge of the Enlightenment and the public and educational emphases of the 19th century. Museums also exist in non-Western traditions, for example in the artefacts and woodcarving displayed in meeting houses in Oceania (Mead, 1983), but these are less well-documented and are not covered in this chapter.

Ethnobotanical specimens occur in many contexts, but in this chapter we concentrate on the history of ethnobotanical collections; that is, the history of separately organised groups of specimens defined by their curators as a collection of useful plants. Thus, for this discussion, we exclude, in general, ethnobotanical specimens held in general or ethnographic museums, except where these are separately classified or displayed. Nonetheless, such museums often include material of significant interest to ethnobotanists and should not be overlooked.

## TABLE 1

Location and date of foundation of selected ethnobotanical collections.

An asterisk indicates collections that no longer exist.

Botanic Garden, **Adelaide** (Australia): Museum of Economic Botany (established 1864).

Museum of Anthropology, University of Michigan, **Ann Arbor** (USA): Archaeobiology Laboratories (1929).

Eka Karya Botanic Garden (**Bali**): Ethnobotany Building (1993).

Escola Superior Agrária de **Beja** (Portugal): Botanical Museum (2002).

Botanical Garden, **Berlin** (Germany): Botanical Museum (1878).

Bogor Botanical Gardens, **Bogor** (Indonesia): Ethnobotany Museum (1982). Possibly incorporates collections from the former Museum voor Economische Botanie, Buitenzorg, which was founded before 1900.

*Department of Agriculture, **Brisbane** (Australia): Queensland Museum of Economic Botany (by 1890).

Harvard University Herbaria, **Cambridge, Massachusetts** (USA): Economic Botany Collections, Botanical Museum (1858).

Government Museum, **Chennai** (India): Gallery of Economic Botany (1851).

Field Museum, **Chicago** (USA): Timothy C. Plowman Economic Botany Collection (1893).

Botanical Garden of Córdoba, **Córdoba** (Spain): Ethnobotany Museum (1980).

*Royal Botanic Garden, **Edinburgh** (UK): Botanical Museum (1851).

National Botanic Gardens of Ireland, **Glasnevin** (Ireland): Economic Collection (1852–1853).

Botanischer Garten, Universität Hamburg, **Hamburg** (Germany): Botanische Museum (1885)

Royal Botanic Gardens, **Kew** (UK): Economic Botany Collection (1847).

Indian Museum, **Kolkata** (India): Economic Botany Gallery (1901).

National Herbarium of the Netherlands, **Leiden** (The Netherlands): Economic Botany Collection (1988)

World Museum, **Liverpool** (UK): Economic Botany Gallery (1932).

*Royal Botanic Gardens, **Melbourne** (Australia): Museum of Economic Botany (by 1893).

National Autonomous University of Mexico (UNAM), **Mexico City** (Mexico): Botanic Garden.

Botanical Garden, University 'Federico II' of **Naples** (Italy): Museum of Paleobotany and Ethnobotany (1980s).

New York Botanical Garden, **New York** (USA): Museum of Economic Botany (1891).

National Museum of Natural History, **Paris** (France): Ethnobiology Collection (1912).

*Royal Botanic Gardens, **Peradeniya** (Sri Lanka): Museum of Economic Botany (1880s).

*University of Pennsylvania, **Philadelphia, Pennsylvania** (USA): Museum of Economic Botany (by 1880s).

*Brown University, **Providence, Rhode Island** (USA): Museum of Economic Botany (by 1891).

Botanical Garden, **Rio de Janeiro** (Brazil): Ethnobotanical Collection (2012).

Missouri Botanical Garden, **St. Louis, Missouri**: Museum (1860).

Komarov Botanical Institute of the Russian Academy of Sciences, **St. Petersburg** (Russia): Collection of Economic Botany, c. 1850.

It is a key argument of this chapter that clearly defined ethnobotanical collections can be identified as early as the 17th century, in the form of materia medica collections, and took on a very distinctive form in the mid-19th century, as economic botany collections (Table 1). Collections from the mid-19th century onwards were clearly recognisable to curators and users as a distinctive type of collection, and share a number of characteristics including special attention to botanical classification.

## FROM CABINETS OF CURIOSITY TO THE ENLIGHTENMENT

The origins of Western museums can be traced back to the cathedral and court treasuries of the medieval period (Pearce, 1995). The origin of universal collections that include botanical and zoological specimens, however, dates to the slightly later development of cabinets of curiosities between 1500 and 1700 (Impey & MacGregor, 1985). Such cabinets — sometimes literally cupboards, more often rooms — represented a 'desire to bring all knowledge into a single space' (Mauriès, 2002: 9). The creators of such cabinets ranged from the nobility, such as the Hapsburg emperors of central Europe, to scholars and apothecaries, such as Ole Worm. Worm (1588–1654), known also by the Latinised form of his name Olaus Wormius, was a widely educated Danish physician who established his cabinet in Copenhagen; plant-based materia medica are clearly visible in a contemporary illustration (Figure 1).

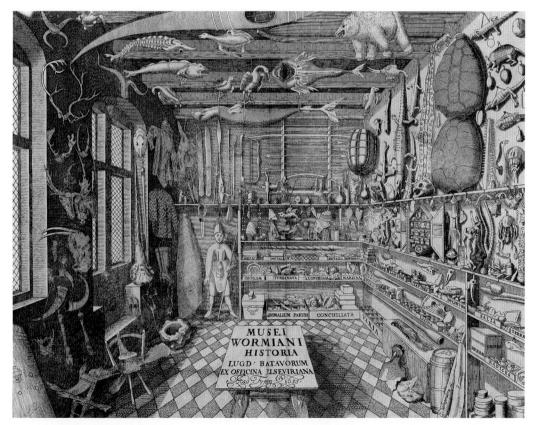

**Figure 1.** Worm's cabinet of curiosities in Copenhagen, illustrated on the title page of *Museum Wormianum* (Worm, 1655). Note the fruits ('fructus'), seeds ('semina'), wood ('ligna'), barks ('cortices') and roots ('radices') of medicinal plants on the right-hand shelves. © WELLCOME COLLECTION.

The period known as the Enlightenment, spanning the 18th century, saw an intense interest in the discovery and classification of both the natural world and human societies. This was reflected in ambitious universal encyclopaedias and museums, containing artefacts and specimens brought back from voyages of discovery. An example of an ethnobotanical collection made during the Enlightenment is that of Sir Hans Sloane, left to the British Museum at his death in 1753 and now housed at the Natural History Museum in London (Huxley, 2003: 75; Jarvis et al., 2012). It comprises 90 wooden drawers, divided into compartments and containing 12,253 specimens of 'vegetable substances' such as seeds, roots and bark (Figure 2). Many, but not all, of the specimens represent medicinal uses. The specimens are numbered, linking them to a three-volume handwritten catalogue. The highly international nature of the collection is typical of the 18th century, when voyages of exploration brought back new materials to Europe. For example, in Portugal, the Royal Cabinet of Natural History (later the Ajuda Royal Museum) was created in 1768 explicitly to preserve and study natural products from Portuguese voyages and colonies (Delicado, 2010).

The second half of the 18th century is a defining period for biology, especially as regards the development of plant names. Linnaeus developed Latin binomials, comprising a genus and a species epithet, as the framework for plant nomenclature. Through the influence of Linnaeus's books, notably the *Species Plantarum* of 1753, and those of Linnaeus's students, the binomial system was widely used by 1800, replacing the use of cumbersome descriptive phrases. For economic botany, standard nomenclature makes collections easier to use and to cross-reference to literature. A second advance was the development of the 'natural' system of plant classification, in which related genera are grouped within families (Adanson, 1763; Jussieu, 1789); in Linnaeus's more artificial system, genera (not always related) had been grouped strictly according to floral characters. Organisation by natural plant families was to become an important element in the display of many economic botany collections.

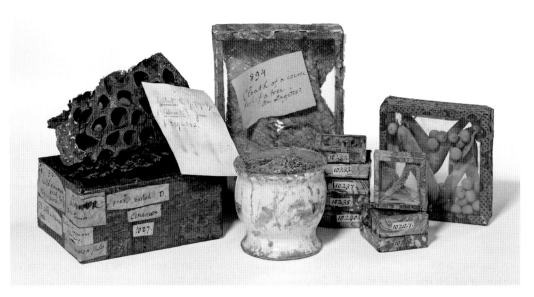

**Figure 2.** Boxes of 'Vegetable Substances' collected by Sir Hans Sloane (1660–1753). © NATURAL HISTORY MUSEUM, LONDON.

## THE 19TH CENTURY: ERA OF PUBLIC MUSEUMS AND WORLD'S FAIRS

### New museum practices

19th century ethnobotanical collecting was shaped by factors from inside and outside of the discipline. Across North America and Europe, this was the era of the public museum and the World's Fair. These were two elements of the 'exhibitionary complex' that characterised the age:

> 'The institutions ... [were] involved in the transfer of objects and bodies from the enclosed and private domains in which they had previously been displayed ... into progressively more open and public arenas where ... they formed vehicles for inscribing and broadcasting the messages of power.'
> (Bennett, 1995: 60–61)

The British Museum, which first opened in 1759, was for a considerable time only partially public; the first universally public museums can be dated to the period following the French Revolution of 1789, when the new Republican government devised a museological programme to make collections accessible to the whole population. In this context, the public museum was envisaged as a means of transforming the populus into a useful resource for the state, by producing an educated and unified citizenry (Hooper-Greenhill, 1992: 167). In 1793, the Muséum Nationale d'Histoire Naturelle was established in the former royal botanical gardens in Paris — the Jardin des Plantes — thus beginning an era of state patronage for institutions of scientific research and display. As a new cadre of professional scientists was created, so too new museum practices emerged: provenancing, cataloguing, documenting, storing, assessing (an object's physical condition but also its pedagogic content) and conserving. In times of war and peace, the Muséum Nationale dominated the field of natural history for the first half of the 19th century and was frequently cited as the model of an exemplary museum (Outram, 1996).

### Ideology and museums

The French *Muséum Nationale d'Histoire Naturelle* may have sprung from 18th century republican fervour, but the dominant ideology underpinning the rise of the public museum in 19th century Europe was undeniably liberalism. This ideology laid particular emphasis on the notion of humankind as capable of change through improved living conditions and education. Interestingly, this influenced both domestic and overseas policy; in Europe, anxieties over urban overcrowding and public order led to state funding of 'rational recreation' initiatives — forms of entertainment that provided alternatives to drinking and gambling. Museums played a prominent role in this strategy. In colonial contexts too, museums were made accessible to local populations on the basis of liberal ideals of bringing 'the backward and barbarous into the light of civilisation and progress' (Hobsbawm, 1975: 67). Linked to this is the notion of the museum as a unifying force, not only in the national museums of new states, where the official narrative was broadcast in the official language, but also in 'world' museums that displayed the objects of colonised peoples and territories.

The second half of the 19th century was also characterised by the rise of the nation-state, including Belgium in 1830, Italy in 1861, and Germany in 1871. Museums and botanical gardens were perceived as potent national statements, and became an essential trait of emergent nations. As new nations built empires, so the need to showcase these led to a contingent increase in sites of display, of which the Royal Museum for Central Africa (1898) in Belgium, and the Berlin Botanical Garden (1897) are examples.

## Economy and museums

For nations both old and new, the 19th century was an age of exploration and imperial expansion. Facilitated by technological advances in travel and communication, such as the steamship, the railroad and the electrical telegraph, overseas voyages of exploration routinely included a botanist who would survey and collect the flora and make observations on indigenous uses of plants. Frequently, museum directors would be involved in the appointment of such scientists, as was the case with John Kirk who was recommended for David Livingstone's Zambezi Expedition (1858–64) by William Hooker, the director of the Royal Botanic Gardens, Kew (Dritsas, 2010). The collections accumulated on such trips were sent back to metropolitan science institutions for identification and assessment, and the specimens and artefacts accessioned into the collections of these institutions.

Imperial expansion was driven by the desire for international prestige but also by the demands of industrialised economies. As Richard Drayton relates:

> 'Machines did not merely run on coal, they consumed cotton, wool, dyes, and vegetable oils, and the strength of the peripheral populations which provided these. Wheat, beef, tea, and sugar allowed operatives to meet the brutal pace of work. Shiploads of timber and rubber went to absorb shocks, and indeed electricity, which steel would not have contained. Without plant fibres twined into rope, woven into sacking, and crushed into paper, no administration could take place, and a whole civilization which depended on commodities being moved and recorded would have collapsed.'      (Drayton, 2000: 194)

Before the age of synthetic materials, the search for new sources of plants and minerals provided the impetus for much exploration and subsequent colonisation.

From 1848 to 1875, there was a period of economic growth during which, according to Eric Hobsbawm, 'the world became capitalist' (1975: 43). 'Economic liberalism' as the prevailing economic theory was called, was concerned with the removal of barriers of trade, thereby enabling the free movement of goods and services around the globe. Britain benefited disproportionately because of her overseas territories, which provided the cheap materials and labour required to undercut the market. Such territories were also targeted as markets for finished goods produced in Britain, such as textiles. Economic botany, with its emphasis on colonial plant raw materials, processed by colonial human labour, enshrined this system in the museum space.

## Networks of acquisition

### World's Fairs

The first World's Fair was *The Great Exhibition of the Works of Industry of all Nations* of 1851, held in the 'Crystal Palace' in London's Hyde Park. Its aim was to promote global trade and industry. The products of the colonised territories of European powers, including plant specimens and ethnobotanical objects, featured prominently. The non-botanical classification systems used in the exhibits were frequently adopted by museums.

At the Exhibition's close, the objects were dispersed to public collections such as those at the Royal Botanic Gardens, Kew and the Victoria & Albert Museum, London. The Great Exhibition set the pattern for a series of similar international exhibitions held across the world, which continued into the 20th century (Findling & Pelle, 2008). Museum staff became variously involved: as jurors of objects on display, as organisers of the displays, or as scientific consultants who were often commissioned to write articles for the various catalogues. With greater involvement came opportunities to determine which products were exhibited and acquired, these often corresponding to gaps in existing museum collections.

## Trade and industry

Trade or commercial museums, and applied science museums, such as those with economic botany displays, often drew on manufacturing and trading companies as donors of raw materials and goods, especially novel products (Conn, 1998). Examples of such museums include the Industrial Museum, Edinburgh (founded 1862), the Commercial Museum, Philadelphia (founded 1897) and the Technological, Industrial and Sanitary Museum, Sydney (founded 1882).

## Government infrastructure

National museums in particular were well-placed to take advantage of diplomatic, naval, governmental and military networks to grow their collections. This could be in the literal sense of using naval vessels to transport objects, or by encouraging members of the forces and other government agencies to collect and donate to national collections. Sometimes, too, this was arranged at the highest levels, as when Sir Harry Smith Parkes, the British Consul in Japan, was instructed by order of the Prime Minister, William Gladstone, to collect Japanese papers and submit them to the Science and Art Department at South Kensington for analysis (Casserley, 2013).

## Independent collectors

A relatively high proportion of the collectors documented in Kew's Economic Botany Collection had no formal government role. Some, such as Richard Spruce in the Amazon, and Charles Newcombe in British Columbia, relied on payments from Kew for their income. Many collected from personal enthusiasm; some were approached by Kew, others wrote to offer their services. Jim Endersby (2008) has documented a complex exchange of favours, in the form of plant identifications, books, botanical equipment and chatty letters, that enabled Sir Joseph Hooker, Director of Kew from 1865–1885, to maintain his worldwide network of collectors. The high proportion of amateur collectors sending material to Kew raises interesting questions as to the degree of central control over what was collected, and perhaps explains the diversity of objects found in such collections.

## Classification and display

The second half of the 19th century saw vigorous debate about the nature of museum displays, particularly as to whether the general public, students, or experts were to be the main audience. Public museums required new architectural forms to enable greater circulation of people around the exhibits, and new modes of display in order to render the collections meaningful to new audiences.

Three modes of classification presented themselves for objects of ethno- and economic botany: systematic, that is taxonomic (e.g. by plant family), typological (e.g.

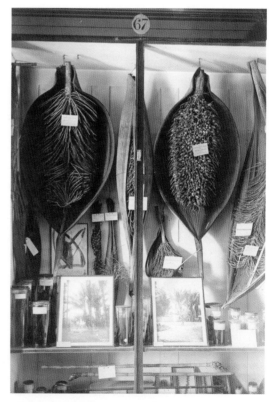

**Figure 3.** 'Economic Museum. Hortus Kew. Fam: Palmae, *Maximiliana regia* (Demerara) maripa palm'. Note the raw materials in the upper part and manufactured objects in the lower; also the use of photographs to show the living plant. Photograph by the Dutch botanist Johannes Lotsy, visiting from Leiden in 1902. © ROYAL BOTANIC GARDENS, KEW.

by function), or geographical. Ethnological museums took two opposing approaches to ethnographic display: geographical and typographical. The former approach sought to group objects according to their ethnic and geographical origin, to demonstrate that 'civilization is not something absolute, but that it is relative, and that our ideas and conceptions are true only so far as our civilization goes' (Boas, 1887: 589). The typological display — also known as a 'deductive' display (Boas, 1887), ordered objects by type, in a sequence demonstrating a perceived evolution from 'natural' to more 'complex' designs. In this taxonomy, objects were chosen for their representativeness; they were akin to natural history specimens in a systematic collection. By contrast, economic botany collections often ordered their collections by plant classification (as at Kew, Figure 3) or commercial use (as at the New York Botanical Garden and at Harvard, Figure 4).

## Dissemination

Ethnobotanical collections were circulated in the 19th century in a number of ways. Objects acquired from World's Fairs might re-surface at subsequent fairs, or objects might be loaned or donated to fellow museums for temporary exhibitions. Global print capacity expanded rapidly during the 19th century, leading to a proliferation of published titles such as official guide books, annual reports and scientific journals. Institutions such as botanical gardens, universities and museums frequently published in-house, and their publications circulated on an international scale. Kew Gardens' *Bulletin of Miscellaneous Information*, first published in 1887, contained information regarding new acquisitions,

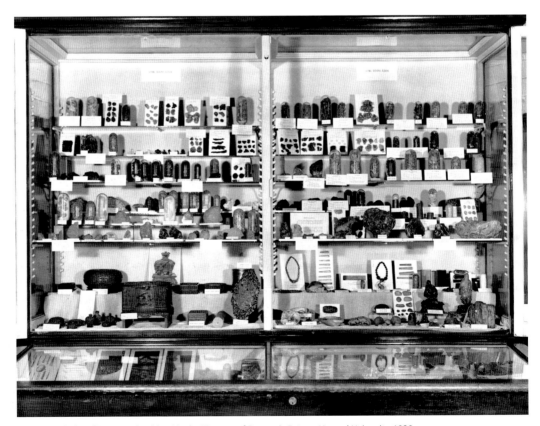

**Figure 4.** Display of 'gums, resins, kinos' in the Museum of Economic Botany, Harvard University, 1920s.
© ARCHIVES OF THE ECONOMIC BOTANY LIBRARY OF OAKES AMES, HARVARD UNIVERSITY.

research results and advice on cultivating economic plants; similarly published were the *Annals of the Missouri Botanical Garden* established in 1914 and the *Journal d'Agriculture Tropicale* established in 1901 in Paris. The meetings and subsequent reports of learned societies such as the British Association for the Advancement of Science (BAAS), and its American equivalent (AAAS) were also widely circulated and had large readerships. The popular press too reported on international exhibitions and museums, and useful plants appear to have had broad appeal, judging from the number of popular articles published on this subject.

## Ethnobotany in the 19th century

It was during the 19th century that museums developed discrete teaching and research collections, which could be used for outreach activities and public lectures, extending the museum beyond its walls.

### *The Museum of Economic Botany at Kew*

The term 'ethnobotany' did not enter the language until 1895, but it is pertinent to consider the form(s) in which knowledge of indigenous uses of plants was produced and circulated in the preceding years of the 19th century. As Paul Minnis (2000: 4) articulates, ethnobotany today has two distinct strands: the search for economically useful plants, otherwise known as economic botany, and 'the quest for indigenous ecological knowledge' or ethnobotany. In Europe, economic botany was the dominant strand for the greater part of the 19th century, although some European scholars pioneered ethnobotanical work (Svanberg et al., 2011: 195–197). The first museum dedicated to the subject was the Museum of Economic Botany at Kew (Figure 5), founded in 1847 by Sir William Hooker, the first director of the Royal Botanic Gardens, Kew (Cornish, 2013). Hooker defined economic botany as 'the practical uses and applications of the study of Botany, and the services thus rendered to mankind' and the museum collections were to consist of 'all kinds of useful and curious Vegetable Products, which neither the living plants of the Garden nor the specimens in the Herbarium could exhibit' (Hooker, 1855: 3). The Museum incorporated an innovative display principle: 'the *raw material* (and, to a certain extent, also the *manufactured* or *prepared article*) ... correctly named, and accompanied by some account of its origin, history, native country, etc., either attached to the specimens or recorded in a popular catalogue'. Such displays would be of use:

> '... not only to the scientific botanist, but to the merchant, the manufacturer, the physician, the chemist, the druggist, the dyer, the carpenter and cabinet-maker, and artisans of every description ...'
>
> (Hooker, 1855: 3)

In light of this, it is particularly interesting that Hooker adopted a systematic, rather than a commercial, arrangement in the museum. His argument was that the former was superior in that it communicated the *kinds* of plants yielding particular substances or with particular properties. This was important because, armed with a knowledge of plant orders and their properties, 'the intelligent traveller may safely estimate the properties with which a plant, though he [*sic*] has never seen it before, may possess' (1855: 6). In particular, botanists accompanying expeditions and 'voyages of discovery' were thus well-placed to identify sources of food, medicine and so forth in new and unfamiliar environments.

As we know, the concept of 'economic botany' was not originated by Hooker; Carl Linnaeus wrote a book on the subject as early as 1748, and the first publication on the subject in the English language was John Lindley's *Medicinal and Oeconomical Botany* (1849). Linnaeus was concerned only with plants cultivated in Sweden, whereas Lindley, who was Professor of Botany at University College,

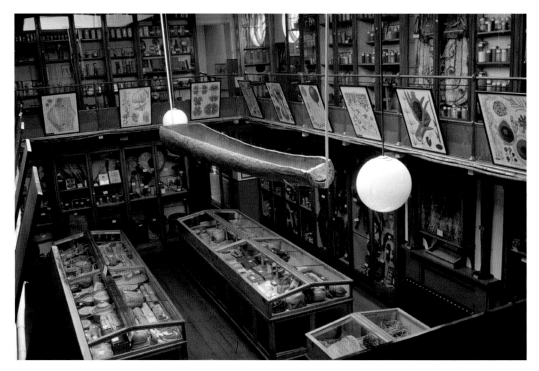

**Figure 5.** The Museum of Economic Botany at the Royal Botanic Gardens, Kew, opened in 1847. Photographed at the time of its closure in 1960. © ROYAL BOTANIC GARDENS, KEW.

London, attempted a comprehensive survey of known plants using the collections of botanical gardens. Hooker's innovation, however, was two-fold: in embracing the notion of manufactured products and in aligning himself with the organs of British exploration and colonial government (the Admiralty, the Colonial Office, the India Office and the Foreign Office), he developed a collection that functioned at the intersection of science and commerce. Economic botany did concern itself with indigenous knowledge systems and practices: local names were given, if known, as were local usages. It was primarily concerned, however, with accruing benefits for the imperial centre. The presence in the Kew Museum of the material culture of colonised peoples signified two interconnected ideas: that the colonies were a virtually limitless source of raw materials for British industry, and that indigenous practices provided the key to tapping such resources. In short, the Museum offered 'a portrait of Providence' (Drayton, 2000: 196).

The 'manufactured or prepared article' cited by Hooker was a term that incorporated a widely heterogeneous array of objects, from ethnobotanical artefacts to bars of Fry's chocolate! Again there were precedents: the India Museum was first established in the offices of the East India Company in London in 1801, since which time it had been collecting 'natural and artificial productions', particularly those plants 'whose produce is an article of commerce'. The original proposal for the Museum in 1799 specified:

> 'Each specimen should be accompanied by a Memorandum of its peculiar qualities, place of growth, etc. The different species of indigo, and other plants used in staining and dyeing, of the sugar cane and tea trees, and of the cotton plants, must not be neglected any more than the numerous tribes of oils, gums, and resins, which are the natural produce of the plants of Asia.'
> (cited in Desmond, 1982: 8–9)

Hooker's collection extended this concept to the whole world, and he energetically networked with importers and manufacturers to acquire what he termed 'illustrative series' —objects representing the phases of production from raw materials to finished goods (Figure 3).

## Museums in the British colonies

On the other side of the world, the Adelaide Museum of Economic Botany opened in 1881 under the directorship of Richard Schomburgk, a German botanist-explorer (Figure 6). With his brother, Robert, Schomburgk had taken part in the Prussian-British expedition to Guyana and Brazil from 1840 to 1844 and had collected for the University Museum of Berlin, simultaneously building up a personal collection of ethnobotanical objects. In 1865, he took up the position of Curator of the Adelaide Botanic Garden and he continued to expand his collection through exchanges with botanists worldwide and through his own expeditions into the Australian interior (Middelmann, 1976). The Museum, now known as the Santos Museum of Economic Botany, is the only surviving economic botany museum with its original displays intact, and has taken on new levels of significance with 21st century concerns over sustainable production and biodiversity, as well as initiatives to preserve 'intangible heritage' (Emmett & Kanellos, 2010).

Imperial museums also collected ethnobotanical material in the 19th century. The Indian Museum in Kolkata (Calcutta) is a case in point; it was formed by the Bengal Asiatic Society in 1814, but only in 1884 did it acquire significant collections of economic plants and ethnological objects, having received extensive donations from the Calcutta Exhibition of 1883–84 (Mackenzie, 2009: 236–239). An Ethnologic Gallery opened to the public in 1892 and an Economic Gallery in 1901,

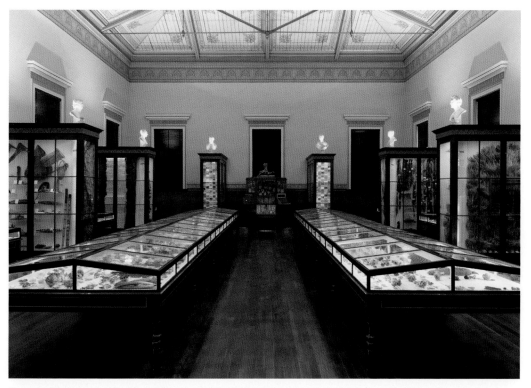

**Figure 6.** The Museum of Economic Botany at Adelaide Botanic Garden. Founded in 1864; moved in 1881 to this purpose-built museum; restored in 2008. © GRANT HANCOCK.

but although the two galleries were adjacent, they were nevertheless conceived of as representing separate disciplines (Indian Museum, 1910). Despite the obvious connection with Britain and British imperial interests, it would be a mistake to think that such museums communicated uniquely with the imperial centre. Just some of the Indian Museum points of contact in 1901 were as follows (Annual Report of the Indian Museum, 1902):

• Dr Stuhlmann of the Natural History Museum, Hamburg published an article on his visit to the Indian Museum;
• Professor Rusby of the New York Botanical Garden requested and received a full description of the Economic Gallery 'for private use in connection with his own rising Museum of Economic Botany';
• M. Bréaudat from the Institut Pasteur in Saigon, visited the Museum twice;
• Mr J. C. Willis, Director of the Royal Botanic Gardens, Ceylon paid an official visit.

Economic botany collections were also established on the continent of Europe, in trade centres such as Hamburg (Botanische Museum, founded in1885) and in places of scholarship such as St. Petersburg (founded c. 1850).

### Museums in the United States

The collection of economic botany objects and their display in museums extended beyond Britain and her colonies. The Harvard Museum of Vegetable Products (later renamed the Botanical Museum) was established in 1858 with a complete taxonomic set of specimens supplied by William Hooker to botanist Asa Gray. Gray's museum was decidedly pedagogic and the objects were used primarily as teaching aids in lectures. His successor, George Lincoln Goodale, shifted the emphasis to display and public access, extending the collections to include interpretative devices such as a magnificent collection of glass flowers by Leopold and Rudolph Blaschka of Meissen. Under Goodale, too, the Museum took on a greater 'economic' orientation and more ethnobotanical artefacts were accessioned into the collection. A museum soon followed at the Missouri Botanical Garden, opening in 1860 with an interior that is an almost exact copy of the Kew Museum (Figure 7).

What we now term 'ethnobotany' originated in North America with the observations made by early explorers and settlers on the indigenous uses of plants, particularly as medicines. This base knowledge was later expanded by government-sponsored explorers such as John Strong Newberry during the 1850s, and later still in the surveys conducted by the United States' Geological Survey and the Bureau of American Ethnology under the directorship of Major John Wesley Powell. The botanists and geologists sent on these missions added to the growing body of knowledge by identifying and cataloguing the plants they observed in indigenous use (Ford, 1978).

In the 1870s, with this growing interest in native American peoples and a growing knowledge of the North American flora, a new set of practices and concerns formed to found the basis of a new discipline: the collection of botanical specimens for taxonomic, evolutionary, ecological, chemical and agronomic studies, and the collection of data on the cultural significance of plants through observation and inquiry (Bye, 1979: 135). The individual who exemplifies the emergent discipline was Dr Edward Palmer, whose research in the western states led to the publication of *Food Products of the North American Indians* in 1870. Another scientist with comparable research was Stephen Powers whose focus was the indigenous peoples of California. In 1874, Powers coined the term 'aboriginal botany' and this became the accepted designation in North America for the ensuing 25 years. By 1895, when John Harshberger announced the advent of 'ethnobotany', the field had taken an ethnological turn, the theoretical focus switching to one that concerned itself more with the interactions between humans and plants as a means of understanding 'the cognitive foundations of a culture' (Davis, 1995: 43).

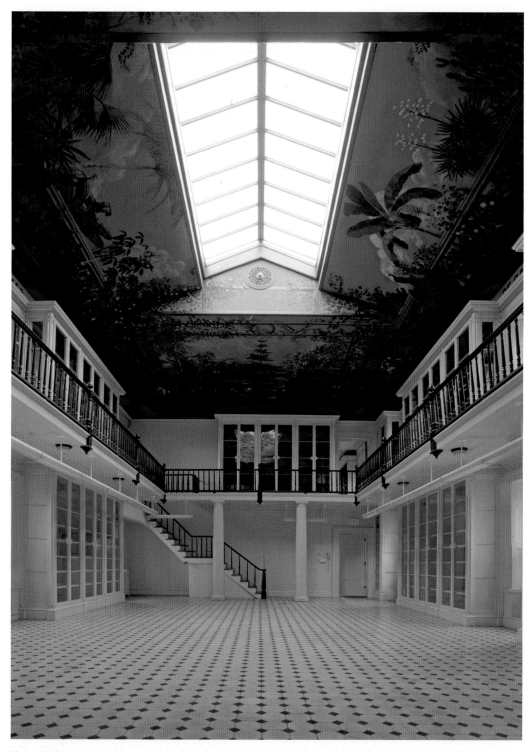

**Figure 7.**  The Museum at Missouri Botanical Garden, designed by George I. Barnett and opened in 1860. Note the likeness to the 1847 Museum at Kew (Figure 3), both were built as a long double-height space with long central skylight, gallery and full-height wall cases. © ARCHIVES, MISSOURI BOTANICAL GARDEN.

American museums and government agencies were avid collectors of the materials described by scientists such as Palmer and Powers; indeed Palmer was collecting archaeological and ethnological material for the Peabody Museum of Harvard University on the 1878 expedition to central Mexico that sparked his interest in indigenous plant uses (Bye, 1979: 135). Also crucial to the funding of collecting trips were the World's Fairs. The ethnographic collections at the 1893 World's Columbian Exposition in Chicago were organised by Frederic Ward Putnam, director of the Peabody Museum. Ethnologist Franz Boas was charged with the task of assembling a collection of artefacts of Northwest Coast Indians (including numerous ethnobotanical objects) for the 'live' ethnographic displays at the 'Alaskan Village' erected on the Exposition's Midway. After the closure of the fair, these items were transferred to the Chicago Field Museum of Natural History, along with plant products from many of the 50 nations exhibiting at the fair. The Field Museum, like other museums of ethnology and natural history, continued to grow its collection (now known as the Timothy C. Plowman Economic Botany Collection) through donations from subsequent expositions, including the Paris Expositions of 1901 and 1915, and the Louisiana Purchase Exposition of 1904, held in St. Louis.

## 20TH CENTURY DECLINE

The beginning of the 20th century saw an increasing emphasis on agricultural and colonial products, rather than on ethnographic artefacts, as demonstrated by the changing pattern in acquisitions at Kew. In 1911, the Laboratoire d'Agronomie Coloniale opened at the Natural History Museum in Paris. Under the direction of Auguste Chevalier (Director, 1912–1946), succeeded by Roland Portères, the collection grew to c. 100,000 specimens, dominated by specimens of cultivated plants.

The early 20th century also saw the beginning of the migration of agricultural research from botanical institutes to specialist institutes, such as those which make up the French institute CIRAD (Centre de coopération internationale en recherche agronomique pour le développement), and the Imperial Institute (now the Natural Resources Institute), founded in London in 1893. By the 1950s, research in tropical agriculture had moved entirely to specialist institutes. Edgar Anderson (1952) of the Missouri Botanical Garden could write of the positive disregard for cultivated (and useful) plants shown by taxonomic botanists of his day, an attitude that remained widespread in herbaria until recently. In addition to a growing divide between herbarium collections-based botanists and research into agriculture and useful plants, we believe that the end of European empires was also a major factor, leading to tropical research taking place in country rather than in European capitals of empire, and a consequent decline in interest in tropical products.

Two more factors are implicated in the pronounced decline of ethnobotanical collections from the 1950s onwards. First, many were housed in 19th century buildings with densely filled cabinets. As part of a wider reaction against 19th century architecture and design, many museum displays were reworked in the 1950s and 1960s to simpler formats with much less material on display. Second, the introduction of synthetic, often oil-based materials, including medicines, textiles and plastics, made natural products appear irrelevant and old-fashioned. The Ashby Report on Kew of 1958 touches on several of these issues:

> 'Modern synthetic chemistry and the immense development of the Commonwealth's agricultural services have reduced the value of the Department's [of Economic Botany] consulting work almost to insignificance ... Members of the public do visit the museums and doubtless get pleasure from some of the quaint and curious exhibits ... the museums have been starved of money and choked with worthless bric-a-brac unloaded upon them by State dignitaries, Government officials, and travellers.'                    (Ashby, 1958: 19, 24)

Between 1958 and 1961, two of the four museum buildings at Kew were closed, and a substantial proportion of the ethnographic collections transferred to the British Museum and other museums. Ultimately, in the mid-1980s, all the remaining buildings were closed and the contents moved into purpose-built storage, the Economic Botany Collection.

Similar closures took place elsewhere, and affected other natural resource collections, such as wood collections. At the Tropenmuseum (Tropical Museum) in Amsterdam, the artefacts have been retained, but the economic botany collections of raw materials and plant products were transferred to the National Herbarium in Leiden in 1989. The collections in Paris and Harvard were moved to attic storage with minimal curatorial resources. Some displays, notably at the Field Museum and in Adelaide remained substantially intact. Perhaps surprisingly, of the 17 19th century collections listed in Table 1, 11 survive today. Others may exist but are subsumed within larger collections and not easily identifiable.

## NEW USES AND USERS — AND A REVIVAL?

The existence of the Biocultural Collections Group (Chapter 1) is evidence of a revival of interest in ethnobotanical collections. We suggest this revival is closely linked to the resurgence of interest in ethnobotany, indigenous cultures, conservation and cultural survival in the past two decades, itself closely linked to events such as the Rio Summit of 1992 and the subsequent signing of the Convention on Biological Diversity. More recently, public and commercial interests in renewable and low-carbon materials have led to an increased role for natural products in industry and craft.

In part, this revival is visible in the cataloguing and curating of old collections, sometimes on a large-scale, as at the Archaeobiology Laboratory at the Museum of Anthropology, University of Michigan, which is the subject of a $482,000 grant from the National Science Foundation to rehouse the 35,000 specimens in its ethnobotanical collection. More often, cataloguing and rehousing is undertaken as part-time curatorial work or by volunteers, as at Harvard and Glasnevin. This work is rarely accompanied by new displays, but as collections are better documented and curated, use by researchers and teachers has increased. Nevertheless, ethnobotanical collections are still often viewed as peripheral to institutional missions and remain vulnerable to shifts in priorities that reduce or eliminate staffing.

Alongside enhanced curation and visibility, the most significant change is in the user community. Until the 1950s, it appears that most users were drawn from botany and commerce. Today, the typical visitor is likely to be from an indigenous community, and/or a specialist in material culture and ethnography, in art and design history, in archaeology or in the histories of science, medicine, empire and exploration. Plants play such a central role in life, past and present, that ethnobotanical collections are relevant to a wide range of research interests. Ironically, at Kew, it feels as if taxonomists are an under-represented user group, despite evidence that our Economic Botany Collection is a rich resource for type specimens (George, 2010; Turner, 2012).

The implications for curators are two-fold. The first is that this broader user community cannot be identified unless the collection's history is, at least in broad terms, documented and understood. For a curator, historical research into collections is thus a necessity, not a luxury. Such research might not be done by curators — these collections are a rich field for postgraduate students — but it must be encouraged and coordinated by them. The second is that the curator must move outside the comfort zone of their specialism, for example by attending meetings of other special interest groups and inviting them into the collection. Working with postgraduate students and postdoctoral researchers is an excellent way of widening networks in unexpected ways.

## THE ETHNOBOTANY COLLECTION — BOTANICAL GARDEN RESEARCH INSTITUTE OF RIO DE JANEIRO

VIVIANE STERN DA FONSECA-KRUEL

Since 2000, a group of scientists comprising researchers from Botanical Garden Research Institute of Rio de Janeiro (JBRJ) and the Department of Botany of Rio de Janeiro's Federal Rural University have been working in a multidisciplinary effort, with the goal of achieving a comprehensive view of the complex and dynamic relationship between the symbolic and material, different human societies and the plants, especially through objects made with native Brazilian plants.

The Ethnobotany Collection is a recent collection, part of the Herbarium of the Botanical Garden Research Institute of Rio de Janeiro (RB). The priorities of the ethnobotany project range from curating the permanent collection and contributions from all other botanic gardens to conservation of biology and global change. Our collection includes handcrafts, objects and products made from different parts of plants (especially from the Atlantic rainforest and Amazonian communities) and natural products commercialised at the local markets.

Artefacts marketed as being made from *Caesalpinia echinata* (brazilwood tree) from the Ethnobotany Collection of the Rio de Janeiro Botanical Garden Research Institute: household items (wooden spoon, skimmers, fork and knife), crafts in the form of a carved dolphin and a pen in the shape of a toucan. These items were made by craftsmen of the town of Gamboa, municipality of Cabo Frio, State of Rio de Janeiro, Brazil and donated by V. S. da Fonseca-Kruel on 20 August 2003. Also shown are a pair of earrings made from the fruit of *C. echinata* L. by artisans of the town of Jacaré, municipality of Cabo Frio, State of Rio de Janeiro, Brazil and donated by V. S. da Fonseca-Kruel on 3 January 2003.
© VIVIANE STERN DA FONSECA-KRUEL.

The increasing interest in ethnobotanical collections has led to an exciting development, the creation of new collections, for example at UNAM, Mexico City, and at the Botanic Gardens in Naples and Rio de Janeiro (see Box). The purpose of these new collections is typically the preservation of and communication about traditional cultures, in line with the purposes of modern ethnobotany.

A few of the older collections are still actively collecting; for example, Kew adds about 2,000 specimens a year to its Economic Botany Collection. All active collections work within the letter and

spirit of the Convention on Biological Diversity, with specimens being collected with prior informed consent (Chapters 1 and 11) for agreed-upon research and purposes (often non-commercial). Some active collections are used for bioprospecting projects, in which case property rights and benefit-sharing are particularly important elements of collaborative agreements (Chapters 1 and 16).

Alongside research and applied ethnobotany, historic collections are also compelling materials for public engagement (Chapter 24). This can be in the context of formal education, such as in postgraduate teaching, in museum displays, or in public interpretation such as heritage events and open days (Figure 8).

**Figure 8.** Public engagement: the re-opening of Kew's original Museum of Economic Botany for Open House London weekend, September 2011. A wide range of ethnobotanical artefacts, reinstalled into the museum for the first time since it closed in 1960, were seen by 1,200 visitors. © ROYAL BOTANIC GARDENS, KEW.

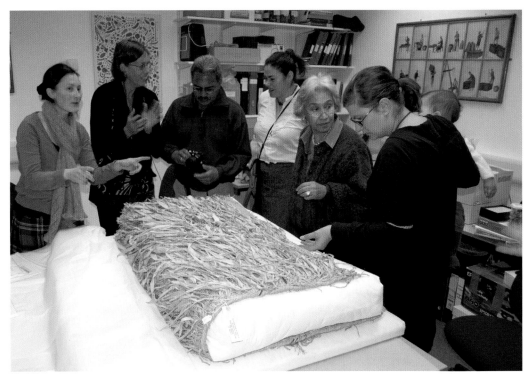

**Figure 9.** Working with source communities: conservator Luba Dovgan Nurse (far left) discusses a 19th century Maori cloak made from tikumu (*Celmisia*) with visitors from New Zealand. Left to right: Cathy and Jim Schuster, Rosanna Raymond, Esther Jessop, Maia Nuku. © DEAN SULLY, UNIVERSITY COLLEGE LONDON.

## SOURCE COMMUNITIES AND MUSEUMS

Research into the history of museum collections enables curators and source communities to understand from where and whom collections came, how they were obtained, and how an object took on different meanings at different points in its history (Moser, 2006; Gosden et al., 2007; Chapters 17–19). The relationship between museums and source communities is complex and often framed within the context of injustices past and present. Plant products such as sugar and rubber are inextricably linked to slavery; indentured labour was widespread following the abolition of slavery, and plant exploration often took place in the context of appropriation of land.

At the same time, research into the Economic Botany Collection at Kew indicates that many collectors in the mid- to late- 19th century were sympathetic to indigenous cultures. For example, William Colenso (1811–1899) learned to speak Maori and published some of the earliest ethnobotanical records for Maori culture. Another collector in New Zealand, Walter Mantell (1820–1895), became a fervent campaigner for Maori rights. Collectors either paid for specimens or, less often, as in the case of an engraved bottle gourd received by Colenso, received items as gifts from indigenous peoples. Charles Newcombe (1851–1924), a prolific collector of artefacts for Kew and other museums, spent significant sums of money on purchases in British Columbia, blaming large purchases by the British Museum for pushing up prices for items purchased direct from the indigenous peoples (Cornish, 2012). Overall, Kew's archives point to subtle and complex relationships between collectors and members of source communities, sometimes based on friendship. Newcombe, for example, worked

in collaboration for many years with the son of a Haida chief, Henry Moody, as his Haida consultant. Objects and knowledge were recorded for utilitarian ends, to meet imperial and commercial agenda, but were sometimes collected with the explicit aim of preserving vanishing traditions. The role of indigenous consultants and the wider subject of how indigenous peoples and collectors interacted are subjects for future research (c.f. Cole, 1985; O'Hanlon & Welsch, 2004).

We believe that an open sharing of object histories is an essential component in building trust between curators and source communities. It is vital that biocultural collections make use of the experience gained by ethnographic museums in building partnerships with source communities. Examples of this are the work of the Pitt Rivers Museum; of the Museum of Anthropology in Vancouver, with First Nations peoples of Canada; of the Museum of New Zealand, Te Papa Tongarewa with the Maori of New Zealand; or of the National Museum of the American Indian, Washington, with native peoples of the Americas. Such partnerships should be grounded in the ethics codes of ethnobotany (Chapter 1), and bring many benefits. Because artefacts in historic collections may well have disappeared from everyday use, in their materials and making they may preserve indigenous knowledge that is threatened or has been lost. Careful 'reading' of construction techniques by traditional craftworkers can lead to the retrieval of knowledge, this time not for the benefit of empire, but in the spirit of modern ethnobotany, to strengthen and preserve cultural traditions (Figure 9).

## RESEARCHING HISTORIES

It will be evident from this chapter that ethnobotany and economic botany collections are neither random accumulations of specimens nor the result of centrally directed and uniform collecting policies. Instead, they result from varied engagements among political and economic climates, institutions, museum staff, field collectors and indigenous peoples. Differences in aims, opportunity and method have led to great variation in the means by which specimens were obtained, the type of material collected and the amount of documentation.

These variations are of significance to users. Whether assessing the quality of a botanical identification prior to sampling for DNA analyses, researching the history of a collector or institution, or working in partnership with a source community, it is essential to find out the context of the specimens concerned. The date and location of the point of collection are particularly important for the identification of source communities.

Resources for researching provenance fall into three types:

1. Archives such as field notes, diaries and letters can give very direct insights into the circumstances of collection. Museum archives tend to be large and only catalogued in outline, so expert assistance may be required in locating material. Bear in mind that archival materials (especially letters) are often scattered and may well be housed in disparate institutions, or with family members. Union catalogues and botanical digitisation projects are increasingly useful, and some are listed at the end of this chapter.

2. Printed materials such as books and periodicals, and increasingly e-libraries, allow full-text searches (Chapter 13). Searching by collector names can lead to rich results. Selected resources are listed at the end of this chapter.

3. A broader body of ethnographic material and knowledge resides with both academic researchers, museum curators and source communities. Ethnographic expertise is a starting point for putting objects into their cultural context, while working with source communities also fosters partnerships for the care and interpretation of specimens (Chapters 17–19).

## CONCLUSIONS

The history of ethnobotanical collections falls in four parts. In the 16th and 17th centuries we see the first materia medica cabinets. This is a time when botany is almost exclusively a medical pursuit, because of the central role of plants in providing medicines. Materia medica collections continued to be central to the teaching and practice of medicine until the 1930s, and often survive as collections within departments of pharmacy today. These specialist collections lie outside the scope of this article, but can be an important resource for the ethnobotanist.

In the age of the Enlightenment, the 18th century, exploration gave Western scientists access to well-documented natural history and ethnographic material from around the world. Major developments in classification, including Linnaeus's development of binomial plant classification, led to the creation of large and well-ordered collections, often in private hands such as those of Sir Hans Sloane.

The mid-19th century saw the rise of the public museum (including botanic gardens) as a major venue for collections research and public dissemination. At the same time, the expansion in global trade and of empire led to strong commercial and government interest in natural products. It is therefore no surprise that well-curated and extensively displayed economic botany collections were formed, often within botanic gardens, natural history museums and the now-vanished genre known as the commercial museum. It would be wrong, however, to see these collections as entirely European imperial enterprises, as demonstrated by the energetic formation of collections of 'aboriginal botany' within the USA.

The mid-20th century saw a decline in interest in natural products both among professional botanists and the wider world, and many ethno- and economic botany collections were placed in storage or dispersed. Recently, however, renewed interest has been driven by ethnobotanists and, increasingly, indigenous peoples, who are interested both in old collections as repositories of indigenous knowledge and history and in forming new collections deliberately aiming at preservation and communication. It seems unlikely that ethnobotanical collections will ever be formed or displayed on the same scale as in the 19th century, but their role within modern ethnobotany appears increasingly secure.

## ACKNOWLEDGEMENTS

We are grateful to Katie Konchar and Jan Salick for the invitation to write this paper, to workshop participants for many thought-provoking comments, and to Felicity McWilliams for useful discussions on past collecting practices.

## *Digital resources for researching object histories*

### *Manuscripts*

National Archives (UK). www.nationalarchives.gov.uk

Typical of many national archives in hosting a wide range of catalogues, not only of material held in the central body. This website includes the National Register of Archives, and Access to Archives (A2A) cataloguing archives throughout England and Wales.

Smithsonian Institution Archives. http://siarchives.si.edu

Natural History Museum (London). www.nhm.ac.uk/research-curation/library/archives

Harvard University Herbaria. www.huh.harvard.edu/libraries/archives.htm

JSTOR Plant Science. http://plants.jstor.org Includes more than 25,000 letters from Directors' Correspondence at the Royal Botanic Gardens, Kew

Missouri Botanical Garden, Tropicos. www.tropicos.org/ReferenceSearch.aspx

### *Printed materials*

Google Books. http://books.google.com Full-text searching of many books, but inconsistent access to original text.

Open Library. http://openlibrary.org/search/inside Interface with the Internet Text Archive, which allows full-text searching of many books, with good reading and download options.

Biodiversity Heritage Library. www.biodiversitylibrary.org Historic botanical literature; currently no full-text text. Botanicus (www.botanicus.org) based at Missouri Botanical Garden is a major contributor.

JSTOR. http://jstor.org Full-text searching of long runs of academic journals from the 17th century to present. Access must be via a university account for full downloads of articles.

### *Ethnobotanical collection databases*

Museum of Anthropology, University of Michigan, Ann Arbor: Southwest Traditional Ethnic Group Plant Use Database. www.lsa.umich.edu/umma/collections/archaeologycollections/archaeobiologylaboratories

Timothy C. Plowman Economic Botany Collection, Field Museum, Chicago. http://emuweb.fieldmuseum.org/botany/search_eb.php

Economic Botany Collection, Royal Botanic Gardens, Kew. http://apps.kew.org/ecbot/

Edward Palmer Collections. http://botany.si.edu/colls/palmer/

Richard Spruce. www.kew.org/collections/ecbot/collections/region/amazonia

Missouri Botanical Garden Ethnobotany and Biocultural Collections. www.tropicos.org/EthnobotanySearch.aspx

### *Ethnographic collection databases*

Many ethnographic collections are online; this is a selection of some of the largest:

Tropen Museum, Amsterdam. http://collectie.tropenmuseum.nl

Peabody Museum of Archaeology and Ethnology, Harvard. www.peabody.harvard.edu/node/37

British Museum, London. www.britishmuseum.org/research/search_the_collection_database.aspx

Museum of New Zealand/Te Papa Tongarewa, Wellington. http://collections.tepapa.govt.nz

Pitt Rivers Museum, Oxford. www.prm.ox.ac.uk/databases.html

Quai Branly, Paris. www.quaibranly.fr/fr/documentation/le-catalogue-des-objets.html

Anthropology Collections, Smithsonian Institution, Washington DC. http://collections.nmnh.si.edu/anthroDBintro.html

## Literature cited

Adanson, J.-P. N. (1763). *Familles des Plantes*. Chez Vincent, Paris.

Alexiades, M. N. (ed.) (1996). *Selected Guidelines for Ethnobotanical Research: a Field Manual*. New York Botanical Garden, New York.

Anderson, E. (1952). *Plants, Man and Life*. Little, Brown, Boston.

Ashby, E. (1958). *Report of a Visiting Group to the Royal Botanic Gardens, Kew*. Unpublished report held in the Library, Royal Botanic Gardens, Kew.

Bennett, T. (1995). *The Birth of the Museum*. Routledge, London.

Boas, F. (1887). Museums of ethology and their classification. *Science* 9(228):587-589.

Bye, R. A. (1979). An 1878 ethnobotanical collection from San Luis Potosí: Dr. Edward Palmer's first major Mexican collection. *Economic Botany* 33: 135–162.

Casserley, N. B. (2013). *Washi: the Art of Japanese Paper*. Royal Botanic Gardens, Kew.

Cole, D. (1985). *Captured Heritage: the Scramble for Northwest Coast Artifacts*. Douglas & McIntyre, Vancouver.

Conn, S. (1998). *Museums and American Intellectual Life, 1876–1926*. University of Chicago Press, Chicago.

Cornish, C. (2012). 'Useful and curious': a totem pole at Kew's Timber Museum. *Journal of Museum Ethnography* 25: 138–151.

Cornish, C. (2013). *Curating Science in an Age of Empire: Kew's Museum of Economic Botany*. PhD Thesis, Department of Geography, Royal Holloway, University of London.

Davis, E. W. (1995). Ethnobotany: an old practice, a new discipline. In: *Ethnobotany: Evolution of a Discipline*, eds R. E. Schultes & S. von Reis, pp. 40–51. Timber Press, Portland.

Delicado, A. (2010). For scientists, for students or for the public? The shifting roles of natural history museums. *HoST - Journal of History of Science and Technology* 4. http://johost.eu/?oid=96

Desmond, R. (1982). *The India Museum 1801–1879*. HMSO, London.

Drayton, R. (2000). *Nature's Government: Science, Imperial Britain, and the 'Improvement' of the World*. Yale University Press, New Haven.

Dritsas, L. (2010). *Zambesi: David Livingstone and Expeditionary Science in Africa*. I. B. Tauris, London.

Emmett, P. & Kanellos, T. (2010). *Santos MEB: the Museum of Economic Botany at the Adelaide Botanic Garden: a Souvenir*. Board of the Botanic Gardens and State Herbarium, Adelaide.

Endersby, J. (2008). *Imperial Nature: Joseph Hooker and the Practices of Victorian Science*. University of Chicago Press, Chicago.

Ethnobiology Working Group (2003). *Intellectual Imperatives in Ethnobiology*. Missouri Botanical Garden, St Louis.

Findling, J. E. & Pelle, K. D. (eds) (2008). *Encyclopedia of World's Fairs and Expositions*. McFarland, Jefferson.

Ford, R. I. (1978). Ethnobotany: historical diversity and synthesis. In: *The Nature and Status of Ethnobotany*, ed. R. I. Ford, pp. 33–49. Museum of Anthropology, University of Michigan, Ann Arbor.

George, A. S. (2010). Australian type material in the Economic Botany Collection, Royal Botanic Gardens, Kew. *Muelleria* 28: 163–171.

Gosden, C., Larson, F. and Petch, A. (2007). *Knowing Things: Exploring the Collections at the Pitt Rivers Museum 1884–1945*. Oxford University Press, Oxford.

Hobsbawm, E. (1975). *The Age of Capital 1848–1875*. Abacus, London.

Hooker, W. J. (1855). *Museum of Economic Botany: or, a Popular Guide to the Useful and Remarkable Vegetable Products of the Museum of the Royal Gardens of Kew*. Longmans, London.

Hooper-Greenhill, E. (1992). *Museums and the Shaping of Knowledge*. Routledge, London.

Huxley, R. (2003). Challenging the dogma: classifying and describing the natural world. In: *Enlightenment: Discovering the World in the Eighteenth Century*, eds K. Sloan & A. Burnett, pp. 70–79. British Museum Press, London.

Impey, O. R. & MacGregor, A. (1985). *The Origins of Museums: the Cabinet of Curiosities in Sixteenth- and Seventeenth-century Europe*. Clarendon, Oxford.

Indian Museum (1902). *Annual Report of the Indian Museum Industrial Section for the Year 1901–1902*. Government Printing, Calcutta.

Indian Museum (1910). *Annual Report of the Indian Museum Industrial Section for the Year 1909–1910*. Government Printing, Calcutta.

Jarvis, C., Spencer, M. & Huxley, R. (2012). Sloane's plant specimens at the Natural History Museum. In: *From Books to Bezoars: Sir Hans Sloane and his Collections*, eds A. Walker, A. MacGregor & M. Hunter, pp. 137–157. British Library, London.

Jussieu, A.-L. de. (1789). *Genera Plantarum*. Herissant et Theophilum Barrois, Paris.

Li, S. (2003). *Compendium of Materia Medica*. Translated and annotated by Luo Xiwen. Foreign Languages Press, Beijing.

Lindley, J. (1849). *Medicinal and Oeconomical Botany*. Bradbury & Evans, London.

Linnaeus, C. (1748). *Flora Oeconomica*. Elias Aspelin, Smolandus, Uppsala.

Mackenzie, J. M. (2009). *Museums and Empire*. Manchester University Press, Manchester.

Martin, G. (1995). *Ethnobotany: a Methods Manual*. Chapman & Hall, London.

Mauriès, P. (2002). *Cabinets of Curiosities*. Thames & Hudson, London.

Mead, S. M. (1983). Indigenous models of museums in Oceania. *Museum International* 35: 98–101.

Middelmann, R. F. (1976). Schomburgk, Moritz Richard (1811–1891). In: *Australian Dictionary of Biography, Volume 6*, pp. 91–92. Melbourne University Press, Melbourne.

Minnis, P. (2000). *Ethnobotany: a Reader*. University of Oklahoma Press, Norman.

Moser, S. (2006). *Wondrous Curiosities*. Chicago University Press, Chicago.

O'Hanlon, M. & Welsch, R. L. (eds) (2004). *Hunting the Gatherers: Ethnographic Collectors, Agents and Agency in Melanesia, 1870s–1930s*. Berghahn Books, Oxford.

Outram, D. (1996). New spaces in natural history. In: *Cultures of Natural History*, eds N. Jardine, J. A. Secord & E. C. Spary, pp. 249–265. Cambridge University Press, Cambridge.

Palmer, E. (1870). Food Products of the North American Indians. In: *Report of the Commisioner of Agriculture for the Year 1870*, pp. 404–428. United States Department of Agriculture, Washington DC.

Pearce, S. M. (1995). *On Collecting: an Investigation into Collecting in the European Tradition*. Routledge, Abingdon.

Svanberg, I., Łuczaj, Ł., Pardo-de-Santayana, M. & Pieroni, A. (2011). History and current trends of ethnobiological research in Europe. In: *Ethnobiology*, eds E. N. Anderson, D. Pearsall, E. Hunn & N. Turner, pp. 189–212. John Wiley, Hoboken.

Turner, I. M. (2012). The contribution of Jonathan Pereira (1804–1853) to plant taxonomy. *Kew Bulletin* 66: 581–585.

Worm, O. (1655). *Museum Wormianum. Seu historia rerum rariorum, tam naturalium, quam artificialium, tam domesticarum, quam exoticarum, quae Hafniae Danorum in aedibus authoris servantur*. Leiden: Iohannem Elsevirium.

# SECTION V

## Broader impacts of biocultural collections

# CHAPTER 21

# *Research using biocultural collections*

### DAVID M. SPOONER

United States Department of Agriculture, Agricultural Research Service, also
Department of Horticulture, University of Wisconsin–Madison

## INTRODUCTION

The purpose of this article is to provide a sampling of the wide breadth of interdisciplinary research conducted using biocultural collections. Because of the range of this work, this chapter clearly cannot provide comprehensive coverage. Instead, I provide a sampling simply meant to illustrate the variation and depth of the field and to illustrate reasons why it is so hard to provide definitions to the various terms used to describe this research (Ethnobiology Working Group, 2003). I concentrate on plants (my own area of expertise) but with a full realisation of the importance of animals. For the purposes of this chapter, ethnobiological disciplines are grouped into: 1) folk classification; 2) archaeology; 3) conservation; 4) cultural anthropology and ethnography; 5) ecology; 6) geography; 7) medicinal plants and natural products research; 8) nutrition; 9) social policy; 10) sustainable development; 11) taxonomy and systematics; 12) crop evolution and domestication; 13) genetic diversity; and 14) germplasm collection and access. The chapter also includes a short synopsis of the major societies engaged in ethnobiological research, their mission, and publications.

## FOLK CLASSIFICATION

Folk systematics is concerned with general principles underlying indigenous classification, naming and identification of living things, and investigates indigenous knowledge of the natural world (Berlin, 1973, 1992; Chapter 15). Pioneering studies in this field were conducted by Berlin et al. (1966) in Tzetal-speaking communities of Chiapas Mexico. Their classification included six mutually exclusive ethnobiological ranks (kingdom, life-form, intermediate, generic, specific, varietal), roughly comparable to scientific taxa. Folk classification is based primarily on morphological (as opposed to functional) traits, and frequently recognises taxa that are very similar to those in modern classification systems, at least at the most basic 'generic' and 'specific' ranks; less so at 'lifeform' rank, where categories such as 'tree', 'bush' and 'vine' cross biological taxonomic boundaries (Brown, 1984; Turner, 1997). Newmaster et al. (2006) list additional indigenous classification criteria that encompass linguistic, hierarchal, utilitarian, ecological, spiritual, behavioural and sensory perceptions. Plants that are of cultural importance are often classified in more detail than those without such importance (Berlin, 1973, 1992). Atran (1998) interprets the cross-cultural similarity of folk and modern taxonomic systems as being the result an autonomous, natural classification scheme of the human mind, which does not depend directly on an elaborated formal or folk theory. Studies of folk classification systems are now frequently part of more comprehensive ethnobiological studies of individual plants (Casas et al., 1997) or of the harvesting of food in individual indigenous communities (Turner, 1987). Studies of folk classification have been extended to animals (Hays, 1983), bryophytes (Harris, 2008) and fungi (Lampman, 2007). These and other publications engendered considerable evaluation of folk classification, mostly supporting the ideas of Berlin and colleagues (Hays, 1983). Biocultural collections such as herbarium vouchers and zooarchaeological specimens are important resources that aid and document this research.

## ARCHAEOLOGY

Plant remains from archaeological sites have long provided primary data and ethnobiological specimens for investigating such questions as the origins of agriculture, diet, land-use practices, trade in plant products, forager behaviour and agricultural economies (Chapter 5). Charred seeds are almost always assumed to have resulted from human activity, but uncharred seeds could have been introduced into archaeological contexts by a variety of mechanisms that could have introduced false data. Miller (1989) provides a set of methods to assess whether uncharred seeds should be ascribed to various archaeological sites.

Coprolites are pieces of desiccated or mineralised faeces that typically contain a variety of macroscopic remains (such as seeds, leaves, other plant remains, feathers, bones, shell fragments, animal scales and insects), as well as microscopic remains (such as pollen, spores, phytoliths and intestinal parasites). The identification of these remains in interrelated data sets is useful for reconstructing the diets and lifestyles of peoples, and for building a picture of the pathogens that affected prehistoric health. Reinhard and Bryant (1992) examined the types of data that can be recovered from human coprolites, list methods of analysis, and evaluate the interpretive value of such data. Berg (2002) describes a related technique of examining remains of the abdominal contents of human remains from Denmark from AD 1100 to 1250 and from Arizona from AD 1250 to 1350. Most remains that helped to reconstruct diets were pollen and seeds.

Human societies alter the environment in various ways; for example, through fire, land clearing for agriculture and the introduction of exotic species. The effects can be devastating; for example, in North America, some 35 genera of primarily large mammals became extinct toward the end of the Pleistocene (ending about 10,500 years ago). There are various hypotheses for the cause of historical extinctions and habitat alterations, especially those that involve small indigenous groups, ranging from overhunting to climate change. Applying the principles of behavioural ecology and optimal foraging theory, Grayson (2001) asked whether there is widespread evidence from the archaeological past that modern peoples, organised into small-scale societies, have caused habitat degradation, including resource depletion and species loss. He documents the overuse of resources among foragers and other small-scale societies.

Hayashida (2005) documented a variety of historical land-use practices (burning, grazing and cultivating) that shifted vegetation composition and succession and that sometimes resulted in overexploitation, degradation and extinctions. She also documented instances of practices that maintained, increased or protected plant resources, resulting in long-term, sustainable harvests and the creation of patches of certain species, fire-adapted forests, or grasslands and other open habitats. She argued that archaeologists have much to contribute to debates about land-use practices, and cautions that archaeological data can be misinterpreted to justify poor practices.

## CONSERVATION

Local knowledge (Chapter 12) can also facilitate conservation research (Chapter 23) and is often supported by and documented alongside biocultural collections. For example, female cones of *Dioon mejiae* (tiusinte), an edible arborescent cycad, are harvested for their seeds. These are used to make tamales, tortillas and other products that supplement maize-bean diets for an estimated 33,000 indigenous and mestizo Hondurans. Populations of this species form common property but are being destroyed by timber extraction, pastoralism and swidden agriculture. Bonta et al. (2006) use ethnographic interviews to document and describe traditional tiusinte protection schemes that are

important for the preservation of *D. mejiae*. The species is protected at a local level because tiusintes are worth more uncut, and their presence does not harm anyone.

Orlove & Brush (1996) provided a review of the relationship between anthropology and the conservation of protected areas and crop genetic resources. They showed that strategies for managing protected areas and for conserving crop genetic resources have evolved in similar ways, with a focus on different scales from individual species to habitats and ecosystems. They observed that the North American model of uninhabited national parks does not work for areas that are inhabited by indigenous people, and that people need to be brought into management schemes. They argued that history shows that the presence of indigenous residents largely resulted in stable ecology, because of the rich ecological knowledge and management practices of native peoples, often integrated with religious beliefs and rituals that support conservation practices.

Edible insects provide food to many ethnic groups in Mexico, but in a study site in Hidalgo, Mexico, some of the insects became overexploited because of increased consumption, human population growth and large demand for these insects from many restaurants in Mexico and in other countries. Ramos-Elorduy (2006) studied insects as food in this area and documented 30 species that were eaten. A decrease in the population of several species was caused by overexploitation by non-qualified, non-local people. Ramos-Elorduy discusses some pragmatic measures that could be implemented in order to avoid the extinction of edible insect species; such measures include the introduction of protected reserves, education programmes and the cultivation of the most desirable insects.

Wyllie-Echeverria et al. (2000) documented global threats to seagrass communities caused by a variety of forces, including habitat loss, pollution, disease and recreational boating. One such seagrass, *Zostera marina* (eel-grass), has a circumpolar northern hemispheric distribution. This species is gathered for insulation, bedding, green mulch and the rhizomes for food. Wyllie-Echeverria et al. caution against ignoring or violating local cultures when attempting conservation measures. They point out that ethnobotanical interviews can aid the conservation of species by informing ethnobotanists of the local distribution, biology and use of a species, as well as by making local people more aware of the global importance and potential threats to certain species.

## CULTURAL ANTHROPOLOGY AND ETHNOGRAPHY

Ethnography is the scientific description of the customs of peoples and cultures (Chapter 12), whereas cultural anthropology is the branch of anthropology that deals with the origins, history and development of human culture. These fields often use biocultural collections to document studies. Crivos et al. (2007) studied processes of spatial mobility among the Mbya-Guaraní, indigenous peoples inhabiting the Paranaense rainforest of north-western Argentina. They indicated that these mobility patterns are important in understanding transformations in the landscape. By direct observation and interviews, these authors studied the local medicinal plants used for the treatment of gastrointestinal illnesses and the pathways used to forage for them. They found that the most frequently used medicinal plants were harvested from areas adjacent to the dwellings, and concluded that as the use of these plants increases, so does the process of planting and growing these plants close at hand, which constantly configures and reconfigures the environment of the Mbya.

Groark (1996) observed, through literature surveys, that seven indigenous communities in south-central California ate red harvester ants (genus *Pogonomyrmex*) (myrmecophagy) during rituals to induce hallucinogenic states; they also used 'toloache' (*Datura wrightii*) and tobacco (*Nicotiana* spp.) similarly. Large quantities of ants are ingested live to induce visions and to evoke 'supernatural' assistance in the form of a 'dream helper'. The ants were also ingested and used externally to treat

illnesses such as paralysis, pain and various gynaecological disorders. The ingestion induces a catatonic near-death state and is thought by people in these communities to help them communicate with dead relatives through visions, gain insight, gain shamanistic powers to heal others and improve behaviour; it is also often used as 'preventative medicine.' This research was supported by taxonomic and toxicological data derived from biocultural collections of *Pogonomyrmex*.

## ECOLOGY

Aswani & Vaccaro (2008) integrated indigenous knowledge with standard research methods to perform a 'socioecological analysis' of Roviana Lagoon in the Western Solomon Islands. These authors summarised the importance of mapping benthic environments and stated that the indigenous participants in this process were able to help by systematically articulating local cultural knowledge and ecological values. They used open-ended and structured interviews of more than 200 indigenous people over a period of 14 years to determine different ecological zones, the species inhabiting these zones, seasonal variations in the availability of these species, seasonal events such as spawning, environmental conditions affecting the habitat and fauna, and human uses of each habitat and its species. The result was a detailed ecological description of the lagoon and its local use. Aswani & Vaccaro claim that their procedures are reliable, cost-effective and provide scientific information, while at the same time enhancing local participation in community-based conservation efforts.

Begossi & Silvano (2008) similarly integrated local knowledge and standard research methods to study the biology and ecology of the commercially important fish dusky grouper (garoupa, *Epinephelus marginatus*). This fish is an important catch for small-scale fisheries along the Brazilian coast, but it is vulnerable to overharvesting. Management plans were hindered by lack of information on dusky grouper biology and ecology. The authors combined data from fish catches, analysis of stomach contents, macroscopic analyses of gonad maturation, and interviews of fishermen from six small communities along the Brazilian coast. Local fisherman were interviewed over a two-year period about the identification, nomenclature, diet, habitat, spawning season, migration and bait used for dusky grouper. They concluded that their research approach was a cost-effective and feasible means of obtaining information about the fishery and biology of a threatened and commercially important reef fish species.

Horstman & Wightman (2001) provided a perspective on the application of Aboriginal knowledge to ecological management in the Kimberley in north-western Australia. They indicated that Aboriginal peoples are often rendered invisible or overlooked in ecological research in Australia, despite their generations of knowledge that can improve ecological assessments. These authors described a 'karparti' research approach to ecological assessments, which roughly translates to non-structured interviews using non-hurried respectful methods that allow the Aboriginal peoples to choose study sites. Such methods increase the motivation of local informants, generate additional data, and produce sustainable management plans that are integrated with local culture.

The raw data from the types of studies described above must be carefully curated if it is to be available to both scientists and indigenous peoples in the future.

## GEOGRAPHY

As outlined by Zimmerer (2001), there are many connections between geography and ethnobiology, including geographical meanings, environmental change, proliferation of landscape-based issues involving indigenous rights (concerning politics, territorial rights and intellectual property), plant and animal domestication, environmental justice, and the innovation and diffusion of local or indigenous

knowledge systems. He uses the term 'ethnolandscape ecology' to encompass the synthesis of geography and ethnobiology, and to include the analysis of cultural environmental knowledge in relation to humanised landscapes that are often highly politicised. Zimmerer's paper provides a scholarly analysis and many examples of such syntheses.

At the time of Zimmerer's review, geographical information systems (GIS) were in their early stages of development. Today, they are a highly developed field that associates georeferenced data with a wide range of environmental and political data and then can be used to analyse these associations. Data can be curated within the GIS programme. Additionally, all the materials used in such research – GIS records, photographs, and land-use maps derived from participatory rural appraisal techniques – are valuable biocultural collections that can be preserved for future research and reference.

Salick et al. (1997) used GIS, field collections, morphological analyses, and semistructured interviews with the Amuesha of the Peruvian Upper Amazon to analyse cassava (*Manihot esculenta*) diversity, thereby aiding the characterisation and conservation of the hundreds of cultivars of this important crop plant. They found that diversity was associated with elevation and topography but less with soil texture, pests or diseases.

Salick et al. (2005) again used GIS, repeat photography, and 'participatory rural appraisal' to associate land use near Mt Khawa Karpo, Northwest Yunnan, China, with indigenous Tibetan forest management, gathering, pastoralism and agriculture. They found that households at higher elevations cultivated more farmland, a greater diversity of major crops, a higher percentage of traditional crops, and fewer cash crops than those in lower elevations, and that villages with roads grow significantly more cash crops.

Gorman et al. (2008) studied the distribution and relative abundance of *Cycas angulata* and *Brachychiton diversifolius* in the Maningrida region of Central Arnhem Land, Northern Territory, Australia with GIS. These species are currently being harvested in the wild for commercial sale as decorative plants and carving wood, respectively. The use of GIS tools in this region was very useful because of its vast natural landscapes, few towns and difficult access, and because of the limited funds and infrastructure available to the Aboriginal resource centres and communities. The study compared predicted distributions to the actual distributions of a sample, which involved seven days of effort for each species. The predictive ability of the model for *C. arnhemica* was classified as moderate and for *B. diversifolius* as fair. The output predicts trends in species distribution that are consistent with independent on-site sampling for each species, but the models tend to over-predict presence. The results show that GIS and environmental modelling are useful for predicting the distribution of species that may be of interest to Australian indigenous groups wanting to engage in sustainable utilisation of their plants for commercial purposes, and can be useful for monitoring management impacts.

## MEDICINAL PLANTS AND NATURAL PRODUCTS RESEARCH

70–80 percent of the population in the developing world depends on medicinal plants for primary health care (Calvet-Mir et al., 2008). Preserving medicinal plants as biocultural collections of various types (herbarium specimens, DNA and so on) conserves their genetic diversity, documents their morphological diversity, and enables medicinal plant research (Chapter 22).

Many studies have included broad field surveys of medicinal plants. For example, Bussmann & Glenn (2011) surveyed 96 plant species used as anti-infective herbal remedies in northern Peru, recording their taxonomy and the plant parts and species mixtures used as medicines, as well as their mode of application or ingestion. Similarly, York et al. (2011) documented the taxonomy, plant parts, mixtures, and mode of application of 30 plant species used by the rural people in South Africa to

treat respiratory infections. Duke & Vasquez (1994) present concise accounts of the various uses of over 1,000 species of Amazonian plants by indigenous people, including plant materials that are used as food and fodder, medicines, artefacts, pesticides and ornamentals, as well as in house construction, with an index to scientific names and Spanish and English names.

Van der Geest & Hardon (2006) documented how the social and cultural effects of pharmaceuticals (non-medical effects) deeply influence the medical outcome of treatment with traditional remedies. Calvet-Mir et al. (2008) studied the perceptions of local indigenous people in lowland tropical Bolivia of traditional and 'Western' medicines used to treat gastrointestinal ailments. They found that these people conceptualise local and Western medicine as two independent domains of knowledge, although they use both in their daily practice and regard Western medicine as having qualities of power, trust and effectiveness. Vandebroek et al. (2008) demonstrated that the treatment offered by traditional medicine overlaps with biomedical health care in many conditions, and that traditional health care appears to be complementary to 'modern' (biomedical) health care for chronic illnesses, especially arthritis, and for folk illnesses that are particularly relevant within the local cultural context.

Other studies have used laboratory methods to evaluate the efficacy of medicinal plants used in traditional healing. For example, Babu et al. (2011) tested, through animal models, the active crude extract of *Clerodendrum phlomidis*, which is used to treat several inflammatory diseases and arthritis in Indian traditional systems and folk medicine. They found that extracts of this species displayed considerable potency in anti-inflammatory action and has a prominent anti-arthritic effect on induced arthritis. Other studies have tested extracts of plants for efficacy in treating various classes of disease. Caamal-Fuentes et al. (2011) investigated the cytotoxic activity of 51 plants purported in the literature of Mayan ethnobotany to treat cancer-like symptoms, using *in vitro* cancer cell lines. They found two plant materials, *Aeschynomene fascicularis* root bark extract and *Bonellia macrocarpa* stem and root bark extracts, that showed promise as anti-cancer plants and chose them for further analyses.

All studies on medicinal ethnobotany need to deposit voucher specimens to verify the species being investigated (Chapters 3, 22). Certain institutions have a long history of research on natural products (Chapters 4, 20). The Forest Products Laboratory in Madison, Wisconsin has long been an international leader in research into natural wood products (Chapter 9). This laboratory was founded in 1910 and its early research priorities focused on timber testing, wood preservation, wood-based distillates, wood technology (timber physics), pulp and paper, and wood chemistry. Throughout its 100-year history, the Forest Products Laboratory has stated approximately 264 broad research and project goals. These goals fall into the following eight general categories: 1) development of basic knowledge of wood and its use; 2) improvement of wood processing to increase yield and quality while reducing costs and waste; 3) extending the service life of wood products; 4) utilising various wood species and studying the qualities of wood; 5) improvement of the quality and usefulness of wood products; 6) development of new products from wood; 7) development of basic knowledge of the biological aspects of wood; and 8) transfer of research findings nationally and internationally. The forest products laboratory currently houses 100,000 wood specimens representing about 18,000 tree species from every corner of the globe — the largest collection of its kind (Spartz, 2009).

## NUTRITION

Many early ethnobotanical surveys provided extensive lists of foods used by indigenous peoples, sometimes with voucher specimens deposited in collections to verify the identity of the source plants, but knowledge of the nutritive value of these foods was poorly understood. However, Kuhnlen & Turner (1996) provided a species list of more than 1,000 traditional native foods used by Canadian

indigenous peoples with botanical descriptions, distributions, uses, native harvest methods and food uses of related species, and with nutritional tables for more than half of the foods. They evaluated the accuracy of their data using various criteria, including publication in the peer-reviewed literature, statement of methods of analysis that were current and reliable, and by using moisture bases so that their data could be standardised.

Ogle et al. (2003) assessed the multiple functions — including human food, animal feed and human medicines — of edible wild plants in Mekong Delta and the Central Highlands of Vietnam. They documented that approximately one-third of the 90 foods they assessed were concurrently used as medicines, termed 'medicinal foods', 'functional foods', or 'nutraceuticals'. The biocultural materials they collected include qualitative lists of known species of natural vegetables, documentation of local wild food plant uses, farmer interviews including drawn maps of farming systems, and herbarium specimens for scientific identification of species.

Sundriyal & Sundriyal (2001) provided nutritive values for 27 of the most commonly consumed wild edible plants in the Sikkim Himalaya. They documented them to be good sources of protein, fat, vitamins, sugars and minerals, and showed that their nutritive values are comparable to those of various commercial fruits. Furthermore, they suggested that the use of these wild plants can complement the nutritive food packages distributed by the government for school children.

Wing & Brown (1979) provided detailed methodologies that can be used to reconstruct prehistoric diets, including the examination of skeletal remains and teeth.

## Social policy

The interplay between indigenous peoples, indigenous knowledge, food, biodiversity conservation, ecotourism, genetic resources, gender and many other interacting factors is imbued with a wide range of economic, legal, political, ethical and social policy implications. Reviews have explored these issues in the contexts of germplasm acquisition and use (Esquinas-Alcázar, 2005), land management and nature preservation (Brechin et al., 2003; Colchester, 2004), gender (Momsen, 2007) and traditional knowledge (Bannister et al., 2009). Two international treaties, the Convention on Biological Diversity (CBD) (Secretariat of the Convention on Biological Diversity, 2002) and the FAO International Treaty on Plant Genetic Resources (IT) address many of these issues, especially as regards plant genetic resources. Ethnobiologists are especially sensitive to these issues and the major scientific societies engaged in ethnobiological research have adopted codes of conduct that form essential guideposts for ethical and effective research. Research agreements, permits, consent forms and so on must be curated along with the relevant specimens (Chapter 1).

Much of the literature on social policy presents broad overviews of issues that must be considered, whereas other studies comment on the policy implications of more focused studies. For example, Reyes-García et al. (2007) assessed the loss of local ecological knowledge and its economic consequences for indigenous Amazonian communities. Orthodox thinking in anthropology and economics predicts that local ecological knowledge will disappear with economic development, but the data differ in different sociological contexts and types of economic development. Reyes-García et al. (2007) associated their data with different types of economic activity carried out at different times of the year. They found that theoretical ethnobotanical knowledge and ethnobotanical skills were only weakly associated with more variation in ethnobotanical skills, that participation in wage labour is associated with fewer ethnobotanical skills, and that the sale of forest and farm products is associated with greater ethnobotanical skills and with greater theoretical ethnobotanical knowledge. They concluded that some forms of economic development can take place without eroding local

ecological knowledge if economic development takes place through activities that allow people to remain in their habitat and in their culture.

## Sustainable development

Bennett (1992) argued that preserving the Amazonian rainforests requires its indigenous inhabitants and their knowledge. He pointed out that, unlike modern temperate ecosystems, Amazonian ecosystems often have little distinction between cultivated species and wild species, or a clear boundary between fields and fallows or between fallows and forests. Many tropical ecosystems that are usually considered to be 'natural' may have been profoundly altered by indigenous populations in the past, and humans were and continue to be an integral part of these ecosystems. Rainforest cultures are, however, disappearing even more rapidly than the forests. Bennett argues that economic systems that integrate indigenous products and processes with sound ecological management can help protect Amazonian rainforests.

Sillitoe (1998, 2006) argued that indigenous people, working in concert with scientists, have much to contribute to development. Berkes et al. (2000) made a similar case, pointing out through literature surveys that there is a tremendous diversity of local knowledge on managing ecosystems. They argued that local knowledge provides more informed, flexible, and adaptive 'qualitative' approaches to resource management that are informed by ecological interactions, in contrast to 'quantitative' management by outsiders that is based more on static practices of maximising yields.

North-eastern India is considered to be one of the most bioculturally diverse regions of India, containing diverse communities, traditional agriculture, governance of resources through indigenous institutions, a high degree of forest dependency, and the use of ethnic foods and medicines. Singh et al. (2010) studied the traditional knowledge of diverse communities in north-eastern India, grouping people by age and gender and assessing knowledge of agricultural practices, foods, health and nutrition, and biodiversity. They found that local people and their indigenous institutions, and particularly women, were rarely recognised or consulted when policy is formulated. They concluded that traditional knowledge offers solutions to the challenges of providing food, nutrition and medicines and sustaining the livelihoods of local communities.

Stepp (2000) reported that the Tzeltal and Tzotzil Maya, who in 1990 numbered approximately 800,000 people in upland Chiapas Mexico, have an elaborate knowledge system and many modes of interacting with their environment. Their landscape today is a mosaic of different ecological zones that were determined by human activities, and they utilise the entire landscape in one form or another. Earlier work by Berlin & Berlin (1996) documented a basic list of medicinal plants that are important for the indigenous Mayans in upland Chiapas. Stepp (2000) describes a project by The Maya International Cooperative Biodiversity Group, a research and development initiative involving more than 30 researchers from three countries, which developed medicinal gardens in upland Chiapas with the aim of supporting traditional indigenous health and conserving local biodiversity (see also Chapter 24, Box 'Sacred seeds — a global network of living useful plants collections').

## TAXONOMY AND SYSTEMATICS

Taxonomy is the theory and practice of describing, naming and classifying organisms. Systematics is a related term, sometimes used synonymously, that involves a broader discipline of discovering phylogenetic relationships through modern experimental methods using comparative anatomy, cytogenetics, ecology, morphology and molecular or other data (Spooner et al., 2003). Ethnobiologists rely on systematists to provide stable classifications for identification and communication, to provide stable names that maintain continuity of the literature, to construct predictive classifications, and to

construct a useful framework that can be used to understand phylogenetic relationships. To achieve these aims, it is imperative that biological specimens be properly curated (Chapters 3 and 22).

A clear illustration of the need for accurate taxonomic identifications was provided by Łuczaj (2010), who estimated the percentage of erroneously identified plant taxa in ethnographic studies. He sampled 45 published sources of Polish-language ethnobotanical literature from the period 1874–2005 and determined that at least 2.3% of taxa in the publications were identified erroneously. The mean misidentification rate was 6.2% per publication, with half of these mistakes being generic misidentifications. As many as 10.0% of voucher specimens (on average 9.2% per collection) were originally erroneously identified, but three-quarters of the identification mistakes remained within the genus rank. Łuczaj suggested a need for the rigorous use of voucher specimens in ethnobotany and greater cooperation between ethnographers and botanists.

Often, the taxonomy of a group must be clarified to place elements of an ethnobiology study into proper context (e.g. Van Beek et al., 1984; Van Wyk & Albrecht, 2008). The clarification of nomenclature is especially important for crop plants (e.g. maize, potato, sorghum, and wheat) which often have recently evolved, which hybridise with related wild and cultivated species, and which exhibit a taxonomically confusing suite of morphological characters that can result in over-description and conflicting taxonomies among different authors (Harlan & de Wet, 1971). For example, past taxonomic treatments of wild and cultivated potatoes differed tremendously among authors with regard to both the number of accepted species and hypotheses of their interrelationships. Ovchinnikova et al. (2011) summarised the many conflicting classifications of cultivated potatoes and placed 626 epithets into synonymy with the four cultivated species previously delimited by a range of morphological and molecular studies (Spooner et al., 2007). This kind of research depends on extensive herbarium collections (Chapters 3, 22).

## CROP EVOLUTION AND DOMESTICATION

Clarifying patterns of domestication provides data that can have far-ranging implications for applied studies. Spooner et al. (2005) determined, in contrast to all prior hypotheses, that landrace populations of potato had a single origin from a group of wild potatoes in southern Peru. Ames & Spooner (2008), using DNA sequence data from historical herbarium specimens, provided the first direct evidence that long-day-adapted Chilean potato landraces, not short-day-adapted Andean landraces as had long been assumed, formed the basis of modern varieties of cultivated potato. Ghislain et al. (2009) showed that a group of germplasm putatively selected from short-day-adapted Andean landraces ('Neo-Tuberosum' clones) was from long-day-adapted Chilean landraces. These combined results reformulate long-standing hypotheses of cultivated potato evolution and have implications for breeding programmes and phylogenetic reconstructions of potato. The single origin of potato matches that of some other crops, such as rice (*Oryza sativa*), which recent evidence suggests has a single origin in China from *O. rufipogon* (Molina et al., 2011). Prior hypotheses had suggested two domestications: one for *O. sativa* subsp. *indica* within a region south of the Himalaya mountain range, and a second for *O. sativa* subsp. *japonica* in southern China. Other crops, such as common bean (*Phaseolus vulgaris*) have two or more areas of origin (Sonnate et al., 1994).

### Genetic diversity

Studies of genetic diversity have a variety of applications in ethnobiology. Jianchu et al. (2001) studied 20 landrace cultivars of taro (*Colocasia esculenta*) in five ethnic communities and Han farming villages in diverse ecosystems in Yunnan Province, China. They documented a new type of flowering taro

cultivated for its edible flower, and grouped the landraces into five major morphotypes according to ethnobotanical, agro-morphological, and random amplified polymorphic DNA (RAPD) and isozyme data. Folk taxonomy and crop uses tended to confirm the five morphotypes, which they suggested would be useful in monitoring potential genetic erosion.

Nuijten & van Treuren (2007) studied morphological and molecular (amplified fragment length polymorphism (AFLP)) variation in upland rice (*Oryza sativa*) and late millet (*Pennisetum glaucum*) from The Gambia to obtain insight into the level of genetic diversity among seeds planted in several villages. The variety names suggested that different rice and millet varieties were used in different villages, but the study revealed that there was a large overlap in the genetic diversity of both rice and millet seed, which was masked by the use of synonyms. The authors attributed this overlap to the exchange of varieties between farmers. For millet, this probably resulted from the development of varieties from the same gene pool, but the genetic overlap in some varieties of rice resulted from apparent hybrids between the *O. sativa* and *O. glaberrima* species. In general, farmer varieties displayed more genetic diversity than formal varieties.

Theory and observation indicated that genetic heterogeneity provides greater disease suppression when diverse crops are grown over large areas. Zhu et al. (2000) planted genetically diverse rice crops in different rice fields and assessed disease resistance in comparison with control plots of monocultured crops. Disease-susceptible rice varieties that were planted in mixtures with resistant varieties had 89% greater yield and rice blast was 94% less severe than when they were grown in monoculture. The experiment was so successful that fungicidal sprays were no longer applied by the end of the two-year programme, supporting the view that intraspecific crop diversification provides an ecological approach to disease control.

## GERMPLASM COLLECTIONS AND ACCESS

Many ethnobiology studies have been aided by the ready availability of germplasm collections (Chapter 8). A worldwide system of national and international genebanks maintains genetic resources collections. The State of the World Report (FAO, 2010) documents 7.4 million *ex situ* germplasm accessions held world-wide in more than 1,750 individual genebanks, about 130 of which hold more than 10,000 accessions each. After accounting for exchange and duplication, however, it is estimated that less than 30% of the total number of accessions are distinct (FAO, 2010). The System-wide Information Network for Genetic Resources (SINGER) is the germplasm information exchange network of the Consultative Group on International Agricultural Research (CGIAR) and its 12 partners. Together, the members of SINGER hold more than half a million samples of crop, forage and tree in their germplasm collections.

Efforts are being made to construct a single access portal to worldwide germplasm collections. In 2011, GENESYS was launched as a portal that combines access to data from SINGER, the European Plant Genetic Resources Search Catalogue, and the Genetic Resources Information Network of the US Department of Agriculture. Currently, these holdings account for about one third of the *ex situ* genetic resources collections worldwide, and the system is expanding. Access to some of the national and international collections has been restricted in recent years and is the focus of continuing discussion (Bretting, 2007).

The US National Plant Germplasm System (NPGS) is a network of genebanks that curate, propagate, analyse and distribute germplasm for scientific use internationally. It maintains 541,000 samples (or accessions) of seeds, tissues and whole plants. The collections are kept at more than 20 Agricultural Research Service genebanks, many of which receive additional support from universities and state

agricultural experiment stations. Each year, researchers conduct about 15 expeditions, coordinated by the Plant Exchange Office, USDA/ARS National Germplasm Resources Laboratory, Beltsville, Maryland, to search for a range of crops and crop relatives with unique traits, such as drought tolerance and pest or pathogen resistance. Foreign explorations are conducted in collaboration with institutions in host countries. The NPGS is one of the most extensive collections of crop diversity worldwide and shares the materials free of charge with researchers and educators around the world. NPGS mailed 183,000 samples to users in the USA and more than 75 other countries in 2008 (O'Brien, 2010). The collections are used for a wide range of basic and applied research, including crop improvement, and supporting disciplines such as systematics, plant pathology, entomology and physiology.

## USE OF BIOCULTURAL COLLECTIONS

Biocultural collections are plants and animals used by people, products made from them, and/or information and archives about them (Chapter 1). As a result, these collections are numerous and diverse. All of the 14 classes of biocultural research briefly reviewed above make use of many of the collection types outlined in Chapter 1. For example, while herbarium specimens are primarily used in the research fields of taxonomy and systematics, crop evolution and domestication, and genetic diversity, their use as voucher specimens has been advocated in almost all biocultural studies (Łuczaj, 2010; Chapter 22) (see taxonomy and systematics section above). Taxonomy and systematics often make use of not just of herbarium specimens, but also of plant and animal extracts, unprocessed economically useful plant and animal parts, DNA collections, live collections *in situ* and *ex situ*, botanical and zoological reference collections, and documentation libraries and archives. Similar listings of many classes of collections could be used for many of the disciplines listed above, highlighting the need for close attention (and funding) to be given to collections management in general. Some collection types, such as germplasm collections, are in an advanced state of development because they are funded by national and international organisations and have direct economic uses.

## SOCIETIES ENGAGED IN ETHNOBIOLOGICAL RESEARCH

Following are some of the major societies engaged in ethnobiological research, their mission and their publications. Many additional societies are specific to individual countries, and other larger societies have sections that are especially relevant to ethnobiology, for example, the Economic Botany Section of the Botanical Society of America.

• **American Anthropological Association** advances anthropology as the science that studies humankind in all its aspects, through archaeological, biological, ethnological and linguistic research. It furthers the professional interests of American anthropologists, disseminating anthropological knowledge and its use to solve human problems. Its primary journal, *American Anthropologist*, seeks to add to, integrate, synthesise, and interpret anthropological knowledge. It publishes commentaries and essays on issues of importance to the discipline, as well as reviews of books, films, sound recordings and exhibits. Through 'AnthroSource', an online portal serving the research, teaching and practicing needs of anthropologists, the association distributes 19 other journals related to anthropology.

• **American Society of Pharmacognosy** is dedicated to the promotion, growth and development of pharmacognosy and all aspects of those sciences related to and dealing in natural products. It publishes the *Journal of Natural Products*, which is devoted to the study of the physical, chemical, biochemical and biological properties of drugs, drug substances, or potential drugs and drug substances of natural origin, as well as the search for new drugs from natural sources. Research in pharmacognosy

includes studies in the areas of phytochemistry, microbial chemistry, biosynthesis, biotransformation, chemotaxonomy, and other biological and chemical sciences.

• **International Society for Ethnopharmacology** is a collaborative, interdisciplinary group of scientists, anthropologists, pharmacists, pharmacologists, ethnobotanists, phytochemists and others who are interested in the study of the global use of medicines. They are particularly interested in understanding the medicinal uses of plants in traditional societies, and in seeking to understand the cultural and pharmacological dimensions of human medicinal plant use. The society publishes *Journal of Ethnopharmacology*, which is concerned with the observation and experimental investigation of the biological activities of plant and animal substances used in the traditional medicine of past and present cultures. It also publishes interdisciplinary papers with an ethnopharmacological, an ethnobotanical or an ethnochemical approach to the study of indigenous drugs.

• **International Society of Ethnobiology** is committed to achieving a greater understanding of the complex relationships, both past and present, that exist within and between human societies and their environments. It endeavours to promote a harmonious existence between humankind and the biosphere for the benefit of future generations. It publishes *ISE Newsletter*.

• **Society for Economic Botany** fosters and encourages scientific research, education, and related activities on the past, present and future uses of plants, and on the relationship between plants and people. It makes the results of such research available to the scientific community and the general public through meetings and publications. It publishes *Economic Botany*, which is concerned with a wide range of topics dealing with the utilisation of plants by people. *Economic Botany* specialises in scientific articles on the botany, history, and evolution of useful plants and their modes of use. It also includes special reports, letters and book reviews.

• **Society of Ethnobiology** is dedicated to the interdisciplinary study of the relationships of plants and animals with human cultures worldwide, including past and present relationships between peoples and the environment. Its interests encompass ethnobotany, ethnozoology, linguistics, palaeoethnobotany, zooarchaeology, ethnoecology and other related areas in anthropology and biology. It publishes the *Journal of Ethnobiology*, which focuses on all areas of ethnobiology. Topics include palaeoethnobotany, zooarchaeology, ethnobotany, ethnozoology, ethnoecology, linguistic ethnobiology and other related areas in anthropology and biology. The society also publishes *Contributions in Ethnobiology*, a digital monograph series that presents original book-length research in any area of ethnobiology, and *Ethnobiology Letters*, an online journal that publishes short communications including research communications, perspectives, books reviews, and notes on data, methods and taxonomies.

## Websites

*American Anthropological Association*. www.aaanet.org

*American Society of Pharmacognosy*. www.phcog.org

*Botanical Society of America — Economic Botany Section*. www.botany.org/governance/sections.php

*GENESYS*. www.genesys-pgr.org

*International Society of Ethnobiology*. http://ethnobiology.net

*International Society for Ethnopharmacology*. www.ethnopharmacology.org

*Society for Economic Botany*. www.econbot.org

*Society of Ethnobiology*. www.ethnobiology.org

## Literature cited

Ames, M. & Spooner, D. M. (2008). DNA from herbarium specimens settles a controversy about origins of the European potato. *American Journal of Botany* 95: 252–257.

Aswani, S. & Vaccaro, I. (2008). Lagoon ecology and social strategies: habitat diversity and ethnobiology. *Human Ecology* 36: 325–341.

Atran, S. (1998). Folk biology and the anthropology of science: cognitive universals and cultural particulars. *Behavioral and Brain Sciences* 21: 547–609.

Babu, N. P., Pandikumar, P. & Ignacimuthu, S. (2011). Lysosomal membrane stabilization and anti-inflammatory activity of *Clerodendrum phlomidis* L.f., a traditional medicinal plant. *Journal of Ethnopharmacology* 135: 779–785.

Bannister, K., Solomon, M & Brunk, C. G. (2009). Appropriation of traditional knowledge: ethics in the context of ethnobiology. In: *The Ethics of Cultural Appropriation*, eds J. O. Young & C. G. Brunk, pp. 140–172. Blackwell Publishing Ltd., Malden.

Begossi, A. & Silvano, R. A. M. (2008). Ecology and ethnoecology of Dusky Grouper [garoupa, *Epinephelus marginatus* (Lowe, 1834)] along the coast of Brazil. *Journal of Ethnobiology and Ethnomedicine* 4: 20. www.ethnobiomed.com/content/4/1/20

Bennett, B. C. (1992). Plants and people of the Amazonian rainforests: the role of ethnobotany in sustainable development. *Bioscience* 42: 599–607.

Berg, G. E. (2002). Last meals: recovering abdominal contents from skeletonized remains. *Journal of Archaeological Science* 29: 1349–1365.

Berkes, F., Colding, J. & Folke, C. (2000). Rediscovery of traditional ecological knowledge as adaptive management. *Ecological Applications* 10: 1251–1262.

Berlin, B. (1973). Folk systematics in relation to biological classification and nomenclature. *Annual Review of Ecology and Systematics* 4: 259–271.

Berlin, B. (1992). *Ethnobiological Classification: Principles of Categorization of Plants and Animals in Traditional Societies*. Princeton University Press, Princeton.

Berlin, E. A. & Berlin, B. (1996). *Medical Ethnobiology of the Highland Maya of Chiapas, Mexico: The Gastrointestinal Diseases*. Princeton University Press, Princeton.

Berlin, B., Breedlove, D. E. & Raven, P. H. (1966). Folk taxonomies and biological classification. *Science* 154: 273–275.

Bonta, M., Flores Pinot, O., Graham, D., Haynes, J. & Sandoval, G. (2006). Ethnobotany and conservation of tiusinte (*Dioon mejiae* Standl. & L.O. Williams, Zamiaceae) in northeastern Honduras. *Journal of Ethnobiology* 26: 228–257.

Brechin, S., Wilshusen, P., Fortwangler, C. & West, P. (eds). (2003). *Contested Nature: Promoting International Biodiversity with Social Justice in the Twenty-first Century*. State University Press of New York, Albany.

Bretting, P. (2007). The U.S. National Plant Germplasm System in an era of shifting international norms for germplasm exchange. In: *XXVII International Horticultural Congress — IHC2006: II International Symposium on Plant Genetic Resources of Horticultural Crops*, Acta Horticulturae 760, ed. K. E. Hummer, pp. 55–60. International Society for Horticultural Science, Leuven.

Brown, C. R. (1984). Life-forms from the perspective of *Language and Living Things*: some doubts about the doubts. *American Ethnologist* 11: 589–593.

Bussmann, R. W. & Glenn, A. (2011). Medicinal plants used in northern Peru for the treatment of bacterial and fungal infections and inflammation symptoms. *Journal of Medicinal Plants Research* 5: 1297–1304.

Caamal-Fuentes, E., Torres-Tapia, L. W., Simá-Polanco, P., Peraza-Sánchez, S. R. & Moo-Puc, R. (2011). Screening of plants used in Mayan traditional medicine to treat cancer-like symptoms. *Journal of Ethnopharmacology* 135: 719–724.

Calvet-Mir, L., Reyes-García, V. & Tanner, S. (2008). Is there a divide between local medicinal knowledge and western medicine? A case study among native Amazonians in Bolivia. *Journal of Ethnobiology and Ethnomedicine* 4: 18. www.ethnobiomed.com/content/4/1/18

Casas, A., Pickersgill, B., Caballero, J. & Valiente-Banuet, A. (1997). Ethnobotany and domestication in Xoconochtli, *Stenocereus stellatus* (Cactaceae), in the Tehuacán Valley and La Mixteca Baja, Mexico. *Economic Botany* 51: 279–292.

Colchester, M. (2004). Conservation policy and indigenous peoples. *Environmental Science & Policy* 7: 145–153.

Crivos, M., Martínez, M. R., Pochettino, M. L., Remorini, C., Sy, A. & Teves, L. (2007). Pathways as 'Signatures in Landscape': towards an ethnography of mobility among the Mbya-Guaraní (Northeastern Argentina). *Journal of Ethnobiology and Ethnomedicine* 3: 2. www.ethnobiomed.com/content/3/1/2

Duke, J. & Rodolfo Vasquez, R. (1994). *Amazonian Ethnobotanical Dictionary*. CRC Press, Boca Raton.

Esquinas-Alcázar, J. (2005). Protecting crop genetic diversity for food security: political, ethical and technical challenges. *Nature Reviews Genetics* 6: 946–952.

Ethnobiology Working Group (2003). *Intellectual Imperatives in Ethnobiology: NSF Biocomplexity Workshop Report*. Missouri Botanical Garden, St. Louis. www.econbot.org/pdf/NSF_brochure.pdf

FAO. (2010). *The Second Report of the State of the World's Plant Genetic Resources for Food and Agriculture*. FAO, Rome.

Ghislain, M., Núñez, J., del Rosario Herrera, M. & Spooner, D. M. (2009). The single Andigenum origin of Neo-Tuberosum materials is not supported by microsatellite and plastid marker analyses. *Theoretical and Applied Genetics* 118: 963–969.

Gorman, J., Pearson, D., & Whitehead, P. (2008). Assisting Australian indigenous resource management and sustainable utilization of species through the use of GIS and environmental modeling techniques. *Journal of Environmental Management* 86: 104–113.

Grayson, D. K. (2001). The archaeological record of human impacts on animal populations. *Journal of World Prehistory* 15: 1–68.

Groark, K. P. (1996). Ritual and therapeutic use of 'hallucinogenic' harvester ants (*Pogonomyrmex*) in native South-central California. *Journal of Ethnobiology* 16: 1–29.

Harlan, J. R. & de Wet, J. M. J. (1971). Toward a rational classification of cultivated plants. *Taxon* 20: 509–517.

Harris, S. J. (2008). Ethnobryology: traditional uses and folk classification of bryophytes. *Bryologist* 111: 169–217.

Hayashida, F. M. (2005). Archaeology, ecological history, and conservation. *Annual Review of Anthropology* 34: 43–65.

Hays, T. (1983). Ndumba folk biology and general principles of ethnobotanical classification and nomenclature. *American Anthropologist* 85: 592–611.

Horstman, M. & Wightman, G. (2001). Karparti ecology: recognition of Aboriginal ecological knowledge and its application to management in north-western Australia. *Ecological Management & Restoration* 2: 99–109.

Jianchu, X., Yongping, Y., Yingdong, P., Ayad, W. G. & Eyzaguirre, P. B. (2001). Genetic diversity in taro (*Colocasia esculenta* Schott, Araceae) in China: an ethnobotanical and genetic approach. *Economic Botany* 55: 14–31.

Kuhnlen, H. V. & Turner, N. J. (1996). *Traditional Plant Foods of Canadian Indigenous Peoples: Nutrition, Botany*. Gordon and Breach, Amsterdam.

Lampman, A. M. (2007). General principles of ethnomycological classification among the Tzeltal Maya of Chiapas, Mexico. *Journal of Ethnobiology* 27: 11–27.

Łuczaj, Ł. J. (2010). Plant identification credibility in ethnobotany: a closer look at Polish ethnographic studies. *Journal of Ethnobiology and Ethnomedicine* 6: 36. www.ethnobiomed.com/content/6/1/36

Miller, N. F. (1989). What mean these seeds: a comparative approach to archaeological seed analysis. *Historical Archaeology* 23: 50–59.

Molina, J., Sikora, M., Garud, N. Flowers, J. M., Rubinstein, S., Reynolds, A., Huang, P., Jackson, S., Schaal, B. A., Bustamante, C. D., Boyko, A. R. & Purugganan, M. D. (2011). Molecular evidence for a single evolutionary origin of domesticated rice. *Proceedings of the National Academy of Sciences of the United States of America* 108: 8351–8356.

Momsen, J. H. (2007). Gender and agrobiodiversity: introduction to the special issue. *Singapore Journal of Tropical Geography* 28: 1–6.

Newmaster, S. G., Subramanyam, R., Ivanoff, R. F. & Balasubramaniam, N. C. (2006). Mechanisms of ethnobiological classifications. *Ethnobotany* 18: 4–26.

Nuijten, E. & van Treuren, R. (2007). Spatial and temporal dynamics in genetic diversity in upland rice and late millet (*Pennisetum glaucum* (L.) R. Br.) in The Gambia. *Genetic Resources and Crop Evolution* 54: 989–1009.

O'Brien, D. (2010). Plant germplasm: preserving diversity, insuring our future. *Agricultural Research* 58: 4–6.

Ogle, B. M., Tuyet, H. T., Tho, C., Duyet, H. N. & Dung, N. N. T. X. (2003). Food, feed or medicine: the multiple functions of edible wild plants in Vietnam. *Economic Botany* 57: 103–117.

Orlove, B. S. & Brush, S. B. (1996). Anthropology and the conservation of biodiversity. *Annual Review of Anthropology* 25: 329–352.

Ovchinnikova, A., Krylova, E., Gavrilenko, T., Smekalova, T., Zhuk, M., Knapp, S. & Spooner, D. M. (2011). Taxonomy of cultivated potatoes (*Solanum* section *Petota*: Solanaceae). *Botanical Journal of the Linnean Society* 165: 107–155.

Ramos-Elorduy, J. (2006). Threatened edible insects in Hidalgo, Mexico and some measures to

preserve them. *Journal of Ethnobiology and Ethnomedicine* 2: 51. www.ethnobiomed.com/content/2/1/51

Reinhard, K. J. & Bryant Jr., V. M. (1992). Coprolite analysis: a biological perspective on archaeology. In: *Archaeological Method and Theory*, Vol. 4, ed. M. B. Schiffer, pp. 245–288. University of Arizona Press, Tucson.

Reyes-García, V., Vadez, V., Huanca, T., Leonard, W. R. & McDade, T. (2007). Economic development and local ecological knowledge: a deadlock? Quantitative research from a native Amazonian society. *Human Ecology* 35: 371–377.

Salick, J., Cellinese, N. & Knapp, S. (1997). Indigenous diversity of cassava: generation, maintenance, use and loss among the Amuesha, Peruvian Upper Amazon. *Economic Botany* 51: 6–19.

Salick, J., Yongping, Y. & Amend, A. (2005). Tibetan land use and change near Khawa Karpo, Eastern Himalayas. *Economic Botany* 59: 312–325.

Secretariat of the Convention on Biological Diversity. (2002). *Bonn Guidelines on Access to Genetic Resources and Fair and Equitable Sharing of the Benefits Arising out of their Utilization*. Secretariat of the Convention on Biological Diversity, Montreal.

Sillitoe, P. (1998). The development of indigenous knowledge: a new applied anthropology. *Current Anthropology* 39: 223–252.

Sillitoe, P. (2006). Ethnobiology and applied anthropology: rapprochement of the academic with the practical. *Journal of the Royal Anthropological Institute* 12(S1): S119–S142.

Singh, R. K., Pretty, J. & Pilgrim, S. (2010). Traditional knowledge and biocultural diversity: learning from tribal communities for sustainable development in Northeast India. *Journal of Environmental Planning and Management* 53: 511–533.

Sonnate, G., Stockton, T., Nodari, R. O., Becerra Velásquez, V. L. & Gepts, P. (1994). Evolution of genetic diversity during the domestication of common bean (*Phaseolus vulgaris* L). *Theoretical and Applied Genetics* 89: 629–635.

Spartz, J. T. (2009). The U.S. Forest Service Forest Products Laboratory: 1910–2010, a century of research working for you. *Forest Products Journal* 59: 5–20.

Spooner, D. M., Hetterscheid, W. L. A., van den Berg, R. G. & Brandenburg, W. (2003). Plant nomenclature and taxonomy: an horticultural and agronomic perspective. *Horticultural Reviews* 28: 1–60.

Spooner, D. M., McLean, K., Ramsay, G., Waugh, R. & Bryan, G. J. (2005). A single domestication for potato based on multilocus AFLP genotyping. *Proceedings of the National Academy of Sciences of the United States of America* 102: 14694–14699.

Spooner, D. M., Núñez, J., Trujillo, G., del Rosario Herrera, M., Guzmán, F. & Ghislain, M. (2007). Extensive simple sequence repeat genotyping of potato landraces supports a major reevaluation of their gene pool structure and classification. *Proceedings of the National Academy of Sciences of the United States of America* 104: 19398–19403.

Stepp, J. R. (2000). Mountain ethnobiology and development in Highland Chiapas, Mexico. *Mountain Research and Development* 20: 218–219.

Sundriyal, M. & Sundriyal, R. C. (2001). Wild edible plants of the Sikkim Himalaya: nutritive values of selected species. *Economic Botany* 55: 377–390.

Turner, N. J. (1987). General plant categories in Thompson and Lillooet, two Interior Salish Languages of British Columbia. *Journal of Ethnobiology* 7: 55–82.

Turner, N. (1997). *Food Plants of Interior First Peoples*. UBC Press, Vancouver.

Van Beek, T. A., Verpoorte, R., Baerheim Svendsen, A., Leeuwenberg, A. J. M. & Bisset, N. G. (1984). *Tabernaemontana* L. (Apocynaceae): a review of its taxonomy, phytochemistry, ethnobotany and pharmacology. *Journal of Ethnopharmacology* 10: 1–156.

Van der Geest, S. & Hardon, A. (2006). Social and cultural efficacies of medicines: complications for antiretroviral therapy. *Journal of Ethnobiology and Ethnomedicine* 2: 48. www.ethnobiomed.com/content/2/1/48

Van Wyk, B. E. & Albrecht, C. (2008). A review of the taxonomy, ethnobotany, chemistry and pharmacology, of *Sutherlandia frutescens* (Fabaceae). *Journal of Ethnopharmacology* 119: 620–629.

Vandebroek, I., Thomas, E., Sanca, S., Van Damme, P., Van Puyvelde, L. & De Kimpe, N. (2008). Comparison of health conditions treated with traditional and biomedical health care in a Quechua community in rural Bolivia. *Journal of Ethnobiology and Ethnomedicine* 4: 1. www.ethnobiomed.com/content/4/1/1

Wing, E. S. & Brown, A. B. (1979). *Paleonutrition: Method and Theory in Prehistoric Foodways*. Academic Press, New York.

Wyllie-Echeverria, S., Arzel, P. & Cox, P. A. (2000). Seagrass conservation: lessons from ethnobotany. *Pacific Conservation Biology* 5: 329–335.

York, T., de Wet, H. & van Vuuren, S. F. (2011). Plants used for treating respiratory infections in rural Maputaland, KwaZulu-Natal, South Africa. *Journal of Ethnopharmacology* 135: 696–710.

Zhu, Y., Chen, H., Fan, J., Wang, Y., Li, Y., Chen, J., Fan, J., Yang, S., Hu, L., Leung, H., Mew, T. W., Teng, P. S., Wang, Z. & Mundt, C. C. (2000). Genetic diversity and disease control in rice. *Nature* 406: 718–722.

Zimmerer, K. S. (2001). Report on geography and the New Ethnobiology. *Geographical Review* 91: 725–734.

# Use of herbarium specimens in ethnobotany

MARK NESBITT

Royal Botanic Gardens, Kew

## INTRODUCTION

The herbarium — a collection of pressed plants mounted on paper — is central to the practice of ethnobotany, and to the use of all the other plant collections discussed in this book. Herbarium specimens both vouch for the identity of the plants being studied, and are themselves documents of plant use by people.

The accumulation of 500 years of plant collecting by botanists and travellers, herbaria are rich and underexploited sources of data about useful plants (useful in the broadest sense) and the human societies that use them. Not only do useful plants form a substantial proportion of plant species (even greater if crop wild relatives are taken into account; see Chapter 8) but they are also likely to be over-represented as specimens in herbaria, as many are widely used and thus abundant in local vegetation. Useful plants were also of particular interest to many collectors (Chapter 20). It is likely that half or more of the specimens housed in large herbaria are of plants of useful or symbolic value to humans; ethnobotany should therefore be central to the use and development of herbarium collections.

During the 20th century, herbarium botany moved away from its roots in physic gardens and applied botany, towards a focus on alpha taxonomy, the detection, description and classification of taxa. Many botanists had little interest in human relations with plants (Anderson, 1952). Perhaps not coincidentally, the late 20th century saw a crisis in natural collections, in which declines in funding coincided with a lack of confidence in the value of museum collections (Clifford et al., 1990). In response, natural history collections have encouraged more diverse uses and users of collections (Funk, 2003; Suarez & Tsutsui, 2004). The current climate is thus one in which ethnobotanists and herbaria have much to offer each other, well beyond the important field of voucher specimens.

In this chapter, I focus on special considerations related to ethnobotany: the importance of voucher specimens, and a wide-ranging exploration of the current and potential uses of herbaria for ethnobotany, expanding on coverage of this in Chapters 21 and 23. The creation, curation and management of herbaria is covered in Chapter 3.

## THE IMPORTANCE OF VOUCHER SPECIMENS

### Why voucher?

To properly document an ethnobotanical study, it is essential to collect quality vouchers in the form of herbarium specimens and to deposit them in a permanent collection where they will be available indefinitely to confirm the identity of the plant(s) under discussion. In some cases, the herbarium specimen itself is the only specimen collected, and it acts as a voucher for the associated ethnobotanical data contained in field notes; in other cases, the herbarium specimen also acts as a voucher for associated specimens such as woods, DNA or artefacts. In both cases, the herbarium specimen is the specimen that enables verifiable identification.

Voucher specimens perform three vital functions: they allow identifications to be made in the first instance; they allow identifications to be checked by subsequent researchers; and they allow work to be updated in the light of new taxonomic concepts. Why are these functions so important?

Most plants encountered in ethnobiological fieldwork will, of course, already have an identification in the form of a local vernacular name. In terms of the preservation of traditional knowledge and the recording of ethnotaxa, vernacular names are essential. Nevertheless, identification by of a species by botanical (Latin) name is also essential, because it also enables knowledge of the plant and its uses to be structured and understood by reference to the wider world of data about that plant: for example uses in other cultures, chemical and medicinal properties, and ecology and cultivation (Bennett & Balick, 2013). Botanical names are also, in principle, less prone to the ambiguity of vernacular names, which are often spelled in many different ways and may be used for more than one plant, as is the case for the wild and domesticated sesame species (Bedigian, 2004).

Reliable plant identification using the standard botanical tools of the flora and herbarium requires the presence of plant parts such as flowers and fruits that are often missing from ethnobotanical specimens, which may consist only of fibres or crude drugs. It is the function of the voucher specimen to provide these parts (Eisenman et al., 2012). It is sometimes assumed that accurate identifications can be made in the field, using handbooks or botanical expertise, but even well-known species can be confused with rare species that are similar in appearance. Field identifications will be uncertain for infraspecific taxa that can only be identified by morphological, chemical or DNA studies of preserved specimens. For example, the phytochemical composition of tarragon (*Artemisia dracunculus*) has been found to vary with ploidy level; similar infraspecific variation has been found in other medicinal plants (Eisenman et al., 2012).

Collection of a voucher specimen is an essential step towards identification, but there is no guarantee that this specimen will always be identified correctly. Even in temperate areas with well-known floras, genera such as *Astragalus*, *Rubus* and *Salix* are difficult for experienced botanists to identify to species level. Łuczaj (2010) revisited four collections of voucher specimens made in Poland between 1874 and 1975. Even in a country with a modest flora (3,000 species) and an exceptionally good botanical infrastructure, 10% of the 465 voucher specimens examined were found to be incorrectly identified. All of the herbarium studies discussed below reported errors in 20th century re-identifications of historic herbarium specimens. Of course, in cases where voucher specimens are not collected, it is impossible to detect these errors. Nesbitt et al. (2010) found that out of 50 recent papers on nutritional analyses of wild plants, only eight cited voucher specimens or genebank or nursery accession numbers. Of 502 plants analysed in the 50 papers, 27% were identified by botanical names that were grossly outdated, or misspelt. This is a strong hint that the underlying identifications are insecure. In most cases, however, they can never be checked because there are no voucher specimens.

Changes in taxonomic concepts may lead to the redefining of plant taxa, and result in changes in the ways that plants are identified. These changes affect both taxa common in well-studied areas and those from more diverse and less explored areas, such as the wet tropics. There are many examples affecting useful plants. In Australia, large genera of trees such as *Eucalyptus* and *Acacia* have seen the identification of many new species, usually involving the splitting of an existing species into two or more species (Barker, 2008). Without a voucher specimen, it is hard to assign a wood specimen from such a species to its new taxon. In North America, *Elymus caninus* (formerly *Agropyron caninum*) is one of many species in the Triticeae tribe of the grasses that has seen extensive changes in the 20th century, sometimes being recognised as a single species, sometimes as four (Barkworth & Jacobs, 2001). In genetics, voucher specimens have enabled the reinterpretation of the results of hybridisation experiments decades after

they took place, in the light of new taxonomic arrangements (Sauer, 1953; Barkworth & Jacobs, 2001). Similarly, new taxonomic work by Schmidt-Lebuhn (2008) on the aromatic genus *Minthostachys* enabled the reinterpretation of many inconsistent records of plant chemistry, use and vernacular nomenclature. Without voucher specimens, it is impossible to carry out this kind of retrospective analysis.

Voucher specimens thus enable the reproducibility of studies, a fundamental quality of science. They have another important attribute. As well as plant material, they also incorporate standard label data such as date and place of collection. As a set of georeferenced specimens that can be linked to other ethnobotanical specimens and data, they can be interrogated using new research questions and techniques. Examples of this, ranging from extraction and testing of plant chemicals to studies of over-harvesting, are presented later in this chapter.

## Vouchers: current practice

Reviews of current practice show that there is wide variation between disciplines in the implementation of routine collection of voucher specimens. In the cases of nutritional analyses, natural products and molecular analyses, it is unacceptable that so few studies cite voucher specimens. The techniques of voucher collection and identification have been routine in the closely related field of ethnobotany for decades, and can easily be adopted by other disciplines. It is clear that the requirement by journals of citation of voucher specimens for plant materials in articles that they publish can be a major force in the adoption of vouchering, and this requirement should be more widely implemented.

### Ethnobotany

Collection of voucher herbarium specimens is standard practice in ethnobotany. Robert Bye's seminal paper of 1986 spelt out the importance of depositing voucher specimens in recognised herbaria, where they would not only receive an initial identification but also be subject to further taxonomic scrutiny as part of the normal process of revision of herbarium holdings. The journal *Economic Botany* had already, in 1981, introduced a requirement for voucher specimens to be cited, and this is likewise compulsory for manuscripts submitted to the *Journal of Ethnopharmacology*, *Journal of Ethnobiology* and other journals within the field.

### Natural products

The collection of voucher specimens is still not standard practice in this field, which is closely related to ethnobotany but usually with stronger emphasis on the commercial use of plants for medicine and other purposes (Flaster & Lassiter, 2004; Wolsko et al., 2005; Smillie & Khan, 2009; Eisenman et al., 2012). In part, this is because the supply chain is often longer, leading to a disconnection between collector and retailer.

### Genetics and DNA

Regular pleas from geneticists for vouchering of plants used for chromosome counts and genetic experiments suggest that this is a long-standing problem (Sauer, 1953; Barkworth & Jacobs, 2001; Chapter 7). To this must now be added to concerns over the failure to voucher material used for molecular studies (Goldblatt et al., 1992; Pleijel et al., 2008).

### Genetic resources

The importance of herbarium voucher specimens for documenting and assuring the identity of germplasm has clearly been well-understood since the early 20th century, and is stressed (with practical instructions) in current handbooks on germplasm collection (Miller & Nyberg, 1995; Way, 2003: 187–191). If a genebank does not have its own herbarium, voucher specimens can be deposited elsewhere.

The plant exploration programme of the Office of Foreign Seed and Plant Introduction, US Department of Agriculture was established in 1898. A high proportion of its collections were and are grown on and vouchered in the USDA's Economic Botany Herbarium, today known as the National Arboretum Herbarium. Collections continue to be grown and vouchered by this herbarium and it remains the official depository for documented specimens of USDA plant introductions, including food, drug, forage, industrial and forest plants. Similarly the N. I. Vavilov Institute of Plant Industry, established in 1923, has a herbarium of voucher specimens for its genebank holdings. Such herbaria are very rich in cultivated plants, which are often neglected in other herbaria.

### Taxonomy

Citation of voucher specimens for new plant taxa — known as type specimens —was recommended in the Rochester Code of 1892, and was widely practiced. Nevertheless, it did not become a mandatory part of the *International Code of Botanical Nomenclature* until 1958. The necessity of type specimens is widely understood, and they have been the initial focus of most herbarium digitisation projects (Chavan et al., 2010).

### Ethnomycology

Preservation of fungal voucher specimens has been urged since the 1970s, but is still not standard practice (Ammirati, 1979). The form of the voucher specimen needs careful consideration, according to the part of the fungus being studied, and whether or not a live culture is preserved (Agerer et al., 2000). Where a live culture is not preserved, the collection locality is particularly important as it will enable re-collection of living material.

### Wood anatomy

Citation of wood specimens, for work involving their anatomy, chemistry or DNA, has long been well-established (Chapter 9). Wood specimens are usually cited by the *Index Xylariorum* code of the holding institution and the accession number allocated by that institution. However, 50 years ago, Stern and Chambers (1960) argued that citations of wood specimens should also include the collector and collector number, and the location of the voucher herbarium specimen (if there is one). It is important to be able to find the original wood specimen, but this does not itself allow an independent identification of the taxon. Barker (2008) reports that citation of herbarium voucher specimens is still not standard practice in wood research, and gives many examples of Australian trees with changed taxonomic status, including the merging and splitting of species, that can only be resolved through voucher herbarium specimens. Citation of herbarium specimens is more important than ever for woods, as wood research moves beyond the easily recognisable commercial species that were the focus of research in the 20th century to encompass non-industrial woody plants that are harder to recognise.

### Nutrition

Nesbitt et al. (2010) found that out of 50 recent papers on nutritional analyses of wild plants, only one cited voucher specimens; a further seven papers cited genebank or nursery accession numbers (good practice, but not sufficient as such material may be incorrectly identified). A recent manual on the documentation of traditional foods only advises collection of herbarium specimens for hard-to-identify taxa (Kuhnlein et al., 2006), but such taxa can be difficult to separate from easy-to-identify taxa in the field.

## HERBARIUM SPECIMENS AS ETHNOBOTANICAL DATA

### A brief history

The earliest herbaria were formed in Italy in the 16th century, and were in the form of pressed plants mounted on sheets of paper, which were bound into books. Binding specimens into books remained standard practice until the 18th century; for example, the herbarium of Sir Hans Sloane (1660–1753), now housed at the Natural History Museum in London, comprises 260 bound volumes, made up of specimens received from many collectors. From the mid-18th century onwards, perhaps reflecting the influence of Linnaeus's new classifications, herbarium sheets were kept loose so that they could be shelved in taxonomic order. Increasingly, herbaria were housed in institutions rather than the homes of wealthy collectors such as Sloane and Sir Joseph Banks (Figure 1).

As with all museum collections, understanding the history of herbaria is crucial to their effective use. A herbarium is, on the one hand, an accumulation of collections created by individuals in specific times and places for particular purposes, and on the other hand, an aggregate of these collections. Its specimens thus encompass a far greater geographical and chronological range than any one researcher can achieve (Drew, 2011). There are therefore two approaches to using herbaria for ethnobotanical research. One is to home in on a discrete collection from a particular time and place within the whole; for example a surviving volume of 170 specimens collected by the herbalist Ferrante Imperato (1525–1621) in Italy, or the 17th century herbarium collected by Hendrik Meyer in Suriname before

**Figure 1.** The herbarium belonging to Sir Joseph Banks, at his house in central London. Sepia painting by Francis Boott, 1820.
© NATURAL NISTORY MUSEUM, LONDON.

1687 (De Natale & Cellinese, 2009; van Andel et al., 2012b). In both cases, significant detective work was required to identify the original collector. The other, and most common, approach is to treat the whole herbarium as an assemblage of data points, allowing research into both geographical and temporal changes in the occurrence of particular species. Herbaria cannot, however, be treated as random samples of nature, and a critical approach to understanding data is required, as demonstrated by the following case studies.

## Ecology and conservation

One of the major challenges facing ethnobotany is detecting and quantifying overharvesting of wild resources. Several attributes of herbarium specimens can be used as proxies for harvesting pressure, including the abundance of specimens (as plants are over-collected they become rarer, and less likely to be encountered by botanists), plant size, and plant maturity (larger and more mature plants are more likely to be harvested, leading to a decrease in size). Of course, a wide range of other factors also affects these attributes, but several studies have made effective use of comparisons of harvested and non-harvested species in order to identify factors specific to harvesting. A study of 915 herbarium specimens of American ginseng (*Panax quinquefolius*) found a decrease in nine of eleven size-related traits, such as root length and leaf width, occurring from 1900 onwards (McGraw, 2001). Plants from northern parts of the USA did not exhibit this decline, suggesting that the cause is more likely to be related to localised effects such as over-harvesting. Living plants of *Saussurea laniceps* were also found to be smaller in more intensively harvested locations today (Law & Salick, 2005). As larger plants are preferred by harvesters, and the plant is harvested just before the seeds mature, there is a strong selection against large plants.

A further study compared the number of ginseng specimens in 85 herbaria to the number of specimens of four closely related species that are not commercially harvested (Case et al., 2007). After allowing for preferential collection of ginseng by some botanists, the proportion of ginseng specimens significantly decreased in most regions over the past 150 years. In a similar study, Applequist et al. (2007) found a decline in the number of collections of *Echinacea purpurea* relative to those of the less-collected *E. pallida* var. *pallida*, which was interpreted as evidence of over-harvesting of *E. purpurea*.

Geographical distribution can also give insights into plant systematics, as in the case of medicinal rhubarb (*Rheum*) species in China where overlapping distributions suggest that three species may in fact be one (Wang et al., 2010).

## Uses

In the past, herbarium specimens sometimes doubled as ethnobotanical specimens, as in the case of Sir Hans Sloane's herbarium specimen of the Jamaican lace-bark tree (*Lagetta lagetto*) housed in the Natural History Museum in London, to which is attached a piece of lace made from the inner bark of the tree (Figure 2; Brennan et al., 2013). However, this is unusual (and not standard practice today); instead, when present, ethnobotanical information is often conveyed by written information on the herbarium sheet (Figure 3), as well as in associated specimens (ethnobotanical, biochemical, wood etc.) for which the herbarium specimen is a voucher.

Such annotated herbarium specimens were very much working collections for the original collectors. The 313 heavily annotated specimens of North American medicinal plants collected by Dr Gideon Lincecum for his personal herbarium between 1835 and 1852 would have been an important educational resource for a physician such as Lincecum who had no formal training (Birch, 2009). Detailed study of the composition of such a herbarium gives valuable insights both into Lincecum's

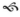

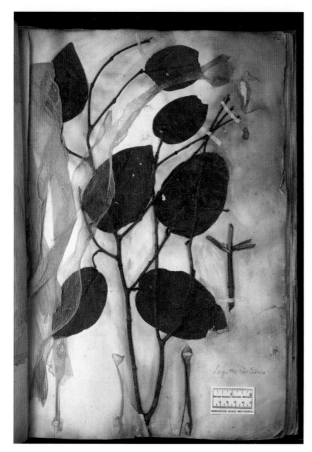

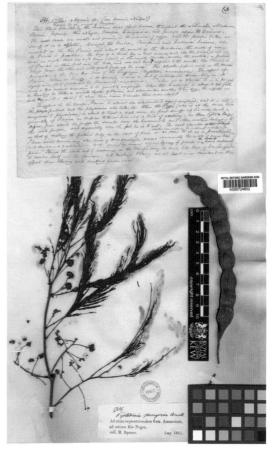

own practice, with its strong links to Native American medical traditions, and into Native American practices in a period predating most written records, most of which date from late 19th century ethnobotanical recording. In addition to the ethnobotanical notations, the medical purpose of the overall assemblage meant that the whole suite of taxa could be understood as a proxy for the materia medica known to and used by Lincecum. If specimens had been studied in isolation, without attention to their history, their medicinal function would not have been fully understood.

The Hermann Herbarium, collected in Suriname by Hendrik Meyer, before 1687, is another example of a herbarium — in this case of 51 specimens — which is almost entirely comprised of useful plants. Again, extensive historical and botanical research has enabled the time and place of collection to be specified (van Andel et al., 2012b). DNA analysis was used to identify an incomplete Malvaceae specimen to species, *Pachira*

*aquatica*. The herbarium is the earliest collection of plant specimens for the Guianas region, and the vernacular names (in the Carib Indian language) and uses recorded on specimens demonstrate considerable continuity in plant use from the 17th century to the present. Of particular interest are two specimens of crops, okra (*Abelmoschus esculentus*) and sesame (Figure 4), the first physical evidence of the cultivation of African crops in Suriname, occurring 30 years after the first African slaves were imported (van Andel et al., 2012a, 2012b).

The Libyan ethnobotanical collection formed by the Italian agronomist Alessandro Trotter, and now housed at the University Federico II in Naples, is a reminder that many historic herbarium specimens were collected in the context of colonisation. Italy conquered the Ottoman province of Libya in the 1911–1912 Italo-Turkish War. Trotter made several expeditions to Libya between 1912 and 1924. In his herbarium of 2,300 specimens, about 80 are annotated with use data; there are a further 87 packets of drugs collected in markets (De Natale & Pollio, 2012). These represent a rare record of early 20th century plant uses from the region. Edward Palmer formed a similar ethnobotanical collection in Mexico; his market and herbarium specimens have been studied by Robert Bye (1979).

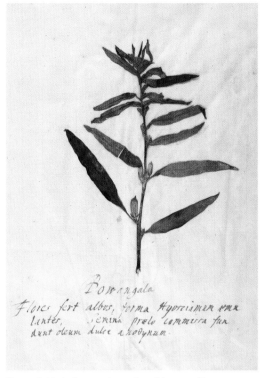

**Figure 4.** Herbarium specimen of a wild sesame (*Sesamum radiatum*) from the Hermann Herbarium, Leiden. Collected before 1687 in Suriname and with okra the first record of an African crop in that country. The annotations give the vernacular name as Bowangala, very similar to the current day Arawak name boangila, and give the uses (translated from Dutch to English): 'Carries white flowers, that in form resemble Hyosciamum. Pressed seeds give rise to a sweet, painkilling oil.' (van Andel et al., 2012a). © NATURALIS BIODIVERSITY CENTER.

Two methodological aspects stand out in the three studies mentioned above: the importance of situating herbarium specimens in their original context through historical research, and the prevalence of incorrect identifications, both by the original collector and in subsequent studies. Not only does this reinforce the point that without the existence of herbarium specimens these incorrect identifications could not be detected, but it is also a reminder that voucher identifications need to be rechecked by subsequent users of specimens. It is also notable that all three herbaria survived as separate collections: the Hermann Herbarium as a bound volume, the Lincecum herbarium in the hands of his descendants, and the Trotter herbarium in a special wooden cupboard. This is counter to standard practice adopted since the 19th century, which is to integrate all herbarium specimens into a general sequence. Such a system makes the herbarium far more convenient to botanists, as all plant material of one taxon can be consulted in one place, but necessarily obscures the place of individual specimens as components of original collections. As herbaria are more completely databased, it will be possible to recreate original collection groupings virtually, enabling similar studies to be carried out more widely.

In contrast to these studies, which focus on single collections, another approach is to study large herbaria as a whole. The formal application of this technique was pioneered in the 1960s

by Siri von Reis Altschul, through the systematic survey of herbarium specimens in the Harvard University Herbaria and the New York Botanical Garden (Altschul, 1967, 1968, 1970, 1973; von Reis 1962; von Reis & Lipp, 1982). This work set out with the aim of finding plants 'valuable to modern medical science' and was sponsored both by the National Institute of Mental Health and pharmaceutical companies. As the aim was to find new uses, those already documented in Uphof's *Dictionary of Economic Plants*, or obvious from the botanical name of the plant, were not recorded. Vernacular names that implied medicinal or food use were recorded, and it is important to note that names (which are recorded by botanists far more often than uses) can embody significant use information. The impact of this work is unclear; it would be interesting to carry out a similar survey, focusing on a region with a well-documented ethnoflora, to see to what extent herbarium specimens do add new information, or indeed can be used as a proxy for field work, particularly for diachronic studies where old data sets may not be available. Such an approach would benefit from the recording of *all* data relating to uses.

A concrete example of the value of label data is a study of the genus *Clitoria*, where significant data on poison and dye properties was obtained from herbarium specimens (Fantz, 1991); herbarium data have also been used in similar reviews of Cucurbitaceae in Mexico (Lira & Caballero, 2002) and *Plectranthus* in Africa (Lukhoba et al., 2006). Data on herbarium specimens were integrated with data from ethnobotanical literature to compare plant use in 40 communities in Ecuador (de la Torre et al., 2012). The potential of herbarium specimens as a source of vernacular names is indicated by the 1,200 Xhosa plant names found on voucher specimens collected by the Bantu Cancer Research Registry in South Africa from 1963 to 1980 (Dold & Cocks, 1999).

## Destructive sampling

As we have seen, much ethnobotanical information can be obtained from looking at herbarium specimens and their label data. Herbarium specimens are also a useful source for analyses that require plant material. They are often reliably identified (and can be easily verified against other specimens shelved nearby), and usually bear the date and location of collection. A comprehensive range of species will be present, enabling wide-ranging research without time-consuming and expensive travel. The disadvantages are two-fold: first, chemical and genetic material does not survive as well, or as predictably, as in extracts from living material; second, each sampling from a herbarium specimen is a form of damage that may reduce the utility of the specimen to future researchers. New techniques have led to greater numbers of requests for samples from herbarium specimens, but at the same time have reduced the quantity of material needed for each genetic or chemical analysis.

### Plant chemistry

Herbarium specimens of plants and fungi have been used as a source of raw material for chemical analysis since the 1960s, both for chemotaxonomy and for natural products research (Farnsworth, 1966; Phillipson & Hemingway, 1975; Phillipson, 1982; Paterson & Hawksworth, 1985). Experiments with plant material of known age has resulted in successful extraction of plant compounds from specimens collected as long ago as 1893. Furthermore, leaf extracts of *Combretum erythrophyllum* dating to 1909 retained their antibacterial activity, pointing to the use of herbarium material for preliminary screening for activity, as well as for the identification of chemicals (Eloff, 1999). Alkaloids are well-documented as surviving for long periods of time (Phillipson, 1982: 2443); examples include mescaline identified in peyote effigies from Texas, radiocarbon dated to about 6,000 years old (El-Seedi et al., 2005) and the identification of harmine, one of the active ingredients

of the hallucinogenic plant *Banisteriopsis caapi* in 1969 in stems collected in the Amazon by Richard Spruce in 1852 (Schultes et al., 1969; Figure 5). Even volatile chemicals such as essential oils can be detected in old material. In a reminder that analytical techniques can be simple, Gyllenhaal et al. (1990) taste-tested small squares of leaf from herbarium specimens of 110 species of *Stevia* to see if any shared the sweetness of *Stevia rebaudiana*.

There is, however, complex variability, which is not yet fully understood, in the survival of compounds and their activity, which means that the analysis of dry, old material must be treated critically (Amoo et al., 2012). Treatment during collection can also affect preservation, with procedures such as the Schweinfurth Method, in which plants are preserved in alcohol before pressing, leading to loss of compounds such as flavonoids (Coradin & Giannasi, 1980). In general, phytochemical characterisation, especially for nuclear magnetic resonance (NMR), requires relatively large quantities of plant material. Taking into account this and the effects of time on secondary metabolites, herbarium material is usually used to fill gaps in sampling, or for special studies, but is not the first choice for phytochemical research.

Although leaves are most often sampled for biochemical analysis, other plant parts are present on herbarium specimens; for example, reference material of *Pinus* resin has been obtained by scraping pine cones housed at the Royal Botanic Gardens, Kew (Stacey et al., 2006).

### Seeds

Herbarium specimens can be a valuable source of viable seeds. If herbarium specimens contain mature seed, and if the specimen has not been treated by microwaving (a popular treatment for pest control in the 1980s, no longer used), then seed viability will depend on the longevity attributes of that species, and the number of seeds available for germination trials. Germination tests of hard-walled orthodox seeds (seeds that survive drying) are regularly successful for seeds 100–200 years old (Bowles et al., 1993; Daws et al., 2007; Leino & Edqvist, 2010; Godefroid et al., 2011), a lifespan covering the great majority of herbarium specimens. Sampling for seed germination should be considered with caution; seeds of many species are more easily available from genebanks, and use should also be made of existing information on the germination characteristics of the species (Chapter 8). Fern spores have also been successfully germinated (Magrini et al., 2010; Magrini, 2011).

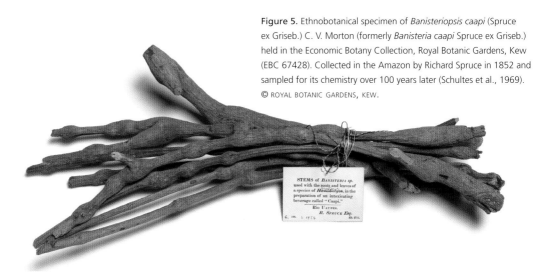

**Figure 5.** Ethnobotanical specimen of *Banisteriopsis caapi* (Spruce ex Griseb.) C. V. Morton (formerly *Banisteria caapi* Spruce ex Griseb.) held in the Economic Botany Collection, Royal Botanic Gardens, Kew (EBC 67428). Collected in the Amazon by Richard Spruce in 1852 and sampled for its chemistry over 100 years later (Schultes et al., 1969). © ROYAL BOTANIC GARDENS, KEW.

## DNA

As with seeds, fresh material or material collected and rapidly dried in the field, or material from specialist storage facilities, is favoured for DNA analysis (Chapter 7). Where permissions allow, DNA samples (leaf fragments in silica gel) can be collected as a routine part of plant collection. DNA from herbarium specimens is often highly fragmented. Trials suggest that closer attention to extraction methods, and acceptance that routine use of DNA will be of relatively short fragments, will both be required (Särkinen et al, 2012). Leaf material is usually sampled, but better-quality DNA may be available from seeds, even those that are no longer viable (Walters et al., 2006). The implications of DNA sampling of herbarium specimens for herbaria are discussed by Jansen et al. (1999), Metsger (1999) and Wood et al. (1999). DNA extraction has proved successful from specimens up to 200 years old (Ames & Spooner, 2008; Andreasen et al., 2009; Lister et al., 2008, 2009, 2010), but is affected both by age and by treatment of the plant material during collection (Erkens et al., 2008; Staats et al., 2011). DNA is of particular ethnobotanical relevance to studies of crop evolution; for example, Malenica et al. (2011) were able to extract DNA from 90-year-old herbarium specimens of grapevine (*Vitis vinifera*) and show that it had an identical single sequence repeat (SSR) genotype to that of the cultivar Zinfandel.

## Pollen

Herbarium sheets are routinely used as sources of pollen for reference collections. This requires some understanding of floral morphology in order to extract one or more stamens from the flower safely. Practical advice is given by Jarzen & Jarzen (2006).

## CONCLUSIONS

The historical links between herbaria and ethno- or economic botany that weakened in the 20th century have been reforged. Herbarium specimens are now widely recognised as the ideal voucher specimen for most ethnobotanical research, and it is likely that the few fields (such as nutrition) that do yet fully implement best practice will soon do so. The core techniques for collecting herbarium specimens remain as straightforward and easy to learn as they were 400 years ago. Herbarium specimens are also the subject of new research questions and techniques: they act as records of use through their labels and associated data, and as biological specimens that can be measured and sampled. As herbaria are gradually databased, their usefulness will increase further. It will be easier to find voucher specimens, regardless of changes in botanical name or in location of deposition, and it will be easier to find specimens that embody ethnobotanical data. These are encouraging times for the symbiotic relationship between herbaria and ethnobotany.

## ACKNOWLEDGEMENTS

I am grateful to Robyn Cowan, Ashley DuVal, Olwen Grace, Alan Paton, Jan Salick and William Milliken for helpful comments on this chapter.

## Literature cited

Agerer, R., Ammirati, J., Blanz, P., Courtecuisse, R., Desjardin, D. E., Gams, W., Hallenberg, N., Halling, R., Hawksworth, D. L., Horak, E., Korf, R. P., Mueller, G. M., Oberwinkler, F., Rambold, G., Summerbell, R. C., Triebel, D. & Watling, R. (2000). Open letter to the scientific community of mycologists: 'Always deposit voucher specimens'. *Mycorrhiza* 10: 95–97.

Altschul, S. V. R. (1967). Psychopharmacological notes in Harvard University Herbaria. *Lloydia* 30: 192–196.

Altschul, S. V. R. (1968). Unusual food plants in herbarium records. *Economic Botany* 22: 293–296.

Altschul, S. V. R. (1970). Ethnopediatric notes in Harvard-University-Herbaria. *Lloydia* 33: 195–198.

Altschul, S. V. R. (1973). *Drugs and Foods from Little-known Plants: Notes in Harvard University Herbaria.* Harvard University Press, Cambridge.

Ames, M. & Spooner, D. M. (2008). DNA from herbarium specimens settles a controversy about origins of the European potato. *American Journal of Botany* 95: 252–257.

Ammirati, J. (1979). Chemical studies of mushrooms: the need for voucher collections. *Mycologia* 71: 437–441.

Amoo, S. O., Aremu, A. O., Moyo, M. & Van Staden, J. (2012). Antioxidant and Acetylcholinesterase-inhibitory properties of long-term stored medicinal plants. *BMC Complementary and Alternative Medicine* 12: 87.

Anderson, E. (1952). *Plants, Man and Life.* Little, Brown, Boston.

Andreasen, K., Manktelow, M. & Razafimandimbison, S. G. (2009). Successful DNA amplification of a more than 200-year-old herbarium specimen: recovering genetic material from the Linnaean era. *Taxon* 58: 959–962.

Applequist, W. L., McGlinn, D. J., Miller, M., Long, Q. G. & Miller, J. S. (2007). How well do herbarium data predict the location of present populations? A test using *Echinacea* species in Missouri. *Biodiversity and Conservation* 16: 1397–1407.

Barker, J. (2008). Disconnection and reconnection: misconceptions and recommendations pertaining to vouchers in wood science. *IAWA Journal* 29: 425–437.

Barkworth, M. E. & Jacobs, S. W. L. (2001). Valuable research or short stories: what makes the difference? *Hereditas* 135: 263–270.

Bedigian, D. (2004). Slimy leaves and oily seeds: distribution and use of wild relatives of sesame in Africa. *Economic Botany* 58: S3–S33.

Bennett, B. C. & Balick, M. J. (2013). Does the name really matter? The importance of botanical nomeclature and plant taxonomy in biomedical research. *Journal of Ethnopharmocology* doi: 10.1016/j.jep.2013.11.042.

Birch, J. L. (2009). A comparative analysis of nineteenth century pharmacopoeias in the southern United States: a case study based on the Gideon Lincecum Herbarium. *Economic Botany* 63: 427–440.

Bowles, M. L., Betz, R. F. & DeMauro, M. M. (1993). Propagation of rare plants from historic seed collections: implications for species restoration and herbarium management. *Restoration Ecology* 1: 101–106.

Brennan, E., Harris, L.-A. & Nesbitt, M. (2013). Jamaican lace-bark: Its history and uncertain future. *Textile History* 44: 235–253.

Bye, R. A. (1979). An 1878 ethnobotanical collection from San Luis Potosí: Dr. Edward Palmer's first major Mexican collection. *Economic Botany* 33: 135–162.

Bye, R. A. (1986). Voucher specimens in ethnobiological studies and publications. *Journal of Ethnobiology* 6: 1–8.

Case, M. A., Flinn, K. M., Jancaitis, J., Alley, A. & Paxton, A. (2007). Declining abundance of American ginseng (*Panax quinquefolius* L.) documented by herbarium specimens. *Biological Conservation* 134: 22–30.

Chavan, V., Berents, P. & Hamerm M. (2010). Towards demand-driven publishing: approaches to the prioritisation of digitisation of natural history collections data. *Biodiversity Informatics* 7: 113–119.

Clifford, H. T., Rogers, R. W. & Dettmann, M. E. (1990). Where now for taxonomy? *Nature* 346: 602.

Coradin, L. & Giannasi, D. E. (1980). Effects of chemical preservations on plant collections to be used in chemotaxonomic surveys. *Taxon* 29: 33–40.

Daws, M. I., Davies, J., Vaes, E., van Gelder, R. & Pritchard, H. W. (2007). Two-hundred-year seed survival of *Leucospermum* and two other woody species from the Cape Floristic Region, South Africa. *Seed Science Research* 17: 73–79.

de la Torre, L., Ceron, C. E., Balslev, H. & Borchsenius, F. (2012). A biodiversity informatics approach to ethnobotany: meta-analysis of plant use patterns in Ecuador. *Ecology and Society* 17: 15.

De Natale, A. & Pollio, A. (2012). A forgotten collection: the Libyan ethnobotanical exhibits (1912–14) by A. Trotter at the Museum O. Comes at the University Federico Ii in Naples, Italy. *Journal of Ethnobiology and Ethnomedicine* 8: 4.

De Natale, A., & Cellinese, N. (2009). Imperato, Cirillo, and a series of unfortunate events: a novel approach to assess the unknown provenance of historical herbarium specimens. *Taxon* 58: 963–970.

Dold, A. P. & Cocks, M. L. (1999). Preliminary list of Xhosa plant names from Eastern Cape, South Africa. *Bothalia* 29: 267–292.

Drew, J. (2011). The role of natural history institutions and bioinformatics in conservation biology. *Conservation Biology* 25: 1250–1252.

Eisenman, S. W., Tucker, A. O. & Struwe, L. (2012). Voucher specimens are essential for documenting source material used in medicinal plant investigations. *Journal of Medicinally Active Plants* 1: 8.

Eloff, J. N. (1999). It is possible to use herbarium specimens to screen for antibacterial components in some plants? *Journal of Ethnopharmacology* 67: 355–360.

El-Seedi, H. R., Smet, P. A. D., Beck, O., Possnert, G., & Bruhn, J. G. (2005). Prehistoric peyote use: alkaloid analysis and radiocarbon dating of archaeological specimens of *Lophophora* from Texas. *Journal of Ethnopharmacology* 101: 238–242.

Erkens, R. H. J., Cross, H., Maas, J. W., Hoenselaar, K. & Chatrou, L. W. (2008). Assessment of age and greenness of herbarium specimens as predictors for successful extraction and amplification of DNA. *Blumea* 53: 407–428.

Fantz, P. R. (1991). Ethnobotany of *Clitoria* (Leguminosae). *Economic Botany* 45: 511–520.

Farnsworth, N. R. (1966). Biological and phytochemical screening of plants. *Journal of Pharmaceutical Sciences* 55: 225–276.

Flaster, T. & Lassiter, J. (2004). Quality control in herbal preparations: using botanical reference standards for proper identification. *HerbalGram* 63: 32–37.

Funk, V. (2003). 100 uses for an herbarium (well at least 72). *American Society of Plant Taxonomists Newsletter* 17: 17–19.

Godefroid, S., Van de Vyver, A., Stoffelen, P., Robbrecht, E. & Vanderborght, T. (2011). Testing the viability of seeds from old herbarium specimens for conservation purposes. *Taxon* 60: 565–569.

Goldblatt, P., Hoch, P. C. & McCook, L. M. (1992). Documenting scientific data: the need for voucher specimens. *Annals of the Missouri Botanical Garden* 79: 969–970.

Gyllenhaal, C., Soejarto, D. D. & Farnsworth, N. R. (1990). The value of herbaria. *Nature* 347: 704.

Jansen, R. K., Loockerman, D. J. & Kim, H.-G. (1999). DNA sampling from herbarium material: a current perspective. In: *Managing the Modern Herbarium: an Interdisciplinary Approach*, pp. 277–286. Society for the Preservation of Natural History Collections, Washington, DC.

Jarzen, D. M. & Jarzen, S. A. (2006). Collecting pollen and spore samples from herbaria. *Palynology* 30: 111–119.

Kuhnlein, H. V., Yesudas, S., Dan, L. & Ahmed, S. (2006). *Documenting Traditional Food Systems of Indigenous Peoples: International Case Studies*. Centre for Indigenous Peoples' Nutrition and Environment, McGill University, Sainte-Anne-de-Bellevue, Quebec. www.mcgill.ca/files/cine/manual.pdf

Law, W. & Salick, J. (2005). Human-induced dwarfing of Himalayan snow lotus, *Saussurea laniceps* (Asteraceae). *Proceedings of the National Academy of Sciences of the United States* 102: 10218–10220.

Leino, M. W. & Edqvist, J. (2010). Germination of 151-year old *Acacia* spp. Seeds. *Genetic Resources and Crop Evolution* 57: 741–746.

Lira, R. & Caballero, J. (2002). Ethnobotany of the wild Mexican Cucurbitaceae. *Economic Botany* 56: 380–398.

Lister, D. L., Bower, M. A. & Jones, M. K. (2010). Herbarium specimens expand the geographical and temporal range of germplasm data in phylogeographic studies. *Taxon* 59: 1321–1323.

Lister, D. L., Bower, M. A., Howe, C. J. & Jones, M. K. (2008). Extraction and amplification of nuclear DNA from herbarium specimens of emmer wheat: a method for assessing DNA preservation by maximum amplicon length recovery. *Taxon* 57: 254–258.

Lister, D. L., Thaw, S., Bower, M. A., Jones, H., Charles, M. P., Jones, G., Smith, L. M. J., Howe, C. J., Brown, T. A. & Jones, M. K. (2009). Latitudinal variation in a photoperiod response gene in European barley: insight into the dynamics of agricultural spread from 'historic' specimens. *Journal of Archaeological Science* 36: 1092–1098.

Łuczaj, Ł. J. (2010). Plant identification credibility in ethnobotany: a closer look at Polish ethnographic studies. *Journal of Ethnobiology and Ethnomedicine* 6: 36.

Lukhoba, C. W., Simmonds, M. S. J. & Paton, A. J. (2006). *Plectranthus*: a review of ethnobotanical uses. *Journal of Ethnopharmacology* 103: 1–24.

Magrini, S. (2011). Herbaria as useful spore banks for integrated conservation strategies of Pteridophytic diversity. *Plant Biosystems* 145: 635–637.

Magrini, S., Olmati, C., Onofri, S. & Scoppola, A. (2010). Recovery of viable germplasm from herbarium specimens of *Osmunda regalis* L. *American Fern Journal* 100: 159–166.

Malenica, N., Simon, S., Besendorfer, V., Maletic, E., Kontic, J. K. & Pejic, I. (2011). Whole genome amplification and microsatellite genotyping of herbarium DNA revealed the identity of an ancient grapevine cultivar. *Naturwissenschaften* 98: 763–772.

McGraw, J. B. (2001). Evidence for decline in stature of American ginseng plants from herbarium specimens. *Biological Conservation* 98: 25–32.

Metsger, D. A. (1999). Recommendations on the use of herbarium and other museum materials for molecular research: a position paper. In: *Managing the Modern Herbarium: an Interdisciplinary Approach*, pp. 345–350. Society for the Preservation of Natural History Collections, Washington, DC.

Miller, A. G. & Nyberg, J. A. (1995). Collecting herbarium vouchers. In: *Collecting Plant Genetic Diversity*, eds L. Guarino, V. R. Rao & R. Reid, pp. 561–573. CAB International, Wallingford.

Nesbitt, M., McBurney, R. P. H., Broin, M. & Beentje, H. J. (2010). Linking biodiversity, food and nutrition: the importance of plant identification and nomenclature. *Journal of Food Composition and Analysis* 23: 486–498.

Paterson, R. R. M. & Hawksworth, D. L. (1985). Detection of secondary metabolites in dried cultures of *Penicillium* preserved in herbaria. *Transactions of the British Mycological Society* 85: 95–100.

Phillipson, J. D. (1982). Chemical investigations of herbarium material for alkaloids. *Phytochemistry* 21: 2441–2456.

Phillipson, J. D. & Hemingway, S. R. (1975). Chromatographic and spectroscopic methods for identification of alkaloids from herbarium samples of genus *Uncaria*. *Journal of Chromatography* 105: 163–178.

Pleijel, F., Jondelius, U., Norlinder, E., Nygren, A., Oxelman, B., Schander, C., Sundberg, P. & Thollesson, M. (2008). Phylogenies without roots? A plea for the use of vouchers in molecular phylogenetic studies. *Molecular Phylogenetics and Evolution* 48: 369–371.

Särkinen, T., Staats, M., Richardson, J. E., Cowan, R. S. & Bakker, F. T. (2012). How to open the treasure chest? Optimising DNA extraction from herbarium specimens. *PloS One* 7(8): e43808.

Sauer, J. D. (1953). Herbarium specimens as records of genetic research. *American Naturalist* 87: 155–156.

Schmidt-Lebuhn, A. N. (2008). Ethnobotany, biochemistry and pharmacology of *Minthostachys* (Lamiaceae). *Journal of Ethnopharmacology* 118: 343–353.

Schultes, R. E., Holmstedt, B. & Lindgren, J. E. (1969). De Plantis Toxicariis e Mundo Novo Tropicale Commentationes III. Phytochemical examination of Spruce's original collection of *Banisteriopsis caapi*. *Botanical Museum Leaflets Harvard University* 22: 121–132.

Schultes, R. E. (1983). Richard Spruce: an early ethnobotanist and explorer of the northwest Amazon and northern Andes. *Journal of Ethnobiology* 3: 139–147.

Smillie, T. J. & Khan, I. A. (2009). A comprehensive approach to identifying and authenticating botanical products. *Clinical Pharmacology & Therapeutics* 87: 175–186.

Staats, M., Cuenca, A., Richardson, J. E., Vrielink-van Ginkel, R., Petersen, G., Seberg, O. & Bakker, F. T. (2011). DNA damage in plant herbarium tissue. *PloS One* 6(12): e0028448.

Stacey, R., Cartwright, C. & McEwan, C. (2006). Chemical characterization of ancient Mesoamerican 'copal' resins: preliminary results. *Archaeometry* 48: 323–340.

Stern, W. L. & Chambers, K. L. (1960). The citation of wood specimens and herbarium vouchers in anatomical research. *Taxon* 9: 7–13.

Suarez, A. V. & Tsutsui, N. D. (2004). The value of museum collections for research and society. *BioScience* 54: 66–74.

van Andel, T., Maas, P. & Dobrefr, J. (2012a). Ethnobotanical notes from Daniel Rolander's *Diarium Surinamicum* (1754–1756): are these plants still used in Suriname today? *Taxon* 61: 852–863.

van Andel, T., Veldman, S., Maas, P., Thijsse, G. & Eurlings, M. (2012b). The forgotten Hermann Herbarium: a 17th century collection of useful plants from Suriname. *Taxon* 61: 1296–1304.

von Reis, S. (1962). Herbaria: sources of medicinal folklore. *Economic Botany* 16: 283–287.

von Reis, S. & Lipp, F. J. (1982). *New Plant Sources for Drugs and Foods from the New York Botanical Garden Herbarium*. Harvard University Press, Cambridge.

Walters, C., Reilley, A. A., Reeves, P. A., Baszczak, J. & Richards, C. M. (2006). The utility of aged seeds in DNA banks. *Seed Science Research* 16: 169–178.

Wang, X. M., Hou, X. Q., Zhang, Y. Q. & Li, Y. (2010). Distribution pattern of genuine species of rhubarb as traditional Chinese medicine. *Journal of Medicinal Plants Research* 4: 1865–1876.

Way, M. (2003). Collecting seed from non-domesticated plants for long-term conservation. In: *Seed Conservation: Turning Science into Practice*, eds R. D. Smith, J. B. Dickie, S. H. Linington, H. W. Pritchard & R. J. Probert, pp. 163–201. Royal Botanic Gardens, Kew.

Wolsko, P., Solondz, D., Phillips, R., Schachter, S. & Eisenberg, D. (2005). Lack of herbal supplement characterization in published randomized controlled trials. *American Journal of Medicine* 118: 1087–1093.

Wood, E. W., Eriksson, T. & Donoghue, M. J. (1999). Guidelines for the use of herbarium materials in molecular research. In: *Managing the Modern Herbarium: an Interdisciplinary Approach*, pp. 265–276. Society for the Preservation of Natural History Collections, Washington, DC.

## CHAPTER 23

# *Biocultural collections for conservation*

ROBBIE HART
University of Missouri, Saint Louis

WAYNE LAW
New York Botanical Garden

PETER WYSE JACKSON
Missouri Botanical Garden

## INTRODUCTION

Biological diversity and cultural diversity are intimately linked. This is evident in the relationship between humans and the natural environment. Humans constantly use and shape the environment in which they live according to their needs. At the same time, human cultures adapt to and are influenced by the environment where they develop. The interrelatedness between the biological and cultural diversity of life is known as biocultural diversity (Maffi, 2005; Maffi & Woodley, 2010). Unfortunately, this interdependent link between humans and nature is gradually being forgotten in the face of globalisation, threatening both our biological and cultural diversity. Biocultural collections (broadly defined herein, Chapter 1) have been used as a resource in conservation efforts, among a myriad of purposes, to slow the loss of both biological and cultural diversity by providing information from the past as well as valuable reference points from which changes can be measured, technologies relearned and organisms reintroduced.

To do justice to the importance of biological collections to biodiversity conservation, and of cultural collections to cultural conservation, is an endeavour beyond the scope of this chapter, and one undertaken in the literature of each discipline. With that caveat in mind, our discussions of this matter are brief and we focus on: how collections that are primarily biological in nature can aid in cultural conservation; how collections that are primarily cultural in nature can aid in biological conservation; and the advantages offered by biocultural collections documenting traditions, practices, or knowledge and capturing the value of a particular biological organism. We intend this review as an inspiration for future uses of biological, cultural and biocultural collections in conservation rather than as an exhaustive description of such uses.

We first introduce the interconnections between the conservation of culture and of biology. Although there is debate about the causal nature of these connections, there is a substantial body of literature documenting their concurrence. We discuss human-influenced landscapes, patterns of biocultural diversity, and plants and animals that are useful as conservation priorities and conservation 'flagships'.

We divide the main body of the chapter into two sections: biological conservation and cultural conservation. It may seem to be at cross-purposes to first emphasise the dependence of biological and cultural conservation and then separate them in our discussion. Nevertheless, we feel that even judging the value of cultural collections against the goals for biological conservation and *vice versa*, there is a strong and clear argument to be made for the value of these collections.

In the first section of the main body, we review some of the major goals for cultural conservation, exemplified by the UN Declaration on the Rights of Indigenous People (United Nations, 2008).

Then we break out collections into some of the major categories treated in this book, and briefly highlight ways in which cultural collections have been used to support biological conservation goals. This is followed by a more extended discussion of how biological collections can and have been used to support cultural conservation goals.

In the second section, we review the goals for biological conservation, exemplified by the UN Convention on Biodiversity and the associated 2011–2020 Global Strategy for Plant Conservation (GSPC), give an overview of how collections have been used to support these goals, and provide detailed examples that highlight the potential of collections that are mainly cultural in nature to support these biological conservation goals. To conclude, we argue for the value of collections that explicitly connect the cultural and biological.

## INTERDEPENDENCE OF CULTURE AND BIOLOGICAL CONSERVATION

### Coupled systems or anthropogenic landscapes

There has been an increasing realisation that the conservation of local and indigenous cultures and biological conservation are linked. This is not to assert that all local and indigenous peoples are necessarily natural conservationists, but rather to recognise that people are a part of the environments in which they live — not external to them. Whether researchers refer to 'coupled human and natural systems' (Liu et al., 2007), 'social-ecological systems' (Berkes & Folke, 2000), or 'anthropogenic biomes' (Ellis & Ramankutty, 2008), they are recognising that many of the ecosystems we wish to preserve have been shaped to some extent by human influence, both in their 'natural' formation and in their current threatened status (Turner et al., 1990; Bowman, 1998; Kimmerer & Lake, 2001; Glaser & Woods, 2004; Ellis & Ramankutty, 2008). Our notion of a 'pristine' landscape is rapidly changing (Hayashida, 2005), to the extent that the term 'wilderness' to describe land without human impact has been called a fiction (Gómez-Pompa & Kaus, 1992). Furthermore, there are many similarities in global patterns of cultural and biological diversity, leading to the possibility of linked strategies to address the conservation of both of these diversities (Maffi, 2005; Stepp et al., 2005).

In the USA, cultural and ecological preservation of traditionally burned landscapes are increasingly intertwined. On the Olympic Peninsula of the Pacific Northwest coast, the indigenous Quinault people observed that populations of the traditional basketry plant beargrass (*Xerophyllum tenax*) were declining and that plants that were of good quality in terms of the functional traits associated with basketry (such as length and pliability) were also harder to find. These reports inspired ecological studies of beargrass populations and associated communities. Then, informed by traditional ecological knowledge, the Quinault, ethnoecological researchers and the Olympic National Forest cooperated to implement controlled burns and to apply new management techniques (Shebitz, 2005). In the maintenance of a culturally important plant, the close pairing of cultural and biological methods hold promise for both biological restoration and cultural preservation.

### Useful plants are conservation priorities and flagships for conservation

Perhaps it should be expected that the connections between humans and the environment (that is, the non-human part of the environment) are invoked so often when humans try to convince other humans to conserve that environment. In fact, the biological side of ethnobiology — the subset of biology that is used by humans or useful to them — is often explicitly or implicitly used to form conservation priorities, or to identify flagship plants that can be used to rationalise or argue for the protection of other biology. These arguments can sometimes vary from the 'medicines in

the rainforest' line of reasoning often heard in the 1990s to a more recent call for conservation based on 'ecosystem services' — which in effect extends the notion of ethnobiology beyond earlier conceptions (Balick, 1996; Constanza et al., 1997; Mertz et al., 2007).

A relevant example of ethnobiology as a conservation priority and flagship for conservation comes in the very first section of the 'Rationale' for the GSPC — a document with biological conservation as its primary focus:

> 'Plants are universally recognized as a vital component of the world's biological diversity and an essential resource for the planet. In addition to the cultivated plant species used for food, timber and fibres, many wild plants have great economic and cultural importance and potential, as future crops and commodities more so as humanity grapples with the emerging challenges of environmental and climate change.'    (Wyse Jackson & Kennedy, 2009)

The prominence of useful plants in this policy-setting document promotes their position not just as conservation priority but also as a flagship group, by which the protection of other plants is implemented.

Ethnobiology appears frequently in the discussion around flagship species in the conservation literature. In what is primarily a task of communication with the public (including residents of protected areas, policy makers, donors and voters), it is vital to consider perceptions about, knowledge of, and uses of the biological systems to be conserved (Bowen-Jones & Entwistle, 2002; Garibaldi & Turner, 2004).

### Cultural knowledge informs conservation strategies and successful implementation

There is a growing consensus that the cultural side of ethnobiology — knowledge systems, cultural heritage, and traditional sciences and technologies that relate to the natural world — has a key role to play in informing conservation strategies. Local perceptions can be an efficient means for rapid environmental assessment (Dalle & Potvin, 2004), as in the example above of the Quinault people observing population changes in beargrass. Oral histories, ethnotaxonomies and toponyms (discussed below) can also store long-term environmental observations made by indigenous peoples and thus are important data for conservation strategies.

Local and indigenous peoples are also those most directly affected by resource degradation, and by policies and strategies intended to ameliorate that degradation. At all scales, from local regulations through protected areas of all sizes to global climate change mitigation efforts, the knowledge held by indigenous and local people has a place at the policy table for both practical and ethical reasons (Orlove & Brush, 1996; Berkes & Folke, 2000; Salick & Byg, 2007; Shackeroff, 2007). Maffi sums this up well:

> '[There is] a link between biodiversity and cultural and linguistic diversity in the area of human rights ... a new vision in which the protections of human rights (both individual and collective) are intimately connected to the affirmation of human responsibilities towards and stewardship over humanity's heritage in nature and culture.'    (Maffi, 2005)

This new vision has made its way into policy and is recognised in both of the UN documents that we use here as examples of conservation goals. It is present throughout the DRIP, but perhaps most concisely stated within this declaration as follows:

> 'Indigenous peoples have the right to the conservation and protection of the environment and the productive capacity of their lands or territories and resources. States shall establish and implement assistance programmes for indigenous peoples for such conservation and protection, without discrimination.'
> 
> (UN Declaration on the Rights of Indigenous People, article 29.1)

The emphasis on cultures is to be expected in a cultural conservation document, but it also finds its way into the short and focused GSPC rationale:

> '(v) the knowledge, innovations and practices of indigenous and local human communities that depend on plant diversity will be recognized, respected, preserved and maintained.'
>
> (Global Strategy for Plant Conservation)

## CULTURAL CONSERVATION: GOALS

In this chapter, we have taken the United Nations Declaration of the Rights of Indigenous Peoples as providing an example of the goals set for cultural conservation (United Nations, 2008). It is certainly not the only document setting such goals, but we have chosen it because it provides goals that are comparable to those set for biological conservation (the GSPC). As the articles of DRIP are concise and can seem cold, we turn to the 2007 Kauai Declaration for a more eloquent rationale and call to action:

> 'Such vital environmental resources as the air we breathe, the quality of the water we drink, the topsoil upon which our agriculture depends, the relatively stable global climate we have enjoyed until recently, and the global stock of biodiversity are all being degraded rapidly. Concurrently, human cultural diversity is being eroded rapidly everywhere. For example, one of the remaining 7,000 languages is being lost every week, yet each one represents a distinct philosophical and pragmatic approach to the organization of our lives. We are losing our cultural heritage at a rate that will seriously diminish our opportunities to achieve sustainability in the future.'
>
> (Aiona et al., 2007)

Here, we excerpt a few of the DRIP articles that seem especially relevant to biocultural conservation (in the examples of collections' value to conservation, we refer to these articles by number.):

### United Nations Declaration of the Rights of Indigenous Peoples

8.2(b) States shall provide effective mechanisms for prevention of, and redress for … any action which has the aim or effect of dispossessing them of their lands, territories or resources …

11.1. Indigenous peoples have the right to practise and revitalize their cultural traditions and customs. This includes the right to maintain, protect and develop the past, present and future manifestations of their cultures, such as archaeological and historical sites, artefacts, designs, ceremonies, technologies and visual and performing arts and literature.

11.2. States shall provide redress through effective mechanisms, which may include restitution, developed in conjunction with indigenous peoples, with respect to their cultural, intellectual, religious and spiritual property taken without their free, prior and informed consent or in violation of their laws, traditions and customs.

12.1. Indigenous peoples have the right to manifest, practise, develop and teach their spiritual and religious traditions, customs and ceremonies; the right to maintain, protect, and have access in privacy to their religious and cultural sites; the right to the use and control of their ceremonial objects; and the right to the repatriation of their human remains.

13.1. Indigenous peoples have the right to revitalize, use, develop and transmit to future generations their histories, languages, oral traditions, philosophies, writing systems and literatures, and to designate and retain their own names for communities, places and persons.

20.1. Indigenous peoples have the right to maintain and develop their political, economic and social systems or institutions, to be secure in the enjoyment of their own means of subsistence and development, and to engage freely in all their traditional and other economic activities.

24.1. Indigenous peoples have the right to their traditional medicines and to maintain their health practices, including the conservation of their vital medicinal plants, animals and minerals. Indigenous individuals also have the right to access, without any discrimination, to all social and health services.

29.1. Indigenous peoples have the right to the conservation and protection of the environment and the productive capacity of their lands or territories and resources. States shall establish and implement assistance programmes for indigenous peoples for such conservation and protection, without discrimination.

31.1. Indigenous peoples have the right to maintain, control, protect and develop their cultural heritage, traditional knowledge and traditional cultural expressions, as well as the manifestations of their sciences, technologies and cultures, including human and genetic resources, seeds, medicines, knowledge of the properties of fauna and flora, oral traditions, literatures, designs, sports and traditional games and visual and performing arts. They also have the right to maintain, control, protect and develop their intellectual property over such cultural heritage, traditional knowledge, and traditional cultural expressions.

## CULTURAL CONSERVATION: THE ROLE OF CULTURAL COLLECTIONS

### Plant and animal products

Quinault traditional knowledge of basketry plants is used in ecological habitat restoration and, in turn, ecological restoration helps maintain basketry traditions. Baskets in museums and private collections have helped maintain and recover parts of the Quinault basketry tradition (Thomson, 2009). Artefact collections have had similar roles in maintaining, recovering and advancing basketry traditions from Louisiana (Ware, not dated) to Tasmania (Gorringe & Gough, 2009). Collections have had a similar role in other traditional plant and animal products.

DRIP goal 11.1 and 31.1 directly relate to the preservation of these sorts of traditions. In a sense, DRIP goal 13.1 is also relevant in the sense that basketry and other iconographic arts can be a means of communication within and across generations. In the words of Michael Pavel of the Puget Salish Skokomish:

'A basket is a sacred item that stores many of the belongings of the native people and gives them an avenue to record the history of their people. You see, they say that we don't have any written language, but they're wrong. Our written language may not be in words, on paper or in books, but they are in symbols that are embroidered and applied to baskets.'

(quoted in Shebitz, 2005)

### Biocultural documentation — archives and libraries

Speakers of small indigenous languages have relied on audio recordings, linguistic field notes, and preserved texts to maintain and revitalise their languages (Hinton & Hale, 2001; Chapter 15). Ecological knowledge is often deeply interwoven with the language preserved in these archives (Hinton, 1994, Harrison, 2007); at the same time, indigenous language teachers and learners have found that incorporating ethnobiology into language learning adds context and relevance (Hinton & Hale, 2001).

Old archival records can also have direct and very topical effects on land tenure debates. Land claims by indigenous people across the world (DRIP goal 8.2b) are current and hotly debated issues, and audio, image and textual archives can be called into service as evidence (Koch, not dated). Traditional place names, or toponyms, have also been a source of evidence for such cultural issues, as they have been for ecological conservation.

## CULTURAL CONSERVATION: THE ROLE OF BIOLOGICAL COLLECTIONS

### Herbarium and zoological specimens

Herbarium and zoological specimens can be important tools for population and habitat modelling (Shebitz, 2005, Applequist et al., 2006) or for studying changes in the traits (Law & Salick 2005, Darimont et al., 2009) of economically useful species, suggesting potentially helpful modifications of harvest techniques. In some cases, this can mean a return to traditional harvesting methods. In response to herbarium and other evidence of shrinking populations and the increasing prevalence of less suitable traits in the overharvested basketry plant sweetgrass (*Hierochloe odorata*, formerly *Anthoxanthum nitens*), the Haudenosaunnee implemented educational programmes about traditional sustainable harvest techniques with considerable success (Shebitz, 2005).

### Xylaria as reference collections for learning about cultural artefacts

Wood specimens and their derived data have been used for a variety of cultural conservation goals (Chapter 9). These include the use of dendrochronological techniques, reference collections and chronologies to date wooden artefacts and to elucidate past species sources and regional provenance, as well as management, harvest season and construction techniques (Haneca et al., 2009). These techniques have been employed to great effect on artefacts as diverse as musical instruments (Burckle & Grissino-Mayer, 2003), architectural remains, religious and art objects, ships and book covers (Haneca et al., 2005). Further, the xylarium as a de facto collection of aging wood can form a valuable reference collection to aid in the physical conservation of culturally important wooden artefacts (Yokoyama, 2011).

### Cultural artefacts can hold unexpected data

Cultural artefacts can often hold unexpected but revealing ethnobiological data, including DNA and chemical residues. In one case, involving feathers on a Comanche spear more than a century old, DNA evidence revealed that the artefact included hawk, chicken and other bird feathers (Kerr & Voelker, 2010). This contradicted ethnographic evidence which suggested that only corvid feathers should be used in construction, allowing better insight into past practices. Residue chemicals on artefacts may also be valuable sources of information, including identification of the foods that vessels have been used to hold. For example, theobromine found on early pottery from New Mexico offers not only valuable information on food culture (in this case, cacao consumption), but also on previously unknown early North American–Mesoamerican trade routes and cultural exchanges (Crown & Hurst, 2009).

Cultural artefacts can also provide valuable insights into the former status, use and distribution of the plant species from which they are derived. They can provide valuable information to help determine whether a species was formerly native to a region, or whether it was specifically introduced for some cultural purpose. By examining the provenances and composition of cultural artefacts, species that may be rare or endangered today can sometimes be determined to have been more widespread in the past, and their cultural use may help to explain the reasons why they are currently threatened. Such information can help to suggest ways in which species recovery programs can be structured, for example, to justify the reintroduction of rare plant species to parts of their former range.

## Living collections

Many botanic gardens have been and remain active in promoting the sustainable use of biodiversity and this is often reflected in their living collections (Chapter 10). Some botanic gardens were founded to introduce and cultivate economic plants, whether they were medicinal plants in Renaissance Europe, tropical crops in the colonial era or ornamental plants more recently.

Botanic gardens maintain extensive collections and undertake research on useful plants of actual or potential value for food, agriculture, forestry, horticulture, ecological purposes (such as habitat management, restoration and reintroduction, land reclamation, soil improvement and stabilisation), amenity (display, tourism or recreation), essential oils, fuels, medicines, forages and many other purposes. Botanic gardens are also active in monitoring domestic and international trade in plants and products that is damaging or potentially unsustainable; this trade is regulated by the Convention on International Trade in Endangered Species of Fauna and Flora (CITES).

The economically important living biodiversity collections of botanic gardens represent most if not all of the major economic plant categories.

Botanic garden collections that are focused on medicinal plants are particularly widespread and historically linked to the original foundation of gardens. Many botanic gardens play an active role in studying medicinal plants and in their cultivation and conservation. Their extensive collections are easily accessed and available; for example, to support the sustainable use of medicinal plants or their used in local initiatives in primary health care, particularly in developing countries. They have also provided material for screening programmes for pharmaceutical companies and to provide material for those working to assess the value and safety of particular herbal medicines. Botanic gardens can also provide the expertise needed to improve the agronomy of cultivated medicinal plants and bring into cultivation those species needed in medicine that have not been cultivated before. Most medicinal plants are at present grown as unimproved wild plants, and so tend to be very variable. Effective plant breeding requires access to a wide range of genetic variation as starting material. Botanic gardens have an important role in the development of a gene pool of wild stock plants that can contribute to breeding programmes.

### ECONOMICALLY IMPORTANT PLANTS IN LIVE BOTANICAL GARDEN COLLECTIONS

| | |
|---|---|
| Aromatics | Invertebrate food |
| Bee plants | Medicinal plants |
| Beverages | Oils |
| Dyes and tannins | Ornamentals |
| Environmental uses | Poisons |
| Fibres and canes | Religious and ceremonial |
| Food crops (including cereals, vegetables, root crops, fruits and seeds) | Spices |
| | Timbers |
| Forage and pasture | Waxes, latex and resins |
| Fuels and fuel woods | Wild crop relatives |
| Intoxicants | Wild crops |

Specialised ethnobotany gardens not only conserve culturally significant plants but also conserve cultural practices. At the National Tropical Botanical Garden, Limahuli Garden, the ethnobotanical collection is made up of the rare varieties of crop plants that were cultivated by the early Hawaiians. These include various cultivars of taro (kalo or *Colocasia esculenta*), which are planted in carefully restored terraces, or lo'i, once used by the ancient Hawaiians. The collection also includes other early Polynesian plant introductions that were important components of daily life in pre-contact Hawai'i. Further, Limahuli Garden is actively working to use a traditional resource management system to serve as a template to preserve, nurture and perpetuate Hawaiian culture and the ecological restoration of the entire Limahuli Valley (Merrill, 2000).

Living plant collections cannot survive without significant financial commitment. The Pavlovsk Experiment Station at the Vavilov Research Institute of Plant Industry is a prime example of the threat that many ethnobotanical collections are currently facing. This station has a global seed vault holding rare, living plants — more than 6,000 varieties of fruits, berries, grasses and grains, 90% of which are not found anywhere else in the world. This diverse collection of crops offers insight into past practices and plant evolution, and holds the promise of new varieties; but despite this, a section of this station is being threatened with being sold off for housing developments (Parfitt, 2010). Public outcry has granted the Experiment Station a temporary reprieve, but without continued support, its future is unclear.

Intact traditional agroecosystems are themselves *in situ* living collections that are valuable for both biological and cultural conservation. Agroecosystems are examples of tightly coupled cultural-biological systems in which cultural knowledge and biodiversity directly affect one another. In this area, development initiatives that promote traditional farming systems not only meet cultural conservation goals but also promote the biological and genetic diversity of crops. Diverse systems that are preserved this way not only provide genetic resources for variety improvement but also tend to be more resistant to pests, pathogens and environmental changes (Altieri & Merrick, 1987). Even if only biological conservation goals are considered, preserving traditional agroecosystems rather than investing only in *ex situ* collections of germplasm remains important (Chapter 8). Traditional agroecosystems not only preserve but continually generate diversity (Achtak et al., 2010), while removing crops from their cultural context in essence results in their 'isolation from evolutionary processes' (Brush, 1989). The viability of preserving traditional agricultural ecosystems as living collections is also mathematically sound — traditional agroecosystems can be shown to be efficient when assessed on the basis of energetic and monetary inputs and outputs (Nautiyal & Kaechele, 2007). In other words, agroecosystems sustainably manage production lands and conserve crop diversity (GPSC targets 6 and 9). Even the analysis of Nautiyal & Kaechele may underestimate the cultural importance of traditional agroecosystems, which produce not only food and cash crops but also medicines, spices, building materials, firewood, animal fodder, ornamentals and religiously important plants (Altieri & Merrick, 1987; Salick & Merrick, 1990). Conservation of these systems is an immediate problem, as almost every traditional agroecosystem studied is subject to both knowledge and genetic erosion (Altieri & Merrick, 1987; Brush, 1989; Salick & Merrick, 1990; Gao, 2003; Nautiyal & Kaechele, 2007; Achtak et al., 2010).

## Archaeobiological remains

Just as old archival records can have extreme topical relevance, so even older archaeobiological remains can have modern impact on both cultural and biological conservation. In the Pacific Northwest, the ongoing policy debate and legal discourse over the resumption of native whaling is informed by numerous types of collections. One study, which combined archaeo-zoological specimens, indigenous

oral histories and the written records of early explorers, found evidence that Makah animal subsistence on marine mammals had decreased from an overwhelming dependence (92%) in the precontact period to nothing (0%) in the present day (Sepez, 2008). This is not merely a historical footnote: in the last two decades Makah whalers received a positive legal ruling on treaty rights, harvested one grey whale amid intense controversy, had a legal setback that removed their hunting privileges, and after several more years in court, illegally harvested a second whale (Sepez, 2008).

## Biocultural documentation

Biocultural documentation, of course, directly impacts the conservation of culture. The bottle gourd (*Lagenaria siceraria*) is intertwined with the rich cultural history of the Kamba people in the Kitui District of Kenya (Maffi & Woodley, 2010). Approximately 50 landraces of the gourd have 61 different major uses that include food, containers, animal traps, instruments and masks. The erosion of knowledge surrounding the uses, value, customs and local culture of the bottle gourd has accelerated with the use of plastic containers. Conservation of bottle-gourd diversity and culture is the aim of the project 'Community-based documentation of indigenous knowledge, awareness and conservation of cultural and genetic diversity of bottle gourd (*Lagenaria siceraria*) in Kitui District in Kenya'. The project has documented 200 gourd landraces for seed cataloguing and propagation in community fields. The project has also gathered information and descriptions through songs and stories in the local language. A museum now displays various types of gourd landraces, serving as a centre that distributes and stores seeds, and as an education centre for school children and visitors. The community now has motivation for conserving both the diversity of gourd landraces and their cultural practices.

## BIOLOGICAL CONSERVATION: GOALS

Global initiatives, policies and frameworks for biological conservation have been transformed over the past two decades, in particular with the adoption of the United Nations' Convention on Biological Diversity (CBD), one of a suite of new international environmental agreements agreed at the Earth Summit in Rio de Janeiro, Brazil in 1992. The CBD is now the most widely adopted international environmental convention and includes almost all of the world's countries as parties (the notable exception being the USA, which has not ratified it). The CBD has three objectives: i) conservation of biodiversity; ii) sustainable use of the components of biodiversity; and iii) equitable sharing of the benefits derived from the use of biodiversity. Although rarely stated as such by the Convention, biocultural collections can and do play an important role in facilitating the achievement of these objectives. In part this is through the use of biocultural collections to raise public awareness of the importance, diversity and vulnerability of collections derived from plant and animal material. In part, biocultural collections also provide resources for research and use in practical conservation projects. For example, there are rare and endangered plant species that have been reintroduced to the wild from zoological, botanical, seed bank and other collections, work that has been undertaken worldwide for several decades (Akeroyd & Wyse Jackson, 1995).

One excellent example of a CBD initiative that highlights the essential role of biocultural collections in biological conservation is the GSPC (Wyse Jackson & Kennedy, 2009). Adopted in 2002, the GSPC included 16 outcome-orientated targets to be achieved by 2010. In October 2010, the 10th Conference of the Parties to the CBD agreed to renew and update the GSPC for the period 2011–2020 with a series of revised targets. Biocultural collections will be invaluable to help in the achievement of several of these targets, including: 1) Target 1 on the compilation of an online world flora; 2) protection of 75% of the world's threatened plant species in *ex situ* collections; and 3) Target

13 on conserving indigenous and local knowledge associated with the use of plant resources. Indeed, the text of the GSPC makes specific reference to the importance in the achievement of the strategy of several sectors that hold biocultural collections — namely botanic gardens and gene banks, as well as other agencies and sectors that house and use biocultural collections such as universities, research institutes, networks, protected-area managers and community groups.

Some specific targets of the GSPC that are of relevance to biocultural collections include:

Target 1: An online flora of all known plants.

Target 2: An assessment of the conservation status of all known plant species, as far as possible, to guide conservation action.

Target 4: At least 15 percent of each ecological region or vegetation type secured through effective management and/or restoration.

Target 5: At least 75 percent of the most important areas for plant diversity of each ecological region protected with effective management in place for conserving plants and their genetic diversity.

Target 6: At least 75 percent of production lands in each sector managed sustainably, consistent with the conservation of plant diversity.

Target 7: At least 75 percent of known threatened plant species conserved *in situ*.

Target 8: At least 75 percent of threatened plant species in *ex situ* collections, preferably in the country of origin, and at least 20 per cent available for recovery and restoration programmes.

Target 9: 70 percent of the genetic diversity of crops including their wild relatives and other socio-economically valuable plant species conserved, while respecting, preserving and maintaining associated indigenous and local knowledge.

Target 11: No species of wild flora endangered by international trade.

Target 12: All wild harvested plant-based products sourced sustainably.

Target 13: Indigenous and local knowledge innovations and practices associated with plant resources maintained or increased, as appropriate, to support customary use, sustainable livelihoods, local food security and health care.

## BIOLOGICAL CONSERVATION: THE ROLE OF BIOLOGICAL COLLECTIONS

### Herbarium and zoological specimens

To conserve the biodiversity of an area, researchers must know the identity of the species present. Therefore, the traditional use of herbarium and zoological specimens for basic taxonomy is essential for any conservation (Mace, 2004). This goes beyond species conservation goals both upwards and downwards in scale – ecosystem conservation and genetic conservation both rely on accurate determination of organism lineages. The use of these collections for taxonomy also directly supports conservation assessments (GPSC targets 1 and 2).

Beyond this, herbarium and zoological specimens represent a massive source of primary data (the physical collections) and secondary data (associated metadata including date and location of collection, usage information, local names, and information about the collector that may indicate collection intensity or effort), amounting to hundreds of millions of herbarium and museum specimens across world repositories (Ponder et al., 2001; Miller et al., 2004; Suarez & Tsutsui, 2004; Primack & Miller-Rushing, 2009; Chapter 22). This wealth of data is increasingly being used to address vital biological

conservation goals. Invasive species, contracting ranges, climate change, diversity patterns, extinction mechanics, conservation population biology, and evolution and adaptation in response to global change are just a few among the conservation themes that collections have been used to address (Lane, 1996; Graham et al., 2004; Suarez & Tsutsui, 2004; Wandeler et al., 2007; Donaldson, 2009; Pyke & Ehrlich, 2009; Primack & Miller-Rushing, 2009; Johnson et al., 2011).   When coverage is consistent enough, population trends can be estimated from specimen data (Jeppsson et al., 2010) and can be carefully used in conservation assessments (Ponder et al., 2001; Willis & Moat, 2003). If the collections have both good coverage and intact DNA, they can also be used as DNA sources for population biology studies that look at genetic diversity within populations across long spans of time (Wandeler et al., 2007).

Collections provide historical records that allow phenotypic trends to be similarly monitored. Morphological changes in size can then be linked to correlative factors such as harvesting (McGraw, 2001; Roy et al., 2003; Law & Salick, 2005; Darimont et al., 2009) or climate change (Babin-Fenske et al., 2008), and this information can be fed into conservation strategies. When the metadata associated with specimens includes the date of collection, long-term changes in phenology can be inferred in the same way, and linked to local or regional changes in climate (Lavaoie & Lachance, 2006; Miller-Rushing et al., 2006; Bowers, 2007), or to local land-use effects such as urban heat islands (Primack & Miller-Rushing, 2009). Likewise, when metadata include accurate location and elevation information, specimens can inform habitat-based predictive modelling and can offer information about range shifts (Elith et al., 2006; Tingley & Beissinger, 2009; Johnson et al., 2011) tied to climate change or land use.

Herbaria, zoological collections and xylaria also serve as important reference collections for identifying and providing provenance for plant and animal products and for preventing trade in endangered species (GSPC, target 11; Parham et al., 2001; Mace, 2004; Donaldson, 2009).

## BIOLOGICAL CONSERVATION: ROLE OF CULTURAL COLLECTIONS

### Biocultural documentation: taxonomies and toponyms

Documentation of ethnotaxonomies — the categories into which people place living organisms — can also inform conservation. Often, these categories provide insights into qualities that are valued by local people. These categories can match poorly with the evolutionary or genetic taxonomies derived from common ancestry. For instance, the basic grammatical distinction the Kayardild of Australia make between edible and non-edible plants matches poorly with our concept of Linnaean phyla but has clear utility in the local context (Harrison, 2007). In certain cases, however, indigenous taxonomies are nearly identical to those based on the newest DNA evidence (Chapters 7 and 21), appearing to anticipate 'cryptic' species that were lumped under older scientific taxonomies (Harrison, 2007; Newmaster & Ragupathy, 2010). Indigenous taxonomies may also offer hypotheses that can be tested to help reach goals related to scientific taxonomy (Newmaster & Ragupathy, 2010; GSPC, target 1). This is no mystery — indigenous and local people are long-term and minute observers of nature, and where indigenous taxa are based on the recognition of morphological or ecological details, these details can reveal underlying lineage distinctions. For instance, one high-profile report of a 'cryptic' species discovery in a heavily studied clade of butterflies found, after the fact, that larval morphology and herbivory patterns varied greatly, although the adult specimens with which previous taxonomists had worked were nearly identical (Hebert et al., 2004; Brower, 2006). This is a case in which collections that are thought of as cryptic, in the context of the (usually adult) butterfly museum, might be obvious to local farmers who see larval forms as more important, be they crop pests, food or simply stinging annoyances:

'The classificatory detail applied is clearly in large part a function of practically motivated interests in the Tzeltal case, but of a compulsion for intellectual order on the part of the civilized butterfly fancier.'                                                                                                      (Hunn, 1982)

Traditional place-names, or toponyms, can also reveal the ecological history of an area. Like taxonomies, toponyms can represent ecological knowledge packaged in language (Harrison, 2007). For instance, although yew (*Taxus baccata*) is now rare in Ireland, the large number and wide dispersal of old Irish toponyms agree with palynological data showing that this culturally important tree was once wide-spread in the country (Delahunty, 2007). Most of these toponyms are now lost, so archival collections were vital in this study.

Another example from Ireland is that of *Arbutus unedo* (Wyse Jackson, unpublished), a rare tree species now recorded mainly in the south west of the country. Nevertheless, the Irish name of this tree, '*caithne*', is included in several place names in regions of Ireland where there are no historic records of this species; for example, Ard na Connia (Ard-na-caithne) is the Irish name for the village of Smerwick, County Kerry.

## Biocultural documentation: oral, textual and image records document long-term change

Oral histories are another way to access and store the decades of careful field observation that local and indigenous people hold. These histories have proven to be increasingly valuable as global change studies gain immediacy (GPSC target 2, and to the extent that climate-driven shifts in habitat should inform conservation areas, also targets 5 and 7). Although such methodology has global applicability, it has been used especially among the indigenous peoples of the North American arctic and subarctic region (Orlove & Brush, 1996; Cruikshank, 2001; Berkes, 2002; Hunn et al., 2003). In combination with textual and image records from early-contact Europeans, oral histories can offer insight into long-term change in natural features as diverse as landscape structure (e.g. glacial retreat), range changes (e.g. treeline advance) and animal behaviour (e.g. migration patterns of birds or large mammals) (Cruikshank, 2005; Baker & Moseley, 2007; Byg & Salick, 2009; Salick & Ross, 2009). Especially for highly visited, culturally salient sites, image archives have also been important sources of data for studies that document long-term phenological change (Miller-Rushing et al., 2006).

Textual records, especially harvest and nature festival records, have also proven to be a valuable source with which to examine the effects of climate change on biological systems. Although there may be difficulties in interpreting these data sets, they can offer both great detail and great range, often stretching over many centuries. Written harvest records, supplemented by oral histories and herbarium or zoological collections, can also provide other sources of information, including data on harvest-driven selection (McGraw, 2001; Law & Salick, 2005; Darimont et al., 2009), over-harvest and extinction mechanics (Turvey & Risley, 2006).

Since the 1980s, European grape harvest records, stretching from medieval to contemporary periods, have been used as proxies for climate (Meier et al., 2007; Etien et al., 2009). Direct use of these records has been criticised because harvest date is not simply a function of the relationship between grape and climate, but of course depends on historical events, harvest technologies and human custom. Some of the newest papers examine harvest date time series as coupled systems involving climate, humans and grapes, and augment harvest records with other archival collection types as diverse as personal diaries, political memoranda and religious records (Garnier et al., 2011).

Another area of research in which textual collections have been used to study phenology is cherry blossoming in Japan. The blossoming of *Prunus jamasakura*, which strongly correlates with

spring temperatures, has been culturally important in Japan for centuries. The longest time series dates back to the 8th century, and draws upon official chronicles, newspapers, poems and diaries kept by 'emperors, aristocrats, politicians, monks and merchants' (Aono & Kazui, 2008). As important as proxy records for climate are, recent studies also go beyond simply turning plants into weather stations. Primack et al. (2009) expand upon this literature to examine the effects of urban heat islands — an important factor for many plants in rapidly urbanising Japan — and differential effects among *Prunus* species and among individuals within species.

## CONCLUSIONS

Many of the positive conservation results that we've reviewed in this chapter would not have been possible without significant resources, effort and luck involved in the preservation and maintenance of the collections. Biocultural collections with great potential for conservation have not always been so lucky. We have noted the rich but threatened resources of the Pavlovsk Experiment Station. Although its collections remain safe for now, the Garrigala Turkmen Experimental Agricultural Station did not receive such a reprieve. It once housed the world's largest collection of pomegranates, 1,117 varieties from 27 countries, amassed over 40 years by Dr Gregory M. Levin. After state funding for research expired, the Turkmen government bulldozed the research station (Levin, 2006).

Even with sufficient funding, informed curation strategies are vital to the continued preservation of collections. Further, preservation of collections has less value without proactive measures to make collections accessible and to disseminate collection metadata (Chapter 11). Today, this effectively means resource-intensive efforts in digitisation and database construction, which are especially important as automated technologies allow utilisation of massive data sets. No less important are more traditional avenues of access such as exhibits (Chapter 26) and education programmes (Chapter 24).

Of course, the accessibility and dissemination of both cultural and biological collections relies on careful attention to intellectual and other property rights, permissions, treaties, laws and cultural norms – often a challenge as great as that of preserving and disseminating the collections (Anderson & Koch, 2003; Secretariat of the Convention on Biological Diversity, 2011; Chapter 16).

## Literature cited

Achtak, H., Ater, M., Oukabli, A., Santoni, S., Kjellberg, F. & Khadari, B. (2010). Traditional agroecosystems as conservatories and incubators of cultivated plant varietal diversity: the case of fig (*Ficus carica* L.) in Morocco. *BMC Plant Biology* 10: 28.

Aiona, K., Balick, M. J., Bennett, B. C., Bridges, K., Burney, D., Burney, L. P., Bye, R. A., Dunn, L., Emshwiller, E., Eubanks, M., Flaster, T., Kauka, S., Lentz, D. L., Linares, E., Lorence, D. H., McClatchey, W., McMillen, H., Merlin, M., Miller, J. S., Moerman, D. E., Prance, G. T., Prance, A. E., Ragone, D., Urban, T., Van Dyke, P., Wagner, W., Whistler, W. A., Wichman, C. R., Wichman, H., Winter, K., Wiseman, J., Wysong, M. & Yamamoto, B. (2007). Ethnobotany, the science of survival: a declaration from Kaua'i. *Economic Botany* 61: 1–2.

Akeroyd, J. & Wyse Jackson, P. (1995). *A Handbook for Botanic Gardens on the Reintroduction of Plants to the Wild*. Botanic Gardens Conservation International, Kew.

Altieri, M. A. & Merrick, L. C. (1987). *In situ* conservation of crop genetic resources through maintenance of traditional farming systems. *Economic Botany* 41: 86–96.

Anderson, J. & Koch, G. (2003). The politics of context: issues for law, researchers and the creation of databases. In: *Researchers, Communities, Institutions, Sound Recordings*, eds L. Barwick, A. Marett, & A. Harris. Faculty of Arts, University of Sydney, Sydney. http://ses.library.usyd.edu.au/handle/2123/1513

Aono, Y. & Kazui, K. (2008). Phenological data series of cherry tree flowering in Kyoto, Japan, and its application to reconstruction of springtime temperatures since the 9th Century. *International Journal of Climatology* 28: 905–914.

Applequist, W. L., Mcglinn, D. J., Miller, M., Long, Q. G. & Miller, J. S. (2006). How well do herbarium data predict the location of present populations? A test using *Echinacea* species in Missouri. *Biodiversity and Conservation* 16: 1397–1407.

Babin-Fenske, J., Anand, M. & Alarie, Y. (2008) Rapid morphological change in stream beetle museum specimens correlates with climate change. *Ecological Entomology* 33: 646–651.

Baker, B. B. & Moseley, R. K. (2007). Advancing treeline and retreating glaciers: implications for conservation in Yunnan, P.R. China. *Arctic, Antarctic, and Alpine Research* 39: 200–209.

Balick, M. J. (1996). Transforming ethnobotany for the New Millennium. *Annals of the Missouri Botanical Garden* 83: 58–66.

Berkes, F. (2002). Adapting to climate change: social-ecological resilience in a Canadian western Arctic community. *Conservation Ecology* 5 (2): 18.

Berkes, F. & Folke, C. (eds) (2000). *Linking Social and Ecological Systems: Management Practices and Social Mechanisms for Building Resilience*. Cambridge University Press, Cambridge.

Bowen-Jones, E. & Entwistle, A. (2002). Identifying appropriate flagship species; the importance of culture and local contexts. *Oryx* 36: 189–195.

Bowers, J. E. (2007). Has climatic warming altered spring flowering date of Sonoran Desert shrubs? *The Southwestern Naturalist* 52: 347–355.

Bowman, D. M. J. S. (1998). The impact of aboriginal landscape burning on the Australian biota. *New Phytologist* 140: 385–410.

Brower, A. V. Z. (2006). Problems with DNA barcodes for species delimitation: 'ten species' of *Astraptes fulgerator* reassessed (Lepidoptera: Hesperiidae). *Systematics and Biodiversity* 4: 127–132.

Brush, S. B. (1989). Rethinking crop genetic resource conservation. *Conservation Biology* 3:19–29.

Burckle, L. & Grissino-Mayer, H. D. (2003). Stradivari, violins, tree rings, and the Maunder Minimum: a hypothesis. *Dendrochronologia* 21:41–45.

Byg, A. & Salick, J. (2009). Local perspectives on a global phenomenon — climate change in eastern Tibetan villages. *Global Environmental Change* 19: 156–166.

Costanza, R., D'Arge, R., De Groot, R., Farber, S., Grasso, M., Hannon, B., Limburg, K., Naeem, S., O'Neill, R. V., Paruelo, J., Raskin, R. G., Sutton, P. & Van Den Belt, M. (1997). The value of the world's ecosystem services and natural capital. *Nature* 387: 253–260.

Crown, P. L. & Hurst, W.J. (2009). Evidence of cacao use in the Prehispanic American Southwest. *Proceedings of the National Academy of Sciences of the United States of America* 106: 2110–2113.

Cruikshank, J. (2001). Glaciers and climate change: perspectives from oral tradition. *Arctic* 54: 377–393.

Cruikshank, J. (2005). *Do Glaciers Listen? Local Knowledge, Colonial Encounters, and Social Imagination.* University of British Columbia Press, Vancouver.

Dalle, S. P. & Potvin, C. (2004). Conservation of useful plants: an evaluation of local priorities from two indigenous communities in eastern Panama. *Economic Botany* 58: 38–57.

Darimont, C. T., Carlson, S. M., Kinnison, M. T., Paquet, P. C., Reimchen, T. E. & Wilmers, C. C. (2009). Human predators outpace other agents of trait change in the wild. *Proceedings of the National Academy of Sciences of the United States of America* 106: 952–954.

Delahunty, J. L. (2007). The ethnobotanical history and Holocene extent of yew (*Taxus baccata* L.) on the Irish landscape. *Journal of Ethnobiology* 27: 204–217.

Donaldson, J. S. (2009). Botanic gardens science for conservation and global change. *Trends in Plant Science* 14: 608–613.

Elith, J., Graham, C. H., Anderson, R. P., Dudík, M., Ferrier, S., Guisan, A., Hijmans, R. J., Huettmann, F., Leathwick, J. R., Lehmann, A., Li, J., Lohmann, L. G., Loiselle, B. A., Manion, G., Moritz, C., Nakamura, M., Nakazawa, Y., Overton, J. McC. M., Townsend Peterson, A., Phillips, S. J., Richardson, K., Scachetti-Pereira, R., Schapire, R. E., Soberón, J., Williams, S., Wisz, M. S. & Zimmermann, N. E. (2006). Novel methods improve prediction of species' distributions from occurrence data. *Ecography* 29: 129–151.

Ellis, E. C. & Ramankutty, N. (2008). Putting people in the map: anthropogenic biomes of the world. *Frontiers in Ecology and the Environment* 6: 439–447.

Etien, N., Daux, V., Masson-Delmotte, V., Mestre, O., Stievenard, M., Guillemin, M. T., Boettger, T., Breda, N., Haupt, M. & Perraud, P. P. (2009). Summer maximum temperature in northern France over the past century: instrumental data versus multiple proxies (tree-ring isotopes, grape harvest dates and forest fires). *Climatic Change* 94: 429–456.

Gao, L. (2003). The conservation of Chinese rice biodiversity: genetic erosion, ethnobotany and prospects. *Genetic Resources and Crop Evolution* 50: 17–32.

Garibaldi, A. & Turner, N. (2004). Cultural keystone species: implications for ecological conservation and restoration. *Ecology and Society* 9 (3): 1.

Garnier, E., Daux, V., Yiou, P. & de Cortázar-Atauri, I. G. (2011). Grapevine harvest dates in Besançon (France) between 1525 and 1847: social outcomes or climatic evidence? *Climatic Change* 104: 703–727.

Glaser, B. & Woods, W. I. (eds) (2004). *Amazonian Dark Earths: Explorations in Space and Time.* Springer, Berlin.

Gómez-Pompa, A. & Kaus, A. (1992). Taming the wilderness myth. *BioScience* 42: 271–279.

Gorringe, J. & Gough, J. (2009). *Tayenebe: Tasmanian Aboriginal Women's Fibre Work.* Tasmanian Museum and Art Gallery, Hobart.

Graham, C. H., Ferrier, S., Huettman, F., Moritz, C. & Peterson, A. T. (2004). New developments in museum-based informatics and applications in biodiversity analysis. *Trends in Ecology & Evolution* 19: 497–503.

Haneca, K., Cufar, K. & Beeckman, H. (2009). Oaks, tree-rings and wooden cultural heritage: a review of the main characteristics and applications of oak dendrochronology in Europe. *Journal of Archaeological Science* 36: 1–11.

Haneca, K., De Boodt, R., Herremans, V., De Pauw, H., Van Acker, J., Van de Velde, C. & Beeckman, H. (2005). Late Gothic altarpieces as sources of information on medieval wood use: a dendrochronological and art historical survey. *IAWA Journal* 26: 273–298.

Harrison, K. D. (2007). *When Languages Die: The Extinction of the World's Languages and the Erosion of Human Knowledge*. Oxford University Press, New York.

Hayashida, F. M. (2005). Archaeology, ecological history, and conservation. *Annual Review of Anthropology* 34: 43–65.

Hebert, P. D. N., Penton, E. H., Burns, J. M., Janzen, D. H. & Hallwachs, W. (2004). Ten species in one: DNA barcoding reveals cryptic species in the Neotropical skipper butterfly *Astraptes fulgerator*. *Proceedings of the National Academy of Sciences of the United States of America* 101: 14812–14817.

Hinton, L. (1994). *Flutes of Fire: Essays on California Indian Languages*. Borgo Press, San Bernardino.

Hinton, L. & Hale, K. (eds) (2001). *The Green Book of Language Revitalization in Practice*. Academic Press, San Diego.

Hunn, E. (1982). The utilitarian factor in folk biological classification. *American Anthropologist* 84: 830–847.

Hunn, E. S., Johnson, D. R., Russell, P. N. & Thornton, T. F. (2003). Huna Tlingit traditional environmental knowledge, conservation, and the management of a 'Wilderness' park. *Current Anthropology* 44: S79–S103.

Jeppsson, T., Lindhe, A., Gärdenfors, U. & Forslund, P. (2010). The use of historical collections to estimate population trends: a case study using Swedish longhorn beetles (Coleoptera: Cerambycidae). *Biological Conservation* 143: 1940–1950.

Johnson, K. G., Brooks, S. J., Fenberg, P. B., Glover, A. G., James, K. E., Lister, A. M., Michel, E., Spencer, M., Todd, J. A., Valsami-Jones, E., Young, J. & Stewart, J. R. (2011). Climate change and biosphere response: unlocking the collections vault. *BioScience* 61: 147–153.

Kerr, K. C. R. & Voelker, W. (2010). Molecular identification of feathers from a Comanche artifact. *Journal of Ethnobiology* 30: 231–239.

Kimmerer, R. W. & Lake, F. K. (2001). The role of indigenous burning in land management. *Journal of Forestry* 99: 36–41.

Koch, G. (not dated). *Cultural Conservation: a Two-way Consultation*. www.folklife.si.edu/resources/unesco/koch.htm

Lane, M. A. (1996). Roles of natural history collections. *Annals of the Missouri Botanical Garden* 83: 536–545.

Lavoie, C. & Lachance, D. (2006). A new herbarium-based method for reconstructing the phenology of plant species across large areas. *American Journal of Botany* 93: 512–516.

Law, W. & Salick, J. (2005). Human-induced dwarfing of Himalayan snow lotus, *Saussurea laniceps* (Asteraceae). *Proceedings of the National Academy of Sciences of the United States of America* 102: 10218–10220.

Levin, G. M. (2006). *Pomegranate Roads: a Soviet Botanist's Exile From Eden*. Floreant Press, Forestville.

Liu, J., Dietz, T., Carpenter, S. R., Alberti, M., Folke, C., Moran, E., Pell, A. N., Deadman, P., Kratz, T., Lubchenco, J., Ostrom, E., Ouyang, Z., Provencher, W., Redman, C. L., Schneider, S. H. & Taylor, W. W. (2007). Complexity of coupled human and natural systems. *Science* 317: 1513–1516.

Mace, G. M. (2004). The role of taxonomy in species conservation. *Philosophical Transactions of the Royal Society B. Biological Sciences* 359: 711–719.

Maffi, L. (2005). Cultural, linguistic, and biological diversity. *Annual Review of Anthropology* 34: 599–617.

Maffi, L. & Woodley, E. (2010). *Biocultural Diversity Conservation: A Global Sourcebook*. Earthscan, London.

McGraw, J. B. (2001). Evidence for decline in stature of American ginseng plants from herbarium specimens. *Biological Conservation* 98: 25–32.

Meier, N., Rutishauser, T., Pfister, C., Wanner, H. & Luterbacher, J. (2007). Grape harvest dates as a proxy for Swiss April to August temperature reconstructions back to AD 1480. *Geophysical Research Letters* 34 (20). www.agu.org/pubs/crossref/2007/2007GL031381.shtml

Merrill, N. (2000). *Limahuli Garden: a Window to Ancient Hawai'i*. The Garden, Hanalei.

Mertz, O., Ravnborg, H. M., Lövei, G. L., Nielsen, I. & Konijnendijk, C. C. (2007). Ecosystem services and biodiversity in developing countries. *Biodiversity and Conservation* 16: 2729–2737.

Miller, B., Conway, W., Reading, R. P., Wemmer, C., Wildt, D., Kleiman, D., Monfort, S., Rabinowitz, A., Armstrong, B. & Hutchins, M. (2004). Evaluating the conservation mission of zoos, aquariums, botanical gardens, and natural history museums. *Conservation Biology* 18: 86–93.

Miller-Rushing, A., Primack, R. B., Primack, D. & Mukunda, S. (2006). Photographs and herbarium specimens as tools to document phenological changes in response to global warming. *American Journal of Botany* 93: 1667–1674.

Nautiyal, S. & Kaechele, H. (2007). Conservation of crop diversity for sustainable landscape development in the mountains of the Indian Himalayan region. *Management of Environmental Quality* 18: 514–530.

Newmaster, S. G. & Ragupathy, S. (2010). Ethnobotany genomics — discovery and innovation in a new era of exploratory research. *Journal of Ethnobiology and Ethnomedicine* 6: 2.

Orlove, B. S. & Brush, S. B. (1996). Anthropology and the conservation of biodiversity. *Annual Review of Anthropology* 25: 329–352.

Parfitt, T. (2010). Pavlovsk's hopes hang on a tweet. *Science* 329: 899.

Parham, J. F., Simison, W. B., Kozak, K. H., Feldman, C. R. & Shi, H. (2001). New Chinese turtles: endangered or invalid? A reassessment of two species using mitochondrial DNA, allozyme electrophoresis and known-locality specimens. *Animal Conservation* 4: 357–367.

Ponder, W. F., Carter, G. A., Flemons, P. & Chapman, R. R. (2001). Evaluation of museum collection data for use in biodiversity assessment. *Conservation Biology* 15: 648–657.

Primack, R. B., & Miller-Rushing, A. J. (2009). The role of botanical gardens in climate change research. *New Phytologist* 182: 303–313.

Primack, R. B., Higuchi, H. & Miller-Rushing, A. J. (2009). The impact of climate change on cherry trees and other species in Japan. *Biological Conservation* 142: 1943–1949.

Pyke, G. H. & Ehrlich, P. R. (2009). Biological collections and ecological/environmental research: a review, some observations and a look to the future. *Biological Reviews of the Cambridge Philosophical Society* 85: 247–266.

Roy, K., Collins, A. G., Becker, B. J., Begovic, E. & Engle, J. M. (2003). Anthropogenic impacts and historical decline in body size of rocky intertidal gastropods in southern California. *Ecology Letters* 6: 205–211.

Salick, J. & Byg, A. (2007). *Indigenous Peoples and Climate Change*. Tyndall Centre for Climate Change Research, Oxford.

Salick, J. & Merrick, L. (1990). Use and maintenance of genetic resources: crops and their wild relatives. In: *Agroecology*, eds C. R. Carroll, J. H. Vandermeer and P. Rosset, pp. 517–548. McGraw-Hill, New York.

Salick, J. & Ross, N. (2009). Traditional peoples and climate change. *Global Environmental Change* 19: 137–139.

Secretariat of the Convention on Biological Diversity (2011). *Nagoya Protocol on Access to Genetic Resources and the Fair and Equitable Sharing of Benefits Arising From Their Utilization to the Convention on Biological Diversity*. www.cbd.int/abs/

Sepez, J. (2008). Historical ecology of Makah subsistence foraging patterns. *Journal of Ethnobiology* 28: 110–133.

Shackeroff, J. (2007). Traditional ecological knowledge in conservation research: problems and prospects for their constructive engagement. *Conservation and Society* 5: 343–360.

Shebitz, D. (2005). Weaving traditional ecological knowledge into the restoration of basketry plants. *Journal of Ecological Anthropology* 9: 51–68.

Stepp, J. R., Castaneda, H. & Cervone, S. (2005). Mountains and biocultural diversity. *Mountain Research and Development* 25: 223–227.

Suarez, A. V. & Tsutsui, N. D. (2004). The value of museum collections for research and society. *BioScience* 52: 66–74.

Thomson, R. (2009). *A Collection of Native Crafts Donated to the Museum of North Beach*. www.indiancountrynews.com/index.php/casinostourism-sections-menu-75/6504-a-collection-of-native-crafts-donated-to-the-museum-of-north-beach

Tingley, M. W. & Beissinger, S. R. (2009). Detecting range shifts from historical species occurrences: new perspectives on old data. *Trends in Ecology & Evolution* 24: 625–633.

Turner II, B. L., Clark, W. C., Kates, R. W., Richards, J. F., Mathews, J. T. & Meyer, W. B. (eds) (1990). *The Earth as Transformed by Human Action: Global and Regional Changes in the Biosphere over the Past 300 Years*. Cambridge University Press, Cambridge.

Turvey, S. T. & Risley, C. L. (2006). Modelling the extinction of Steller's sea cow. *Biology Letters* 2: 94–97.

United Nations (2008). *United Nations Declaration on the Rights of Indigenous People*. www.un.org/esa/socdev/unpfii/documents/DRIPS_en.pdf

Wandeler, P., Hoeck, P. E. A. & Keller, L. F. (2007). Back to the future: museum specimens in population genetics. *Trends in Ecology and Evolution* 22: 634–642.

Ware, C. *Half-Hitch Palmetto Basket by Janie Luster*. www.louisianafolklife.org/FOLKLIFEimagebase/FLImagesListing.asp?Page=78

Willis, F. & Moat, J. (2003). Defining a role for herbarium data in Red List assessments: a case study of *Plectranthus* from eastern and southern tropical Africa. *Biodiversity and Conservation* 12: 1537–1552.

Wyse Jackson, P. & Kennedy, K. (2009). The Global Strategy for Plant Conservation: a challenge and opportunity for the international community. *Trends in Plant Science* 14: 578–580.

Yokoyama, M. (2011). Evaluation of aging wood from Japanese historical buildings. *Sustainable Humanosphere* 3: 9. www.rish.kyoto-u.ac.jp/W/LBMI/research31_e.html

# Using biocultural collections for education

CATRINA T. ADAMS

Botanical Society of America

GAYLE J. FRITZ

Washington University in St. Louis

## BENEFITS AND DRAWBACKS TO USING
## BIOCULTURAL COLLECTIONS FOR EDUCATION

Collections of biological materials and archaeological and ethnographic artefacts are a wonderful resource for education on a diverse array of topics. Ethnobiology links disciplines as wide-ranging as ecology, biology, history, archaeology, sociology, current events and economics. As the 2007 Kaua'i Declaration puts it, 'ethnobotany is the science of survival' (Aiona et al., 2007). The same can be said for ethnozoology and other fields of ethnobiology. Because of the breadth of topics that relate to collections of ethnobiological materials, and the intrinsic relevance they hold to basic quality of life in the past, present and future, potential for public interest is very high.

Since the mid-1980s museums have become more focused on extending educational programming associated with collections of all kinds. They have extended the diversity of the communities they serve, by creating stronger partnerships with local schools and by incorporating educational theory into the development of curricula and exhibit design (MacFarlan, 2001). As part of the 2003 'Intellectual Imperatives in Ethnobiology', a call to ethnobiologists was made to encourage the development of educational materials that focus on local knowledge, skill development from many disciplines, and the involvement of students in significant research experiences at younger ages (Ethnobiology Working Group, 2003).

Students who are allowed to work directly with collections gain a great deal if their studies are properly managed. The ability to collect data from museum collections and to pursue their own research questions and direct their own learning by designing and carrying out research using collections has broad benefits to their ability for critical thinking (National Science Foundation, 1997), as well as instilling in them a respect for the collection, its conservation, the importance of record-keeping and so on. It is also a way for students with diverse interests in the sciences, social sciences and humanities to have a chance to explore career options that involve collections, whether as museum professionals or academics.

At a broader level, developing curricula and programmes based upon examining artefacts or replicas of artefacts from ethnobiological collections, as well as conducting research using collections or exploring traditional crafts featuring ethnobiological raw materials, can enhance students' cultural exposure and their respect for traditional ecological knowledge and the conservation of resources. These activities also develop multidisciplinary skills, and encourage students to think about place-based knowledge and how plants and animals are used in different cultures around the world, as well as in local communities (Nguyen et al., 2008; Ethnobiology Working Group, 2003).

## Teaching collections, benefits and drawbacks

Despite the significant benefits that can be obtained by using collections for education, there are some drawbacks to using collections in this way. By exposing collections to inexpert handling, there is a greater risk of potential damage and of loss of the associated provenance of materials. Providing access to collections can potentially have costs associated with increased conservation requirements, display of artefacts, and staff time to provide supervision and access. Staffing and funding concerns are two major factors limiting the extent to which educational programmes can be instituted using a collection. There are also safety concerns that can become an issue when using an ethnobiological collection for education, including issues relating to the safety of exposure to potentially hazardous residues from past treatment of artefacts. It can be helpful to catalogue and have a way of advertising potential safety concerns about certain materials that can be present in a collection (Suits, 1998; Kubiatowicz & Benson, 2003).

In many institutions, subsets of a collection have been specifically assigned as 'teaching collections' or 'handling collections'. These are often composed of unprovenanced or deaccessioned materials from the collection. In a number of cases, such 'educational collections' lack a unifying theme or a systematic plan for acquisition or deaccessioning, and they may have suffered from curatorial neglect (MacFarlan, 2001; Johnson & MacFarlan, 2004). Teaching collections can be in poor condition, and are subject to handling and wear that can quickly render them useless for any purpose. In some cases, it might be possible to reprovenance this material using field notes or other archival records. Using artefacts that may have research value in such a way can result in the eventual destruction of these objects. Care should be taken to evaluate teaching collections, and to curate them with thought to selecting objects with a view to the teaching value of the artefacts and the collection as a whole, as well as to stabilising and maintaining objects that will be used in such a hands-on way in a safe manner (Suits, 1998; MacFarlan, 2001; Johnson & MacFarlan, 2004; Pye, 2007; Chatterjee, 2008).

In summary, there are many trade-offs that exist when deciding how best to share a collection with the public or with students. Damage to a collection must be balanced with reaching a wide and diverse audience. The decision to use actual artefacts or reproductions in teaching collections depends on the trade-offs between giving students a hands-on experience and giving students a chance to work with authentic materials. Reaching out to new audiences and providing extended programmes surrounding a collection must be balanced with the staff time and financial resources needed for other areas of collection management.

In this chapter, we address three separate potential educational sectors for programmes related to ethnobiological collections: informal education, primary and secondary education, and higher education. We address some of the different ways that collections have been used to reach each of these audiences. We aim to provide suggestions for best practices, we talk about some of the challenges inherent in working with these different groups, and we provide examples that show educational programmes in use at several different institutions. We conclude with a look to the future of collections in education, and give some tips for preparing educational resources involving ethnobiological collections.

## BIOCULTURAL COLLECTIONS FOR INFORMAL EDUCATION: EXHIBITS, TOURS AND COMMUNITY OUTREACH

Ethnobiological collections are uniquely positioned to draw interest from a community because of their cross-disciplinary appeal and the way that plants and animals relate to the everyday needs of humans in every culture. Ethnobiology can be a way to bring communities closer together, to preserve community plant or animal knowledge, and to encourage cross-cultural understanding and respect.

## Exhibits

One popular form of public outreach is exhibits: large or small, permanent or temporary, local, travelling or virtual. Exhibits are an excellent way of using collections to tell a compelling story about human ingenuity, biodiversity, and plant and animal use around the globe. Suggestions for creating exhibits and successfully creating interpretive stories surrounding biocultural collections are included elsewhere in this volume (Chapter 25). Living collections can also be venues for exhibiting information about ethnobiology using signage or exhibits. Designing and following a well-thought-out interpretive storyline when developing signage for living collections can be a much more powerful way of connecting with visitors than simply providing a list of historic uses on a plant label (Chapter 10).

### Movable interpretive carts at the Missouri Botanical Garden

The education division at the Missouri Botanical Garden makes use of travelling interpretive carts placed in different high-traffic areas of the garden during peak hours as a way of interacting with guests of all ages, enhancing learning, and engaging visitors in conversations about plants and their importance to cultures around the world. The volunteer interpreter programme began at the Botanical Garden in 1999 as a drop-in educational experience for visitors. Volunteers use carts with simple props and activities to inform visitors about various plant and garden subjects. In 2008, the carts were renamed 'Germination Stations' and continue to enrich visitors' experiences with discovery and learning. These carts are staffed by adult or high-school-aged education volunteers and are themed on the basis of their location within the garden (Figure 1). The carts link the living collections of

**Figure 1.** Rainforest interpretive cart at the Missouri Botanical Garden staffed by a high-school-aged volunteer. Participating visitors identify spices by scent. © MISSOURI BOTANICAL GARDEN.

the Botanical Garden with topics in biology, ecology, conservation, history, culture and art. Many of the carts include biocultural items. For example, a rainforest cart that can be found outside the Garden's Climatron includes tropical products and sensory items (e.g. spices for visitors to identify by scent), as well as activities designed to help visitors tie the plants they have just seen (or are about to see) with their own experiences in using these plants, or with information about how people from other cultures use these plants in their daily lives. The carts are located throughout the gardens and are exposed to a wide range of environmental conditions, which does put stress on the objects. This method of interpretation would not be a good choice for museum objects or artefacts. The carts are considered 'drop-in' interpretation opportunities, where guests can stop by to look briefly and stay as long as their interest is maintained.

## Tours

Tours of collections are another way to meet the public's interest in biocultural collections. These may be advertised regular or sporadic public tours with volunteer or staff guides or tours for interested members of the public that are arranged by appointment. Behind-the-scenes tours for special events can be led by specially trained volunteers. For example, volunteers working in pairs (to help ensure timely movement of the group and aid security), with groups of no more than 15, led tours of the Economic Botany Collection during Kew's 250th anniversary year. Biocultural collections are often of special interest to local artists and craftspeople who work in similar media. Close study of artefacts

**Figure 2.** A school group visiting Shaw Nature Reserve matches prairie plants with medicinal uses along a prepared trail.
© SHAW NATURE RESERVE.

in these collections can be greatly beneficial to those visiting, and in return the specialised knowledge of the media held by these visitors can often also be beneficial to curators and researchers. Skilled visitors can become valuable collaborators who contribute ideas that may help to explain how artefacts are made, who might make suggestions about repairs, or who may be contracted to create replicas of fragile pieces for educational use or display. Tours that are run for university students can both provide a valuable educational experience and be a means of recruiting students for collections-based dissertation projects and internships. Tours that (subtly!) feature research or conservation projects in need of funding can lead to unsolicited donations to fund such work. Although many museum collection storage spaces were not designed to accommodate groups, research has shown that the attitude of museum management is far more important in determining whether behind-the-scenes areas are opened to visitors than are other restricting factors (Keene et al., 2008).

### Ethnobiological tours and classes using living collections

Shaw Nature Reserve (SNR) is an extension of the Missouri Botanical Garden that features 2,500 acres of natural Ozark landscape and managed plant collections. Located 35 miles south-west of St. Louis in Gray Summit, Missouri, it provides a variety of public and school programming for visitors. Ethnobiological topics are integrated within themed classes or tours. For example, several classes and tours featuring SNR's prairie ecosystem include information on plant-based medicine, natural dyes, historic prairie housing construction and the historic uses of buffalo. Tours of the living collections are integral to nearly all classes and programmes at SNR, and are held for adults, families, school groups and teacher development.

One example of an activity used to introduce plant-based medicines at SNR is a 'medicinal plant trail'. In this activity, laminated cards are pinned to medicinally valuable prairie plants along a section of trail (Figure 2). The cards include an image and description of a plant on one side and the procedures for preparing and using the plant as medicine on the other. A matching set of cards with a duplicate image and description on one side and a symptom or disease on the other are passed out to visitors, who then attempt to match their card to the appropriate plant and learn how the plant is used to treat the symptom or disease. This activity is prepared at two different education levels, one (picture-based) for use with elementary grades and one (including more detailed text) for use with middle school through adult audiences. The activity has been used with school tours, as a drop-in activity for families during large events and at teacher development workshops. A similar activity involving laminated images and descriptions of Chumash ethnobotanical plants is also offered successfully in the gardens at the Santa Barbara Museum of Natural History (pers. comm. Jan Timbrook, July 2011).

Adult and family classes on Native American and pioneer medicine, edible wild plants, herbal soap making and natural dyeing are some of the ethnobiological programming available at Shaw Nature Reserve (Figure 3). Many of these classes involve tours of the living collections.

## Community outreach

A third form of public education, one that is increasingly felt as a responsibility of collection holders, is community outreach, both among the communities where the collections are obtained and the communities that surround the collection itself. Both sets of communities often find that biocultural collections are an important way for them to reconnect with plant use or animal use in their own families or neighbourhoods. Several botanical gardens have launched successful campaigns to provide outreach to communities, with the explicit aim of educating communities in sustainable plant use and to reconnect communities with their own ethnobotanical knowledge. Community outreach of this

**Figure 3.** Sod house built at Shaw Nature Reserve aids in interpretation of the human aspect of prairie life. © SHAW NATURE RESERVE.

sort creates a reciprocal relationship between the collection management and the community, with information going back and forth between the researchers and curators of the exhibit and members of the community. All members of the community are encouraged to seek out biocultural knowledge within the community, and that information can then be reincorporated within the collection's scope (Linares et al., 1999; Atiti, 2011).

The Royal Botanic Gardens, Kew, has set up an educational website '*Plant Cultures: Exploring Plants and People*' that addresses the connections between South Asia and Britain. The website includes information and stories about a wide range of South Asian plants, a map of places such as museums within the UK to explore South Asian cultures, and a large resource of activities for primary and secondary school students and teachers. Much of the content was created by South Asian community members in the UK (Harcup & Nesbitt, 2006).

At the Missouri Botanical Garden, Sacred Seeds is an example of a programme that provides community outreach and education while focusing on the conservation of ethnobotanically valuable plants and the knowledge associated with them. Sacred Seed sanctuaries (living gardens) are developed with local communities to promote traditions associated with plant use and to conserve the plants themselves. The goal of these gardens is to promote plant conservation and the harbouring of ancient knowledge, to serve as a venue for creating and sharing traditional practices and knowledge, to encourage sustainability through practicality, to engage local communities and to cultivate education, especially with the youngest members of a community.

## SACRED SEEDS — A GLOBAL NETWORK OF LIVING USEFUL PLANTS COLLECTIONS

ASHLEY GLENN
WILLIAM L. BROWN CENTER, MISSOURI BOTANICAL GARDEN

Sacred Seeds is network of ethnobotanical gardens serving as sanctuaries for useful plant species, including those of medicinal, craft, food and ceremonial value. Our approach stands on the idea that plant knowledge and useful plant species are best protected as living collections curated by the people who have always been the custodians of this knowledge. Supporting the local custodians as curators enables them to develop and improve their knowledge and best practices at an established headquarters. Our local experts use the sanctuary as a classroom for themselves and their community, sharing insights in conservation, education, documentation and nutrition. For most traditional communities, this philosophy aligns with their desires to keep their knowledge 'in house' and to control the form and function of the space as culturally significant and pragmatic for intensive local use. Our local experts inform not only their local programme design, but also the larger network of gardens. An evolving collaboration between local experts within our unique sites and our global experts in botany, anthropology, agriculture and traditional medicine expands the perspective of the whole. It also allows each living collection to be curated with a wider understanding of the myriad approaches to the host of obstacles and opportunities inherent in attempts to save useful plant species and knowledge relating to them in a community-empowering programme.

PHOTO BY GLENN MCRAE, COURTESY OF SACRED SEEDS.

## THE USE OF BIOCULTURAL COLLECTIONS IN PRIMARY AND SECONDARY EDUCATION AND TEACHER PROFESSIONAL DEVELOPMENT

Teachers and students at the primary and secondary level are a significant audience for biocultural collections. Students can often grasp and become interested in biocultural uses of plants and animals because it is easy to relate these ideas to their own lives, and to see connections between plant and animal use and human survival. This can be a bridge to many other disciplines, and teachers often see value in using biocultural connections to connect lessons in biology, chemistry, physics, history, writing, political science and other subjects. In addition to school tours and visits to exhibits, teachers are often looking for solid curricular ideas and ways to expand bioculturally relevant ideas into their classrooms. Even if a tour of an exhibit or collection is planned, it is very helpful for teachers to introduce topics thoughtfully and to allow for further reflection before and after a field trip.

A recent challenge is to encourage free-choice and inquiry learning for primary and secondary students while acknowledging the standards-based pressures teachers face in justifying class time spent on biocultural topics, and on potential field trips to collections. As Córdova and Murawski (2009:11) put it '… in light of the last eight years under the pressure of No Child Left Behind, the ways in which schools interact with their local museums have been reduced to 'standards-related' only experiences, forcing both teachers and museum educators to reduce a potentially complex literacies-learning experience to a scavenger hunt or set of checklists that will guide the information students must take away from their museum visits'.

Collaboration between research and education divisions can be an excellent way of improving the direct use of collections for education, and of improving the scientific authenticity of educational curriculum and programming. The Education Division of the Missouri Botanical Garden, working in collaboration with the William L. Brown Center, developed an ethnobotany teacher-training workshop held in St. Louis from July 6–9, 2011 to encourage and support local teachers in designing ethnobotany units that meet their classroom needs.

Collaborations between museums, botanical gardens, zoos, other institutions housing biocultural collections and local teachers are also essential for the development of curricula and school visits that meet the needs of classroom teachers. The St. Louis Art Museum hosts an annual teacher-research community partnership workshop each summer at which teachers work closely with the museum to develop ways to enhance student learning and to meet classroom learning goals through museum visits and museum resources. 'These opportunities for professional learning should be meaningful two-way exchanges, grounded in a co-expertise approach, in which both teachers and museum educators can jointly reflect on their practices and learn together in support of a shared vision to present museums in new ways and to engage in new types of learning experiences – both within and beyond the cultural locations of schools and museums' (Córdova & Murawski, 2009: 25).

Clearly, a classroom with walls has its limitations for the integration of indigenous- and mainstream-style education. Gardens, however, are ideal settings for expanded curricula. At the National Science Foundation (NSF)-sponsored Workshop on Priorities in Ethnobiology (April 4–6, 2002; St. Louis, Missouri), we heard several excellent examples of how students and teachers from mainstream schools can be brought to botanical gardens to meet experts (both indigenous and not) to observe and experience the propagation and utilisation of culturally significant plants and plant products. As an example, Dr Lorna Holtman summarised the education programme at Kirstenbosch National Botanical Garden in Cape Town, South Africa, in which teachers and students representing 11 different languages have opportunities for kinetic learning and personal access to indigenous knowledge. This is part of the programme officially sanctioned by the South African Government in

order to recognise indigenous knowledge systems (IKS) as legitimate and to incorporate them into the nation's curriculum. Field schools and workshops taught outside of the Western academic setting are options that enable students to learn within the context of another cultural environment.

Stories involving plants and animals, their uses, and the discovery or history of these uses, are an excellent tool for engaging primary and secondary school audiences with biocultural collections, whether these stories focus on myths and legends from a particular culture, a snapshot into daily life in a past or contemporary culture, or stories from recent or historic fieldwork or laboratory research. There is definitely a need for an easily accessed database of these stories among educators who are interested in biocultural relationships, and several groups are working on compiling such resources (e.g. the Open Science Network in Ethnobiology; Edwards & Kelpie, 2011). One excellent resource for primary and secondary school students wishing to learn about ethnobotany is published by the New York Botanical Garden, and includes hands-on activities leading students to explore the features of a useful plant from their own culture (Paye, 2000).

School tours of institutions that host biocultural exhibits often provide themes that can tie in with a teacher's current unit. Some exceptional exhibits include 'earthshrinking' exhibits and tours like the 'Expedition!' programme at the Royal Botanic Gardens Edinburgh, where students at the primary and secondary levels are exposed to immersion experiences and inquiry topics that encourage them to work to solve global issues and to explore career options in ethnobotany (Edwards & Kelpie, 2011).

Sometimes, opportunities exist to use biocultural collections as a teaching tool in classrooms even without a visit to the collections themselves, or to supplement visits that will occur before or after the material has been covered in a classroom. Some institutions (e.g. Botanical Research Institute of Texas; St. Louis Art Museum) housing biocultural collections use travelling teaching kits, which include images of artefacts, replicas, or raw materials that can be borrowed by a classroom teacher. Other institutions provide copies of activity guides or downloadable curricula that encourage hands-on or participatory learning.

## Teaching kits and other educational resources at Cahokia Mounds

Cahokia Mounds is a UNESCO World Heritage Site owned by the state of Illinois and managed under the Historic Sites division of the Illinois Historic Preservation Agency. The visitor centre at this site is a museum with impressive exhibits that include authentic artefacts as well as casts and other replicas. The Illinois State Museum in Springfield, approximately 100 miles to the north, has ultimate, long-term curatorial responsibility for the artefacts on display that have been unearthed from the site as a result of past and on-going excavations. Hundreds of busloads of school children (primarily grades 4–9) visit Cahokia every year, and the staff hosts Teachers' Workshops as well as in-classroom speaking engagements.

At least 12 different educational kits are available for teachers to check out and use in their classrooms for up to a week (Figures 4 and 5). Six of the kits deal with biocultural themes: People and animals of Illinois' past; Prairie plants; Trees; Dyes; Indians and the Marsh; and a large box on Wetlands. Several were put together by the State's Department of Natural Resources (DNR), but the others were made by interpretive staff members at Cahokia Mounds, one of whom had professional training and experience in primary education. Lesson plans geared at elementary and middle school students are included in some of the kits. Few if any ancient artefacts or ecofacts are included in the kits, but there are many examples of pressed plants, dried seeds, fruits, animal bones, mussel shells and replicas of wooden and bone tools, in addition to photographs, videos, DVDs, CDs, books, posters and so on. In 2010, the education kits were checked out 21 times and served 462 students.

**Figure 4.** Several teaching kits are available from Cahokia Mounds for teachers to borrow and share with their classes.
© GAYLE FRITZ.

The majority of the teachers who check out the kits use them to prepare their students to visit the site, while others use the kits as a substitute for a field trip if they are unable to visit the site with their classes. The kits experience minimal damage, and a $5 checkout fee per kit (except for the DNR-prepared kits, which are free to check out) covers replacement costs for any damaged items. It can be labour-intensive to examine each kit for damage or missing items as they are returned because of the sheer number of items contained within the kits (pers. comm. William Iseminger, June 2011) .

**Figure 5.** Teaching kits from Cahokia Mounds include replica items, raw materials, pressed plants and other biocultural items.
© GAYLE FRITZ.

## Evolving teacher kits and hands-on materials at the St. Louis Art Museum

At the St. Louis Art Museum (SLAM), where collections include many bioculturally relevant artefacts, teacher kits have evolved over the past 10 years. In the past, a teacher resource centre stocked teacher kits on diverse topics related to the museum's collections, and circulated these in a way similar to the way Cahokia's kits were circulated. However, SLAM has since refocused on enhancing primary and secondary school learning at the museum itself and has donated all the existing teaching kits to the St. Louis Public Library for continued circulation. To replace circulating kits, SLAM now offers downloadable curriculum guides and boxed printed versions for open distribution to teachers (St. Louis Art Museum). Many teacher development courses are offered during which experts are brought in to talk directly to teachers. Collaboration between teachers and SLAM staff ensures that the curriculum and guided tours provided by the museum meet teachers' expectations and needs for student learning.

Although the teacher resource centre no longer provides circulating teacher kits, hands-on activities and touchable collections are available to school groups for use in gallery tours. These collections include replica artefacts, modern ethnographic art and raw materials representative of those that were used to create ethnographic work or artefacts in the collections. This teaching collection of materials was obtained by donation from community members or volunteer docents and it is used to make the gallery experience more hands-on and participatory for school groups who visit the St. Louis Art Museum (pers. comm. Michael Murawski, School Services Director SLAM).

## BIOCULTURAL COLLECTIONS IN HIGHER EDUCATION

Biocultural collections can be used in a myriad of ways to enhance the undergraduate and graduate learning experience, in situations including, but not restricted to, hands-on laboratories, the creation or expansion of collections, the use of specimens from collections to stimulate interviews in local or far-away communities, use as reference comparative materials for identifying collected or excavated materials, and use as the basis for collection-based research within one collection or involving several collections.

One of the uses to which biocultural collections are often put is to enhance undergraduate and graduate training and research. Interest in ethnobiology is high among undergraduate students (Bennett, 2005), and some research has shown that getting undergraduate college students involved in research has a positive effect upon whether they choose to pursue graduate studies (National Science Foundation, 1997; Seymour et al., 2004)). Not only does access to collections enhance students' research experience in a real way, it also gives them an opportunity to gain training in working with collections responsibly. For students studying museum conservation, short placements with museum collections can be invaluable training (e.g. Barter & Liria, 2011). There is a wide range of disciplines for which natural resources are of interest, and biocultural collections may provide information on a wide array of research topics. Students need not have a focus on ethnobiology to benefit from the study of biocultural collections.

There are certain drawbacks specific to collections used primarily for training graduate and undergraduate students. First, unlike public tours or primary and secondary education opportunities, undergraduate and graduate students are often given less supervised access to collections. They are expected to work more closely with collections and to assume responsibility for handling materials safely and maintaining their provenance. This poses a risk to the collections when students are not adequately trained or supervised. Contamination, mixing of specimens, mislabelling or mis-shelving

occur frequently in many teaching collections, and the need for easy access to the collections leads to less than ideal curation conditions in these environments. Furthermore, some biocultural collections include items that can be dangerous to students if not properly handled (Kubiatowicz & Benson, 2003). We include below three case studies of biocultural collections that have faced some of these challenges.

## Ethnobotany Laboratory, University of Michigan Museum of Anthropology

The Ethnobotany Laboratory at the University of Michigan Museum of Anthropology (UMMA) serves as a prime example of a facility that has, for nearly a century, been one of the world's leading centres of both archaeological and ethnological plant collections and has faced most of the education-related issues discussed in this chapter. Founded in 1929 by Melvin R. Gilmore, who was joined in 1931 by Volney H. Jones, the core collection includes ancient and modern plants from around the world, with especially strong coverage of North America and Mexico (Figure 6).

The University of Michigan hosts a prestigious graduate programme in palaeoethnobotany within the Department of Anthropology, directed between 1969 and 2006 by Dr Richard I. Ford, and numerous doctoral students have added to the reference collections as they have conducted their dissertation or other research. These students have been invited to take selected seeds with them to augment their new or expanding reference collections at the institutions where they teach upon completing their degrees. One large cabinet has been devoted to 'teaching collections'; this includes taxa that constitute core economic staples or other species that beginning students are likely to encounter and therefore need ready access to. Undergraduate and graduate-level courses, as well as

**Figure 6.** Ethnobotany Laboratory, University of Michigan Museum of Anthropology. © KAREN O'BRIEN, UMMA.

independent studies under the direction of Richard Ford or advanced graduate students, have enabled aspiring palaeoethnobotanists to acquire training in the analysis and identification of collections. The collections are used for senior honours theses and doctoral dissertations, as well as for non-course-related research by internal and external scholars.

The large wooden cabinets in this laboratory were beautiful and probably valuable as antiques, but not up to modern curatorial standards, so UMMA curators successfully obtained a $482,000 National Science Foundation grant for a massive rehousing project. This project is currently ahead of schedule (personal communication, Karen O'Brien, UMMA Collections Manager, May 20, 2011), with progress being made at a rate that demonstrates a major commitment to ethnobotanical collections.

Because the Museum of Anthropology is a division of the University of Michigan Exhibits Museum and is located in the same building as the rest of this museum, educational opportunities have long been a central part of the mission. The Museum hosts an annual 'Behind-the-Scenes Day' for middle and high school students, and classes visit the Ethnobotany Lab in conjunction with this activity. In addition, there is an annual 'Archaeology Day' at the museum, during which four or five tables are set up with interesting plant remains such as corn cobs, along with stone tools, pot shards and other artefacts. Anthropology graduate students, including those specialising in ethnobotany, also participate in the state of Michigan's new Middle School Teaching Curriculum by making guest presentations in local classrooms. Finally, special temporary exhibits with ethnobiological themes have been installed in the main museum area, including one featuring foods and adaptations of the prehistoric South-west.

The UMMA website provides another educational resource, as well as having obvious research value. Links are provided to 569 Ethnobotanical Laboratory Reports and to Richard Ford's recently completed 'Southwest Traditional Ethnic Group Plant Use Database'.

## Palaeoethnobotany Laboratory, Washington University in St. Louis

The Washington University Palaeoethnobotany Laboratory (Figure 7) also has deep intellectual roots, going back to Hugh C. Cutler who received his Ph.D. in Botany at Washington University in St. Louis in 1939. Dr Cutler served as Curator of Useful Plants at the Missouri Botanical Garden from 1953 to 1977, where he also taught Washington University students. His fascination with archaeology and early New World agriculture led to decades of collaborative research with archaeologists who sent him plant remains for analysis, especially corn, beans and squash. Cutler invited local amateur archaeologists to hold their meetings in the Museum Building at the Missouri Botanical Garden, which is where Leonard Blake, an investment securities analyst and leading St. Louis area avocational archaeologist, began volunteering to help Cutler measure corn cobs and to identify seeds and other specimens. After retiring in 1965 at the age of 62, Blake worked with Cutler two full days a week, and the two men actively co-authored laboratory reports and publications (Blake & Cutler, 2001; Fritz & Watson, 2001). Upon Cutler's retirement, Blake shifted his *pro bono* work to the Anthropology Department at Washington University, where he began building up reference collections and training students including Charles Miksecek and Gail Wagner. We have a very small portion of the archaeological and modern plant remains that were formerly housed in Cutler's offices at the Missouri Botanical Garden, but the large Cutler-Blake Collection is currently curated at the Illinois State Museum in Springfield, where our students benefit from it as do researchers from around the world. Blake continued his analysis, publishing and mentoring of students until a few years before his death at the age of 99 in 2002.

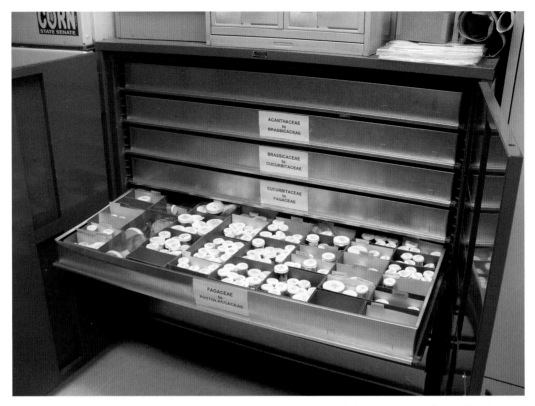

**Figure 7.** The Palaeoethnobotany Laboratory at Washington University in St. Louis includes a comparative collection of modern seed and plant materials arranged by plant family. © GAYLE FRITZ.

A tenure-track position in anthropology for a specialist in palaeoethnobotany was advertised by Washington University in 1989, and one of this chapter's authors, Gayle Fritz, has filled it since autumn 1990. At that time, the Palaeoethnobotany Laboratory was built in the basement of Old McMillan Hall and a new, museum-quality cabinet was purchased for storing the reference collections. A standard steel herbarium case was already filled with voucher specimens and materials, including a good reference collection of beans and other leguminous seeds that Leonard Blake inherited from Hugh Cutler. The plants in this case were protected from insects by a powerful — to the point of being nauseating — battery of mothballs, which had to be removed due to their suspected carcinogenic properties. During the past 20 years, the reference collection has been increased many-fold by taking advantage of *Index Seminum* exchanges offered by botanical gardens in Europe and the USA, by collecting seeds ourselves, by purchasing seeds from organisations such as Native Seeds SEARCH, and by accepting kind offers made by colleagues, including Dr Dorian Fuller of University College London and Dr Karen Adams of Crow Canyon Archaeological Center, who have been willing to share species from regions of the world for which our coverage was deficient. The collection is shaped in part by the interests of graduate students past and present. As students amass their own region- or period-specific comparative collections, they are also encouraged to deposit seeds in the Washington University comparative collection for the use of future students. In this way, the collections are continually growing in multiple directions, becoming useful for a wide range of research interests. An electronic database cataloguing the comparative collection is also maintained to facilitate a quick search of the contents of the collection.

Washington University is not connected to a museum, and therefore, our educational activities are almost exclusively devoted to undergraduate and graduate students. A single two-hour introduction to a palaeoethnobotany laboratory session is included in the department's freshman-level 'Introduction to anthropology' course, but most of the collection's use is by upper-level undergraduate classes and for graduate seminars and graduate-student training. Students in these upper-level classes and seminars spend the majority of their laboratory time sorting archaeological flotation samples on one of several stereoscopes (including a dual-head 'teaching scope'), scheduling laboratory time to work in small groups with Dr Fritz or the course's graduate-student teaching assistant. We have added an auxiliary lab on the first floor (the 'Ethnobiology laboratory'), which has been used for photometry, digitising, charring specimens in the muffle furnace, starch grain analysis and textile analysis.

It has been much more difficult than might be imagined to keep students from bringing food into the laboratory. Maintenance crews periodically spray pesticides throughout the hallways, and we have never had a major insect outbreak, but we need constantly to monitor the reference collections and to freeze seeds brought in from the field before adding them to the cabinet. Inevitably, when inexperienced students are using the collections, there is a risk that taxa will be mixed up or returned to the wrong place (our reference collections are arranged alphabetically by plant family and, under family, by genus and species), or that damage will occur during handling. Our laboratory has been extremely fortunate to have been consecutively assigned five undergraduate work-study students, each of whom worked for three or even four years and became competent in managing the collections as well as in sorting flotation samples. One of these, Kimberly Schafer, defended her PhD dissertation in palaeoethnobotany in 2011 at the University of North Carolina-Chapel Hill. Another, Paul French, deserves special thanks for creating a website for our 'Laboratory Guide to Archaeological Plant Remains from Eastern North America' (Department of Anthropology, Washington University in St. Louis, 2009).

## Economic Botany Collection, Royal Botanic Gardens, Kew

At Kew, the biocultural collections mainly support education at postgraduate (masters or doctoral) level. Each year, tours of the Economic Botany Collection are given to students on about 10 masters courses from universities in or near London, in subjects including object and paper conservation, museum studies, material culture, environmental archaeology, ethnobotany, the history of design, and nature conservation. Tours take place in the collection building. Purpose-built in the 1980s, this was not designed to accommodate groups, and tours are limited to 15

Figure 8. Teaching student conservators in the Economic Botany Collection at Kew. © DEAN SULLY, UNIVERSITY COLLEGE LONDON.

students at a time. Tour content is tailored to each group; for example, paper conservators will see a wide range of raw materials and products associated with paper production in the period 1850–1900. Some objects will be highlighted as having potential as masters dissertation projects or conservation projects, and most tours lead to one or more students coming forward to take these on. The curator of the Collection, Mark Nesbitt, works closely with university staff to match student and project, and most students achieve the highest grade (distinction) for their project. Students also undertake placements of 2–3 weeks when they help with practical tasks in the collection. Several students have gone on to do PhD work in the collection (e.g. Caroline Cornish, Chapter 20), and many have returned as volunteers, for example to assist with exhibitions and tours.

The success of this programme over the past decade comes both from the high calibre of students typically attracted by biocultural collections, and by close collaboration between curatorial staff at Kew and university staff in choosing projects and jointly advising students. This is time-consuming for curators, but able students are able to contribute a great deal of hands-on work, for example in archives or conservation laboratories, and to write it up to professional standards that often merit formal publication. A further benefit to collection staff is the intellectual stimulation of working with university students and staff, leading to the introduction of new ideas and literature, and to raised standards of curation.

## THE FUTURE OF BIOCULTURAL COLLECTIONS USED IN EDUCATION

Today, biocultural collections face challenges so that many are not meeting their true potential for education, but positive trends suggest that collections may be better able to meet educational needs in the future.

As mentioned earlier in this book (Chapter 1), preparation of a list of biocultural collections around the world and increasing online archiving of contents and information about collections makes it easier to share information of use to interested members of the public, teachers and students engaged in collections research. The trend towards re-curation of orphaned collections and a reassessment of the curation needs and purpose of 'teaching collections' will prevent much valuable material from being destroyed through neglect or from becoming inaccessible because of poor cataloguing (MacFarlan, 2001; Johnson & MacFarlan, 2004). Increasingly, collaboration among staff working with biocultural collections, indigenous communities, modern artisans and teachers has shown the value in sharing and respecting multiple sources of expertise and knowledge, and in integrating these knowledge sources to progress how a collection is exhibited, interpreted and in some cases curated. Major strides are being made to collect biocultural interaction stories, to encourage communities to record their biocultural knowledge and preserve their biocultural resources, and to make these records accessible to members of their community or to a wider audience. There is also a call to provide and encourage the use of open-source curricular materials for teachers at the primary, secondary and higher education levels (Open Science Network in Ethnobiology).

New technologies and social web media offer even more ways for communities, collections institutions, educators and students to share knowledge about biocultural interactions. Resources for creating ethnobiology-themed video as a way of recording plant use have been developed to share best practices (Fuller, 2007). Several universities are taking advantage of video as a means for students to share knowledge that they have gathered with a wider online community. One example is Gail Wagner's (University of South Carolina) 'Knowing Nature Project' and associated YouTube channel.

Highlighting biocultural interactions is a key to stimulating interest in science in the next generation. Because of the multi-disciplinary appeal of biocultural collections and their relevance to today's global and local economies, those that maintain these collections can have a leading role in promoting lifetime learning and science literacy for audiences of all ages. Research on biocultural collections is an important means of training young scientists in ethnobiology, and also of increasing their comfort with and interest in working with collections in general. Using biocultural collections to promote education is not without challenges, but there are significant benefits to the development of educational resources and programming in collaboration with members of the community and other knowledge-holders, and to sharing these resources with as wide an audience as possible.

## ACKNOWLEDGEMENTS

We would like to thank William Iseminger (Cahokia Mounds), Mike Murawski (SLAM), Jennifer Wolff (MBG), Gail Wagner (USC) and Karen O'Brien (UMMA) for their assistance in providing examples for this chapter. We'd also like to thank the participants of the July workshop for their comments, especially Mark Nesbitt, Jan Timbrook and Katie Konchar.

## Websites

Botanical Research Institute of Texas. *Ethnobotany: Exploring Plants in our Lives*. www2.brit.org/education/the-brit-seed-school-for-educators/ethnobotany-curriculum-exploring-plants-in-our-lives/

Department of Anthropology, Washington University in St. Louis. (2009). *Laboratory Guide To Archaeological Plant Remains From Eastern North America*. www.artsci.wustl.edu/~gjfritz/

*Open Science Network in Ethnobiology*. https://sites.google.com/site/osntechtalk/

Royal Botanic Gardens, Kew (2005). *Plant Cultures: Exploring Plants and People*. www.kew.org/plant-cultures

St. Louis Art Museum. *Learning Resources*. www.slam.org/Education/schools.php?id=learning

University of Michigan Museum of Anthropology, Archaeobiology Laboratories www.lsa.umich.edu/umma/collections/archaeologycollections/archaeobiologylaboratories

Wagner, G. E. *Knowing Nature*. https://sites.google.com/site/knowingnatureproject/

William L. Brown Center. *Sacred Seeds*. www.wlbcenter.org/sacred_seeds.htm

## Literature cited

Aiona, K., Balick, M. J., Bennett, B. C., Bridges, K., Burney, D., Burney, L. P., Bye, R. A., Dunn, L., Emshwiller, E., Eubanks, M., Flaster, T., Kauka, S., Lentz, D. L., Linares, E., Lorence, D. H., McClatchey, W., McMillen, H., Merlin, M., Miller, J. S., Moerman, D. E., Prance, G. T., Prance, A. E., Ragone, D., Urban, T., Van Dyke, P., Wagner, W., Whistler, W. A., Wichman, C. R., Wichman, H., Winter, K., Wiseman, J., Wysong, M. & Yamamoto, B. (2007). Ethnobotany, the science of survival: a declaration from Kaua'i. *Economic Botany* 61: 1–2.

Atiti, A. B. (2011). *Botanical Gardens Conservation International: Education Centre. The Role of Botanic Gardens in the Dissemination of Ethnobotanical Knowledge in Kenya*. www.bgci.org/education/1769/

Barter, D. & Liria, C. (2011). Conservators Care for Tapa Cloth at Kew. www.kew.org/news/kew-blogs/economic-botany/caring-for-tapa.htm

Bennett, B. (2005). Ethnobotany education, opportunities, and needs in the U.S. *Ethnobotany Research and Applications* 3: 113–121.

Blake, L. W. & Cutler, H. C. (2001). *Plants from the Past*. University of Alabama Press, Tuscaloosa.

Chatterjee, H. J. (ed.) (2008). *Touch in Museums: Policy and Practice in Object Handling*. Berg, Oxford.

Córdova, R. & Murawski, M. (2009). Cultural landscapes for literacies learning: an innovative art museum and teacher-research community. *Missouri Reader: Journal of the Missouri Reading Association* 34: 9–28.

Edwards, I. D. & Kelpie, S. (2011). *Botanical Gardens Conservation International: Education Centre. Plants and Culture: Ethnobotany and Education*. www.bgci.org/education/1714/

Ethnobiology Working Group (2003). *Intellectual Imperatives in Ethnobiology: NSF Biocomplexity Workshop Report*. Missouri Botanical Garden, St. Louis. www.econbot.org/pdf/NSF_brochure.pdf

Fritz, G. J. & Watson, P. J. (2001). Introduction. In: *Plants from the Past*, eds L. W. Blake & H. C. Cutler, pp. xi–xiv. University of Alabama Press, Tuscaloosa.

Fuller, R. J. M. (2007). Guidelines for using video to document plant practices. *Ethnobotany Research and Applications* 5: 219–231.

Harcup, C. and Nesbitt, M. (2006). Attaining the Holy Grail: How to encourage wider engagement with museum collections through participation in new media projects. *Museums and the Web Conference* www.archimuse.com/mw2006/papers/harcup/harcup.html

Johnson, E. & MacFarlan, S. J. (2004). Education collections as museum collections. *Curator* 47: 101–113.

Keene, S., Stevenson, A. & Monti, F. (2008). *Collections for People: Museum' Stored Collections as a Public Resource*. UCL Institute of Archaeology, London. www.ucl.ac.uk/storedcollections/

Kubiatowicz, R. & Benson, L. (2003). Oh no! ethnobotany. The safe handling and storage of hazardous ethnobotanical artifacts. *Collection Forum* 18: 59–73.

Linares, E., Herrera, E., Bye, R., Jimenez, C. & Novoa, P. (1999). Ethnobotanical education beyond the garden. *Roots* 1 (19). www.bgci.org/worldwide/article/0430/

MacFarlan, S. J. (2001). A consideration of museum education collections: theory and application. *Curator* 44: 166–178.

National Science Foundation (1997). *Shaping the Future, Volume II: Perspectives on Undergraduate Education in Science, Mathematics, Engineering, and Technology*. National Science Foundation, Arlington, Virginia. www.nsf.gov/pubs/1998/nsf98128/nsf98128.htm.

Nguyen, M. L., Doherty, K. T. & Wieting, J. (2008). Market survey research: a model for ethnobotanical education. *Ethnobotany Research and Applications* 6: 87–92.

Paye, G. D. (2000). *Cultural Uses of Plants: a Guide to Learning about Ethnobotany*. New York Botanical Garden Press, New York.

Pye, E. (ed.) (2007). *The Power of Touch: Handling Objects in Museum and Heritage Contexts*. Left Coast Press, Walnut Creek.

Seymour, E., Hunter, A., Laursen, S. L. & Deantoni, T. (2004). Establishing the benefits of research experiences for undergraduates in the sciences: first findings from a three-year study. *Science Education* 88: 493–534.

Suits, L. N. (1998). Hazardous materials in your collection. *National Park Service Conserve-O-Gram* 2: 1–4. www.nps.gov/museum/publications/conserveogram/02-10.pdf

CHAPTER 25

# Biocultural collections:
# the view from an art museum

MATTHEW H. ROBB

de Young Museum, Fine Arts Museums of San Francisco

## INTRODUCTION

An art historian comes to the topic of curating and exhibiting biocultural collections with an eye towards a better understanding of objects made from natural materials, and objects that depict the natural environment — animals, plants and other manifestations of the biocultural world. Institutionally, these objects are most often held by art museums, natural history museums and ethnographic museums, and it is important to remember that the lines drawn by these institutions (and the individuals that work in them) among the categories of 'art object', 'ethnographic object' and 'plant or animal product' rarely match the categories these same objects might have held within the cultural systems that created them. For objects produced outside the Western tradition, this taxonomic status is always an issue. Different kinds of museums deal with the same kinds of objects very differently, at every stage from cataloguing to database categorisation to the interpretation presented to the public.

The issue of distinction operates not only at the level of an object's categorical placement within an institutional framework, but also often within the iconography of the object itself. Scholars from the disciplines of art history and anthropology struggle and occasionally succeed at securing identifications of specific plant and animal species using a range of visual cues shown in a wide variety of objects, from the handheld to the monumental. These identifications can offer insight into what these kinds of biocultural items meant in a given cultural system. But other imagery resists this level of specificity, and we are often left to wonder if our efforts to recognise or impose this kind of taxonomy potentially obscure more than they reveal.

Art historians recognise that indigenous traditions around the world developed systems of aesthetic value: some materials were deemed more valuable than others, and societies and individual creators devoted enormous time and energy into transforming raw materials of both commonplace and exotic status alike into objects of exceptional beauty, according to their standards. The challenge of presenting these objects in the context of an art museum is to recover the parameters of a given ancient and/or indigenous aesthetic system and to attempt to convey its structure to visitors. The conceptual framework of the biocultural object may allow for a taxonomic category that transcends traditional disciplinary and institutional lines, revealing connections that might have gone unnoticed and prompting questions that might have otherwise gone unasked, while at the same time suggesting possible parallels that may make the unfamiliar and alien considerably more accessible.

This paper has two sections: one devoted to outlining general principles for developing exhibitions and installations with biocultural objects, and the second analysing several objects with biocultural questions in mind.

## EXHIBITION DESIGN: FROM CONCEPTION TO INSTALLATION

Museum exhibitions and installations provide spaces for individuals and communities to enhance their knowledge of themselves, of others and of the world around them. An installation or exhibition's success may be judged on a number of levels — strictly by attendance numbers, through more detailed visitor surveys demonstrating a depth and quality of experience in keeping with the stated mission of the exhibition and/or the institution, or through more specifically scholarly contributions that advance knowledge and interpretation.

The exhibition design process varies from institution to institution (Chapter 26), but generally speaking, at large art museums, the process is manifold and often collaborative. In this context, the term 'exhibition' generally refers to a special exhibition combining a number of objects from various institutions brought together for a limited time (typically two to three months). An installation refers to the presentation and display of objects from an institution's permanent collection, often for an extended period of time (typically three to five years). The advantage of the former is that it creates a unique opportunity for members of the local community to 'travel without leaving home' and to learn more about a specific artist, culture, or idea. The advantage of the latter is that longevity encourages repeat visitors to become more familiar with different aspects of an institution, and allows the regular, dependable use of the collection by interested constituents — most notably teachers and school groups.

Art museums place a premium on aesthetic experience above all others. Every detail of an exhibition or installation should be considered in the context of its overall effect — will it contribute to or detract from the viewer's aesthetic experience? In many art museums, this means that exhibitions and installations are designed in some respects to disappear — that is, in emphasising and staging primarily aesthetic experiences with objects, the casework, lighting, colour choices and other myriad details (from vitrine placement to label and text size) should not overly intrude but should instead visually enhance an individual's encounter with an object. Naturally, budgetary concerns will come into play; if the installation is designed to be on display for a short length of time, it may not be cost-effective to repaint an entire gallery (or suite of galleries) or to manufacture new vitrines.

Conceptualisation of meaningful installations comes about after hands-on experience and familiarity with an institution's permanent collection. Encyclopaedic art museums have a tendency to create sweeping narratives of formal and aesthetic change over centuries, or even millennia, but they must also acknowledge that their collections have changed over time. Every collection has its idiosyncrasies and gaps. Collectors and donors have a profound impact on the long-term trajectory of what it is possible to exhibit. Curators and board members make decisions to acquire certain objects, deaccession others and, in some cases, return collections to countries or places of origin (see Box, 'Repatriation of the Zimbabwe birds' in Chapter 19). Each of these events constitutes a moment unique to the history of the object in question; this creates an aggregate of highly individualised narratives. Each object, in turn, also has its place in a wider network of narratives, some historic, some aesthetic, some cultural, some scientific. The curatorial challenge is to bring order to these narratives, or to orchestrate and elaborate their chaos in a way that makes the multivalency of the objects and the information about them available and meaningful to as wide an audience as possible.

The exhibition and installation process (see Klein, 1986; Lord & Lord, 2001; Chapter 26) will vary considerably from institution to institution. Each will have its own separate procedures for evaluation, approval and implementation. Regardless of size or mission, at every institution, one rule will hold: communication is the key to a successful exhibition. If the primary ideas behind an exhibition or installation are not communicated clearly to internal institutional constituents, they cannot be communicated clearly to museum visitors.

## Conceptualisation and selection: arguing with objects

The first stage in installation design is deciding what the installation is about, and what objects will best illustrate that theme. Every installation and exhibition has (or should have) an argument. Conversely, given a selection of objects, a concept or thesis may emerge. The included objects are simultaneously evidence for and expression of — they are the words and sentences of — the argument. By extension, groupings of objects are like paragraphs, and the entire effort can be likened to an essay. Keeping this level of clarity in mind at every step of the process allows curators to make sure that other parts of the design process do not obscure the exhibition's fundamental premise. The argument for an art museum will often differ significantly from those explored in a natural history museum; however, with biocultural collections, we have the opportunity to explore shared or interrelated arguments.

## Evaluation

At most large art museums, exhibition ideas emerge from the curatorial departments. Once the curator has made a preliminary selection of objects and an outline of the installation's major premises, s/he may engage in a variety of informal and formal evaluation processes. Staff members in exhibition departments will want to weigh in on budgetary feasibility and scheduling issues; designers on construction, casework and colour selection; educators on programming opportunities; marketing staff on the timing of publicity campaigns; development on donor and sponsorship opportunities; and conservators on the physical condition of the objects and attendant limitations on environmental conditions during display. All of these levels of expertise must be managed and successfully incorporated. As part of these and other conversations, the curator may find that certain issues are insurmountable, while other more positive possibilities may emerge.

For those exhibitions and installations planned to include culturally sensitive materials, as is potentially often the case with biocultural collections, great care must be taken to communicate with indigenous stakeholders so as to provide the potential to incorporate their viewpoints. This is a consistent concern with respect to Native American objects, where the display or indeed possession of certain classes of objects in both art and natural history museum contexts violates deeply held religious beliefs (Clavir, 2002: 78–84). According to the Haudenosaunee Confederacy, for example, 'False Face' society masks should never be exhibited (or indeed owned) by non-members (Lord & Lord, 2001). Catlinite pipe bowls from many Plains groups should not be exhibited joined with their carved wooden stems (Ogden, 2004: 15). In the USA, the Native American Graves Protection and Repatriation Act of 1990 (also known as NAGPRA) creates a special set of obligations (Chapters 17 and 18). Although its implementation has not been without difficulty, NAGPRA means that institutions with extensive Native American holdings have every reason to engage actively with tribal representatives to discover and realise appropriate and respectful displays of potentially sensitive objects (Fine-Dare, 2002; Mittal, 2010).

The key factor is that every group, like every object, will have its own ideas and requirements, and it is the responsibility of the institution to learn how to incorporate those ideas and requirements into its best practices, if possible. Individuals and institutions may find that this effort occasionally presents significant ontological and political conflicts; for example, the very definition and implication of the word 'biocultural' could shift profoundly when attempting to understand 15th century Inca concepts surrounding stone, or the place of the Willamette Meteorite, which Native American people know as Tomanowos, in the sacred and cultural landscape of the Confederated Tribes of the Grand Ronde (Thomas, 2006; Dean, 2010).

For archaeological objects and ancient art, provenance should be assessed against the provisions of UNESCO's 1970 *Convention on the Means of Prohibiting and Preventing the Illicit Import, Export and Transfer of Ownership of Cultural Property*. In the light of this, museum ethics codes, such as that of the Association of Art Museum Directors, take 1970 as the threshold date for the application of more rigorous standards to acquisition (Chapters 1 and 16). This Convention may also serve as a useful benchmark in discussing the inclusion of objects in exhibitions that require international collaboration.

## IMPLEMENTATION

Once the installation has gone through the evaluation processes successfully, different aspects of implementation may begin. At large institutions with dedicated design staff, drafting of drawings and case specifications can be done digitally. Placing digital images of scaled objects within a similarly scaled spatial model significantly enhances the ability to visualise the relationship between those objects and that space, and can call attention to 'virtual' problems before they manifest themselves in the 'real' world. Smaller institutions may want to investigate programmes like SketchUp (www.sketchup.com), which, while occasionally cumbersome and time consuming, can introduce a new level of detailed spatial planning at a fraction of the price of AutoCAD software.

This is also the best stage to consider the role of text and images in an installation. Does every object need a label? If so, what kind of information should be presented there? Does other text in the installation convey the same or different information? Do all of these texts address a specific audience? Basic data on visitor behaviour and educational background is of vital importance (Serrell, 1996). In an art museum, where the goal is to focus viewer attention on objects, word length for labels is often quite limited from the curator's perspective (generally no more than 100–150 words per object and around 250 for larger introductory text panels). Too much text can overwhelm visitors, and not enough can fail to stimulate them; in either case, the installation has failed.

## OUTREACH, PUBLICITY AND (RE)EVALUATION

Once a collection or exhibition has been successfully installed, the effort to bring visitors into the space will begin in earnest. In fact, the process began months before, when media-relations staff attempted to place stories, solicit reviews and draft press releases. Increasing reliance on digital sources for news and community information has radically shifted the relationship among museums, media outlets and the audiences they both seek to attract. Cutbacks at city newspapers have led to an astonishing paucity of arts reviewers in several major metropolitan areas; the development of arts blogs, although welcome as a general development and often of superior critical quality, has yet to achieve the same level of market penetration once held by newspapers (Szántó, 2009). Social networking sites like Facebook, Twitter, Pinterest and Flickr increasingly provide museums and institutions with radically different ways to engage audiences old and new. Exhibition and installation feedback has, by and large, remained fairly analogue in the face of these developments, as institutions large and small are often hesitant to embrace their digital potential fully. Some institutions have incorporated 'crowdsourcing' into their exhibition programming, providing a direct connection between the museum's visiting public and its curatorial practice. There can be no doubt that the landscape has shifted profoundly, and that the only constant will be continued change (Simon, 2010).

## ICONOGRAPHY AND MEDIUM

In the remainder of this chapter, I will focus on four objects from the ancient cultures of the Andes and Mesoamerica. Two of the objects are made of organic materials and two depict aspects of the natural environment and the practice of obtaining resources from it. With one pair, we see how questioning the biocultural status of an object's material can provide greater insight into social organisation and production, whereas with the other, we see how some of the processes of acquisition can be visualised and made more permanent. The goal is to see how much information we can extract about the ancient indigenous view of biocultural materials from these objects, and to consider frameworks that might make this information more accessible to visitors and researchers alike.

A particularly striking example of how an object easily positioned within an art museum context can also reveal an entire domain of biocultural activities is a repoussé silver disc (Figure 1) dating to the 14th century, identified variously as Chimu or Lambayeque (for a brief discussion of the overlap between Lambayeque and Chimu, see Stone-Miller, 2002: 153–174). St. Louis businessman and philanthropist Morton D. May acquired the silver disc on the art market in 1966, and donated it to the Saint Louis Art Museum in 1978. Although the disc was undoubtedly found somewhere in the northern coastal regions of Peru, its exact origin cannot be determined. It has been traditionally

**Figure 1.** Repoussé Disc, 14th century. Chimu or Lambayeque, Late Intermediate; silver; 34.5 cm. Gift of Morton D. May (#282: 1978).
© SAINT LOUIS ART MUSEUM.

linked to a group of similar discs and other silver objects, which, stylistically, probably date to the 14th–15th century (Cordy-Collins, 1996: 218–222; King, 2000: 44).

Technically, with its paper-thin material efficiency (the disc's thickness measures under half a millimetre) and meticulous chasing, the disc and others like it represent 'a high point in Andean metallurgy' (Pillsbury, 2003: 76). Silver deposits were found all over the Andes, and objects made from silver date back as early as the 9th century BC (King, 2000: 12). But the use of precious metals like gold, silver and copper exploded in the Late Intermediate period (c. 1000–1475 AD), culminating in the elaborate articulations of the Korikancha, perhaps the most important structure at the heart of the Inca capital of Cuzco. The Korikancha legendarily included a garden filled with plants and animals made of gold and silver (Bauer, 2004: 143–147). As empire builders, the Inca relied on extensive economic networks that extracted raw materials from all over their domain, known as Tawantinsuyu, which stretched along the Pacific coast from Ecuador to Chile (McEwan, 2006). In metallurgy, they also relied on the skilled artisans of Peru's northern coasts, who had created objects like this disc for the earlier kings of Chimor. The designers and fabricators of the disc created a detailed image of the world that incorporated knowledge of a maritime culture and long-distance trade networks. Although made out of an elite metal and intended for luxury use, the disc actually describes the acquisition of an even more valuable material: the bright orange-red shell of *Spondylus princeps*, the spiny oyster that dwells in the warm waters of the Pacific Ocean off the coast of Ecuador. The kingdom of Chimor relied so heavily on *Spondylus* as a prestige item in its political economy that there was a specific office whose primary responsibility was the procurement of this shell (Cordy-Collins, 1991).

The main motif of the outermost ring is a curved shape with one pointed end and another broader, flaring end. These are reed boats, documented in Andean imagery as early as Moche Phase I (1–200 AD) (Donnan & McClelland, 1999), and still in use in parts of the Titicaca basin today (Banack et al., 2004). Although it is relatively straightforward to identify the reed plant — it is almost certainly *Schoenoplectus californicus* or *Schoenoplectus acutus* — the avian creatures that perch atop the bows of the reed boats do not provide a level of clarity that can enable their identification. Crammed in and around the boats are similarly non-descript anthropomorphic figures; each reed boat seems to carry at least two passengers holding paddles and wearing a stepped-fret headdress. Of particular interest is the small cross-hatched dome that appears in each boat; this would seem to represent a net, as it is possible to see fish and even a manta ray on two of the boats. Being able to identify certain species readily may suggest that the object is meant to convey specific information about a particular domain — sea creatures rather than sky creatures, for example. But we must recognise the possibility that a Chimu observer probably readily recognised certain visual cues that elude us today.

Similarly, the four rings of the disc do not seem to convey any degree of spatial specificity that correlates to our dominant representational schema. But such images often hold multiple cues designed to indicate overlapping objects, depth of field and other forms of visual organisation. If we take the outermost ring, with its *Schoenoplectus* reed boats, as representing the surface of the water, then the inner rings represent the lower depths of the sea. The presence of *Spondylus* at the third level does indicate a certain specificity: these creatures live at this particular level; go too deep and you will pass them, stay too shallow and you will miss them. In this way, one object can come to represent a whole way of thinking about and visualising an entire oceanographic domain as well as the creatures that inhabit it. The silver disc originally operated in a world of opulent material wealth and staggering monumental architecture, and was one of many such images, its references easily understood by its creators and audience. In the present day, it becomes a singular key to potentially unlocking this ancient indigenous scheme of classifying natural phenomena.

The Chimu disc offers us an image of an ancient worldview through the representation of different objects that we can recognise as biocultural, although the medium of the object itself (i.e. silver metal) is not biological. Other objects yield information of a more material sort. For example, despite its apparent lack of representation, a feather panel (Figure 2), probably dating to the 8th or 9th century, reveals almost as much about ancient value systems and worldviews as the disc.

In late 1942 and early 1943, several dozen feather panels were found inside large ceramic jars at a site on the southern coast of Peru. The find spot is typically given as La Victoria, Hacienda Hispaña, in the Churunga Valley near its juncture with the Ocoña River. The site is also identified as Corral Redondo and the region given as Pampa Ocoña (Rowe, 1967: 27–28). According to a 1950 Arequipa newspaper article, there were eight jars that each contained twelve mantles (Málaga, 1950). Most of the ninety-six feather mantles were blue and yellow; others were solid yellow or solid red. Early reports suggest that a sacrificed llama was also found with or near the mantles. Allegedly, Inca metal objects were also found nearby, which led to confusion regarding the date of the mantles themselves. Radiocarbon dates eventually suggested a date in the Middle Horizon (between 700 and 900 AD). Approximately 44 of the 96 mantles were deposited at the archaeological museum of Arequipa, Peru, and several of the large ceramic jars were deposited at the Museo Nacional de Arqueología in Lima, Peru (Candler, 1991: 12; Cook & Conklin, 1996: 417–418). Many of the remaining 50 can be found in other museum and private collections around the world. The Saint Louis Art Museum purchased one of the blue-and-yellow examples in 1949 from the dealer Walram von Schoeler, making it one of the first art museums to acquire a type of object that has come to serve as a hallmark of ancient Andean featherwork.

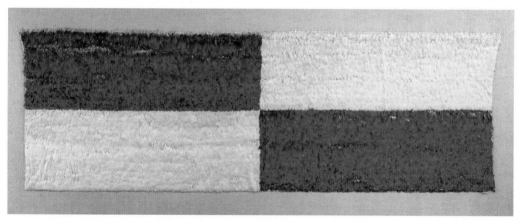

**Figure 2.** Mantle Hanging, 8th–mid-9th century. Huari, Middle Horizon (700–900 AD); feathers and cotton cloth; 68.5 x 209 cm. Museum Purchase (#285: 1949). © SAINT LOUIS ART MUSEUM.

Featherworking is a practice with deep roots; one of the earliest examples, dating to c. 3000–2500 BC, comes from the Huaca de los Idolos at the site of Aspero, on Peru's central coast, and continued up to the Spanish invasion of the 16th century (Feldman, 1986: 35; King, 2013). Although early attempts at species identification for the La Victoria cache oscillated among hummingbirds and macaws, it now seems evident that tropical macaw species such as *Ara ararauna* must have provided the vast majority of the feathers for these panels (Robbins, 1991: 121–122).

The La Victoria find represents but one result of featherworking efforts, and its scale is astonishing. Each panel consists of four quadrants, in roughly forty rows of roughly one hundred

feathers individually tied onto the backing. Extrapolating these numbers for the entire panel yields about 4,000 feathers per quadrant and 16,000 total for each panel, making an estimate of 1,500,000 individual feathers a reasonable total for the entire set. The area surrounding La Victoria is typical of the mountainous, semi-arid valleys of coastal Peru; the macaw's natural tropical domain lies at least 250 miles away. Yet the macaw is relatively easy to train, and there may have been well-organised programmes to support large-scale domestication.

How many feathers can one bird generate over a lifetime? How long would it have taken to accumulate the number of feathers for just this one set? What would it take for a macaw to survive the journey from one environment to the other, and how many would it take to establish a breeding colony? These questions are not, strictly speaking, art historical or even archaeological. But answering these biocultural questions would allow scholars in both disciplines to better understand certain aspects of cultural production with respect to featherwork in the ancient Andes, and could give insight into the impact of cultural practices in biological realms.

Thousands of miles to the north, archaeologists have determined that scarlet macaws were traded from Mesoamerica to the American South-west site of Paquime in sufficient numbers and with sufficient knowledge to support breeding in small adobe cages, presumably helping to sustain a robust ritual economy (Minnis et al., 1993). Macaw imagery does proliferate in the art and iconography of Paquime at roughly the same time (Bradley, 1993: 127). Thus, aspects of avian domestication are testable and observable, but identifying and interpreting them does take a certain awareness of the scope of possible behaviours (both human and animal) and a willingness to entertain hypotheses that lie across disciplinary boundaries.

There is some evidence that the Inca practiced a form of avian domestication. *El Primer Nueva Corónica y Buen Gobierno*, an early 17th century manuscript written by Felipe Guamán Poma de Ayala, a member of the surviving indigenous elite, documents the history of the Inca empire in rich detail (see Guamán Poma de Ayala (2009) for the most recent English translation and Adorno (2001) for a digital facsimile and commentaries). The seventh coya, or queen, a woman named Ipa Huaca Mama Machi, is described as one who 'enjoyed taking care of little birds, parrots, and macaws' (Guamán Poma de Ayala, 2009: 100–103; fig. 132). The accompanying illustration shows a detailed rendition of a macaw in the foreground, suggesting that the live animals were part of courtly economies in the Andes for centuries.

The fragility of objects like the feather panel and the paucity of contemporary evidence with which to interpret them means we depend on significantly later texts such as Guamán Poma's *Coronica* to generate hypotheses about what such objects meant and how they might have been used. A similar situation exists in central Mexico, where, in the mid-16th century, the Franciscan friar Bernadino de Sahagún compiled *La Historia General de las Cosas de Nueva Espana*, a twelve-volume work akin to an encyclopaedia that documents the Aztec world prior to the Spanish invasion of 1519–1521. Also known as the *Florentine Codex*, de Sahagún's text was translated into English by Arthur Anderson and Charles Dibble (see Anderson & Dibble, 1953). Despite its complicated hermeneutic position, its bilingual text, which is often accompanied by detailed illustrations, provides insight into the life of Nahua-speaking elites, many of whom contributed to de Sahagún's project (Carrasco, 2000: 11). The text's multiple perspectives make it useful as a starting point for interpreting a rare wooden sculpture of the Aztec goddess of water, Chalchihuitlicue, 'She of the precious jade skirt' (Figure 3).

Radiocarbon tests performed in 1966 suggest the piece was carved around 1400 AD, and the wood itself has been identified as Montezuma cypress, also known as ahuehuete or *Taxodium mucronatum* (now *Taxodium huegelii*) (Nicholson & Berger, 1968: 13). While the number of surviving

wooden sculptures from the Aztec world is vanishingly small (Pasztory, 1983: 274), there are a number of interpretive texts from which we may glean something of the function of such objects. The Nahuatl word for wooden sculptures is *cuauhximalli*, and such objects almost certainly served as the central focus point for religious rituals (Matos Moctezuma & Solís Olguín, 2002: 411). Chalchihuitlicue's attributes tied her blue-green skirt to precious waters, life-giving and life-threatening, and she was often understood in relation to Tlaloc, the god of rain and storms. The traces of carefully outlined black and blue pigment on the headdress, face and skirt indicate that the figure was probably painted originally over much of its surface. Although the stiff pose is typical of much Aztec art, the figure's face is finely modelled, with an almost fleshy curve to the cheeks, suggesting a tradition of dynamic wood carving that is now almost completely unknown.

Most artistic processes — metal casting, stone working and the most esteemed art of feather mosaic — are treated in Book 10 of de Sahagún's *General History* (de Sahagún, 1961). Intriguingly, references to woodworking are largely restricted to architectural practices. But the religious rituals surrounding Chalchihuitlicue are described extensively in Book 1 (de Sahagún, 1950). Her feast day came in the month of Etzalqualiztli, roughly late spring, and known as the time of the eating of a cooked maize and bean porridge. Etzalqualiztli saw the performance of numerous rain and water rituals, as well as the sacrifice of human

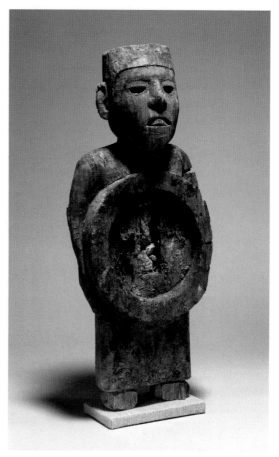

**Figure 3.** Female Figure, c. 1400 AD. Aztec, Late Postclassic; wood, plant remains and paint; 52.5 x 22.5 x 11.8 cm. Gift of Morton D. May (#381: 1978). © SAINT LOUIS ART MUSEUM.

impersonators of Tlaloc and Chalchihuitlicue. De Sahagún's Nahua informants also described the offering of *yauhtli*, identified today as Mexican marigold or *Tagetes lucida*. This plant was also closely linked to Tlaloc rituals; its mild analgesic capacities may have made aspects of priestly fasting during Etzalqualiztli easier to endure (Heyden, 1987: 117).

Intriguingly, the Chalchihuitlicue sculpture was supposedly found preserved in a bog-like environment with another, putatively male, wooden sculpture of about the same size (Nicholson & Berger, 1968: 6). It too holds a central circular disc, this time with a circular interior cavity rather than a rectangular one. The carving details, particularly the hairline and treatment of the shoulders, suggest that the two sculptures were made by the same workshop, if not the same hand. Although the female sculpture's identification with the Goddess of Water seems secure, no comparable deity can readily be linked to the male sculpture.

Of particular note on both sculptures is a central disc, its large diameter seemingly imposed over the figure's body, whose arms encircle its raised outline. Inside the disc held by the female figure is a short rectangular cavity; in the male's, a circular one. Similar cavities can be seen on many Aztec stone sculptures, and it has often been suggested that they served as repositories for pieces of precious

greenstone, which was thought to imbue the object with a certain life. Although no greenstones have been described in the histories of either sculpture, the interior cavities in both seem to still hold a large quantity of organic material. In the case of the female figure, this material was tellingly described by an early cataloguer as 'crap'. Such attitudes reflect a certain myopia regarding the potential usefulness of such material, but fortunately it was not removed. It may yet be possible to use this material to confirm or deny the quasi-legendary tales of the object's find spot in the remnants of Lake Texcoco. It may also be possible to correlate the materials found inside the cavity with descriptions of those used during Etzalqualiztli. If any of the organic substances could be identified in any way that ties them to *Tagetes lucida*, we would have an extraordinary material correlation and confirmation that the sculptures were involved in the rituals described in de Sahagún's text. To date, museum staff have elected to leave the material as it is, given its fragility and irreplaceability together with the technical and financial issues raised by potential analytic techniques.

One of the other major pieces of Aztec sculpture in the Museum's permanent collection (Figure 4) shows organic materials in use, and can provide great insight into biocultural activities even if they are made of (to the Western way of thinking) non-organic material. This standing male figure, measuring some 76.8 cm (30 in) in height, is carved from dark grey basalt. The figure leans forward, knees slightly bent, and with legs and feet separated, resting on a rectangular base. The torso widens towards the shoulders, with bent arms reaching back to hold a tumpline across the forehead, which in turn attaches to a container holding seven conical objects. The tied ends of the tumpline across the forehead form two snakes, each with deeply set oval eyes, an open mouth, and a long forked tongue. The figure wears a conical hat with a wide, tightly undulating band at its base, and a simple loincloth, known as a *maxalatl*. As with the wooden figure, a rectangular cavity runs the length of the chest.

The conical headdress seen on this figure is most closely associated with Ehecatl, the god of wind, and one of the most important aspects of Quetzalcoatl, the Feathered Serpent (Nicholson, 1971: 428–430; Pasztory, 1983: 223). In codices and sculpture of the Late Postclassic period (c. 1200–1521), the most elaborate representations of Ehecatl-Quetzalcoatl show him with a conical cap, a red duckbill mask, and a chest ornament made from a transverse cut shell jewel called an *ehecailacocozcatl* (Nicholson, 1971: figure 8). Conical hats are often associated with the Huastecs of the Gulf Coast, underscoring Ehecatl-Quetzalcoatl's putative origins in the eastern lands of clouds and mist; the duck and shell imagery also pointed to this windy, watery environment (Sullivan, 1982: 11; Miller & Taube, 1993: 84–85). Although the sculpture lacks some of the key iconographic diagnostics, the presence of the tied snakes of the headband may be an oblique reference to coatl,

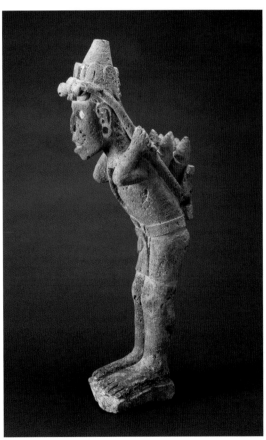

**Figure 4.** Figure carrying corn, c.1400–1500. Aztec, Late Postclassic period; painted basalt; 76.8 x 18.7 x 22.9 cm. Gift of Morton D. May (#304: 1978).
© SAINT LOUIS ART MUSEUM.

or snakes. Additionally, as part of a set of a small number of similar sculptures in basalt showing a figure carrying a tumpline burden (Pasztory, 1983: pl. 202, 205), we can connect the object to a foundational legend describing the acquisition of maize, the single most important agricultural product in all of Mesoamerica.

The Leyenda de los Soles ('Legend of the Suns') is a section of a 16th century manuscript called the *Codex Chimalpopoca*, now known only through facsimiles, that records various creation myths of the Aztecs (Bierhorst, 1992: 1–14). One story in the Leyenda describes the discovery of maize (Bierhorst, 1992: 146–147). The god Quetzalcoatl, seeking food for his fellow deities, spies a red ant carrying a maize kernel and asks him where it came from. Although the red ant refuses to reveal the location at first, he eventually relents to Quetzalcoatl's insistence. Equipped with the answer, Quetzalcoatl follows the ant into the Mountain of Sustenance by transforming himself into a black ant. He returns with maize, which the gods eat, and eventually feed to humans too. It may be that this object references Quetzalcoatl's return from the mountain, carrying a sack of corn.

The economy of the Aztec empire was completely dependent on human porters known as *tlameme* to move finished products and raw materials in the Postclassic period (Hassig, 2001). Lacking draft animals, merchants paid porters to carry food and other products across long distances. These porters, often of low social standing, would use tumplines to balance baskets on their backs. Strictly speaking, a *tlameme* was not a slave, in that the person who hired his services did not own the individual outright, and the *tlameme* was paid for his services. This object and others like it probably functioned in household or neighbourhood shrines as a useful, almost regal, reminder of the divine importance of such a burdensome task.

## CONCLUSION

Clearly, art museums are rich troves of objects that often overlap with the types of objects found in biocultural collections. Curators interpret biocultural objects primarily through aesthetic insights, and these often require elucidation through a keen understanding of a culture in its specific place and time. Biology and biocultural processes play a significant role in the creation and reception of these objects. Art museums, because of their sensitivities to cultural aesthetics and meanings, can demonstrate how to work with indigenous cultures to considerately display and occasionally repatriate objects through access and imaging. The contemporary trend toward interdisciplinary and inter-institutional projects and exhibitions should encourage the development of research programmes and installations with biocultural concerns in mind. The techniques with which art museums customarily educate, develop and inspire their patrons and visitors offer models for the display of objects in other types of institutions that house biocultural collections.

## ACKNOWLEDGEMENTS

I would like to thank Jan Salick and Katie Konchar for inviting me to participate in this book, and the other participants and reviewers for their insights and suggestions, particularly Linda Bishop, Charles McNair, Robert Bye and María Edelmira Linares Mazari. I also thank Joanne Pillsbury, Heidi King and Stella Nair for their guidance on Andean source material.

## Literature cited

Adorno, R. (2001). *The Guaman Poma Website*. Royal Library of Denmark, Copenhagen. www.kb.dk/permalink/2006/poma/info/en/project/project.htm

Anderson, A. J. O. & Dibble, C. E. (eds) (1953). *Florentine Codex: General History of the Things of New Spain, Introductions and Indices*. School of American Research and the University of Utah, Santa Fe.

Banack, S. A., Rondón, X. J. & Diaz-Huamanchumo, W. (2004). Indigenous cultivation and conservation of totora (*Schoenoplectus californicus*, Cyperaceae) in Peru. *Economic Botany* 58:11–20.

Bauer, B. S. (2004). *Ancient Cuzco: Heartland of the Inca*. University of Texas Press, Austin.

Bierhorst, J. (1992). *History and Mythology of the Aztecs: the Codex Chimalpopoca*. University of Arizona Press, Tucson.

Bradley, R. J. (1993). Marine shell exchange in northwest Mexico and the Southwest. In: *The American Southwest and Mesoamerica: Systems of Prehistoric Exchange*, eds J. E. Ericson & T. G. Baugh, pp. 121–142. Plenum Press, New York & London.

Candler, K. L. (1991). Featherworking in Pre-Columbian Peru: ancient plumage. In: *The Gift of Birds: Featherwork of Native South American Peoples*, eds R. E. Reina & K. M. Kensinger, pp. 1–15. University Museum, University of Pennsylvania, Philadelphia.

Carrasco, D. (2000). *Quetzalcoatl and the Irony of Empire: Myths and Prophecies in the Aztec Tradition*. University Press of Colorado, Boulder.

Clavir, M. (2002). *Preserving What Is Valued: Museums, Conservation, and First Nations*. UBC Press, Vancouver.

Cook, A. & Conklin, W. J. (1996). Nasca/Huari and other South Coast textiles. In: *Andean Art at Dumbarton Oaks*, vol. 2., ed. E. H. Boone, pp. 413–423. Dumbarton Oaks Research Library and Collection, Washington, DC.

Cordy-Collins, A. (1991). Fonga Sigde: shell purveyor to the Chimu Kings. In: *The Northern Dynasties: Kingship and Statecraft in Chimor*, eds M. E. Moseley & A. Cordy-Collins, pp. 393–417. Dumbarton Oaks Research Library and Collection, Washington, DC.

Cordy-Collins, A. (1996). Lambayeque. In: *Andean Art at Dumbarton Oaks*, vol. 1., ed. E. H. Boone, pp. 189–222. Dumbarton Oaks Research Library and Collection, Washington, DC.

Dean, C. (2010). A Culture of Stone: Inka Perspectives on Rock. Duke University Press, Durham.

de Sahagún, B. (1950). *Florentine Codex: General History of the Things of New Spain, Book One*. Translated by A. J. O. Anderson & C. E. Dibble. School of American Research and the University of Utah, Santa Fe.

de Sahagún, B. (1961). *Florentine Codex: General History of the Things of New Spain, Book Ten*. Translated by A. J. O. Anderson & C. E. Dibble. School of American Research and the University of Utah, Santa Fe.

Donnan, C. B. & McClelland, D. (1999). *Moche Fineline Painting: Its Evolution and its Artists*. UCLA Fowler Museum of Cultural History, Los Angeles.

Feldman, R. A. (1986). Early textiles from the Supe Valley, Peru. In: *The Junius B. Bird Conference on Andean Textiles*, ed. A. P. Rowe, pp. 31–46. Textile Museum, Washington, DC.

Fine-Dare, K. S. (2002). *Grave Injustice: the American Indian Repatriation Movement and NAGPRA*. University of Nebraska Press, Lincoln.

Guamán Poma de Ayala, F. (2009). *The First New Chronicle and Good Government: on the History of the World and the Incas up to 1615*. Translated by R. Hamilton. University of Texas Press, Austin.

Hassig, R. (2001). Transport. In: *Archaeology of Ancient Mexico and Central America: an Encyclopedia*, eds S. T. Evans & D. L. Webster, pp. 767–768. Garland Publishing, New York.

Heyden, D. (1987). Symbolism of ceramics from the Templo Mayor. In: *The Aztec Templo Mayor*, ed. E. H. Boone, pp. 109–130. Dumbarton Oaks Research Library and Collection, Washington, DC.

King, H. (2000). *Rain of the Moon: Silver in Ancient Peru*. Metropolitan Museum of Art, New York; Yale University Press, New Haven.

King, H. (2013). The Wari feathered panels from Corral Redondo, Churunga Valley: a re-examination of context. *Nawpa Pacha* 33: 23–42.

Klein, L. (1986). *Exhibits: Planning and Design*. Madison Square Press, New York.

Lord, B. & Lord, G. D. (2001). *The Manual of Museum Exhibitions*. AltaMira Press, Walnut Creek.

Málaga, L. B. (1950). El descubrimiento de noventa y seis mantos de arte plumaruio de los antiguos peruanos en una tumba precolombina de la Hacienda Hispana en el distrito de Andaray, provincia de Condesuyos, el 12 enero de 1943. *El Debe*.

Matos Moctezuma, E. & Solís Olguín, F. (eds) (2002). *Aztecs*. Royal Academy of Arts, London.

McEwan, G. F. (2006). *The Incas: New Perspectives*. ABC-CLIO, Santa Barbara.

Miller, M. E. & Taube, K. A. (1993). *The Gods and Symbols of Ancient Mexico and the Maya: an Illustrated Dictionary of Mesoamerican Religion*. Thames and Hudson, New York.

Minnis, P. E., Whalen, M. E., Kelley, J. H. & Stewart, J. D. (1993). Prehistoric macaw breeding in the north American Southwest. *American Antiquity* 58: 270–276.

Mittal, A. (2010). *Native American Graves Protection and Repatriation Act: After Almost 20 Years, Key Federal Agencies Still Have Not Fully Complied with the Act*. United States Government Accountability Office, Washington, DC.

Nicholson, H. B. (1971). Religion in pre-Hispanic central Mexico. In: *Archaeology of Northern Mesoamerica,* Handbook of Middle American Indians. vol. 10, eds G. F. Ekholm & I. Bernal, pp. 395–446. University of Texas Press, Austin.

Nicholson, H. B. & Berger, R. (1968). *Two Aztec Wood Idols: Iconographic and Chronologic Analysis*. Studies in Pre-Columbian Art & Archaeology No. 5. Dumbarton Oaks Trustees for Harvard University, Washington, DC.

Ogden, S. (2004). *Caring for American Indian Objects: a Practical and Cultural Guide*. Minnesota Historical Society Press, St. Paul.

Pasztory, E. (1983). *Aztec Art*. H. N. Abrams, New York.

Pillsbury, J. (2003). Luxury arts and the Lords of Chimor. In: *Colecciones Latinoamericanas; Latin American Collections: Essays in Honour of Ted J. J. Leyenaar*, eds D. K. Jansen & E. K. de Bock, pp. 67–81. Tetl, Leiden.

Robbins, M. (1991). The sources of feathers. In: *The Gift of Birds: Featherwork of Native South American Peoples*, eds R. E. Reina & K. M. Kensinger, pp. 116–127. University Museum, University of Pennsylvania, Philadelphia.

Rowe, J. H. (1967). *An interpretation of radiocarbon measurements on archaeological samples from Peru*. In: *Peruvian Archaeology: Selected Readings*, eds J. H. Rowe & D. Menzel, pp. 16–30. Peek Publications, Palo Alto.

Serrell, B. (1996). *Exhibit Labels*: an Interpretive Approach. Alta Mira Press, Walnut Creek.

Simon, N. (2010). *The Participatory Museum*. Museum 2.0, Santa Cruz.

Stone-Miller, R. (2002). *Art of the Andes: from Chavín to Inca*. 2nd ed. Thames & Hudson, London.

Sullivan, T. D. (1982). Tlazolteotl-Ixcuina: the great spinner and weaver. In: *The Art and Iconography of Late Post-Classic Central Mexico*, ed. E. H. Boone, pp. 7–37. Dumbarton Oaks, Trustees for Harvard University, Washington, DC.

Szántó, A. (2009). With newspapers in terminal decline, what future for arts journalism? *The Art Newspaper* 202.

Thomas, D. H. (2006). Finders keepers and deep American history: some lessons in dispute resolution. In: *Imperialism, Art and Restitution*, ed. J. H. Merryman, pp. 218–254. Cambridge University Press, Cambridge.

# Biocultural collections: exhibition concept, planning and design

TOM KLOBE

University of Hawai'i Art Gallery

MICHAEL B. THOMAS

University of Hawai'i at Mānoa

Museums are public institutions that emerged from the European Age of Enlightenment (Chapter 20). Historically, they have been committed to the notion that 'through the study of things gathered together from all over the world, truth would emerge' (MacGregor, 2009). For centuries, museums have broadened the cultural horizons of the general public in ways that foster greater understanding of human, cultural and biological diversity.

During the past quarter-century, however, a wide range of social forces has called this concept into question and turned museum and public gallery spaces into sites of conflict (Cooper, 2007; McLaren, 2010). Global processes of ethnic assertion and redefinition, indigenous rights, evolving ideas about colonisation, and the intensifying struggle over cultural property have converged on the museum to cast doubt on its legitimacy and public mission (Brown, 2009).

Today, it is imperative that individuals who engage in the public exhibition of biocultural collections are aware of existing codes of ethics, best practices and policies. Within the confines of this chapter, we introduce fundamental principles and provide a broad outline of best practices for development of the concept, planning and design of a public exhibition of biocultural collection objects. These themes are explored in more detail in the book *Exhibitions: Concept, Planning and Design* (Klobe, 2013). The proposed guidelines have not been articulated for a specific type, size or kind of exhibition, therefore the suggested best practices should be used as a general reference from which to develop appropriate practices in your institution. We avoid the controversial issue of displaying human remains; readers interested in this contentious topic should review Lohman & Goodnow (2006) and Jenkins (2011).

## WHY EXHIBIT BIOCULTURAL OBJECTS?

Over the past 200 years, museums all over the globe have systematically built collections. Ritual objects, clothing, tools for hunting, fishing and transportation, household items, jewellery, pottery and baskets were collected to document the material culture of what was assumed to be the disappearing cultures of the world. Little did the curators or collectors realise that their collections would one day hold far more value than as simply indigenous items manufactured by vanishing civilisations. These collections would embody Native peoples' history, science, heritage and traditional knowledge. Increasingly, these collections — if identified, studied, and understood — contain implicit information and traditional knowledge about how humans make and utilise both biological organisms and material culture.

Today many Native peoples have lost much of their traditional knowledge, but they often have the opportunity to learn about their respective cultures from items in collections found in museums around the world. Museums play a very important role in the preservation of indigenous peoples' history. They

are caretakers of objects that have proven to be a pathway for Native peoples to learn, understand, and in some instances, recreate past traditions and practices. Without these collections, Native people would have an even harder time demonstrating links to their prehistory and the heritage of their people.

While collections are often the greatest resource of an institution, visitors experience museums primarily through displays and exhibitions. The general public has little knowledge of the role of collections management, care and preservation. The public often views the museum simply as a place to see 'things'. Therefore, an exhibit's most important role is as a tool for communicating and educating the public. The current trend in exhibit development is to present information that supports a 'Big Idea' and has a particular point of view (Nordstrand, 2004). This is a shift from previous eras in which some museums displayed their indigenous collections simply as objects, without cultural context. Native peoples played a vital role in developing this shift in museum exhibition policy. Even before the Native American Graves Protection and Repatriation Act (NAGPRA), informal consultation processes often allowed Native peoples' perspectives to inform the direction of exhibitions. A recent growth in the number of tribal museums reflects the need for alternative perspectives towards biocultural collections.

## EXISTING CODES OF ETHICS

Many respected professional scientific societies interfacing with biocultural diversity — such as the American Association of Museums, the International Society for Ethnobiology, the Society for Economic Botany and the Society for Ethnobiology — have developed codes of ethical conduct (Chapter 1) and their members are bound in good faith to abide by these codes of ethics as a condition of membership. However, these codes lack detailed guidance for preparing exhibitions of objects in biocultural collections. Many of the principles of these codes do not directly apply to exhibit planning, as the documents provide broad frameworks for decision-making and conducting field research and for the use of the products of research and related activities. They are especially concerned with the collation and use of traditional knowledge of collections of flora, fauna and other elements of biocultural heritage found on community lands or territories (ISE, 2006 online). As many of these codes of ethics are documents that are periodically updated, they will adapt over time to meet changing needs and understandings of the presentation of biocultural collections.

## CONCEPT

To begin, exhibition planners must clearly formulate the concept of the exhibition and then explore ways in which those ideas can be communicated. An integrated concept is the framework that allows comprehension of the meaning imbued in bringing objects together. Museum objects are like words, they make sense only when they are organised to present a message. Thus, comprehension of the exhibition concept is imperative as the first step in the planning process.

A strong, well-planned interpretive framework that provides visitors the opportunity to construct meaning that extends beyond pure aesthetics is integral to a good exhibition (Figure 1). Ideally, the manner in which objects are displayed should communicate their visual power and their significance in the culture that made and used them. Above that, the presentation and interpretation should enable the visitor to perceive the expressive potential of the objects and the ideas they embody in new ways, which address cultural interpretation and personal meaning. The exhibition's design should assist in conveying these messages and the overall purpose of the exhibition to visitors. Just as care is given to how exhibitions are intended to be understood, how they may be misinterpreted should also be anticipated.

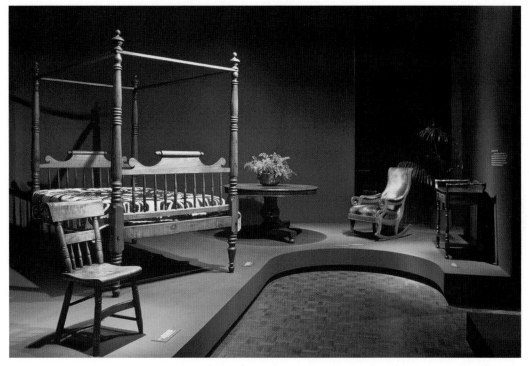

**Figure 1.** One of the conceptual considerations of the Koa Furniture of Hawai'i exhibition at the University of Hawai'i Art Gallery was to show the esteem that the people of Hawai'i have for koa furniture. This dictated the nature of the installation and the colour selection, and precluded an initially-considered experimental presentation in a slick scaffold environment that would have communicated very different information to visitors about the significance of koa to Hawai'i's people.
© UNIVERSITY OF HAWAI'I ART GALLERY.

## Best practices

- Develop an integrated concept that fosters comprehension of the meaning and purpose of the exhibition.
- Help visitors to identify and address cultural interpretation and personal meaning.

## RESEARCH AND FORMULATING THE 'BIG IDEA'

A well-formulated conceptual framework is essential. Often, it is termed the 'Big idea'— a theme that allows visitors to comprehend a particular subject. It enables visitors to feel there is a certain order — a beginning, middle and end that guides their visitor experience. The 'Big idea' establishes the meaning and intention of the exhibition and provides the rationale for the objects that are included. Conceptual structure and familiarity with the objects most often convey a thematic feeling — an atmosphere — that suggests the general character of the exhibition.

Exhibit development is a complex, nuanced process that integrates scholarship with the goals of audience engagement. It usually starts with the curator, but sometimes an exhibit team includes education specialists, exhibit designers and other specialists, who work together to define the concept and refine the 'Big idea'. When pertinent, identifying and including indigenous representatives on the team provides increased richness, improved depth of scholarship and significant cultural interactivity.

The team approach, where curators, indigenous consultants and collaborators, educators and exhibit designers work together, has certain advantages in combining multiple skills and diverse approaches in exhibition planning. This process demands democratic interaction, in which all team members feel free to advocate for their areas of concern without fear of alienating others. The collaborative approach results in a broader range of ideas and often a stronger conceptual context. When using a collaborative method, often in the beginning the planners do not have a precise notion of the evolving direction of the 'Big idea' — especially of what the conclusions will be. This method fosters creativity and produces an exhibition that is almost always more interesting to experience. Optimally, the collaborative approach provides those working on the exhibition, and subsequently the visitors, with new insights and allows them to make discoveries that are more engaging and certainly more interesting. Connections may be articulated that, at first, would not have been imagined.

To develop the focus of an exhibition, planners need to assume a visitor's perspective, by asking themselves fundamental questions about the exhibition topic. What is the message to be conveyed? What is the purpose? Who and what are involved? When and where were they involved? Also, ask how and why questions that go beyond basic facts and into inquiry. Why is the topic relevant or interesting today? How does the topic fit into current scholarship? What impact do I want to make? Then ask: who is the audience? What do they already know and what do they expect to learn?

An efficient strategy for creating questions from an exhibition topic is to develop a one-sentence statement that becomes the preliminary 'Big idea' and guides the planning. State the topic, formulate a research question and provide a rationale for the research: I am researching topic X, to answer research question Y, to understand rationale or significance Z (Figure 2).

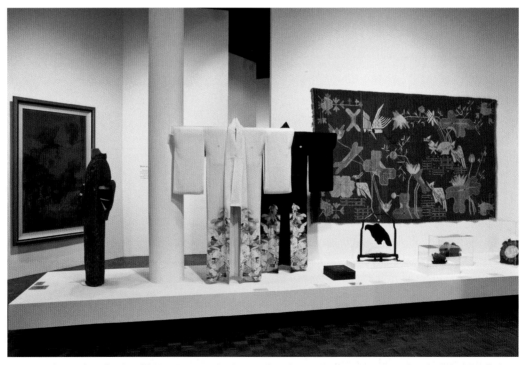

**Figure 2.** The statement for the exhibition *On Heavenly Wings: Birds and Aspirations* was: "I am researching birds (topic) to find out how birds have influenced our lives (research question) to understand the interconnection of our world (rationale/significance)." From that sentence a framework was created that showed how vastly different cultures, artists and scholars of diverse disciplines are inspired and derive meaning from birds and flight. © UNIVERSITY OF HAWAI'I ART GALLERY.

Articulating the premise of the exhibition in this simple and forthright manner keeps the research focused. This approach forces the exhibit team to analyse the significance of the available objects in relation to the theme of the exhibition. It aids in the development of a storyline that uses the artefacts to tell the story. Then, the artefacts serve as powerful tools to enable the objectives of the exhibition to be communicated. The overriding mission is to help people leave the exhibition feeling differently from when they came in. For visitors, an exhibition succeeds when the research strategy surrounding the 'Big idea' comes through: when the topic makes sense, the research question matters and the rationale or significance inspires.

An effective method of organising thoughts is to simply make random lists of topics, subjects and ideas that could be addressed in the exhibition. Second, begin to search for resources: books, periodicals and internet references, and consult with other experts. Critically evaluate the resources, keep adding to your list and, as you do so, certain patterns will emerge. Cluster these ideas and fill out the list in greater detail, constantly grouping and regrouping ideas. New ideas and modifications will occur. Some of these ideas will help to tie things together, to serve as transitions. Throughout the process, one should stay focused and keep returning to the essence of the exhibition contained in the one-sentence statement. As a result of the process, depending on the objects and the information discovered in the research, a flexible outline will emerge.

The written statement that expresses the 'Big idea' is used by the exhibit team and rarely serves as a label or introductory statement for visitors. Nevertheless, it guides the development and interpretation and subsequently increases the potential for visitors to decipher the exhibition's objectives. Often, it allows them to see multiple viewpoints and to reach their own conclusions.

An analysis of how the material to be presented can best be understood by visitors and of how the installation design can enhance the intended visitor response is integral to a conceptual approach to planning and design. The objective is to make the collection accessible to visitors. It must encourage visitors to gather, from their experience, a greater understanding of and appreciation for what they are seeing.

## Best practices

- Establish a team that includes curators, indigenous consultants, educators and exhibit designers who work collaboratively.
- Formulate the premise of the exhibition in a one-sentence statement that establishes the 'Big idea'.
- Create a simple checklist of ideas based on thorough literature research.

## SELECTING OBJECTS FOR DISPLAY

The exhibition team must exercise caution in balancing conceptual concerns with the visual qualities of the displayed objects. Without careful orchestration, theoretical ideas can dominate and, subsequently, diminish the visual interest and success of an exhibition.

A balance of cultural considerations is necessary for the selection of objects for exhibit display. In many cultures, certain traditional knowledge may be viewed as privileged information only accessible to a few individuals, not community knowledge for all. Objects as well as images, especially those used for ceremonial or religious purposes, are often integral to this knowledge. In the past, museum curators often did not respect these traditions or unknowingly displayed sensitive objects that were never intended for public view. A well-balanced approach that includes Native peoples in the decision-making process for object selection is ideal. Before initiating object selection, several fundamental questions should be asked.

- Did the maker intend for the object to be publicly displayed or even preserved beyond its original use?
- What was the maker's intention in creating the object?
- Is the object a work of art or an historic artefact?
- Is the object considered to be 'living' or non-living?

To properly address these fundamental questions, the object-selection process should include consultation and collaboration with indigenous representatives of the object's provenance. Exhibit developers should also provide an exhibit plan for review by indigenous collaborators. It is a poor practice to assume that all indigenous peoples share a similar view of object care and handling as practiced in conventional museums.

With more museums under indigenous or tribal management, many cultural groups have developed guidelines for the handling and display of sensitive objects to assist curators in developing exhibits. These best practices may call for special mounting, removal of the object at certain times, or exclusion for periods of time. Some items may require specific protocols or prayer and specialised care. Increasingly, guidelines can be requested from tribal councils, cultural preservation representatives or repatriation coordinators.

## Best practices

- Ask fundamental questions pertaining to object presentation and provenance.
- Consult and/or collaborate with cultural representatives (elders, indigenous scholars, curators, advisory boards, practitioners and community representatives) to provide an opportunity for input as to why and how objects should or should not be displayed in accordance with respect for cultural traditions.
- Be familiar with the various professional Codes of Ethics.

### EXHIBIT DESIGN

The manner in which objects are presented in a museum, botanical garden, herbarium or gallery affects the response of visitors. Good exhibition design fosters thought and elicits emotion. Design should help visitors become aware of the objects and the exhibition concept. It should not call attention to the way things are exhibited. It must allow objects to speak for themselves without the clutter of distractions caused by over-elaboration or attention-grabbing display techniques.

Exhibit design is best when the visitor is unaware of how material is being presented. Objects should look like they belong the way they are. The design must be so natural that it enhances the objects and does not compete with them or the narrative. There should be no distractions that lead the eye and mind of the visitor away from what is being presented. In this way, design reduces the phenomenon of 'museum fatigue'.

When objects are assembled and seen together, they either visually enhance or detract from one another. Since exhibit design specifically involves bringing items together, the objective is to achieve a whole that is greater than the sum of its parts. But it is one in which each of the parts maintains its unique identity, its distinctive importance. Planners need to exercise caution so that the display of one object does not sacrifice the value and quality of others. Simplicity and restraint, pacing and flow, and careful attention to the utilisation of space are keys to making objects appear to belong naturally together, and of providing the visitor with a sense of unity and visual continuity.

The environment that surrounds exhibit objects influences the ways in which visitors interpret those objects. The environment helps to present meaning. The background surroundings of an exhibition can suggest a synergy compatible with the objects, or it can create a tension that either heightens the impact or conversely serves to distract from the conceptual integrity and meaning. For example, changing a space's proportions, colour, value (the darkness or lightness of objects or backgrounds) or lighting all affect the way visitors feel in an exhibition space. The intricacies of context inevitably influence human perception and give significance to the objects. Thus, good design depends on an articulation and understanding of the exhibition's overall concept.

An understanding of the elements and principles of art and an ability to apply this understanding are essential qualities for those who prepare exhibitions. It is important for the designer to conceive of the creation of an exhibition as the formulation of a work of art. When the designer plans and thinks of the exhibition as a group of objects that exemplify the elements and principles of art, organisation will become easier and the results more successful.

While the message to be conveyed may dictate a narrative, it is necessary for the designer to conceptualise abstractly — to let knowledge of the elements and principles of art determine the nature, flow and sequence of the exhibition. Even when the narrative aspect is essential to maintain, the designer must structure the installation with an understanding of what kind of shape, colour or space is necessary at a particular point in the exhibition. Then a specific object or manner of presentation needs to be found to fulfil that requirement. Working abstractly helps to assure that the final outcome of an exhibition is effective.

For the purpose of planning an exhibition the designer has certain tangible elements that have concrete reality — that is, elements that can be seen, sometimes even felt. These elements are space, line, form, value, colour, texture and time or motion. The elements work in conjunction with each other. No element can be isolated or employed independently of the others. Neither can the elements be considered separately from the principles of art: unity, repetition, movement, transition, opposition, emphasis, balance, variation and simplicity.

While the elements are tangible and concrete, the principles are intangible, only sensed. They involve the feelings elicited by the organisation of the elements and result from a human inclination to search for order.

In a good exhibition, there is a synthesis of elements and principles that work together to create a sensation within the observer. The designer effectively manipulates the elements and principles until the dynamic energy of their relationships is brought into harmony.

## Best practices

- Design with simplicity and restraint so that visitors maintain an awareness of the objects and the exhibition objective.
- Create a background setting that is compatible with the objects and the exhibition concept.
- Consciously apply the elements and principles of art to the organisation of the exhibition.

## APPLICATION OF THE ELEMENTS OF DESIGN

Good exhibition design is contingent upon giving first priority to careful development of the space. Consideration of all the other elements of art is secondary to effective articulation of space. Space must be defined by the objects that will be on display, by the ability of visitors to view the works effectively, and by efficient movement of people through the exhibition. Additionally, space can

be developed to convey an intended mood and thereby heighten a visitor's experience. Thus, the feelings evoked by the exhibit space must be appropriate to its purpose and context.

Plan drawings or a three-dimensional model are essential to the development of the exhibition space. They need to be formulated with consideration given to planning a space for every object that will be on display. A model is especially important in the formation of space relative to expressing the concept or feeling of the exhibition, but it also helps in determining visitor flow and the visual arrangement of objects. A good model can save hours of time trying to accommodate objects later.

Line is an important organising element, a strong device that can bind together a variety of units. Much of the visual continuity of an exhibition depends on the skill with which linear movements are established. A well-organised linear structure helps to reveal the exhibition's intention with clarity and conviction.

Careful consideration must be given to the size and shape of objects when planning an exhibition, so that appropriate spaces can be selected or constructed for the works being presented. It may be necessary to group objects to create a larger form or shape in a certain part of an exhibition. Still, care must be exercised in the selection of objects that are brought together. The capacity to establish coherence is dependent on the visual similarities and differences between the units, and on their relative positions. The purpose of the exhibition must be clear so that the juxtapositions established by bringing objects together will communicate the intended message.

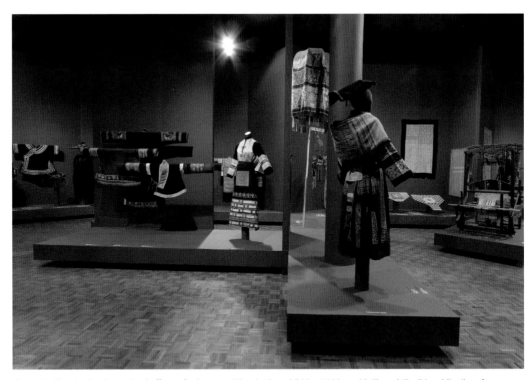

**Figure 3.** The visual and emotional effects of value are evident in the exhibition Writing with Thread: Traditional Textiles of Southwest Chinese Minorities. Space and value were determined to be of equal importance to the selection of colour that had strong cultural significance. Value allowed the background to recede, to blend in value with the floor and ceiling. By reducing contrast between the objects and the background, emphasis was given to the exhibition elements — the textiles. Even the low levels of illumination necessary for conservation purposes allowed the textiles to stand out. © UNIVERSITY OF HAWAI'I ART GALLERY.

The ability of forms or their groupings to establish mood by their interaction with space is a powerful tool for the designer. By utilising form to contract or expand space, the designer subtly influences visitor response to an exhibition environment and to the collection objects within it.

Value results from a combination of two factors: the inherent value of an item or its darkness or lightness, excluding the effects of light; and the incidental value created by light or illumination (Figure 3). Value is a vital element in establishing thematic emphasis and compositional order in an exhibition. Even more than colour, value has an impact on the nature, feeling and mood of an exhibition. Sensitive value considerations have the ability to focus the viewer's attention on that which is most important and to enhance the conceptual meaning of the exhibition.

Colour can convey a wide range of expressive moods. It often produces the first and most lasting impression on those who enter an exhibition, and thus the sensitive selection and combination of hues, values and intensities are of paramount importance. The designer's responsibility is to understand the purpose and theme of the exhibition and to analyse how colour should determine the nature of the visitor's experience.

Aside from cultural and conceptual reasons that prescribe a specific colour, colour is not important in and of itself. The result of bringing various colours together is the significant thing. Our eyes perceive colour in relation to all that is around it, and the nature of a colour changes radically when it is placed next to another. Contrasts are emphasised, whether they are hue, value or intensity.

Texture brings two important considerations to exhibition design. One is texture within the setting or the environment, and the other is the texture of that which is being displayed. Of the first, texture within the setting, designers must be careful to use restraint. Too many variations of textures in the setting create a situation in which attention is diverted to the background rather than to the objects. The second consideration, the texture of that which is being displayed, has to do with textural correlations between objects. Besides establishing visual continuity of line, shape, value and colour, care must be exercised in the determination of tactile relationships.

Physical space always involves the element of time or motion. Attention to the development of effective and dramatic sight lines, especially at the entrances to sections, is essential to eliciting and maintaining visitor interest. Careful pacing of an exhibition or the entire museum experience helps to reduce visitor fatigue, both physically and mentally. Viewing an exhibition requires the concentrated use of a visitor's eyes and mind. The ability of the visitor to deal comfortably with a succession of experiences must be given consideration. Calculated places along the viewing route should permit visual and mental rest.

Conscious attention to the application of the elements of art is one of the most effective methods of assuring that an exhibition will have the vitality to sustain a visitor's interest. It will enhance the visitor's ability to focus. When the elements are considered with sensitivity, attention is directed to what is on display and not to careless and inconsequential details.

## Best practices

- Development of space for each object and for visitors should be a high priority.
- Develop a floor plan or three-dimensional model to visualise the exhibit design.
- Use background values and colours that communicate the cultural or conceptual context of the exhibition.
- Employ continuity of line, variation in shapes and spaces, and restraint in the selection of textures.
- Allow the exhibition to reveal itself to the visitor slowly.

## EMPLOYING THE PRINCIPLES OF DESIGN

Consciousness of the principle of unity is of paramount importance in the presentation of exhibitions. Unity helps to keep the attention of the visitor focused on the objective or purpose of the exhibition and on what is being presented. When there is unity, we sense an overriding harmony and continuity that even encompasses contrasting elements.

Conceptual unity is essential to communicating the 'Big idea'. Thematic unity is not, however, sufficient to hold together an exhibition or even a portion of an exhibit. Without careful integration of the visual elements, even the most obvious conceptual relationships will not succeed.

The underlying principle of integrating all the parts of an exhibition is to develop similarities and connections. In a good exhibition, visitors will identify and find endless interactions. They will constantly discover new relationships, new connections.

The repetition of elements in an exhibition helps to guide the visitor harmoniously through the space. Continuity results as rhythmical order and relationships establish progressions that repeat and recall each other, so that the finished exhibition is a satisfying whole. Nevertheless, unvaried repetition has a danger of becoming monotonous. A good exhibition team should find a way of giving variety to the cadence of common elements. This can be achieved through attention to spacing or to subtle changes in the nature of the other elements. When subtle rhythms are established, an unobtrusive harmony envelops the work.

In an exhibition, the establishment of locations of interest and their integration into the total composition creates movement. Objects should be placed in a way that leads the observer on with a comprehension of the overriding message of the exhibition.

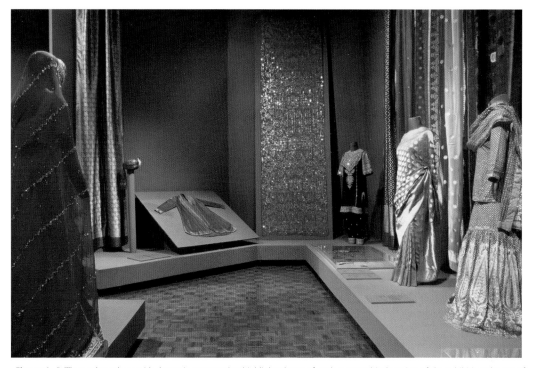

**Figure 4.** Brilliant colour along with dramatic presentation highlighted part of each geographical section of the exhibition The Art of Asian Costume. Meanwhile subtlety, usually of colours, values and textures, characterised subordinate areas.
© UNIVERSITY OF HAWAI'I ART GALLERY.

When the change between different units within an exhibition is abrupt, a transition may need to be employed to bind dissimilar elements together. Transition serves as a bridge between opposing forces and helps to establish unity. It is an integrating factor that fuses a variety of unrelated parts into an ordered and cohesive whole.

Opposition, contrast or tension produces a dynamic expressiveness. It creates a vital, interesting and exciting exhibition. When connections are sought between contradictory parts of an exhibition, unity is achieved through this juxtaposition of opposites. Designers use opposing forces to give exhibitions vitality. In doing so, they run the risk of creating chaos, of not being able to reconcile the diversity of ideas and objects into a greater harmony. In the end, the visitor must feel that opposites, those contrasting elements, are reconciled into an overall unity.

The creation of visual emphasis within an exhibition is essential to alleviating visitor museum fatigue (Figure 4). Undifferentiated sameness contributes to monotony. As a consequence, an exhibition can fall short of effective communication. After formulating the motivational idea of an exhibition, designate those objects or parts of an exhibition to which attention must be given. Begin by placing key pieces and work others around them. In turn, subordinate areas gain importance by being quiet. Neglecting the principle of emphasis sets everything on a plane of equal importance, presenting a confusing visual image in which the visitor is given no direction.

Balance is that aspect of an exhibition in which everything shown is arranged in a way that creates a sense of stability. A designer must work to create a final form that achieves a state of visual balance. All must appear related to the other components of the exhibition.

The objective of exhibition presentation is to achieve a balance between variation and continuity. Too many variations and contrasts can lead to chaos and confusion; too many similarities to boredom. Designers must work to achieve variety in unity through the development or expansion of various aspects of the exhibition's basic concept. They can bring variety yet continuity to an exhibition by the repetition of an idea, theme or presentation method, each time in a slightly new and different way. The irrelevant, extraneous and superficial must be eliminated or the result may be merely a collection of objects, choppy and confusing, much like a yard-sale display.

Simplicity is paramount to bringing attention to the objects and the exhibition's intended message. Each aspect of the exhibition must be indispensable to the exhibition's overall value. No elements that are not essential should be present, but all that are necessary must be present.

Economy of expression is vital to any communication. Clutter is confusing and taxes the cognitive abilities of observers. Unimportant and intrusive details dull meaning. Simplicity summarises and amplifies meaning. Thus, all the parts of an exhibition need to be brought into agreement. Keep in mind the adage, 'When in doubt, leave it out'. This fosters a questioning approach, in which the need for each and every element, every decision, is questioned and evaluated in relation to the total statement.

Foremost to the development of good exhibitions is the search for effective visual and conceptual associations between the objects and ideas presented. Establish correlations that bridge a diverse array of material and information. Similarities and connections must be developed that effortlessly guide the visitor toward a sense of satisfaction and comprehension.

## Best practices

- Work for visual and conceptual unity to keep the visitor focused on the objective of the exhibition.
- Work to achieve variety yet continuity in the exhibit presentation.
- Maintain simplicity in conceptual development and exhibit presentation.

## INTERPRETATION

Museums have an obligation to present exhibit material in a manner that encourages visitor access to that content. Good interpretation promotes communication between the audience and the resource by providing information that enriches and adds resonance to personal experience. Successful interpretation cultivates active looking by encouraging close observation and discovery. It kindles the imagination, fosters inquiry and allows visitors to make their own judgments.

The intent and purpose of the exhibition will determine the specific messages contained in the interpretation of individual objects. Keep the 'Big idea' in focus when developing all aspects of an exhibition's interpretation. The primary objective is to help visitors focus on that one, overriding and all-important message: the significance of the exhibition and how the artefacts contribute to it. Nevertheless, the exhibition should be sufficiently multi-layered in meaning to generate the broad involvement of diverse audiences, where understanding is elastic and variable and might even elicit conflicting interpretations.

In the process of planning potentially controversial exhibitions and programmes, museums should find ways to acknowledge multiple interpretations, and to involve and balance the voices of diverse groups. Museums are currently trying to address with heightened sensitivity the issues of interpretation of objects relating to indigenous peoples and cultures. Concerns about who has the authority and right to display and interpret the biocultural properties of another have opened many museums to the involvement of indigenous communities in the planning and interpretation of exhibitions. Indigenous people often feel it is only they who should decide if and how they want biocultural collections to be presented. Fortunately, the voices of long-silenced people are becoming part of the messages that museums provide. Optimally, the voices serve as a conduit to multi-cultural communication and understanding.

As educational institutions, museums have an obligation to present sensitive issues, but they must do so in a responsible manner without offending any cultural group. Exhibitions should advance cultural equity, understanding, empathy and tolerance, and should show the universality of human values. The interpretation in which the museum engages should bring insight to all and, especially when it exposes a destructive event imposed by one group on another, it should encourage a commitment to understanding and behavioural change.

People learn in different ways. Consequently, it is the responsibility of museums to structure exhibitions that allow people to encounter and respond with their own manner of thinking. Exhibitions are most effective when they encourage multiple means of access and learning —when they accommodate differences among learners by providing a variety of ways to engage a subject.

Appealing to a variety of learning styles adds depth to visitors' experiences. Linear, structured approaches should be balanced with dynamic, interactive and multi-sensory experiences, along with shared, participatory and social activities. When a variety of experiences conveys similar messages, the exhibition in its entirety will reinforce communication of the 'Big idea' to the greatest number of visitors. Then, even if visitors choose only the elements that appeal to them, the intent of the exhibition should become evident.

Methods of interpretation include: labels; sensory and interactive experiences; multimedia and audio-visual productions; taped, docent, self-guided or living-history tours; storytelling; lectures; workshops; and publications. Central to all these approaches is the importance of maintaining the clarity of the exhibition's essential message. Whatever the selected modes of interpretation, the interpretive planner must define the objectives. What is the purpose of the exhibition and of presenting the material? Once defined, the interpreter's job is to simplify and make interesting the

important information about the objects as they relate to the context of the exhibition. Render the story in simple, standard language supported by sound, factual research.

Interactive exhibits create a fun and more accessible learning environment. They must, however, go beyond pushing 'start' buttons and viewing scripted presentations. Like all interpretive methods, they should utilise the museum's resources and authority to engage visitors in inquiry and critical thinking. When they are developed to be multisensory and hands-on, interactive exhibits engage the visitor in a participatory learning experience, one that is varied and that provides physical, intellectual and sensory involvement.

## Best practices

- Develop interpretation methods that encourage close observation and discovery.
- Keep the 'Big idea' in focus when developing all aspects of interpretation.
- Develop multiple means of visitor access.

## LABELS AND SIGNAGE

Labels should closely integrate with and narrate the ongoing message of an exhibition. The person who writes the labels should be thoroughly aware of the 'Big idea' and understand the purpose of the exhibition, so that concise and intelligible labels can be developed. Write labels that help visitors see the objects and experience the resonance of the exhibition. Label objectives should be no more than two: Why is the label needed? What is it supposed to do? Most importantly, the objectives must support the 'Big idea'.

Good labels reflect and interpret the people, times and places of an object's creation. They serve as vehicles to educate and enlighten. They provide the historical, social and political context for the artefact, by considering what it denotes to individuals within the culture, the implications it has, and how it reflects that culture.

Preparing good exhibition labels requires time and patience. They are best when they are produced by an experienced label writer, using research provided by experts. The non-specialist has the advantage of seeing the topic from a position closer to the interests of the general public. They have less difficulty in synthesising the specialised knowledge of the expert into a few simple sentences that communicate with a general audience.

Labels should be written in a manner that guides visitors but allows them to reach individual conclusions. Simplicity is imperative to good exhibition writing, which is free of superfluous and intrusive details that only dull meaning. Label writers should use informal, conversational language and an expressive voice that gets people involved. They should choose active verbs and sensory words and should avoid the verb 'to be' in all its forms. Writers should refrain from beginning sentences with 'This is' or 'These are.' They should avoid repeating the same words or phrases, but should find ways of restating the exhibition theme, not assuming that the visitor will remember it.

Labels should have sentences of different lengths, from five to 25 words. Long compound sentences hinder comprehension. The length of labels should also vary; labels of uniform length imply monotony and that everything is of equal importance.

An integrated system of signage and labels provides simplicity and helps visitors comprehend an exhibition. Title labels should be short, arouse interest and provide enough information for visitors to know what the exhibition is about. Introductory labels clearly state the theme of the exhibition or its subsections and summarise the main concepts. They are best when they are short (25 words

LI – HAINAN ISLAND

**BENDI UPPER GARMENT**
Baisha style
c. 1920

The Bendi group resides primarily in Baisha County and is renowned among the Li people for its strong artistic traditions. Men excel in woodcarving and women, in the textile arts.
Star, forest, and dragon motifs in satin stitch dominate the front and back panels of the upper garment. Mica chips add to the glittering effect of a night lit by stars. The complex images of frogs, dragons, deer, and other motifs on the rectangles flanking the center panels suggest the omnipresent custom of animism and ancestor worship.

**Figure 5.** For the exhibition *Writing with Thread: Traditional Textiles of Southwest Chinese Minorities*, which emphasised the cultural significance of textiles, care was given to computer match the background label colour to the painted platforms and walls. Samples showed that the labels were easier to read if the type was screened a percentage of grey (although it appeared white) rather than left the bright white of the paper. The stark white text on the dark red background made the type seem to vibrate. Samples also showed that the initial selection of type size and leading needed to be changed to permit better visibility when the labels were placed on the foot-high platforms. Finished label size: 30 x 43 cm (11 ¾ x 17 in).
© UNIVERSITY OF HAWAI'I ART GALLERY.

or less) and use large print. Section labels are usually longer and provide the rationale for grouping items. They help visitors understand the intended cohesiveness of the objects in certain areas of the exhibition. Captions, placed near the objects, interpret individual artefacts by referencing specific visible characteristics and emphasise the object's significance and meaning in relation to the exhibition concept. Identification labels that give basic facts — name, date, material, scientific name, accession number and donor information — are often combined with interpretive captions.

Care given to consistency of typefaces, size, boldness, colour, italicisation and placement helps visitors to see and absorb information and to understand the logic of the exhibition interpretation system. The readability of labels is of vital importance to maintaining visitor interest and reducing visitor 'museum fatigue'. Choose a typeface with letters that are easy to distinguish from one another — with full lower case letters, where the x-height is not condensed or extended and where the 'o' is round. The letters should not have extensive contrast between their thick and thin elements. Use upper and lower case letters in body copy. Boldface may be used for titles, but be cautious of its use for body copy. Display type (typefaces of elaborate or unusual design) should be reserved for exhibition titles and subtitles as they are too hard to read when set in paragraph form.

The determination of type size is contingent upon the context of its use: its position, purpose, colour and lighting, and should consider visitors with visual impairments. Be sure the size is sufficiently large to accommodate the reader's range of visual acuity. Assure that line length will allow the reader to return easily from the end of one line to the beginning of the next. About 50 to 65 characters (including spaces) per line are generally acceptable. Use leading and negative space within the label to enhance readability. Exhibition graphics are most effective when they are set with ragged-right margins. Don't hyphenate words.

Glossy vinyl type and labels on glossy paper or covered with acrylic sheeting decrease readability. Type colour and background (Figure 5) are critical elements in legibility. Poor colour contrast makes reading difficult, but an exhibition in which the labels contrast with the wall colour (for example, where white labels are placed on dark walls) causes the labels to dominate over the objects and destroys the aesthetic unity of the exhibition.

Position labels so that they are clearly visible: about 137 cm (54 in) from the floor to the top of the label is an effective height for people in wheelchairs as well as the general public. Always test actual-size exhibition signage and labels in the gallery under the anticipated light conditions.

## Best practices

- Write labels that communicate the message of the exhibition.
- Use informal, conversational language and an expressive voice that gets people involved.
- Simplicity of language and label design is the key to communication — keep labels short.
- Select a typeface and type size that is easily readable.

## LIGHTING

Good lighting affects visitors' perceptions of an exhibition. Lighting creates atmosphere, establishes mood and, above all, determines how things are seen. Appropriate lighting gives expression to the exhibition's meaning and concept, and elicits visitors' emotional responses. It sets up important relationships between objects, ideas and the visitor. At its best, light should seem to emit from an object with minimal attention drawn to the light source.

While objects need to be seen adequately, this can be accomplished at relatively low levels of illumination. When light levels are consistently low, especially for conservation or thematic reasons, the human eye adjusts and makes even dimly lit objects visible. Once the eye has accommodated itself to low levels, light-sensitive objects can be highlighted at low levels of brightness. This slightly increased illumination will appear bright if the eye has already adapted to even lower levels. When

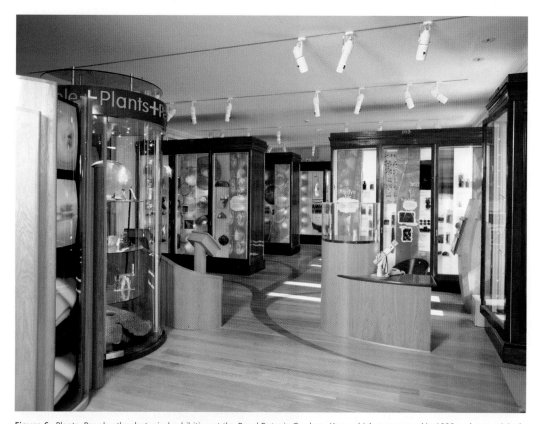

**Figure 6**. Plants+People ethnobotanical exhibition at the Royal Botanic Gardens, Kew, which was opened in 1998 and uses original 19th century showcases. The lighting of the objects and labels within the cases uses fibre-optic units mounted on top of the cases.
© ROYAL BOTANIC GARDENS, KEW.

strong contrasts of light intensity occur within the visitor's field of vision, however, the ability to distinguish details is hampered.

Natural light adds a comforting human dimension to exhibition spaces, but it is unpredictable and often uncontrollable. In addition, natural light contains high levels of harmful ultraviolet radiation that contribute to the deterioration of many types of art and artefacts, especially organic materials, dyes and certain pigments. Some of the damaging effects can be controlled by limiting the quantity of light and by the use of ultraviolet filters. Nevertheless, within all temporary exhibition spaces, provisions must be made to allow the possibility of complete control of light and exclusion of any natural illumination.

Artificial light constitutes the most reliable source of illumination in museums. It provides the flexibility and continuity necessary to create aesthetic and conservation-stable environments. While all types of artificial lighting systems present specific disadvantages, fluorescent light emits large quantities of damaging ultraviolet radiation and should be avoided in museum displays.

Incandescent lamps do not emit significant amounts of ultraviolet radiation, but they produce heat and therefore are not recommended for use in enclosed cases, unless the cases can be ventilated adequately. In addition to the thermal heat generated at the fixture, incandescent lamps emit infrared heat that warms the objects on which they are focused. Infrared rays can, however, be reduced with filters. Movement sensors that dim lighting when visitors are not present in the gallery provide an effective method of reducing the duration of light exposure.

Tungsten-halogen or quartz-halogen lamps are more efficient and produce a whiter light, but they also emit higher amounts of ultraviolet rays that need to be reduced with glass filters.

Low-voltage lamps produce less heat and a tighter beam spread that can be projected from a great distance. Thus, they are useful for high ceiling mounting. They are not, however, as warm in colour as standard incandescent lamps.

Fibre optics are useful for lighting display cases that require low light levels. Their distinct advantage is that the light source can be a single lamp located some distance from where the lights are needed. This flexibility eliminates heat within the case interior and permits lamp replacement and maintenance outside the vicinity of the displayed artefacts. Also, virtually no infrared and ultraviolet rays are emitted from the system, thereby delaying object disintegration caused by continued exposure to light.

The use of light meters that measure all frequencies of light, including visible and ultraviolet, is recommended. The

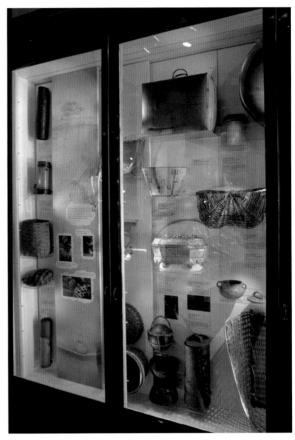

**Figure 7**. View of a display case in the Plants+People exhibition at the Royal Botanic Gardens, Kew. © ROYAL BOTANIC GARDENS, KEW.

light meters that are commonly used by photographers can, however, only measure the quantity of visible light. They must be held parallel to the surface being checked (vertical for a painting, horizontal for a flat surface). The entire surface of an object should be scanned to assure the light is even. Light levels are measured in foot-candles, each of which is the amount of light produced by one candle at a distance of one foot. 'Lux' is the term used in the metric system and is the approximate equivalent of ten foot-candles (fc).

Textiles, watercolours, paper, albumen or colour photographs, botanical specimens, fur, feathers, wood, leather, lacquer and ivory are especially sensitive to light and should be exposed to a maximum illumination of 5 fc. Oil, acrylic and tempera paintings tolerate 15 fc. Metal, stone, glass, ceramics, jewellery and enamel can be lit to 30 fc. These constitute general guidelines; Ogden (2004) and Chapter 2 should be consulted for a more thorough review of caring for biocultural objects. Curatorial or conservation advice should be sought to determine the maximum light level for a given object. Because perception is determined by the amount of ambient light in the environment, exhibit lighting can be designed around these requirements. Thus, if a gallery is lit at 3 fc, objects that are illuminated at 5 fc will appear bright. The salient point in effective lighting remains – avoid contrasts of light intensity in the same environment.

The constantly changing nature of light technology demands that new construction or remodelling teams include a consultant who is experienced in museum lighting.

## Best practices

- Work to achieve consistently low levels of illumination throughout an exhibition that contains light-sensitive objects.
- Avoid natural light and the use of fluorescent lamps.
- Seek the advice of conservators to determine the maximum light level that an object should be exposed to.

## SECURITY AND CONSERVATION

Security of collection objects is of major importance in the presentation of exhibitions. This entails not only securing objects against theft but also safeguarding objects from being touched by visitors. Rare, fragile or small items should be placed in vitrines, or alternate approaches to display must be developed to assure their security.

Likewise, environmental factors such as light and fluctuations in temperature and humidity can cause damage. Designers must be conversant with conservation concerns, which include material and finish selection, case construction, lighting design, display mounts and insect control. In exhibitions of objects that have different physical properties, the divergent responses of various materials to environmental conditions can pose a challenge to designers. The advice of conservators is always necessary in formulating wise design solutions that maximise the preservation of objects. Ideally, a conservator will be part of the design team.

## Best practices

- Be aware of current conservation standards.
- Consult with conservators as the exhibition is planned.
- Regularly monitor the finished exhibition.

## CONCLUSION

The presentation of biocultural objects within exhibitions is most effective when the planning process includes the advice and expertise of diverse specialists. Collaboration must be integral to the planning and manner of working. Individuals, departments, institutions and communities should be brought together. Leaders must foster an environment in which all exhibit participants work cooperatively and collaboratively.

## NOTE

In this chapter, we use the terms 'indigenous', 'Aboriginal' and 'Native' more or less interchangeably. In some countries, one of these terms may be favoured over the others; conventions about their capitalisation also vary. Here we follow the most common usage in the USA in 2010.

## *Websites*

International Society of Ethnobiology (ISE) (2006). International Society of Ethnobiology Code of Ethics (with 2008 additions). http://ethnobiology.net/code-of-ethics/

Kosasa, K. (2010). Exhibition Planning and Design: Writing with Thread series. Museum Studies Graduate Certificate Program, University of Hawai'i at Manoa, Honolulu. www.youtube.com/watch?v=T73_pWmlPNY

## *Literature cited*

Brown, M. F. (2009). Exhibiting indigenous heritage in the age of cultural property. In: *Whose Culture? The Promise of Museums and the Debate over Antiquities*, ed. J. Cuno, pp. 145–164. Princeton University Press, Princeton.

Cooper, K. C. (2007). *Spirited Encounters: American Indians Protest Museum Policies and Practices*. Alta Mira Press, Lanham.

Jenkins, T. (2011). *Contesting Human Remains in Museum Collections: the Crisis of Cultural Authority*. Routledge, New York.

Klobe, T. (2013). *Exhibitions: Concept, Planning and Design*. American Alliance of Museums Press, Washington, DC.

Lohman, J. & Goodnow, K. J. (eds) (2006). *Human Remains and Museum Practice*. Museum of London, London.

MacGregor, N. (2009). To shape the citizens of "That Great City, the World." In: *Whose Culture? The Promise of Museums and the Debate over Antiquities*, ed. J. Cuno, pp. 39–54. Princeton University Press, Princeton.

McLaren, N. (2010). *Aboriginal Protest Closes 'Offensive' Art Show*. www.abc.net.au/news/2010-10-13/aboriginal-protest-closes-offensive-art-show/2295774

Nordstrand, P. (2004). The voice of the museum: developing displays. In: *Caring for American Indian Objects: a Practical and Cultural Guide*, ed. S. Ogden, pp. 11–14. Minnesota Historical Society Press, St. Paul.

Ogden, S. (ed.) (2004). *Caring for American Indian Objects: a Practical and Cultural Guide*. Minnesota Historical Society Press, St. Paul.

# Subject index

This index gives comprehensive coverage of curation principles and techniques. Coverage of organisms, institutions and people is limited to substantial entries only.